IMPRESSIONISM

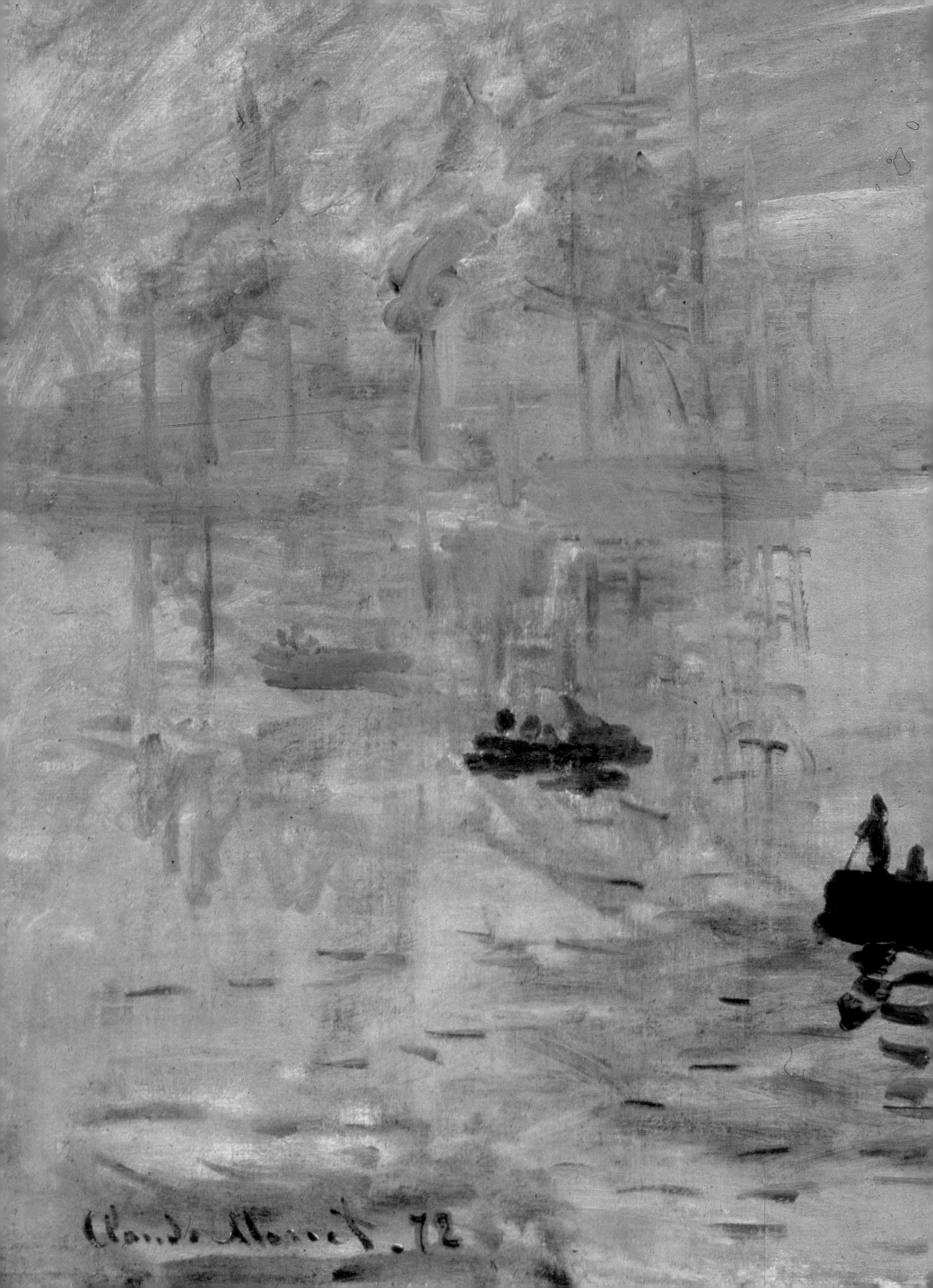

IMPRESSIONISM
The Painters and The Paintings

BERNARD DENVIR

MALLARD
PRESS

MALLARD PRESS
An Imprint of BDD Promotional Company
666 Fifth Avenue
New York, N.Y. 10103

Mallard Press and its accompanying design and logo are
trademarks of BDD Promotional Book Company, Inc.

Copyright © 1991 Studio Editions
Text copyright © 1991 Bernard Denvir

This edition first published by Studio Editions, London
First published in the United States of America in 1991
by The Mallard Press

Designed by Jane Ewart,
Dutjapun Williams and Christine Wood

ISBN 0-7924-5637-8

Printed and bound in Hong Kong.

Frontispiece: CLAUDE MONET *Impression: sunrise* 1872

Contents

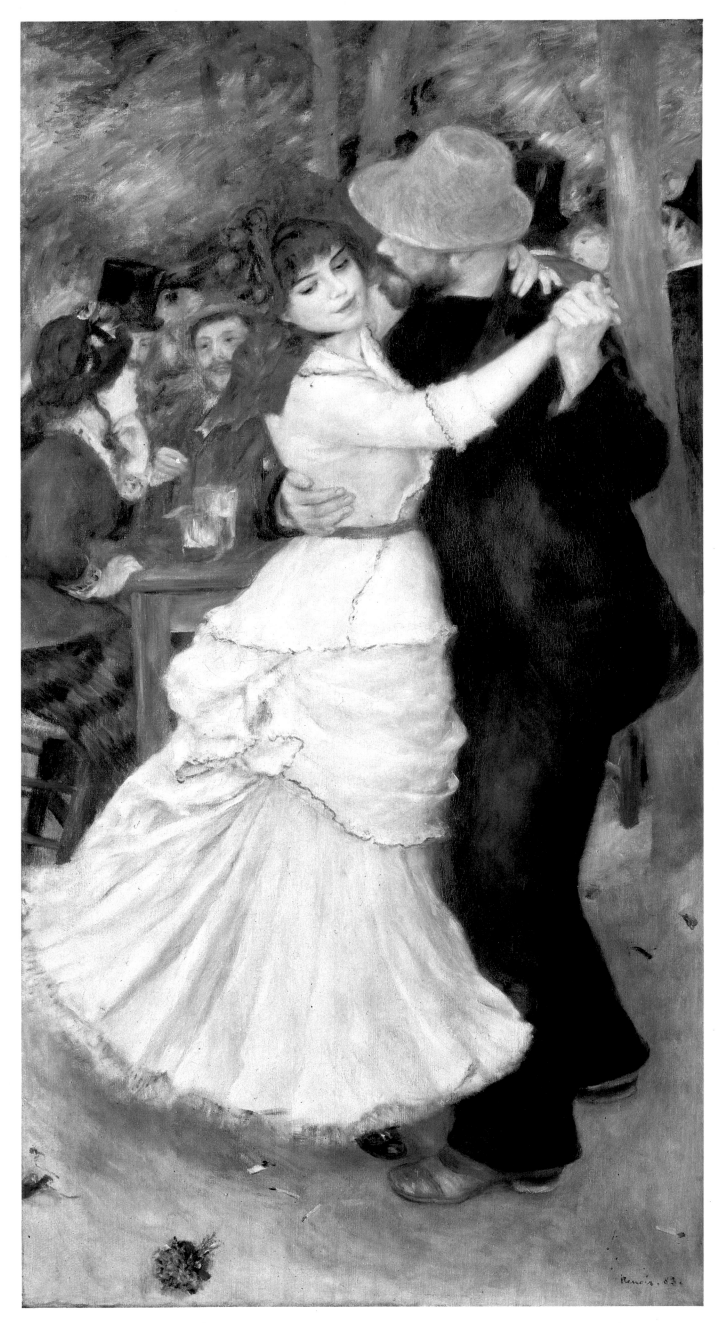

PIERRE-AUGUSTE RENOIR *Dance at Bougival* 1883

Foreword

In the closing years of the twentieth century it would be virtually impossible to write a truly comprehensive survey of Impressionism. Since John Rewald's masterly *The History of Impressionism*, the foundation stone of all subsequent studies of the subject, was first published in 1946, the amount of attention paid to the history of the movement has proliferated at an extraordinary rate. There have appeared massive works such as the huge four-volume catalogue of Monet's works by Daniel Wildenstein, or the catalogue of the Degas exhibition held at the Grand Palais in 1988, with its 700,000 words of text and 500 illustrations, as well as significant scholarly articles in specialized periodicals, such as M. Bodelsen's 'Early Impressionist Sales 1874-94 in the light of some unpublished *procès verbaux*' which appeared in *The Burlington Magazine* in 1968, or the illuminating investigation of Monet's *Déjeuner sur l'herbe* by Hélène Adhémar published in 1958 in the pages of the *Bulletin du Laboratoire du Louvre*. To encompass all these discoveries and present all the new interpretations they embrace within the scope of a single volume, in a form accessible to the general reading public, would demand the possession of powers and erudition beyond the capability of any single author.

In terms of a temporal span I have therefore confined myself, as Rewald did, to what might be called the 'Golden Age of Impressionism' covered by the eight exhibitions which took place between 1874 and 1886, although remaining conscious of the fact that most of the major figures of the movement were still productive during the first two decades of the twentieth century, and that the origins of the movement must be traced back to at least twenty years before it took formal shape.

At the same time too, however, I have tried to present in a digestible form some of the new interpretations of the nature and significance of Impressionism to have emerged in the course of the last twenty years or so, especially in the works of scholars such as Robert L. Herbert, John House, T. J. Clark and Paul Hayes Tucker, to whom I owe a significant and gratefully acknowledged debt. Impressionism is no longer to be seen as a purely aesthetic phenomenon, but as the product of a whole variety of social, economic, and even political pressures which helped to create it, and which it reflected. As a movement it did not possess the tidy coherence which neat-minded historians have sometimes imposed on it, nor were its participants, as I have tried to point out, as consistent in their characters or as single-minded in their actions as hagiographers of the movement would have us believe. In the course of little more than a century Impressionism has moved from a position of contempt to one of universal adulation, when a work by Cézanne can cost $7334 a square inch. It is one of the most remarkable phenomena in the history of art, and this is at least a partial attempt to explain it in language comprehensible to what Virginia Woolf described as 'the common reader'.

It would be almost impossible to acknowledge the debt of gratitude I owe to those who made this book possible, especially my predecessors in the field. I must, however, express my special thanks to Ken Webb, who conceived the idea, to Peggy Vance and Elisabeth Ingles, who guided me to its realization, to Sara Waterson, who with admirable patience and pertinacity secured the illustrations, to Mandy Howard for typing services more extensive and helpful than that phrase would imply, and of course to my wife Joan for her patience and co-operation. It would be almost otiose to praise the admirable facilities offered by the staff and the resources of the London Library to myself, as to so many other writers.

1 CLAUDE MONET *Rue Montorgeuil* 1878

Chapter 1

The Birth of a Revolution

In 1874 the critic Louis Leroy, at the age of 62, was a well-established figure in the French art world. A mediocre genre painter and a skilful if not inspired engraver, he was also a fairly successful playwright, and brought to his journalism something of the humour which he displayed in his writings for the theatre. As an art critic he was influential, especially because his writings were read for their light touch by those who would have jibbed at the more ponderous prose of many of his colleagues. The by now acknowledged power of the press was then a fairly new thing in France, as in the rest of Europe. Improvements in the printing industry, especially the application of steam power to the presses, the abolition of those taxes on papers which had hampered their growth in the eighteenth century, the swift and economical distribution systems made possible by railways, the scope for illustrations afforded by the invention of lithography and improved skills in engraving, as well as the mere fact that, because of the growth of popular education, more people were actually able to read than at any other time in French history meant that, whereas in the early 1850s only some quarter of a million Parisians regularly read newspapers and magazines, by the middle of the 1870s this figure was approaching two million.

It was inevitable that editors, especially of magazines, should turn to art to provide them with some of their copy, for the Parisians were notoriously preoccupied with the subject. The big annual exhibition of contemporary art, the Salon, attracted over half a million visitors during the three months that it was open, and was written about in some 30 or more papers and magazines. Prominent amongst the latter category was *Le Charivari*, which had been founded by Charles Philipon in 1832. A humorous paper – the prototype of the English *Punch* which until the Second World War used as its subtitle 'The English Charivari' – it employed some 200 artists, including Daumier, Grandville and Cham, to illustrate its pages, and paid a great deal of attention to the fine arts. Leroy was a frequent contributor to *Charivari*, both as an illustrator and a critic, and in April of this year he decided to send in a piece he had written about an exhibition which had opened on the 15th at a disused photographic studio situated in the boulevard des Capucines.

It had been mounted by a group of artists, one or two of whom were in their sixties, but most in their thirties, who curiously called themselves 'La Société Anonyme des artistes, peintres, sculpteurs, graveurs etc' (which has nothing to do with anonymity, the phrase 'Société Anonyme' meaning 'Limited Company') and which included Edgar Degas, Paul Cézanne, Félix Bracquemond, Armand Guillaumin, Claude Monet, Berthe Morisot, Camille Pissarro, Pierre-Auguste Renoir and Alfred Sisley. They had chosen this deliberately neutral title after a good deal of discussion precisely because they did not want to be thought of as a 'group' with an avowed artistic style and policy. Degas had, rather poetically, suggested that they called themselves 'La Capucine' after the name of the boulevard, and some 30 years later Renoir told the art dealer Ambroise Vollard, 'I was afraid that if the group was

2 Nadar's studio at 35 boulevard des Capucines, around 1860.

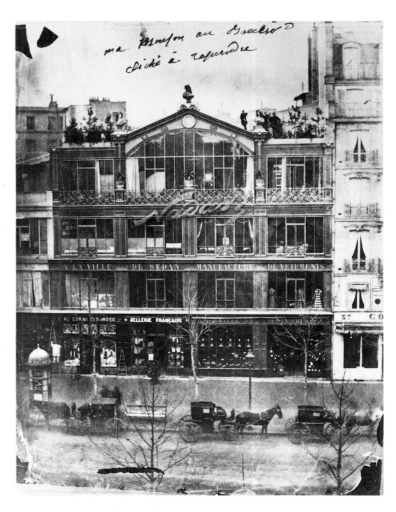

called "The Somebodies" or the "So-and-Sos" or even "The Twenty-Nine"[1] the critics would immediately start talking of "a new school", when all that we were really after, within the limits of our abilities, was to try and induce painters in general to get in line and follow the masters if they really didn't want to see painting sink without trace'. Fate however, in the person of Louis Leroy, decided otherwise.

He had two problems. The first was to devise a formula whereby he could write an amusing account of an exhibition which he found at the very least bizarre. The second was to find a suitably engaging title for his article, for who would read a piece entitled 'The Exhibition of the Limited Company of Artists, Painters, Sculptors, Engravers etc.'? He found the answer to the first by devising the fiction of himself accompanying an imaginary elderly, respected academic painter, M. Joseph Vincent—'recipient of medals and honours under various governments' — around the exhibition and recording his comments. In his own terms it was successful enough, reading rather like a music-hall or vaudeville sketch. The dominant theme was first struck in front of a painting by Camille Pissarro, *The ploughed field*:

At the sight of this astounding landscape, the good man thought that his spectacles were dirty, and wiping them carefully set them on his nose: 'Good God', he said, 'what on earth is that?' 'It's a hoar frost on deeply ploughed furrows,' I replied. 'Those things furrows? That stuff frost? They look more like palette scrapings placed uniformly on a dirty canvas. It has neither head nor tail, top nor bottom, front nor back.' 'Perhaps, but the impression is there.' 'Well, it's a damned funny impression.' Then in front of Monet's painting of the boulevard des Capucines, M. Vincent spoke again. 'Ah-ha', he sneered in a Mephistophelean manner, 'Is that brilliant enough now? There's an impression, or I don't know what it means.' A little later he stopped in front of Monet's *Impression: sunrise*. His countenance was turning a deep red. A catastrophe seemed to me imminent, and it was reserved for M. Monet to contribute the last straw. 'Ah, there he is; there he is!' he shouted in front of No. 98, 'I recognize him; Papa Vincent's favourite! What does the canvas depict? Look at the catalogue, *Impression: sunrise*. I was certain of it! I was just telling myself that since I was impressed there had to be some impression in it...and what freedom; what ease of workmanship! Wallpaper in its embryonic state is more finished than that seascape.'

At last, in front of the attendant looking after the exhibition, Papa Vincent, in a rage, finally confirmed with an initial capital the word which had been the leitmotif of the article:

3 CAMILLE PISSARRO *Ploughed field* 1874

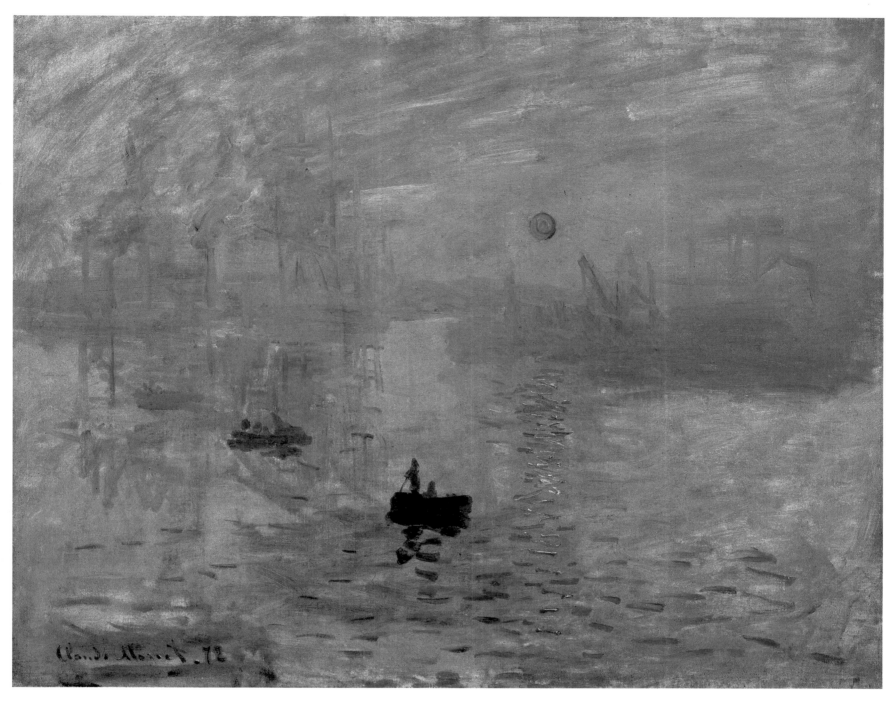

4 CLAUDE MONET *Impression: sunrise* 1872

'Is he ugly enough?' he shouted, shrugging his shoulders. 'From the front he has two eyes, a nose and a mouth. The Impressionists wouldn't have sacrificed to detail in this way.'

Having solved his first problem, Leroy realized that he had also solved his second. He called his review 'The Exhibition of the Impressionists'. The title caught on almost immediately. Any future reference to the group would always describe them as 'Impressionists' and within a year it had spread to the USA, where Henry James used it in an article, as part of the language of the art world. Yet it was intended to be pejorative. Although the word had been used earlier by artists such as Delacroix and Corot, it implied something evanescent and half-finished, entirely lacking in technical detail, and suggesting an instinctive, unthinking approach. In actual fact it had very little to do with either the aims or the techniques of the group, both of which were far more considered, wide-ranging and painstaking than the implied desire to give an 'impression' of anything. Monet himself had chosen the title of his picture merely because he had done several of the same subject, the harbour at Le Havre, and was anxious to hit on a new one for the work he was showing in the boulevard des Capucines

exhibition. Practically all the members of the group at first hated the name; it never appeared on the title-page of the catalogues of any of the seven subsequent exhibitions, which were always described as 'Exhibition of paintings by' followed by the names of the participants. Eventually, however, they came to accept it, and by 1877 Renoir had persuaded his friend the art critic Georges Rivière to start a weekly journal entitled *L'Impressionniste* (it ran for only four issues, between 6 and 28 April, during the course of the third exhibition).

For all his intentional malevolence, Leroy had performed an important public relations service for the group in endowing them with a partially unreal unity. This was always to be repugnant to Degas, and was not well received by Manet who, though he considered himself and was acknowledged as the head of the group, was strangely reluctant to be too closely identified with it and never participated in any of its exhibitions. More importantly, Leroy had given a name to what became the most significant movement in art since the Renaissance, one which was to influence the history of painting in the future, and one which it is the purpose of this book to describe and analyse.

5 EUGENE DELACROIX *Woman with a parrot* 1827
The vitality of his colour and the vigour of his handling made Delacroix a hero
of the Impressionists. His influence is especially apparent in the works Manet
was painting in the 1860s.

The analogy with the Renaissance is not merely fortuitous.
One certain thing about Impressionism is that it was not
the sudden whim of a group of artists working in late-
nineteenth-century France, driven purely by a desire to
create a revolution in painting. It was an essential part of
the unfolding history of western civilization. The Renais-
sance had been the culmination of a movement towards
asserting the importance of the individual human being –
hence its emphasis on 'humanism' – which had been
evolving throughout the Middle Ages, motivated not only
by philosophical concepts but by simple technical innova-
tions such as the use of chimneys, the invention of
spectacles, the discovery of paper, the use of movable type
for printing, and a host of other developments which
improved the physical quality of human life and facilitated
the transmission of ideas. Between the fifteenth and the
seventeenth centuries this produced a group of phenomena,
all of which asserted the importance of the individual in
the order of things. To the hierarchical structure of medieval
religion, with its emphasis on salvation through the medium
of the church, an alternative was offered in the various
forms of Protestantism, with their emphasis on the idea of
the ordinary man establishing a personal relationship with
God, based on his own interpretation of scripture available
in his native tongue and not in an arcane language.
Nascent capitalism, stimulated by the discovery of the New
World, by the adoption of Arabic numerology and by the
invention of double-entry book-keeping, prompted the
notion that man's position in society was not necessarily
preordained and could be improved by his own efforts. In
art, instead of the older reliance on a transcendental
iconography in which images and paintings reflected an
order of things determined by spiritual considerations,
new perspectival disciplines imposed the individual's vision
of what he saw from his own viewpoint. Perspective was
the first vindication of individuality in art, and it was
accompanied by the emergence of named artists as opposed
to the usually anonymous ones of the Middle Ages.

By the second half of the eighteenth century the advance-
ment of the individual was taking another important step
forward, in that cluster of activities in art and literature
generally known as Romanticism. This can be seen as a
vindication of personal feelings and emotions, placing a
greater emphasis on sensibility than on sense, on the
heart, whose reactions are special to each human being,
rather than on the head which was seen as the repository
of inherited ideas, adherence to rules and the acceptance
of preordained categories of excellence. The manifestations
of this were manifold. In politics it led to that most seminal
of events, the French Revolution, and the notion that all
men are 'equal', exemplified in the American constitution.
In art it led to a refutation of the long-held principle that
works of art could be judged by their subject-matter alone,
'history' paintings being superior, for instance, to genre
paintings, religious subjects to profane. It brought landscape
painting into a prominence which it has never lost, because
nature was supremely capable of arousing those deep
responses, those feelings of wonder and delight which had
become essential for any true aesthetic experience. It
promoted the concept of the artist as a person whose
refined sensibilities had to find expression in his work, and
who was therefore a rebel against conventional society, an
image typified by Murger's novel *La Vie de Bohème*, with
all its operatic and literary derivatives; it eventually led to
the virtual canonization of those few artists such as Van
Gogh whose lives actually conformed to this fantasized
concept. More precisely, the emphasis on feeling and

6 EDGAR DEGAS Drawing after Ingres.

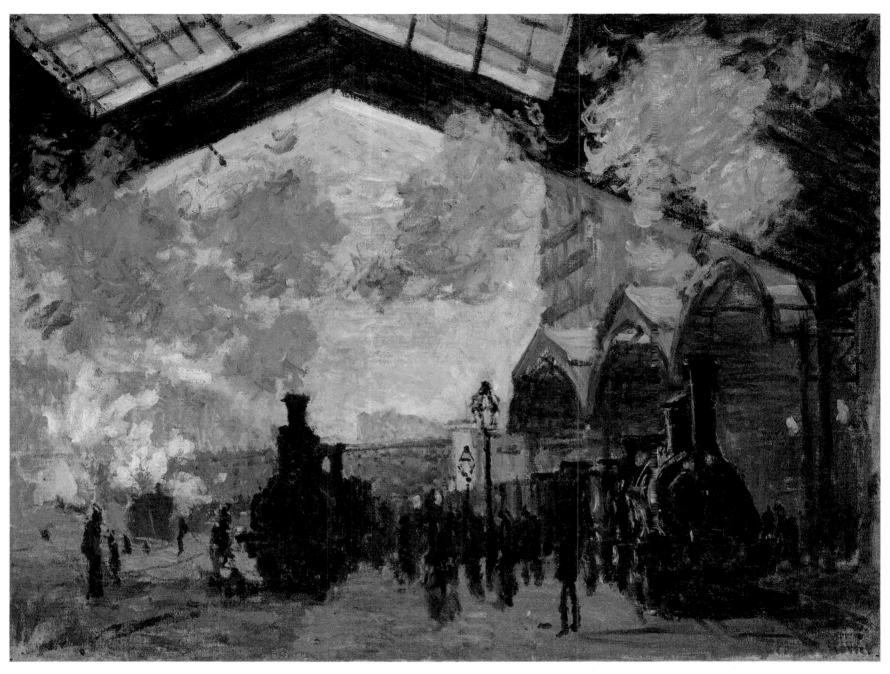

7 CLAUDE MONET *The Gare St-Lazare* 1877

emotion led to a new concern with colour rather than with line – epitomized in the antithesis between Ingres, the classicist, and Delacroix, the romantic.

The Impressionists were nurtured in this romantic tradition, and its influence on their works and careers persisted, even when they had gone beyond its limitations. Landscape played a predominant role in their art – Degas, the heir of Ingres, being, as ever, the exception. Colour was their constant preoccupation, its manipulation constituting one of the basic elements of their special contribution to the evolution of European art. Although they did not see themselves as 'rebels', they were cast in that role by both critics and the general public, as well as by subsequent generations of commentators who have tended to over-emphasize their comparatively brief periods of poverty and exaggerate the hostility with which they were received in their lifetimes. But their most significant contribution to the promotion of individualism was their insistence on painting not what they 'knew' but what they actually saw. On the whole, artists before them transferred to oil and canvas what was in effect an idealized version of the outer world in which, for instance, all shadows were black or dark brown, all landscapes bathed in a fixed, unchanging, motionless light. The Impressionists discovered that shadows were multicoloured, reflecting their environment, that local colours do not exist in nature in their pure state but are influenced by their chromatic context, that light is not static but transient and flickering, and that this effect can be expressed in paint by the use of quick, scattered brush-strokes and similar technical devices. They asserted the primacy of the human eye, the importance of the individual vision. They substituted a perceptual art for a conceptual one, and in so doing staked a claim, for the first time in history, for a work of art to be seen and judged as an object in its own right, independent of any reliance on external criteria.

That they were able to achieve this triumph of subjectivity, admittedly albeit gradually, painfully and often inconsistently, was due in part at least to that seemingly most objective of disciplines, science, and its practical handmaid technology. Man's concern with establishing control over the phenomena which surrounded him by observation, analysis and categorization reached new levels of intensity in the nineteenth century. A typical figure was that of Eugène Chevreul (1786-1889), who at the age of 27 had become Professor of Dyeing in the state-owned Gobelins tapestry factory, and published two important books, *De la Loi du contraste simultané des couleurs et de l'assortiment des*

objets colorés ('On the Law of Simultaneous Contrast of Colours and Matching of Coloured Objects', 1839) and *Des couleurs et de leur application aux arts industriels à l'aide des cercles chromatiques* ('On Colours and their Application to the Industrial Arts with the Aid of Chromatic Circles', 1864). The theories which he put forward were the basis of the Impressionists' approach to colour, which involved the use of all colours mainly without mixing, the separation of local colour from the colour of light, and the use of small dabs of different pure colours side by side to mix in the eye of the spectator and so create a third.

An examination of Renoir's *The Seine at Asnières* (Plate 35) shows that the artist used the following colours: lead white, cobalt blue, lemon yellow, chrome yellow, chrome orange, vermilion and crimson lake, which he applied in unmixed dabs, sometimes painting wet on wet, as in the reflexions on the water in the foreground, sometimes wet on dry to create a haze effect, as in the background. The only mixing of colours occurs where a tiny touch of viridian is introduced to modify the colour of the foliage, which is predominantly yellow-green. The actual creation of colour takes place in the spectator's eye. Looking at the National Gallery version of Monet's *Gare Saint-Lazare* (Plate 7), the eye notices a range of blacks in the roof of the station and the engine. These blacks, however, are made up of dark purple laid on side by side with an intense blue, in the roof

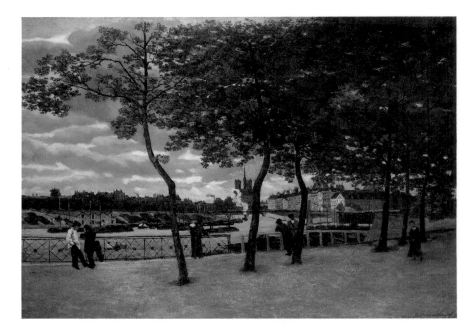

9 ARMAND GUILLAUMIN *The Seine at Paris* 1871
Like Plate 36, this view of another aspect of the Seine was shown at the third Impressionist exhibition of 1877.

the warmer colour predominating to the right, the cooler to the left.

Technology too, at various levels, made possible certain aspects of the Impressionists' technique which would have been impossible before. Round about the middle of the century synthetic pigments derived from the by-products of industrial processes made their first appearance, including the clear-toned cobalt blue so favoured by Renoir, cerulean blue, yellow and orange cadmium, the alizarin crimsons, the coal-tar group (which included Prussian blue), composed chiefly of carbon, hydrogen and nitrogen, with the frequent addition of sulphur or iron, and permanent green viridian, the brilliant transparency of which had been unavailable to earlier artists. These new pigments and the older ones were available too in more accessible forms. A patent for collapsible tin tubes for use with oil colours had been taken out by an American, John Rand, in 1842 and had become of universal use by the time the Impressionists had started painting, thus making easier the practice of painting in the open air which was an essential part of their technical approach. In 1844 the English firm of Reeves had started producing watercolour paints using virgin wax instead of gum, and marketing them in gutta-percha pans, arranged in tins which could be conveniently carried around for outdoor use. The use of metal ferrules which could be formed by pliers into different shapes to join the bristles of a brush to the handle, making stronger brushes than the older type which had used twine, had become common by the 1850s, so allowing the Impressionists to apply their pigment with more vigour than had previously been possible. Nibs, which, until the advent of cheap postage systems with the arrival of railways, had been costly to manufacture, were now mass-produced and available in a far greater variety of styles and shapes. New instruments and new processes – some activated by electricity – were becoming available and were experimented with extensively by Degas, Pissarro, Bracquemond, Guillaumin and others, as well as that enthusiastic amateur Dr Gachet (see p.218).

The industrial revolution which had made these technical

8 FREDERIC BAZILLE *Portrait of Renoir* 1867
Renoir was 26 when Bazille, his close friend, painted this relaxed portrait of him, suggesting the lively, humorous person he then was.

advances possible transformed Europe in the nineteenth century and influenced the lives and work of the Impressionists in a wide variety of ways. Railways started to proliferate mainly during the reign of Napoleon III. In 1848 only 1,931 kilometres had been built in France but by 1870 this had risen to 18,000 kilometres. Not only were previously remote areas of the country opened up but new prosperity and importance were brought to the towns and villages which were on the line. The growth of the railways enabled the Impressionists to visit easily and frequently those places which became closely associated with them: the villages on the Seine such as Bougival. Chatou, Asnières and Argenteuil and the Channel resorts such as Etretat, Le Havre, Honfleur and Sainte-Adresse. It also opened up Provence and the south of France. When Cézanne first came to Paris the journey took him three days; by 1890 he could do it in one. The landscape possibilities of all France and most of Europe became accessible with an ease unknown in the past. In the course of his career, for instance, Monet visited Africa, Norway, Italy, Holland, Spain and England – the latter many times. The development of gas and electric lighting – Paris was the first city in Europe to be lit by electricity – extended the working day and made it possible, for instance, for the first of the Impressionist exhibitions to remain open until ten o'clock in the evening. Large department stores like the Bon Marché and the Galeries Lafayette sold mass-produced clothes at low prices and so provided painters such as Renoir with gaily dressed young women to throng their paintings with an elegance and colour which would have been impossible for working girls of an earlier generation.

More directly pertinent to the nature of the Impressionists' art was the invention of photography, which within a few decades had established itself as the most popular visual art of the century. As early as 1849, ten years after Daguerre's process was made public, 100,000 of his productions were sold in Paris alone, and the pessimistic comment of the academic painter Paul Delaroche, 'From today painting is dead', seemed to many when he made it in 1850 a reasonable prognostication. Among the first casualties were the painters of miniature portraits, who disappeared from the artistic scene until the increasing vulgarization of camera portraits brought them back again at the beginning of the next century. But the camera had relieved art of one of its most inhibiting functions, that of being a mere recorder. With the apparent realism of a machine which could not lie documenting people and places, painters could pursue their more private goals – as the Impressionists did – with a new freedom. They took advantage of the camera too. Degas is the most obvious example of this (see p.288) but Corot, Bazille, Monet (despite his protestations to the contrary) and Cézanne all relied on photography – although, except for Degas, they were reluctant to admit to it. The camera influenced how people saw things in a multiplicity of ways. Degas spoke about its 'magical instantaneity', a quality which was reinforced in the 1880s when the 'snapshot' camera was introduced by Kodak. In 1900 it was estimated that 17 per cent of the people admitted to the Paris Universal Exhibition carried portable cameras; Zola was a particular enthusiast about them and a gifted one at that.

The influence of photography on the general visual sensi-

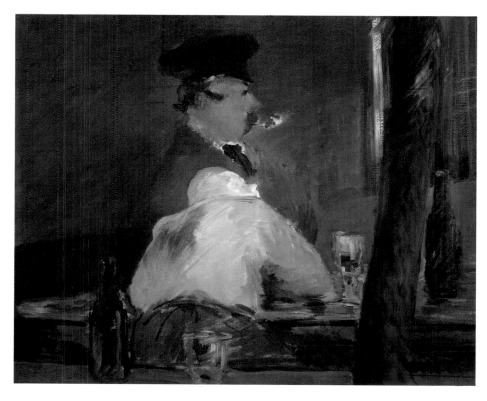

10 EDOUARD MANET *The Bar* 1878
The sketch-like quality of the brushwork suggests that this was the fruit of one of Manet's perambulations of the bars and cafés of Paris.

bilities of the age, and one which had a great deal to do with the nature of Impressionism, went beyond the uses which individual artists made of the camera. Despite the improvements in engraving processes, until the advent first of the camera and then of the half-tone plate which allowed photographic images to be mass-produced in papers and magazines, nobody had any accurate idea of the appearance of people and places outside the range of their own individual experience. Photographic imagery produced a new visual awareness which led to a scepticism about the idealized imagery of academic art. Anybody who had seen the photographs of the nude produced by people such as Julien Villeneuve (see pp.88, 89) could no longer take at their face value the naked ladies of Bouguereau and started, albeit reluctantly, to demand from painters something of that realism which it was the avowed intention of the Impressionists to express.

Photography too had a more specialized contribution to make. Until its invention people's knowledge of the art of the past or beyond their own topographical limits was limited to engravings of varying degrees of accuracy. Now all this was changed. Firms such as Alinari of Florence made available excellent black and white photographs of paintings and monuments, thus enlarging notions about the nature of art entertained by those whose previous experience of it had been restricted. In France the role of Alinari was taken on by Adolphe Braun (1811-77), who had the exclusive right to reproduce paintings in the Louvre, and who had teams of photographers visiting the museums and art galleries of Europe, eventually amassing a stock of 20,000 different reproductions. Unlike Alinari, however, he also photographed contemporary art, making his choice from among the works accepted by the Salon, but sometimes going further afield. By the end of the century he had 9,000 modern works available, including many by Millet. Corot and Puvis de Chavannes, as well as one by Manet, two by Monet and five by Degas. Colour

also came to play an increasingly significant role in the reproduction of works of art, first through the medium of chromolithography and then through colour photography, one of the pioneers of which was the poet Charles Cros (1842-88). The Impressionists themselves and the public on whose support they depended were far more visually sophisticated than any previous generation had been.

The industrial revolution had changed much more than techniques and visual attitudes. The Impressionists lived through a monarchy, an empire, two republics and, for a very short time, a Commune. These political tergiversations however were trivial compared with the basic changes in society which they disguised but did not control. A whole new moneyed class had evolved with its own standards, its own cultural preoccupations, its own way of life, so vividly described in the novels of Zola. If its representatives could be seen as politically dominant, however, the backbone of social life was what might be described as the middle bourgeoisie; it was from their ranks that the Impressionists were largely drawn, and it was they who produced most of their patrons. Manet came from a dynasty of magistrates, Degas from an aristocratic banking family which had spread its interests into various mercantile undertakings; Sisley's father was a rich English businessman involved in trade with America, Bazille's an affluent vineyard owner and wine producer from the Montpellier region; Morisot was the daughter of a high-ranking civil servant from Bourges with strong monarchist leanings, Pissarro came from a family which had made its fortune trading in the West Indies, and later moved to Paris. Cézanne's father, who in one way or another dominated most of his life, had started off as a hat-maker in Aix-en-Provence but, by lending money to the farmers from whom he bought the skins used in his trade, amassed enough capital to buy the only local bank and became one of the city's leading citizens. Caillebotte's family were successful textile manufacturers from Normandy, who increased their fortunes by speculating on the Paris property market. The American Mary Cassatt was the daughter of a wealthy Pittsburgh businessman. The only near-exceptions to this rule were Monet, whose father had left Paris in 1845 to work in his brother's wholesale business in Le Havre, and Renoir, whose parents had migrated from Limoges to Paris and opened a tailoring business in Montmartre. But both families became rich enough eventually to buy country homes for their retirement.

There were dangers, however, in the world of speculative capitalism, on which they all depended. The American Civil War and the Franco-Prussian War ruined the Sisleys and reduced their son to penury for the latter part of his life. Degas's brothers became involved in hazardous, if not shady, speculations, and he devoted most of his own inheritance to paying the family debts at a time of his life when he might reasonably have expected relief from financial worries. The dealers who handled the work of the Impressionists, depending as they largely did on borrowed money, were especially vulnerable to the winds of economic change. Durand-Ruel, the dealer with whom they were most intimately connected, experienced many changes of

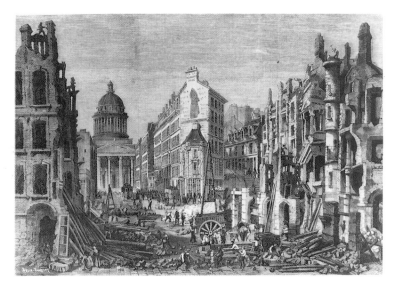

11 Demolition of a portion of the Latin Quarter, 1855.

fortune. His first big set-back was in 1874 when the boom which France had unexpectedly enjoyed after the Franco-Prussian War came to a sudden end. The depression which followed stopped him making any further acquisitions, so encouraging his artists to stage their first exhibition in the boulevard des Capucines. He retrieved his position within a year or so and secured the backing of the Catholic bank, the Union Nationale, but it crashed in 1882, leaving him for a short time on the edge of bankruptcy, from which he was largely saved by the growth of the American branch of his firm, opened in 1886. Obviously economic changes greatly affected the sale of the Impressionists' work, and these were especially violent in the period between 1871 and 1885, when they were still financially insecure. This was shown dramatically in 1875 when a group of them decided to try selling their works at the Hôtel Drouot, the state-controlled auction house. Because of the depression, and partly too because of the hostile reaction of the audience, it was a disaster. Half of Renoir's paintings did not even reach 100 francs (about £25 or $50) and he had to buy several back. Monet's works sold at about 200 francs each, and Sisley's ranged from 50 to 300 francs. In all cases the prices they got were far below what they were getting from Durand-Ruel and private buyers.

Despite these economic fluctuations, however, and despite the disastrous war of 1870 and the subsequent troubles, France was a prosperous country with an expanding empire in Africa and Indo-China. Infant mortality dropped to 179 per 1000 in 1900 and during the same period the number of houses rose from seven million to nearly ten million. Between 1850 and 1870 wages rose by 45 per cent and profits from all businesses by 280 per cent. Education improved remarkably; a network of provincial universities was established in 1897, and at both primary and secondary level a new emphasis was placed on art education. The period between 1875 and 1914, the period of the Impressionists, deserved the title subsequently bestowed on it – admittedly with some nostalgia – of the *belle époque*.

It was, above all else, a period of rapid urbanization. Never before had so many people lived in such close proximity to each other in large towns and cities. It was these urban inhabitants who provided the Impressionists with their main source of inspiration, not the aristocrats who featured in the art of the eighteenth century nor yet the peasants so

beloved by Millet, but the dressmakers, laundresses, prostitutes, dandies, professionals and ordinary people who walked the streets of Paris.

The capital had always been unique. As early as the reign of Louis XIV, who for political reasons wished to diminish the power of the local nobility with their regional bases, governments had striven to give Paris an importance in the life of the nation possessed by no other European capital, with the possible exception of Vienna. The Paris of the Impressionists would have been completely unrecognizable to the contemporaries of Delacroix and Ingres. Between 1840 and 1900 its population trebled. fed by immigration from the countryside and the provinces. This is typified by the Impressionists themselves: they were nearly all from the provinces or born abroad, and although both Degas and Sisley were born in Paris, the parents of the one were Italian, of the other English. Only Manet came from purely Parisian stock. Between 1850 and 1870 the city had been transformed in appearance, largely by Napoleon III

and his imaginative Prefect, Baron Haussmann. Thirty-one miles of large tree-lined boulevards were cut through the mass of narrow streets, each with its splendid perspective and wide pavements allowing the proliferation of those *terrasses* outside cafés and restaurants where so much of the social and cultural life of the city went on. One commentator in 1864 described the boulevard des Italiens as 'a long open-air room, where waves of humanity follow one another, a room that is enlivened in the evenings by innumerable gas-jets'. New systems of water-supply and drainage removed the foul smells which had once been the city's distinguishing characteristic and so reduced the incidence of cholera, which in 1836 had carried off more than 20,000 of a population at that time numbering

12 CAMILLE PISSARRO *Boulevard des Italiens* 1897
The most impressive aspect of the rebuilding of Paris under the Second Empire was the great network of boulevards, providing the setting for an urban life of unparalleled colour and movement which so attracted Pissarro, Renoir and Monet.

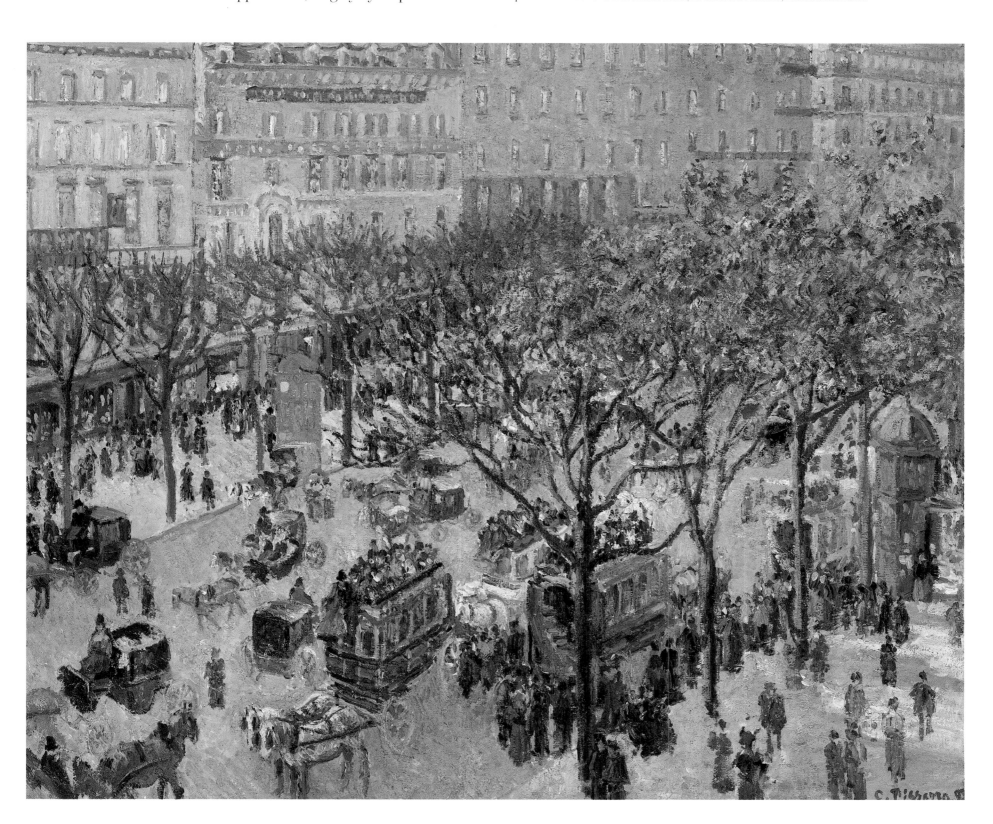

861,000. Public parks on the English system were laid out, not only in the centre but at Vincennes, Boulogne and the Buttes-Chaumont. Huge and spectacular buildings conferred on Paris a sense of grandeur: Charles Garnier's Opéra, the rebuilt Hôtel de Ville, as well as constructions such as the Palais de l'Industrie, built to accommodate the international exhibitions which took place from the late 1850s. Then there were the cathedral-like stations and the massive food market at Les Halles. Ostentatious private residences and great department stores proliferated.

Paris had indeed become the capital of Europe, despite its ordeal in 1870, and it attracted a constant flow of visitors from all over the world. In 1867 Thomas Cook was able to offer four days in Paris to his compatriots for £1 16s. to see the Universal Exhibition, lodging half of them in special accommodation at Passy. Over 12,000 took advantage of the offer. Not all the visitors were tourists. From about 1850 there were innumerable Americans studying art in Paris, the most famous being Whistler and Mary Cassatt, who became one of the leading Impressionists.

Paris of the second half of the nineteenth century was made for the Impressionists, and they for it. No other group of painters has ever recorded so felicitously the

13 EDOUARD MANET *George Moore* 1879
The Anglo-Irish novelist and critic was 27 when Manet drew this portrait of him in pastel. Moore thought it unflattering.

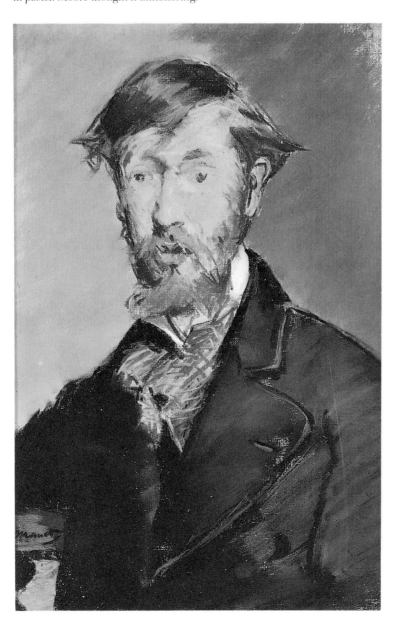

genius loci of a modern city, its unique qualities giving so many of their paintings a character which they could not have achieved elsewhere. In 1868 Eduardo de Amicis, an Italian, was one of the many visitors to the city and he published his impressions in a book which was translated into English some years later, *Studies of Paris* (New York 1882). Few have recorded better than he the splendour of what he called 'this vast glittering net'.

At night the boulevards are blazing. Half closing one's eyes it seems as though one can see on both sides two rows of flaming furnaces. The shops cast floods of brilliant light and encircle the crowd in a golden dust. The kiosks which extend in two interminable rows, lighted from within, with their many-coloured panes, resembling Chinese lanterns placed on the ground, give to the boulevard the fantastic and child-like aspect of an oriental fête. The numberless reflections of the mirrors, the thousand luminous points shining through the branches of the trees, the illuminated signs on the fronts of theatres, the rapid movement of carriage lamps, that seem like myriads of fireflies agitated by the wind, the purple lamps of the omnibuses, the great flaming halls opening onto the streets, the shops which resemble incandescent caves of gold and silver, the thousands of illuminated windows, the trees which seem to be on fire, all these theatrical splendours, half concealed by the leaves of the trees, whose movements allow one to see a partial view of the illuminations, and present the general vista in successive sections – all this broken light, refracted, variegated and ever-shifting, falling in showers, collected in cascades, and scattered in stars and diamonds, produces, when one sees it for the first time, an impression of which no idea can be given.

Paris was a city designed for the pleasures of the eye and of the senses, and the places which catered for them are scattered throughout the iconography of the Impressionists: the Folies-Bergère, the corridors and stage of the Opéra, the dance-halls of Montmartre, the brothels of the Porte St Denis, the brilliance of the cirque Fernando, the powerful imagery of the great railway stations, the boulevards themselves; Impressionism could hardly have existed without them. But above all else there were the numerous cafés.

In his *Confessions of a Young Man* (1888) Moore wrote, 'He who would know something of my life must know something about the academy of fine arts. Not the official stupidity you read about in the daily papers but the real French academy, the café', and it could be said, with considerable justification, that the theory and practice of Impressionism were evolved and that its programmes were hammered out there. Unlike most Nordic peoples, the French lived public lives. The transformation of Paris by Baron Haussmann prompted the rapid expansion of the café phenomenon, on which foreign visitors have commented from the days when Voltaire popularized the Procope to those in which Jean-Paul Sartre and his companions converted the Deux-Magots into a tourist attraction. By the end of the century there were no less than 24,000 cafés in the Parisian area, a large proportion of which catered for a specialized clientèle, determined by their regional origin, Brittany or the Auvergne for instance, by their sporting interests, or by their trade or profession. Going to the café was part of the ritual of daily life, allowing easy social intercourse, but not imposing it, so that people could choose solitude or gregariousness. It provided ink, pen and writing paper, all the latest journals (some had more than 50 on display), and an enormously

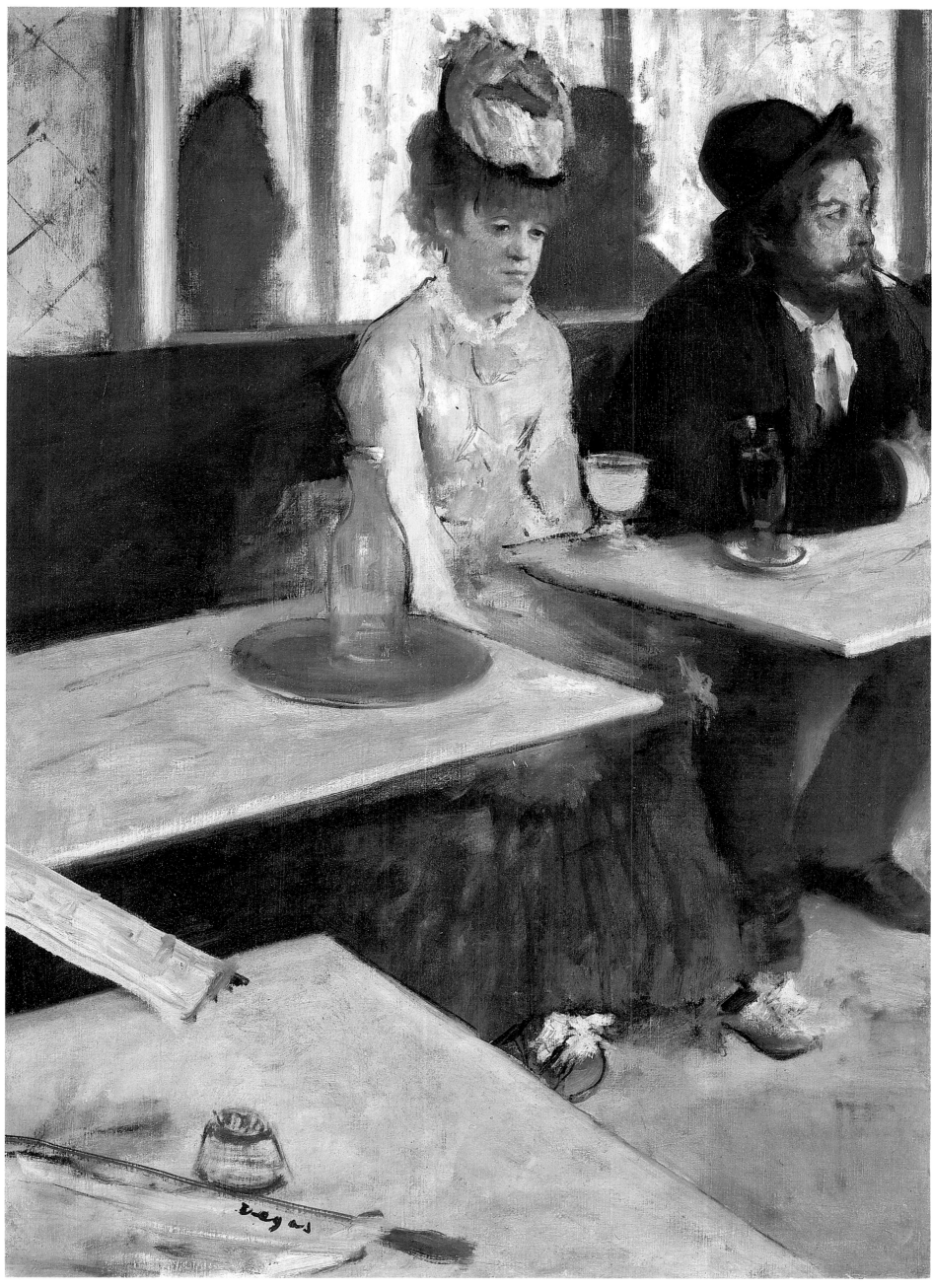

14 EDGAR DEGAS *The absinthe drinker* 1876

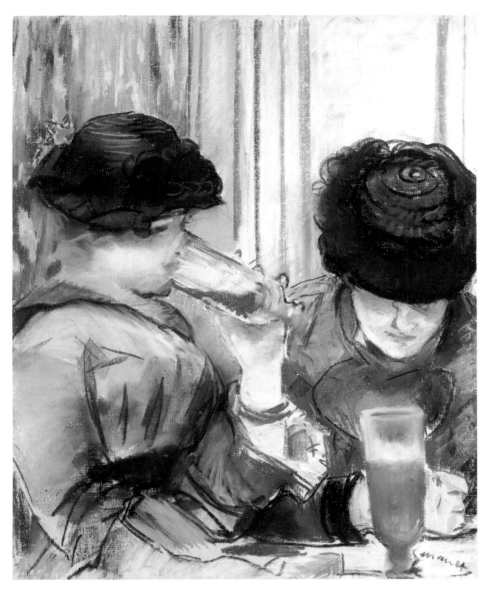

15 EDOUARD MANET *Two women drinking beer* 1878
Complementary to *The bar*, this sketch of two women forms part of the extensive
repertory of images of the popular life of Paris which Manet built up in the
course of his career.

wide range of drinks from coffee and lemonades to the
newly fashionable *apéritifs*. These were, at that period,
considered harmless and encouraged women to invade
what till the middle of the century had been considered a
male preserve. By 1874 the French were drinking some
two million gallons a year of absinthe, 'the green fairy',
which was subsequently discovered to be a cumulative
poison and contributed very largely to the deaths of Van
Gogh and Toulouse-Lautrec. (None of the Impressionists
or their associates, with the exception of Jongkind, had
alcoholic problems of any kind.)

If the birthplace of Impressionism can be pinpointed, the
most convincing candidate is the Café Guerbois at 11
Grande rue des Batignolles, a street subsequently trans-
formed into the boulevard Clichy. By the 1870s Manet had
developed the habit of going there almost every day round
about six o'clock. He established what was in effect a kind
of court of fellow painters and critics, of whom the most
regular attenders were Zacharie Astruc (1833-1907), critic,
painter and sculptor, who had once hailed him as 'one of
the greatest artistic characters of his time', Duranty, Duret,
Cézanne's friend the rather conservative Antoine Guillemet
(1843-1918), Bazille and Bracquemond. Renoir, Monet,
Degas and Fantin-Latour were frequent visitors, and
always turned up on Thursday, the *nuit par excellence* for
the group to discuss common ideas and evaluate the works

of their contemporaries. Monet, who, like Cézanne and
Pissarro, was usually living outside Paris at this period,
came whenever he could, and subsequently commented:
'Nothing could have been more interesting than those
frequent endless discussions with their constant clash of
opinions. They kept our wits sharpened, they filled us with
stocks of enthusiasm which sustained us for weeks and
weeks, until we finally gave expression to the ideas which
had been born there. From these discussions we emerged
with a more resolute will, our ideas clearer and more
defined.' One of the other habitués of the Guerbois was
the critic, novelist and journalist Armand Silvestre (1837-
1901), who in his autobiographical *Au pays du souvenir*
(1892) devoted a whole chapter to describing the place and
its customers. Two characters predominate in his account:
Edouard Manet,

With his often gaudy trousers, his short jacket, his flat-brimmed hat set
on the back of his head, always wearing immaculate suede gloves....
Although very generous and very good-hearted, he was deliberately
ironic in conversation, and often cruel. He had a marvellous command
of the annihilating and devastating phrase. But at the same time his
expression was always benevolent, the underlying idea always right

and Edgar Degas,

Amongst the other figures to be detected in the gaslight of the Café
Guerbois against the clicking of billiard balls on the table, I would like to
pick out the painter Degaz [sic][2], who never used to stay seated for long;
Degaz, with his very Parisian, very original looks, infinitely mocking and
witty.

With two such conversational *agents provocateurs*, it is not
surprising that tempers on occasion became frayed.
According to Antonin Proust, a discussion between Manet
and Duranty led to a duel in the forest of St-Germain on
23 February 1870, with Zola acting as Manet's second. It
was apparently fought with considerable energy, so ill-
directed, however, that neither participant was injured and
they were seen again amicably together that same evening
in the Guerbois.

16 EDOUARD MANET Drawing of the Café Guerbois at 11 rue des
Batignolles, now avenue de Clichy, 1869.

Duels of a more verbal and possibly more bitter kind seem to have gone on frequently between Manet and Degas, about whom Duranty was especially revealing in his *Au pays des arts*, published in 1888:

An artist of rare intelligence, preoccupied with ideas which seemed strange to the majority of his colleagues, taking advantage of the fact that his brain worked instinctively without method or logical progression, and it was always boiling over with ideas. They called him the master of intellectual chiaroscuro.

A frequent visitor was Zola, who was by this time rapidly establishing himself in the pages of *L'Evénement* as the defender of the doctrines and ideas which circulated round the café and who as well as being a critic had recently published his first important 'realist' novel, *Thérèse Raquin*. Silvestre described him as being

still in a period of struggle, though the prospects of a not too distant triumph were already visible in the serenity of his gaze and the quiet firmness of his speech. You had to be blind not to get an impression of the man's mind just by looking at him....His most striking features were the patent power of thought written on his forehead, as well as his restless and searching spirit, suggested by his fine but irregular nose and finally the determined line of his mouth and a Caesarean chin. It was impossible not to expect from him something strong, wilful, bravely opposed to convention, something personal and audacious. He always spoke with the calmness of somebody sure of himself in a voice that lacked sparkle but which was cutting and precise, expressing in a picturesque but not unduly figurative way ideas that were invariably lucid.

Zola himself was less phrenologically inclined when he used characters from the Guerbois to people his novels. Here, for instance, from *Le Rêve* is Bazille,

Tall, blond and slim, very distinguished. A little the style of Jesus, but virile. A very handsome fellow. Of fine stock, with a haughty, forbidding air when angry; very good and kind usually. The nose somewhat prominent. Long, wavy hair. A beard a little darker than the hair, very fine, silky in a point. Radiant with health. A very white skin with swiftly heightened colour under emotion. All the noble qualities of youth; belief, loyalty, delicacy.

Compared with this paragon, other frequenters of the café were variously described as a good deal less attractive. In Zola's notebooks, which he carried with him everywhere, Cézanne went down as tall, thin, bearded with knotty joints, with narrow, clear, tender eyes, a little stooped and prone to an habitual nervous shudder. Both Renoir and Monet, perhaps (as John Rewald suggests: *The History of Impressionism*, 1973, p.202) because they had both left school early and came from more humble backgrounds than the others, were very unobtrusive. Renoir was the more lively, with a complete lack of concern for either theories or sophisticated jokes, sprinkling his conversation with Parisian slang, and resolutely refusing to be classed as a rebel in art.

Of all the Impressionists, Manet seems to have been the one most deeply interested in the café as a phenomenon in itself, apart from the facilities for social intercourse which it afforded. It was a theme to which he was to revert frequently in the course of his career. In 1873 he had had accepted at the Salon a portrait of the engraver Emile Bellot seated in the Guerbois, a glass of beer in his hand,

entitled *Le bon Bock* ('A good glass of beer', Plate 172). Six years later, when he had become, as it were, a fully-fledged Impressionist (see p.254), he reverted to the beer-drinking theme in *Woman reading in a café* (Art Institute of Chicago) in which, although the beer is still evident on the table beside her, the atmosphere is light and sophisticated, showing in luminous colouring one of the more 'liberated' women of the time, assured of her position even in such a context. In the same year he also went to a café with a garden, a few doors away from the Guerbois, to paint the owner's son chatting hopefully to Judith French, a cousin of the composer Offenbach. This picture, *Chez le Père Lathuille* ('At Père Lathuille's', Plate 32) was a more psychologically interesting work, typical of Manet's constant preoccupation with people coming into contact with each other. The scenario has been imaginatively analysed by Robert L. Herbert in his *Impressionism, art, leisure and Parisian society* (Yale 1988, p.68).

The pair in *Chez le Père Lathuille* have been described as 'lovers', but this is not so. Manet's vignette of Batignolles life is more subtle than that, and careful observation discloses the particular adventure that is taking place here on the edge of the city. The waiter is holding a coffee urn, doubtless wondering if it is time to serve coffee to this table. He would wish to do so because the woman is his last customer – at least the tables beyond the glass partition are empty. Of course he would serve coffee only at the end of a meal. On the table, in effect, we see the last course. The woman holds a broad-bladed fruit knife in her right hand, and on the plate between her hands is a rounded fruit. The waiter therefore is right, she should soon finish her fruit and be ready for coffee. By now we have noticed there is only one place setting, the man has none. The wine glass he touches is not his, it is the woman's, white wine to go with her fruit. He fondles her glass, the familiar gesture by which a man encroaches on a woman's terrain. His right arm rests on the back of her chair, another territorial manoeuvre. As for her, she has leaned forwards and avoids his touch, her back very erect. In truth her whole body is proper and stiff, her gloved arms forward in sphinx-like rectitude. Will she succumb to his blandishment? The fact is that this

17 A contemporary view of the rue des Sept Arts, one of the main thoroughfares of the Left Bank.

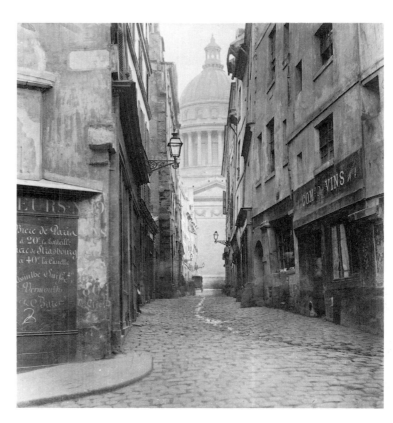

young man did not come to this restaurant with her. Not only does he lack a meal, he lacks a chair. In the American vernacular, he is putting the make on her. She is a well-got-up woman dining alone, and he is a young artist or fashionable Bohemian on the look-out for a conquest.

It is obvious that a taste for problem pictures in the nineteenth century was not confined either to the British Isles, or to academic painters.

Marital boredom and beer rather than flirtation and white wine are the dominant theme in another of Manet's café paintings, *At the café* (Oskar Reinhart Collection, Winterthur), painted in 1878, whilst the *Café-Concert* (The Walters Art Gallery, Baltimore) of the same year depicts the more mondaine and erotic world of the Brasserie Reichshoffen on the boulevard Rochechouart with a girl looking disconsolately out of the picture, a cigarette smouldering in her hand, a *bock* in front of her. Beside her a dandified older man stares almost aggressively in the opposite direction. Between them a waitress is finishing off what seems to be the remnants of a customer's beer. Reflected in the mirror is the figure of the singer *La belle Polonaise*. Equally disconsolate, though pastel-pretty in its delicate colouring, is *The Plum* (Plate 18), also painted in 1878, showing a young girl seated at a café table, waiting for someone, possibly a client, a look of utter desolation on her face, an untouched glazed plum in front of her in a glass dish.

Degas, when he came to dwell on the bitterness of pleasure-seeking and the sense of loneliness which can afflict people in the apparently social conviviality of café society, chose the background of the Nouvelle-Athènes for the famous work now known as *L'Absinthe*, but which he himself called *Dans un café* when he painted it in 1875–6 (Plate 14). It shows Ellen Andrée and the engraver Marcellin Desboutin seated at a rather roughly planed table, she with an absinthe in front of her, he with a more conventional *apéritif*. Neither has any eye or other contact with each other; she looks sulkily bored, he morosely reflective as he smokes a pipe which apparently was never out of his mouth. Degas had painted it specifically for the second Impressionist exhibition, held in 1876, but was not able to finish it in time. At the end of the year, when he had done so, he sent it to an exhibition in England; it was bought by a Captain Hill, who lived in Brighton and exhibited it there in September under the title *A Sketch in a French café*, clearly using the word sketch to explain to English viewers what must have seemed to them, accustomed as they were to the smooth finish of painters such as the Pre-Raphaelites, the apparent crudity of the technique. In the following year it was sent back to France to feature, along with other paintings by Degas on similar café subjects, in the third Impressionist exhibition. Chief amongst these was *Women on a café terrace; evening* (Plate 19), a pastel showing four bored prostitutes seated outside what seems to be a café on one of the boulevards, clearly discussing their professional problems, one of them tapping her finger reflectively on her teeth in what one commentator suggested was annoyance at the smallness of the fee she had just received. Degas himself, later in life, was to describe the work as 'too cynical and cruel', but, whatever might be thought of its subject-matter, it is a superb composition, remarkable for its simplicity and the finely balanced division of the work by the vertical lines of the café pillars.

The Paris of the Impressionists was not just a city of pleasure, a centre of self-indulgence and sexual licence. The intense humiliation of the war and its aftermath had stimulated an immense sense of national pride, and a determination to recreate the past greatness of France which took many different forms. In the *Gazette des Beaux-Arts* of October 1871, for instance, one writer stated,

Today, called by our common duty to revive France's fortunes, we shall devote more time to the role of art in the nation's economy, politics and education. We shall continue to back the cause of beauty so closely allied to the causes of truth and goodness. And we shall struggle for the triumph of those teachings which will help the arts to rebuild the economic, intellectual and moral grandeur of France.

Between 1870 and 1900 the national income doubled, and one of the less obvious results of this was that the buying of works of art was spread amongst a far wider section of the population. Of the patrons of the Impressionists only a few, such as the Prince de Wagram and the Bibescos, were aristocrats. Gachet and De Bellio were doctors, Faure and Chabrier musicians, Chocquet a civil servant, Murer a patissier and café owner, Charpentier a publisher, Hoschedé a department-store owner and the Abbé Gaugain a priest and teacher. As one writer, Georges de Sonneville, put it in 1893, 'Every rich family is necessarily obliged to collect a gallery of pictures, and this for two compelling reasons: first from a taste for modern luxury, and secondly because the possession of wealth has its obligations.'

To satisfy this demand, in Paris alone by 1874 there were 112 picture dealers. Outstanding amongst these was Paul Durand-Ruel (1831-1922), whose father had been one of the first to support Delacroix and sell the works of Corot, Daubigny and others at that time considered advanced. Paul, who took over the business in 1865, introduced into dealing the notion of seeking a monopoly of the works of artists whom he patronized, and started by building up a stock of the Barbizon School (see pp.55-6). In 1866, for instance, he bought 70 paintings by Théodore Rousseau. When, in temporary exile in London, he came into contact with the future Impressionists, first of all through Pissarro and Monet, he decided to take them under his wing. In 1872 he exhibited in his London gallery works by Monet, Pissarro, Sisley, Manet and Degas and in the same year bought 23 paintings from Manet's studio for 35,000 francs. Astute, enterprising and commercially imaginative, he had a keen sense of public relations, producing an expensive catalogue of his stock, suborning critics to write favourably about his exhibitions and himself producing, for a short period, a magazine, *Revue de l'art et de la curiosité*, in one issue of which he expounded his own views: 'A true picture dealer should also be an enlightened patron; he should, if necessary, sacrifice his immediate interests to his artistic convictions and oppose rather than support the interests of speculators.' No other dealer was more resourceful in seeking out new market openings. Although he did not continue his gallery in London for

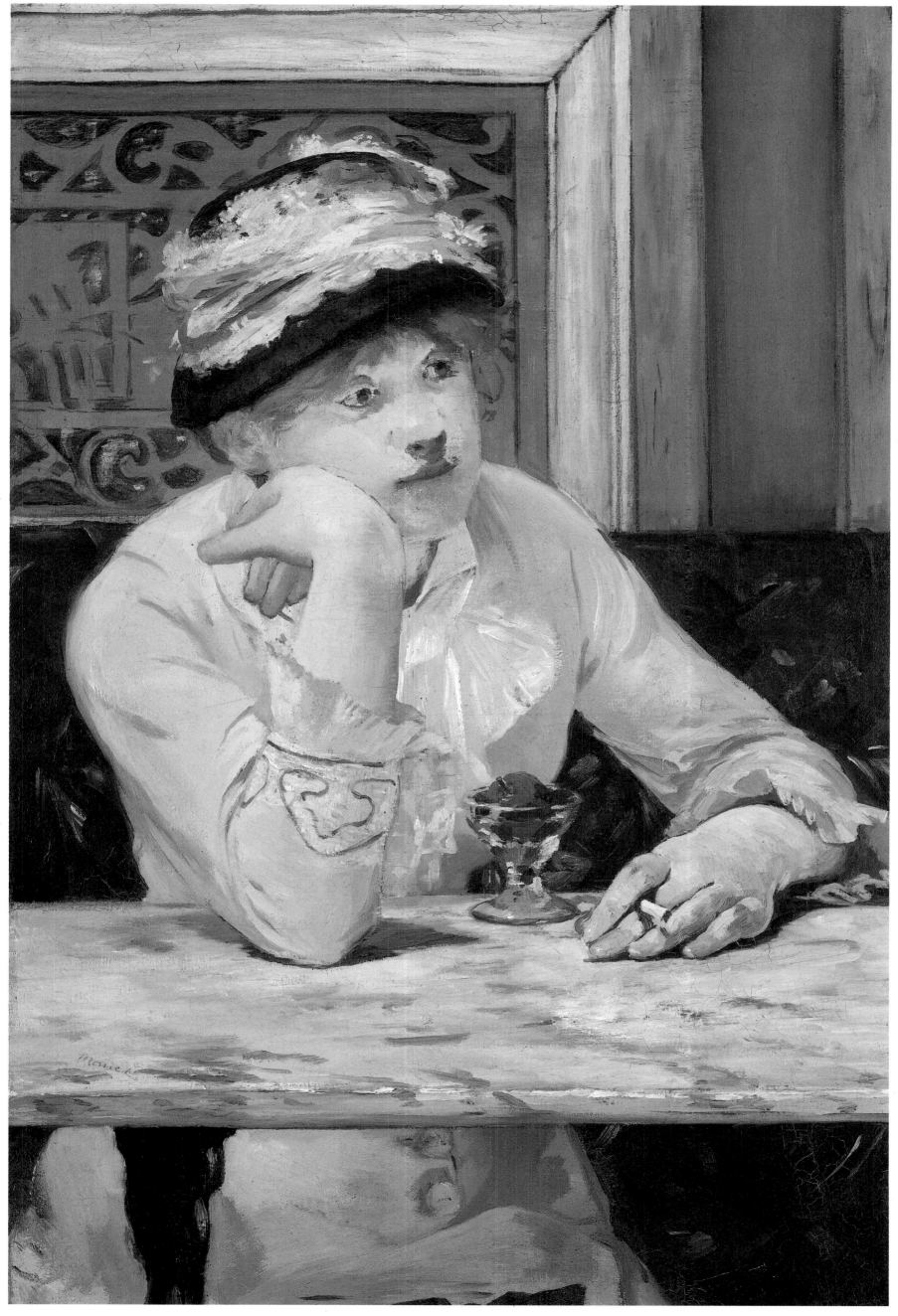

18 EDOUARD MANET *The plum* 1878

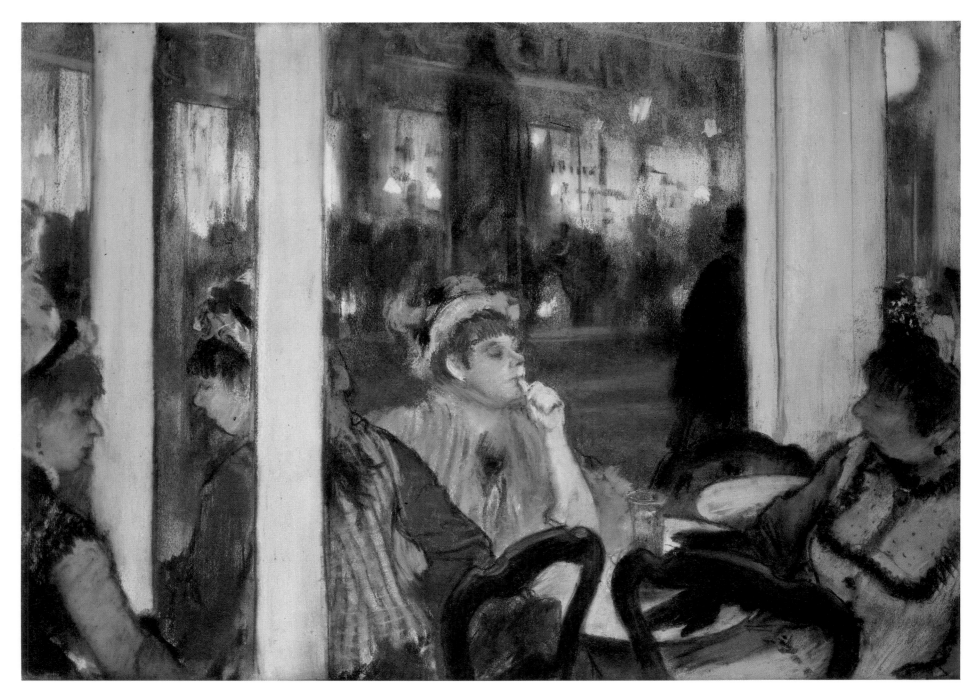

19 EDGAR DEGAS *Women on a café terrace; evening* 1877

long after the war which had caused its creation was over, he continued his interests there, and from 1886 onwards was active in the United States (see p.296), eventually opening a gallery in New York. His rival in selling, if not promoting, the Impressionists was Georges Petit (c.1835-1900), who ran an impressive gallery in the rue de Sèze, from which he sold to the *haute monde* works by predominantly traditional painters such as Sargent and Boldini. In the early 1880s he organized a series of Expositions Internationales de Peinture, at which Monet, Renoir and Sisley exhibited, and their success prompted him into taking more interest in the movement. His greatest success was a joint exhibition of the works of Monet and Rodin, which floated the rather nugatory notion of 'Impressionist' sculpture.

Dealers, however, were not the only outlet for artists, nor indeed the most important one. Reputations were made or broken, largely in the annual Salon. Founded in the eighteenth century to exhibit works by members of the Académie Royale de Peinture et Sculpture, it had become by the middle of the nineteenth the most important single event in the French artistic calendar. The selection process was constantly changing, but generally it was open to everybody. There were constant complaints about this,

reaching a crisis point in 1863 when, as a consequence, Napoleon III created an oppositional exhibition, the Salon des Refusés (see p.81). In the year of the first Impressionist exhibition, 3,657 works of art were accepted at the Salon and hung in the Palais de l'Industrie between the Champs-Elysées and the Seine; they were seen by over half a million visitors, who paid admission fees according to the time of day or the day of the week – Sundays and sometimes Thursdays were free. The opening day, usually in May, was a great social occasion and the exhibition space was immensely impressive. A decade earlier the English critic Philip Hamerton – he who later attacked the Impressionists for 'their resolute refusal of concession to all established views about taste' – wrote in *The Portfolio*:

On entering visitors find themselves at the foot of a magnificent staircase of white stone, on ascending which they arrive at the exhibition of pictures, which is on the upper floor and extends the whole length of the room, with tent-like ceilings of white canvas to subdue the glare from the glass roof. There are three large halls, one in the middle and one at each end of the building, with a double line of lower rooms between. The halls at the two ends open upon two other magnificent staircases, where the wearied traveller may refresh himself with brioches and babas and Malaga or Xerez to his liking. You then

descend at the other end of the building into the garden, which occupies the whole of the immense nave and there, under the broad glass roof, you see a great number of statues.

It was in these palatial surroundings that artists made their reputation, and their fortune, very much as was the case in London with the Summer Exhibitions of the Royal Academy. Papers and magazines gave extensive coverage and the 1863 exhibition, for instance, was covered by Leroy in no less than 18 consecutive issues of *Charivari*, whilst Ernest Chesneau contributed 12 articles to *Le Constitutionnel* and Théophile Gautier 13 to *Le Moniteur Universel*. It has for long been a widely held belief that the Impressionists were deeply opposed to the Salon, which they were presumed to see as the very antithesis of all they stood for. But in fact that was far from being the case. Between 1859 and 1882 Manet submitted works to nearly every Salon and they were only occasionally rejected; indeed, the favourable reception of *Le bon Bock* in 1873 marked the beginning of his popular fame. Very much the same can be said too of Renoir's *Madame Charpentier and her children* (Plate 227), which was widely acclaimed at the Salon of 1878 and led to an immediate rise in the prices he was getting for his works. In 1865 Monet's *The Seine estuary at Honfleur* had been lauded when it was shown at the Salon, and though he was later to be more chary about showing there, this was partly due to the fact that the nature of the other works submitted demanded the painting of pictures of a size and format which did not appeal to him. The Salon of 1870 contained works by Bazille, Degas, Eva Gonzalès, Manet, Berthe Morisot, Renoir and Sisley. As time went by, however, the Impressionists tended to lose interest in the Salon, partly because of the growing success of their own exhibitions, partly because of a more wide-spread disillusion with the institution throughout the whole of the art world. Indeed, a number of critics praised the exhibition at the boulevard des Capucines just because it seemed to offer a vital alternative to the Salon; Emile Cardon, for instance, the art critic of *La Presse*, whilst stating that 'the sketches of the new school are disgusting', went on to say that the show 'represented not just an alternative to the Salon, but a new road, for those who think that art, in order to develop, needs more freedom than that granted to it by the administration'.

In addition to the Salon as a place to exhibit and get known, there were the great international exhibitions held in Paris between 1855 and 1900 which not only added greatly to the popularity and *réclame* of Paris but, as each of them had a section devoted to the fine arts, made French painting more widely known outside the boundaries of France. Taking place in 1855, 1867, 1878 and 1900, each of them attracted more than a million visitors, and at the first 982,000 visited the fine art section alone. For that of 1867, Manet, who painted a panoramic view of it (Plate 27) showing Nadar's balloon in the right-hand corner, built his own pavilion in which he hung some 50 of his works. Largely ignored by the critics and the general public, it was accompanied by a catalogue which was apparently written by the critic and sculptor Zacharie Astruc and which expounded the artist's attitude, emphasizing, amongst other things, in what sounds like Manet's own words,

This year M. Manet decided to offer directly to the public a collection of his own works. He does not say 'Come and look at works without fault', but 'Come and look at sincere works'. It is sincerity which endows works of art with a character which makes them resemble a protest, although the artist has only intended to convey his impression[5]. M. Manet has never desired to protest.

By the time of the 1889 international exhibition, however, the fine art section was to include works by Monet, Pissarro and Cézanne whose *House of the hanged man* (Plate 203) was included thanks to the manoeuvring of its owner, Dr Gachet.

These international exhibitions were not merely places to exhibit. They had an influence on the taste and sensitivities of the age which helped to transform the nature of painting itself. That of 1855, for instance, in its concern with emphasizing the importance of the French Empire, laid particular emphasis on Algiers and Morocco, and the effect was immediately apparent not only in the Salon but in the works of Renoir. More remarkable was the exhibition in 1889, displaying the art and cultures of non-European nations in a manner which had made them more accessible to the general public than had ever been possible before. Cambodian temples, Javanese dancers – they greatly attracted the attention of Degas, who did numerous sketches of them – Polynesian sculptures and Tahitian crafts not only directly influenced artists such as Gauguin, but created a general awareness amongst the public that there were styles of art other than those fashioned by the Renaissance, and so helped to make the work of artists such as the Impressionists less incomprehensible.

20 PIERRE-AUGUSTE RENOIR *Portrait of Paul Durand-Ruel* 1910
Renoir was 69, and the dealer who had done so much for Impressionism ten years older, when this portrait was painted. The age of the artist is not reflected in the technique of the painting, nor is that of the sitter, with his assured pose and shrewd eyes.

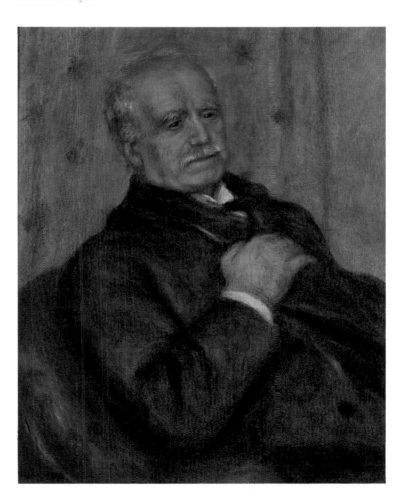

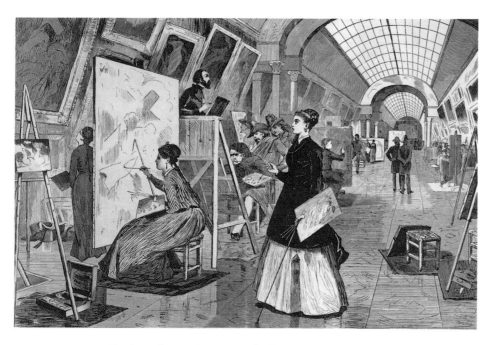

21 *Art students and copyists in the Louvre*, an engraving in *Harper's Weekly*, 11 January 1868, done by the celebrated American artist Winslow Homer, in the course of a short visit to France in the preceding year.

Paris was, in effect, a cultural treasure-house unsurpassed in its wealth by any other city, with the possible exception of Vienna. The Louvre had been a great public art gallery since the time of the first Napoleon. Its collections had been enlarged and made more readily available to the public under Louis-Philippe, who made considerable Spanish additions to its stock of paintings, as well as by Napoleon III and the astute Nieuwerkerke, his Director-General of Museums. The artists of Paris nourished themselves on its artistic provender. Copying in the Louvre was an essential part of a painter's education (although in later life Pissarro said it should be burned), and it was there that Manet first met Degas, having been impressed by the skill with which he was copying a Poussin. Fantin-Latour used to drag Renoir along, exclaiming, according to Edmond Renoir, 'The Louvre! the Louvre! there is only the Louvre! You can never copy the masters enough', and Fantin did indeed copy them, producing hundreds and even making a small income by selling them. Renoir was mainly attracted by the French masters of the eighteenth century, who were then becoming fashionable, thanks to the writings of the Goncourt brothers and the collecting activities of the expatriate Marquis of Hertford, whose collection is now splendidly housed in London in the erstwhile home of his illegitimate son, Sir Richard Wallace. Artists such as Watteau and Boucher were to have a decisive effect on the subsequent style of his art. The works chosen by the other Impressionists to copy all reflected their artistic personalities: Manet copied Velasquez, Titian, Rembrandt and Tintoretto; Degas Holbein, Delacroix, Poussin and the Italian primitives such as Mantegna. Amongst the contents of his studio which were offered for sale in 1918 there survived his copy of Mantegna's *Calvary* from the Louvre, which in 1934 was donated to the Musée des Beaux-Arts at Tours. Cézanne copied, amongst other paintings, the *Dante and Virgil* of Delacroix, who exerted a powerful influence on his early works, while Bazille confined

himself to Rubens and Tintoretto. Slightly on the margin of this group were two women students, Edma and Berthe Morisot; they worked in the Grand Gallery under the watchful eye of their private tutor, the Academician Joseph Guichard (1806-80), who had been a pupil of Delacroix and was famous for his romantic and religious paintings. The only exception to this enthusiasm for the Louvre and its works was Monet who, when forced by Renoir to go there, seemed mainly irritated by the paintings he saw, expressing a particular detestation of Ingres.

What might be thought of as the modern annexe to the Louvre was the Musée du Luxembourg, built for Marie de' Medici and converted in 1818 into a gallery of contemporary French art. By 1874 it housed some 300 paintings, most of them acquired at successive Salons. It was not, however, a static collection; when an artist became famous his works were transferred to the Louvre, as was the case with David's in 1824, and lesser works were relegated, after an interval, to provincial museums or town halls. In 1870, for instance, the museum had acquired Eva Gonzalès's *The little soldier*, partly because her father was an influential figure, partly because its patriotic theme, appropriate to the mood of the moment, had made it a favourite at the Salon of that year. Almost immediately, however, it was transferred to the town of Villeneuve-sur-Lot, and was consigned to a cellar in the Mairie, where it languished till the 1960s. In 1902 Gauguin voiced the sentiments of many artists when he said that the Luxembourg was 'a vast prison, a kind of compulsory brothel. Kings are buried at Saint-Denis, painters in the Luxembourg. It is no more than a house of the past which should be destroyed.' Whatever its demerits, however, it did testify to a state patronage of the arts which no other European country, except possibly Bavaria, could equal.

New public galleries and museums were introducing fresh vistas of visual experience and aesthetic sensibility. In 1879 the Musée des Monuments Français opened, with its rich display of medieval art, which was so greatly to influence artists such as Rodin. In 1889 Emile Guimet (1836-1918) opened to the public his extraordinary collection of Chinese and Japanese art and two years later Henri Cernuschi (1821-96) was to found the similar museum which bears his name. A new direction, too, indicative of the future, was suggested by the creation at the end of the century of a museum of 'art applied to industry' in the Palais Galliéra.

Paris was indeed the Mecca of the art world, a place to which artists and students flocked from many different places: a sparkling, exciting place, it provided as no other city could have done the background for the artistic revolution signalled by the exhibition in the ebullient Nadar's old studio in the boulevard des Capucines.

[1] Actually there were 30 members.

[2] This seems to prove that the correct version of the name involves the pronunciation of its last letter.

[3] The use of the word seven years before Leroy's article is interesting.

22 EDGAR DEGAS *Russian dancers* 1899
One of the many spectacles provided by Parisian theatres, the troupe of Russian dancers who
appeared at the Folies-Bergère in 1899 anticipated Diaghilev's dancers by eight years.

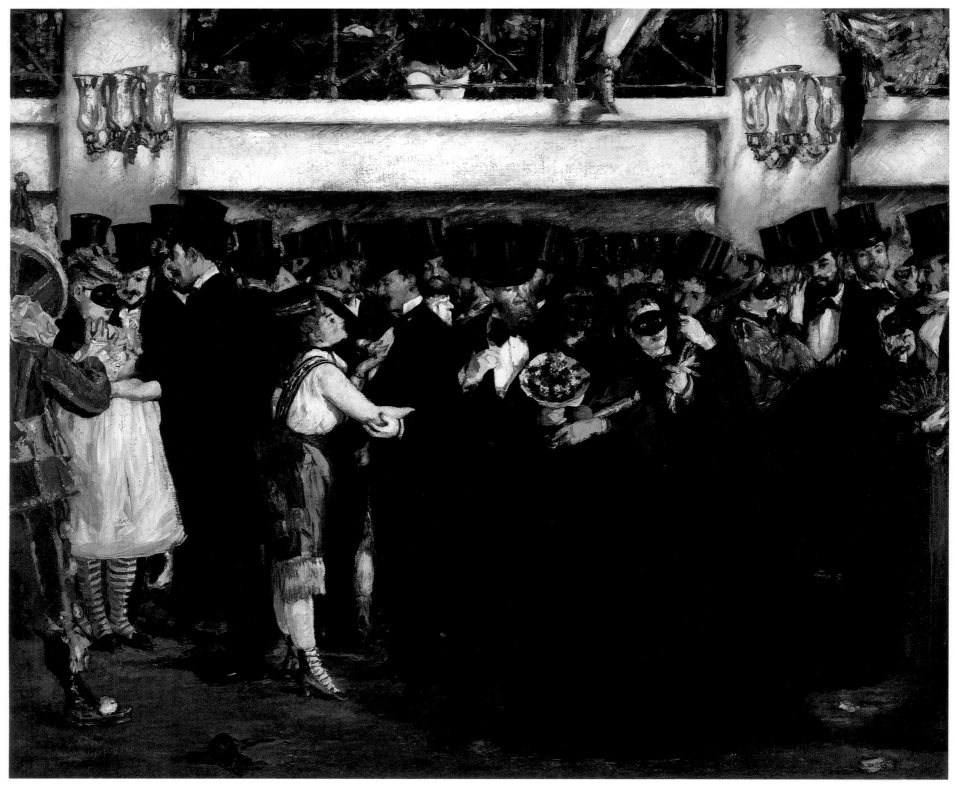

23 EDOUARD MANET *Masked ball at the Opéra* 1873
One of the events of the Paris season which, according to a guide-book of 1870, was 'boisterous and not well behaved', the Masked Ball encapsulated the risqué reputation of the Opéra as a happy hunting-ground for Don Giovannis. Manet's painting included several of his friends amongst the men, and he heightened the sense of excitement by contrasting the heavy blacks to the right of the picture with the bright colours of Ponchinello and the dancers on the left.

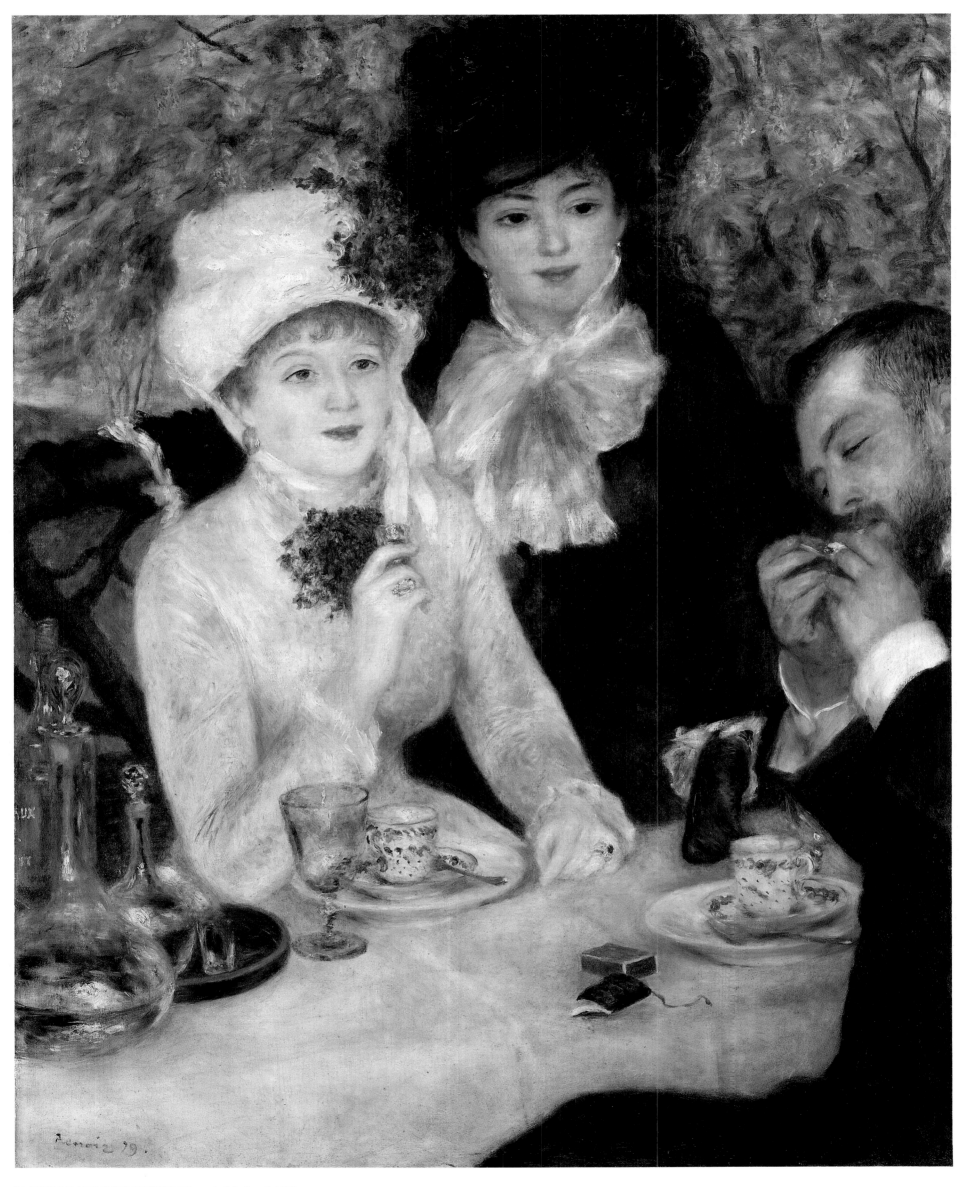

24 PIERRE-AUGUSTE RENOIR *The end of the lunch* 1879
A snapshot of life in the garden of a Montmartre café. The actress Ellen Andrée gazes
lovingly at her host as he lights an after-lunch cigarette. Her friend seems equally smitten.

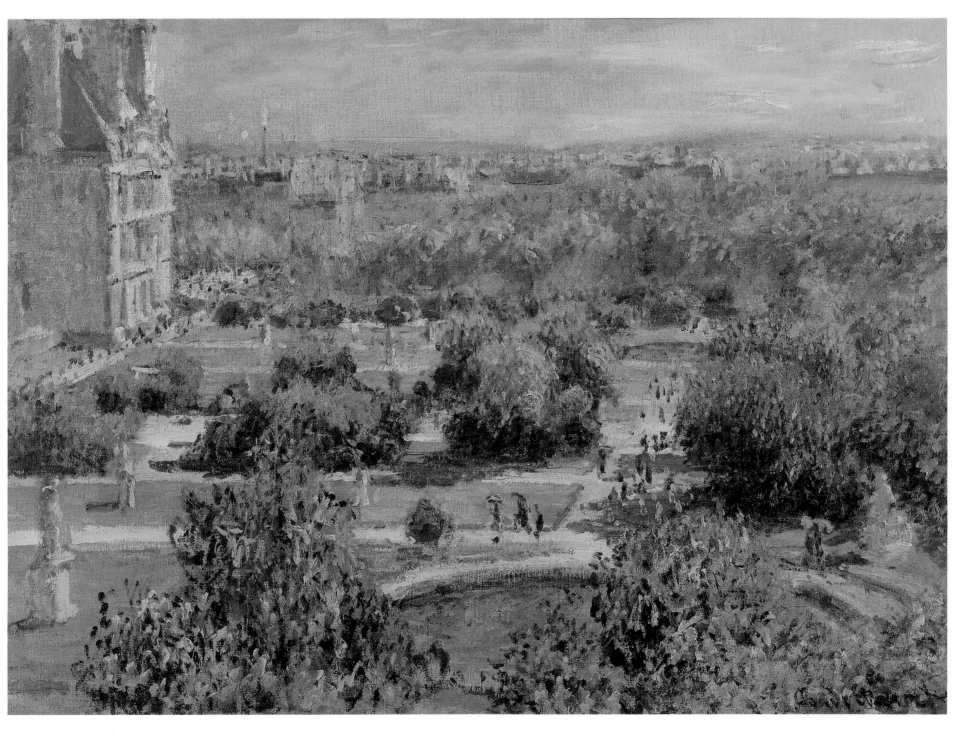

25 CLAUDE MONET *The Tuileries* 1876
The palace of the Tuileries was destroyed during the Commune, and by 1876 its extensive
gardens had already become a centre of social life. This was one of Monet's last major
paintings of Paris.

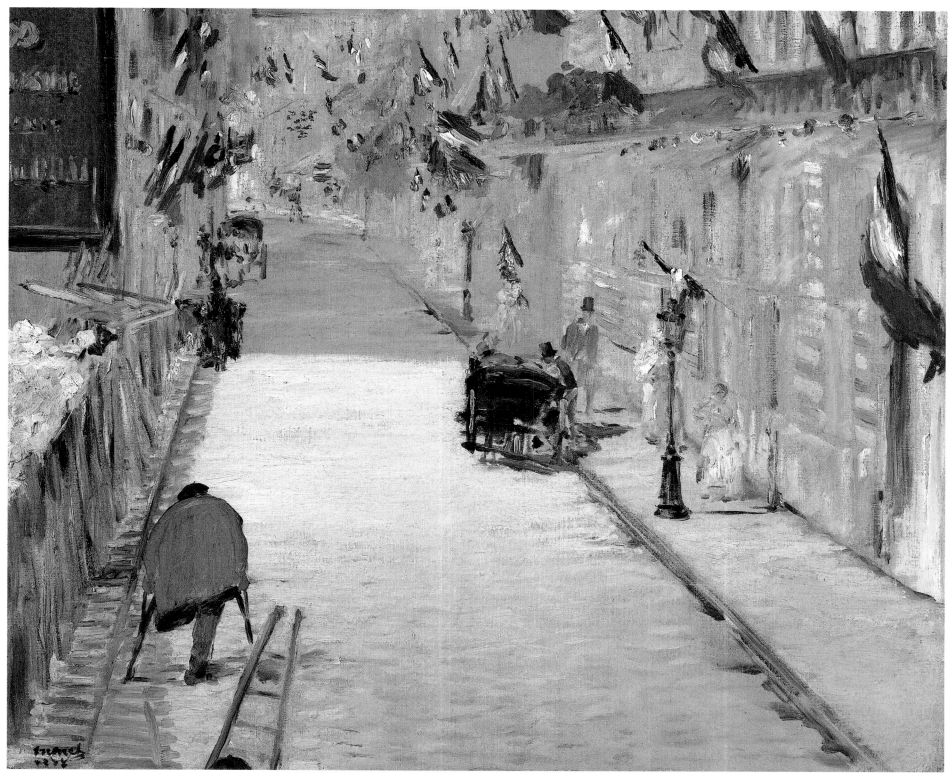

26 EDOUARD MANET *Rue Mosnier with flags* 1878

In the 1870s Manet had a studio at 4 rue St Pétersbourg, and in
1878 he painted three pictures of the rue Mosnier (now the rue
de Berne), down which he had an uninterrupted view from his
window. Recently built, part of Haussmann's rebuilding
programme, it features in Zola's Nana as a street used very
largely by 'respectable' prostitutes for assignations. Here the
street is decked out in flags. The pretext for this jollification was
the national holiday on 30 June 1878, intended to celebrate the
World's Fair which was being held in Paris to mark France's
recovery from the trauma of the Franco-Prussian war and the
Commune. The government had allocated a sum of half a
million francs for decorating the capital and providing for
outdoor music and dancing.

It has been suggested, not without reason, that Manet had a
slightly ironic intent in the way he treated the subject. On the
left there is a fenced-in pile of rubble, and crawling painfully
past it is a one-legged man, presumably a casualty of the war or
the fighting which brought about the end of the Commune.

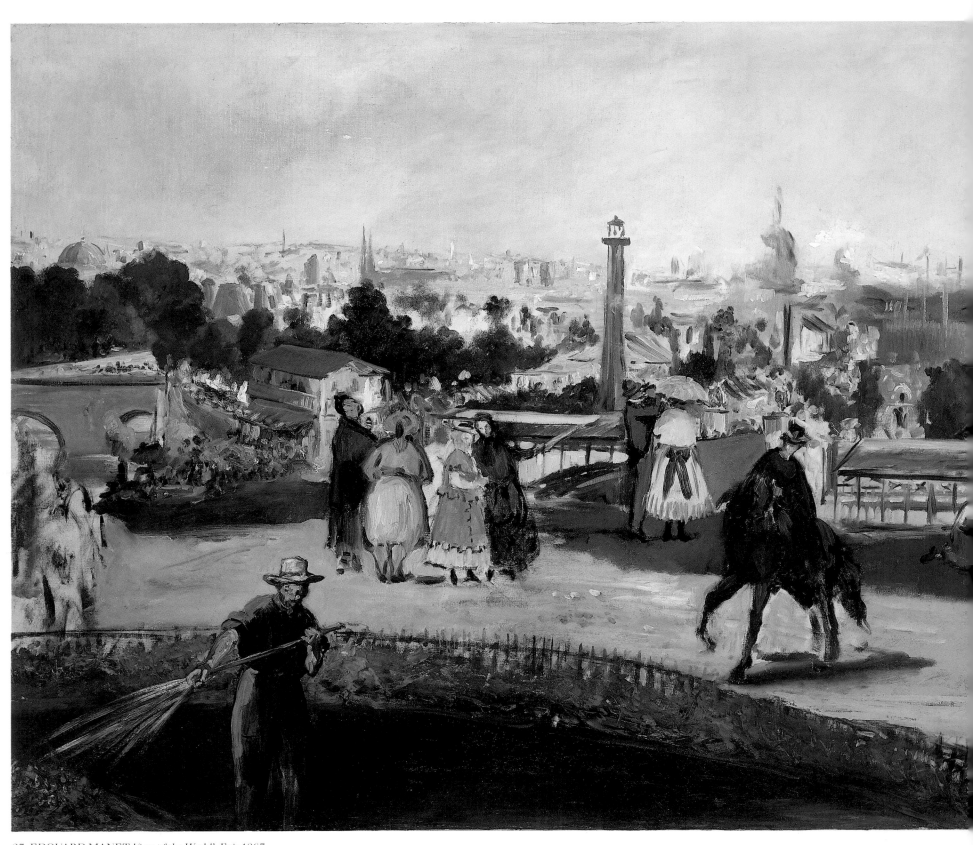

27 EDOUARD MANET *View of the World's Fair* 1867

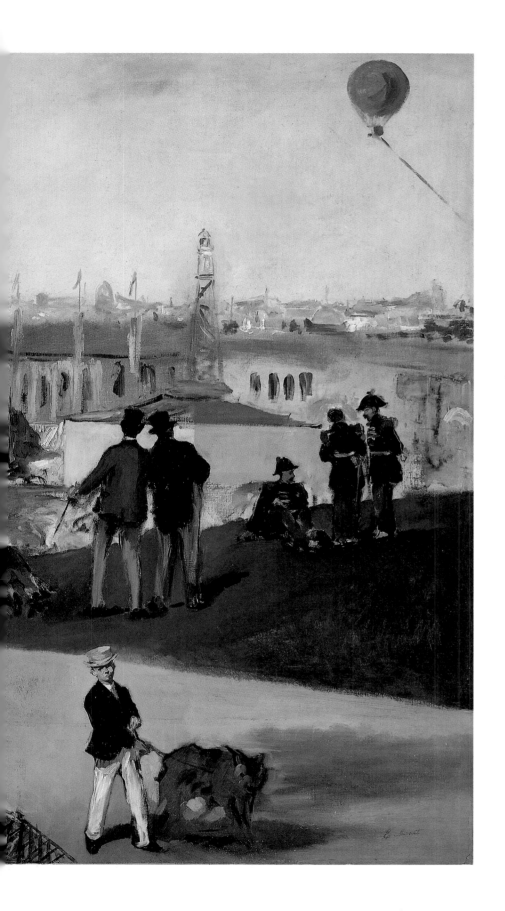

The 1867 World's Fair in Paris was intended to be a vindication of the blessings of mass production. Sewing machines at 300 francs, cast-iron furniture and machine-sewn shoes competed with such novelties as typewriters, rubber tyres and phonographs. 3,100 square metres of exhibition space were devoted to the fine arts, and 769 to 'objects for the improvement of the masses'. But no representative of the more progressive movements in art was given a look-in. Both Courbet (who had done the same thing during the 1855 exhibition) and Manet decided to hold their own private exhibitions, advertised in the official catalogue. Manet borrowed 18,305 francs from his mother and had a pavilion constructed in a small garden belonging to the Marquis of Pomeraux in the place de l'Alma, just by the entrance to the Fair, where he showed 53 paintings, including copies of works by Titian, Tintoretto and Velasquez.

Monet and Renoir had already done general views of the exhibition before Manet did this one, painted from a spot near his own pavilion. In the sky on the right can be seen the balloon from which Nadar, the photographer, took his panoramic views of Paris.

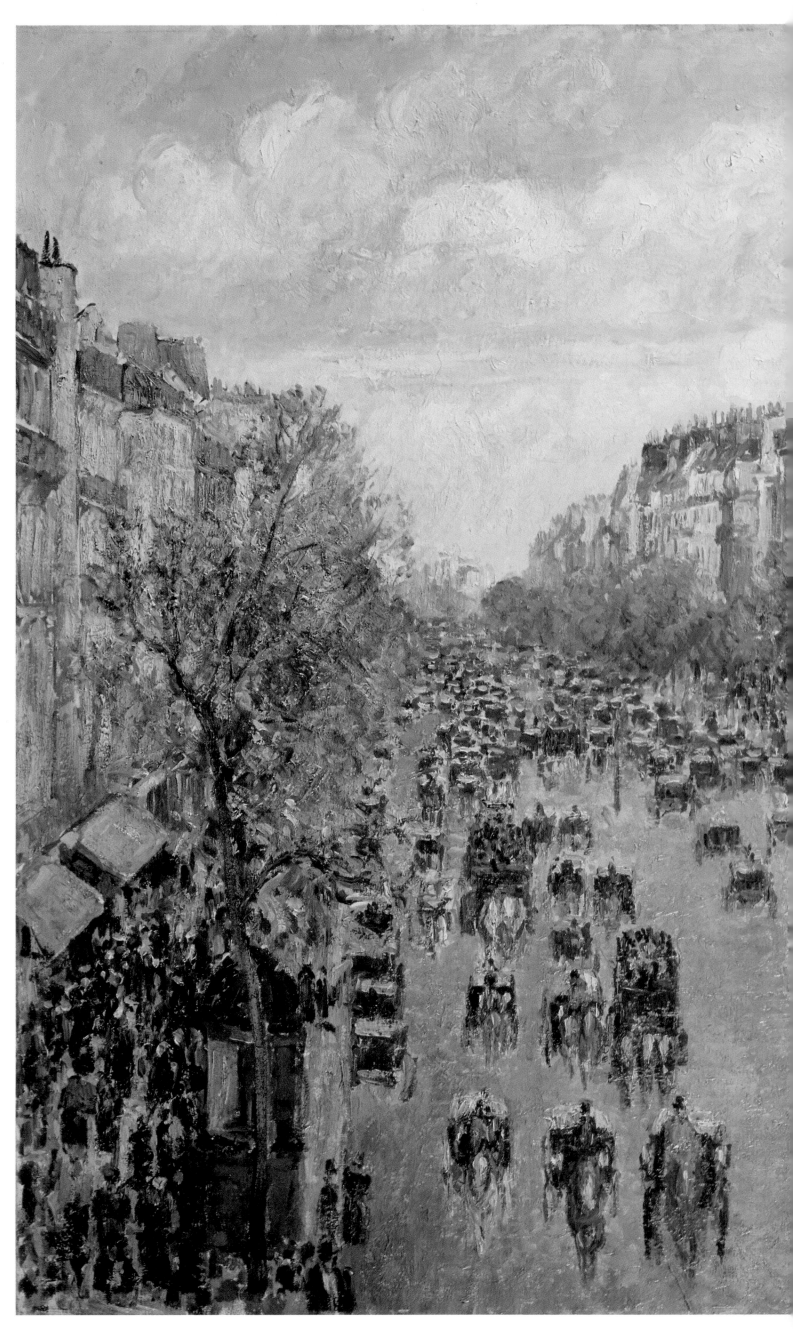

28 CAMILLE PISSARRO *Boulevard Montmartre, afternoon sun* 1897

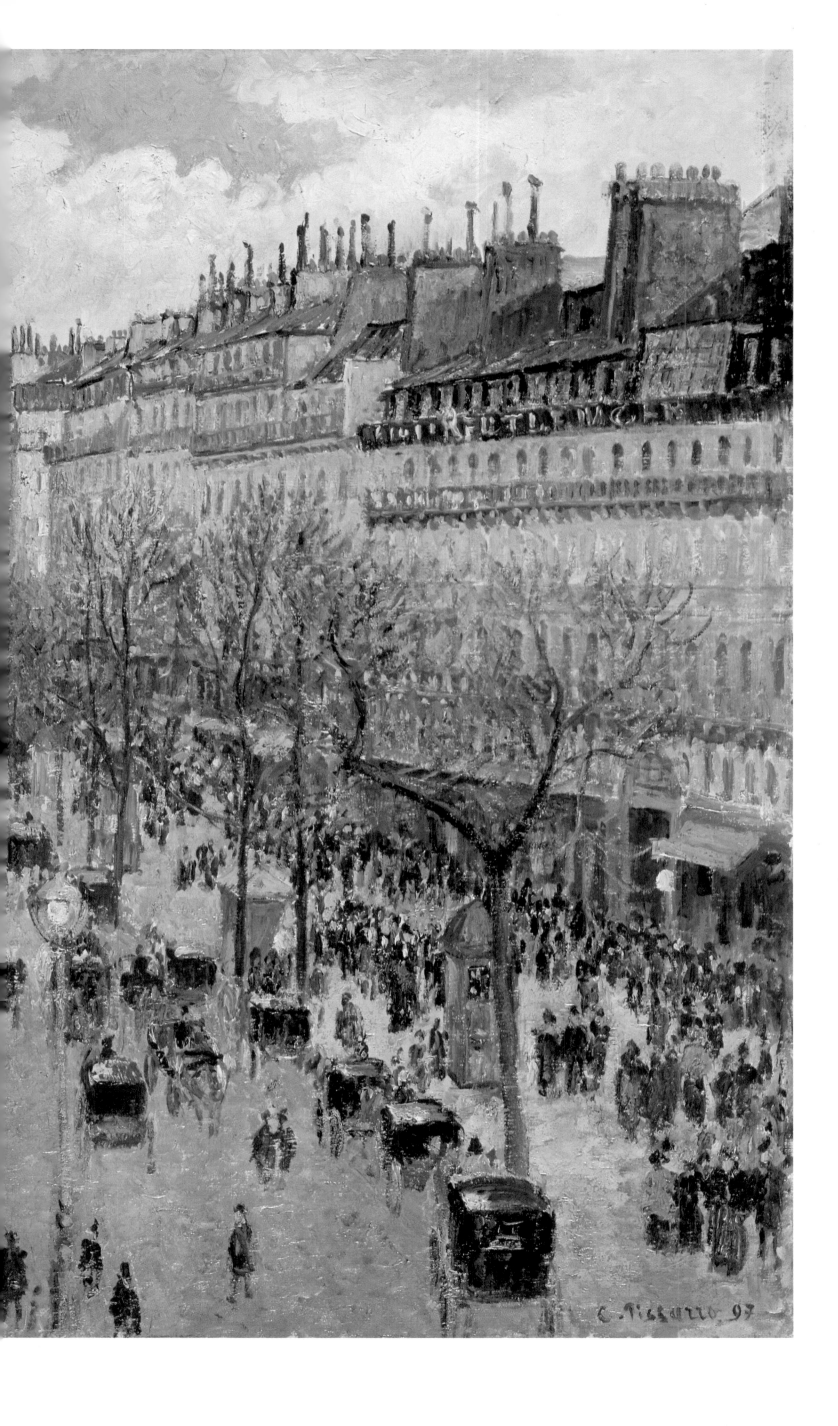

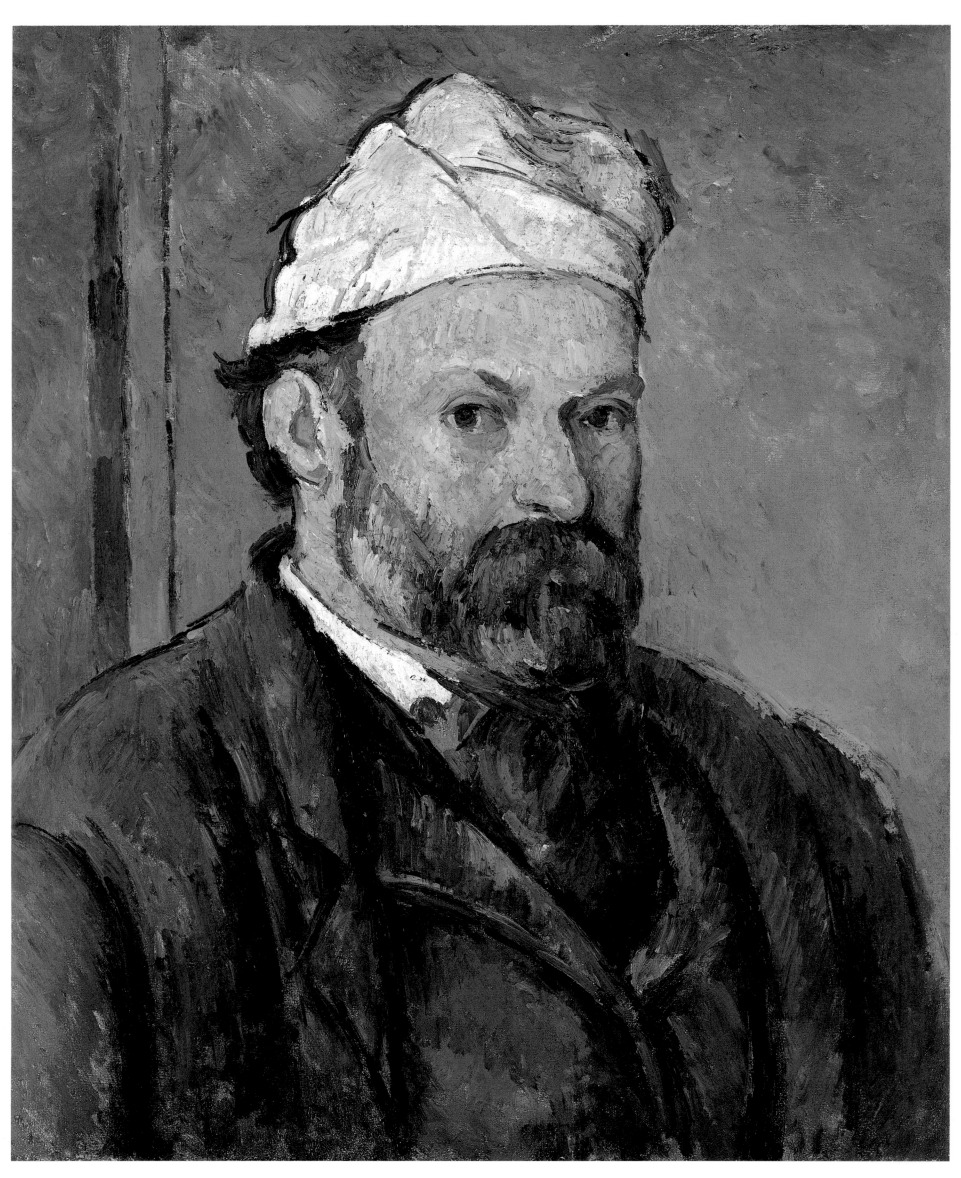

29 PAUL CEZANNE *Self-portrait in a white hat* 1881
Cézanne painted more self-portraits than any other Impressionist, partly out of an interest in
recording his changing appearance over the years, partly because he provided an ever-
accessible subject who presented none of the embarrassment he experienced when dealing
with a model. When he did this picture he was 42 years old.

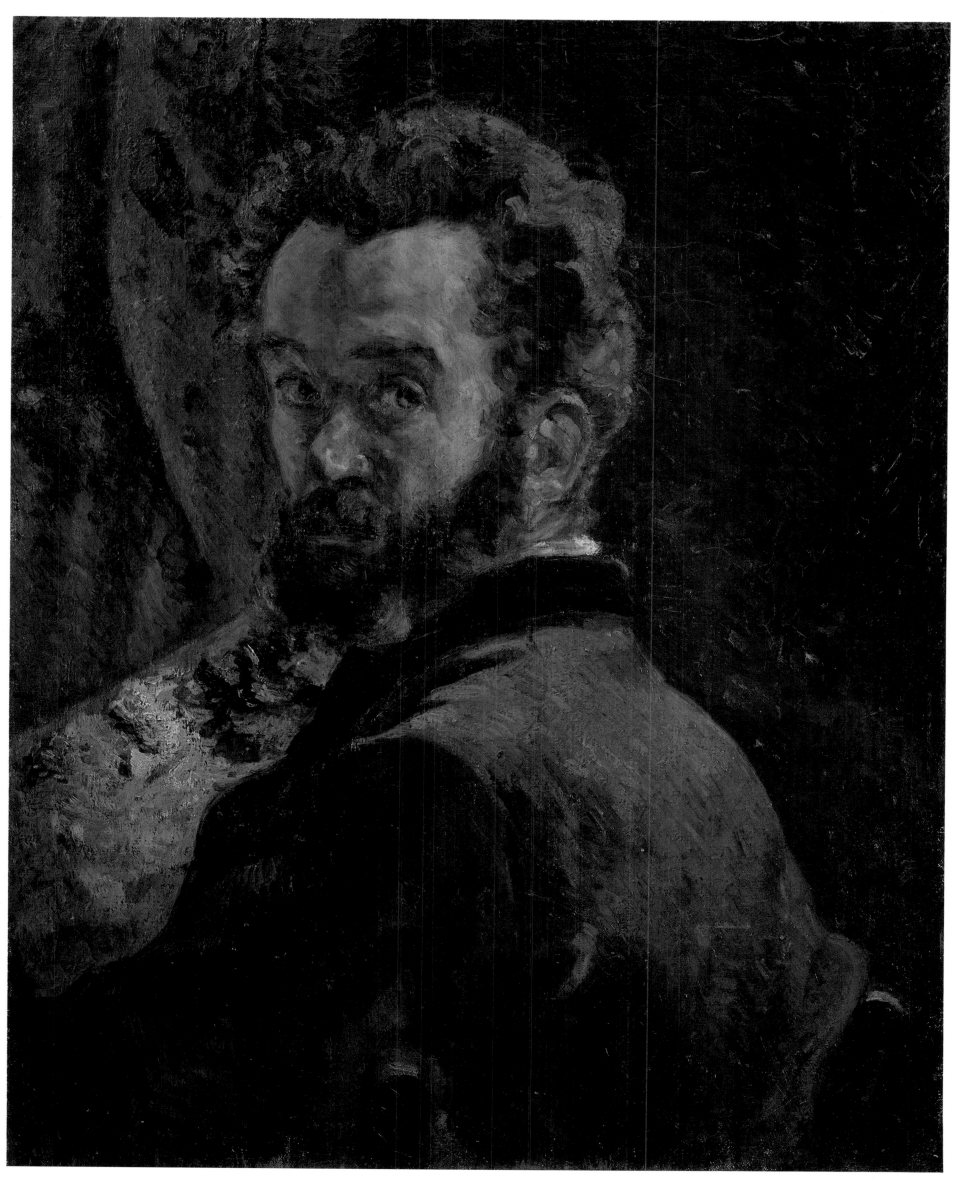

30 ARMAND GUILLAUMIN *Self-portrait* 1878
The longest surviving Impressionist, who died in 1927 at the age of 86, Guillaumin was also
the most consistent, and he influenced the work of both Van Gogh and Matisse. The early
hardships of his life were alleviated when he won the Loterie Nationale in 1891.

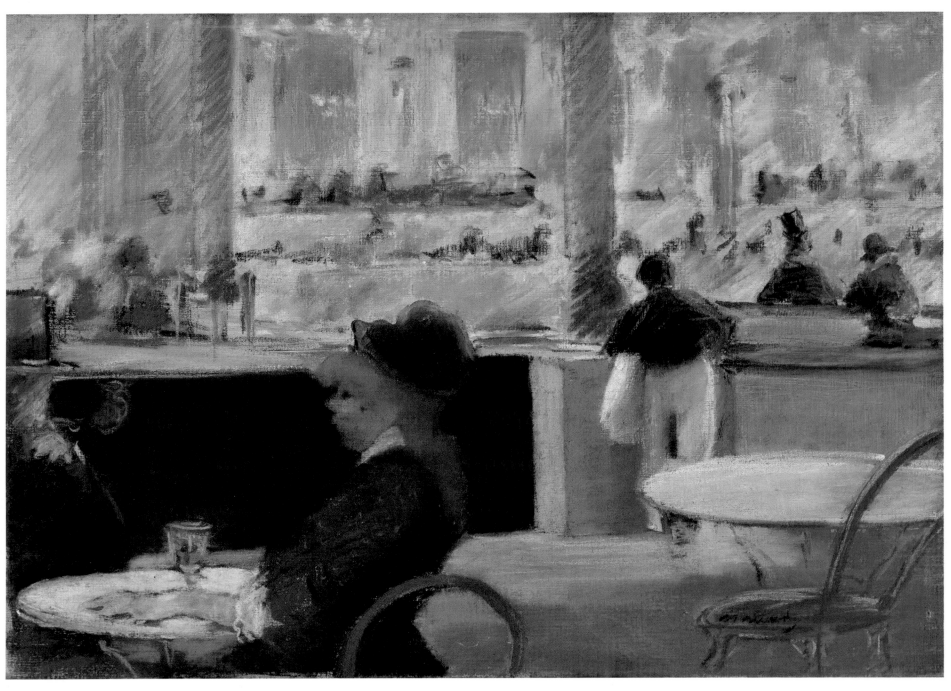

31 EDOUARD MANET *Café, place du Théâtre Français* Pastel, 1881

It may well have been the café subjects which Degas had shown at the 1877 Impressionist exhibition that prompted Manet to undertake a number of works on the same theme during the early 1880s – a period when he was showing a burst of creative activity, quite possibly a reaction to his increasing ill-health. There are definite resemblances between this work and Degas's Women on a café terrace (Plate 19), a pastel of 1877. The locality of the scene is known from a drawing in the Louvre on which Manet has written 'La place du Théâtre Français vue à travers la glace d'un café'. Executed in brush and India ink over pencil on squared paper, the drawing contains notes of the colours, but when he came to do the pastel, he made several alterations to the composition. It contrasts very strongly with the intimacy and emotional undercurrents of At Père Lathuille's, suggesting rather the kind of ironic objectivity practised by Degas.

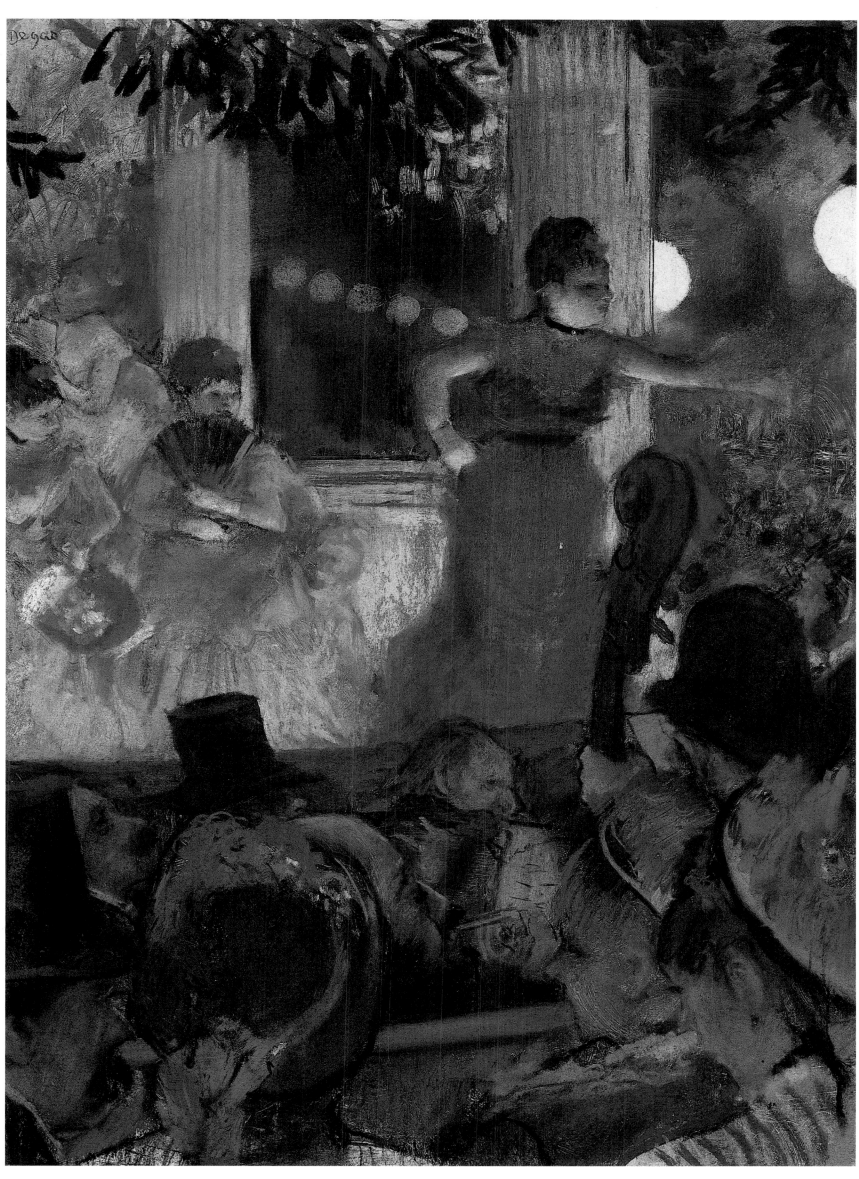

35 EDGAR DEGAS *Café-concert at the Ambassadeurs* 1877
The most popular *café-concert* in Paris, the Ambassadeurs was for long one of Degas's most
popular haunts. In this pastel, one of several he did of the place, he shows Victorine Demay
singing one of her bawdy songs as she gesticulates to the audience.

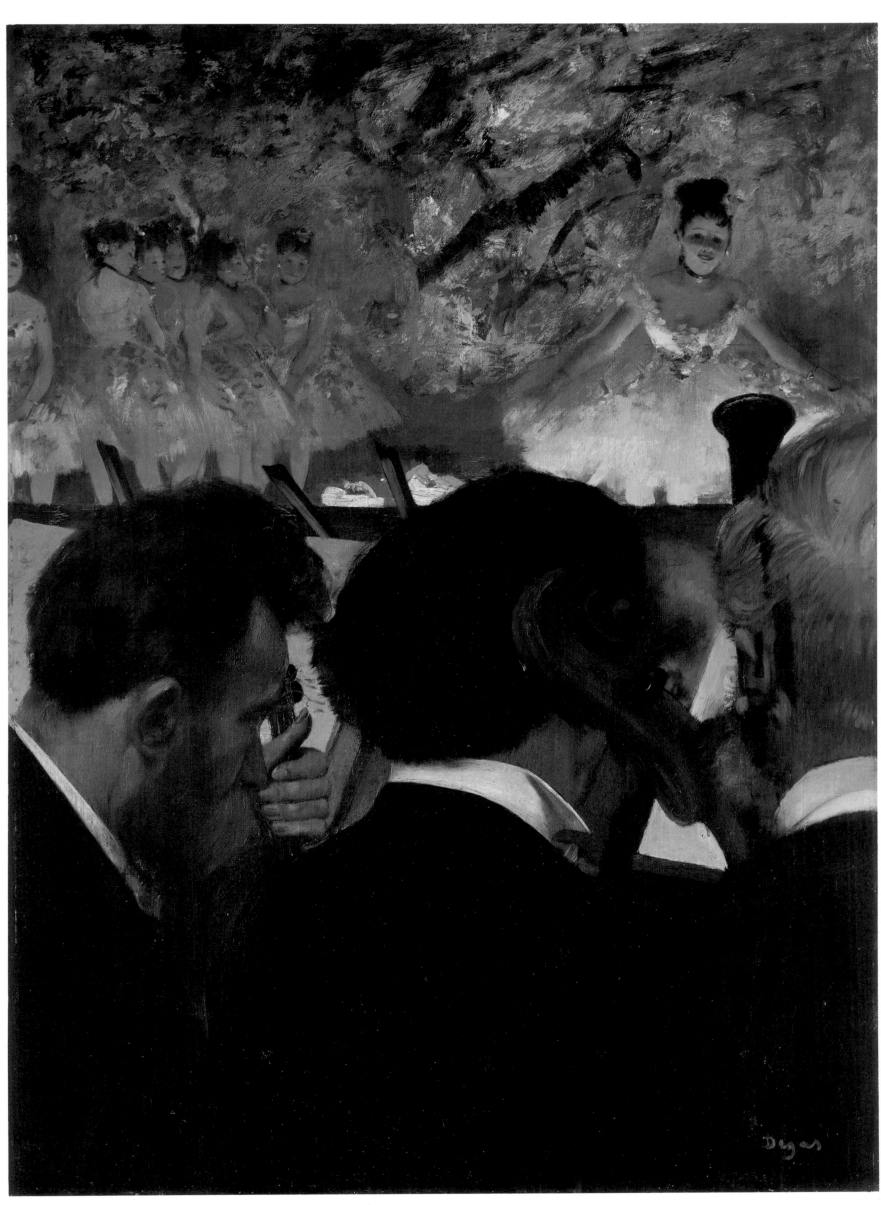

34 EDGAR DEGAS *Musicians in the orchestra* 1874/6
Unlike his other painting of the orchestra at the Opéra, now in the Musée d'Orsay, this one
contains no portraits, but is a kind of tribute to the magic of the theatre. No other artist had
painted the stage and the orchestra from such a close and unusual viewpoint, and in doing so
Degas has created an atmosphere of gripping intensity.

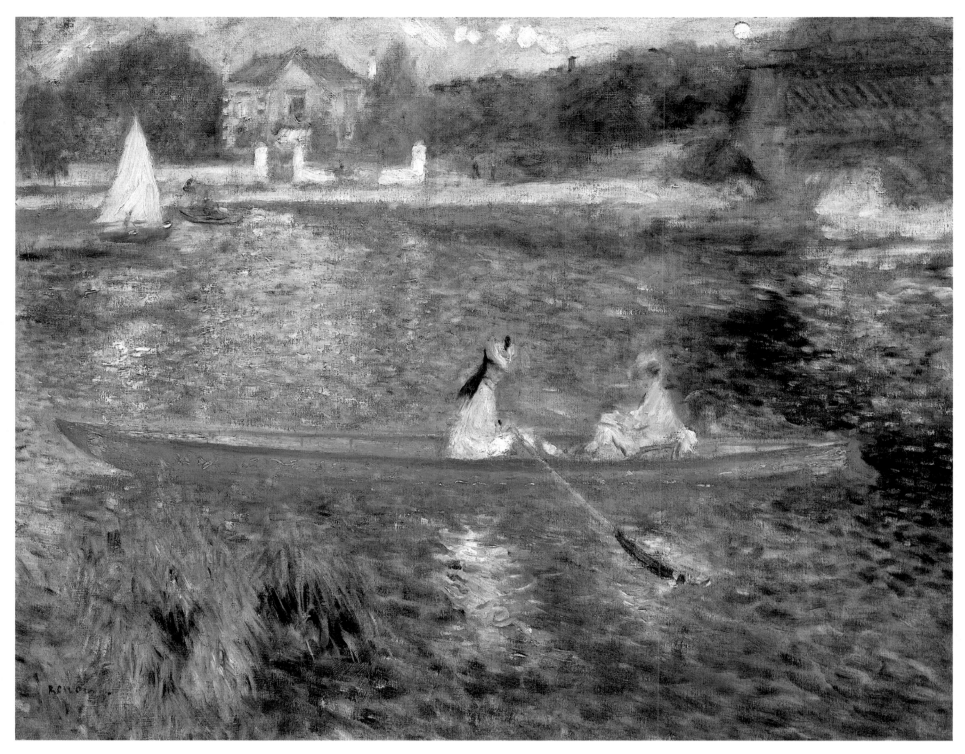

35 PIERRE-AUGUSTE RENOIR *The Seine at Asnières c.* 1879

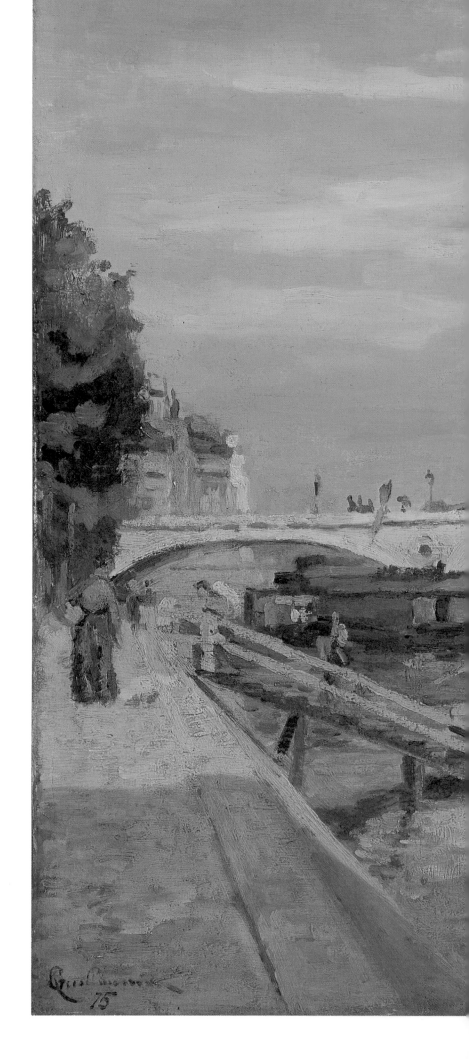

36 ARMAND GUILLAUMIN *Charcoal thieves on the quai de Bercy* 1882
The Impressionists' indefatigable zest for recording the realities of contemporary life is
demonstrated in this picture. It was at the quai de Bercy that coal, charcoal and wood were
unloaded from the barges which brought them up the Seine into the heart of Paris.

37 ARMAND GUILLAUMIN *The Pont Louis-Philippe* 1875
One of the main arteries of Parisian life, its water covered with barges, its banks lined with
houseboats, bathing-places and landing jetties, the Seine had a particular attraction for the
Impressionists, especially Guillaumin, Sisley and Pissarro.

58 PIERRE-AUGUSTE RENOIR *The cabaret of Mother Anthony* 1866

Chapter 2

Early Days

The desire to be an artist usually affects many people at an early age. The critical point, however, usually in adolescence, is when that desire is forced to be translated into practical action. There was, and indeed still is, a notion that this engenders strong parental opposition. This is by no means borne out by the experience of the Impressionists. Some had initial difficulties. The youthful Manet, though encouraged in his artistic ambitions by his uncle, had some opposition from his father, who sent him on a six months' sea voyage in 1848 in the hope that he would eventually become a naval officer, but when he failed the entrance exam reluctantly allowed him in 1852 to become a pupil of Couture. Monet had a helpful aunt, who persuaded his father to let him leave the family shop in Le Havre to spend an exploratory year in Paris in 1859 and then, after he had done his military service in 1861–2, supported him, admittedly somewhat intermittently, as an art student in Paris from 1862 till virtually the end of 1869. Pissarro, who had been sent there from the West Indies to be educated, was forced to return home in 1847 to serve as a clerk in his father's shop, though he spent most of his time there drawing. After five years of this he ran away to Caracas in Venezuela in the company of Fritz Melbye (1826–59), a noted Danish marine painter, whom he had met while sketching in the port of St Thomas, then a Danish colony. His parents, impressed by this gesture, reconciled themselves to the reality of his determination to be a painter but wisely insisted that he go to study in Paris, where he arrived in the year of the great exhibition of 1855 to work at the Académie Suisse. Degas was fortunate in that his father, who willingly gave him permission to quit his legal apprenticeship to study art, was deeply interested in the subject himself, and constantly showered his son with what was often very sage advice, which was to guide him through the rest of his career:

You know that you have no, or almost no, money and that as a consequence you must make painting your career, your existence. All thoughtless actions, all reckless decisions made without due considera-tion are like boulders which, rolling down the side of an abyss, destroy the castle of ambition. Whatever one undertakes, one will then arrive at the end of one's days without having achieved financial security, and without having created or done anything. If an artist has to be enthusiastic about his art, he should nevertheless regulate his conduct for fear of remaining a nonentity.

It might indeed almost seem that not only Degas but the rest of the Impressionists guided their lives by the same principles. Not for them the extravagant self-indulgence, the disordered lives, the erratic dedication to work, which over the following decades were to become almost an essential part of the mythology of the artist's life. But Degas *père* was something more than a bourgeois sage, and indicated to his son artistic principles which he was also going to follow: 'The masters of the fifteenth century are the only really true guides to follow. When one fully appreciates them and understands what they are about, only then can one perfect the techniques of representing nature, and so arrive at artistic success.' And when he thought that his son was falling too much under the influence of colourists such as Rubens and Delacroix, he wrote to him on 25 November 1859, 'Have you really studied the works of those adorable masters of the fifteenth century and absorbed their spirit? Have you made crayon sketches, or better still watercolours after their works, the better to be able to remember their colours?'

Sisley, born in Dunkirk, the son of a successful silk merchant of Kentish stock, had been sent to London at the age of 18 to learn the basic principles of commerce, but devoted more time to the study of the paintings of Turner and Constable, an activity which confirmed him in his desire to become an artist. When he returned to Paris in 1862 his family supported this ambition and encouraged him to study under Gleyre. For Renoir the situation was slightly different. Born into a tailor's family, which had no particular preconceptions about the evils or otherwise of becoming an artist, but on the other hand was not likely to provide a great deal of support in any attempt to achieve this ambition, he was largely dependent on his own efforts, and these were directed into the kind of artisan-like training which had once been common in the art world. Showing an early aptitude for drawing, he started working as a porcelain painter for a M. Levy, whose craft-based factory was being undermined by competition from more industrialized firms. During his apprenticeship there he began to attend classes at the Ecole gratuite de dessin du IIIe arrondissement de Paris under the sculptor Calouette. After completing his statutory three years with M. Levy, he spent some time painting fans and heraldic designs for his elder brother Henri, who ran a small business as a

medallist and general supplier of *objets de luxe*. By this time his artistic ambitions had become a good deal more concentrated, and he had begun to do oil paintings in the family home at 23 rue d'Argenteuil. In 1859 he secured a job working as a decorator for a painter of blinds in the rue du Bac, who described himself as 'Manufacturer of blinds of all types for apartments, shops, steamboats. Specialist maker of religious blinds, perfect imitation stained glass for churches, waterproof blinds, monumental and artistic blinds.' In 1860 he was given an admission card allowing him to copy paintings in the Louvre, and in 1861 started studying under Gleyre, applying for admission to the Ecole des Beaux-Arts and coming 68th out of the 80 candidates who sat the entrance exam in that year. All this time, however, and for some years afterwards, he still had largely to support himself from his earnings at the blind-maker's. He was in fact never to lose the basic craftsmanlike approach to art which characterized his early background, describing himself as 'a painting workman', decrying involved theories about art, and in later life writing an introduction to that most artisan-like handbook, Cennino Cennini's fifteenth-century *Il libro dell'Arte*. He was always yearning after a lost world of traditionalist craftsmanship, telling Julie Manet in 1899,

Today for instance there is nothing interesting for the workman, who in the old days could make a chair according to his own design, and get real pleasure out of it. Today one person makes the legs, another the seat, a third the back, and somebody else puts them together. Everything has to be done as quickly as possible, to get the money in quickly. In the old days an artist painted the Virgin with care, because it was a way of securing entry into heaven; now he bangs out a picture of her as quickly as possible, so he can get his fee as quickly as possible.

Cézanne's position – like so many things in his life – was a complicated one. His desire to be a 'real' artist was

39 PAUL CEZANNE *The negro Scipio* 1866-8

formulated only slowly in Aix. He had been an excellent student at school, winning prizes for Greek, Latin, science and history, but only once, in 1854, for drawing. In that year, however, he decided to attend the free public classes given by a charismatic teacher, Joseph Gibert (1808-84), who, though in some ways a hidebound academic artist turning out official portraits and religious paintings by the score, was responsive to the needs and aware of the potentialities of his students. Curator of the well-stocked Musée Granet in Aix, named after a local painter who founded it and had been his teacher, Gibert laid great emphasis on life studies and copying both from antique statues and paintings in the museum. There still survive some meticulous life-drawings done by Cézanne at this time, as well as copies of paintings there such as *The prisoner of Chillon* by Louis Edouard Dubuffe (1820-80) and *The kiss of the Muse* by Félix Nicolas Frillie (1821-63). Throughout the whole of his subsequent career, paintings from the Musée Granet were to echo through his works. *The negro Scipio* (Plate 39) was based on a section of *The death of Camoëns* in Lisbon by J. de Lestang-Parade; *The rape* of 1867 (Plate 137) on a sketch by Rubens of Hercules strangling Althea, and three different paintings: *Woman with a mirror* (Musée d'Orsay, 1872), *Leda and the Swan* (Barnes Foundation, Merion, 1886) and *Nude* (Von der Heydn Museum, Wuppertal), were obviously based on *The triumph of Galatea* by Jean-Baptiste Greuze (1725-1805), one of the museum's outstanding masterpieces.

During the time he was attending Gibert's classes, which were held in the evenings, Cézanne, at the behest of his domineering but not actually tyrannical father Louis-Auguste, had been first attending law school and then working in the family bank. But the ambition to become a real painter, which had been nurtured in Gibert's classes, became so dominant in his life that in April 1861 his father not only allowed Paul to go up to Paris, but accompanied him to help in the search for lodgings. It did not turn out as Paul had hoped. He enrolled at the Académie Suisse, where he was ridiculed by his fellow-students, struck up a lasting friendship with Pissarro, and saw less of his old school-friend Zola than he had expected. At the end of the year, completely disheartened, he returned to Aix and started working at the bank again. For the next five or six years he was constantly moving between Aix and Paris, entirely dependent on his father, who used his purse-strings to keep an erratic control over his son persisting more or less until his own death in 1886 at the age of 89.

In deciding to become art students, the future Impressionists were committing themselves to becoming part of a system more complex, more comprehensive and more extensive in its influence than any comparable professional institution in the world. It was older too. Created in the seventeenth century by Louis XIV's minister, the energetic and far-seeing Colbert, it was based on the assumption that art can enhance the power and reputation of the state as well as increase the wealth of the country. Colbert's scheme eventually came to include, during the course of the eighteenth century, an elaborate system of state patronage,

40 PAUL CEZANNE *Sketch showing the artist's father reading* 1879/82
Cézanne painted three pictures of his father, with whom he had a complex
relationship, and made countless drawings in his notebooks showing him in a
wide variety of poses, but invariably wearing the hat which Frenchmen of his
generation considered essential for repelling draughts.

of 15 and 30, the competition was virtually confined to
students at the Ecole, who did not have to sit for a
qualifying examination. Discontent with the Ecole was
widespread, and that not only amongst students. The
architect Viollet-le-Duc, who was one of the most influential
figures in the art world of mid-century France, voiced a
general opinion in 1862 when he wrote in the *Gazette des
Beaux-Arts*:

A young man shows an inclination for painting or sculpture. His powers
are doubted, proofs of his abilities are required. If his first attempts are
not crowned with success of some kind, he is considered mistaken or
lazy; no more allowance from his parents. Hence it is necessary to
pursue that kind of success. The young artist enters the Ecole, he gets
medals, but at what price? Upon condition of keeping precisely and
without any deviation within the limits imposed by the corporation of
professors, of following the beaten track submissively, of having only
exactly the ideas permitted by the corporation, and above all of not
having the presumption to have any of his own. We observe besides that
the student body naturally includes more mediocrities than talented
people, that the majority always aligns itself on the side of routine; there
is no ridicule sufficient for the person who shows some inclination to
originality. How is it possible for a poor fellow, despised by his teachers,
chafed by his companions, threatened by his parents, if he does not
follow the middle of the marked-out highway, to have enough strength,
enough confidence in himself, enough courage to withstand this yoke –
commonly adorned with the title 'classical teaching', and to walk freely?

This was, in fact, something of an exaggeration. By the
1850s many of the Academicians were emphasizing the
importance of the sketch and of the generative as opposed
to the productive process in a work of art, and several such
as Gleyre, Delaroche and Couture, who took his students
on painting trips to the Channel coast, were advocating
the importance of painting in the open air, a notion which

41 Central Hall of the Ecole des Beaux-Arts, showing casts from which
students worked.

involving not only the purchase of works of art but the
provision of free studios and the establishment of a
prestigious art school in Rome, where students could study
the monuments of antiquity and the great works of the
Renaissance; it also included the subsidizing of a tapestry
factory at Gobelins and a porcelain factory at Sèvres. At
the apex of this system, which throughout the nineteenth
century experienced a number of changes, its members
being absorbed into the Institut Français which included
sections devoted to all the major art forms, was the
Académie des Beaux-Arts, consisting of 14 painters and
sculptors, elected by their peers. It was they who virtually
controlled the official art world of France, setting certain
stylistic standards, dispensing patronage and, until 1863,
directly controlling what, theoretically at least, was the
gateway to artistic success, the Ecole des Beaux-Arts.
Admission to this institution, situated on the Left Bank,
was through competitive examination, preparation for
which was provided by a number of art schools, usually
presided over by an Academician. The teaching at the
Ecole was of the most rigorous kind, with a heavy emphasis
on drawing and a preoccupation with the main incentive to
the course, to obtain the Prix de Rome, which provided an
annual scholarship to the French school there. Although it
was theoretically open to all Frenchmen between the ages

42 GEORGE DU MAURIER *Taffy à l'échelle*
For his novel *Trilby* George Du Maurier drew this picture of a typical boisterous scene from art-student life in the ateliers he knew in the 1860s.

was to become one of the pillars of Impressionist doctrine (see pp.56-7). Moreover, sometimes acting as a preliminary to the Ecole des Beaux-Arts, sometimes as a supplement to it, various Academicians ran painting schools, usually in their own studios, and it was here that adventurous spirits could, in Viollet-le-Duc's phrase, 'walk freely'. Typical of these was that of Thomas Couture (1815-79), situated on the ground floor of a house in the rue Laval (now more tactfully renamed the rue Victor Massé), which Manet started attending in January 1850 in the company of his old school-friend Antonin Proust (1832-1905), later to become Minister of Fine Arts in the Third Republic and one of his most enthusiastic supporters. Like others of the same kind, Couture's atelier accommodated about 30 students who paid an annual fee of 120 francs for tuition, plus a small fee for the use of a model when life classes were being held. The master would drop in four or five times a week, dispensing advice, giving demonstrations, and recounting anecdotes about his past life. A German painter, Anselm Feuerbach, who was there at about the same time as Manet, was most enthusiastic about the teaching, praising Couture's amiability, his emphasis on freshness and spontaneity, his belief in a passionate response to nature, and the doctrine that he expressed: 'Make sure first of all that you have mastered material procedures, then think of nothing and produce with a fresh mind and lively spirit whatever you feel like doing.' Couture took his students to the Louvre and drew their particular attention to the works of Raphael, Titian and Veronese. His greatest triumph had been his *Romans of the decadence* of 1847 (Musée d'Orsay), which contained references to Veronese's *Wedding feast at Cana*, Rubens' Marie de' Medici cycle and Marcantonio Raimondi's engraving of Raphael's *Judgement of Paris*, significantly the source of Manet's great *succès de scandale* of 1863, the *Déjeuner sur l'herbe* (Plate 73). When he opened his school, Couture had issued a publicity leaflet about it which stated, amongst other

things, that 'it is necessary to study all the schools to reproduce the wonders of nature and the ideals of our own time in a noble and elevated style'. Perhaps this is not what Manet achieved in the sense that Couture was using the words, but it is certain that the training he received there had a far greater influence on him than he was often prepared to admit.

Couture had a number of foreign students, including William Morris Hunt (1824-79), John La Farge (1835-1910) and Robert Loftin Newman (1827-1912), but the most famous American student in Paris during the period, James Abbott McNeill Whistler (1834-1903), whose career was to be so closely linked with Impressionism, opted for the studio of Charles Gabriel Gleyre (1808-74), which also attracted Monet, Renoir, Sisley and Bazille. Taking no money for himself, Gleyre, who had been a pupil of Ingres, only exacted from his students the costs of the studio in the rue Vaugirard and the fees paid to the model. George Du Maurier, the English artist who was a student there in 1857, later described in his highly successful novel *Trilby* the programme which the students followed:

They drew and painted from the nude model every day but Sunday, from eight till twelve, and for two hours in the afternoon, except on Saturdays, when the afternoon was devoted to much-needed Augean sweepings and cleanings. One week the model was male, the next female, and so on, alternating throughout the year. A stove, a model-throne, stools, boxes, some 50 strong-built, low chairs with backs, a couple of score easels and many drawing-boards completed the mobilier. The bare walls were adorned with endless caricatures – *des charges* in charcoal and white chalk – a polychromous decoration not unpleasing.

He also goes on to describe the kind of atmosphere which prevailed:

Irresponsible boys, mere rapins, all laugh and chaff and mischief; little lords of misrule – wits, butts and bullies; the idle and industrious apprentice, the good and the bad, the clean and the dirty (especially the latter) – all more or less animated by a certain *esprit de corps*, and working very happily and genially together, on the whole, and always willing to help each other with sincere artistic counsel if it was asked for seriously, though it was not always couched in terms flattering to one's self-love.

Born in Switzerland, Gleyre combined romantic and sometimes allegorical themes with classically academic elements. He was an indulgent teacher, seldom correcting a student's work, and by nature rather shy. His main advice to his pupils was, inevitably, to learn how to draw and to prepare the tone in advance, because, disliking a concern with colour, he felt that only in this way could they concentrate on the draughtsmanship. Since Renoir, who found the hearty atmosphere more than a little irritating, Bazille and Sisley were already deeply enamoured of colour, and looked back towards the chromatic fervour of Delacroix rather than towards the linear austerity of Ingres, so beloved by Gleyre, they felt alien to the atmosphere of the studio and because of this tended to cohere in a group of their own. But their reaction was not violent, for they were sincerely anxious to learn what they could from a practitioner whose technique they respected, if not admired. As Renoir later pointed out to Emile Faure, 'Whilst the others shouted, broke the windows, made the model's life unbearable and ragged the professor, I was always quiet in my corner, very attentive and docile, studying the model,

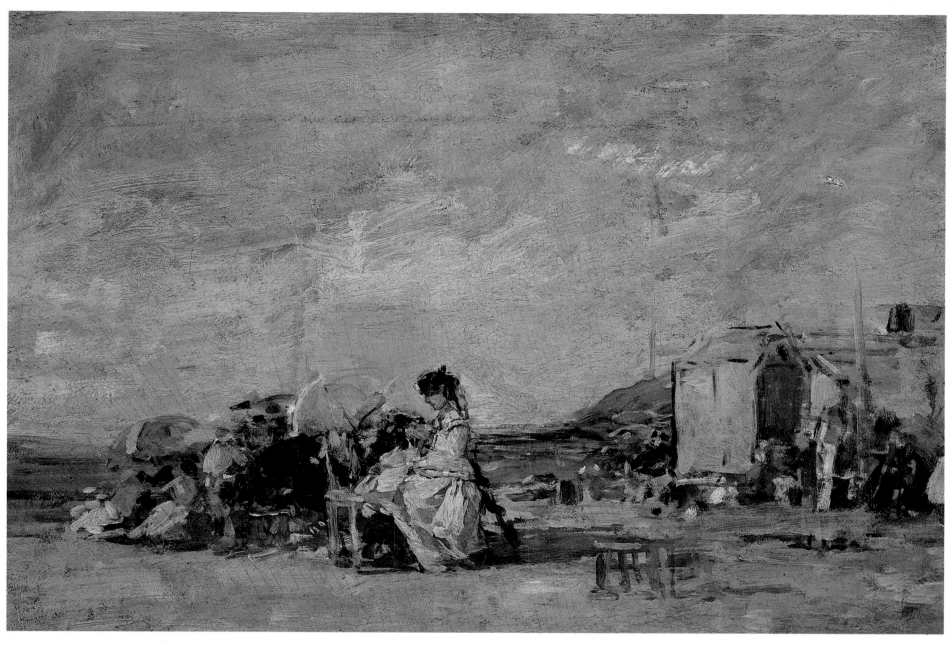

43 EUGENE BOUDIN *The beach at Trouville c. 1863*

listening to the teacher. Yet I was the one who was dubbed the revolutionary.'

Monet, however, was a good deal more intractable. After all, he had been in touch with painters who were outside the confines of the academic circle. In Le Havre he had met Boudin in a framemaker's, where he was exhibiting the caricatures which at the time were securing him local notoriety, and had been deeply impressed, after an initial aversion. Boudin's seascapes had a simplicity, a freshness, a concern with light and atmosphere which were entirely new in French art and Monet, at the age of 18, virtually became his pupil, learning from him ideas which were to be integrated into the new kind of painting already taking shape in the art schools and cafés of Paris. 'The sea, the sky, people, animals, trees are so beautiful just as nature has made them, with their character, their authenticity, in the light, in the air, just as they are'; 'Everything that is painted directly on the spot has always a power, a strength, a vividness of touch that one can't retrieve in the studio'; 'It is not one part of a picture that should strike the spectator, but the entirety of the work.'[1] Another belief of Boudin which was to be incorporated into the Impressionists' doctrine, though it was very much in the air at the time, was that of the importance of contemporary reality as a fit subject for art. In a letter written in 1868 he commented.

This approach is making headway again, and a number of young painters, chief amongst whom I would put Monet, find that it is a subject that has hitherto been too much neglected. The peasants have had painters who have specialized in painting them...but quite honestly between ourselves don't those middle-class men and women walking along the pier towards the setting sun also have a right to be *brought to light?*

At the beginning of 1862 Monet had also been introduced by an Englishman to Johann Barthold Jongkind (1819-91), a Dutchman who was then painting in Le Havre, working on those seascapes so vibrant with light which were to help mould Monet's own style and have a lasting effect on Impressionism as a whole. Painters such as Boudin and Jongkind produced work which was far removed from the quiescent canvases which Gleyre taught his students to produce and which were, in any case, alien to Monet's more rumbustious personality. In later life he was to claim, either from forgetfulness or, more likely, from a desire to confer on himself a retrospective independence of personality, that he left Gleyre's studio after a fortnight, taking Renoir and Sisley with him. In fact, all of them left in 1863 when, because of failing eyesight and other afflictions - he died the following year - Gleyre retired from teaching. But there can be little doubt that Monet

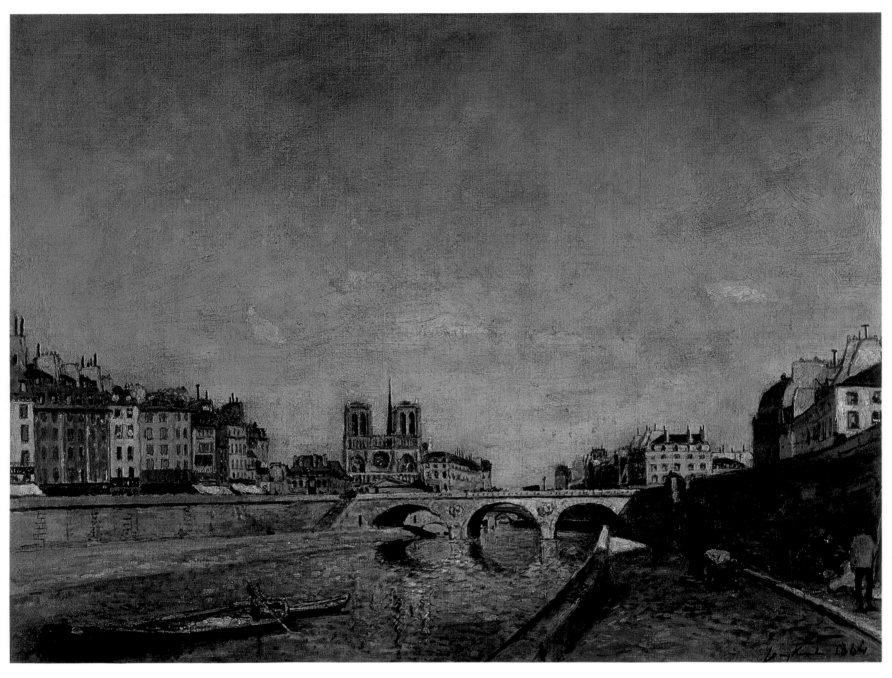

44 JOHAN BARTHOLD JONGKIND *The Seine and Notre-Dame* 1864

had already established for himself a kind of dominance over his like-minded fellow students.

Another artist with whom Monet had made contact before arriving at Gleyre's was Pissarro who, though he was mainly at that time working in the countryside around Paris, had made the Académie Suisse, on the Quai des Orfèvres, his headquarters. Founded by an unsuccessful pupil of David's named Suisse, it was on the first floor of a ramshackle building, the ground floor of which was occupied by a *dentiste du peuple* named Sabra, who extracted teeth for the very modest fee of 20 sous. The main studio contained a platform for the model, placed against the wall with a protective iron rail in front of it, and a rope hanging from the ceiling on which the model could support himself when called upon to adopt one of those complicated poses usually thought to have been favoured by Greek deities. On the other walls were shelves adorned with plaster heads, arms and other anatomical para-phernalia. The students sat around the platform on stools which varied in height according to their distance from it. The Académie was open in winter from 8am till 5pm, and in summer from 6am till 10pm. There were male models available for three weeks, female for one. Very occasionally children posed. The fees were 40 francs a month. The title

of Académie which it assumed was a blatant misnomer; its great charm was that it was just the opposite; there was no tuition of any kind – a fact which endeared it to both the independent-minded and the incompetent. Courbet had worked there, and Manet used to drop in from time to time. When Pissarro was working there, amongst the other students who attended were Cézanne, who wrote to a friend that he was busy there every day from six till eleven, and a clerk from the Paris-Orléans railway, 20-year-old Armand Guillaumin, who was to become a regular exhibitor at all the Impressionist shows. Then there was Antoine Guillemet, who had been a pupil of Corot and a friend of Manet. Guillemet, though a partisan of the Impressionists, whose works he supported in the Salon in which he was eventually an influential figure, never became part of the movement, being reluctant to escape from the influence of Corot. Another fringe figure at the Suisse was Cézanne's friend from Aix, the dwarf Achille Emperaire (1829-1910), of whom he produced a memorable portrait, rejected by the jury of the Salon in 1870 but which may be thought of as one of the first truly modern portraits (Plate 136). Originally a pupil of Couture, Emperaire worked for lengthy periods at the Suisse, and made an uncertain living copying works from the Louvre. His whole life, most

of which he spent in Aix selling soft pornography to the students there, was dogged by misfortune and poverty, but he was a remarkable artist, whose drawings are slightly reminiscent of those of Odilon Redon and occasionally suggest those of Seurat, whom he had never met, and of whose works he must have been ignorant.

The popularity of the Suisse, with its complete freedom from the conventions of the Ecole des Beaux-Arts and the rigid formulae of academic teaching, as well as the discontent of Monet with even the mild conservatism of Gleyre, pointed up a polarity which had been becoming increasingly apparent in French painting since the first quarter of the century. Its roots were in the past, and indeed it might be thought of as being fundamental to the artistic process itself. At base it involved the dichotomy between thought and feeling, between line and colour, between classicism and romanticism. One of its earlier manifestations had been apparent in the Renaissance between the art of Florence, clear, intellectual and linear, and that of Venice, relying heavily on colour, atmosphere and expressiveness. In seventeenth-century France it had been represented in one of its most dramatic forms by the contrast between the classical paintings of Poussin, with their clear colours and their sculptural draughtsmanship, and the landscapes of Claude, full of atmosphere and feeling, converting the Italian countryside into an idyllic dream world of sylvan delight. Ever since the Renaissance there had been an emphasis on the significance and importance of the

45 PAUL CEZANNE *Uncle Dominique in a cap* 1866
Cézanne's mother's brother, Dominique Aubert was a bailiff by profession, and a helpful and compliant model for his 27-year-old nephew during the periods when he was virtually marooned in Aix. Cézanne painted him in a variety of guises.

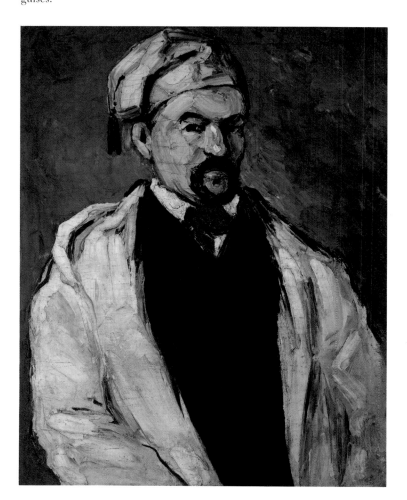

46 EDGAR DEGAS *View of Naples* c. 1856
One of the many drawings Degas made in the notebooks which he carried around with him during his trips to Italy.

individual as opposed to the institution, on personal belief rather than on institutionalized doctrines, on justification by achievement rather than by the accidents of lineage. This attitude was fostered as much by the improving quality of life itself as by more theoretical considerations; it promoted the growth of sensibility and gradually assumed the characteristics of what the ever-expanding body of commentators and historians came to call a movement, Romanticism. Once identified, its manifestations became both more apparent and more diverse. Feeling took precedence over thinking, sensibility over sense; the Middle Ages with their apparent irrationality were preferred to the equally fictitious rationalism of Greece and Rome; the novel, with its creation of imaginative worlds, became a dominant literary form. Democracy, with its emphasis on the rights of the ordinary citizen – the United States was the first romantically conceived state – was to be preferred to political systems based on the imposition of rules by those endowed with powers from above.

But, just as in the political world the first great assertion of this attitude, the French Revolution, was followed by the rule of Napoleon, more autocratic than that imposed by his Bourbon predecessors, so in art, the growth of feeling and sensibility apparent in the work of painters such as Greuze was replaced by the doctrinaire classicism of David, with its emphasis on the primacy of draughtsmanship, its imposition of a hierarchy of subject-matter, and its general authoritarianism. When in 1799 David exhibited the *Rape of the Sabine Women* (Louvre) the *Journal de Paris*, which reflected the view of the government, noted:

The old habits of the art world have changed. Brought back once more to their true goal by the imitation of nature, supported by the study of antique models, they turn once more to moral and political preoccupations. In perpetuating the characteristic features of heroism and virtue, even during the storms of the Revolution, they have ventured on a new path, and all proclaim that this state of greatness should gain in strength and that they should receive from the new order of things a real and permanent lustre.

This view of the nature and functions of art was to remain, with only minor modifications, the dominant official one in France throughout the century, and it was to receive

47 EDGAR DEGAS *Marie-Thérèse Morbilli*
Degas also painted another oil portrait of his sister, the wife of Edmondo Morbilli
in *c*. 1869, when she was on a visit to Paris, staying with their father in his house
at 4 rue Mondovi.

48 EDGAR DEGAS *Two riders by a lake c.* 1861
An unusually 'soft' watercolour sketch, done in one of his notebooks.

further support from David's natural heir, Jean-Auguste Dominique Ingres (1780-1867), a dominating figure who believed that art should depict only beauty and be concerned only with the sublime; that drawing 'is everything, it is the expression, the interior form, the plan, the modelling' and that the best advice to be given a painter is 'copy, copy simply, wholeheartedly, abjectly that which you have before your eyes; art is never so perfect as when it resembles nature herself'.

Yet this tidy picture of a simple dichotomy between Ingres and the young Turks of painting needs qualification. Degas, who had been a student of Louis Lamothe, one of Ingres's pupils, always admired and was influenced by his work, and it was to him personally that Ingres said in the course of a visit Degas made to his house in 1864, 'Draw lines, many lines, from memory or from nature; it is by this that you will become a good artist.' The drawings Degas made during this period, especially a copy of Ingres's *Le bain livre*, and the portraits of members of his family all show how seriously he took the advice of this pillar of artistic authoritarianism, this enemy of free colour and uncontrolled sensibility. Like Ingres, Degas was a single-minded explorer of form, and like him he was largely to eschew landscape painting, the major preoccupation of all the other Impressionists. Yet it was in effect attitudes towards landscape painting which were to undermine the edifice of academic art and bring about the triumph of the revolution symbolized by the exhibition in the boulevard des Capucines in the spring of 1874.

Despite a widespread popular belief to the contrary, the Academy did not disdain landscape painting as some earlier theoreticians had, and it was established as an essential part of the training programme of the Ecole des Beaux-Arts in 1817. After all, nature had come to play a dominant role in the romantic canon, with manifestations as varied as the poetry of Goethe, the growing popularity of the seaside, and the predominance of the Alps as a place to spend holidays rather than as an unpleasant hindrance to reaching Italy. The problem was that convention demanded highly finished, 'polished' paintings, whereas the romantic principle, with its belief in the primacy of spontaneous individual feeling, laid great emphasis on the idea of direct observation uncorrected by the subsequent manipulation necessary to achieve the kind of patina so beloved of Salon painters. There was evolving, therefore, a style of landscape painting independent of the Academy which came to be known as the *style champêtre* and which had been defined by J.B. Deperthes in a book on landscape painting published in 1818 as depicting 'an expanse of country, dominated by an area of sky, seen in the light that falls on it at the exact moment when the painter sets out to capture the scene...it is imperative that in a landscape painting, which can only reproduce an instantaneous effect, there should be a perfect harmony between the tone of a landscape as a whole, and that of the sky which illuminates it.'

49 JOHN CONSTABLE *Weymouth Bay* 1816

There were precedents for this approach to art which seemed as convincing as those on which the Academicians relied. When Holland was incorporated in Napoleon's empire in 1806, the French had shown a new interest in Dutch and Flemish painting with its concern with light, landscape and atmosphere. The works of Jacob van Ruisdael, Jan van Goyen and Albert Cuyp started to assume fresh significance, and the genius of Rubens as a colourist was appreciated by painters who had hitherto been dominated by the doctrines of David and Ingres. There were more contemporary influences at work too. When Marie Henri Beyle, better known by the pseudonym of Stendhal, under which he wrote those novels which became pillars of literary romanticism, first saw John Constable's *The Hay Wain* in the Salon of 1824 he wrote in the *Journal de Paris*:

The English have sent us magnificent landscapes this year, those of Mr Constable. I do not think that we have anything to equal them. The truthfulness catches the eye and draws one to these charming works. The casualness of Mr Constable's brush is extreme, and his composition is not thought through, also he has no ideal, but his delightful landscape with a dog at the left is the mirror of nature.

It was just this casualness of brush which endeared Constable to Delacroix and the younger generation of artists, and when the English art dealer John Arrowsmith opened a brasserie in Paris, it contained a Salon Constable, hung with his paintings.

One of the habitués of Arrowsmith's place was Théodore Rousseau (1812-67), who was as fiercely attracted to the *style champêtre* as he was opposed to the academic establishment. He was the virtual leader of a group of painters which was to be the catalyst between that style of painting and Impressionism and which came to be associated with Fontainebleau. Not very far from Paris, this forest, which had once been the arboreal pleasure grounds of François I, and had already given its name to a sixteenth-century school of painting reflecting the first influence on France of the Italian Renaissance, had become by the early nineteenth century what James Fenimore Cooper, who visited there in 1827, described as 'exceeding in savage variety' anything he had seen in his native country. But 'savage variety' was just what the sensation-seeking painters of the period wanted. Rousseau arrived there in the 1830s, and established himself at Barbizon, a hamlet of thatched cottages without school or church, the only important building being an inn run by François Ganne, who also rented houses. Rousseau was a typical example of the generation which had been attracted to the Dutch painters. In his case the dominant influence was Ruisdael, but by the late 1850s his interest was changing from the overtly dramatic and emotive to a more controlled objectivity,

50 THEODORE ROUSSEAU *Holm-oaks, Apremont* 1867

showing a particular interest in the creation of atmospheric effects, though always concerned with what he described as 'keeping alive the virgin impression of nature'. He was soon joined at Barbizon by Narcisse Diaz de la Peña (1807-76), a one-legged painter who had been born in Bordeaux of Spanish parents and who, after having had some success as a painter of historical works, turned to landscape, producing pictures with a thick impasto rubbed down to create effects of light and atmosphere especially suitable for describing the dappled sunshine percolating through the leaves of the Fontainebleau trees. Renoir was to say that Diaz's example led him to lighten his palette, and the flickering brush-stroke which characterized much of the older artist's work was to be picked up by other Impressionists.

Diaz had been introduced to Rousseau by Millet who, in a state of great poverty and scared of cholera, had first come to Barbizon from Paris in 1849. Born of a peasant family in Normandy, Jean-François Millet added a new element to the ferment of artistic ideas bubbling away in this remote village (though its remoteness was lessened by the opening of a railway line to Fontainebleau from Paris in 1849). He re-introduced human beings into landscape, choosing them from one of the most underprivileged classes of society, the peasantry. Moreover, although his peasants seem sentimentalized to twentieth-century eyes, they were considerably less so than those who had appeared hitherto in the paintings of artists such as Boucher, Greuze or Fragonard. It was an approach which was to be followed by the Impressionists, even though they were to choose the urban rather than the rural proletariat.

That a group of young artists discontented in varying degrees with the art education they had received and resentful of the tyranny of official art should have migrated to Barbizon was inevitable. Monet and Bazille had made their first excursion to Fontainebleau while they were still in Gleyre's atelier, spending three weeks at Chailly, which was just on the edge of the forest, but not far from Barbizon. When Gleyre's studio closed Monet persuaded Renoir, Sisley and Bazille to come and stay at Chailly for varying periods between 1864 and 1866. Naturally they saw the forest and its surroundings through the eyes of those who were already established there. Millet seems to have been rather unapproachable. Monet, who was a great admirer of his work – in a painting of 1864, *Road in the forest with woodgatherers* (Museum of Fine Arts, Boston), there is a distinct quotation from a drawing by Millet which later served as an inspiration to Van Gogh – found him personally unfriendly and told a friend who wanted to meet him, 'Don't go. Millet is a terrible man, very proud and haughty. He will insult you.' The great difference between the two, and one which became more significant as time went by, was that, whereas Millet painted in his

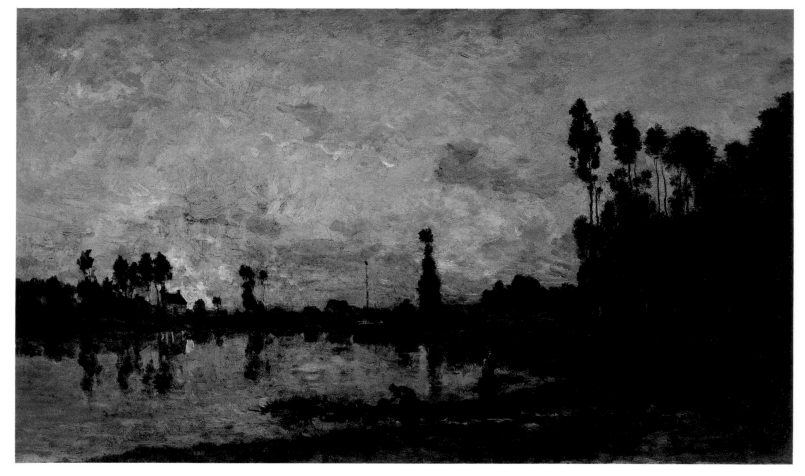

51 CHARLES-FRANÇOIS DAUBIGNY *Sunset on the Oise* 1865

studio from sketches done in the open, which perhaps accounts for the contrived quality of some of his more famous works, Monet had already adopted the principle of painting directly from nature. In this he had been very much influenced by Charles Daubigny (1817-79), who did not live at Barbizon although he had worked there in the late 1840s. He too had experienced early success in the Salons, but developed a passion for landscape, especially rivers, beaches and canals, which he painted in a limpid style owing a clear debt to the Dutch school. His passion for painting out of doors was carried to such lengths that in 1857 he had a small boat constructed for himself which he used for his painting excursions on the river Oise. It must have been with a sense of prescience that Théophile Gautier, some ten years before the opening of the exhibition in the boulevard des Capucines, wrote of his work:

It is really a shame that this landscape painter, who possesses such a true, such a just, and such a natural feeling, is satisfied by an impression and neglects details to this extent. His pictures are but rough drafts and very slightly developed. Each object is indicated by a real or apparent contour, but the landscapes of M. Daubigny offer merely spots of colour juxtaposed.

In 1864 Daubigny had exhibited at the Salon a view of Villerville on the Normandy coast, the genesis of which was described by his friend and biographer Frédéric Henriet:

He had fixed his canvas to some posts firmly driven into the ground, and there it remained, continuously exposed to the horns of cattle and the pranks of mischievous children, until it was completely finished. The painter had deliberately chosen a turbulent grey sky with big clouds chased by an angry wind. He kept watch for the favourable sky and ran out to work there as soon as the weather promised to correspond to the effect of the picture.

The belief that direct physical contact with nature promoted creativity and a heightened sensitivity in the artist was one of the tenets of Romanticism, defined at an early stage by Wordsworth:

> One impulse from a vernal wood
> Can teach us more of man,
> Of moral virtue and of worth
> Than all the sages can

and it was to remain one of the basic beliefs of Impressionism, but often more honoured in the breach than the observance. Monet was later to claim: 'I threw myself body and soul into *plein air* painting. It was a dangerous innovation. Nobody had ever done it before,' a statement which was patently untrue. His own first full-scale open-air painting, *Women in the garden* (Plate 100), which was so large that he had to dig a trench in the garden to be able to reach the upper sections, was begun out of doors in the summer of 1866, finished indoors at Honfleur early in 1867 and rejected at the Salon of that year. An earlier work, *Le déjeuner sur l'herbe*, painted in emulation of Manet's much-publicized work, which seems to have been painted out of doors, was in fact a studio work, reliant on outdoor sketches. But the ideal of painting on the scene was to obsess him. Some 14 years after his fruitful contact with Daubigny he had a studio boat built in imitation of the latter's, and was painted in it by both Manet and Sargent. In

52 NARCISO DIAZ DE LA PENA *Landscape c. 1870*

1876 he painted himself at work in it (Barnes Foundation, Merion, PA). Maupassant, who met him at Etretat on the Normandy coast in 1885, described him working there: 'Off he went, followed by children carrying his canvases, five or six of them representing the same subject at different times of the day. He picked them up or put them down in turn according to the changing weather.' The story of Turner lashed to the mast of a ship at sea so that he could paint a storm had an unvarying appeal to him, and there are frequent accounts of him painting in oilskins, with a hot-water bottle to keep his hands warm, his brushes and palette being blown away by the wind, his canvases covered with sand. He was very sensitive to any suggestion that he had relied on anything other than direct observation. Much later in life, on 12 February 1905, he was to write to Durand-Ruel about a story being put about by William Rothenstein and the American painter J.W. Alexander that he used photographs for his series of paintings of the Houses of Parliament:

I know neither Mr Rothenstein nor Mr Alexander, but only Mr Harrison[2], whom Sargent commissioned to do a small photo of Parliament for my benefit, which I was never able to use. But it is hardly of any significance, and whether my *Cathedrals* and my *London* paintings and my other canvases are done from life or not is none of anyone's business and is quite unimportant. I know so many artists who paint from life and produce nothing but terrible work. That's what your son should tell these gentlemen. It's the result that counts.

He was, in fact, like Degas and Zola, deeply interested in photography, possessed a number of cameras, and in the 1890s had a dark-room constructed in his house at Giverny; he was known to have photographed Rouen cathedral a number of times. There can be little doubt that his adherence to the doctrine of open-air painting was neither as complete nor as consistent as he claimed. It is known that most of his Venetian paintings were done in the studio from sketches made on the spot, and it is fairly certain that throughout his career the mere physical hindrances to painting a picture completely out of doors caused him to adopt some compromise solution of the kind he described to Durand-Ruel in a letter of 1886:

You asked me to send what I have that's finished. I have nothing finished, and you know that I can only really judge what I have done when I see it at home. I always need a moment of peace and quiet before I can put the final touches to my canvas. For many of the motifs I have much trouble finding the same effect again, and I'll have a lot to do once I get back to Giverny.

Their experience at Barbizon confirmed Monet, Bazille, Renoir and Sisley in their belief in the merits of *plein air* painting. It was one which was to play an important part in their subsequent careers, although it should be noted that the independently-minded Pissarro, who had little or no contact with Fontainebleau, had already been adopting the same approach in his excursions around the outskirts of Paris and on the banks of the Marne. The main influence on him had been Camille Corot (1796-1875), and he described himself on the entry form of two works which he sent to the Salon of 1864 as 'the pupil of A. Melbye and Corot'. The luminous atmospheric landscapes of this benevolent man, who was a kind of father-figure to young artists, were themselves dependent on extensive open-air painting, though they had a smooth finish which earned them official approval; even Napoleon III bought one of his works for his private collection. Corot emphasized the importance of always picking subjects that suited the artist's particular inclinations, and of studying the relationship of colours to each other. Pissarro's paintings at this time were very close to those of Corot, as were those of Monet. When in 1864 Monet sent three paintings to Bazille in Montpellier in the hope that he might interest a local collector, Alfred Bruyas,[3] in them, he commented, 'One of these three canvases is a simple sketch which you saw me begin. It is based entirely on nature, you will perhaps find in it a certain relationship to Corot, but that this is so has simply nothing to do with the motif and especially the calm and misty effect are the only reasons for it.' In his old age Monet told Gustave Geffroy, who was writing a book about him, that Corot's work, along with that of Boudin and Jongkind, were 'at the origin of what has been called Impressionism'.

53 J. M. W. TURNER *Tours: sunset c.* 1841
Although Monet was later to deny it, the influence which Turner had on the Impressionists was unquestionable. It was all the more accessible because of Turner's extensive travels in France and Switzerland.

54 JEAN-BAPTISTE CAMILLE COROT *Avray village showing the Cabassud houses*

Renoir, who at this time was painting pictures in the open air predominantly with a palette-knife technique, was to remain influenced by Corot for many years. This was especially evident in the views of Paris which he painted in the late 1860s. But Corot's closest link with the future Impressionists was through the Morisot family, with whom he had been brought into contact through one of his pupils, Oudinot. The Morisot girls, Berthe and her elder sister Edma, had shown an early talent for art and had been encouraged by their parents, who had engaged the academic Joseph Guichard, himself a friend of Corot though not an admirer of his works, to become their teacher. Both, however, in their early twenties, had more adventurous ideas, being especially enamoured of working in the open air – in 1862 they spent the summer in a painting tour of the Pyrenees – and decided to leave Guichard for the younger and more innovative Oudinot. In effect they virtually became Corot's pupils and he, not usually a sociable man, used to dine at their parents' home every Tuesday. The summer after their Pyrenean excursion they spent painting feverishly on the Oise, between Pontoise and Auvers, an area favoured by Pissarro; there they met Daubigny, then living in Auvers, and Daumier, who had a house nearby. In the same year Berthe had two paintings accepted at the Salon.

The financial independence which the Morisot sisters enjoyed allowed them to indulge their passion for open-air painting as much as they wished. It was not, however, so simple for others such as Monet and Renoir, compelled to depend very largely on their own financial resources. Monet was busy painting prolifically what he described to Bazille as 'stunning seascapes, figures and gardens', adding in the next sentence, 'I'm asking you to send me whatever you can, the more the better, since although I'm getting along with my parents, they warned me that I could stay here as long as I liked, but if I needed money I had to earn it.' His position was further complicated by the fact that he was having an affair with Camille Doncieux, later to become his wife and by whom in 1867 he was to have a child. His parents were violently opposed to the liaison, and he had to abandon Camille in Paris whenever he went home to try and collect money from them. His begging

letters to Bazille became more and more impassioned; the most dramatic one, dated 29 June 1868, ran:

I've just been turned out, without a shirt to my back, from the inn where we were staying [at Bennecourt]. I have found somewhere in the country for Camille and my poor little Jean to stay for a few days. I leave this evening to try and see if my patron¹ can help me. My family refuses to do anything for me, so I don't even know yet where I'll be sleeping tomorrow.
Your loyal and devoted friend, Claude Monet.
I was so upset yesterday that I was stupid enough to hurl myself into the water. Fortunately no harm was done.

An attempt at suicide? Or more likely an ambiguously worded statement to try and make Bazille think that it was? As his stepson Jean-Pierre Hoschedé was later to point out, Monet was an extremely good swimmer, and if he had chosen this way of solving his problems he must have been pretty certain that it would not succeed. Another economy with the truth was that he continued receiving money from his family – though, it has to be said, erratically – until 1869.

He was painting now mostly in Normandy, though for a period he shared a studio flat in Paris with Bazille, not entirely to the latter's content. Many of the paintings he was producing were seascapes near Honfleur or at Sainte-Adresse near Le Havre, themes also taken up by Bazille on one or other of his visits to the area. His art, however, was at the same time developing along more complex lines, suggested by *Women in the garden*, *The Quai du Louvre* and *The Terrace at Sainte-Adresse* (Plates 100, 122, 157) – the last named reflecting a distinct Japanese influence.

The effect of Japanese prints on the whole group is discussed in detail in Chapter 4 (pp.130-34). Quite often the example of this art did not provide entirely innovative effects. More frequently it acted as a confirmation of the validity of approaches which many more adventurous artists had already been exploring. This was especially true in the case of Degas, who had been virtually untouched by the passion for open-air painting and had preferred to follow his father's advice and keep the study of the Italian old masters well to the fore of his artistic activities. And yet the Japanese were to have a perceptible influence on him. On his death it was recorded that he possessed 15 drawings by Hiroshige, two triptychs by Utamaro, 16 albums of prints and individual works by Hokusai, Shunsho and others. He was especially impressed by the pictures of

55 FREDERIC BAZILLE *Monet after his accident* 1866
When he was staying at Chailly Monet wrote to Bazille suggesting that he should join him there. Shortly after his arrival, Monet fell and injured his leg. As the best way of keeping him quiet Bazille painted this picture of him lying in the hotel bedroom.

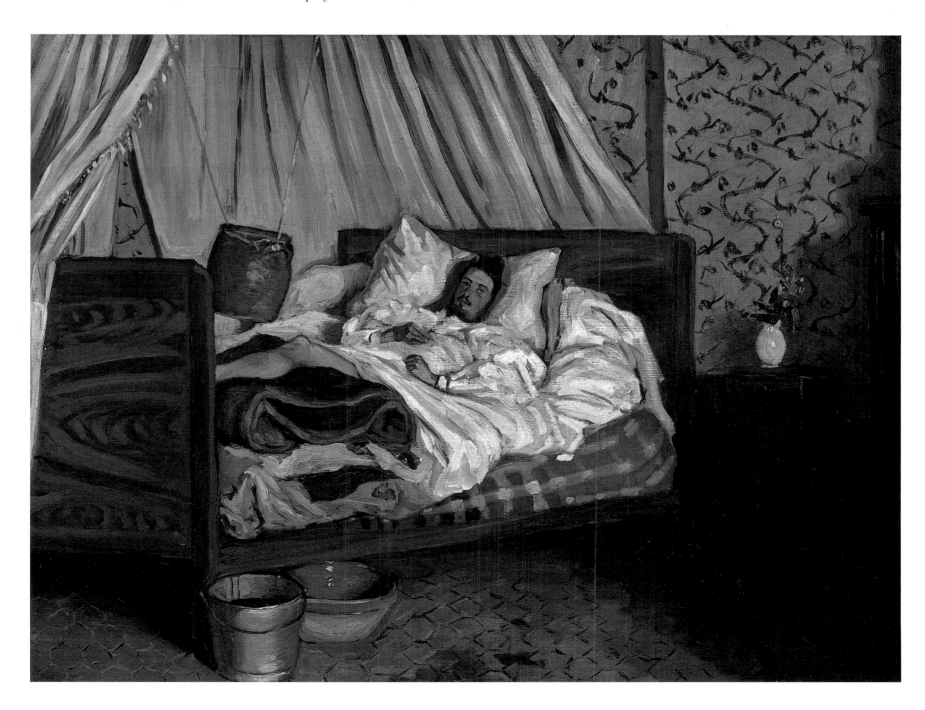

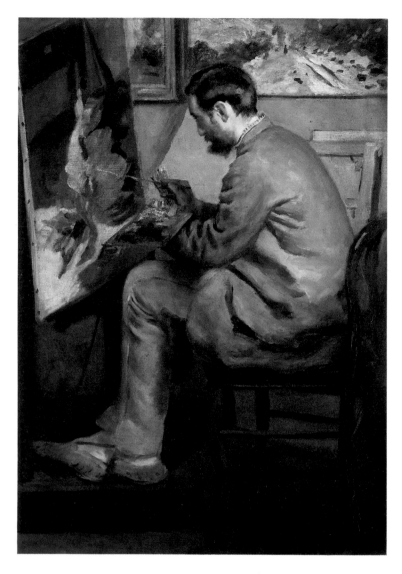

56 PIERRE-AUGUSTE RENOIR *Bazille at his easel* 1867
In the winter of 1867-8 Renoir was sharing a studio with Bazille in the rue de la
Paix – the rent being paid by Bazille. It was here that he painted this portrait of
him, at work on the *Still life with heron* also reproduced here.

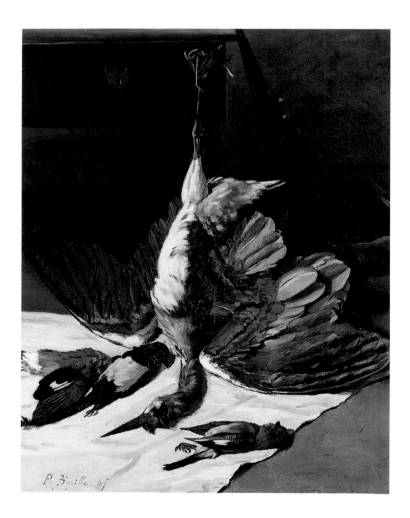

courtesans, actors and dancers depicted in the transitory
world of the masters of that popular Japanese school, the
Ukiyo-e, which specialized in delineating ordinary con-
temporary life. Such a concern however had already been
apparent in French art, notably in the works of Daumier,
Courbet and, to a lesser degree, Boudin. It was apparent
too in Monet's *The Quai du Louvre* and Renoir's *The Pont
des Arts* of 1867 (Norton Simon Foundation, Los Angeles)
as well as in the work of Salon painters such as Gervex and
Béraud, but the Japanese precedent reinforced that inclina-
tion, and in the case of Degas helped him to evolve that
iconography of ballet-girls, milliners and prostitutes which
he was to make so much his own.

Renoir too was interested in this newly discovered enclave
of taste, though its effects were less apparent in his
paintings. Before, like the others, he abandoned the rustic
delights of Fontainebleau, he painted what was to be
perhaps the most poignant memorial of this shared
experience, not a landscape but a group portrait painted in
the inn of Mère Anthony where they all stayed (Plate 38).
Some 20 years later he described it to the dealer Ambroise
Vollard (1863-1939):

The *Inn of Mother Anthony* is one of my pictures which I remember
with most pleasure. It is not that I find the picture itself particularly
exciting, but it does remind me of good old Mother Anthony and her
inn at Marlotte. That was really a village inn! I took the main bar, which
doubled as a dining room, as the subject of my study. The old woman in
a headscarf[5] is Mother Anthony herself, and the splendid girl serving
the drinks is her barmaid Nana. The white poodle is Toto, who had a
wooden leg. I had some of my friends including Sisley and Le Coeur
pose round the table. The motifs that make up the background were
borrowed scenes painted on the wall; they were unpretentious and often
successful paintings by the regulars. I myself drew a sketch of Murger[6]
on the wall, and copied it in the upper left corner of the painting.

This group portrait was indicative of Renoir's growing
interest in portraiture, an interest which had at least some
degree of economic motivation. His portrait of William
Sisley, the painter's father, was exhibited at the Salon
(Musée d'Orsay) and in 1868 he painted what is presumed
to have been a portrait of the younger Sisley and his wife
entitled *The engaged couple* (Plate 127), which was intended
for the Salon and could be seen as a counterpart to Monet's
Women in the garden. Round about this time too he
produced a vivid portrait of Bazille seated painting at his
easel (Plate 56). It was bought by Manet, who greatly
admired it but after Bazille's death gave it to his father in
exchange for *Women in the garden*. The picture on which
Bazille is working is the *Still life with heron* (Plate 57).

Gradually, however, Renoir was moving towards a theme
which he was to make especially his own, the female
figure. In part this was connected with the appearance in
his life of Lise Tréhot, a young brunette who first appeared
in *Lise with a parasol* (Folkwang Museum, Essen, 1867)
and who was to be his mistress for the next seven years. In
that same year he painted her nude in what seemed like a

57 FREDERIC BAZILLE *Still life with heron* 1867
Both Sisley and Bazille painted exactly the same still life, though from slightly
different angles. Bazille's version features in Renoir's portrait of him.

of nudes which stretched through the whole of his career until virtually the very end.

The curious thing about Renoir's sensuous imaging of women's bodies is that (as with Etty and Russell Flint, two other painters who specialized in the nude), although he was theoretically a sensualist, his attitude towards women was both reactionary and physically unenthusiastic. His often quoted remark that he painted women as he would paint carrots was no doubt a jocular exaggeration, but it contained more than a grain of truth. He was profoundly reactionary and defensive in his attitudes to the opposite sex; his most enthusiastic praise for his wife Aline, whom he married when he was 49, was that she was like his mother. and he tended to estimate the attractiveness of a woman almost entirely in terms of whether or not she was paintable. His basic belief was that woman's place was in the home; he preferred simple peasant-like types to sophisticated city women, whom he clearly found alarming. Once when watching a boy and girl quarrelling he observed tartly to his friend Rivière that the girl would win: 'he took pleasure in noting the inevitable victory of the woman over the man'. Most at ease in male company, where he felt secure, he saw women as decorative adjuncts to life on much the same plane as most natural phenomena, save that they had the additional advantage of providing essential services. Two years before Freud started publishing his excursions into the murky labyrinth of the subconscious, Renoir said to a friend, 'It's with my brush that I make love.' In so doing he created untold numbers of grateful voyeurs.

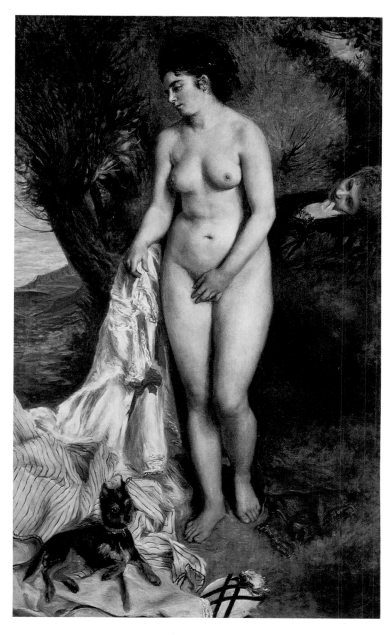

58 PIERRE-AUGUSTE RENOIR *Bather with a griffon* 1870

straightforward Ecole des Beaux-Arts classical study; but, to the surprise of Renoir and his friends, it was rejected by the Salon of that year, a rejection which fuelled their anger with the artistic establishment. In 1869 *Summer; study* (Nationalgalerie, Berlin), a study of Lise, sometimes known as *La Bohèmienne*, was accepted, despite the vigorous and deliberately unfinished handling of the leaves in the background and the treatment of the girl's hair. It attracted a good deal of attention, and was bought for 400 francs by the critic Théodore Duret, who had never seen a work by Renoir before but admired 'the charm of the girl and the quality of execution'. His most spectacular picture of Lise. however, was the *Bather with a griffon*, shown in the Salon of 1870 (Plate 58); it may be seen as the first of that long line

[1] Extracts from Boudin's notebooks quoted by R.L. Benjamin, *Eugène Boudin*, New York 1937.

[2] Presumably L.A. Harrison, an American painter who had worked in Paris, was a friend of Sargent, and lived close by him in Cheyne Walk.

[3] Bruyas (1801-73) was a patron of Courbet, and is the central figure in that painter's *Bonjour, Monsieur Courbet* of 1854. He encouraged the young Bazille, whose parents were his neighbours in Montpellier, and initiated Dr Gachet, then a medical student in the city, into his subsequent career as a collector.

[4] Louis-Joachim Gaudibert (1812-78), a successful Le Havre businessman, who lived in a château at Montivilliers. He was an amateur artist and very generous to Monet, giving him an allowance this year and the following. He also commissioned portraits from him, which Monet executed in a conventional style (such as the portrait of Marguerite-Eugénie-Mathilde, Gaudibert's daughter-in-law, in the Musée d'Orsay).

[5] Seen with her back towards the spectator in the top right between Sisley and Le Coeur.

[6] Henri Murger (1822-61), the author of *Scènes de la vie de Bohème* which did so much to popularize the romantic notion of artists' lives. He spent lengthy periods in the 1850s staying at what was then Père Anthony's.

59 EDGAR DEGAS *Self-portrait* 1854-5
During the early part of his career Degas produced several self-portraits, all marked by the same quizzical stare. On some occasions he seemed to have copied them directly from photographs.

60 EDOUARD MANET *Street-singer c.* 1862
Victorine Meurent was the model for this painting; it was based on an actual experience when Manet had seen a girl, holding her dress and carrying a guitar, coming out of a café, and had asked her to pose. She refused, and he substituted a bunch of grapes for the guitar in this version of the event.

61 PAUL CEZANNE *Gardanne* 1866
Gardanne was a village at the foot of Mont Sainte-Victoire where Cézanne frequently went
on his painting expeditions. Ten kilometres from Aix, it is now completely unrecognizable.

62 FREDERIC BAZILLE *Landscape at Chailly* 1865

The influence of Barbizon on the evolution of Impressionism was seminal. Nowhere is it more apparent than in this landscape which Bazille painted at Chailly in 1865, when he, Renoir, Monet, Sisley and Pissarro were staying at the cabaret *(a word deriving from the Dutch, meaning originally a country tavern) of Mère Anthony. Unlike the crisp clarity of his later work, this exudes the atmosphere of romantic expressionism which he and the others had picked up from artists such as Diaz and Théodore Rousseau. It is remarkably similar in feeling and technique to Sisley's* Chestnut trees at St-Cloud *(Plate 69).*

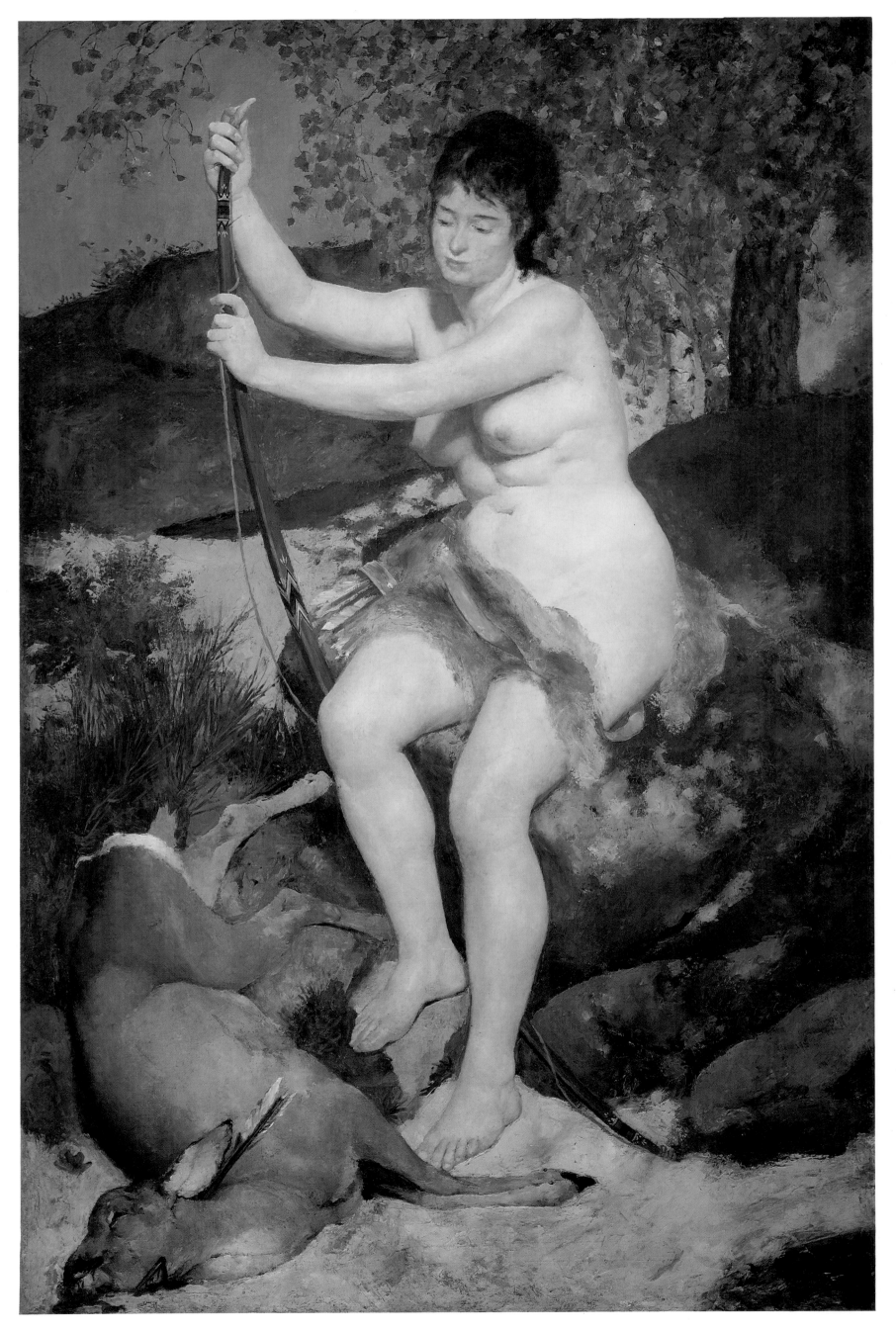

63 PIERRE-AUGUSTE RENOIR *Diana* 1867

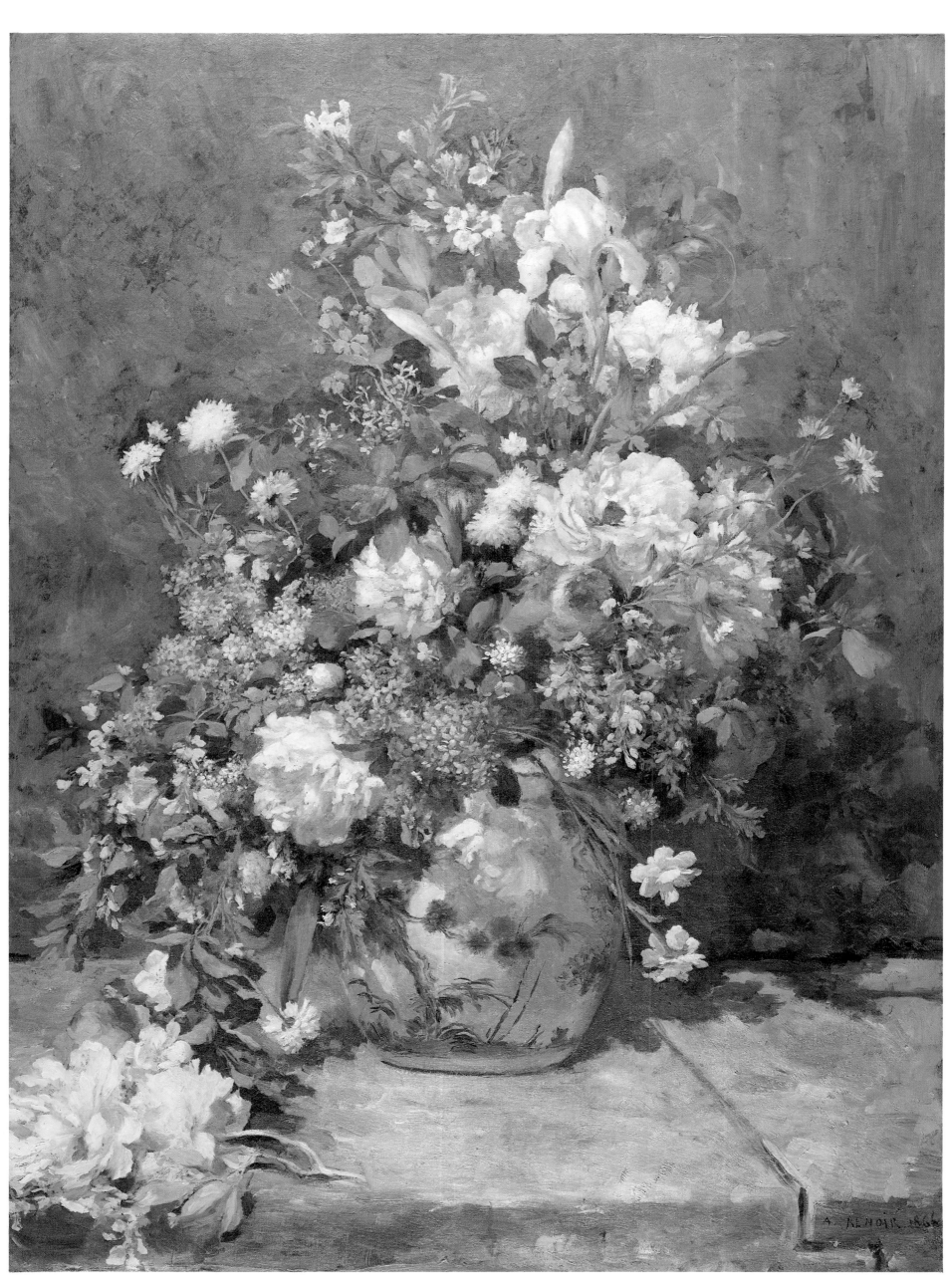

64 PIERRE-AUGUSTE RENOIR *Spring bouquet* 1866
Renoir's early training as a painter on porcelain predisposed him throughout a large part of his career to producing floral paintings of this kind, which had the additional advantage of being very saleable.

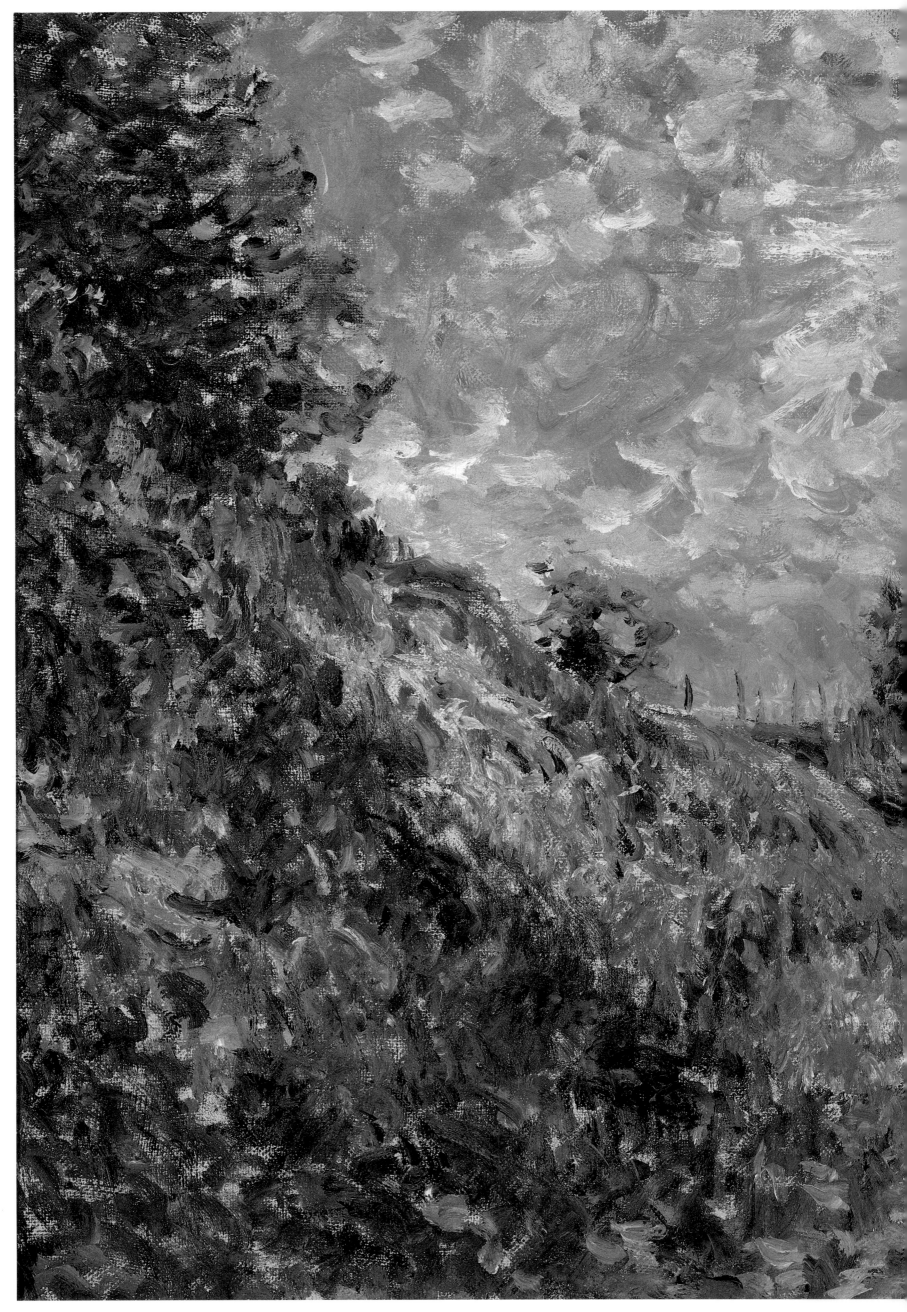

65 ALFRED SISLEY *Landscape* 1870

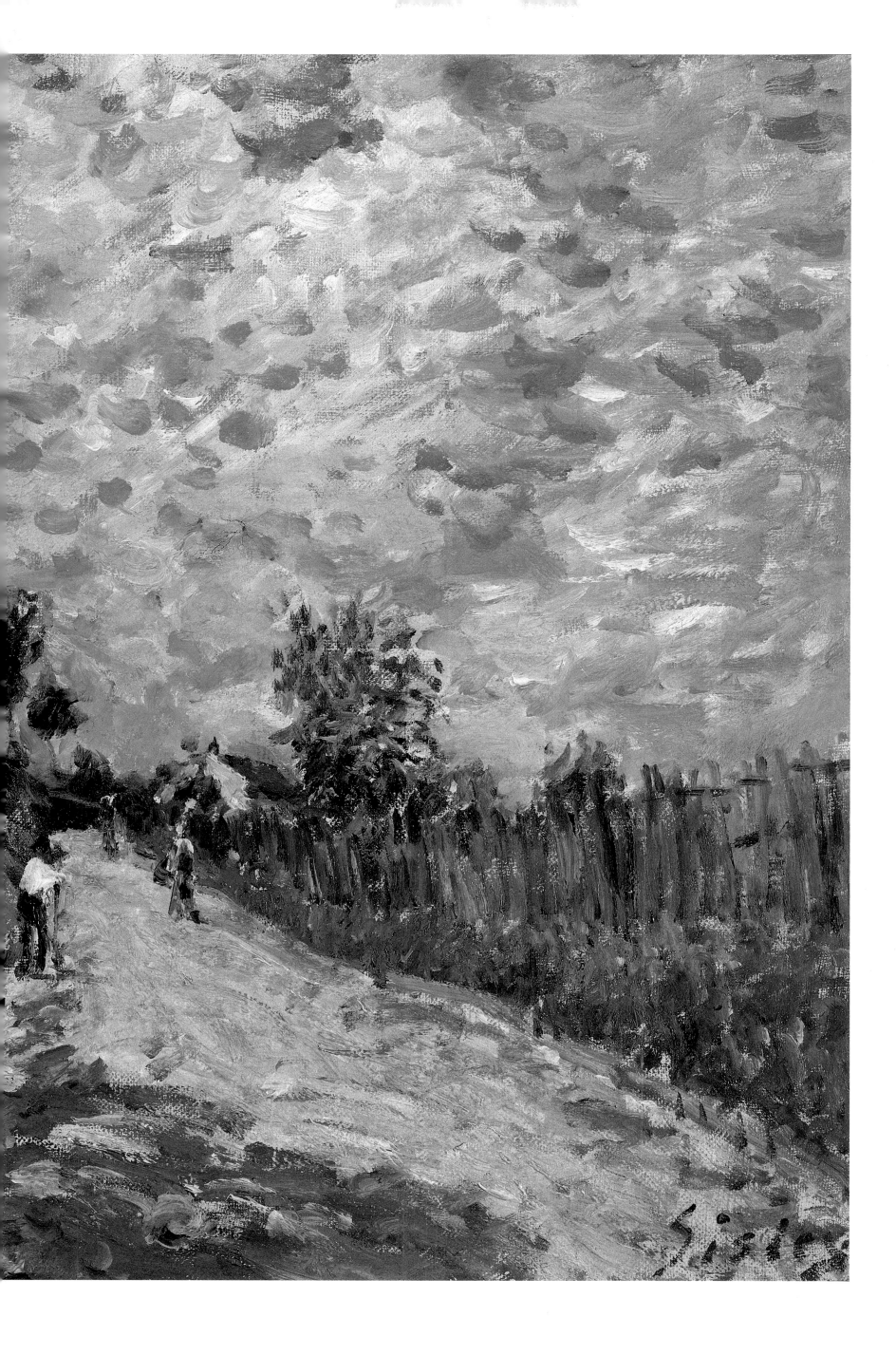

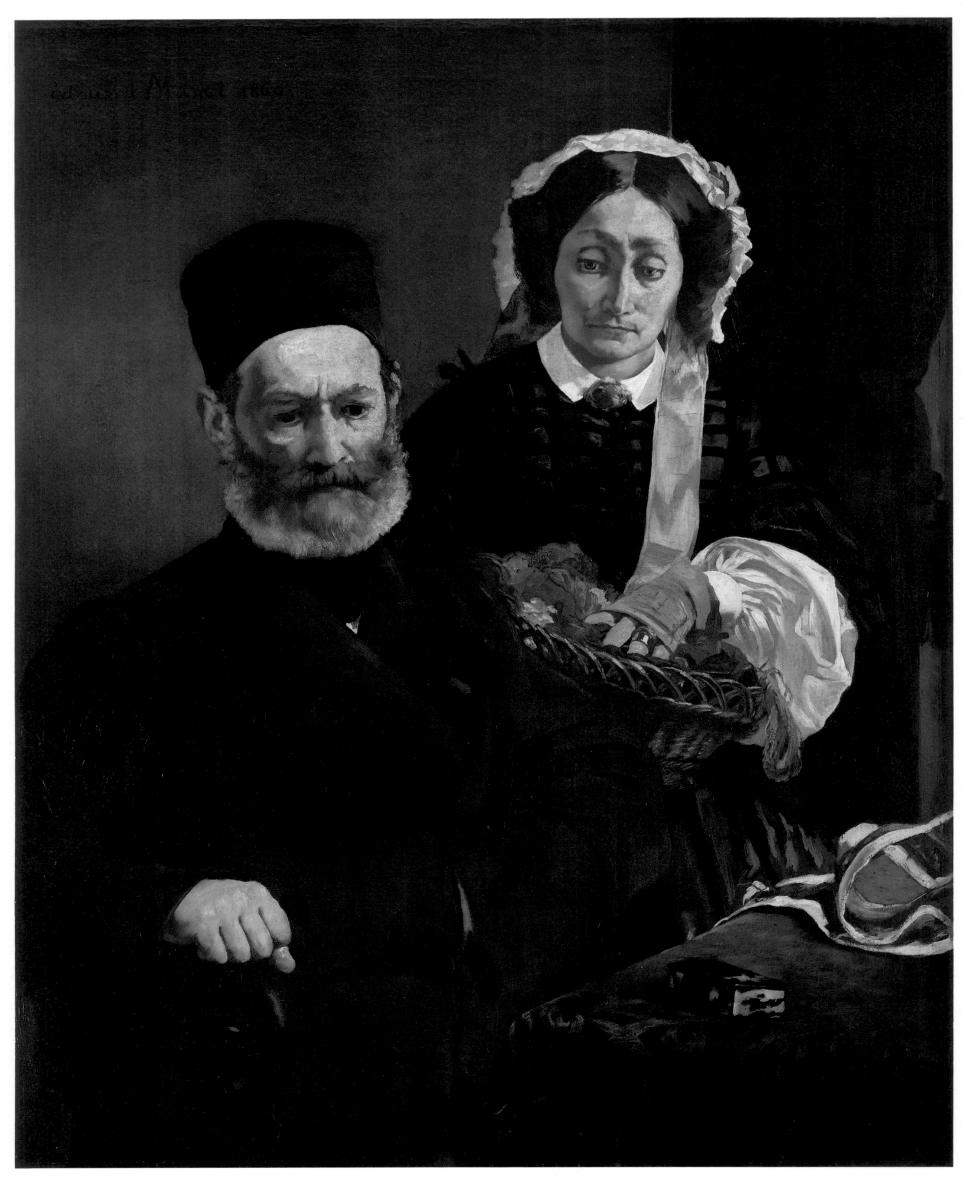

66 EDOUARD MANET *Portrait of M. and Mme Manet* 1860
This portrait of the 63-year-old Auguste Manet and his wife, Eugénie-Desirée, née Fournier,
was probably painted in their home at 5 rue des Petits-Augustins, and was one of two works
by their son accepted at the Salon of 1860.

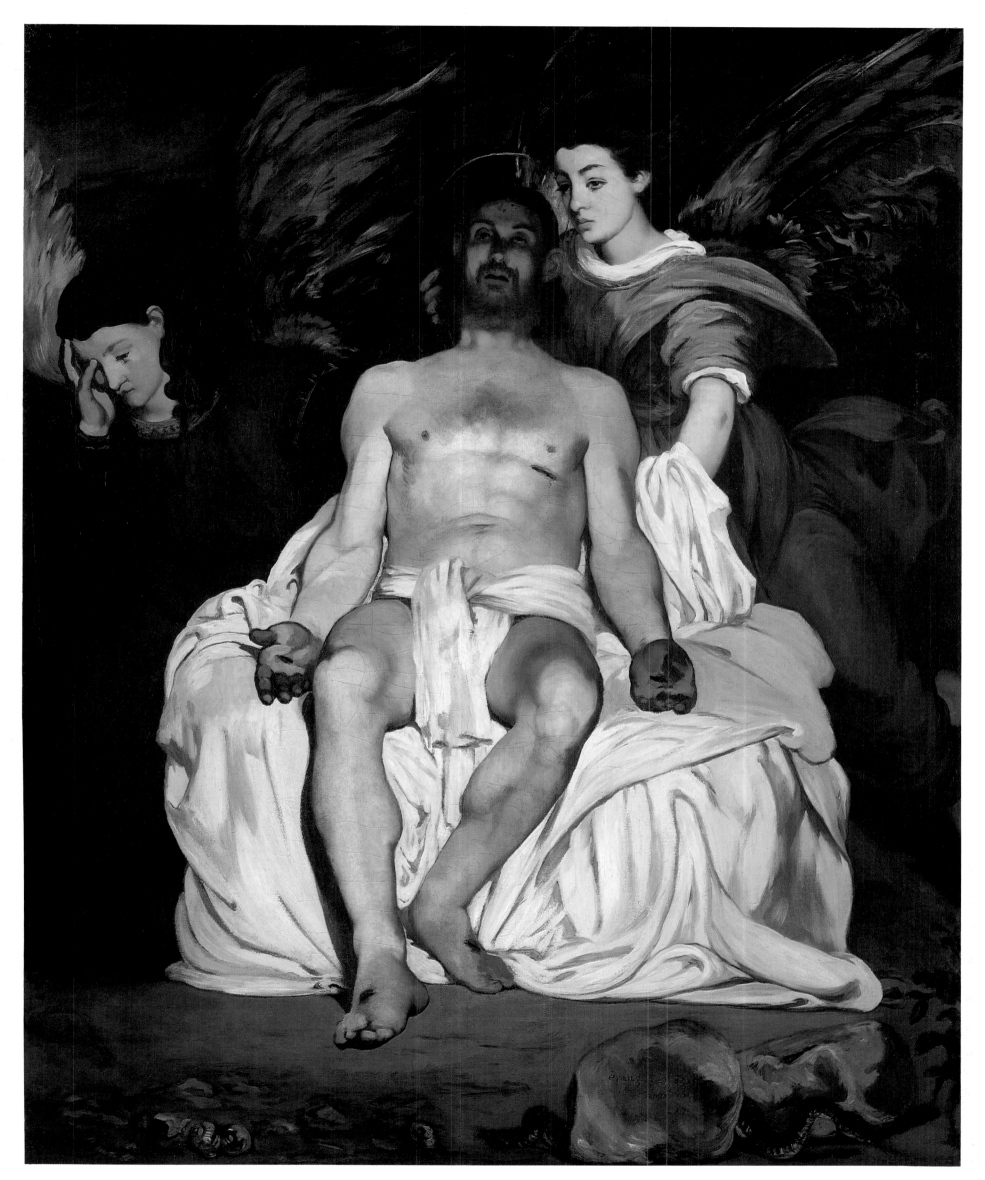

67 EDOUARD MANET *Dead Christ with angels* 1864
How tentative were Manet's early explorations of the road which would lead to Impressionism
is suggested by the fact that, only ten years before the movement became an accepted
phenomenon, he was painting religious works precisely of the kind which might be set for
students entering the Prix de Rome competition. The influence of Spanish art with its
interest in the Passion of Christ is apparent too.

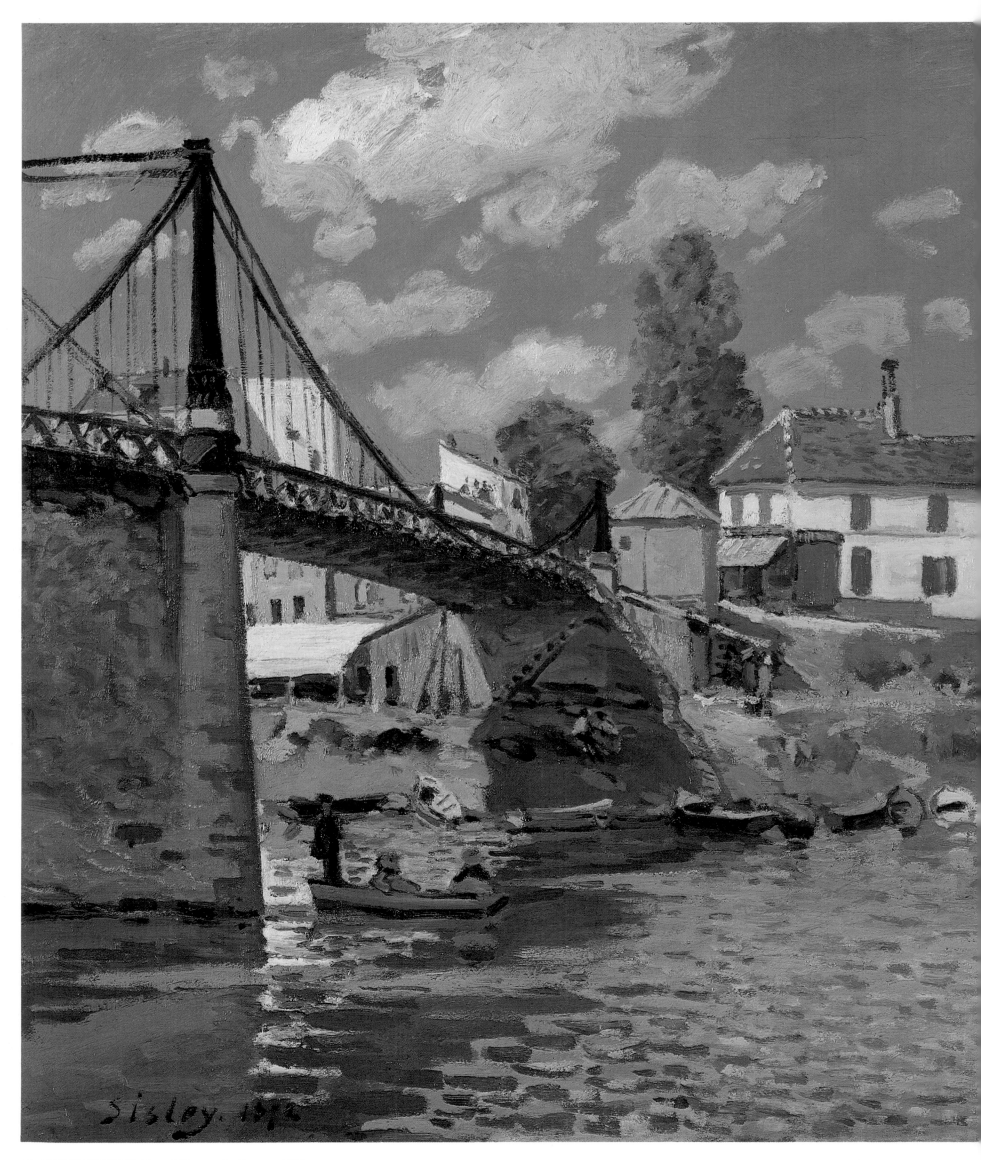

68 ALFRED SISLEY *Bridge at Villeneuve-la-Garenne* 1872

Situated on the Seine upstream from Argenteuil, Villeneuve-la-Garenne had become easily accessible from Paris in 1844 when this bridge was built, linking the small riverside town to St-Denis and its railway station. As a result Parisians had started building houses here like those in this painting. On the far end of the bridge is the toll-house which made it a profitable as well as a useful adjunct to village life. Villeneuve was the port for Gennevilliers, a village at the centre of the segment of land almost encircled by the Seine, where Manet's family had a holiday home. Berthe Morisot painted a picture of the bridge when she was staying at Bougival, though her viewpoint is further downstream than Sisley's. One of Sisley's most delightful paintings, it illustrates admirably how far Impressionism had evolved as a result of the close collaboration of Monet, Sisley, Renoir and Pissarro during the period leading up to the first Impressionist exhibition, when they were living and working together in the resorts on the upper reaches of the Seine.

69 ALFRED SISLEY *Chestnut trees at St-Cloud* 1867
Painted near La Selle in the forest of St-Cloud, the painting shows Sisley still using the dark tonalities of the Barbizon school from which his friends Renoir and Monet were beginning to escape.

70 CAMILLE PISSARRO *The Marne at Chennevières* 1864/5
Exhibited at the Salon of 1865, this pellucid view of the waters of the Marne as they open out near the village of Chennevières, south-west of Paris, shows how greatly the 34-year-old Pissarro was indebted to Corot at this period of his development.

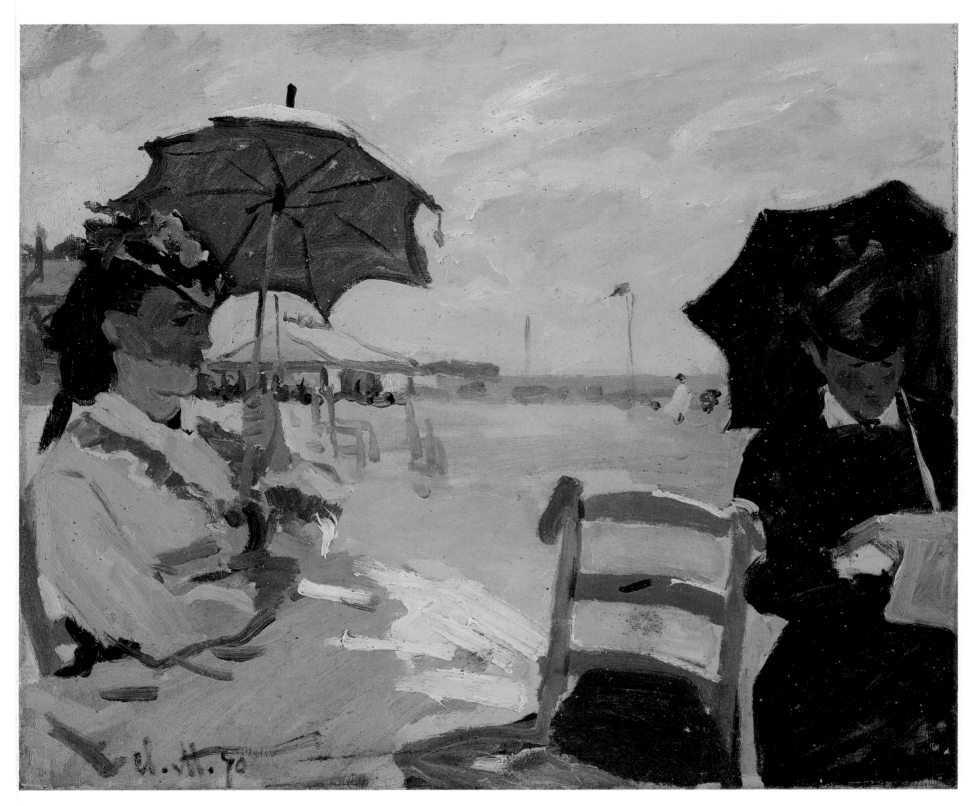

71 CLAUDE MONET *The beach at Trouville* 1870
This lively, spontaneous painting is one of the undoubted examples of a work painted out of doors. Analysis of the paint surface reveals grains of sand embedded in it. Trouville was where Monet had met Daubigny; he paid several visits there with his wife and son Jean.

72 EDOUARD MANET *Monet painting in his studio-boat* 1874
During the summer they spent together in Argenteuil Manet, newly arrived at a completely Impressionist technique, painted several pictures of Monet and his family. This one shows him painting in the studio-boat which he had constructed in imitation of Daubigny's similar contraption.

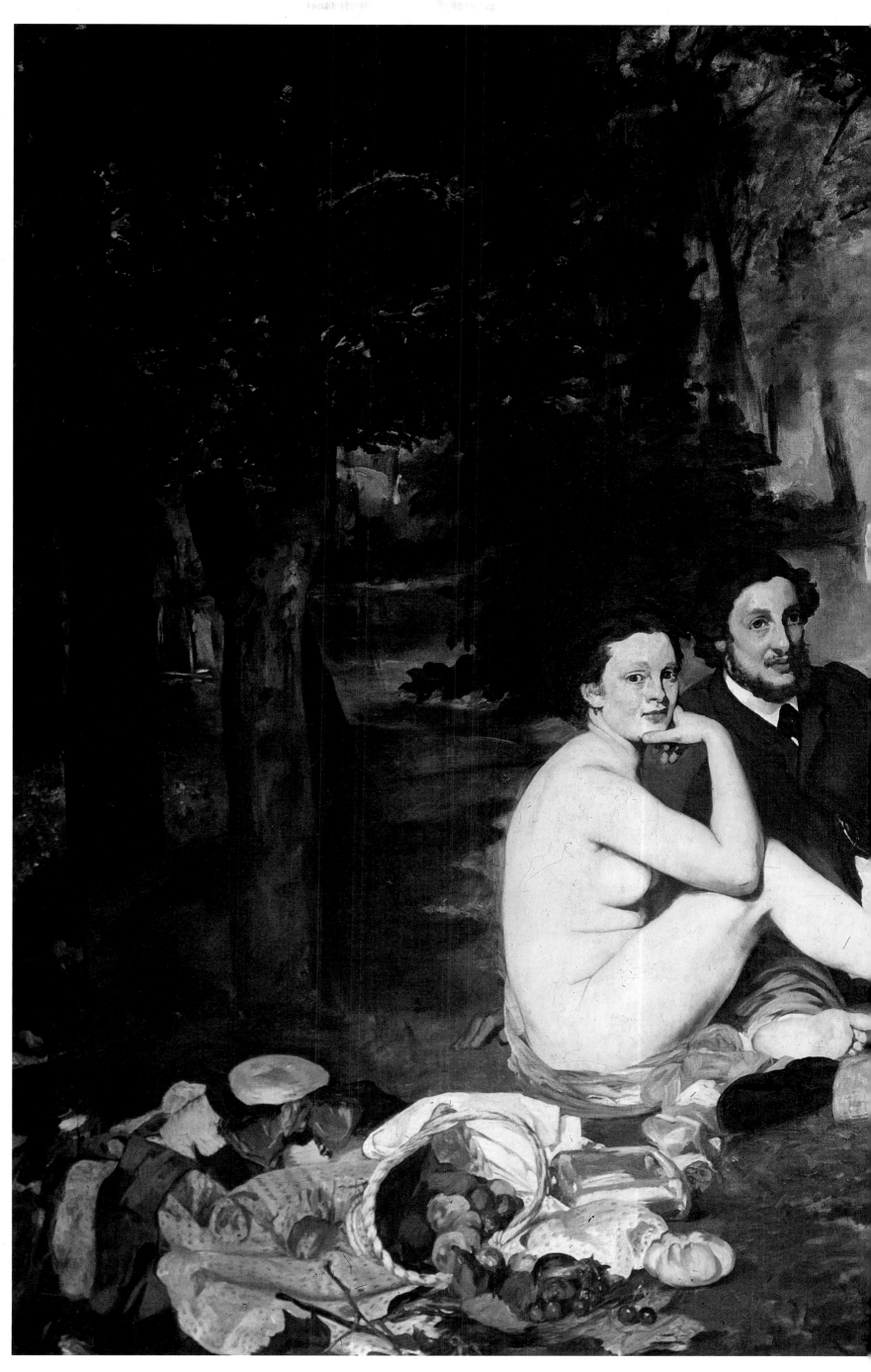

73 EDOUARD MANET *Le Déjeuner sur l'herbe* 1863

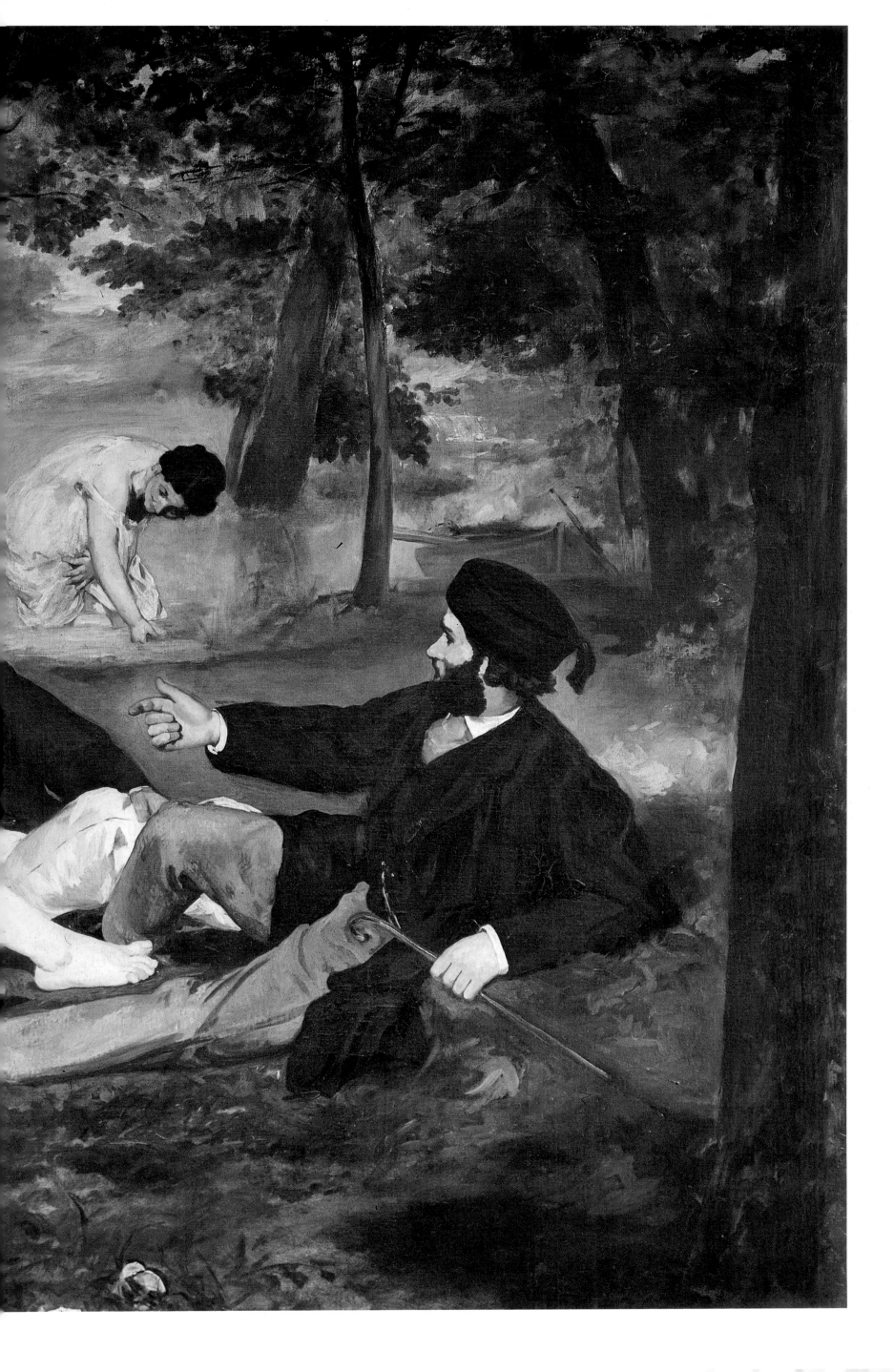

Chapter 3

A New Realism

Renoir had been lucky to have a nude accepted by the Salon. It looked at first sight as though it were an exercise in that restatement of the myths of Greece and Rome which, for the artists of an industrialized society in the second half of the nineteenth century, was considered an appropriate field for the exercise of their pictorial imaginations. Closer inspection however reveals that this 'classic' nude was very different from the 'classic' nude of the type which Ingres might have painted a quarter of a century earlier. The hairstyle, the muscular, rather plump body, the heavy face, all suggested that this was a real person – Lise Tréhot – not an arcadian idealization. It was evidence of the acceptance, even in official circles, of a new spirit in painting, and it was exhibited in a Salon which also contained works by Manet, Degas, Sisley, Pissarro and Berthe Morisot. Fantin-Latour's *A studio in the Batignolles Quarter* (Plate 115) was also shown, a portrait of most of this group of painters who had come to be associated with that area of Paris between the Gare St Lazare and the outskirts of Montmartre where most of them lived.

From the very beginning of the 1860s there had been a ground-swell of discontent amongst the 2,000 or so artists who lived and worked in Paris. In part it was directed against the art establishment as such rather than against the stylistic ideals which it upheld and to a degree imposed, and it was nurtured by a political undercurrent of opposition to the half-hearted authoritarianism of the government of Napoleon III. Inevitably it contained strong elements of envy and frustration centred on the process of selection for the Salon, which was to all painters, whatever their stylistic allegiance, the only real gateway to success. Things had come to a head in 1863 in a happening which, though a failure in itself, assumed retrospectively the kind of significance which the storming of the Bastille – also intrinsically trivial – has assumed in the popular imagination of later generations.

In that year the sending-in days for the Salon had been from 20 March to 1 April, and over 5,000 works had been submitted by 1,430 artists, including Manet, Whistler and Jongkind. Ever since the unfortunate occasion when the jury had inadvertently rejected works by its own members, a rule had been established whereby all members of the Académie and all those who had been awarded medals in previous exhibitions had a right to sit on the jury, a system which encouraged those artists who ran teaching ateliers to favour their own students. Usually the jury was dominated by its most forceful member, and this year it happened to be Emile Signol, who had been Renoir's teacher at the Ecole des Beaux-Arts, and was an embattled upholder of the most rigid ideals. By 5 April rumours began to circulate around the cafés of Batignolles and the Left Bank that the jury had been uncompromising. In the event, 2,783 works by 442 artists had been rejected and, significantly as it turned out, they were not all by revolutionaries of the Barbizon school's ilk – some were even by artists patronized by the Empress. The outcry was enormous. On 20 April Napoleon III himself decided to visit the exhibition accompanied by his aide-de-camp General Leboeuf. He asked to see some of the rejected paintings and, finding in them little difference from those which had been accepted, issued an announcement in *Le Moniteur Universel*:

The Emperor has received numerous complaints about works of art which have been refused by the jury of the Salon. His Majesty, wishing to let the public come to their own conclusions about the legitimacy of these complaints, has decided that the rejected works of art are to be put on show in another part of the Palais de l'Industrie. This exhibition will be voluntary, and those who do not wish to participate will only need to inform the administration, which will immediately return their works to them.

By 7 May, the deadline for deciding whether an artist wished his submission to be withdrawn, some 600 of the works submitted had in effect been returned to their creators. As Jules Castagnary (1830-88), the great defender of innovation in art at that time, pointed out in an article in *L'Artiste*, the situation was not quite as simple as it seemed:

When the Parisians first heard the news the studios were convulsed. People laughed, cried and embraced each other. But the first fine careless rapture was soon succeeded by second thoughts. What should the artists actually do? Profit from the measure and exhibit? That meant deciding, to one's detriment perhaps, the answer to the question implied in such a decision, delivering oneself to the judgement of the public, if the work is considered definitely bad. It meant testing the impartiality of the Commission and siding with the Institut, not only in the present but for the future. Not to exhibit? That, on the other hand,

meant assenting to the judgement of the jury, and so adding to its prestige by admitting one's own lack of ability.

Known unofficially as the Salon des Refusés, the exhibition opened on 17 May in an annexe decorated in the same way as the main Salon, but, to avoid any controversies about the hanging spaces allotted to different artists, the works were arranged in a straightforward alphabetical order, which though intellectually comprehensible was visually confusing. In terms of attendance, the exhibition was a wild success: 10,000 people turned up on the first day, and the figures remained high, with more visiting the annexe than the Salon itself. It was an extraordinary mélange of pictures. Battle pieces and chaste nudes hung alongside works by those artists who were beginning to make a name as the revolutionaries of art: three paintings and three etchings by Manet, three by Pissarro, three by Jongkind, and uncatalogued works by Cézanne, Guillaumin, Bracquemond and Fantin-Latour. Whistler scored a triumph among all shades of opinion with his *White girl* (Plate 102).

If the Whistler had been successful, one of Manet's works, *Le Déjeuner sur l'herbe* ('Luncheon on the grass', Plate 73), was cataclysmic in its effect on the general public, and equally so, though in a different way, on the subsequent development of painting itself. Zola described, in his usual vivid prose, the general reaction. In his novel *L'Oeuvre*, published in 1886, the hero Claude Lantier, quite clearly modelled on Cézanne (see pp.144, 332), visits the exhibition:

74 EDGAR DEGAS *Manet at the races c. 1864*
This drawing dates from the period in the mid-1860s when Degas's interest in horse-racing reached its apogee: he painted several pictures of Longchamp, Argentan and elsewhere, and Manet often accompanied him.

As soon as they reached the doorway, he saw visitors' faces expand with anticipated mirth, their eyes narrow, their mouths broaden into a grin, and from every side came stertorous puffings and blowings from portly gentlemen, thin, rusty wheezes from thin ones, and dominating all the rest high-pitched flute-like giggles from the women. A group of young men on the opposite side of the room were writhing about as if somebody were tickling their ribs. One woman had collapsed on a bench, her knees tight together, gasping and struggling to regain her breath, her face hidden in her handkerchief. The rumour that there was a funny picture to be seen must have spread rapidly, for people came stampeding in from every other room in the exhibition, and groups of sightseers, afraid of missing something, came pushing in, shouting 'Where?', 'Over there', 'Oh I say, would you believe it?' Shafts of wit fell here more thickly than anywhere else. It was the subject that was the main target for witticisms. Nobody understood it; everybody thought it crazy, and hilariously funny. 'There you are, you see, the young lady's too hot, but the gentlemen are cold, that's why they're wearing their suits.' 'No, that's not it! Can't you see that she's green? She must have been in the water for some time when they pulled her out. That's why he's holding his nose.' 'Pity he painted the man back to front, makes him look so rude somehow'.

To obtain a contemporary description of the painting, and understand why it was provoking such mirth amongst French spectators, one has to turn to the shocked prose of the English critic Philip Gilbert Hamerton, describing it for the benefit of Queen Victoria's subjects in the pages of *The Fine Arts Quarterly Review:*

I ought not to omit a remarkable picture of the realist school, a translation of a thought of Giorgione into modern French. Giorgione had conceived the happy idea of a *fête champêtre*, in which, though the gentlemen were dressed, the ladies were not, but the doubtful morality of the picture is pardoned on account of its fine colour. Now some wretched Frenchman has translated this into modern French realism, on a much larger scale, and with the horrible modern French costume instead of the graceful old Venetian one. Yes, there they are under the trees, the principal lady entirely undressed, sitting calmly in the well-known attitude of Giorgione's Venetian women, another female in a chemise coming out of a little stream that runs hard by, and two Frenchmen in wide-awakes sitting on the very green grass with a stupid look of bliss. Cabanel's *Venus*, though wanton and lascivious, is not in the least indecent, but this picture *is*.

It would be almost impossible to encapsulate in so few words such a rag-bag of attitudes, which must be understood to comprehend the temper of the age. The word 'realism' is used in a purely pejorative sense; the notion is put forward that, had the people in the picture been wearing old-fashioned Venetian clothes, everything would have been forgivable. There is the endemic dislike of foreigners, especially when they are French, looking blissful and wearing a type of hat which was thought to be not quite what a gentleman should wear; the strange supposition that the girl is reprehensible because she is sitting calmly on the grass (ought she to have shown signs of hysteria?); the hypothesis that Cabanel's lascivious and wanton Venus is not indecent because it is supposed to portray a goddess who gave her name to a disease widely prevalent in the middle of the nineteenth century; finally, the distinctly odd assumption that even an indecent picture can be tolerated if it is nicely painted. These were notions that most of the readers of *The Fine Arts Quarterly Review* would have accepted without demur.

But what did the refined, gentlemanly, 31-year-old Manet think he was doing when he produced what one French

critic described as 'this shameful open sore'? According to his friend Antonin Proust, who was always to be one of his main sources of support and encouragement, and whose portrait he painted in 1880 when he was Minister of Arts in Gambetta's government,

Not long before he did *Déjeuner sur l'herbe* we were at Argenteuil, one Sunday, lying on the bank, watching the sailing boats go by on the Seine. Some women were bathing. Manet's eyes fixed on their flesh as they came out of the water. 'They tell me', he said, 'I must do a nude. All right, I shall. I shall do them a nude. Back in our student days (Proust had also been a pupil of Couture) I copied Giorgione's women, those who are with some musicians. But his is a dark picture; the background has sunk in. I'm going to do it in the luminosity of the atmosphere, with figures like you see over there. I'll probably get a caning for it. They'll start saying that now after imitating the Spaniards I'm getting inspiration from the Italians.

When he actually came to paint the picture, however, he moved away from anything other than a generalized reliance on the Giorgione prototype and, because he possessed prints of them, used Marcantonio Raimondi's engravings of Raphael's *Judgement of Paris*, which determines the posture and placing of the three main figures. The woman in the background is a quotation from another work by Raphael, the much-illustrated cartoons for tapestry by the same artist in the Victoria and Albert Museum, London, where she figures in the scene depicting the miraculous draught of fishes. The nude woman was Victorine Meurent[1], a model whom Manet had first met in the previous year when she had been posing in Couture's studio and who, according to Vollard, had the Parisian street girl's bluntness of speech. She was a gifted guitar player and later, after a torrid affair with the painter Alfred Stevens, spent some time in the USA and then herself became a painter, having a self-portrait hung in the Salon of 1876, from which, ironically, Manet had been excluded. Opposite her is one or other of Manet's brothers, Eugène and Gustave. The ambiguity lies in the fact that, once again according to Proust, both brothers posed at varying times. The other young man is the Dutch sculptor Ferdinand Leenhoff, the brother of Suzanne, Manet's current mistress and later his wife. The name of the other girl is not known; presumably she was a professional model. The landscape was made up from sketches, most of which had been done in the Ile Saint-Ouen near his father's country home at Gennevilliers. Some of the details in the picture are especially worth noting. Although the woman is nude, her clothes and hat, seemingly of a fashionable type, are lying on the ground beside her, implying that she has disrobed on the spot and so, provocatively, presumably for some vaguely immoral purpose. The hat worn by the gesticulating figure is one of the type then associated with art students. The mixture of fruits is purely arbitrary – they are not of the sort that are in season at the same time – melons, cherries, figs; and the presence of a silver flask suggests the consumption of alcohol. There were indeed many superficial reasons for the atmosphere of immorality which so many critics seized upon as one of the major evils of the work. 'A common prostitute, stark naked at that...lounges between what seems to be two students on holiday, misbehaving to prove themselves men', wrote the author of a special handbook

to the exhibition, and Hamerton's onslaught had a clear moralistic basis.

Manet himself seems to have had no idea of creating a *succès de scandale* by titillating the sexual susceptibilities of his viewers. Ironically, in the year before he painted the picture, a new edition had been published of what was to be – for traditionalists and innovators – one of the most influential art manuals of the century, Lecoq de Boisbaudran's *L'Education de la mémoire pittoresque*. First published in 1847 (a later edition of 1875 had an introduction by Rodin, who had been one of his pupils, as had Fantin-Latour), its main contribution to art education had been the introduction of two new techniques; the development of visual memory, with the creative selective element it involves, by making students draw objects after they had been removed from their sight, and exhorting them to go on sketching expeditions on which they could draw and

75 EDGAR DEGAS Pencil drawings based on engravings by Marcantonio Raimondi (*c.* 1515) after Raphael's *Judgement of Paris*, which Manet also used for the central group of figures in the *Déjeuner sur l'herbe*.

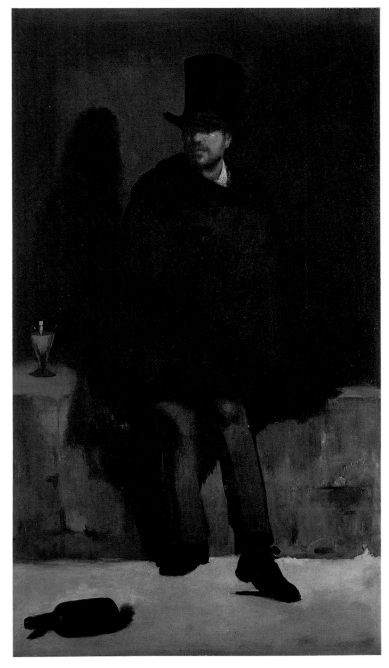

76 EDOUARD MANET *The absinthe drinker* 1858-9

paint away from the inhibiting confines of the studio. In connexion with the latter, he recommended that students should go with their models 'to some picturesque spot, a great natural park or somewhere where a wide glade open to the sky gives a perfect light, and near the wood, a pond reflecting the tall trees, and there the models should be asked to walk, sit and run, sometimes clothed, sometimes nude. In this way mythology comes to light before our very eyes.' This was very much the scenario of the *Déjeuner sur l'herbe* (the title which Manet had originally given it, incidentally, was *Le Bain,* 'The bathe'), just as it had been the underlying principle informing Degas's *Young Spartan girls provoking boys* (Plate 86), painted in the previous year.

On the whole there was not a great deal of hostile criticism of Manet's actual painting technique. Although one writer commented, 'Manet will show talent once he learns drawing and perspective', another remarked on 'the qualities of colour and light in the landscape and indeed very true bits of modelling in the torso of the woman', and a third suggested that 'there's a certain life in the colour, a certain directness in the touch that are in no way vulgar. But then what? Is this drawing? Is this painting? M. Manet means to be firm and strong, he is merely hard.'

There were indeed various aspects of the technique of the *Déjeuner* which might have attracted criticism from the purists. The landscape, especially in the light area behind the bending figure, is very loosely brushed in, mainly in an attempt to capture the effect of light, and forecasts much of the effects of his later paintings, while the more careful handling of the trees on the left is redolent of the approach of the Barbizon school. There is, however, a problem about the composition and, as so frequently happens in such cases, it is difficult to say whether it has arisen by design or from a certain technical maladroitness, occasioned by the fact that the picture consists of two different elements, each painted at different times and in different conditions and then melded together. These two elements – the landscape and the figures – do not relate compositionally to each other. The group of people looks almost as though it had been cut out and mounted on the landscape background. The notion that this was intentional is based on the assumption that it reflected the influence of Japanese prints (see p.131), but this seems special pleading, and we know that Manet himself was conscious of his own weaknesses in this respect. In 1860, for instance, he had painted another Giorgionesque *Finding of Moses by Pharaoh's daughter,* which we know only through a sketch in the Nasjonalgalleriet in Oslo. Because of his inability to reconcile the other figures in this with the background, he cut out the figure of Moses' daughter and her surrounding landscape, and converted it into *The surprised nymph* (Museum of Fine Art, Buenos Aires).

What really stuck in the gullet of the critics and titillated the general public was the 'realism' of the painting and its substitution of the naked for the nude. Here was an undressed woman unadorned with any of the classical impedimenta which ornamented the other pictures in the exhibition dealing with the same theme, diaphanous clouds, the bow and arrows of Diana, the cupids of Venus, the martial attributes of Athene; her actuality as a living person, emphasized by the bundle of contemporary clothes and by her direct open stare at the spectator, inevitably gave ammunition to the prurient, who saw her merely as a prostitute, a word which, in the opinion of most, was interchangeable with that of model. Her companions too did not wear those brightly shining helmets which had come to be identified with the gods and heroes of Greece and Rome, and which had been responsible for earning those academicians who painted them so assiduously the soubriquet of *pompiers.* They were not dressed in togas or chitons, they carried no swords or spears: they were obviously artists, belonging to that group of people whose real or imagined licentiousness aroused, in almost equal proportions, the envy and the disapproval of the bourgeoisie.

Manet had taken some time to arrive at a position where he could create a picture deemed so outrageous in its content, so provocative in its presentation. When he left Couture's studio at the age of 24 in 1856, he started sharing a studio in the rue Lavoisier with another dandy, Comte Albert de Belleroy (he appears in *La Musique aux Tuileries,* Plate 109), four years older than himself, who specialized in animal and hunting pictures, and was an accomplished portraitist. Manet was already showing some interest in vaguely contemporary themes, and the first work he submitted to the Salon of 1859, *The absinthe drinker* (Plate 76), reveals his approach, which has a strong streak of theatricality in it. The top-hatted, cloaked figure –

actually a rag-picker named Collardet who spent much of his time cadging in the Louvre, where Manet frequently went to copy Spanish and Italian paintings – has something of the character of a figure in an opera or a highly dramatic play, even though he is intended to represent the dregs of society.[2] Inevitably, in that it contrasted with the flattering portraits, the classical fantasies, the scenes from medieval legend, the devout representations of religious imagery which made up the other entries to the Salon, Manet's work was rejected, despite its impeccable artistic antecedents in the work of the Dutch genre painters and the realism of Ribera and Caravaggio. These were evident too in the first picture he ever had exhibited, *Boy with cherries*, painted in the same year as *The absinthe drinker* and shown by Louis Martinet at his gallery in the boulevard des Italiens (Plate 77).

What started off as a stylistic inclination was, however, largely transformed into a state of mind by his meeting at around this time with the poet and critic Charles Baudelaire. Eleven years older than Manet, he had been projected into fame as the spokesman and hero of the younger generation by his prosecution for offences against public morality in his book of poems *Les Fleurs du mal*. As a writer Baudelaire, though strongly drawn towards the visual arts, was basically more interested in their content than in their aesthetic substance, and had first expounded his theories in a review of the Salon of 1846 in which he discussed 'The Heroism of Modern Life'. The ideas sketched out roughly in this essay were developed at greater length in an extended essay on Constantin Guys, published shortly before he met Manet and entitled *The Painter of Modern Life*. In the Salon review he wrote,

Before trying to distinguish the heroic side of modern life, and before bringing examples to prove that our own age is no less fertile in sublime themes than past ages, we may assert that since all centuries and all peoples have their own form of beauty, so inevitably we have ours...I

78 EDOUARD MANET *The Spanish singer* 1860

have observed that the majority of artists who have attacked modern subjects have contented themselves with public and official subjects – with our victories and our political heroism. Even so they do it with an ill grace, only because they are commissioned by the government which pays them. However, there are private subjects which are very much more heroic than these. The pageant of fashionable life and the thousands of floating existences – criminals and kept women – which drift about in the underworld of a great city; the *Gazette des Tribuneaux* and the *Moniteur* all prove to us that we have only to open our eyes to recognize our heroism. The life of our city is rich in poetic and marvellous subjects: we are enveloped and steeped in it, as though in an atmosphere of the marvellous, but we do not notice it...The nude – that darling of artists, that necessary element of success, is just as frequent and necessary today as it was in the life of the ancients, in bed for example, or in the bath or in the anatomy theatre.

In these words Baudelaire had sketched out a programme and an ideology which over the next half-century was to become one of the dominant elements in the Impressionists' credo. Indeed the last sentence might well be seen as the justification, even the cause of *Le Déjeuner sur l'herbe*. Manet was to remain on friendly terms with Baudelaire throughout the rest of the latter's life, and there can be no doubt that he was deeply impressed by this apologia for modern life, even though, it should be observed, it was not peculiar to the poet; the Goncourts' 'realistic' novel *Germinie Lacerteux* of 1864 contained a preface which set out in even stronger terms the right of 'the sufferings of the poor and hungry' to be material for literature.

77 EDOUARD MANET *Boy with cherries* 1858

Theoretical considerations apart, Manet had been deeply interested in Spanish art – though his only visit there took place in 1865. A knowledge of the art of the peninsula had been growing steadily, with the Louvre acquiring works by Velasquez, Murillo, Zurbarán and Ribera. Baudelaire's own essay on Goya's etchings had appeared in 1857, and a life of that artist by Louis Matheron was published in Paris in the following year. The Spaniards were deeply concerned with the life of their own time, the peasants of Velasquez, the Seville street urchins of Murillo, the plebeian vigour of Ribera's saints; during the early part of his career Manet chose a virtual predominance of Spanish subjects – of the 53 oils he exhibited at Martinet's in 1867, 28 were on Spanish themes. But he was not living in Spain; he was dependent on props and models. *The Spanish singer* (Plate 78), which was accepted in the 1861 Salon, is typical of this. The clothes are Spanish; so too are the accessories on the ground, the onions, the cigarette ends and the wine-jar, which looks as though it has been lifted from a Velasquez. We know that Manet kept a stock of Spanish clothes in his studio, and it is worth noting that those worn by the guitarist appear, in differing combinations, in *Mlle V. in the costume of an espada* (Metropolitan Museum of Art, New York; 1862), *Young man in the costume of a majo* (Metropolitan Museum of Art, New York; 1863) and *The dead toreador* (National Gallery of Art, Washington DC; 1864) as well as in two etchings and a watercolour of 1862. A more revealing proof of the contrived nature of the painting is the fact that Manet posed his model as a left-handed player, holding a guitar strung for a right-handed one. Left-handed players can play instruments strung this way, but the chord which the man is playing suggests that Manet knew nothing about music. Realist in intention, realist in style, *The Spanish singer* was not realist in substance in that it was not a true representation of anything in the life of mid-nineteenth-century France. But, being the first of Manet's paintings to be seen by the large audience of the Salon, it immediately established him as a realist, prompting one critic in the *Gazette des Beaux-Arts* to complain, 'By the choice of subject as well as by the way it is painted, the Spaniard playing the guitar recalls the method of the school of Seville. But what a scourge to society is the realist painter.' To younger artists it was a revelation, and was the first step in establishing Manet as the 'leader' of a new school and in saddling him with the paternity of what was to be Impressionism. The critic Fernand Desnoyers, an habitué of the Brasserie des Martyrs, a noted haunt of artistic and political dissent, wrote a few months later:

MM. Legros, Fantin-Latour, Karolus Durand [*sic*] and others looked at each other in amazement, searching their memories, and wondering, like children at a magic show. Where could Manet have come from? *The Spanish musician* was painted in a new, strange way that the young painters had believed to be their own secret, a kind of painting lying between the realist and the romantic. Some landscape artists, who play non-speaking parts in this new school, communicated their stupefaction by miming with significant gestures...It was resolved by acclamation that the group of young painters should go in a body to visit M. Manet. This striking manifestation of the new school duly took place.

Manet welcomed the group, and it led to the gradual establishment of a kind of corporate identity.

Desnoyers was right in a way. Manet's art was not yet truly realistic; it contained strong elements of romanticism, especially in choice of subject. He was capable too of producing paintings such as *La Pêche*, finished in 1863 (Metropolitan Museum of Art, New York), which was a virtual pastiche of works by Annibale Carracci and Rubens in the Louvre. But at the same time he was moving steadily towards his own interpretation of Baudelaire's notions about the heroism of 'countless floating existences'. In 1862 he painted *The old musician* (National Gallery of Art, Washington DC), which consisted of a group of people cut off, as it were, from society. They include the Wandering Jew, the absinthe drinker – virtually the same as the earlier painting – a young gipsy woman with a baby, and two children who look like intruders from another, more bourgeois world. It is an idealized picture of the artist (the musician) on the fringes of society, strongly reminiscent of the works of the seventeenth-century Le Nain brothers.

But in the same year that he painted *The old musician* he also produced a work which was intended to fulfil the other part of Baudelaire's advice about suitable subject matter, 'the pageant of fashionable life'. *La Musique aux Tuileries* ('Music in the Tuileries Gardens', Plate 109) was a panorama of a segment of fashionable society, brought together because, by order of the Emperor Napoleon III, concerts were held there twice a week in the summer, and the audience usually spilt out into the surrounding park. It is a remarkable work, owing not a little in concept to the engravings of social events which figured in the illustrated magazines of the period. It could also be seen as part of the tradition of the conversation piece, especially in its carefully staged groupings of Manet's friends and connexions, most of whom are identifiable, and who may have been painted from photographs. From the left there is Manet himself talking to his friend de Belleroy, and seated on a chair near them is the critic Zacharie Astruc, who was to play a significant role in the evolution of Impressionism. Near the trunk of the tree Baudelaire is talking to Baron Taylor, inspector of museums and a passionate admirer of Spanish painting; behind Baudelaire on the left is Fantin-Latour. The moustachioed figure in a tall hat behind Astruc is the journalist Aurélien Scholl and the head between Manet and de Belleroy is that of Jules Champfleury, a patron of the Brasserie des Martyrs and a staunch upholder of realism, for whose book on cats Manet designed a cover in 1869. The two women in bonnets are Madame Lejosne, wife of the Commandant Lejosne, in whose house Manet met Baudelaire and later Bazille, and who himself was to be involved in the discussions at the Brasserie des Martyrs and later at the Café Guerbois, and (in a veil) Madame Offenbach, the wife of the composer Jacques, who is seated with his back to the most prominent tree in the right-hand section. Beside him, stooping over to speak to somebody, is the painter's brother Eugène. Clearly defined in profile, doffing his hat, is Charles Monginot, a painter who was one of Manet's friends and had also befriended the young Monet.

According to Antonin Proust, who may have been putting a retrospective gloss on the event,

A little court had gathered round Manet. He would go almost daily to the Tuileries from two till four o'clock, doing studies *en plein air* under

the trees, of children playing and groups of nursemaids relaxing on the chairs. Baudelaire was his usual companion. People watched with curiosity as this fashionably dressed artist set up his canvas, took up brush and palette and painted away.

At this point in his career, Manet certainly did not paint out of doors on canvas. The picture was clearly painted in the studio, though he certainly made a number of sketches of the landscape, and the chairs – which form such an interesting element in the composition. When it was first shown to the public at Martinet's in the year after it was painted, there were strongly unfavourable reactions, centring on the technique, the element of caricature in the faces, the sketchiness of the landscape and the violence of the colour, which according to one critic 'hurts the eye as carnival music hurts the ear'. Baudelaire did not mention it, which is not really surprising because, though Manet felt that it was in the tradition of Constantin Guys – he owned 60 of his drawings – as an oil painting it lacked the vivacious immediacy of the older artist's work, and *mutatis mutandis* could have been a subject chosen by Winterhalter or Tissot.

With *Le Déjeuner sur l'herbe*, however, Manet had hit just the right note of a provocative presentation of the contrasts and enigmas of the contemporary scene. He followed it in the same year with *Olympia* (Plate 98), which involved many of the same elements as the *Déjeuner*, obvious references to the Old Masters, in this case Titian's *Venus of Urbino*, which he had copied in Florence on his earlier trip to Italy, and Goya's *Naked Maja* (Prado, Madrid) of 1802, which possesses just the same front-faced look of arrogant impudence. The subject is clearly a prostitute, attended by her black maid, who is carrying a bouquet implicitly a gift from an imminent client. But the combination of elements in the picture was not fortuitous.

When the work was exhibited at the Salon of 1865, Manet printed in the catalogue entry a poem by Zacharie Astruc:

> *Quand, lasse de songer, Olympia s'éveille,*
> *Le printemps entre au bras du doux messager noir,*
> *C'est l'esclave à la nuit amoureuse pareille,*
> *Qui veut fêter le jour délicieux à voir,*
> *L'auguste jeune fille en qui la flamme veille.*

(When, tired of dreams, Olympia awakes/Spring enters on the arm of the gentle black messenger/She's the slave of the amorous night/Who wishes to celebrate the day, so delicious to see/The august maiden, keeper of the flame.)

This pseudo-Baudelairean gibberish, full of inconsistencies – how is the *nuit amoureuse* reconciled with *l'auguste jeune fille*, and which *flamme*? – was written after the picture was painted rather than as the theme for it. Olympia's face is the clue to the basically anti-romantic stance of the work. It could be described as coldly curious, possibly calculating, without a hint of the languishing lust deemed *de rigueur* for paintings of this nature; it faces the spectator squarely, as though posed for a photographer. Nor is her body especially attractive – it is somewhat on the small and mean side, narrow in the chest, her fingers stumpy. Her occupation is further signalled by the adjacent waiting-room which can be detected through the part-open door. Even the black 'slave' had become an accepted symbol of the prostitute in academic painting, appearing for instance in Nattier's *Mlle de Clermont* (Musée Condé, Chantilly) of 1729, which was then in the Louvre, as well as more recent works such as Ingres's *Odalisque with slave* (1839), Jean Jalabert's *Odalisque* of 1842 (whose eyes are tactfully closed) and Jean-Achille Benouville's remote and virginal *Odalisque* of 1844.

Its impact was, and has remained, significant. In 1870 Cézanne painted what might be seen as a variation of it

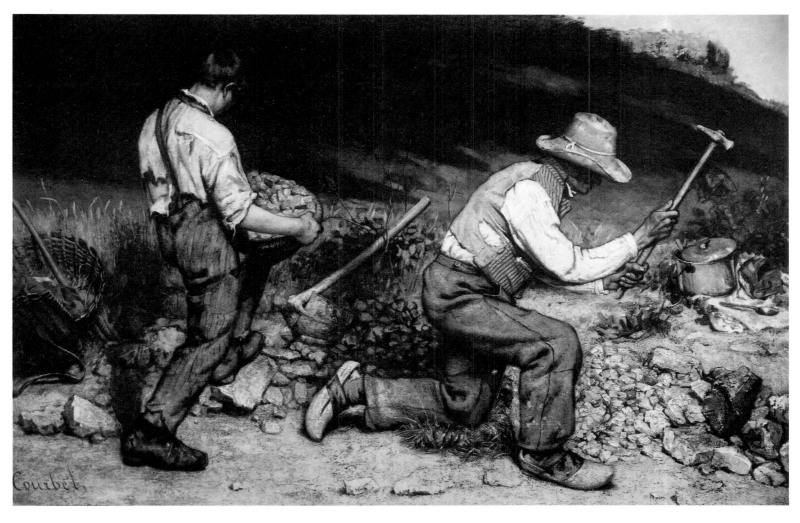

79 GUSTAVE COURBET *The stone-breakers* 1849

(Private Collection) and another between 1873 and 1875 (Musée d'Orsay). Gauguin painted a more or less straight replica in 1901 and in the same year the 20-year-old Pablo Picasso produced a parody of it with himself seated by the bed, Olympia a black woman, two cats and a moustachioed client holding aloft a bowl of fruit. Renoir copied the bouquet of flowers in the *Still-life with bouquet* of 1870 (Museum of Fine Art, Houston) and more recent versions have been produced by Dubuffet in the style of *art brut* and by Larry Rivers (Private Collection, 1950; Musée d'Art Moderne, Paris). Literary references have been frequent too. In *L'Artiste* four years later Zola in a tribute to Manet wrote,

For you a picture is an exercise in analysis. You wanted a nude and you took Olympia, the first one to come along; you wanted bright, luminous patches, and the bouquet provided them; you wanted black patches, and you added a black woman and a black cat. What does all this mean? You hardly know, nor do I. But I do know that you succeeded admirably in creating a masterpiece of painting, of great painting, and in vigorously translating into a special language the verities of light and shade, the realities of people and objects.

In *A la Recherche du temps perdu* Oriane de Guermantes, after a visit to the Louvre, where the painting had been recently hung thanks to a campaign led by Monet, noted:

The other day we came across Manet's *Olympia*. Nobody is shocked by it any more. It looks like Ingres, yet goodness knows I've got involved in countless quarrels defending it, even though I don't entirely like it, though clearly it's by *somebody*.

This ambiguity was reflected 15 years later by Paul Valéry, still bewitched by its lubricity:

A monster of profane love, she is a scandal and an idol; a public presence which exudes the power of the skeleton in Society's cupboard... A bestial Vestal consecrated to absolute nudity, she bears dreams of all the elemental barbarism and animal ritual preserved in the customs and practices of modern prostitution.

Some 20 years later Kenneth Clark was to observe more judiciously:

Although no longer shocking, the *Olympia* remains exceptional. To place on a naked body a head with so much individual character is to jeopardize the whole premise of the nude, and Manet succeeds only because of his perfect tact and skill as a painter. He himself may have felt that so delicate a feat of balance could not be repeated, for he never again chose the nude as a subject for one of his principal works.

But while similar academic paintings had been applauded when they appeared at the Salon, Manet's was greeted with howls of condemnatory vituperation which persisted until the twentieth century. 'What's this yellow-bellied Odalisque, this vile model picked up who knows where?' wrote the critic of *L'Artiste*; Théophile Gautier, who until then had nothing but praise for Manet, wrote of 'this wretched model...the flesh tones are dirty...the shadows are indicated merely by broad strokes of monochrome', and even as late as 1932 Christian Zervos, that great impresario of so much twentieth-century art, could write in an article in his own prestigious magazine *Cahiers d'Art:*

Olympia is a small, mean character, living on the cheap, and on the canvas she holds the quite modest place assigned her by the painter's brush. If his creative powers had been less meagre he would have given *Olympia* something of the grandeur of the *Naked Maja*, not this silly, vapid creature.

A whole host of factors conspired to create this revulsion. In the first place, Manet had not given it some anodyne title such as *Venus awakes* or even *Odalisque*. Olympia was an accepted name for a high-class whore – Dumas gave it to the heroine's rival in *La Dame aux camélias* – and there was the implied insult to academic art, with its penchant for such Hellenistic titles. There was the provocativeness of the thin black ribbon, emphasizing her nakedness and her vulnerability. There was another factor too. At this time in Paris there was an enormous market in nude and porno-graphic photographs, some of them, such as those produced by Julien Vallou de Villeneuve, being specifically, if some-what hopefully, designed for the use of artists; even the more risqué ones which showed pubic hair and the clitoris had to put up the pretence of being 'artistic'. The pose and appearance of Olympia must have seemed to many to have been based on just such photographs, with their inevitable provocation of feelings of guilt.

The violence of the reaction to these two paintings enhanced Manet's newly acquired role as the leader of the young, progressive element in the art world, composed as it was of people who were at that rebellious stage of life when artistic revolt tends to become involved with political and social bloody-mindedness. The curious thing is that the artist whom Manet was to supplant in this role of rebel leader had also largely achieved it by a similar type of *succès de scandale*, or rather a series of them. Gustave Courbet had first attracted attention at the Salon of 1850 when he was 31 with two large canvases, *The stone-breakers* (Plate 79) and *The burial at Ornans* (Musée d'Orsay). These depict with strong dramatic vigour scenes from country life which he himself had experienced not, as he liked to imply, as a peasant but as the son of a landed proprietor near Ornans. Stylistically nurtured on the same Spanish artists who influenced Manet, he was preoccupied by the appropriate-ness of subject-matter for an artist, and when he was painting *The stone-breakers* he wrote a description of it to his friend, the novelist and political writer Francis Wey, which underlines his almost purely literary approach:

There is an old man of 70, bent over his work, his pick raised in the air, his skin burnt by the sun, his head shaded by a straw hat; his trousers of rough cloth are patched all over, inside cracked wooden clogs he wears stockings which were once blue with the heels showing through. Beside him there's a young man, his head covered in dust, his skin greyish brown; his disgusting shirt, all in rags, exposes his arms and sides; leather braces hold up the remnants of his trousers, and his dust-covered leather shoes are gaping everywhere. The old man is on his knees, the younger standing up behind him carrying a basket of stones. In a job like this you start like the one and end up like the other!...All this is set in the bright sun, in the open country, by a ditch at the side of the road.

The emphasis on the trappings of poverty, the choice of a scene far removed from the idyllic peasantry who usually peopled paintings of rustic scenes, underline the extent to which Courbet was motivated in much of his painting by political convictions which were at once nebulous and sincere, and which were to play a vital role in his career and eventual downfall. Baudelaire, whose reactions to him

varied a good deal, once described him as 'a clumsy Machiavelli who has made a theory out of an innocent farce with an intensity of conviction which is positively dangerous'. This 'intensity of conviction' spilled over into Courbet's estimate of himself, which was almost completely untouched by any suspicion of critical objectivity. When his paintings were rejected by the jury selecting the 5,000 works which appeared in the Palais des Beaux-Arts at the World Fair of 1855, he had a Pavillon du Réalisme built near it in which he exhibited 50 of his own works. Despite constant reductions in the entrance fee it was little visited, and when Delacroix went there on 3 August he found himself absolutely alone. The exhibition was dominated by an enormous work depicting Courbet's studio, entitled *L'Atelier du peintre, allégorie réelle, déterminant une phase de sept années de ma vie artistique* ('The painter's studio; a realistic allegory, defining a seven-year period of my artistic life'; Plate 80). This extraordinary statement of a megalomania unique in the history of art brought together all the social types and principles which motivated him, displaying him as at once the down-to-earth master painter and the unifying centre of groups of people representing Capital, Labour, the Arts, Literature and much else besides, all tinged with the crypto-religious social doctrines of Charles Fourier.

It was these socio-political preoccupations of Courbet which enraged the establishment and endeared him to the young rebels, both factions sensing a link between socio-political and aesthetic discontent. Realism was bad enough but, as Courbet and after him Manet were to discover, when it was combined with the depiction of people from the lower classes and any sense of sexual titillation it was seen as dangerous and appalling. This view was typified in the reactions to Courbet's *Les demoiselles au bord de la Seine* (Palais de Beaux-Arts de la Ville de Paris), which aroused howls of disapproval at the Salon of 1857, and his *Baigneuses* of 1853, which had so important an effect on Renoir (see p. 61) with their heavy, muscular bodies, so different in actuality from the slender nudes of approved artists, and which especially aroused the ire of Napoleon III, that much practised expert in such matters. More considered criticism was directed against their resemblance to photographs, and indeed Courbet's quest for actuality did lead him to depend heavily on the camera. He was introduced to the work of Julien Vallou de Villeneuve in 1854 by Alfred Bruyas, and when he was painting *L'Atelier* wrote to him asking him to send 'that photograph of the nude woman which I have mentioned to you. She will stand behind the chair in the middle of my picture.' The camera offered the realists not only a more natural view of the human body, but a range of poses wider than that afforded by the postural syntax of academic art.

The mere existence of this new method of recording reality brought into question the whole value and significance of painterly realism. On the one hand it had considerable artistic aspirations itself, being often significantly described as 'the pencil of nature'. In response to pressure from the Société Française de Photographie, the Ministry of Fine Arts organized in 1859 a Salon of photography, which

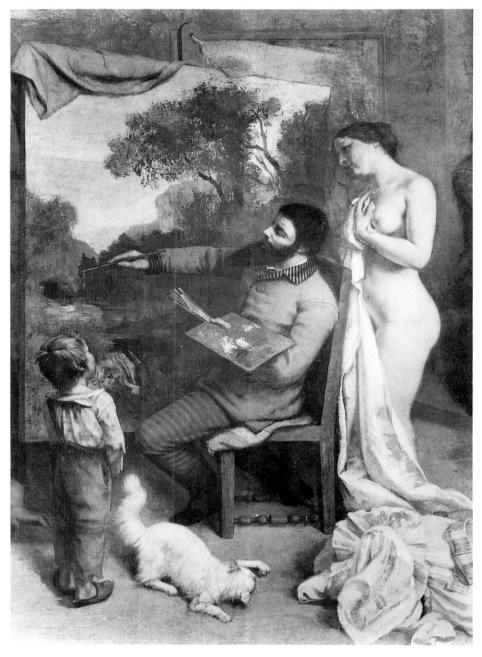

80 GUSTAVE COURBET *The studio* (detail) 1854–5
The central figure in Courbet's huge self-congratulatory painting of 1855 anticipates some of Renoir's nudes of 15 years or so later. It is very similar in stance to nude photographs of the kind then very popular in Paris.

would form an integral part of the main Salon itself. There were nearly 3,000 entries and the reception by the critics and the general public was not only positive but enthusiastic, comparisons unfavourable to art often being drawn between photographs and the paintings exhibited in the main hall. Particular attention was directed to landscapes and Ernest Chesneau, a friend of Ruskin and an important figure in the art world, chided artists for their churlish reception of this new competitor:

This ingratitude is obvious when one knows that the majority of painters today use photography as their most precious tool. They won't do without it. I find this in the general toning down of their colour range during the last few years.

This was certainly true. At Corot's death in 1875 more than 200 landscape photographs were found in his studio, and his work in the late 1840s shows the kind of blurred effect created by the lack of definition as light eats away the emulsion on the glass plates then used for photographs. The Barbizon painters, too, despite their avowed concern with direct observation, had utilized the camera. Millet wrote to a friend who was going to Italy in 1865:

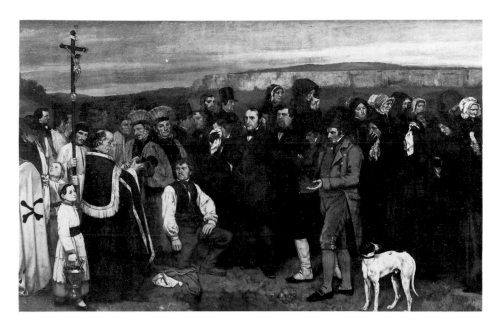

81 GUSTAVE COURBET *The burial at Ornans* (detail) 1848

If you should happen to find any photographs which are not too exorbitant in price, buy them...Bring whatever you can get there, works of art, or landscapes, human beings or animals. Diaz's son, who died, brought home some excellent ones of sheep among other subjects. In buying figures you must select those that have the least suggestion of academic art, or of having been posed by artists' models.

Courbet too used photographs for his landscapes, and in the authoritative *Art and Photography* (1974) Aaron Scharf reproduces a photograph of the castle of Chillon which is almost identical with one of Courbet's paintings, as well as one of the remarkable camera studies by Gustave Le Gray off the southern French coast, with the sea and clouds appearing in dramatic horizontal lines, which parallels Courbet's *The artist saluting the Mediterranean at Palavas* (Musée Fabre, Montpellier, 1854).

Photography, however, posed another problem. Did it, by its very nature, invalidate realism as a style? Critics constantly used to decry paintings such as *The burial at Ornans* for being 'work which might be mistaken for a faulty daguerreotype, showing that natural vulgarity which always comes from taking nature as it is, and in reproducing it just as it is seen'. There was a lively apprehension of a dichotomy between art and inspiration on the one hand, science and unreformed nature on the other. The critic Etienne-Jean Delécluze expressed a widely held view when he wrote:

The intellect and eye of the naturalist [i.e. realist] painter are transformed into a kind of daguerreotype which, without the imposition of the will, without taste, without consciousness, lets itself be subjugated by the appearance of things, whatever they may be, and mechanically records their images. The artist, the man, renounces himself; he converts himself into an instrument, he flattens himself into a mirror, and his principal distinction is to be perfectly uniform and to have received a good silver finish.

This concept of the camera replacing art and making artistic realism as it were redundant was a very widespread one, but it did nothing to diminish the appeal of this style to young artists reacting against the conventional and what they saw as the reactionary. It seemed inevitable that they should look to Courbet, with all his bombast, his self-confidence, his skills at public relations and his innate rebelliousness, to be their leader, for this new idea of

movements and groups in art, each with its own doctrine, its own principles, seemed to demand one. Of the two previous manifestations in European art of this phenomenon, the Nazarenes in Germany had been led by Friedrich Overbeck, the Pre-Raphaelites by Rossetti. But though Courbet presided over a cenacle at the Brasserie Andler and later the Brasserie des Martyrs, he always wanted to be in Paris, but not of it, and insisted on maintaining the façade of a simple peasant, larding his speech with patois and maintaining a kind of pseudo-provincialism of the type common in British intellectual circles almost exactly a century later. The nearest that he ever got to becoming that kind of figurehead was in 1862 when a group of students from the Ecole des Beaux-Arts asked him to become their teacher. Courbet replied in a long letter that he did not want to do so because every artist should be his own teacher, but suggested that he would open an atelier, like a *bottega* in the Middle Ages, where he would consider them as collaborators and apprentices, allowing each the freedom to search for his own form of expression.

Early in January of the following year, this studio opened in the rue Notre-Dame-des-Champs. Each student contributed 20 francs a week for the rent of the premises and the model, which was usually a bullock or a horse with a 'peasant'. Courbet's teaching seems to have been very discursive, and mainly autobiographical, and he soon got tired of it. The 'school' closed after three months. Courbet was not the type of person to be a leader, whereas the impact of the two works at the Salon des Refusés with their violent rejection of the tradition of the Beaux-Arts and their blatant realism had shown that Manet was. When Lehmann, a member of the Institut and an erstwhile pupil of Ingres, gave up teaching in 1864, his students invited Manet to take over his atelier. He refused, knowing that the real way to make revolutions and gain leadership of them was in places such as the Café Guerbois, where ideas could be discussed among equals and programmes evolved by those experienced in the ways of the art world. Already the Batignolles group had emerged as an artistic entity,

82 EDGAR DEGAS *Nude c.* 1863
One of a series of nude drawings in black chalk which Degas did for the painting *War scene in the Middle Ages* (Musée d'Orsay).

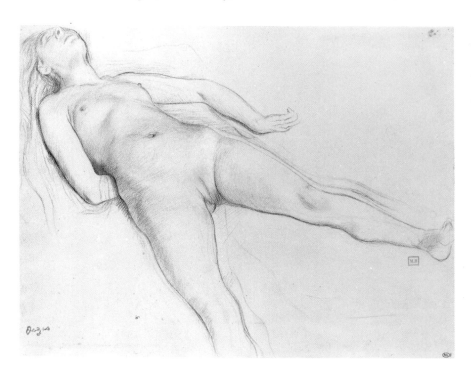

and by 1868 Edmond Duranty, who was to be one of the main pillars of the Impressionist Pantheon, was writing testily to Alphonse Legros:

I proposed to the group that we should start producing a journal in which criticisms of the Salon are signed by the painters, but Commandant Manet did not wish this, and the NCOs and privates did not dare oppose their chief. Manet becomes more and more megalomaniac and discontented with those who do not flatter him.

Although Courbet had not become the leader of the discontented, he was still a potent, charismatic figure, who was linked in many minds with Manet, and a song popular with art students of the period went:

Courbet, Manet, tous ceux qui ont génie,
N'ont pas la croix, ça dégoûte de la vie.
(Courbet, Manet and all those who have genius/Do not have the cross of the Legion of Honour. It's enough to make one sick of life.)

Moreover, he was to have a powerful influence on those members of the Batignolles group who were to be the Impressionists of the post-1874 era. In 1864 he visited the studio in the rue Fürstemberg which Monet was sharing with Bazille and paid several visits to Chailly when both the younger artists were staying there. He also visited the Normandy coast in the company of Boudin, Monet and Whistler, all of them producing paintings on similar coastal themes, and introduced Monet to the Porte d'Aval at Etretat, a subject to which he often returned (Plates 83; 309). By 1865 Monet was sending begging letters to him:

My family won't give me anything, and right now I have absolutely no money, not even enough to stamp this letter. Forgive me. You who know, my dear friend, what it is to be a painter, you can understand my predicament better than anyone.

When Monet was working at Ville d'Avray in 1866 and completing his first large-scale open-air painting, *Women in the garden* (Plate 100), he later recorded to a friend,

At Ville d'Avray I was advised periodically by Courbet, who came to visit me. One day he asked me, 'Why aren't you working, my young friend?'

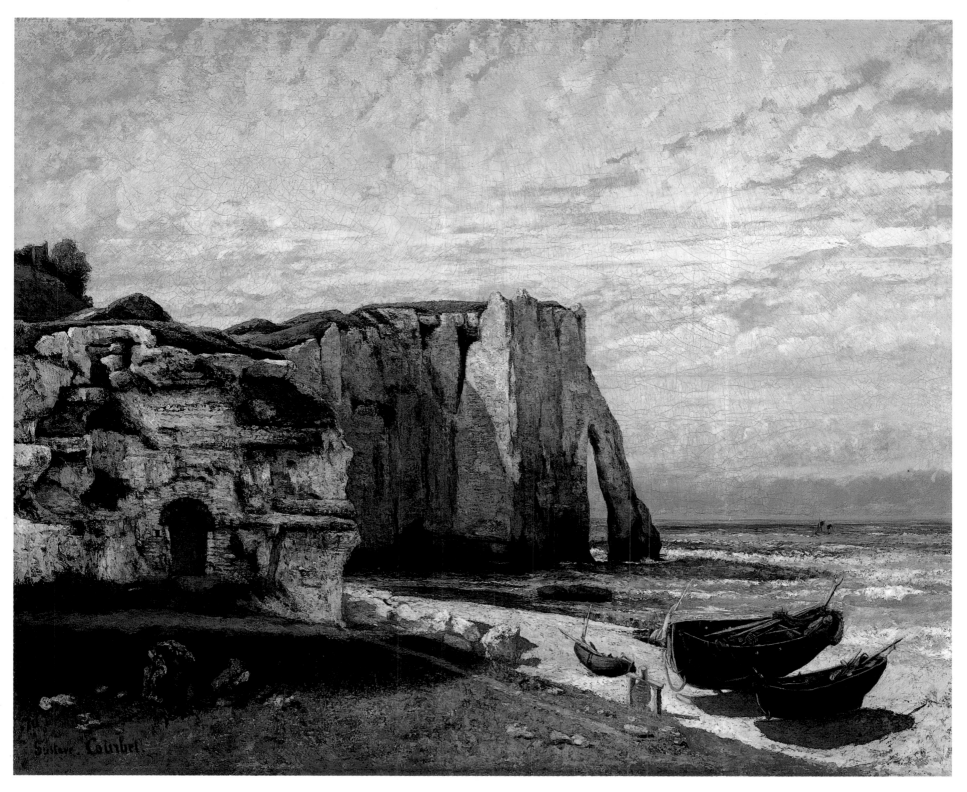

83 GUSTAVE COURBET *Cliffs at Etretat after a storm* 1870

I answered him, 'Can't you see there's no sunlight?' That meant nothing to him since he thought you could always work on the landscape sections, but there had been a bit of a smile on his face when he asked the question, and it is possible he was just speaking in irony.

Courbet's technique with its freedom and its use of palette knife painting profoundly influenced not only Monet but Pissarro, Cézanne and Renoir, whose works during the later 1860s showed Courbet's rich density of colouring, his rendering of grass and foliage by flatly scrubbed and brushed pigment and his alternation of regular and intermittent brush-strokes. Of all the group Pissarro surrendered most completely to the influence of Courbet, seen at its most obvious in the paintings of Pontoise (Plates 108, 133, 135). Both Bazille and Pissarro's friend Armand Guillaumin, who had been a fellow student at the Académie Suisse as well as an exhibitor at the Salon des Refusés, also fell under the same potent spell.

So too, though to a lesser extent, did Degas. The influence of Courbet's approach with its alternation of sombre tonality highlighting by contrast the vivid colours of the main figures, as can be seen in his *Semiramis building Babylon* of 1860-62 (Plate 84) and, as late as 1868, in his *Portrait of Mlle Eugénie Fiocre in the ballet 'La Source'* (Plate 113), was important. But until he first met Manet, who came up to him in about 1862 as he was engraving an etching of Velasquez's *Infanta Maria Margarita* in the Louvre and introduced himself, Degas had little contact with

the new movements which were taking shape. His dedication to the old masters, both in Italy and in the Louvre, had been almost complete, and many of his major works until the end of the 1860s had been of subjects which would have appealed to the most reactionary academician. But he did not actually treat them in an academic way. *Semiramis*, for instance, the theme of which was largely taken from the account by Diodorus Siculus published in French in 1851, incorporates elements of recent archaeological discoveries in Assyria, recent theatrical innovations (Rossini's opera on the same theme was first performed in July 1860), and an indefinable quality which was very much in the air at this time, and was reflected for instance in Flaubert's novel *Salammbô*, begun in 1857 and finished in 1862. At the same time, too, it shows very clearly one of the strongest influences at work on Degas during this period, that of Gustave Moreau, with whom he was on terms of close friendship in the late 1850s. Though eight years his senior, Moreau (whose portrait he painted in 1860; Plate 85) was very like him in personality, introspective, inclined to be solitary, and melancholic. In September 1858 Degas had written to him from Florence, a letter in which he had expressed some of his problems:

I have done a few drawings. On the whole I have been less courageous than I had hoped to be. I don't want to give up before I have achieved something, however. Having nothing else to do here, the best thing I can do is study my craft. I could not undertake anything of my own. It takes a lot of patience to pursue the hard path I have chosen; I used to have your encouragement, and as I am missing it, I am starting to

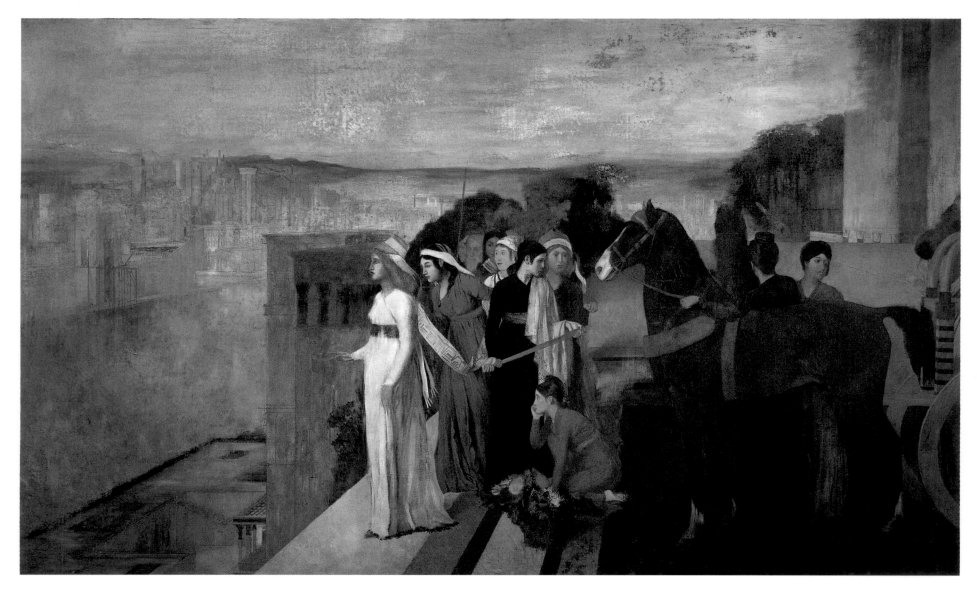

84 EDGAR DEGAS *Semiramis building Babylon* 1860-62

despair a little, the way I used to in the past. I remember the conversation we had in Florence about the sadness which is the lot of those involved in art. There was less exaggeration in what you were saying than I thought at the time. This sadness has indeed no compensations. It increases with age; progress and youthfulness no longer exist to console you with a few illusions and hopes...What else can a man say when he is as lonely and abandoned as I am? He has but himself in front of his eyes, he sees only himself, he thinks only about himself.

Quite apart from the strain of introspective misery, which seems to have been an endemic part of Degas's personality, there seems to have been a strong streak of escapism which prompted him to find, in the copying of works by the Florentine masters and in the choice of semi-academic themes drawn from history, a solution to his difficulty in thinking up subjects more expressive of his personal vision of life – although the choice of a ballet scene was an interesting hint about the future. At the same time, however, he endowed his works, as Moreau did, and indeed was to continue doing for the rest of his career, with a diffused lusciousness very much of his own age.

Degas was never to lose his affection and indeed respect for his early works, even later in life. He intended, for instance, to exhibit *Young Spartan girls provoking boys* (Plate 86), which he had painted at about the same time as *Semiramis*, at the fifth Impressionist exhibition in 1880: it appeared in the catalogue as No. 33; but apparently he had been retouching it and was not satisfied with what he had done. The theme was taken from the Abbé Barthélemy's *Voyage du jeune Anarcgasis en Grèce*, first published in 1787 and very popular in traditional schools such as the lycée Louis-le-Grand, which Degas had attended. This recorded that

Young girls in Sparta are not brought up like those in Athens. They are not kept shut up at home spinning wool, and they are not forbidden to drink wine or eat rich viands. On the contrary, they are taught to sing, to dance, to wrestle amongst themselves, to race along the sands, to throw the javelin and play at quoits, half-naked and without veils, in the presence of magistrates and citizens, even including young boys, whom they spur on to glory, either by their example, or by honeyed words of praise.

In a preliminary drawing (Art Institute of Chicago), Degas had put a temple-like structure in the centre of the composition, but in the final work this was replaced by a group of women, and a 'citizen' in a kind of toga. It is a large and spectacular composition with the wide landscape stretching into the distance. He himself emphasized that he had drawn on the youthful *gamins* of Paris for his models, and clearly he had imposed a very personal and even 'realistic' imprint on a subject which would have been treated very differently by David or any *pompier*.

He was certainly aware, even before his association with Manet, of the move towards realism which was in the air. This is especially evident in his first treatment of a theme which was to attract him throughout the rest of his career, the world of horse-racing. Immensely fashionable as part of the wave of Anglomania which was sweeping France in the middle of the nineteenth century, it appealed especially to that 'dandy' side of his character which he shared with Manet. *A gentleman-amateurs' race; before the start* (Plate 87) was painted in 1862 in the course of one of the

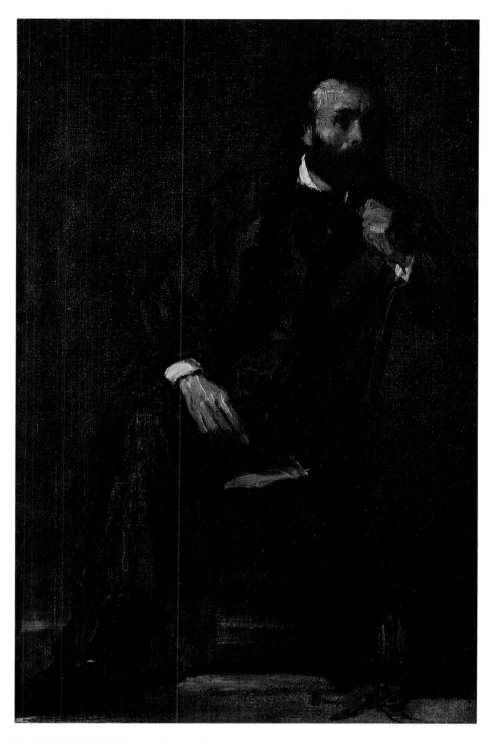

85 EDGAR DEGAS *Portrait of Gustave Moreau* 1860
Degas first met Moreau in Florence in 1858, and was to remain on close terms for over two years, during which the older artist had a considerable influence on him. Later in life, however, Degas spoke scornfully of him and denied the debt he owed him.

visits he made to his friends the Valpinçons, who had a country estate in Normandy near the race-course at Argentan. He was in fact going through a very English phase, finding resemblances between the Norman and English landscapes, reading Fielding's *Tom Jones*, and even entitling another of the horse-racing scenes he painted at this time *Jockeys at Epsom* (Fogg Art Museum). Once again in *A gentleman-amateurs' race*, as in the Spartan painting, he has emphasized the horizontal element of the distant landscape, with the factory chimneys of Argentan, a famous lace centre, in the near background. The colouring owes a debt to Courbet and through him to Géricault, also a pronounced Anglophile.

It seems to have been about this time that Degas first began to turn his attention to sculpture, and there exists a number of statues of horses (three in the Musée d'Orsay and one in the Paul Mellon collection), at least one of which can be related to the *Mlle Fiocre* ballet painting.

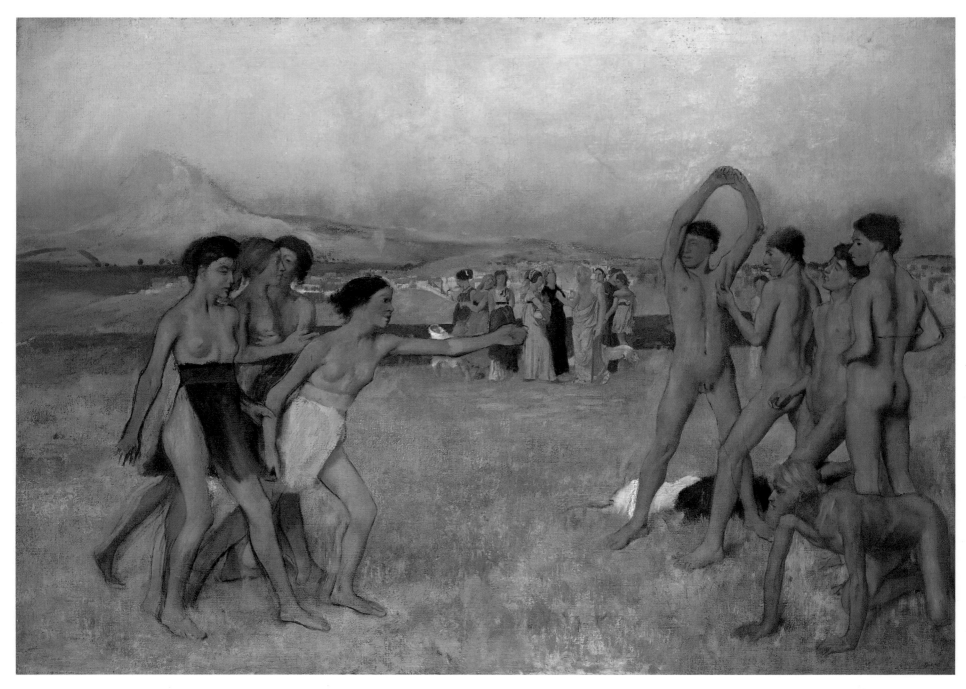

86 EDGAR DEGAS *Young Spartan girls provoking boys* c. 1860

Originally made in red wax, they were cast in bronze after his death. Although most of his equine sculpture belongs to a period some 25 years later, there is ample evidence that he was working in this medium at quite an early age. In 1897, for instance, in an interview with the journalist François Thiébault-Sisson, later reprinted in *Le Temps*, when asked if he had found his currently publicized venture into sculpture difficult he had replied, 'But I have been familiar with this medium for a long time. I have been practising it for more than 30 years, not, it is true, in a regular way, but from time to time as I felt in the mood for it, or I had need of it', and he went on to comment on the fact that when Dickens was writing his novels, he would make little plasticine models of the characters which he kept on his writing table. Unlike Degas's later sculptural exercises, these early ones depicted stationary horses in conventional stances.

———————————

Portraiture offered a source of inspiration for an artist short of more daring themes, and throughout his career Degas was to make it an important part of his work. This was especially so in the 1850s and 60s, when he produced not only a number of self-portraits but numerous portraits of members of his family. More clearly than any of his other works they show the influence of those Renaissance artists, mainly Florentine, whose works, at his father's behest and from his own inclination, he so assiduously studied. The most ambitious of these, painted intermittently between 1858 and 1867, *The Bellelli family* (Plate 88), was the outstanding work of his youth, but one for which he seemed in later life to have had no affection, and which was virtually unknown until the sale of the contents of his studio after his death in 1917. The only time it had been exhibited was at the Salon of 1867. More than a group portrait, it possesses that quality characteristic of so many of Degas's works in this genre of being a 'conversation piece' – in the eighteenth-century sense – in which the various personages are bound together by some dramatic tension; the spectator is conscious of participating in a situation with just a hint of domestic drama. The woman standing with her arm around her daughter Giulia is the Baroness Gennaro Bellelli, his father's sister; the second child apparently talking to her father Gennaro is Giovanna. (Degas also painted the two girls together seven years later.)

He started the work in Florence. The Bellellis were living there in exile since being forced to leave Naples in 1849 as a result of their involvement in the rising against the Bourbons, in the course of which Degas's cousin Morbilli was shot. The atmosphere of the Bellelli household he found disturbing; Gennaro had nothing to do and had become moody; his wife was intolerant of his lassitude and lack of enterprise; the two girls were fractious. Degas's original intention had been to finish the work in a month, but his difficulties in so doing were compounded by an outburst of advice from his father:

Since you have started the portrait of your aunt, I suppose you are eager to finish it. But so far you have only done a sketch, and a sketch must be allowed time to dry before you go back to it, otherwise the whole thing will become a mess. If you want the picture to become something strong and lasting, it will be impossible for you to finish it in a month, and the more pressed for time you are, the more time you will waste through constant chopping and changing. It seems to me therefore that you should confine yourself to making a drawing rather than starting off on a canvas.

Then, a few weeks later, early in 1859 he wrote again:

So you have started a large portrait on December 29th and hope to have finished it by February 28th. I very much doubt that, and I have a piece of advice to give you, that is to work on it with calm and patience, otherwise you run the risk of never finishing it and giving your uncle Bellelli a just cause for displeasure. Since you have undertaken to paint this picture you must do so, and do it well. I hope that you have changed your habits for the better, for I must confess that I place so little reliance on your resolutions and will only be satisfied when I hear from your uncle that you have finished the work, and finished it well. That indeed will be a great weight off my mind.

With such paternal breathings down his neck it is not remarkable that Degas was somewhat diffident about his work. In any case, the pains he took about preparing for a painting, especially a portrait, were endless. In the event, when he left Florence in March of 1859, he had not finished the work but had with him several notebooks of rough sketches, various studies on separate sheets of paper – one of them of Giulia Bellelli (Dumbarton Oaks) – and a pastel sketch (Ordrupgaard Samlingen, Copenhagen)

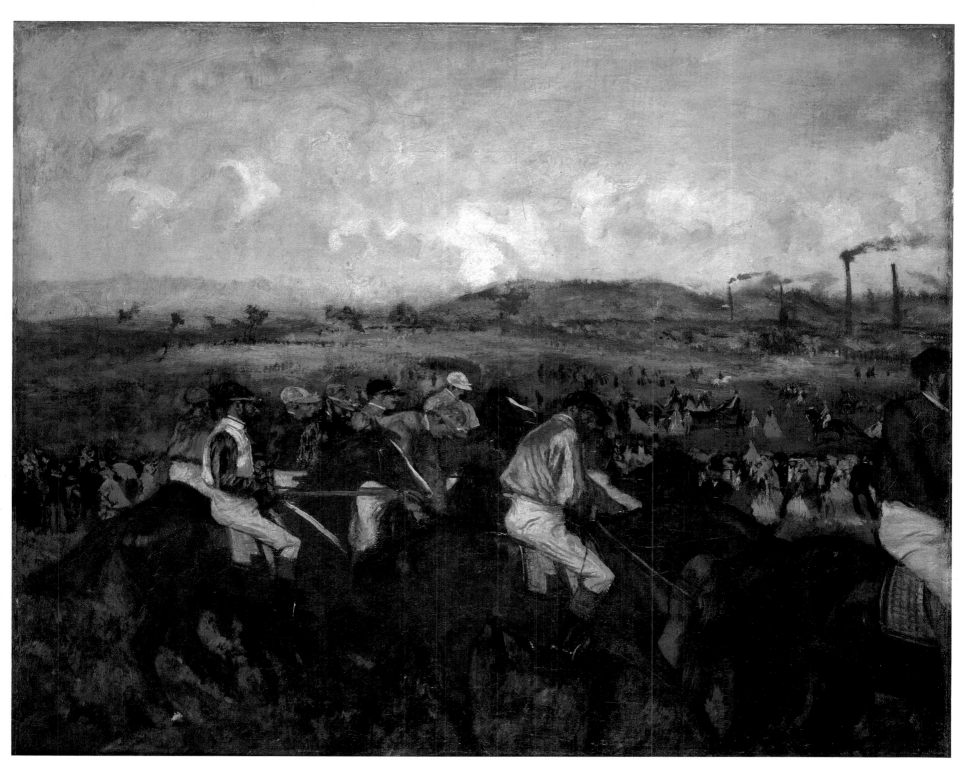

87 EDGAR DEGAS *A gentleman amateurs' race; before the start* 1862

showing the complete grouping very much as it appeared in the finished painting. In the following year, when he was in Florence again, he did another sketch of Gennaro and he seems to have gone on working at the picture until the end of 1859. He himself claimed a distinguished lineage for the work. Writing to Moreau in November 1858, he cited Giorgione, Mantegna and Carpaccio; more recent commentators have pointed to the influence of Holbein, whose work he had known in the Louvre; Van Dyck, about whose works in Genoa he had been very enthusiastic when he passed through that city; and, as far as the composition goes, to the family portraits of Ingres, and Courbet's essay in the same genre. Above all else it is an exercise in realism of both the visual and the psychological kind.

What is presumed to be a portrait of Madame Paul Valpinçon, *Woman with chrysanthemums*, dated 1865 (Plate 89), is a single-figure and much more problematic picture. He had been visiting the Valpinçon family estate of Ménil Hubert near Argentan for several years and had

stated quite early an ambition to paint a portrait of her; moreover the flowers correspond to drawings he made in his notebook of types growing in the château gardens. It is often suggested that the painting started off as a flower piece and that some time later the figure was added on the right. Militating against this theory is the fact that such a work was unlikely at this point in Degas's life, and that it would be unusual to site a still-life in a complex setting involving an open window and an elaborately patterned wallpaper. Moreover, there is a suggestion of anecdote; the presence of the water-jug suggests that the sitter has been arranging the flowers. But what gives the woman her dominance in the picture is the look of reflectiveness on her face, as though she were trying to find the significance of something which had recently happened, or was reflecting on the past.

The same meditative look plays over the face of James Tissot in the portrait Degas painted of him in 1867 (Plate 91). At this time the two artists were very close, having first met in 1862. They were bound together by a common

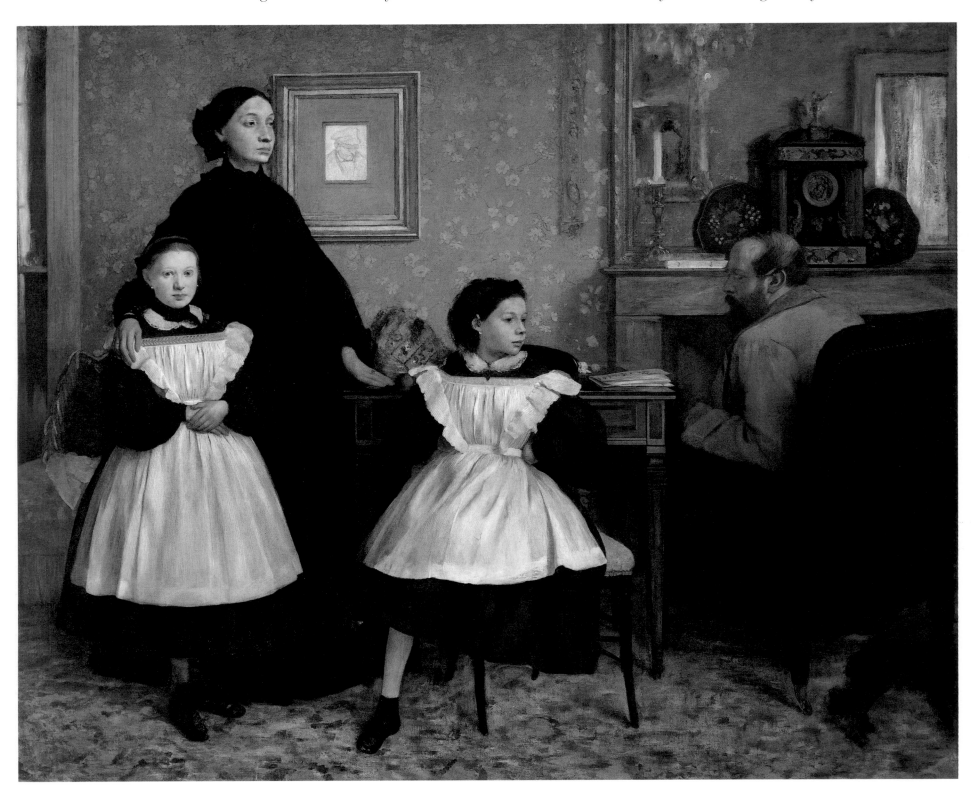

88 EDGAR DEGAS *The Bellelli family* 1858-62

liking for Italian Renaissance art, by a certain elegance in dress and behaviour and by shared tastes. The portrait by Cranach of Frederick III, the Japanese-style painting on the wall behind (it hangs in the Louvre) and the general atmosphere of the room with Tissot posed nonchalantly, his cane loosely held in his hand, his top hat on the table beside him: all bespeak an air of dandified refinement in an artist who was already achieving a wide popular success. Degas was more than a little jealous of this – Tissot was two years younger. In later years their paths were to divide: Tissot, by then mainly living in England, was to have great success as a society painter before ending up as a religious one.

Manet, too, was at this time quite deeply involved in portraiture. Indeed, were it not for the unusual circumstances, the *Déjeuner sur l'herbe* could be thought of as an exercise in realistic portraiture and the face of Olympia seen as not very different in visual intensity from that of Laura Bellelli. In one of his earliest portraits, that of his parents, painted in 1860, his mother is holding a basket of wools, ribbons and different kinds of yarn, there are various objects on the table, and no attempt is made to glamorize their faces. When the picture was exhibited in the Salon of 1861, one critic commented, 'What a scourge to society is a realist painter. To him nothing is sacred. M. Manet tramples on even more hallowed affections, M. and Mme M. must have more than once rued the day when they allowed a paint brush to get into the hands of this ruthless portrayer' (Plate 66).

The portrait in which he made most use of significant accessories was that of Zola, which he painted in 1868 (Plate 90). Emile Zola had been a fellow pupil of Cézanne in Aix, and had always got better marks than he at drawing. Returning to Paris (where he had been born before his father had been commissioned to build an aqueduct in Aix), he became a clerk in the publishing house of Hachette, and endeavoured unsuccessfully to become a playwright before turning his attention to fiction and journalism. In 1866 he became editor of the left-wing paper *L'Evénement*. His interest in art, already aroused,

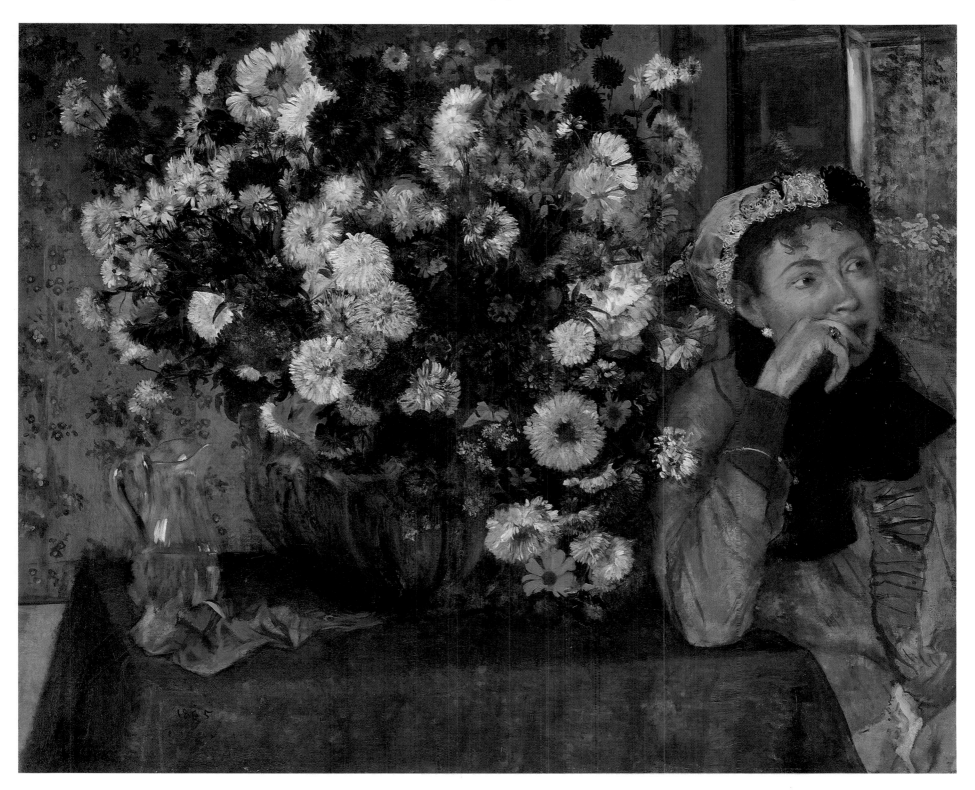

89 EDGAR DEGAS *Woman with chrysanthemums* 1865

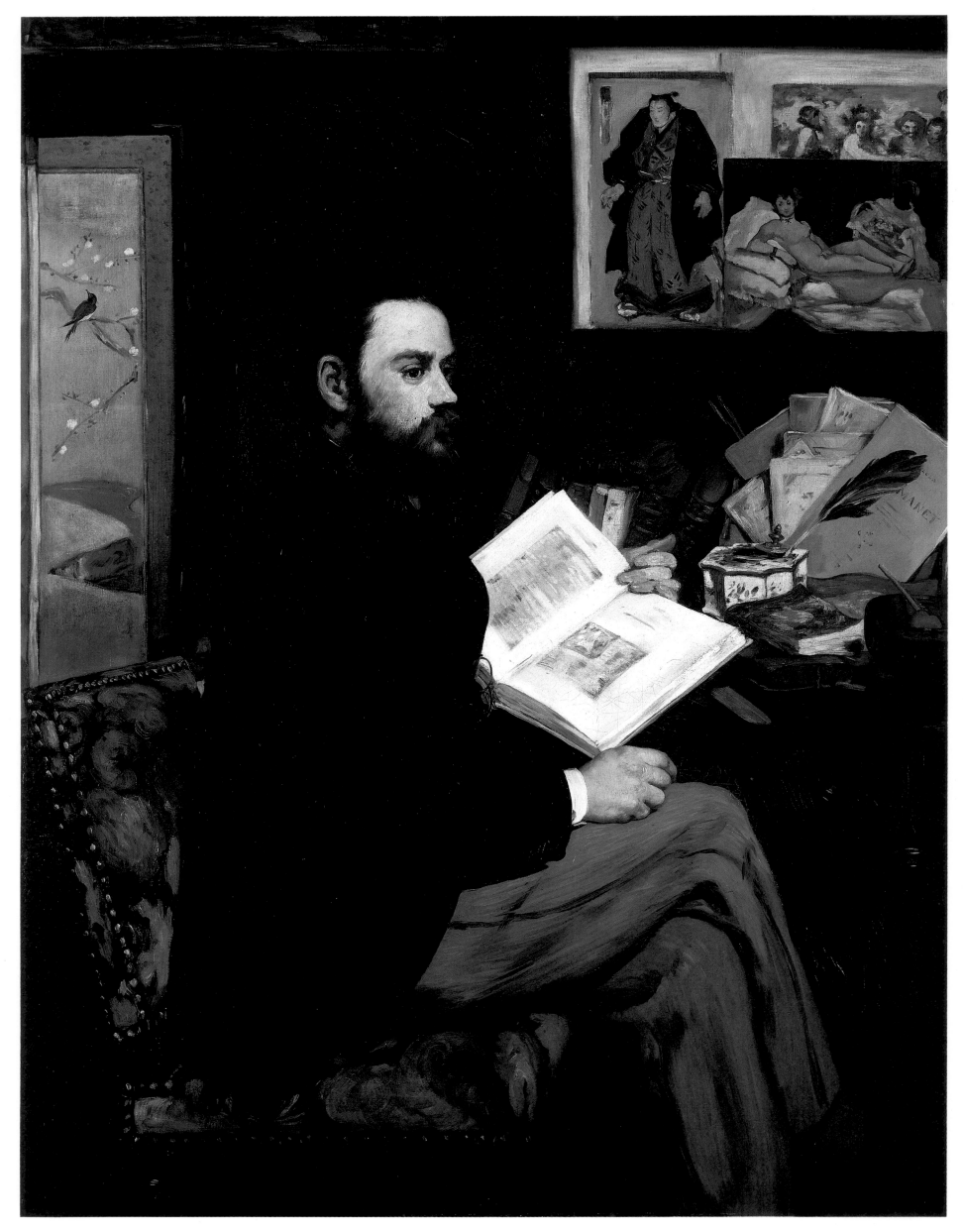

90 EDOUARD MANET *Portrait of Emile Zola* 1868

was stimulated by his contact with Cézanne and Antoine Guillemet (see p. 52), with whom he became a regular visitor to the Café Guerbois. He was to become the most vehement defender of the Impressionists, not only for reasons of friendship, but because he was already beginning to plan the great Rougon-Macquart series of novels, which were to give a detailed, realistic picture of life under the second Empire. His approach to art was essentially literary, and he had little feeling for purely painterly qualities: he tended to evaluate artists according to how far they adhered to the realistic ideology which he was constructing for his own work. At the same time, too, he was influenced by basically romantic notions about the nature of art.

The objects or persons to be painted are pretexts. Genius consists in transmitting this object or person in a new, more real or greater sense. As for me it is not the tree, the face, the scene which touches me; it is the man I find in the work, the powerful individual who has known how to create alongside God's world a personal world which my eyes will never be able to forget and which they will be able to recognize anywhere.

Zola's first important venture into art criticism was his lengthy review of the Salon of 1866 in successive numbers of *L'Evénement*, in the course of which he bitterly attacked the jury for rejecting Manet's submissions:

Since nobody else is saying it, I shall do so myself. I shall shout it from the housetops. I am so sure that M. Manet will be accounted one of the masters of tomorrow that I think it would be a sound investment, were I a wealthy man, to buy all his canvases today. M. Manet's place is marked for him in the Louvre, like Courbet's, like that of any artist with a strong and uncompromising talent.

At this point he did not know Manet well, and had probably been taken along by Guillemet to see the pictures which had been rejected by the Salon, including *The fifer* (Plate 92), about which he was to write enthusiastically in *L'Artiste* a year later:

It has been said in mockery that Edouard Manet's paintings are reminiscent of popular Epinal prints[5] and there is much truth in the jest, as well as high praise; the methods are alike, with colours applied in flat plaques, except that the Epinal craftsmen use pure tones, paying no attention to values, whereas Manet multiplies his colour tones and sets them in their proper relationships. It would be more to the point to compare this simplified painting with Japanese prints, which are similar in their strange elegance and splendid colour areas.

Manet was so impressed by Zola's spirited plea on his behalf that he invited him to meet him at the Café de Bade, and together they expanded Zola's writings about Manet to create a booklet for Manet's one-man exhibition in 1867, held in a pavilion off the avenue de l'Alma built at the artist's expense. The portrait was a token of gratitude for this. It had been begun in February 1868, and finished in about a month. Zola wrote an account of the experience:

I remember those long hours of sitting; the numbness that overtakes motionless limbs, the fatigue of gazing, in full daylight with fully opened eyes; the same thoughts would always drift through my mind with a soft, deep murmur. The nonsense talked in the streets, the lies of some, the inanities of others, all that human sound which, worthless as ditch-water, flows and eddies around, seemed very far away.

From time to time as I posed, half-asleep, I looked at the artist standing by his easel, his features drawn, clear-eyed, absorbed in what he was doing. He had entirely forgotten me; he no longer realized I was there;

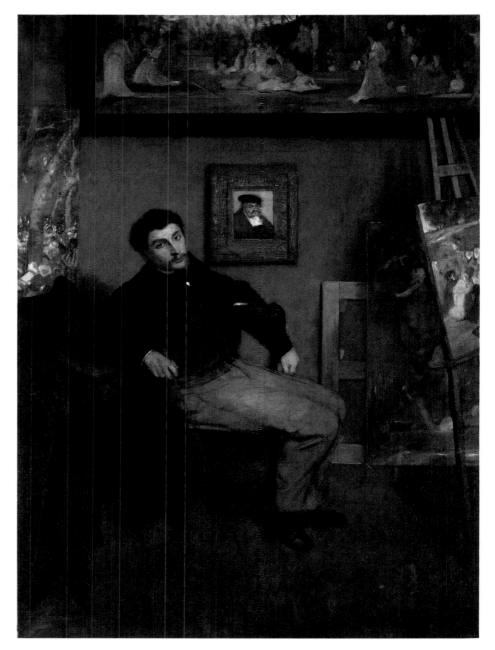

91 EDGAR DEGAS *Portrait of James Tissot* 1868

he simply copied me as if I were some human animal, with a sense of concentration and artistic integrity that I have seen nowhere else... Often when he was dealing with some detail of minor importance I wanted to stop posing, and suggested to him that he should make it up.

'No', he answered me. 'I can do nothing without Nature. I do not know how to make things up. As long as I have tried to paint something in accordance with the lessons I have been taught, I have never produced anything worthwhile. If my work has any real value today, it is because of the exact interpretation and truthful analysis.' That is the secret of all his talent. His eye sees things and records them with elegant simplicity.

Although the portrait gives the impression of portraying Zola seated at his writing table, it was painted in Manet's studio, and the arrangement of objects was the artist's way of building up a composite portrait of the sitter in which the accessories were as important as the figure, and also of imposing his own personality. The books on the table imply Zola's authorship, but the one which can be most clearly identified is the light blue booklet on Manet himself. The book which he is reading is one of the volumes of *L'Histoire des peintres* by Charles Blanc (1813-82), the founder and editor of the still-flourishing *Gazette des Beaux-Arts*, a book on which Manet apparently relied heavily for his knowledge of art history. The idea of the frame with various prints in it was a familiar one; it had been used two years earlier by Degas in *The print collector*

(Metropolitan Museum of Art, New York). Dominant among them is a sketch of *Olympia* with the model's face significantly turned towards Zola. Behind that is an engraving by Manet's favourite artist, the *Los barrachos* of Velasquez. The Japanese print is by the contemporary Kuniaki II (1835-88) and depicts a *sumo* wrestler. Japanese screens such as the unidentified one on the left were almost *de rigueur* as symbols of modernism. They appear in Degas's *Print collector* and in works by Tissot, Fantin-Latour and the 'Japanese' works of Whistler, who gave one such screen an important role in *The princess from the land of porcelain: rose and silver* (Freer Gallery of Art, Washington DC, 1863).

The portrait was accepted in the Salon of 1868 and had a generally favourable reception. Wilhelm Bürger (who wrote under the pseudonym of Théophile Thoré), a friend of Baudelaire who was to become a defender of Manet and the other Impressionists, wrote in the Constitutionnel:

This portrait has not aroused the wrath of over-sensitive souls. It has not been found too obviously unsuitable. The books, especially the wide-open illustrated volume and the other objects cluttering the wall and table, are admitted to being astonishingly realistic. Certainly the execution is broad and generous. But the chief merit of the Zola portrait, as of other works by Edouard Manet, is the light pervading the interior, the overall effectiveness of the modelling and the relief.

The most pertinent criticism of the work, however, came in a letter which the 28-year-old Odilon Redon wrote to a friend:

The picture is very attractive, it bears the marks of originality, it arouses interest by its harmony, its modernity, its elegance of tone. M. Manet's fault, and the fault of all who like him would stay content with a literal version of reality, lies in sacrificing the man and his thoughts to external things, to the triumph of accessories...their human figures are without interior spiritual life. The picture is more like a still life than the image of a living human being.

Zola himself was apparently not very keen on it, keeping it in the billiard-room of his house at Médan, which in any case was not, according to most visitors, furnished in the best of taste. The only other pictures he had there were those which had been given him by Cézanne.

The qualities of coldness which some detected in the portrait of Zola are not to be found in the various domestic portraits which Manet was painting at this time of his wife Suzanne, playing the piano or being read to by her son. In 1868, too, Degas himself, then at the height of his intimacy with Manet, painted him listening to her playing the piano (Plate 93), a work which Manet later ruined by cutting off almost a quarter of the right-hand side – to Degas's extreme annoyance.

It was in this year that Manet decided to embark on a work which, as Degas had said about his Bellelli picture, would be more a tableau than a portrait. When staying at Boulogne he had been struck by a group of people standing on a balcony, a scene which put him in mind of Goya's *Majas on the balcony*, which he had seen reproduced in Charles Yriate's book on the artist, published the previous year. Back in Paris in the autumn he got together three friends to pose for him in his studio in the rue Guyot for a painting on this theme (Plate 94), which he called *The balcony* and which he had finished in time to submit to the Salon in the spring of the following year. Standing in the centre is Antoine Guillemet (1842-1918), a pupil of Corot, whose style had a persistent effect on Manet's work. His paintings were invariably accepted at the Salon, and there he came to exercise a great deal of influence, which he used on behalf of his more artistically explorative friends. It was he who had first introduced Cézanne to Manet. Barely visible in the background is Léon Leenhoff, Manet's putative son, holding a carafe. On the right of the group, looking extraordinarily Japanese in appearance, is the pianist Fanny Claus (1846-77), a member of the Sainte-Cécile Quartet; she often played music in the Manets' house with Suzanne Manet, herself a talented pianist—her father had been an organist in Holland—especially interested in the music of Schumann, then little known in France.

The Manets used to hold regular musical evenings on Thursdays, which Degas, Zola and the others used to attend. A comparative newcomer to the circle was the third and central figure in the painting, Berthe Morisot, who

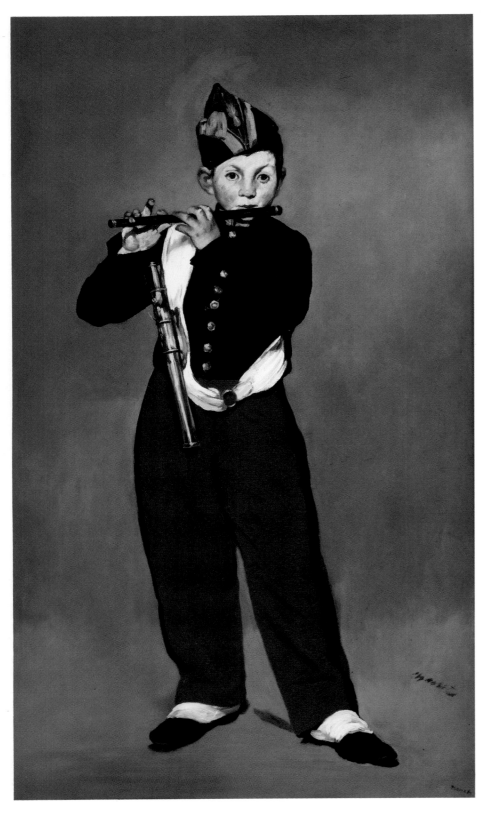

92 EDOUARD MANET *The fifer* 1866

had been introduced to Manet by Fantin-Latour the previous year in the Louvre, where she had been copying a work by Rubens. 'I quite agree with you', he wrote to Fantin on 26 August 1868, 'the Mlles Morisot are charming. Too bad they're not men. All the same, women as they are, they could serve the cause of art by each marrying an academician, and bringing discord into the enemy's camp.' Despite the bantering note of male sexism, Manet was deeply impressed; during the following decades their relationship was to be very close, and her influence on his painting career of the greatest significance. After all, by this time even she had become much more deeply involved in *plein air* painting than he was. *The harbour at Lorient*, which she was to paint in the following year (Plate 111),

was to reveal a modernity of handling not shown in any of his landscape backgrounds.

It was not easy for the sitters. Berthe's mother wrote to her middle daughter, Edma:

Antoine says Manet has made him pose 15 times, with no likeness to show for it, that Mlle Claus looks terrible, but that both, exhausted from standing in the pose, declare, 'It's perfect. No improvement needed.' They are all amusing enough, but not to be taken seriously. Manet appears quite mad; at one minute he seems certain of a great success, then doubts assail him, and he turns moody.

This is apparent today. The relatively heavy paint over the whole picture suggests that there were constant changes made, and this is confirmed by X-ray examination. The

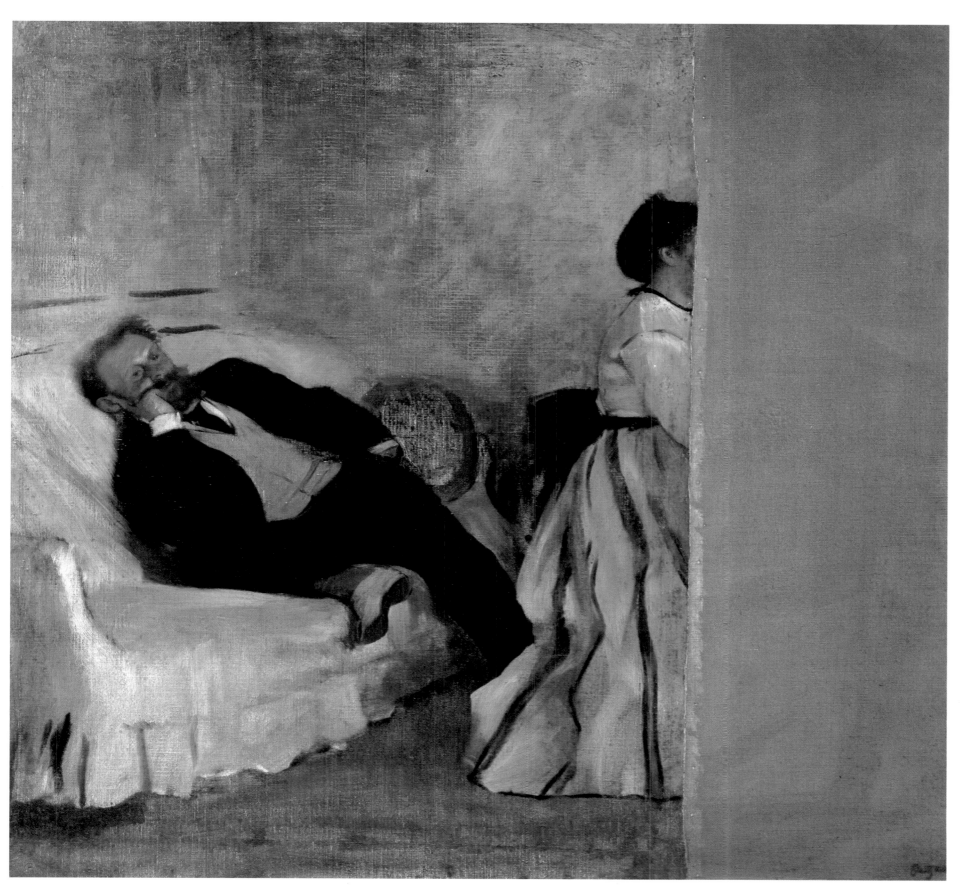

93 EDGAR DEGAS *Monsieur and Madame Manet* 1868-9

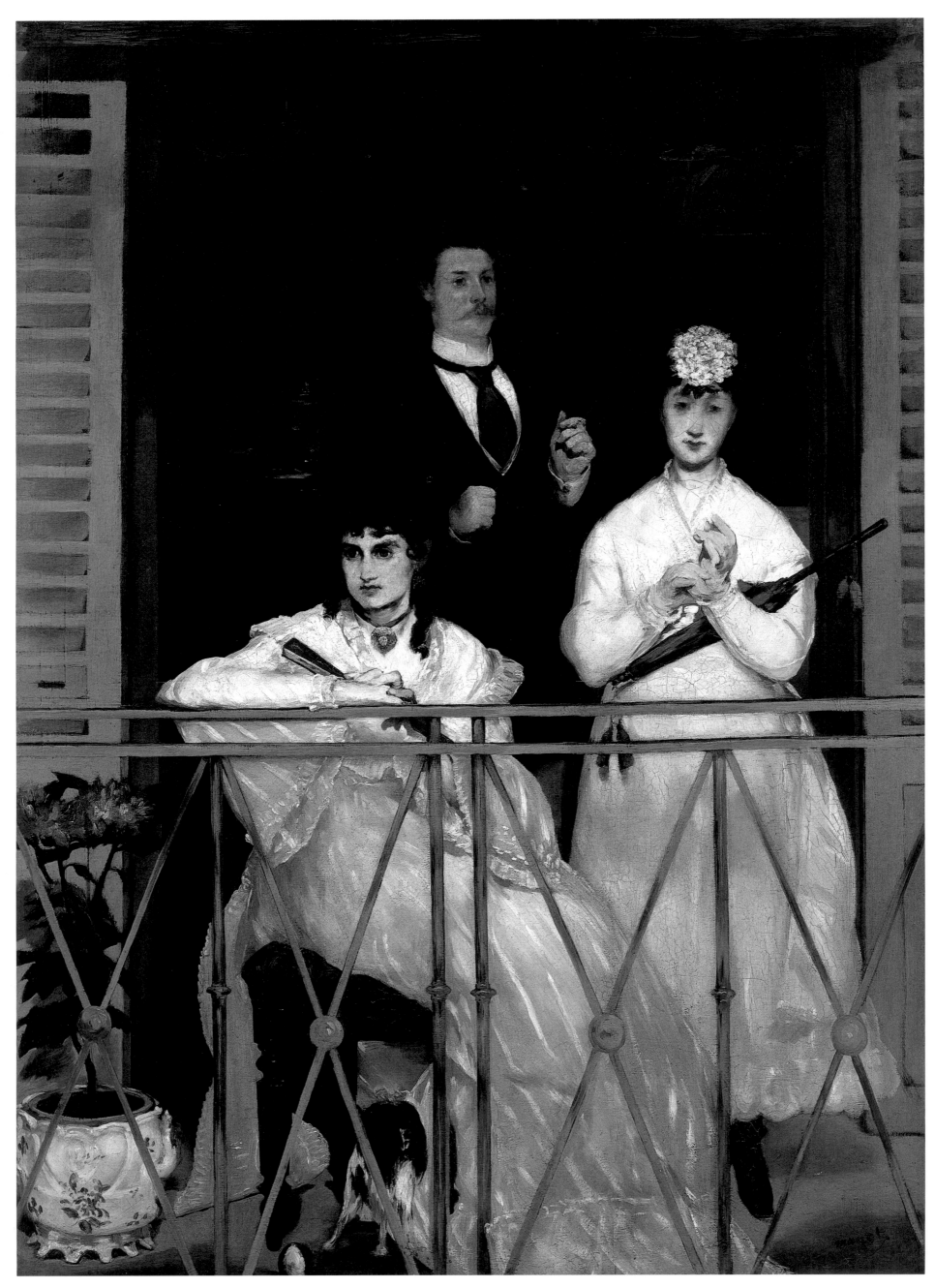

94 EDOUARD MANET *The balcony* 1868-9

boy seems to have been added as an afterthought. Fanny Claus was considerably altered: her face was originally much fuller, her eyes further apart and more clearly defined, her hat larger. Berthe Morisot's face has been made more vivacious; indeed, in the finished picture she is the most psychologically well defined and dominant figure of the trio. There is a strange feeling of suspense about the whole work. Each of the three figures has a private preoccupation. They are almost entirely unrelated to each other, all looking in different directions. It is hard not to feel that it might have been a far greater work had it been confined to the figure of Berthe Morisot, though it might then have lost the strange quirkiness which is part of its fascination.

A year later he produced the first, and possibly the finest, of the single portraits he painted of her. It is an interesting comment on her personality that she was persuaded to sit for him out of jealousy as much as anything else. Early in 1870 she wrote to her sister:

Manet is lecturing me and holds up that eternal Mlle Gonzalès as an example...she gets things done. Meanwhile he's starting her portrait over again for the 25th time [Plate 97]. She sits every day, and in the evening her hair has to be washed with soft soap – what an inducement that is to pose for him!

Then a few weeks later another rival appeared, and she wrote to Edma:

I went round the Salon the other day with that overplump Valentine Carré. Manet caught sight of her and is lost in admiration. He's been after me ever since to make her come and pose for something in his studio. I don't entirely like the idea, but when he gets a thing in his head it has to happen immediately.

Fortunately for Berthe, fat Valentine's mother wouldn't let her pose, and so Berthe's way was open. The final result was *Repose: portrait of Berthe Morisot* (Plate 95). Much looser than the *Balcony* painting, almost unfinished in parts – especially the chair on the left, and her right hand – it has a lightness and freshness which hints at the shape of things to come in Manet's art. Of especial interest is the poignant expression on her face. This may have been melancholic introspection or it may well have had more mundane causes. Several years later her daughter recorded that her mother had painful memories of the sittings, as her left leg had to be half drawn back under the skirt, a pose which became increasingly painful, and Manet would not let her move it lest the skirt be disarranged.[4]

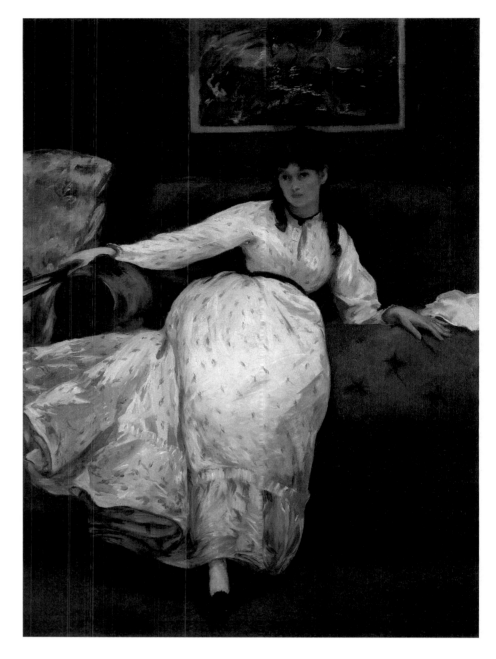

95 EDOUARD MANET *Repose: portrait of Berthe Morisot* 1870

[1] When Manet later painted a smaller version he changed the girl's face.

[2] Absinthe, which was to play an important role in the iconography of Impressionism – Manet was to paint a very different version later – was named from the Greek word 'apsinthion' meaning impossible to drink, and was made from a distillation of wormwood, which gave it a bitter taste and a characteristic green colouring. Originally developed for medical purposes in Switzerland, at this time in France it was mainly drunk by soldiers who had seen service in Africa; it had not achieved that popularity and social acceptability which it maintained until the belated discovery that it was actually poisonous, when it was banned by the government. In the meantime it had been very largely responsible for the misfortunes of Toulouse-Lautrec and Van Gogh – among others.

[3] Prints sold by street-hawkers, most of which were produced in the town of Epinal near Nancy.

[4] The subsequent history of the portrait is interesting. In 1872 Manet sold it to Durand-Ruel for 2,500 francs – more than he was paid for *Music in the Tuileries* at the same time – and gave Berthe a photograph of it. In 1880 the dealer swapped it for a Daumier with the critic Théodore Duret, whose portrait Manet had painted in 1868, but he had to sell it at auction in 1884. Berthe tried to buy it but failed, and it was acquired by the singer Jean-Baptiste Faure for 11,000 francs. By 1895 it was back in Durand-Ruel's hands, and was exhibited at his New York gallery; it was bought by George Vanderbilt, who had just built a huge country mansion near Asheville, North Carolina. On his death it passed to his widow Mrs Edith Stuyvesant Vanderbilt Gerry, who bequeathed it to the museum in Providence.

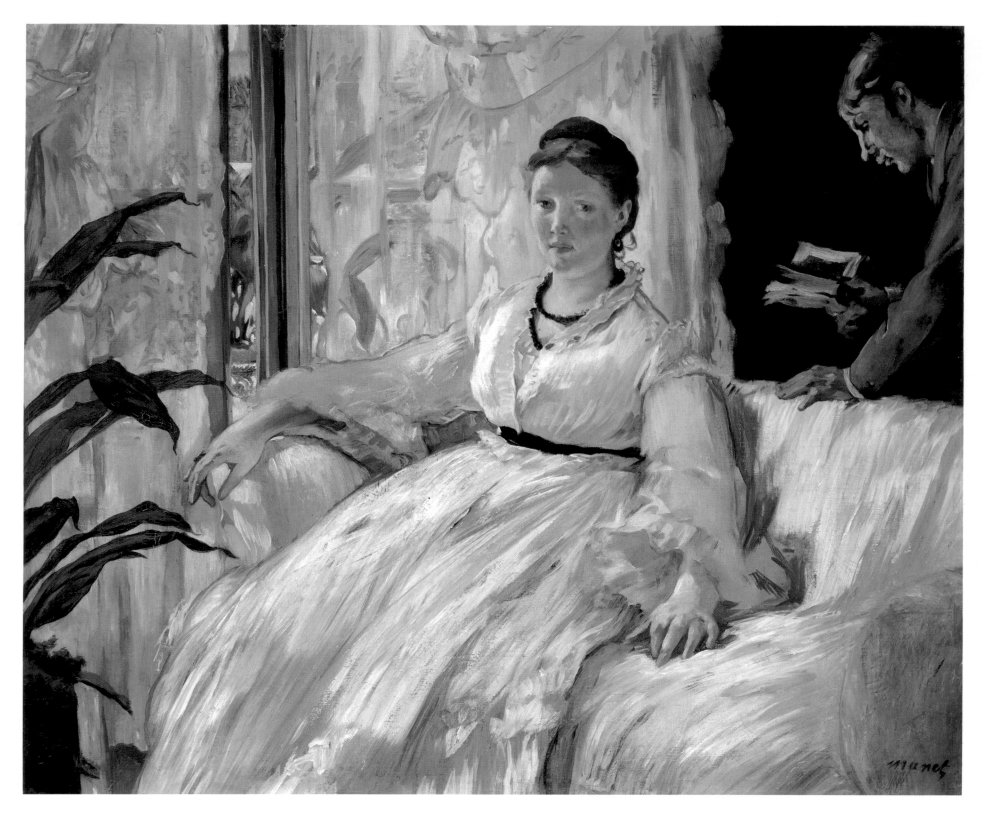

96 EDOUARD MANET *The reading c.* 1865
The most charming of the many portraits Manet painted of his wife, whom he
had married two years earlier. The figure of the man reading was added several
years later and is their son Léon, the pretence being that, as he had been born
before they married, he was her brother. It is the most 'Impressionist' work which
Manet had painted up to that date.

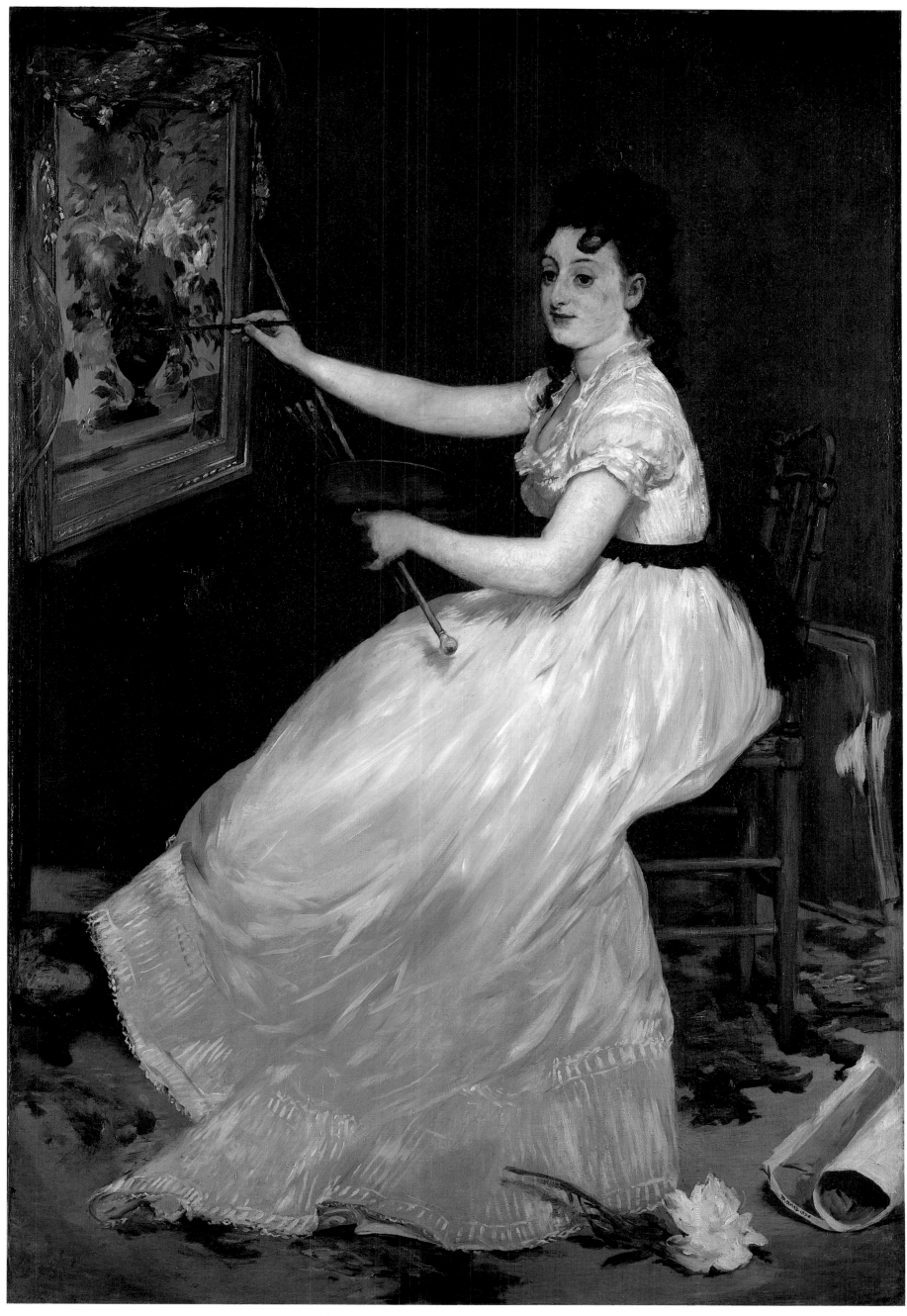

97 EDOUARD MANET *Portrait of Eva Gonzalès* 1870

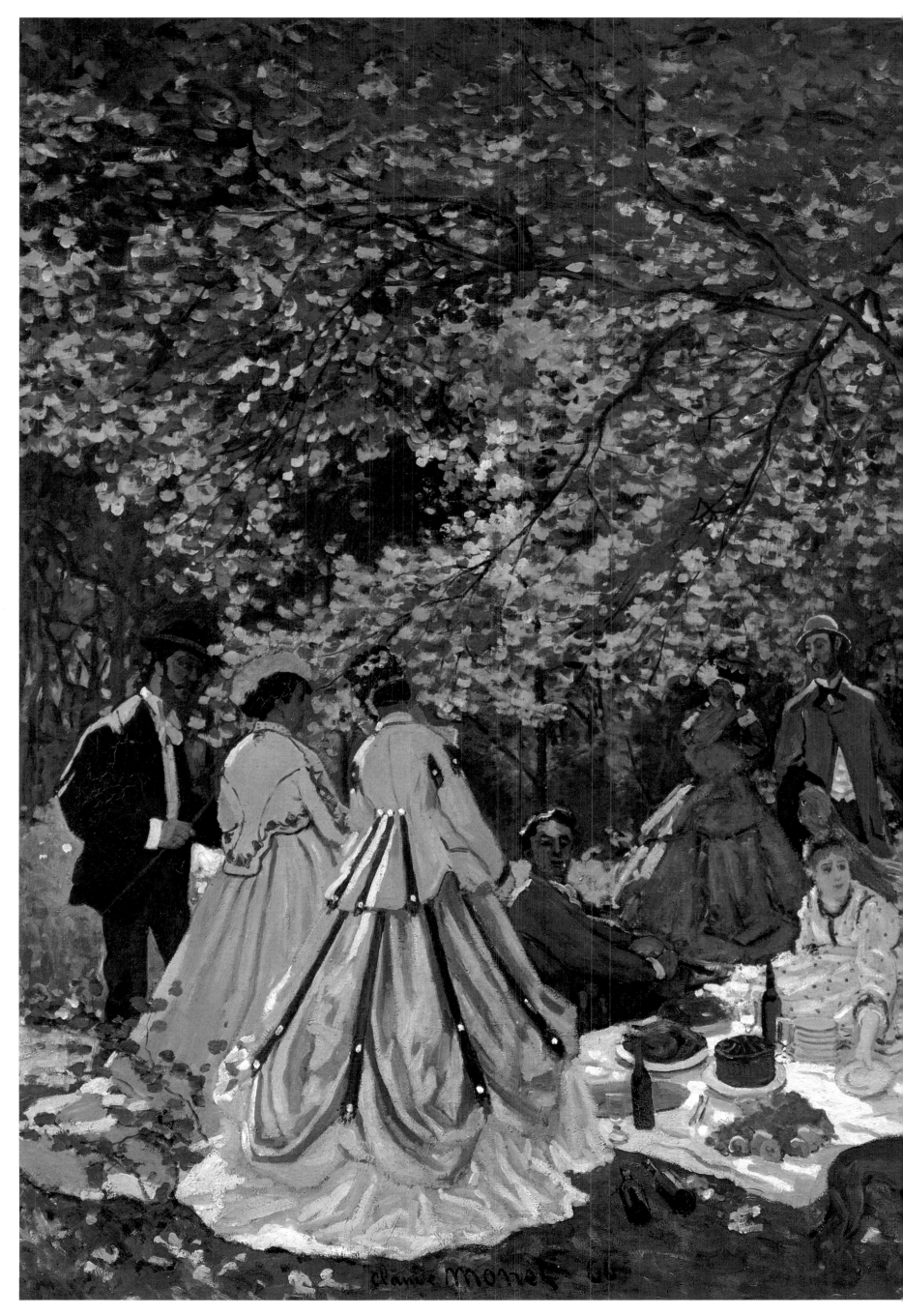

99 CLAUDE MONET *Le déjeuner sur l'herbe* 1866

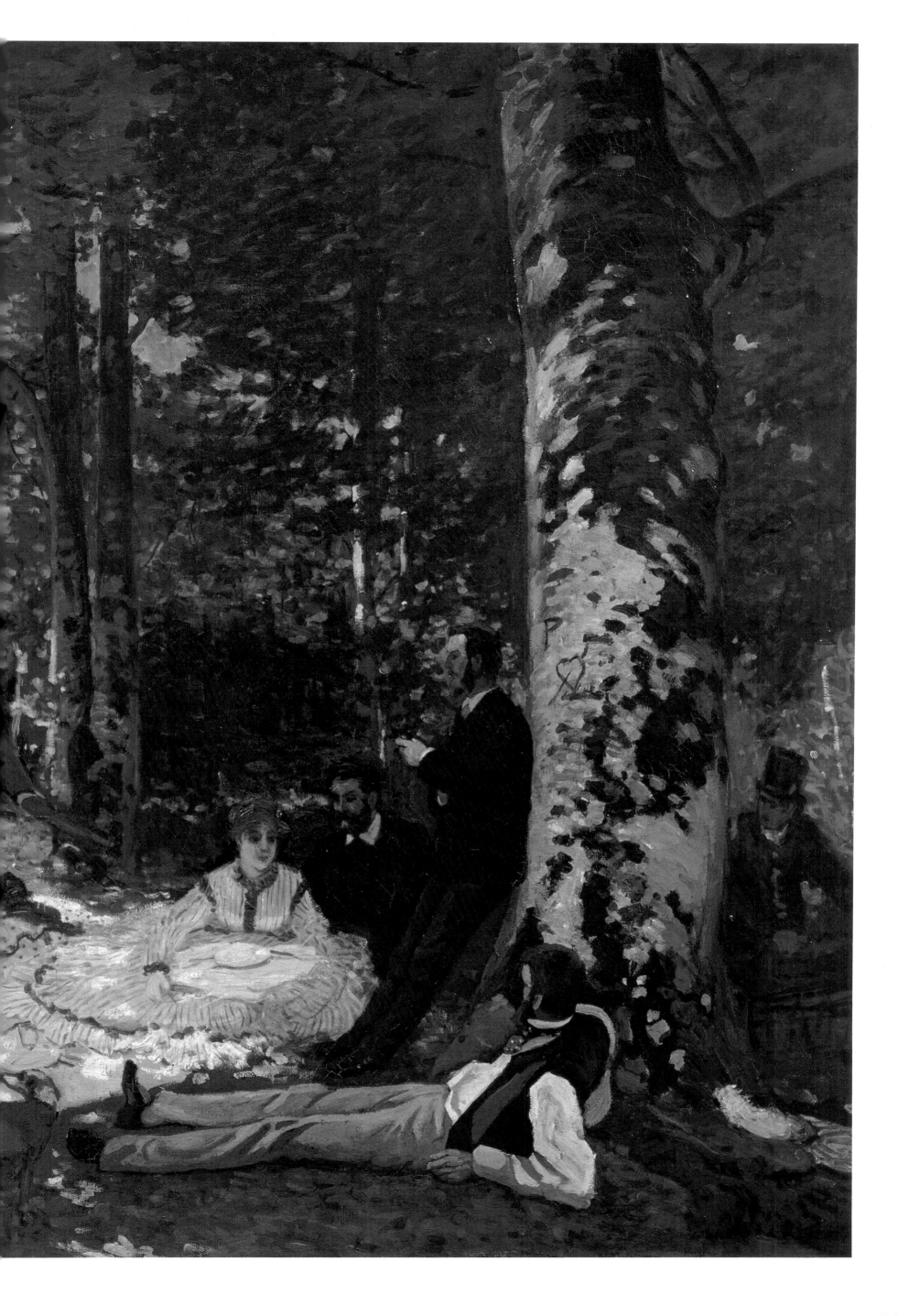

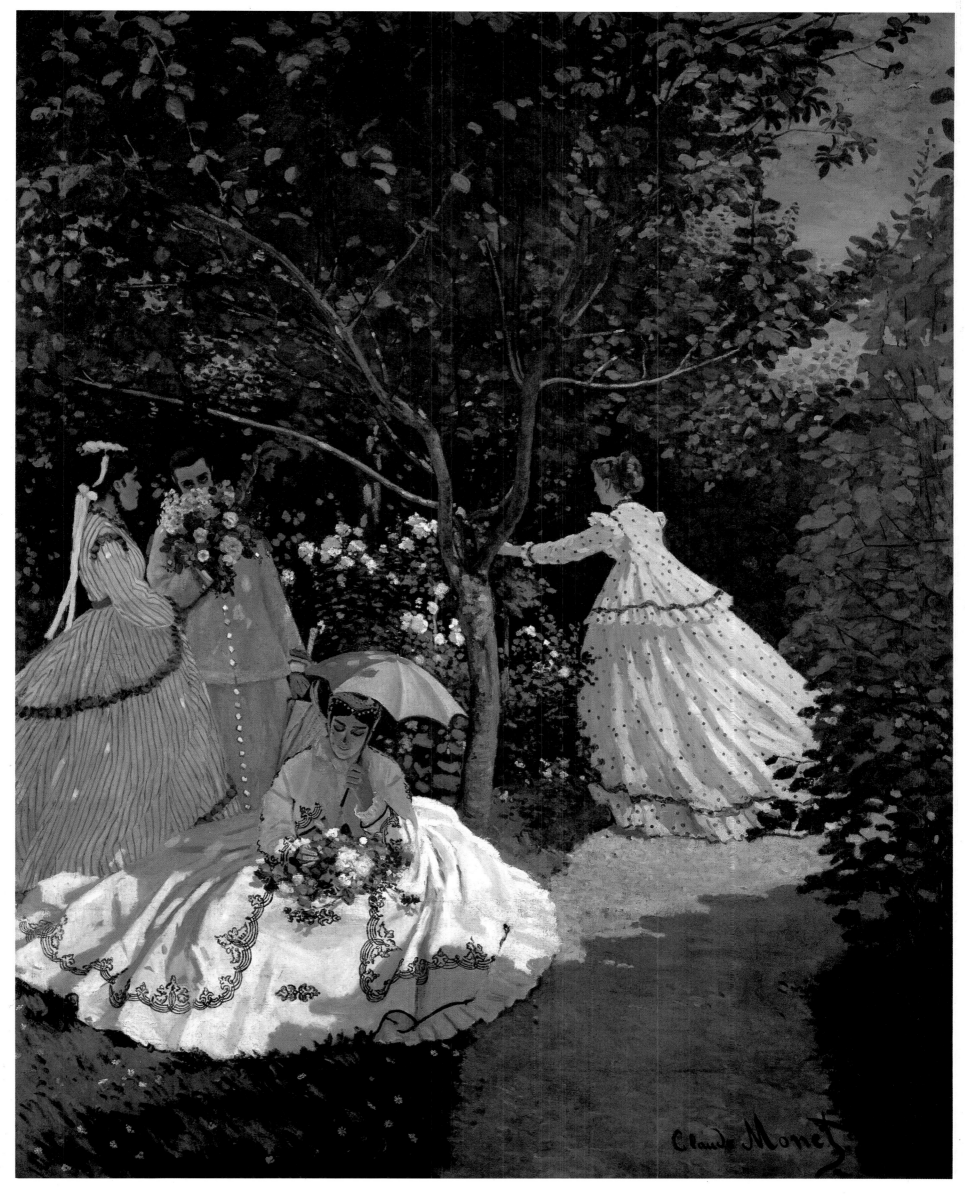

100 CLAUDE MONET *Women in the garden* 1866

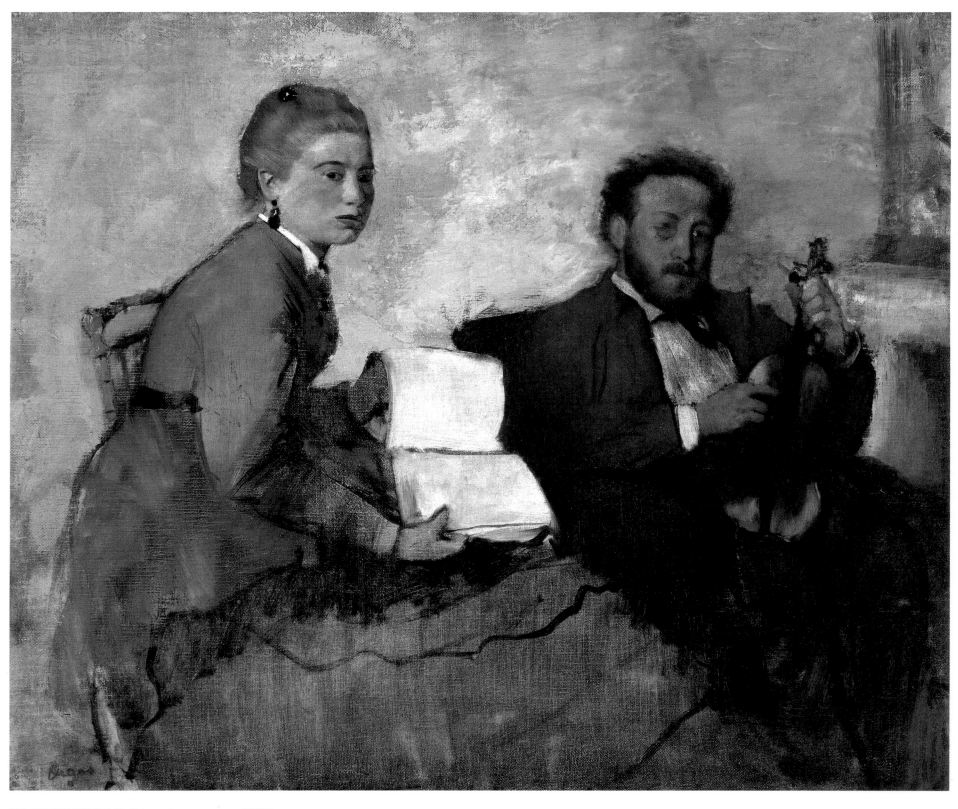

101 EDGAR DEGAS *Violinist and young woman* 1870/1
Nothing is known about the identity of the two sitters; whether or not they are
professionals it is difficult to say.

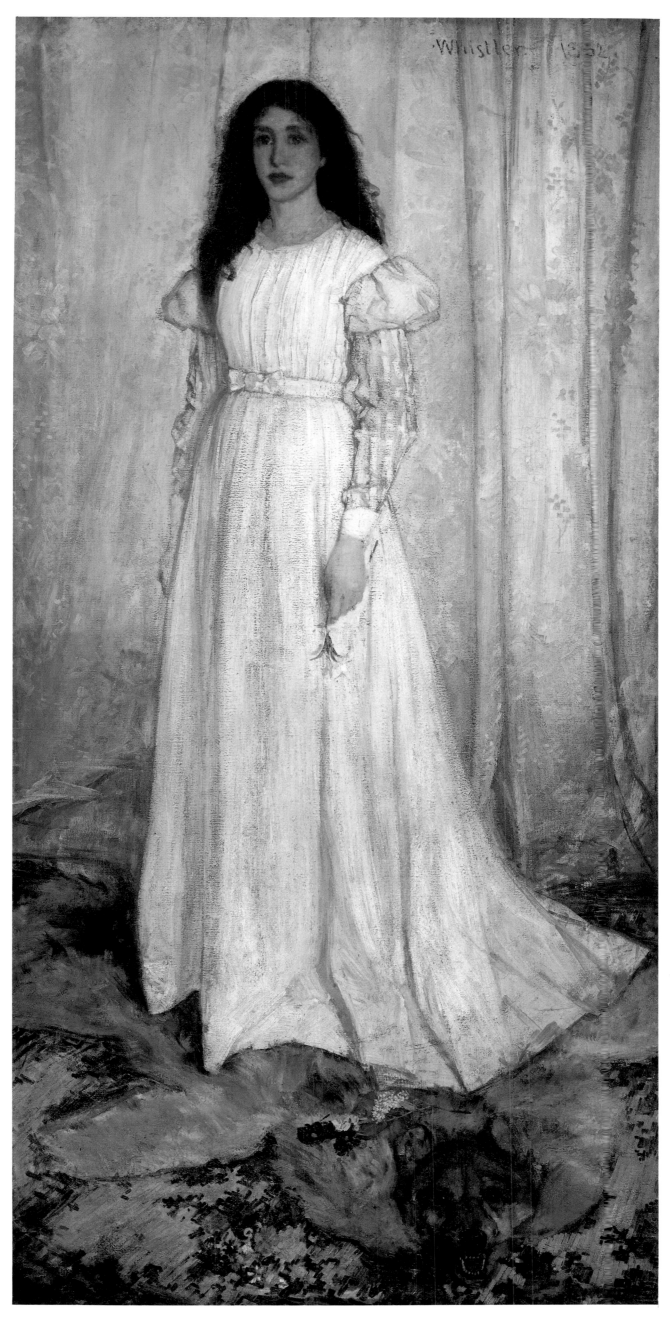

102 JAMES McNEILL WHISTLER *Symphony in white, No. 1* 1862

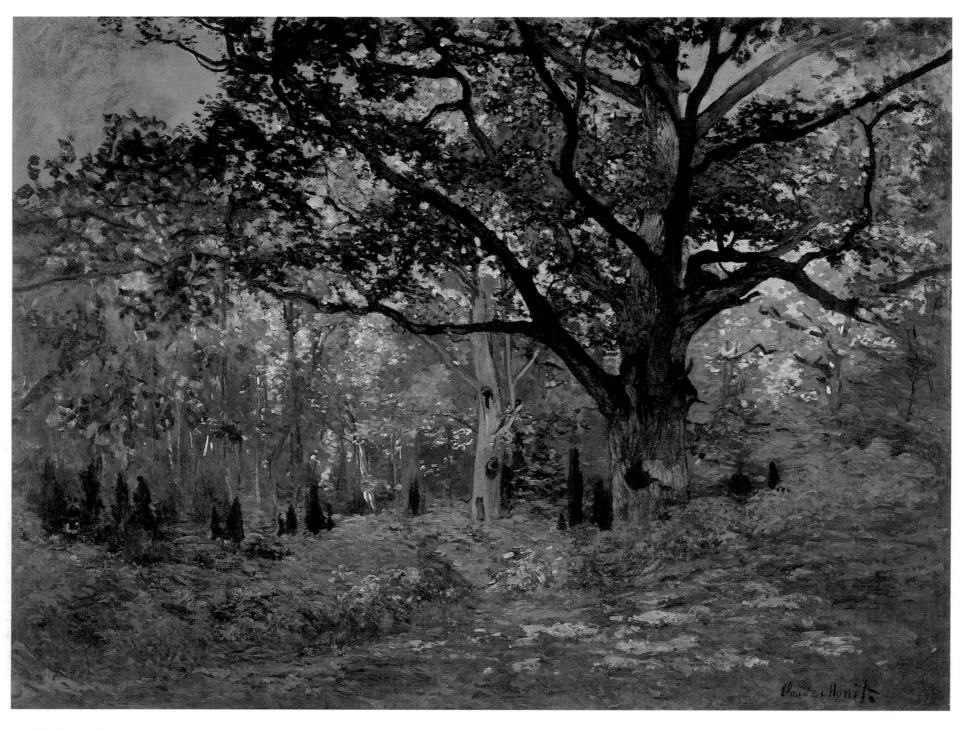

103 CLAUDE MONET *Forest interior, Fontainebleau c. 1866*
At this period in his life Monet, although he had produced essays in realism expressed in the
new manner, was still painting works such as this, which he thought might have a wider
appeal and would capture the market for rural scenes already won by the Barbizon school.

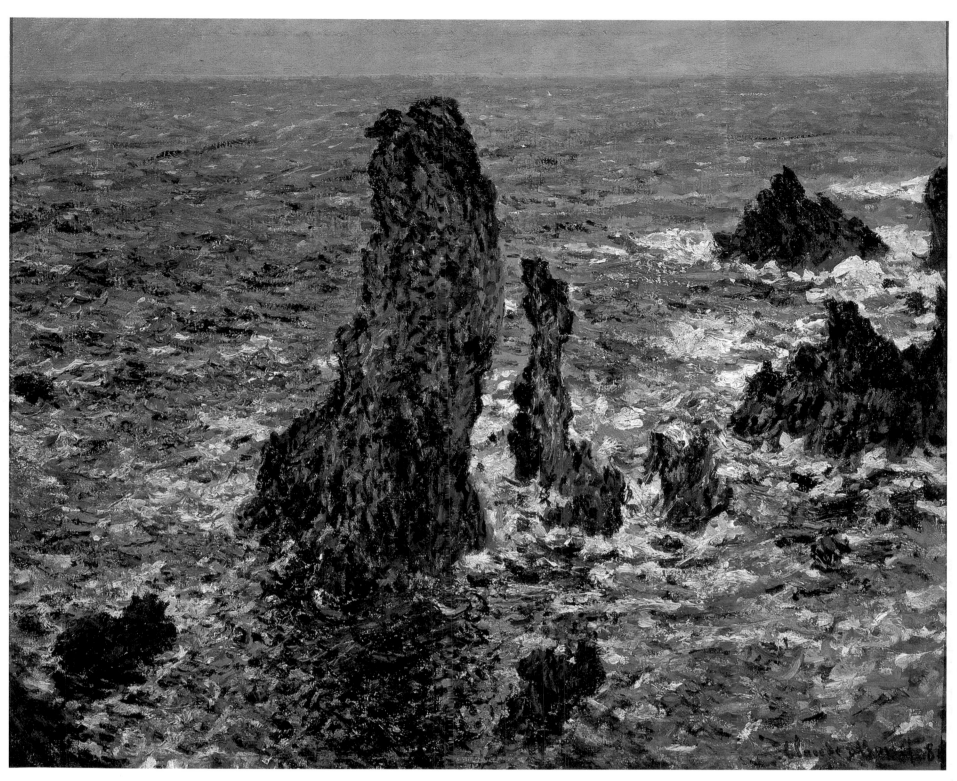

104 CLAUDE MONET *The rocks of Belle-Isle* 1886

When he painted this dramatic picture Monet was 46, and a great change had come over his life. His shrewd manipulation of dealers and patrons had forced up his prices; he was free from financial and domestic worries; he had virtually abandoned Paris, certainly as a source of subject-matter. He found in the wilder features of the Channel coast material from which he could create masterpieces at once helping to establish his status as a great painter and at the same time appealing to the tastes of a generation which increasingly found that part of France both attractive and chic. Nearly every year he made an excursion to places such as Etretat, Pourville, Varengeville and further south to Belle-Isle, off the Breton coast. The almost bizarre intensity of a work such as this seems to be a throw-back to a kind of romantic vision which would have appealed to Turner or to Courbet.

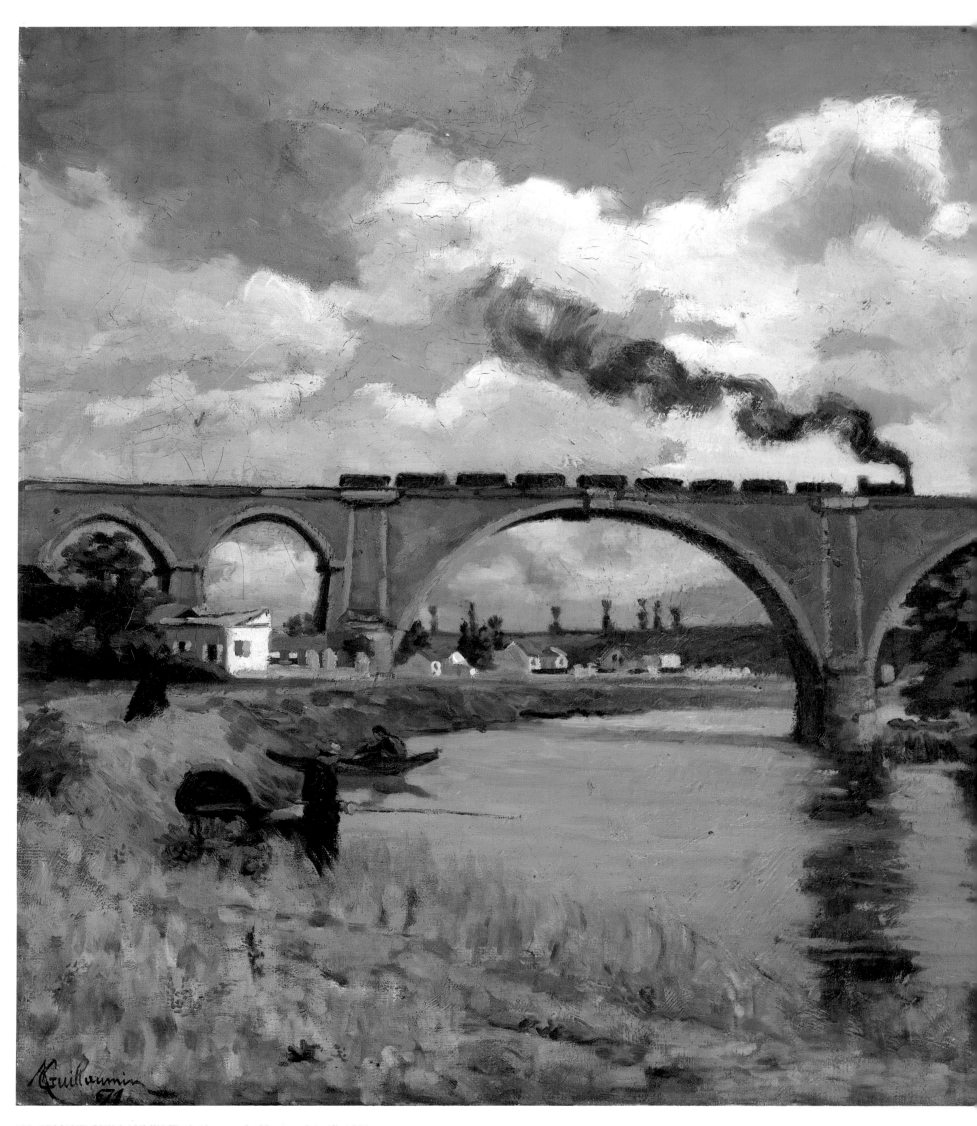

105 ARMAND GUILLAUMIN *The bridge over the Marne at Joinville* 1874
Joinville, on the banks of the Marne south of Reims on the road to Dijon,
is a small historic town much frequented at the time by visitors from Paris
and Orléans.

106 PAUL CEZANNE *Landscape* 1865-7
This richly painted landscape with its areas of palette-knife painting and its
quick, jabbing brush-strokes shows the influence of Courbet, and comes close,
despite its rather sombre tones, to some of Renoir's work in the same genre.

107 FREDERIC BAZILLE *The walls of Aigues-Mortes* 1867
A medieval town and port, famous for its salt-beds, it still retains its medieval
fortifications; from here St Louis embarked for Egypt during the eighth crusade.
It is some 50 miles (80 km) west of Bazille's native town of Montpellier.

108 CAMILLE PISSARRO *The Oise at Pontoise, grey weather* 1876
In its handling reminiscent of the landscapes of Corot, this painting was one
of several Pissarro did of the Seine at Pontoise. Originally a market town, situated
25 kilometres to the north-west of Paris, it was rapidly becoming industrialized
by the 1870s, but apart from the single factory chimney and two small industrial
buildings Pissarro seems to have ignored this development.

110 CLAUDE MONET *The magpie* 1868-9
This was executed during the period when open-air painting had begun to
dominate Monet's work, but it is difficult to imagine him working directly on a
canvas of this size (89 x 130 cms) out of doors.

111 BERTHE MORISOT *The harbour at Lorient* 1869

The young Morisot sisters were great travellers, sketching and painting wherever they went. in the Pyrenees, or in Brittany, where Berthe painted this remarkable picture. A long-established naval port (German U-boats were based there during the last war, and it was pounded mercilessly by Allied air attacks), its most remarkable feature is its harbour, an estuary formed by the confluence of the Scorff and the Blavet. Manet was so entranced by the painting that she gave it to him, and Puvis de Chavannes shared his enthusiasm. It is a resounding vindication of her skills at painting works other than those of domestic intimacies – broad in conception, subtle in its harmonies. In it she has achieved what other Impressionists were trying to do at the time: to relate a human figure – in this case her sister Edma – to the landscape. Bazille was very preoccupied at this time with the same problem, which he at least partially solved in The pink dress *and* View of the village *(Plates 114 and 145).*

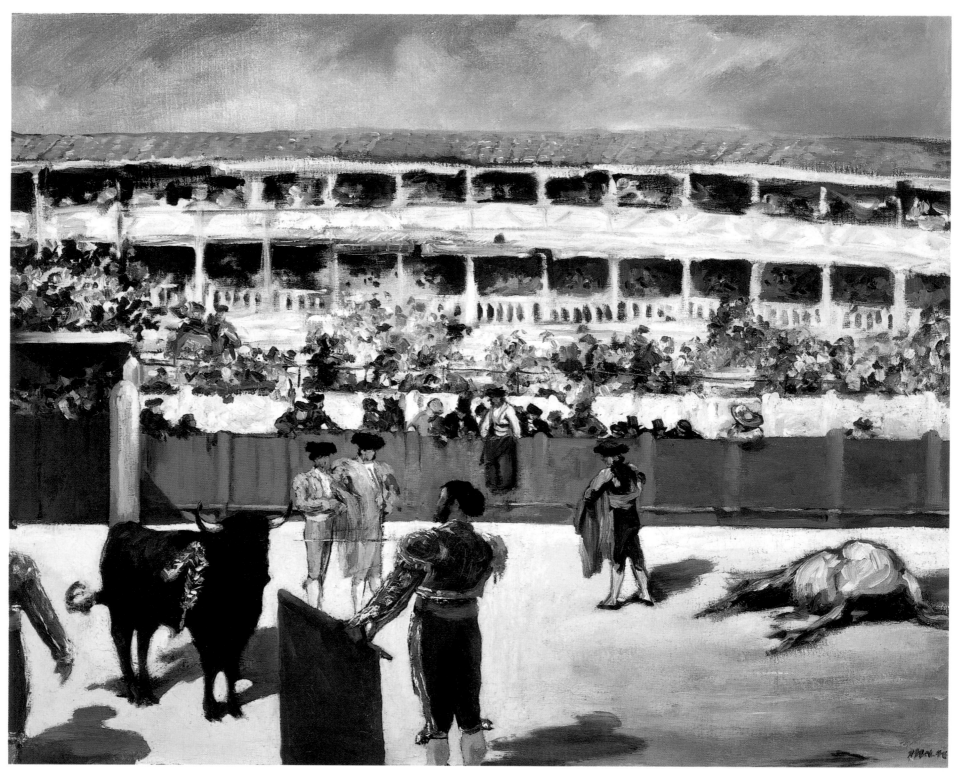

112 EDOUARD MANET *Bullfight in Spain* 1865/6

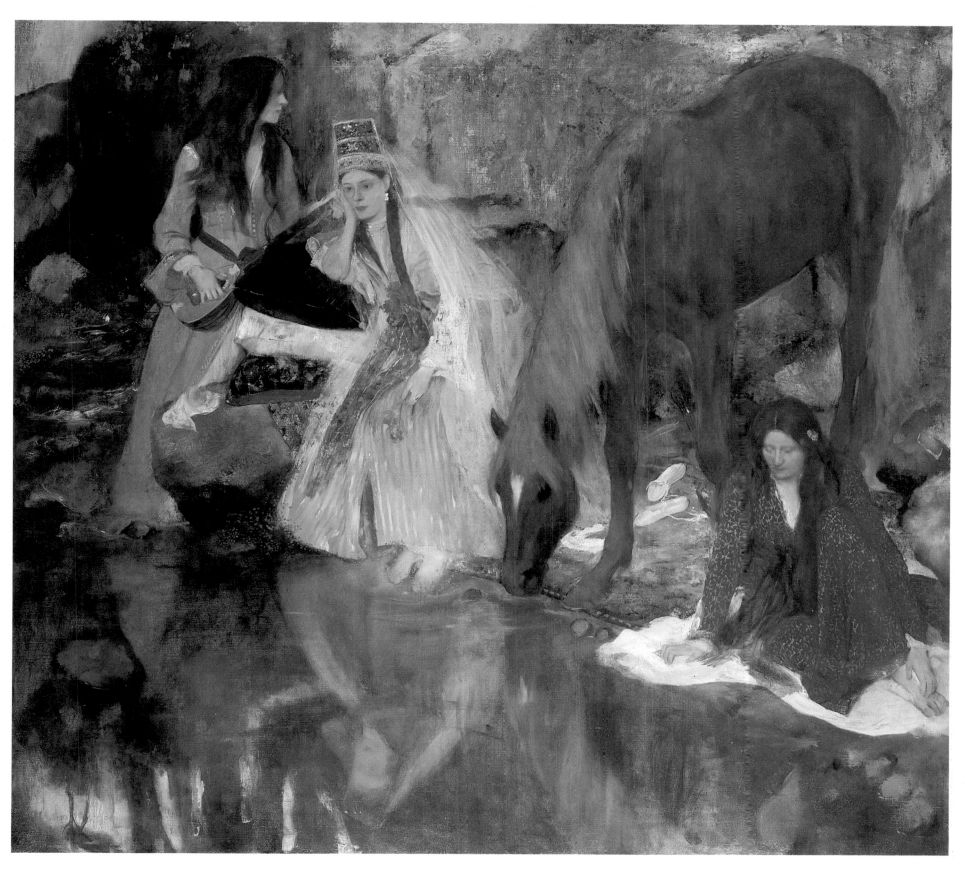

113 EDGAR DEGAS *Mlle Fiocre in the ballet of 'La Source'* 1867-8

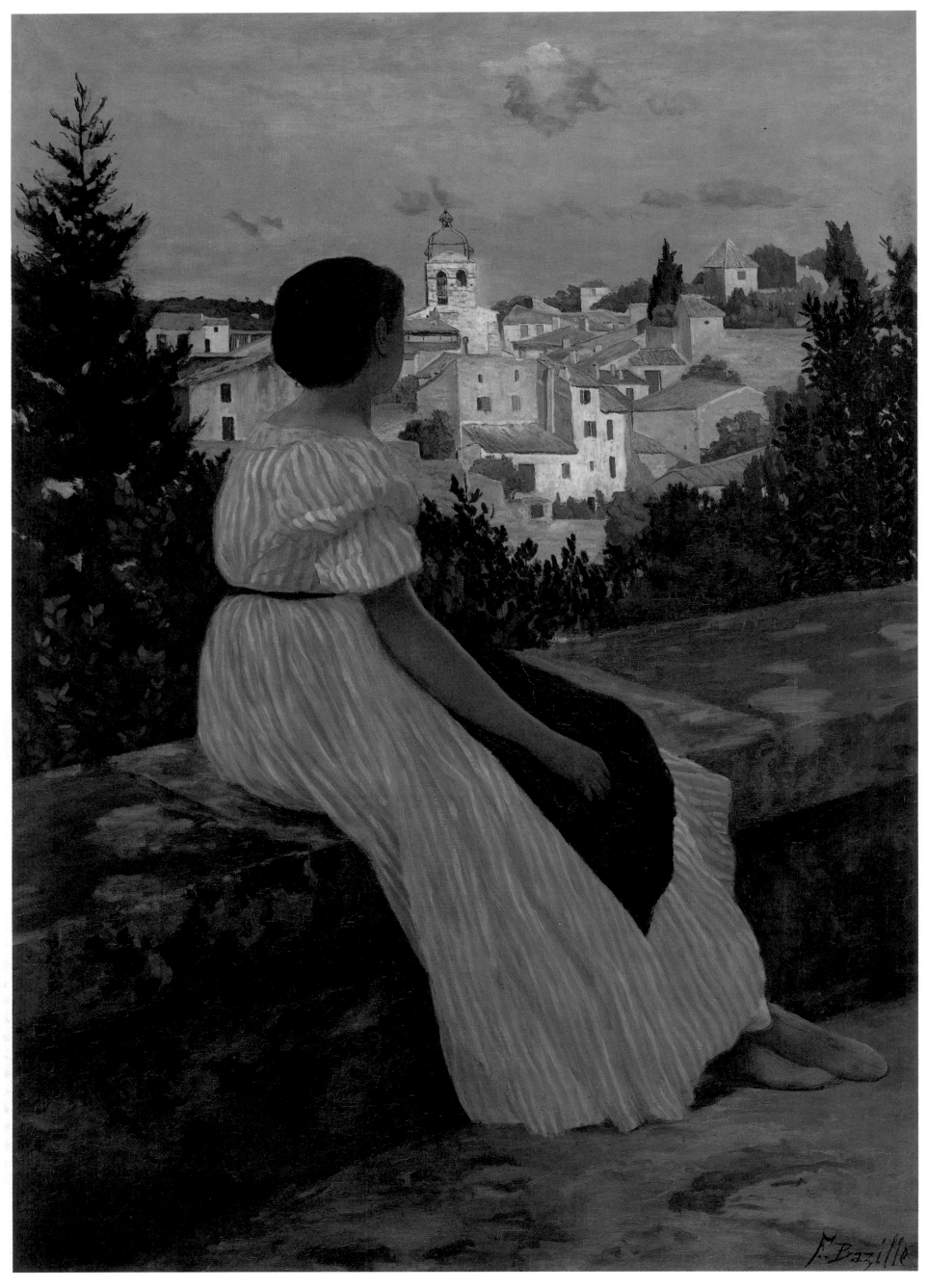

114 FREDERIC BAZILLE *The pink dress* 1870

Chapter 4

Debates and Discussions

By the late 1860s it had become apparent that there was developing in France an artistic opposition, not yet quite sure of its precise aims and objectives, not yet united in any common doctrine beyond a commitment to realism whether of treatment of or subject-matter, but certain of its discontent with the academic establishment. It had been given a certain degree of coherence by the emergence of Manet as a hero-figure: his *Déjeuner sur l'herbe* and *Olympia* had been seen as a manifesto of a revolution which was none the less real for having as yet taken no clear form. There were indeed inconsistencies even about Manet's stance, which resulted from ambiguities in his own character. He was always keen to have his works hung in the Salon; he was reluctant to irritate the establishment, and in the introduction Astruc wrote for the exhibition Manet arranged in 1867 to coincide with the International Exhibition he emphasized, at the artist's behest:

M. Manet has never wished to protest...he has no intention to overthrow old methods of painting, or to create new ones. He has merely tried to be himself and nobody else.

He was anxious at one point to secure an official commission to paint murals in the newly rebuilt Hôtel de Ville in Paris. When he belatedly received the Legion of Honour in 1881, during Antonin Proust's tenure as Minister of Fine Arts, he wrote bitterly to Nieuwerkerke, his predecessor in that post, 'It would have made my fortune once, but now it is too late to make up for 20 years of failure.' Despite the pleas of Degas and others, he absolutely refused to participate in the first Impressionist exhibition, or indeed in any of them. On the other hand, as we have seen, he took a dominant role in the discussions at the Café Guerbois, where he virtually held court, 'always', in the words of the critic Duranty, 'overflowing with vivacity, bringing himself forwards, but with a gaiety, an enthusiasm, a hope, a desire to throw light on what was new, which made him very attractive.' At the same time too, according to Armand Silvestre:

He was naturally ironical in his conversation and frequently cruel. He had an inclination for verbal fisticuffs, cutting and slashing with a single blow. But how striking were his expressions, how apt his observations. He was the strangest sight in the world, his elbows on the table, distributing his jibes in a voice which had a slight hint of a Montmartrois accent; strange and unforgettable he was, with his immaculate gloves and his hat pushed to the back of his head.

There could have been no more striking tribute to his dominance than the picture *A studio in the Batignolles Quarter* (Plate 115), which Fantin-Latour painted in 1869 and exhibited at the Salon of 1870, at a time when Bismarck was laying plans for the destruction of France. Born in Grenoble 34 years earlier, Ignace-Henri-Jean-Théodore Fantin-Latour was of very mixed descent: his mother was Russian, his father Franco-Italian, a pastel painter, who gave him his first lessons. He then studied with Lecoq de Boisbaudran (see p.83), became a close friend of Whistler and was introduced by him to England, where he was always to have considerable success, and became deeply involved in the artistic life of Paris. Close to the circle of the Café Guerbois, favourably disposed to its aims and sympathetic to what the group was trying to do, he never let it influence his own work, and he continued painting in a style of realistic observation, intermingled in his highly successful flower paintings with an attractive lightness of touch and freshness of colour. Late in life he started painting vaguely Symbolist pictures based on themes from Wagner and Berlioz, which were close in feeling to the works of Gustave Moreau.

He had a penchant for group portraits. In 1863 he had painted one (Musée d'Orsay) entitled *Homage to Delacroix*, in which he had included Baudelaire, Legros, Whistler, Bracquemond and himself. Somewhat naïvely he had wanted to include Rossetti, who, never having been in the slightest influenced by the artist to whom he was supposed to be paying homage, naturally refused. *A studio in the Batignolles Quarter* was a more ambitious affair. Seated in the centre, his brush reaching out to an easel, is the Master, Manet himself. Looking respectfully at what he is doing are Otto Scholderer on the left and Renoir on the right. Born in Frankfurt in 1834, Scholderer was at this time an accepted member of the group, but on the outbreak of war he fled to England, where he spent the rest of his life and exerted a considerable influence on Sickert. Seated beside Manet is Zacharie Astruc, who had written the introduction to his 1867 exhibition, and whose portrait was painted by him in 1866 (Kunsthalle, Bremen) and by Bazille in 1869 (Montpellier). Himself a sculptor, whose most famous work is *The mask-pedlar* in the Luxembourg Gardens,

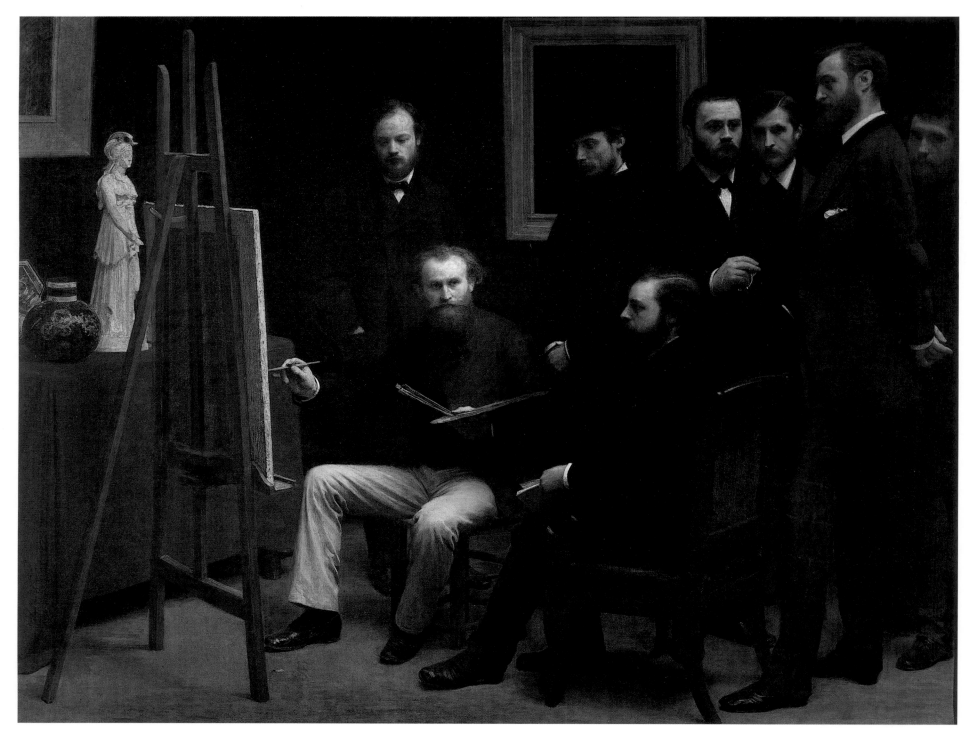

115 HENRI FANTIN-LATOUR *A Studio in the Batignolles Quarter* 1870

Astruc made a bust of Manet in about 1857. Standing immediately behind him is a reflective Zola. Sandwiched between him and the tall figure of Bazille is the face of the latter's close friend, the musician Edmond Maître (1840-98), who is to be seen playing the piano in the group portrait that Bazille painted in 1870 (Plate 116) showing his studio in the rue de la Condamine, with Manet, Renoir, Zola and Monet. Maître was a Wagner enthusiast and converted into Wagnerites both Bazille and (to a lesser extent) Renoir, who later painted a portrait of the composer while he was staying at Palermo (Plate 225).

With the addition of Pissarro and a few others, this group of artists, the hard core of the resistance, so to speak, was collectively referred to as the 'Batignolles group' by critics and more journalistic commentators. An alternative term, of wider connotation, often used to imply anything which was not strictly conformist, was 'les japonais', a tribute to the influence which Japanese art was exerting on a wide group of painters, and which was to persist as a recurrent element in much Impressionist painting.

Although Chinese art and culture had been known and influential in Europe as far back as the middle of the seventeenth century, and reached their apogee in the Chinoiserie of the eighteenth, Japan had remained hermetically insulated from any contact with the outside world. In 1812 some Japanese prints were brought to Europe by Isaak Thyssen, the head of a Dutch trading centre near Nagasaki, but they were too few to have had anything but a curiosity value. In 1854, however, on the orders of the American president, Commodore Matthew Perry with a small fleet of battleships forcibly opened up trade with Japan, and commercial treaties were signed in the following year with the USA, Great Britain, France and Russia. The results of this contact were first publicly presented at the second International Exhibition in London in 1862, triggering off a craze for Japanese art and design which was to last throughout the rest of the century. Even the President of the Royal Academy in London, Lord Leighton, gave a lecture about Japanese art, though his own was to remain untouched by it.

In France, where the first great impact from the East came with the Japanese participation in the Universal Exhibition

of 1867, in which works by print-makers such as Kuniteru, Hiroshige III and Sadahide, the weakest inheritors of a great tradition, were shown, there had been earlier manifestations. Monet, whose memory tended to be self-indulgently selective (see pp.57-9), claimed that he had bought his first Japanese prints in 1856 'in a shop in Le Havre, where they sold curios brought back on ocean liners'. A more certain and more potent influence however was that of Félix Bracquemond (1833-1914), primarily an etcher and engraver, who was to show at the Impressionist exhibitions of 1874, 1879 and 1880. In 1856 he came across a volume of Hokusai's sketches at the shop of his printer Delâtre, who had found it in a crate used for packing porcelain and would not part with it. After a year Bracquemond managed to acquire another copy, again from a printer, Eugène Lavielle, and shared it with his friends Philippe Burty, one of the first critics to see the significance of Impressionism and an ardent collector, and Zacharie Astruc. He also introduced them to Manet, whom he was instructing in the techniques of print-making. The effect was immediate. The geisha-like feeling of *Olympia* is immediately apparent, and as we have seen Zola, himself a dedicated *japoniste*, commented on the general relationship with Japanese prints in many of Manet's works. Even more obvious is the Japanese influence on his prints. Many of those with which he illustrated Jules Champfleury's book on cats are almost direct quotations from prints by Utagawa Kuniyoshi (1798-1861) and Katsushika Hokusai (1776-1849); his

illustrations to Charles Cros's book *Le Fleuve* ('The river'), in their quick, lively spontaneity, are remarkably close to some of the sketches in the Hokusai volume which Bracquemond possessed, and of which he too may have had a copy. His friend Théodore Duret commented:

Manet always used to keep sheets of drawing-paper ready to use in his studio, and a notebook and pencil in his pocket. The slightest object or detail of an object which caught his attention was immediately noted down on paper. I know of no one with whom he can be compared in this respect except Hokusai, whose rapid drawings in his sketchbooks combine simplicity with perfect definition of character. Manet greatly admired what he had been able to see of Hokusai's work, and praised unreservedly the drawings of the sketchbooks he had come across. Indeed, like Hokusai, Manet conceived the purpose of drawing to be to seize the salient characteristics of an object without any of its redundant accessories.

When in 1875 he came to illustrate a French translation of Edgar Allan Poe's *The raven*, searching for source material he had recourse to the woodcuts of the contemporary Kawanabe Kyosai, who died in 1889.

As early as December 1861 Baudelaire had been describing a batch of Japanese prints which he was

116 FREDERIC BAZILLE *The artist's studio* 1870
Bazille was living in the rue Condamine when he did this, virtually his last painting. Edmond Maître is at the piano; Manet is looking at a painting on the easel, watched by Monet smoking a pipe behind him; Bazille himself stands close by with his palette in his hand. Zola is leaning over the stairs talking to Renoir sitting at a table. Manet painted the figure of Bazille later.

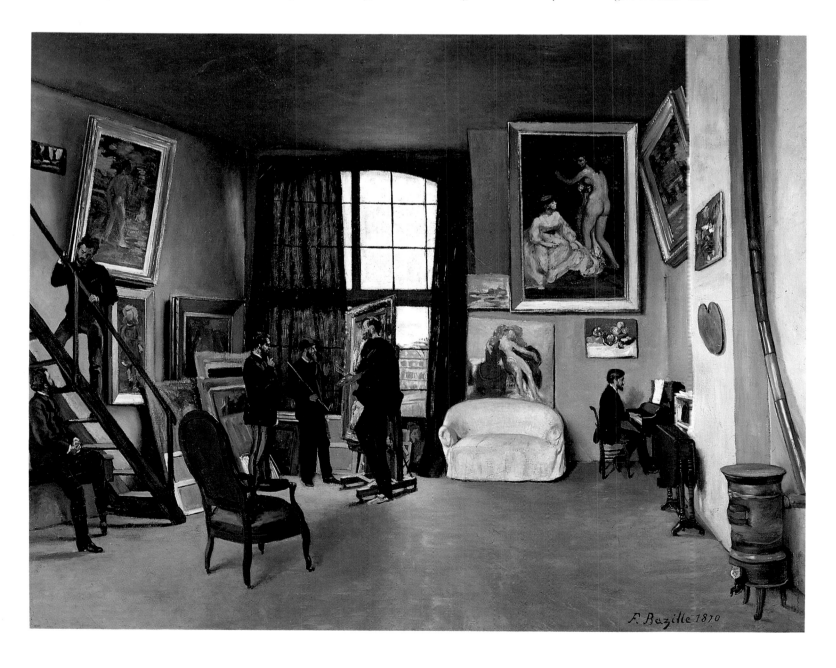

117 EDOUARD MANET *Cats' rendez-vous* 1868
A lithograph drawn by Manet in 1868 to advertise a charming book on cats by Champfleury. It was made into a poster, the first by an avant-garde artist.

118 UTAGAWA KUNIYOSHI *Cats in various attitudes c.* 1850
Manet's debt to this work is apparent.

distributing to his friends as '*Images d'Epinal* from Japan', and indeed many of the prints which were becoming most popular in France at the time were those belonging to the so-called Ukiyo-e or Floating World school, concerned with depicting urban life in the growing cities of Japan; they were in fact 'realist' in the sense that the word was coming to be understood in the studios of Paris. All Japanese art and craft was becoming more accessible. In 1862 the Desoyes, a French couple who had lived for some time in the Far East, opened a shop in the rue de Rivoli, La Porte chinoise, which was much frequented by Degas, Whistler, Fantin-Latour, Baudelaire and others. Japanese art was widely publicized by works such as the Goncourts' novel *Manette Salomon*, published in 1866, in which a whole chapter is devoted to the effect of Japanese art on its hero, though two years later the brothers were complaining: 'We were the first to have this taste for things Japanese, but today it is spreading to everybody, idiots and middle-class women. Who has cultivated it, felt it, preached it more than we?' The sale of their collection in 1897 included 1,500 Japanese items including 372 prints and illustrated books.

There can be no doubt that virtually all of the Batignolles group could be included among the Goncourts' 'idiots', though in the work of Degas and Pissarro the full effect was not discernible until the end of the 1870s. With Monet, however, the case was very different, and the complexities of the interrelationship between Impressionism and the Japanese influence can be most fruitfully examined

in the context of his work. Although his claim to have been the precursor of the cult may be exaggerated, there is no doubt that he was throughout his life an enthusiast. There are accounts of Japanese fans hanging on the walls of his house at Argenteuil when he was living there in the 1870s but, although his last home at Giverny still holds the extensive collection of Japanese prints which he accumulated in the course of his career, most of them were bought from Wakai and Hayashi who were dealing in Paris in the 1880s, and in 1892 Edmond de Goncourt noted in his diary that he frequently met him at the Galerie Bing, which had taken over from the Porte chinoise as the main emporium for the sale of Orientalia. Only on one occasion did Monet attempt a Japanese painting, in the sense that artists such as Whistler and Fantin-Latour understood it, namely a painting with Japanese accessories: in 1876 he exhibited at the Salon *The Japanese girl* (Plate 119), which he later dismissed as 'rubbish'. It showed a young woman in an oriental kimono, her head thrown back, a fan in her hand and about a dozen others arranged on the wall behind her. The pose is typical of those in the prints of artists such as Hokusai, but it is also a straightforward reversal of that adopted in an earlier portrait of his wife painted in 1867.

Well before this, however, he had discovered from Japanese prints the compositional effects which could be obtained from high viewpoints and dramatic cut-offs. Much later in life he told the Duc de Trévise, 'In the West what we have most appreciated about Japanese artists is their bold way of cutting off their subjects; those people have taught us to compose differently, there is no doubt of that.' His work was indeed full of new types of composition. In 1867 he painted *The terrace at Sainte-Adresse* (Plate 157), a work which he referred to as his 'Chinese painting with flags on it'. It was for the time a startling composition, with its high viewpoint and its lack of a single focus. The wide sea is studded with some 30 boats of differing sizes; together with a band of sky itself divided into cloudy and clear sections, it shares half the composition with the actual terrace, which is alive with bright gladioli and nasturtiums, the variety of colours being enhanced by the two slightly asymmetrical flags flying at either end of the terrace wall. As John House points out in his book on Monet:

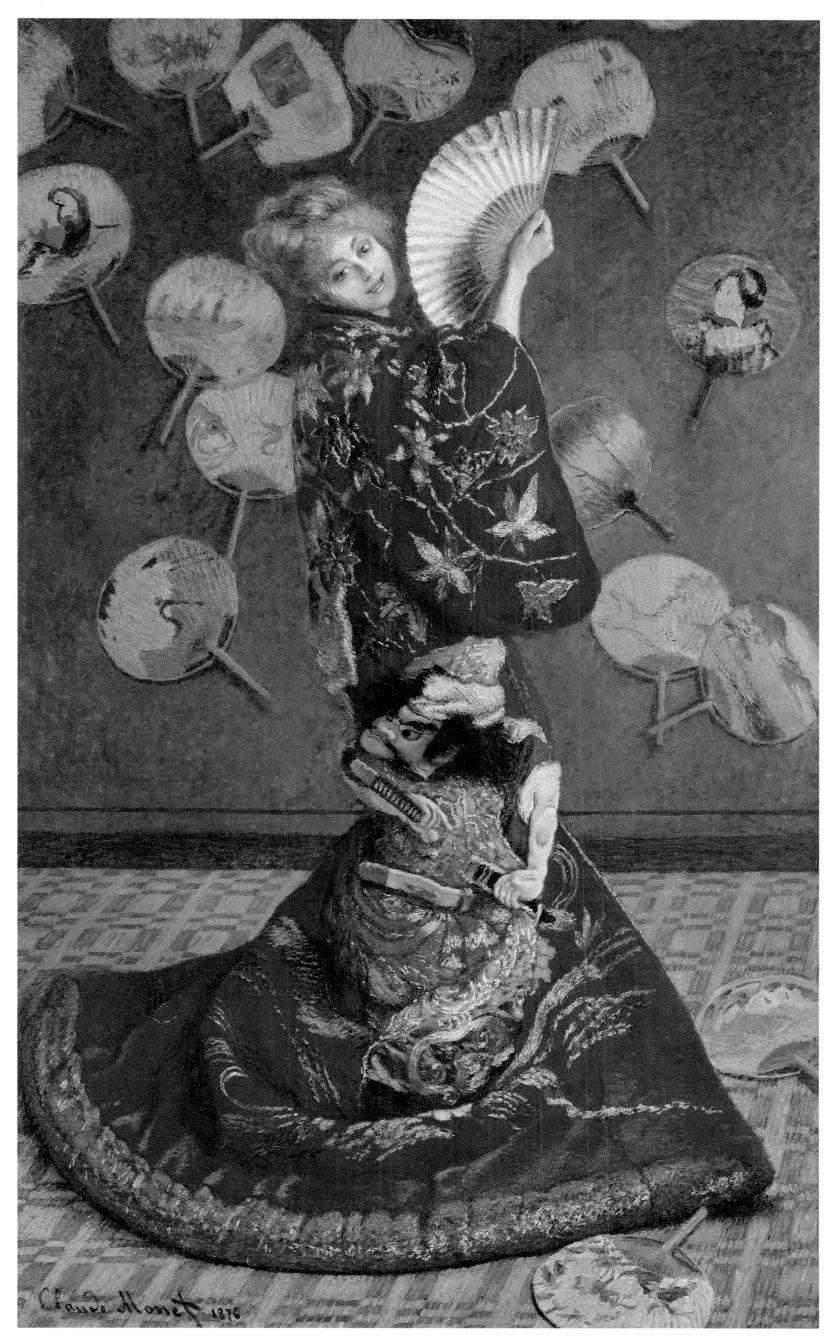

119 CLAUDE MONET *The Japanese girl* 1876

There are jumps in space between viewer and terrace and sea, and the flagpoles impose an emphatic grid pattern on the surface. This rectilinear grid is accented by the overt, and surely deliberate distortion of perspective in the line of the top of the fence on the right. The fence top is below our eye level and runs towards us in space (as shown by the shadows cast on it by the gate); it should thus slope upwards towards a central vanishing point on the horizon, rather than being a virtual horizontal.[1]

There are obvious resemblances in this complex composition to a print by Hokusai, *The Sazaido of the Gohyaku-ji temple*. We know Monet had a copy of this which, by its battered condition and the fact that it does not bear a dealer's seal, he must have acquired at an early stage. In it a group of women are looking out from a balustraded terrace across an expanse of water to distant Mount Fujita, the long coastline and the rail of the balustrade giving the same horizontal accent as in Monet's work, and the differing groups of people providing the same diversity of interest. The cutting-off technique, which may also have owed something to the influence of the photographic vision (see p.89), is apparent in several other paintings, notably the *Quai du Louvre* (Plate 122) painted in the same year. In many of his paintings of the cliffs of Normandy, such as *The cliff walk at Pourville* (Plate 123), he used the dramatic compositional effects which were part of the technical repertoire of the Japanese to express the sensationalism of nature. He was also very much influenced, as Manet had been, by the Japanese use of colour. This is evinced especially in paintings such as *La Grenouillère* of

121 KATSUSHIKA HOKUSAI *The Sazaido of the Gohyaku-rakanji temple c. 1850-2*
One of the print-series *Thirty-six views of Fuji* which had such an impact on French taste and art in the mid-nineteenth century.

1869 (Plate 155), with its clear, flat areas of colour, as Théodore Duret pointed out in his booklet *Les peintres impressionnistes* published in 1878.

We needed the arrival of Japanese albums in our midst before anyone dared to sit down on a river bank, and juxtapose on a canvas a roof which was bright red, a wall which was white, a green poplar, a yellow road and blue water. Before the Japanese this was impossible. The painter always lied. Nature with its bold colours blinded him; all one ever saw on a canvas were subdued colours, drowning in a general half-tone.

It is, however, a gross oversimplification to see Monet and other painters being, as it were, dominated by the East. They found in Japanese prints hints at solving problems which they had already started to address, and confirmation of attitudes, to realism for instance, which they were already adopting. In a sense what Monet saw in Japanese art was not so much its individual mannerisms as a robust 'anti-intellectual' approach to art – the pure unreflecting response of eye and hand.

This was one of the subjects which must have motivated the constant discussions taking place at the Café Guerbois and in the studios of the Batignolles quarter. Others were about prosaic matters; the difficulty of getting one's works exhibited; financial problems. Renoir, who till then had been living at home, and Monet, whose family supported him only intermittently and tried to use financial pressure to make him break with Camille (see p.58), were in especially dire straits; Monet was only able to go on painting with the constant support of Bazille, with whom he 'shared' a studio in the rue Visconti. Cézanne was entirely dependent on his father, and his position too was to be complicated in 1870 when he commenced a liaison with the 19-year-old Hortense Fiquet, by whom he was to have a child two years later, but whom he was not to marry until 1886 when his 89-year-old father gave his consent.

The main subjects for discussion were, however, more germane to the actual techniques of painting. By their very nature these centred around landscape painting and the discoveries which were being made as a result of the

120 EDGAR DEGAS *Princesse Pauline de Metternich c. 1861*
This portrait of the wife of the Austrian ambassador, a famous beauty, is based on, indeed almost copied from, a photograph of the kind widely on sale in Paris.

122 CLAUDE MONET *The Quai du Louvre* 1867

ever-spreading habit of painting out of doors, even though, at this point, it did not necessarily involve finishing a painting in the open. The major discovery, and it was one which was to dominate most Impressionist painting for the next four decades, was that a subject cannot be seen merely in terms of light and shade. Shadows themselves had their own colours and, by observing and reproducing these colours, it was possible to indicate depth and three-dimensional qualities. One of the more obvious results of this was the fact that the resulting work seemed much brighter, as it was not dominated by the overall bituminous shades which had previously indicated absence of direct light. This pragmatic discovery had been reinforced by the work of the industrial scientist Eugène Chevreul (see p.13). What was evolving was a new dimension of realism. First applied to the depiction of a figurative object, moving on to choosing 'real' subjects from everyday life, realism had now come to involve painting what you 'really' saw, not what you thought you saw. Painting was coming to be concerned with what was seen on the retina of the eye, a perceptual not a conceptual process, and paintings were to become expressions of light and atmosphere in which the primacy of the object was diminished. Light and colour had become multi-faceted phenomena, the real nature of which could better be expressed by quick, flickering brush-strokes than by flat, homogeneous areas of colour smoothly and evenly applied.

The acceptance of these ideas was not universal. Manet was entirely unconvinced at this point:

Light appeared with such unity that a single tone was enough to convey it and it was preferable, even though apparently crude, to move abruptly from light to shadow than to accumulate things which the eye doesn't see and which not only weaken the strength of the light, but enfeeble the colour scheme of the shadows which it is important to concentrate on.

In a few years he was to think differently but in the meantime it was Renoir and Monet who were going furthest in the exploration of light, shade and colour.

From July of 1869 Renoir was living at his parents' retirement home at Voisins-Louveciennes and travelling nearly every day to where Monet was staying at Bougival, on the banks of the Seine. On 25 September Monet wrote of a project to Bazille:

I do have a dream, a painting of the bathing place at La Grenouillère. I have made a few poor sketches, but it is no more than a dream. Renoir, who has just spent two months here, also wants to paint the same picture.

123 CLAUDE MONET *The cliff walk at Pourville* 1882

The area was a new one for members of the group, very different in feeling and appearance from the remote shaded glades of the forest of Fontainebleau, and much closer in feeling to the realities of life in 1869. The whole valley of the Seine stretching northwards had been opened up by the railway lines to the Channel coast. Bougival had first been developed as a country retreat as far back as the time of Louis XIV and, during the first half of the century, had become the site of a number of splendid country houses for celebrities such as Alexandre Dumas, the politician Odilon Barrot, who had been one of those responsible for the downfall of Louis-Philippe, and the Pereire brothers, who had financed the building of the railway line from Paris to nearby Chatou. In the 1840s and 50s it had been much frequented by artists; in 1855 the Goncourts on a visit there wrote in their *Journal*:

Bougival is the very homeland of landscape, its very studio, where every patch of ground reminds you of an exhibition, and wherever you go you hear people saying, 'This was painted by so-and-so; that drawn by somebody else'.

By 1869, however, it had started to go down-market and, along with places such as Argenteuil, had become a resort for day-trippers from Paris; it was, after all, only a 20-minute train journey from the Gare St-Lazare.

La Grenouillère was on the island of Croissy dividing the Seine at Bougival; it was joined to the town by a bridge which Monet had painted earlier in the year. It was a combined bathing-place and restaurant which had been created some ten years earlier by Alphonse Seurin, a shrewd publicist who managed to attract a lot of attention from the Parisian press, and even persuaded the Emperor and Empress to stop off there for a short time on one of their progresses up the Seine. Two contrasting, but in a sense complementary, accounts describe the scene which was so to attract Renoir and Monet. The first, written by one Raoul des Presles, appeared in *L'Illustration* of 20 June 1868 (Plate 124):

La Grenouillère is Trouville on the banks of the Seine, a meeting place for the noisy, well-dressed crowds that emigrate from Paris and set up camp in Croissy, Chatou or Bougival for the summer. On a well-tarred old barge moored to the bank stands a wooden hut painted green and white, and there is a wooden balcony situated in the front of the barge. Refreshments of all kinds are available in a large room. To the left there is a boat-builder's yard; the bathing huts are to the right. One reaches the place by crossing a series of highly picturesque but primitive footbridges. One of them connects the island with an islet no more than ten metres square, which contains one tree, looking surprised to find itself there. Most of the men and women who want to see the human race reduced to its most basic expression crowd onto this tiny islet. There is a small bathing area to the left of the islet, the river bed is of fine sand, and the bathing area is roped off so that no one can get out of their depth. Boats are moored all round the island, and their owners, men and women alike, lie asleep in the shade of the tall trees.

Guy de Maupassant, who described the same scene twice in *La Femme de Paul* (1881) and *Yvette* (1885), was a good deal less flattering about M. Seurin's clients, describing them as

a rowdy, screaming crowd, a mixture of drapers' assistants, ham actors, hack journalists, gentlemen whose fortunes are still in trust, shady stockbrokers, degenerate revellers and corrupt old pleasure-seekers.

Whichever view was more accurate, it was obvious that La Grenouillère presented a fascinating segment of just that 'modern life' to which realism was seeking to address itself.

Renoir painted three major views of La Grenouillère. One version at Winterthur centres on one of the picturesque bridges; another in Stockholm depicts the islet with its solitary tree, crowded with people; the third, in Moscow (Plate 154),[2] shows the crowded river-banks, the bathers, the tall trees. The lightest and most dazzling of the three, it is a remarkable proof of how far Renoir had gone in perfecting a technique for expressing light and atmosphere. The complexity of the colouring, the vivacity of the brush-strokes depicting the rippling water and the shimmering of the leaves, the intricacy of the play of light on the dresses of the women and on the bark of the trees are all quite remarkable, and give considerable support to the theory that, because of its spontaneity and immediacy, this was the first of the series.

Only one of Monet's three versions, that showing the islet (Plate 155), coincides with any of Renoir's. Although it too is a brilliant rendition of the scene, and passages such as the sparkling water in the foreground have an intensity

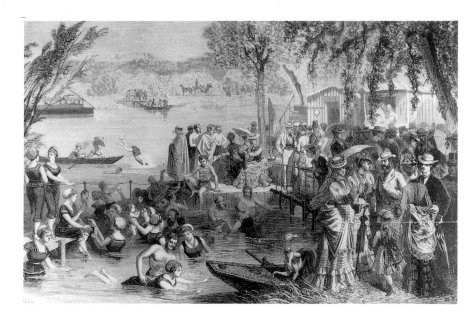

124 Engraving of La Grenouillère by Yon from *L'Illustration*, 20 June 1868.

and skill of expression as striking as almost anything in the later history of Impressionism, the whole work is much more structured than Renoir's. Its careful modulations of distance and scaling of the figures are features of a sophisticated composition, the island situated at a point where the lines of the bridge, the boats in the foreground and the balcony of the café converge and make a contrast to the horizontality of the distant river-bank. Although his range of colours is more limited than that of Renoir, the sense of an almost mosaic-like pattern is much more emphatic than Renoir's more supple construction, and shows a concern with suggesting space and depth in a manner independent of accepted linear perspective. In 1866 he had already tried out many of these innovations in his *Déjeuner sur l'herbe* (Plate 99), with its implied rivalry to Manet. This was the second version of a work on a larger scale which he had completed in the previous year. It shows a group of people, including Camille and Bazille, who posed for at least two of the figures, in a sylvan setting standing or sitting around a meticulously laid-out picnic. It was a work to which he had clearly given a good deal of consideration. There are several oil sketches of the landscape and separate ones of the figures, as well as a drawing in which he worked out the whole composition. Marked by intense patches of colour, the finished painting shows a notable preoccupation with effects of light and shade, which however had not at this point been completely resolved as they were in the La Grenouillère painting. Later in life he was to give this advice to an American artist, Lilla Cabot Perry:

When you go out to paint, try to forget what objects you have before you – a street, a house, a field or whatever. Merely think, here is a little square of blue, here an oblong of pink, here a streak of yellow, and paint it just as it looks to you, the exact colour and shape until it gives your own naïve impression of the scene before you.

It was an oversimplification but it gave a hint of the direction in which his mind worked.

Renoir's approach to the problems which were exercising so many of the Batignolles painters, and leading them to reconsider the nature of light and of vision itself, was much more pragmatic than that of Monet, but that did not mean that he was not consciously aware of what he was doing and why, as shown by his later advice to a young painter who brought him a snow scene for his comments and reactions when he was in Germany in 1910:

White does not exist in nature. You admit that you have a sky above that snow. Your sky is blue. That blue must show up in the snow. In the morning there is green and yellow in the sky. These colours must also show up in the snow if you painted your picture in the morning. Had you done it in the evening, red and yellow would have had to appear in the snow. And look at the shadows. They are much too dark. That tree, for example, has the same local colour on the side of it on which the sun shines as on the other side where the shadow is. But you paint it as if it were two different objects, one light and one dark. Yet the colour of the object is the same, only with a veil thrown over it. Sometimes that veil is thin, sometimes thick, but always it remains a veil. You should paint it that way. Look at Titian; look at Rubens - see how thin their shadows are, so thin that you can look through them. Shadows are not black; no shadow is black. It always has a colour. Nature knows only colours; black and white are not colours.

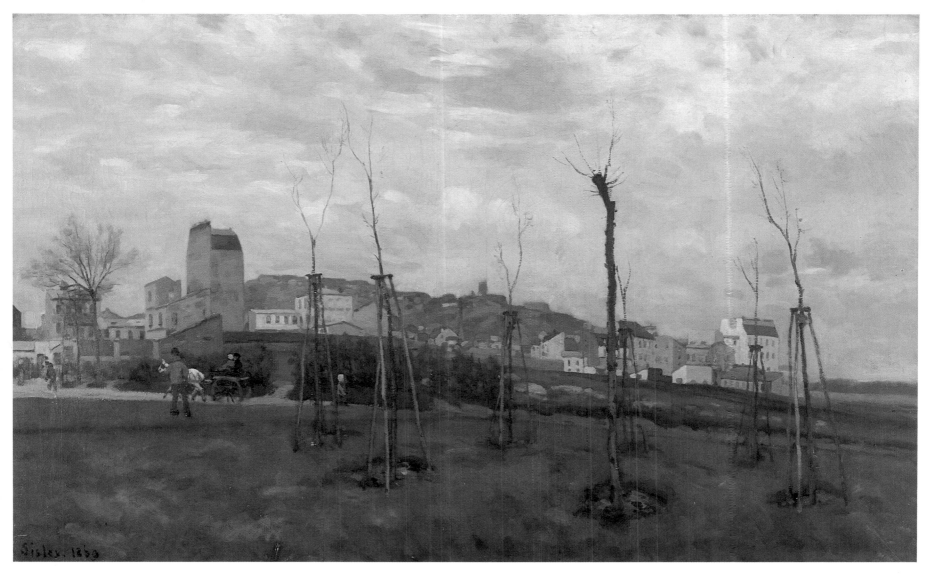

125 ALFRED SISLEY *View of Montmartre* 1869

This new way of seeing things, which was to be one of the main characteristics of Impressionism, was already taking shape and form in the discussions in the Café Guerbois, and it was affecting others than Monet and Renoir. Even the work of Sisley, who, largely because he was at this period financially independent, was not possessed of a complete dedication to painting, was showing signs of having absorbed at least some of the innovatory ideas which were being explored by Monet and Renoir. His *View of Montmartre* of 1869 (Plate 125), though still echoing Corot in its limpid tonal qualities, was also showing signs of having absorbed the advice which Monet had given to Lilla Cabot Perry, and contrasts with the *Village street in Marlotte* (Plate 126) of three years earlier, with its dark Barbizon-like masses of shadow and intricate pattern of converging lines. But his work was for long to be marked by a certain diffidence which he did not finally overcome till the middle 1870s.

Frédéric Bazille too was cushioned by a comfortable income from having to concentrate on artistic success, but he was a far more positive character than Sisley, and far more actively engaged in the discussions and plans of the group. His portrait of 1870 (Plate 116) suggests how deeply he identified with them. It is in his letters home that we find the first mention of what was eventually to be the exhibition of 1874. In the spring of 1867 he wrote to his parents:

I'm not going to send anything else to the Salon jury. It's far too ridiculous to have to expose oneself to these bureaucratic whims. What I am now going to tell you is the common aim of a dozen or so young painters who share my ideas. What we are going to do is to rent a studio where we shall exhibit as many of our works as we wish. We shall also invite painters whom we admire to send us works. Courbet, Corot, Diaz, Daubigny and many others have already promised to send us pictures and strongly support the idea. With these people and Monet, who is stronger than any of them, we are sure to succeed. You'll see that soon we'll be getting talked about.

A few weeks later, however, he had to confess that, despite valiant efforts, all that they had been able to rustle up amongst themselves was 2,400 francs, an inadequate sum for such an undertaking. Much of that sum came probably from himself. He was indefatigably generous to other members of the group, often buying pictures from them at what were then ridiculously inflated prices. Close in personality to both Manet and Degas, he was less inhibited than either. His devotion to Monet was absolute. In 1864 he had spent some time at Honfleur, lodging in a baker's house, having his meals at the famous Saint-Siméon farm, much beloved by Boudin and where Courbet used to stay, and lunching on one occasion at Sainte-Adresse with Monet's parents, whom, contrary to their son's opinion, he found 'charming people'. At this point in his career Bazille was producing works which were very close to those of Monet, but by 1869 he had evolved in his *The artist's family on a terrace near Montpellier* (Plate 128) his own very

127 PIERRE-AUGUSTE RENOIR *Portrait of Alfred Sisley and his wife* 1868
Sometimes known as *The engaged couple*, this shows Sisley with his mistress Eugénie Lescouzec, the daughter of an army officer killed in a duel, who worked as a professional model; she bore Sisley three sons whom he legally recognized, and she died the year before him. An alternative account is that the girl is Renoir's favourite model, Lise Tréhot.

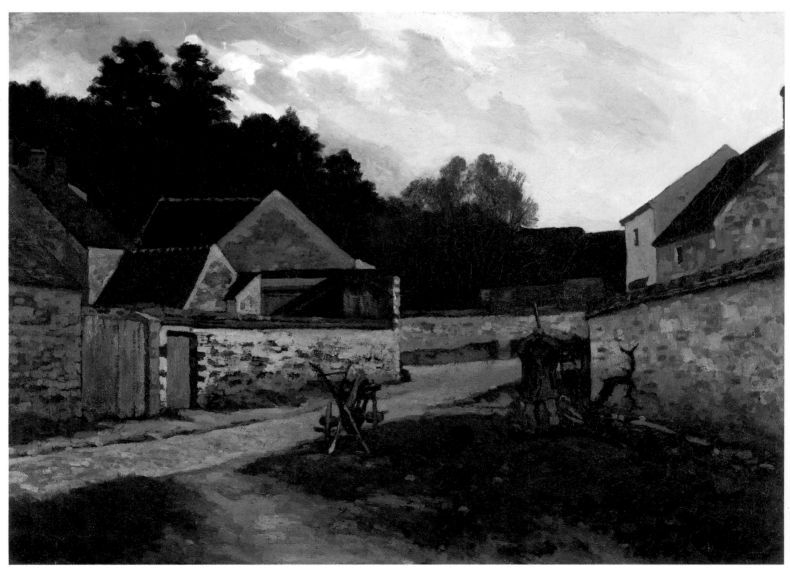

126 ALFRED SISLEY *Village Street in Marlotte* 1866

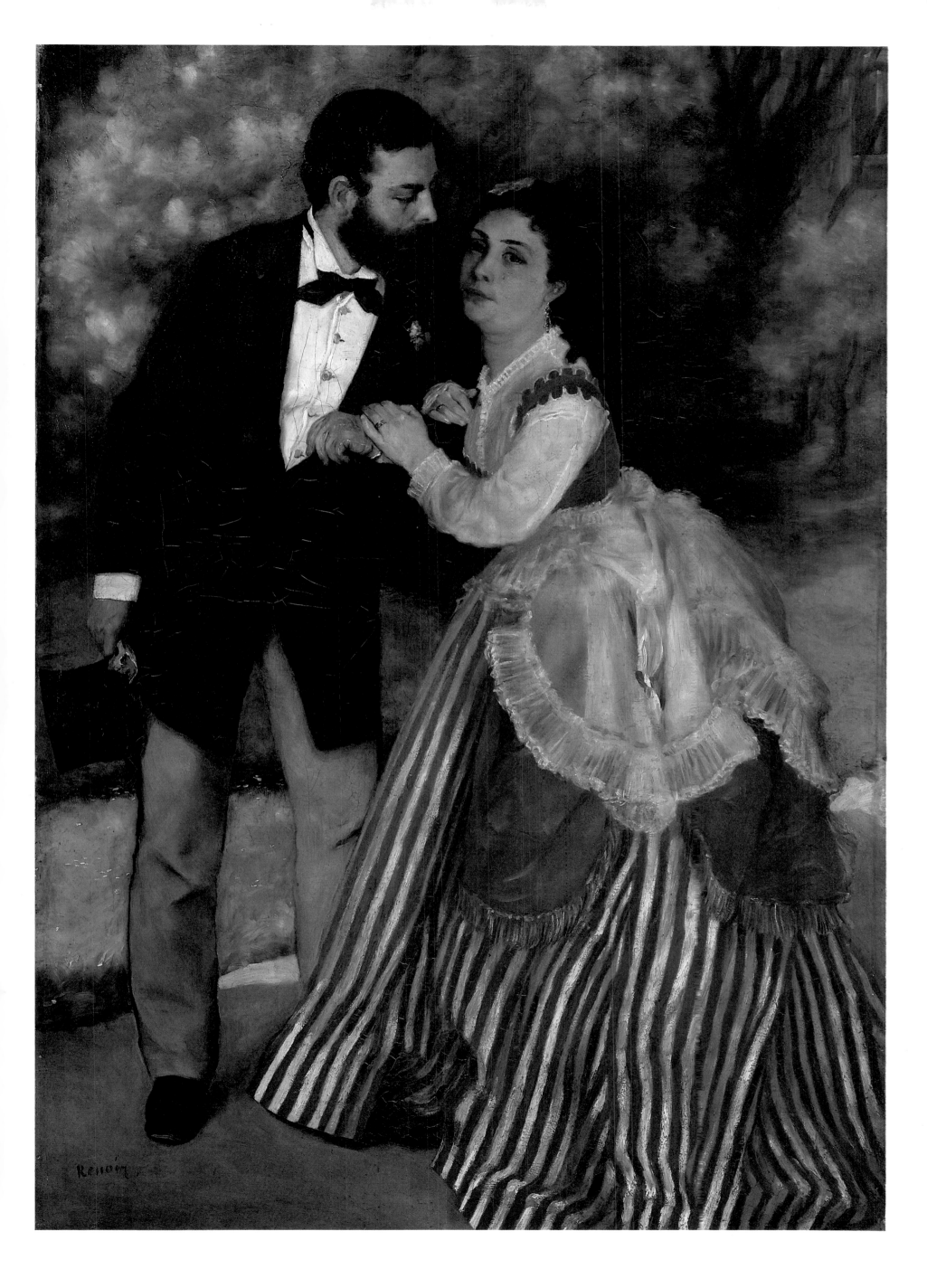

personal style, combining clear, limpid and emphatic colour with a kind of engaging simplicity. It is related to both Monet's *Déjeuner sur l'herbe* and his *Terrace at Sainte-Adresse* (Plates 99 and 157) and to Renoir's *Mother Anthony's Inn* (Plate 38), but there are also strong suggestions of the influence of Manet. It was one of the first attempts to produce a group portrait out of doors. He devoted a great deal of preliminary work to the project, including drawings from nature to determine the disposition of the figures, and oil sketches to determine relationships of light, colour and space in the setting. But what Bazille was trying to produce was not only a painting but a family document, with the relationship of each of the figures in the hierarchy clearly indicated. It is in fact more successful as portraiture than as a painting. Each of the people in it is shown looking at the spectator with the same kind of directness as the central figures in Manet's *Déjeuner sur l'herbe* and his *Olympia* (Plates 73 and 98). This however helps to create so many differing foci of attention that the picture has a disorganized appearance, and emphasizes the cut-out appearance of the faces of the Bazille family.

The problem was, and other artists tended to discover this, that the technique that Monet was evolving could not be a combination of academic drawing and what would soon be called 'impressionist' background. The whole thing had to be conceived as a stylistic unity, and not 'composed' out of disparate units. Bazille's portraits, such

as that of Renoir and the self-portrait of 1867 (Plate 130), which did not demand this kind of fusion, were much more satisfying, but less interesting than the scene on the terrace. When he painted what was virtually a single portrait, as in *The pink dress* of 1870 (Plate 114), this problem became simplified, so that there is an unresolved conflict between the figure in shadow and the light-infused background, painted with a Monet-like freedom.

Bazille's work seemed to foreshadow many of the problems which were to vex the Impressionists even during their period of greatest cohesion, and which were to lead to the revolt against its 'formlessness' implicit in the later works of Cézanne as well as in the symbolism of Gauguin and the Pointillists. Indeed, during the last few years of his life – he was killed in 1870 in a minor skirmish at Beaune-la-Rolande in the third month of the Franco-Prussian War – Bazille seems to have come under the sway of Pierre Puvis de Chavannes (1824-98), who was to have such an influence on Post-Impressionism as a whole. This is especially evident in *Summer scene; bathers* of 1870 (Plate 132), which might almost have been designed as a mural. It contains eight figures of boys swimming, wrestling, dressing and undressing in a way which suggests some element of symbolism, half-pagan like riparian gods of classical mythology, half-baptismal. There are suggestions too of Degas's Spartan painting (see p.93).

Unlike either Bazille or Sisley, Pissarro had little

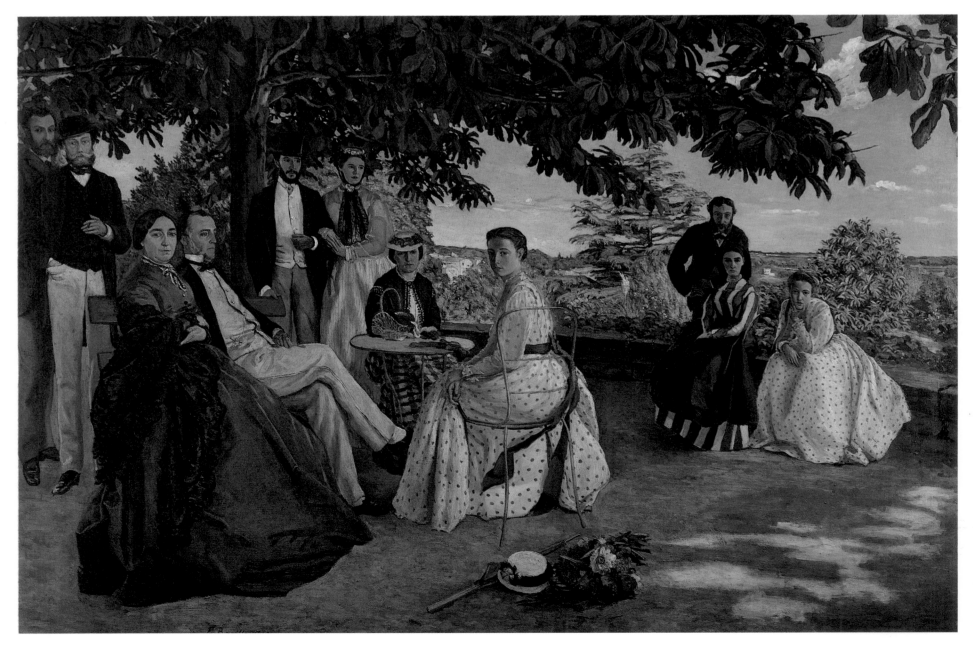

128 FREDERIC BAZILLE *The artist's family on a terrace near Montpellier* 1869

insulation against the effects of poverty and depended on his art to make a living. He was driven too by an incessant urge to improve and to keep abreast of every new development. Initially he had been somewhat apart from the other members of the Batignolles group. His situation was a precarious one. He had rejected the career which his parents had intended for him; in 1863 he had had a child, Lucien, by his mother's maid Julie Vellay, who was later to become his wife, although she was a Gentile, a fact inevitably resented by his parents. Brought up in the colonies and with a family background of peripatetic merchandising, he was resolved to dedicate himself to painting the French countryside, where he lived much more consistently than any of his colleagues. But it was the countryside of the Paris basin, more an immense market-garden, which attracted him, rather than the areas which had appealed to Courbet or Millet. Pontoise, for instance, where he lived from early 1866 till 1869 (Plates 133, 135), had easy access to the capital, thanks to the railway station which had been opened there three years earlier; Louveciennes, where he moved later, was conveniently situated between Versailles and Bougival, already frequented by Renoir, Manet and Sisley (Plates 141, 142). His energy was remarkable.

129 CAMILLE PISSARRO *Madame Pissarro sewing* 1879
Although they had been living together since 1860, Pissarro did not marry Julie Vellay, the daughter of a Burgundian farmer and his mother's maid, until 1870 when they were in London. Their relationship, as this picture suggests, was always of the happiest.

150 FREDERIC BAZILLE *Self-portrait* 1867
This was painted at a time when Bazille had become one of the leading figures of the group, in very close contact with Monet, whom he was virtually supporting. He offered generous hospitality to them all at his studio, where they met celebrities such as Baudelaire, Courbet and Gambetta.

On his return to Louveciennes after his stay in London during the war, he complained that the Germans had left behind only 40 paintings of the 1,500 that he had left there – which suggests an annual output of 150 during the previous decade or so. Nor was he entirely unsuccessful. He had works accepted at the Salon in 1859, 1864, 1865, 1866, 1868 and 1869 (*The Hermitage*) and 1870. He also had three works hung in the Salon des Refusés.

Pissarro had met Monet at the Académie Suisse, but it was not until his first contact with Manet in 1866 and his regular attendance at the Thursday parties organized by Zola,[3] at which he first met Manet, that he was drawn completely into the Café Guerbois circle. His own artistic stance at this period was not a simple one. His imagination was still dominated by a traditional view of landscape painting, with its emphasis on structure and technical skill, but at the same time he was influenced by his early devotion to Corot, who had told him,

You are an artist, you don't need advice from me – only this. Study values. We don't see things in the same way. You see green; I see grey and light colours. But this is no reason for you not to work at values because they are above all what one feels and experiences, and one can't make good painting without them.

Typical of this period is *The house of Père Gallien, Pontoise* (Plate 133), with its Corot-like atmosphere, its carefully

contrived composition with the strategically placed fruit trees, and the delicate colouring of the walls and out-buildings setting off the emphatic whiteness of the house. He had derived a good deal too from Daubigny, and from Courbet he acquired for a while a palette-knife technique, apparent in the charming *The Hermitage at Pontoise* (Plate 135), with its varying textures, its subtle interplay of lighting, and its delicately expressed feeling of a late summer afternoon. Commenting on another similar painting of the Hermitage, Odilon Redon, then a young art student, wrote in a provincial magazine:

The colour is somewhat dull, but it is simple and well felt. What a talent which seems to brutalize nature. He treats it with a technique, which in appearance is very rudimentary, but this denotes above all else his sincerity. M. Pissarro sees things simply; as a colourist he makes sacrifices which allow him to express vividly the general impression, and this impression is strong because it is simple.

Redon's use of the word 'impression' is interesting. If he thought of Pissarro's work as simple and rudimentary, it is hard to know what he would have made of the paintings of the friend Pissarro acquired in the spring of 1865, and who was to be closer to him than any other member of the group. After his abortive sojourn in Paris in 1861, Cézanne had returned to Aix to work in his father's bank and carry on the perpetual duel with him which both seemed to relish. The following year he triumphed – temporarily at least – and for the next few years visited Paris intermittently for varying lengths of time, but continued painting even when he was in Aix. He seems to have been introduced to Pissarro by Antoine Guillemet, who often visited him in Aix, and acted as a mediator with his father. In the autumn of 1866 Guillemet recorded in a letter to Zola his activities in what he called 'this Athens of the South':

151 CAMILLE PISSARRO *Kitchen gardens at the Hermitage* 1874
In Pontoise Pissarro found the ideal rural community for which he was always yearning. The rue de l'Hermitage was a combination of a peasant hamlet and a growing suburb of Pontoise itself, and apart from a short period in 1872 when he lived in the town, he was there between 1866 and 1883, doing some 500 paintings of the area.

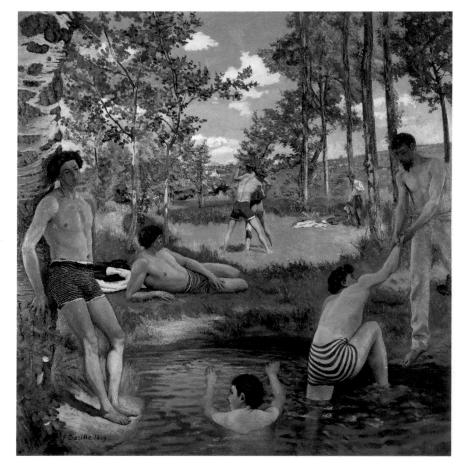

152 FREDERIC BAZILLE *Summer scene; bathers* 1869

In his two letters Paul has spoken more about me than about himself, and I shall do the same, i.e. the opposite, and tell you a lot about the master. His appearance has improved, his hair is long, his face glowing with health, and his very bearing creates a sensation along the Cours.[1] You can therefore rest easy on that score. His spirits, while always ebullient, have their calmer moments, and painting, abetted by a few firm commissions, promises to recompense him for his efforts, in short 'tomorrow's sky seems to be less threatening'. On his return to Paris you will see some pictures that will please you a great deal; among others an *Overture to 'Tannhäuser'* that might be dedicated to Robert since it contains a very successful piano. Then there's a portrait of his father in a large armchair, looking very genial. The painting is light and very attractive. His father would look like the Pope on his throne, were he not reading *Le Siècle*. In short everything is getting on famously, and you may be sure that we shall soon be seeing some very fine things. The people of Aix get on his nerves; they ask to come and see his paintings and then run them down. He has therefore taken a very aggressive line to them. 'You make me sick,' he tells them, and the timid flee in terror. In spite of, or perhaps because of this, there seems to be a reaction in his favour, and I believe that when the time comes he may be offered the curatorship of the museum. This is something to be hoped for, because, unless I don't know him very well, that is the only way that some of the very successful landscapes he has been doing with a palette-knife will ever have a chance of getting into a public art gallery.

Guillemet also wrote enthusiastically to Pissarro about the work Cézanne was doing. The *Overture to 'Tannhäuser'* (Plate 134) was probably suggested by the influence of Heinrich Morstatt (1844-1922), a German musician and a fervent Wagnerite, who later became director of a music school at Stuttgart, and was a close friend of the Cézanne family. The two girls are Cézanne's cousins, one a year younger, the other a year older than he, and the wallpaper suggests that the picture was painted in the Jas de Bouffan, a property on the outskirts of Aix which Cézanne's father had bought in 1859. It is in many ways an astonishing work, the colours almost naïvely simple, the wild outburst of inverted arabesques on the wall foreshadowing Matisse,

the paint applied with a palette-knife in slabs of varying size and intensity. Intensity is the word which can be most aptly applied to the painting. It is a complete denial of all the moderation which characterized so much of the painting being done at the time.

The *Overture to 'Tannhäuser'* is one of a whole series of domestic pictures which Cézanne was working at in Aix, finding in the members of his family suitable material for exercising his, as yet, indecisive technical skill. In the portrait of his father to which Guillemet refers he changed the title of the newspaper he was reading from that of the conservative *Le Siècle* to the more left-wing *L'Evénement*, for which Zola wrote. He painted his obviously co-operative uncle, Dominique Aubert, in a variety of clothes – as a lawyer, an Arab, a Dominican friar, and as a simple citizen of Aix, in a cotton cap and a white coat (Plate 45), which shows his palette-knife technique at its most apparent but also suggests, in the extreme solidity of its modelling, the later still-lifes and landscapes which were to be his most significant contribution to the vocabulary of Western art.

The most remarkable portrait Cézanne painted at this period, however, was that of Achille Emperaire (Plate 136), showing the dwarf painter sitting in the same chair that his father occupied in the painting referred to above. In visual terms it is one of the most monumental figure paintings of the century, the thick paint with its rigidly defined colour contours creating an almost three-dimensional effect, the whole emphasized by the inscription ACHILLE EMPERAIRE, PEINTRE stencilled in yellow ochre on purple across the top of the canvas. There is great feeling, too, in the sadly resigned look on Emperaire's face, and the pathetic shrivelled legs which have an intense poignancy.

In most of his work during this period Cézanne demonstrates the effect Manet had exerted on him although, as one critic unkindly commented at the time, it was 'Manet gone mad'. Cézanne himself emphasized this debt by painting his own versions of *Olympia* and *Le Déjeuner sur l'herbe*. Both are, to put it mildly, extremely vigorous, and form part of a series which started as early as 1861 with Lot and his daughter, showing one of the girls sitting astride the naked patriarch, who is holding her bottom passionately and clearly having intercourse, or something akin to that, with her. In part these paintings are an attempt by Cézanne to present his own vivid versions of accepted Salon or religious subjects (in 1867 he painted a *Christ in Limbo* with strong undercurrents of El

133 CAMILLE PISSARRO *The house of Père Gallien, Pontoise* 1866

134 PAUL CEZANNE *Overture to 'Tannhäuser'* 1866

135 CAMILLE PISSARRO *The Hermitage at Pontoise* 1867

Greco), but much more they are expressions of a powerful, repressed sense of violence and sexuality. When Zola came to write *L'Oeuvre* (published in 1886), the novel which led to the break-up of his friendship with Cézanne, on whom the hero is clearly based, he wrote of him in connexion with his contempt for women:

It was a chaste man's passion for the flesh of women, a mad love of nudity, desired but never possessed, an impossibility of satisfying himself, of creating as much of this flesh as he dreamed to hold in his frantic arms. The girls whom he chased out of his studio he adored in his paintings; he attacked or caressed them, in tears of despair at not being able to make them sufficiently beautiful, sufficiently alive.

That this was a specific reference to Cézanne is proved in the notes Zola wrote before embarking on the novel, in one of which he commented:

Cézanne distrusted women. He never brought them to his room; he always treated them like a youth, in an agony of shyness, hidden under boastfulness. 'I don't need women,' he said, 'it would be too much of a nuisance. I don't even know what their use is; I've always been afraid to find out.'

In the margin Zola added and underlined 'Very important'.

There could be no better exemplification of this repressed desire to violate the unattainable than *The rape* (Plate 137) of 1867. This has recently been shown to represent

the rape of Persephone by Pluto, with its dark threatening background, the violent contortions of the two figures, his browned with the sun, hers almost deathly white, and the sense of violence accentuated by the two unmoved bathers on the left of the composition. More violent, but lacking the sexuality of *The rape*, *The murder* (Plate 139), painted in the same year, shows one person holding another down on the ground, whilst a third plunges a knife into him. Sombre, menacing, the background almost indecipherable, it is reminiscent of the paintings of Daumier and the early works of Van Gogh. It was his meeting with Hortense Fiquet which seemed to purge Cézanne of this suppressed sexuality and, though he was to paint one more 'passionate' picture in 1876, the *Afternoon in Naples* (Plate 138), it seems to have been a version of an earlier work painted in 1867.

The murder is almost certainly based on a popular print. Aix was the judicial centre of a large area, possessing its own guillotine. In what was one of the areas of heaviest alcohol consumption in France, crimes of violence, especially in the countryside, were a frequent occurrence, and capital offences often prompted local printers to produce (as indeed often happened in England) broadsheets purporting to illustrate the crime. The attitudes of the figures suggest that the painting was based on one of these prints, and one was shown pinned on the wall in the study of a nude model by Cézanne, now lost. Printed material supplied him with many of his pictorial ideas, isolated as he often was from the artistic resources of Paris, and the opportunities of painting from the model offered by institutions such as the Académie Suisse. He frequently made copies of fashion plates from the magazines to which his two younger sisters subscribed to keep abreast with the latest developments in the fashion world. He also copied and used similar plates for his still lifes.

It is not easy to discover what the other members of the group thought of him. He was not a frequent visitor to the Café Guerbois, and his appearance was not prepossessing: Zola described him in his Notebooks as

bearded, with knotty joints, and a strong head. A very delicate nose hidden in his luxuriant moustache. His voice was loud. He was a little round-shouldered, and had a nervous tic which became habitual.

Some years later Mary Cassatt, who met him at Giverny gave a fascinating account of his older persona:

When I first saw Mr Cézanne he looked like a cut-throat, with large red eyeballs standing out from his head in a most ferocious manner, a rather fierce-looking pointed beard and an excited way of talking that positively makes the dishes rattle. I found out later that I had misjudged his appearance, for far from being fierce or cut-throat, he has the gentlest nature possible, 'comme un enfant' as he would say. His manners at first rather startled me. He scrapes his soup plate, he then lifts it, and pours the remaining drops in his spoon, he even takes his chop in his fingers, and pulls the meat from the bone. He eats with his knife, and accompanies every gesture, every movement of his hand, with that implement, which he grasps firmly when he commences his meal, and never puts down until he leaves the table. Yet in spite of that total disregard for the dictionary of manners, he shows a politeness towards us which no other man here would have shown. He will not allow Louis to serve him before us in the ordinary order of succession at table; he is even deferential to that stupid maid, and he pulls off the old tam-o-shanter he wears to protect his bald head when he enters the

136 PAUL CEZANNE *Portrait of Achille Emperaire* 1868

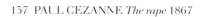
137 PAUL CEZANNE *The rape* 1867

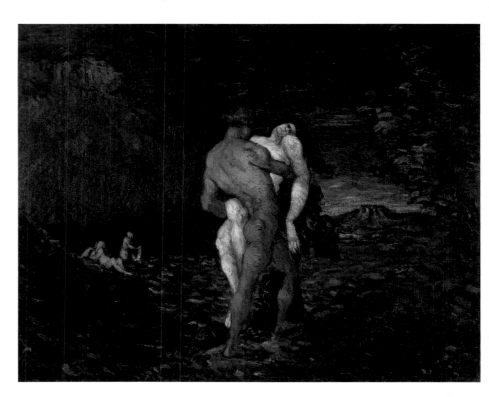

room... Cézanne is one of the most liberal artists I have ever seen. He prefaces every remark with 'pour moi', it is so and so, but he grants that everyone may be just as honest and faithful to nature from their own convictions; he doesn't believe that everyone should see alike.

The only remark he was ever recorded as making at the Café Guerbois was when one evening, going to greet Manet, he said, 'I shan't shake hands with you, M. Manet, since I haven't washed them for eight days.' Clearly a good deal of this presentation of himself was contrived. In France the south plays the same role that the north does in England, and the Provençals were notorious for their gritty behaviour. Cézanne used to affect an exaggerated Aixois accent, which Zola had lost soon after his arrival in Paris. But his attitude was successful in its own way; he came to be thought of as a rather mysterious character, and his works were spoken of in hushed tones. Both Pissarro and Monet were admirers of his work, were to remain so, and bought examples of it at quite an early stage; so too was Renoir, who introduced him to various collectors; they maintained close contact with him throughout the rest of their lives. Manet's attitude varied from the appreciative to the dismissive. Degas too was appreciative, acquired one of his works, but made no particular statement about them, surprisingly since they seemed so different from his own.

139 PAUL CEZANNE *The murder* 1866

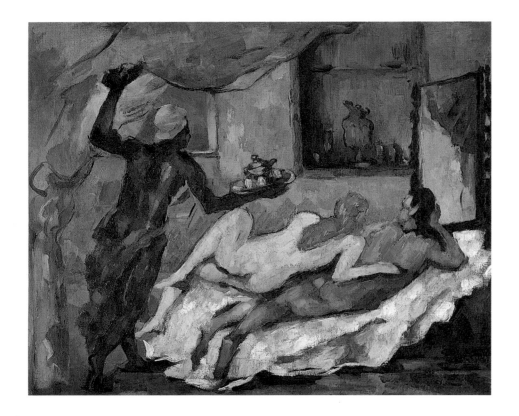

1 In *Monet: nature into art*, Yale University Press, p.51.

2 It was eventually acquired by Ambroise Vollard, who in 1908 sold it for 20,000 francs to Mikhail Morozov (1870-1905), the enlightened Russian collector, who hung it in his house in Glazovsky Lane. After the Revolution it was transferred to the Museum of Modern Western Art and then to the Pushkin Museum in 1948.

3 Zola had been the first to comment favourably on Pissarro's work; in his review of the 1866 Salon he wrote: 'M. Pissarro is an unknown artist about whom probably nobody will talk. I consider it my duty to shake his hand warmly. His winter landscape refreshed me for a good half hour during my trip through the great desert of the Salon. His picture will please few and it will be found too black...an austere and serious kind of painting, with an extreme concern for truth and accuracy, demonstrating a rugged and strong will.'

4 The Cours Mirabeau is the main thoroughfare of Aix.

138 PAUL CEZANNE *Afternoon in Naples c.* 1876

140 PAUL CÉZANNE *Melting snow, L'Estaque* c. 1870
Cézanne was delighted by his discovery of the village of L'Estaque, just outside
Marseilles, and painted it many times, usually in the summer. This ominous
view, which recalls the emotional vehemence of his early works, foreshadows the
work of the Fauves.

141 CAMILLE PISSARRO *View from Louveciennes c.* 1869
A village to the west of Paris between Bougival and Versailles,
from where the French made a sortie against the Prussians
during the Franco-Prussian War. Pissarro lived there in
1869-70 and 1871-2. Many of his paintings are intended to
present a record of rural life there.

142 CAMILLE PISSARRO *Winter landscape at Louveciennes
c.* 1870
The Impressionists' concern with atmosphere and changing
light, seen at its most elaborately conceived in Monet's series
paintings, was evident in Pissarro's continuous recordings of
the places where he lived.

143 CLAUDE MONET *Train in the countryside c. 1872*
Trains played a large part in the life of the Impressionists, especially those which
left from the Gare St-Lazare and served the countryside of the Parisian
perimeter. Living in Argenteuil and then at Vétheuil, Monet used the railway on
his frequent visits to Paris, and this is the first of the many paintings he devoted
to it.

144 PAUL CEZANNE *Mme Cézanne in the conservatory* 1890

145 FREDERIC BAZILLE *View of the village* 1868
Exhibited at the Salon of 1869, this delightful picture attracted the praise of
Berthe Morisot, who wrote, 'Tall Bazille has done something very fine. It
contains a lot of light and sun. He is attempting what we have often tried, putting
a figure out of doors; this time he has succeeded.'

146 EDOUARD MANET *Races at Longchamp c. 1867*
As a man about town Manet was interested in racing, and like Degas often went
to Longchamp. The freedom of handling and wide brush-strokes are indicative
of the extent to which he was moving away from his earlier rather tight style.

147 EDGAR DEGAS *Houses by the seaside 1869*
Towards the end of 1868 Degas started to draw a series of small pastels. This one
was drawn in the summer of 1869 when he was staying at Etretat and Viller-
ville-sur-Mer, and visiting Manet, who was staying at Boulogne with his family.

148 CAMILLE PISSARRO *The Seine at Bougival* 1870

149 EDOUARD MANET *Portrait of Théodore Duret* 1868
Duret suggested to the painter that he should hide his signature, beguiling
ignorant viewers into admiring the work without realizing that it was by the
notorious rebel they had so fiercely criticized. Manet signed the work upside down.

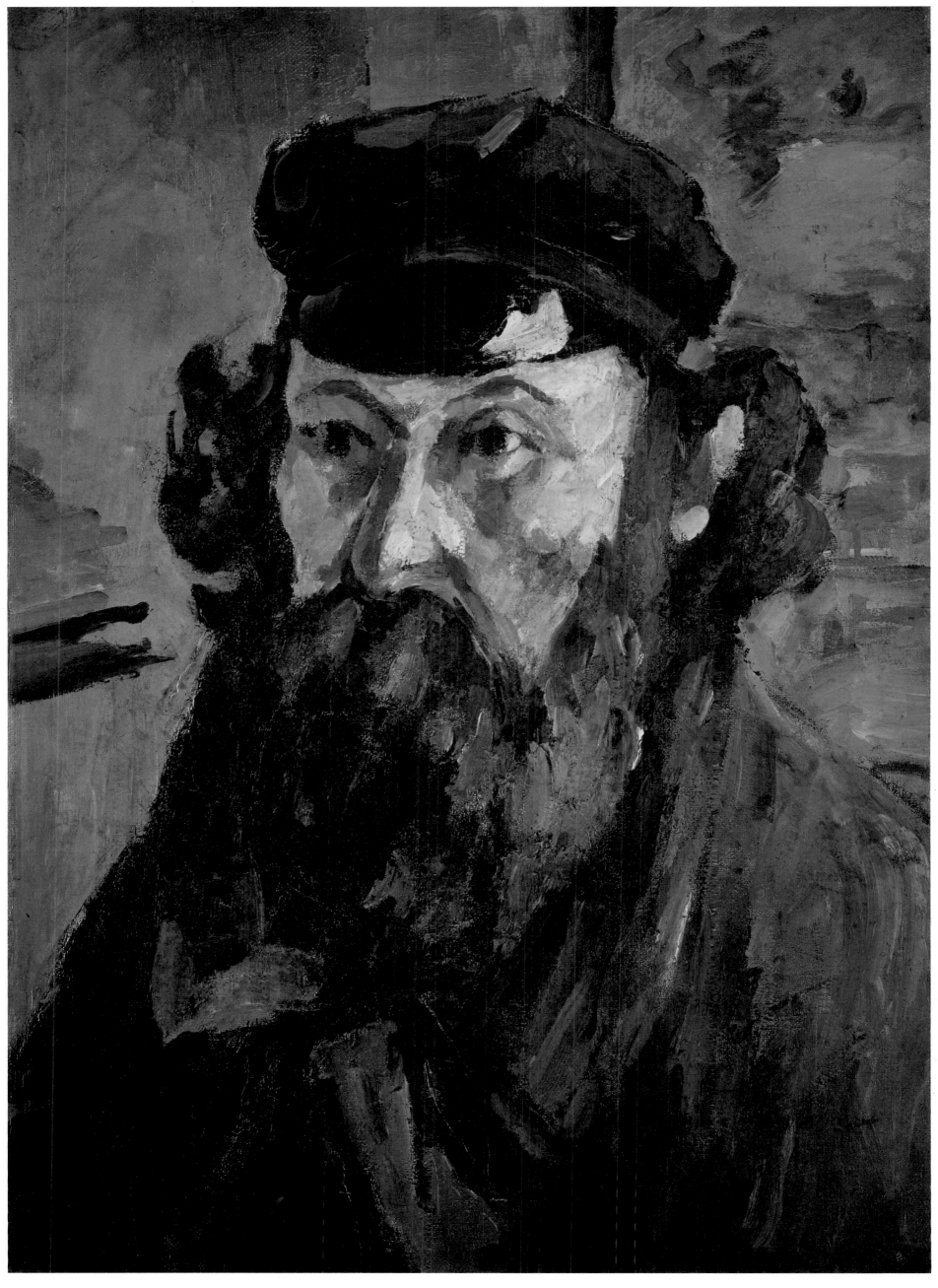

150 PAUL CEZANNE *Self-portrait in a cap* 1873

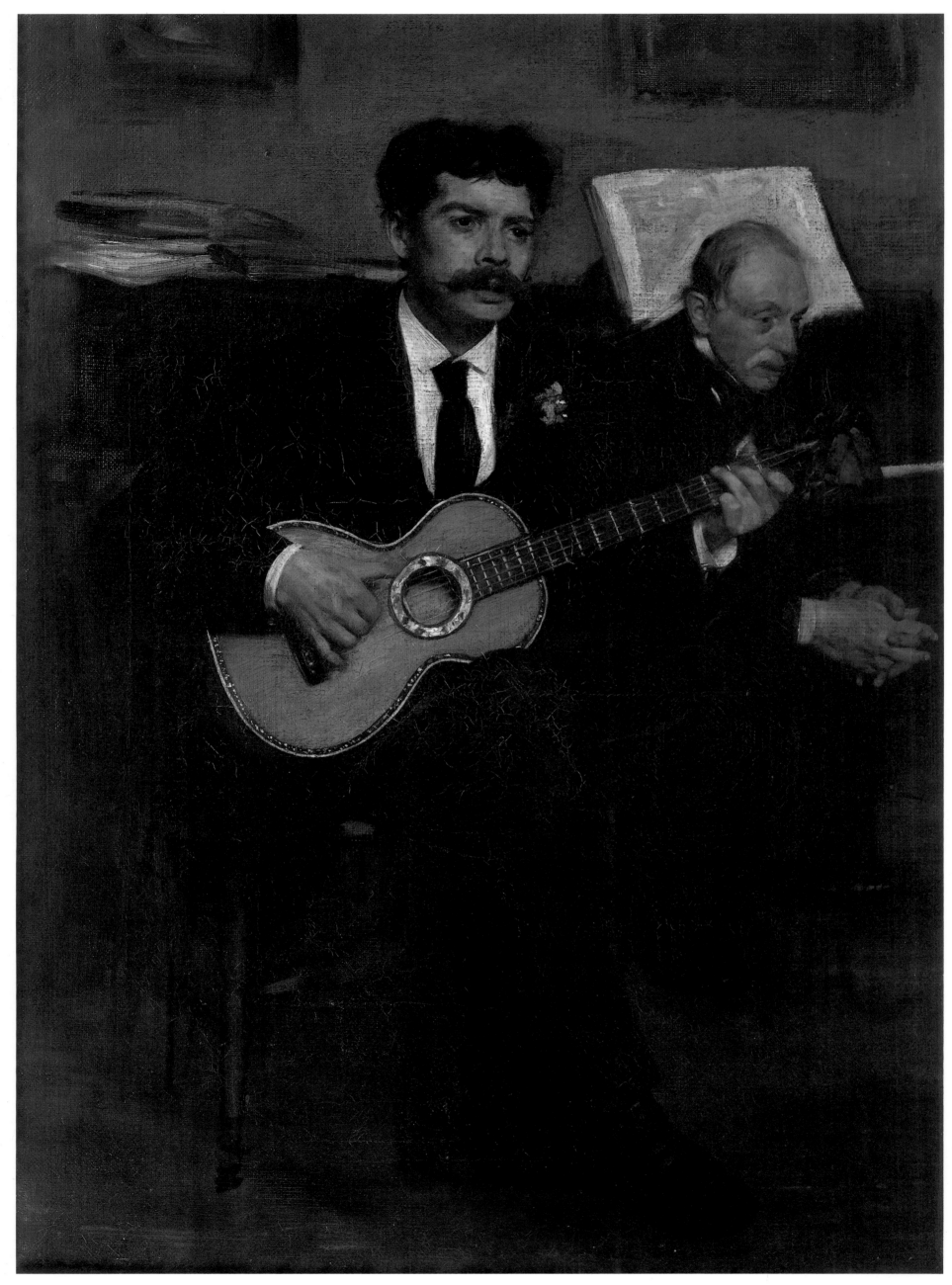

151 EDGAR DEGAS *Portrait of Pagans and Auguste de Gas* 1872
This portrait of his father sitting listening to the 34-year-old Spanish tenor
Lorenzo Pagans singing to the accompaniment of his guitar was kept by the
painter all his life

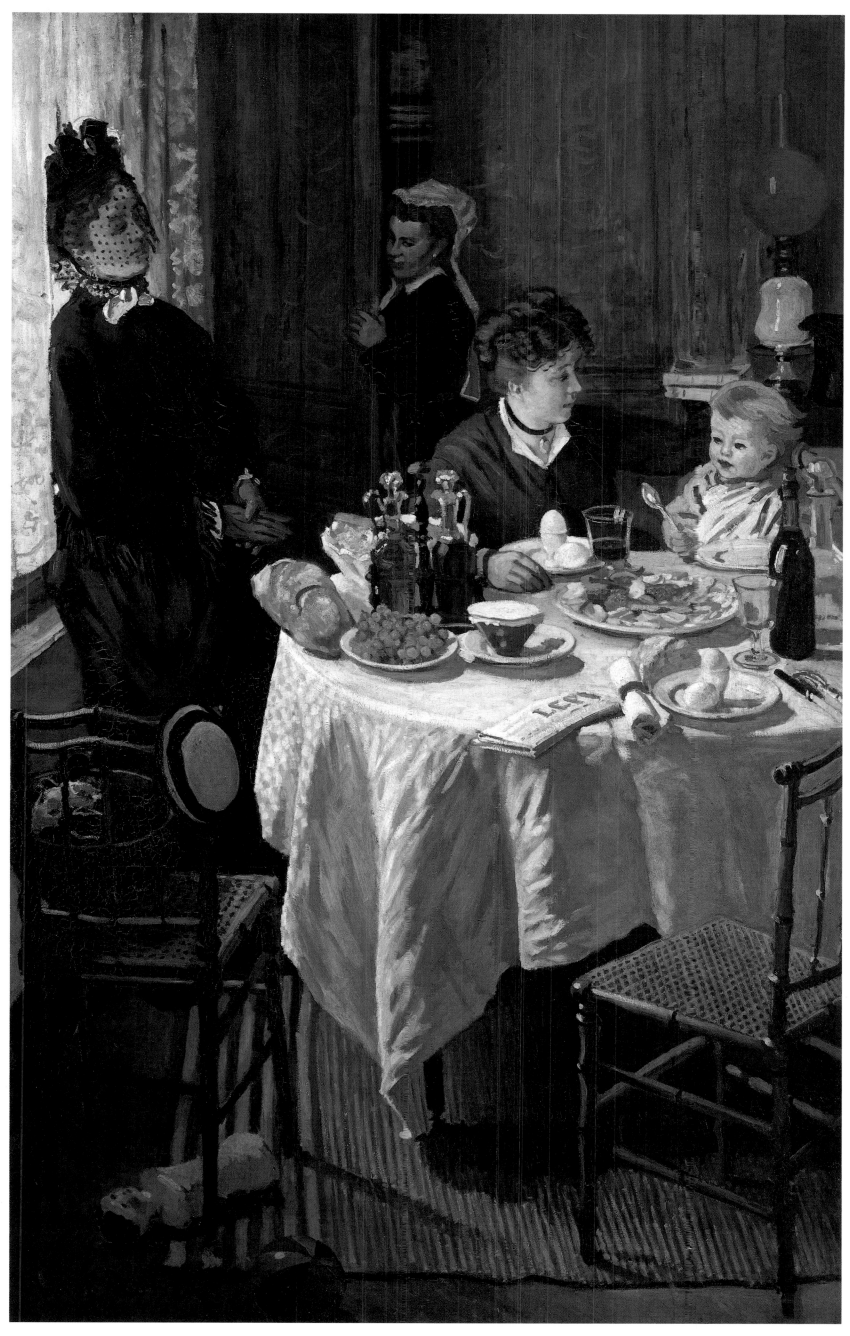

152 CLAUDE MONET *The luncheon* 1866

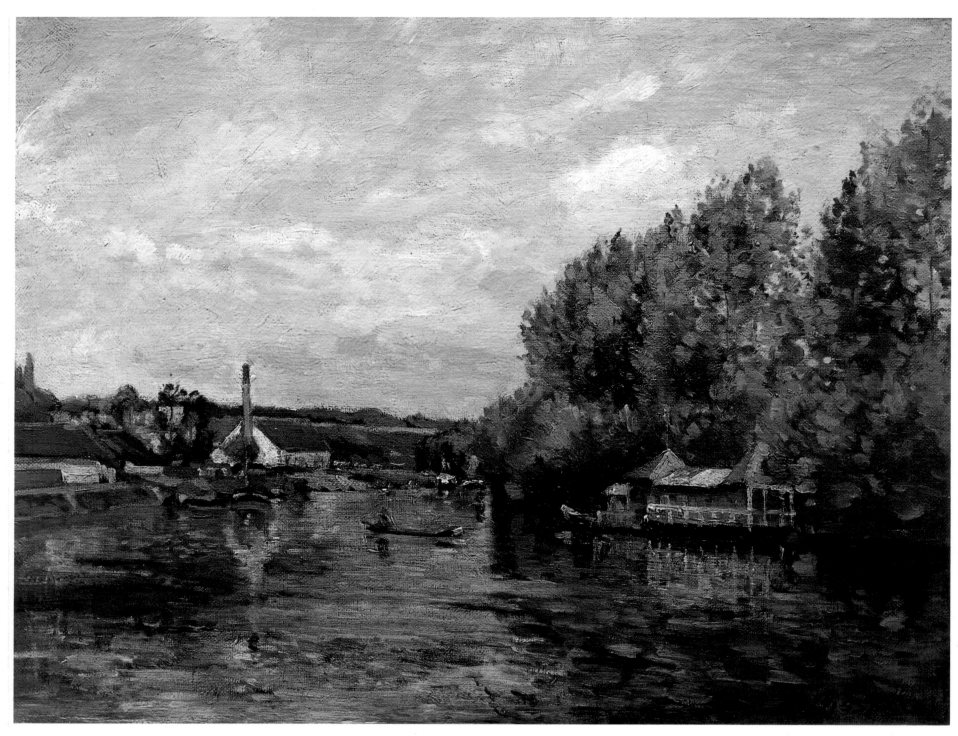

153 CAMILLE PISSARRO *La Grenouillère at Bougival* 1869

The year 1869 was the annus mirabilis *of Impressionism. In the last summer of the Third Empire a whole group of painters including Monet, Renoir, Pissarro and Sisley were working in and around Argenteuil and Bougival, riverside resorts on the Seine above Paris, finding there a carefree, sunlit atmosphere marked by gaiety, by sunshine, by the dappled reflexions of places and people in the calm waters of the Seine. It was here that the movement first realized its ideal and produced a series of memorable images of what now seems a lost Elysium. The centrepiece of this bourgeois paradise was the restaurant and bathing-place called, unromantically, The Froggery (La Grenouillère), which had recently been visited by no less a person than the Emperor himself. It was painted twice by Pissarro and Renoir, as well as once by Monet. Their interpretations reflect their varying personalities, expressing themselves in what was becoming a stylistic idiom common to all of them. Pissarro's view is the most panoramic, showing the*

quite small wooden edifice of the café on the right counterbalanced by a prosaic factory on the left. The tone is quiet and restrained; the influence of Corot is still strong, especially in the silvery tones of the landscape and the reflexions in the river, but there is more than a suggestion of Monet's livelier approach in the handling of the texture of the water, especially in the right-hand corner. Monet's own version (Plate 155), however, is boldly ambitious, the play of light on the water indicated by strong brush-strokes, the figures of bathers and onlookers indicated with peremptory panache, the opposite banks painted in convincing monochrome, the whole work sparkling with visual vitality. Renoir, on the other hand, adopting the same viewpoint, took a closer look, adding touches of brightness, taking more obvious pains with the glittering foliage, seeing the opposite banks with greater chromatic veracity; producing a more integrated, a more lyrical, but a less dramatic interpretation than Monet's.

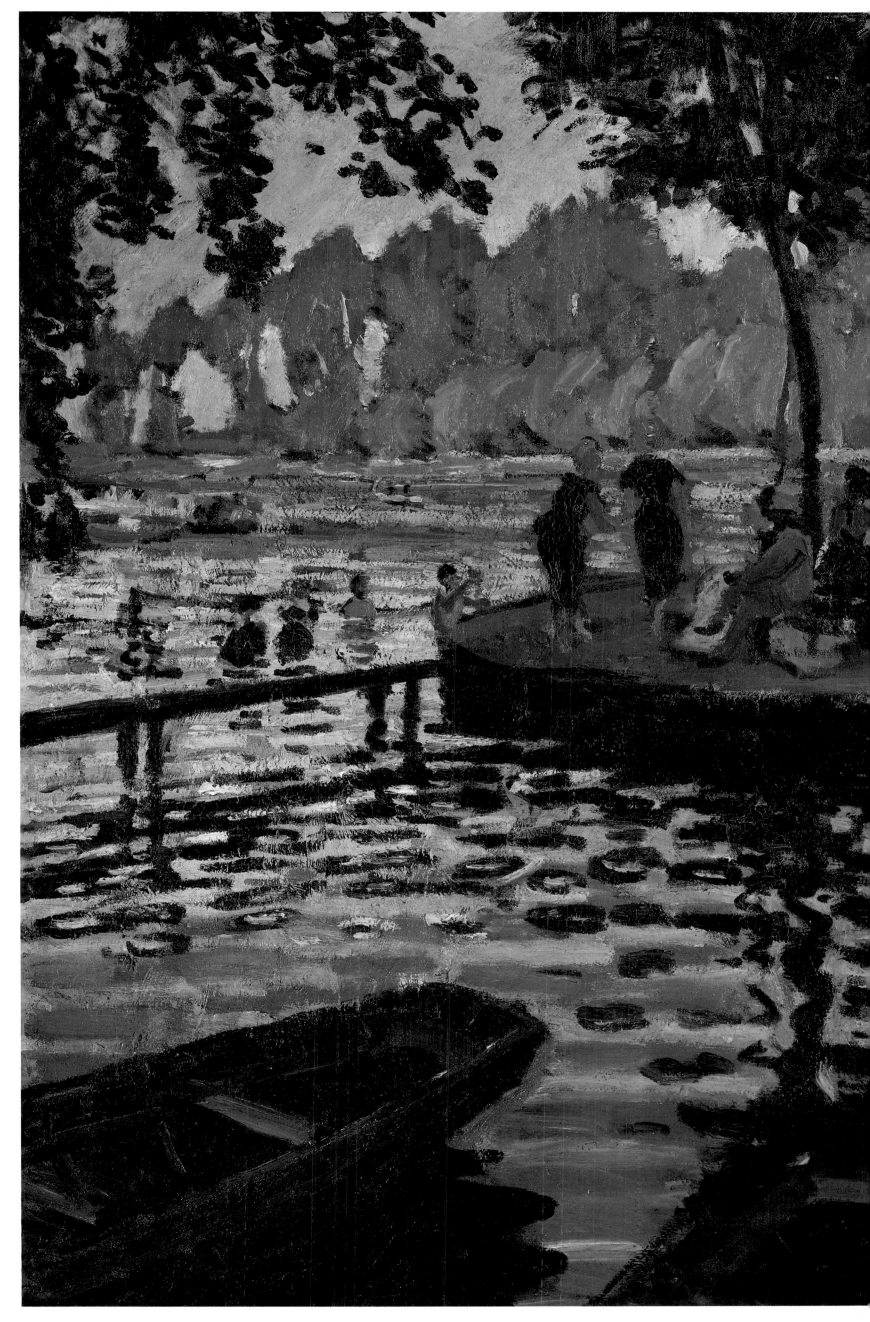

155 CLAUDE MONET *La Grenouillère* 1871

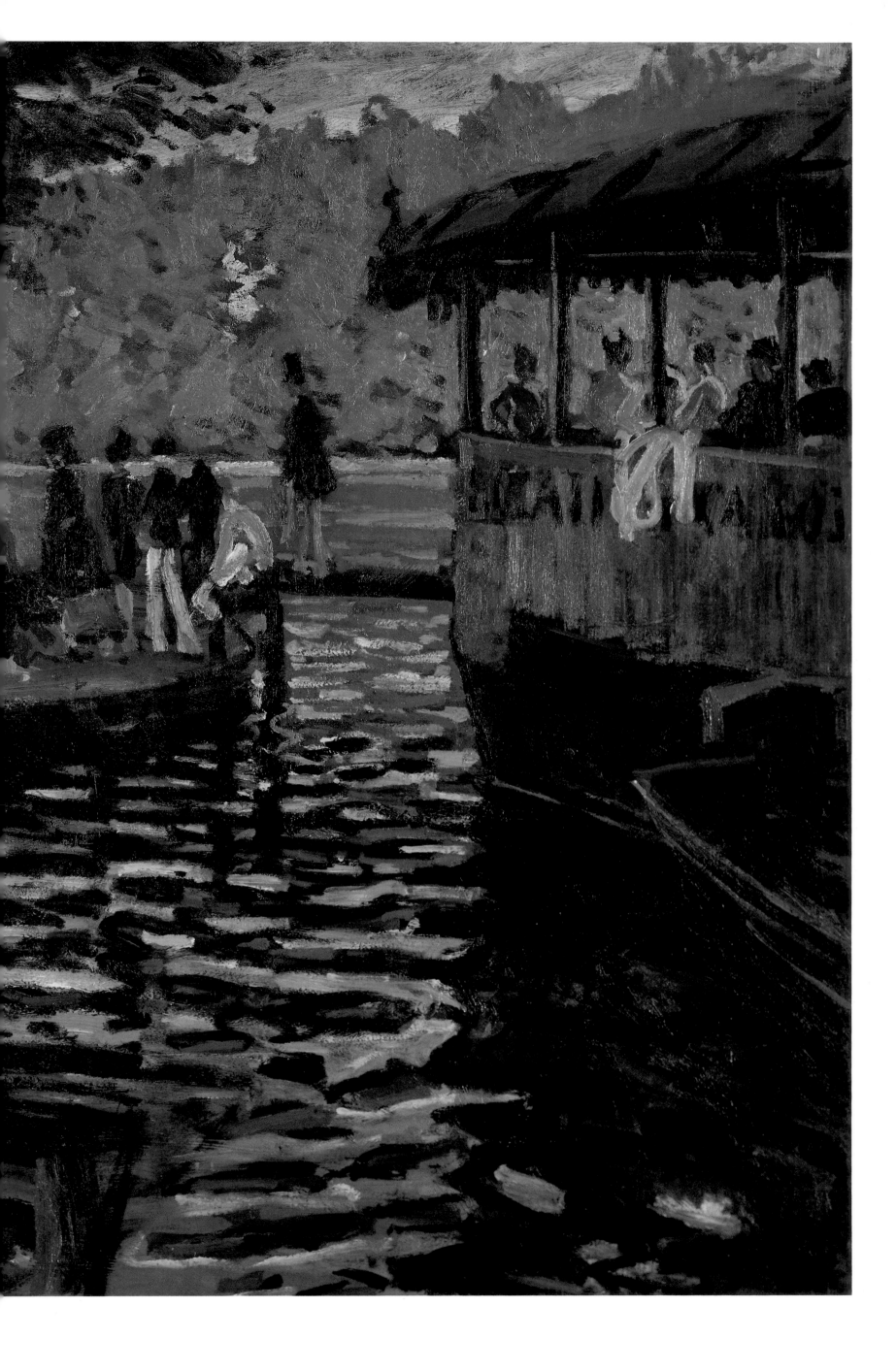

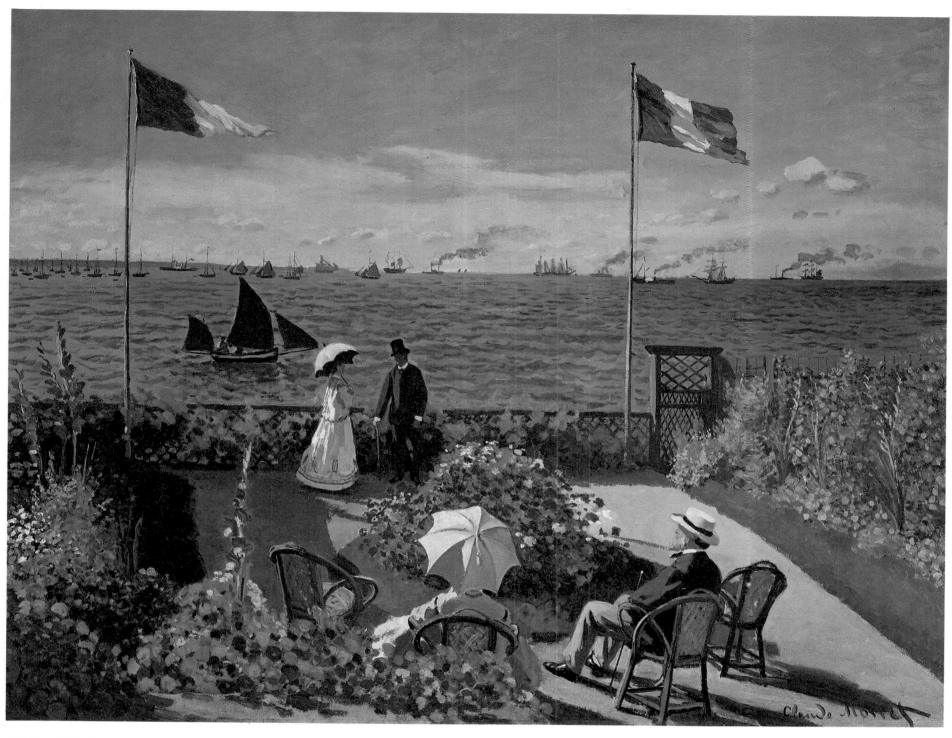

157 CLAUDE MONET *The terrace at Sainte-Adresse* 1867

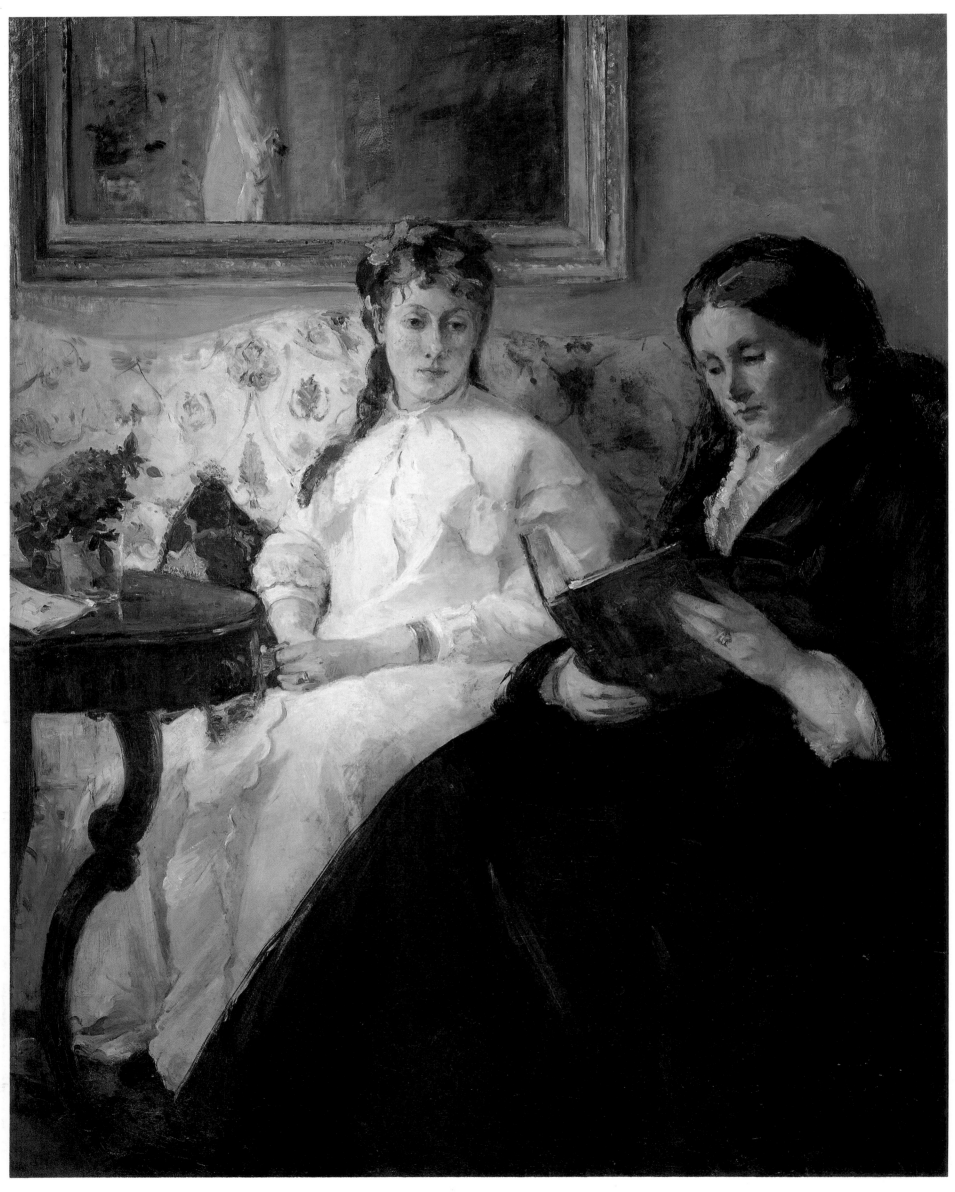

158 BERTHE MORISOT *The mother and sister of the artist* 1869/70

Chapter 5

War and its Aftermath

The year 1870 opened auspiciously enough for the Batignolles group, despite the failure of a concerted but already doomed attempt to have a jury for the Salon nominated by themselves and including Manet, Millet, Courbet, Daumier, Corot and Daubigny. The last-named resigned because the jury would not accept any of Monet's submissions. Apart from that, however, the group was very successful. In addition to his *Bather with a Griffon* (see p.61) Renoir had his *Woman of Algiers* accepted. Degas, who in April had sent a letter to *Paris-Journal* suggesting improvements to the Salon including the hanging of paintings in two rows, that there should be a distance of at least 30 cm between each work, and that artists should have the right to withdraw their works if they so desired, had two works on view, his *Madame Camus in red* (Plate 159), showing the sitter in profile holding a Japanese fan, and a pastel portrait of Madame Théodore Gobillard, Berthe Morisot's sister (Metropolitan Museum of Art, New York). Berthe herself wrote to her other sister Edma:

Your friend Fantin is having a real success. I met him on Saturday morning, and he was very friendly to me; because he had criticized me, I accepted his praise as genuine, and it has given me a little courage again. All in all, since I am talking about myself, I do not make as absurd an impression as I had feared; the little portrait I did of you at Lorient is hung so high that it is impossible to judge it. Manet is in despair about where he is placed. However, his two paintings look well, as usual they attract much attention. Monsieur Degas has sent a very pretty painting, but his masterpiece is the portrait of Yves in pastel. I am sorry that you did not see it during your stay here. Mademoiselle Gonzalès is passable but nothing more.

In another letter a few days later, she added:

Now having got over my first emotion, I find that one always derives benefit from exhibiting one's work, no matter how mediocre it may be. On the other hand, I am not receiving a great number of compliments as you seem to think, but everyone is kind enough not to make me feel any regrets, except of course Degas, who has a supreme contempt for anything I do. I cannot say Manet has spoiled his paintings. Indeed I saw them in his studio the day before the exhibition, but I do not know how to account for the washed-out effect of the portrait of Mademoiselle Gonzalès; the proximity of the other paintings, execrable though they are, is enormously detrimental. The delicacies of tone, the subtleties that charmed me in the studio, disappear in strong daylight. The head remains weak, and is not pretty at all.

Despite the note of jealousy which Berthe always strikes when she mentions Eva Gonzalès, the two of them had clearly become, as it were, honorary members of the Batignolles group, and were to remain so for the rest of their lives. Eva, the daughter of a successful novelist, had first been the pupil of the Salon painter Charles Chaplin, renowned for his paintings of women and children, but since 1867 she had been a private pupil of Manet. Her contribution to the Salon of 1870 was *The little soldier* (Plate 160), a portrait of a 12-year-old bugle boy from a barracks near her home. Degas had painted a similar subject in the 1850s, and Manet's *The fifer*, which had been rejected by the Salon in 1866, was still hanging in his studio; an obvious influence. The critics were not slow to pick on this. Jules Castagnary, an embattled defender of realism, who was later to become Minister of Religion in Gambetta's government, and then Minister of Arts, commented:

It is very important for Mlle Gonzalès to leave Manet to his faults. She paints in a rather sombre manner and, like that artist, has a tendency to suppress the intermediate hues. This is a perilous slope at the end of which lies mannerism and not the sincere practice of art.

159 EDGAR DEGAS *Portrait of Madame Camus in red* 1869

160 EVA GONZALES *The little soldier* 1870

caricature that was ever seen. The carter was waiting to take it away, and he made me put it on the hand-cart willy-nilly. My only hope is that it will be rejected.

Then came the next hurdle, recounted this time by Madame Morisot, on 22 March:

Berthe must have told you about all the mishaps. Yesterday she looked like somebody who was going to have a breakdown. She worked herself to such a point on the last day before sending-in that she really could not see any more, and it seems that I made matters worse by telling her that the improvements Manet had made on my head seemed to me to be atrocious. When I saw her in this state, and when she kept telling me that she would rather be at the bottom of the river than have her work accepted, I thought it would be the right thing to ask for its return. I have managed to get it back, but now we're in a new predicament. Won't Manet be offended? He spent all Sunday making this pretty mess, and took charge himself of consigning it to the carter. It is impossible to tell him that the entry did not get there in time, since the little sketch of Lorient went with it. It would be puerile to tell this to anyone except you; but you know how the smallest thing here takes on the proportions of a tragedy because of our nervous and febrile dispositions, and God knows I have endured the consequences.

All this hysteria – and one must remember that it was probably repeated in the household of every artist who submitted works to the Salon – seems to have been ill-conceived, and indeed four years later Berthe included the portrait amongst the pictures she sent to the first Impressionist exhibition. There are no evident signs of Manet's interference and the resemblance to some aspects of his style in the figure of Madame Morisot, with its heavy black passages, is primarily meant as a counterpoint to the radiantly bright image of Edma (the picture was painted a week before the birth of her first child). In many ways it is more sophisticated in its treatment of light and colour than anything Manet himself had yet achieved.

Pissarro and Sisley had two works each accepted, including the latter's *The Canal Saint-Martin, Paris* (Plate 163), and although Bazille had only one work hung he wrote to his parents:

I am delighted with my exhibition. My picture is very well hung. Everybody sees it and talks about it. Often more bad than good is said about it, but at least I'm in the swim, and whatever I shall show from now on will be noticed.

It was not only his work which was noted. The 1870 Salon marked the emergence of the Batignolles group as a clearly defined body of painters, a fact that was emphasized by the success of Fantin-Latour's *A studio in the Batignolles Quarter* (see pp.129-30), a virtual apotheosis of Manet and his followers. Not that Manet's own works were well received: Albert Wolff, an inveterate enemy of his (Manet actually painted his portrait in 1877), wrote in *Figaro* about the portrait of Eva Gonzalès, 'It is an abominable and flat caricature in oils by a painter who produces coarse images for the sole purpose of attracting attention.'

On the other hand, the group received its first full-length panegyric by a man who was to produce in 1878 the first convincing book devoted to the group, and whose portrait Manet had painted two years earlier. Théodore Duret, Comte de Brie, owner of a cognac distillery, left-wing politician, President of the Vinegrowers' Society of Charente, journalist and art critic, was a relation of Courbet. In 1868, together with Zola and others, he had

In actual fact, Eva's picture was a good deal more sombre, and less lively, than Manet's vivacious rendering of the same theme. Viewers were, however, struck by its strength – after all, she was only 20 at the time – and the subject-matter appealed to a nation which, in view of the mounting threats from Prussia, was becoming more warlike. Within a few years, however, she was to be producing works such as *The morning awakening* (Plate 162), of a very different nature.

With one of her own contributions Berthe had experienced several problems. The picture was a double portrait of her mother and sister (Plate 158), and she described to Edma what happened:

Until this point my worries were not too bad; then, feeling rather tired and out of spirits, I go to see Manet in his studio. He asks me how things are, and noticing my indecision, says in high spirits, 'Tomorrow after I've got my own things off to the Salon, I shall come and see your picture, and believe me, I'll tell you what's got to be done with it.' The next day he arrives about one o'clock and says that everything's fine, except for the lower part of the dress. He takes some brushes and paints in a few accents. Mother is delighted. But here my troubles start. Once he has started, nothing can keep him back; from the skirt he went on to the bodice, from the bodice to the head to the background. He is full of a thousand jests, laughs like a child, hands me the palette and takes it back; finally by five o'clock in the afternoon we had made the prettiest

started a republican paper, *La Tribune française*. In May and June of 1870 he wrote a series of articles about the Salon for another left-wing paper, *L'Electeur libre*, in which he praised the works of Pissarro, unnoticed by anyone else, of Degas, and above all others of Manet, but said nothing about Renoir, Sisley or Berthe Morisot. On the other hand, Arsène Houssaye, a director of *L'Artiste*, who in 1867 had bought Monet's *The cradle, Camille and Jean* (Mellon Collection, Upperville, VA) and a nude by Renoir, showed a keen sense of the way things were going when he wrote in the magazine:

The two true masters of Manet's school, who instead of saying 'art for art's sake' say 'nature for nature's sake', are MM. Monet (not to be confused with Manet) and Renoir; two true masters, like Courbet of Ornans, by virtue of the brutal frankness of their brush. They tell me the jury has refused M. Monet; it had the good sense to accept M. Renoir. One can study the proud, painterly temperament which appears with such brilliance in *A woman of Algiers* that Delacroix could have signed it. Gleyre, his master, must be surprised to have fathered such a prodigal son, who makes fun of all the laws of grammar because he dares to establish a law of his own. Remember well then the names of M. Renoir and M. Monet. I have in my collection works by both of them which one day I shall give to the Luxembourg when that museum opens its doors to all opinions of the brush. In the meantime they arouse admiration, I shall not say among the French, who scarcely see anything except through convention, but among the Spanish and the English, who salute a painting where there is one, that is truth under the light.

What precisely Houssaye meant by that last sentence it is hard to say. Manet had visited Spain in 1865, and it had been noticed that his work showed Spanish influences, but there are no indications of what admirers, if any, he had in the Peninsula. In 1868 he had visited London, hoping to find possible support there but, although he wrote to Tissot, 'I was enchanted by London, by the good reception I was given by everyone I met. Legros was very friendly and obliging. The excellent Edwards[1] was

161 The Salon, caricature by Stock, 1870.

162 EVA GONZALES *Morning awakening* 1876

charming', and to Zola he wrote optimistically:

Some days ago I went to London, and was enchanted by my excursion. I was very well received, and I believe there is something there for me, and I am going to try it out next season. I met some extremely charming painters who invited me to their homes. They do not possess that kind of ridiculous jealousy that we find here in France; they are all real gentlemen. I feel that at the right moment we could circulate the brochure[2] here

nothing fruitful happened. In a letter to Degas he even suggested that he should join him for a short stay in London, but nothing came of that. None of his pictures were shown in England until the period between 1871 and 1875, when Durand-Ruel exhibited them, and it was not until the 1890s that one was sold to an English collector. The English may have been 'gentlemen', but they were pretty chauvinistic ones. As Ernest Chesneau pointed out some years later in his *The English School of Painting*:

It would seem as though English artists keep their studios closed by a portion of the Great Wall of China. They keep up a Continental Blockade, but it is against themselves. European art is a sealed book to them.

This, of course, was not entirely true. Fantin-Latour, Tissot and Legros had been well received; Meissonier, Rosa Bonheur and Millet were favoured by some English collectors and had books about them published there, but that was only because they were stylistically respectable. We have already seen Philip Hamerton's comments on *Le déjeuner sur l'herbe*, and Rossetti, often considered in England to be the leader of 'the modern school', dismissed Manet's work as 'mere sketches' in a letter to his mother, and 'simple putrescence and decomposition' in one to his brother, the critic William Michael.

The Salon had closed by 18 July 1870 when France, largely tricked by the manoeuvrings of Bismarck, declared war on Prussia. It was to be the first war of modern times, when whole nations marshalled by universal conscription fought each other with weapons perfected by new industrial techniques into killing instruments of an efficacy unknown

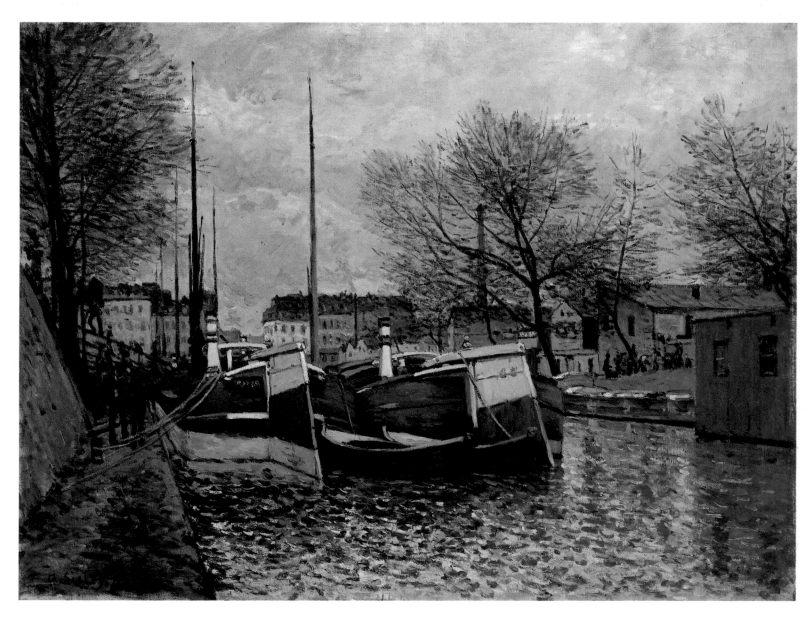

163 ALFRED SISLEY *Barges in the Canal St-Martin, Paris* 1870

before in human history. Victory went to the side which used most effectively such hitherto unexploited facilities as railway transport, the efficient organization of which by the Germans was largely responsible for the outcome. It came after less than eight months of fighting. The French suffered catastrophic defeats at Metz and Sedan, where Napoleon III surrendered with all his army and was taken to Germany as a prisoner. After a short siege Paris fell on 28 January 1871 and, by the Treaty of Versailles signed two months later, France lost Alsace (except Belfort) and part of Lorraine, her richest mineral provinces, and had to pay an indemnity of five billion francs, to secure the payment of which parts of the country stayed under German occupation.

Worse was to follow. Provoked by a series of repressive measures and called upon to surrender the guns which they had acquired to fight the Prussians, the citizens of Paris rose in a bloody insurrection and established a Commune. An organization which was at once idealistic and bloodthirsty – its adherents executed numerous 'hostages', including the Archbishop of Paris – it had unfortunate results for Courbet, who was elected a Representative of the People and became President of an Assembly of Artists. In the name of this he abolished the Academy in Rome, the fine art section of the Institut and the Ecole des Beaux-Arts. He also became involved in what all right-thinking people saw as a supreme act of unpatriotic vandalism, the destruction of the Colonne Vendôme, in the

Place of the same name: this monument had been erected in 1810 in honour of Napoleon's Grande Armée, created from 1,200 cannon seized from various enemies in the course of their campaigns, and Courbet, for no very clear reason, saw it as a monument to the oppression of the people.

The government forces, operating from Versailles, besieged Paris and eventually took it, although in the process the Tuileries, the Hôtel de Ville and the Cour des Comptes were destroyed. Thousands of Communards were executed or sent to penal colonies. Courbet was comparatively lucky. Ten days after the fall of the Commune he was arrested, imprisoned and condemned to pay for the reconstruction of the Colonne but, probably with the connivance of the authorities, escaped and took refuge first in Brussels and then in Switzerland, where he died of alcoholism six years later.

Apart from the death of Bazille, the most engaging of the whole Batignolles group, few had any really unpleasant experiences. When it became apparent that the Germans would besiege Paris, Manet sent his mother, wife and son to Oloron-Sainte-Marie, near Pau, in the foothills of the Pyrenees. He himself joined the National Guard, in which his commanding officer was the famous painter of battle scenes, Ernest Meissonier. He kept up a regular correspondence with his family, informing them of the vicissitudes of life in Paris; at first his letters are full of an easy optimism:

The Prussians give the impression of being sorry they undertook the siege of Paris. They probably thought the task would be easier. It is true we can no longer get milk in our coffee, that the butchers are only open three times a week, and that there are queues at their doors from four o'clock in the morning and that latecomers go away empty-handed. We no longer have more than one meal with meat.

Within a month, however, he struck a more sombre note:

We are now eating horsemeat. Even the flesh of mules has become a delicacy. But in spite of everything we seem to get along. One becomes dreadfully self-centred, we don't see anyone, all our personal relationships are cut off. It is boring and sad.

Even the Café Guerbois, to which he went sometimes, was getting 'pretty monotonous' and, despite the fact that he said that his knapsack was packed with everything ready for painting, he does not seem to have done any, though he did produce an etching of a queue outside a butcher's shop (Plate 165). When Paris capitulated he left on 12 February 1871 to rejoin his family, returning late in May in time to see the 'Bloody Week' of the suppression of the Commune, which prompted the drawing *The barricade* (Plate 166). Together with the lithograph *The civil war* this drawing was all that emerged from a more grandiose plan to paint a large canvas devoted to a Commune subject which he hoped to submit to the Salon of 1872.

The Morisots stayed on in their home at Passy despite appeals from Manet to leave, and Madame Morisot kept her daughter Edma informed of what was going on. On 18 October she wrote:

Each day we hear the cannon fire, and a great deal of it. All the fighting is taking place near us – so far without any important results. It is impossible to keep still. Berthe and I got as drenched as water-spaniels when we went to see a body on a stretcher, the victim of a fire on the viaduct. There are often disasters of this kind. For instance, two chemical plants across the river blew up only the other day. Degas was so affected by the death of one of his friends, the sculptor Cuvelier, that he was quite impossible. He and M. Manet nearly came to blows, arguing over the methods of defence, and the use of the National Guard, though each of them was prepared to die to save his country. M. Degas has joined the artillery, and by his own account has not yet heard a cannon fire. He is looking for an opportunity to hear that sound because he doesn't know whether he will be able to stand the noise of his own going off.

The spectacle of Manet and Degas disagreeing was a familiar one to any habitué of the Café Guerbois, but on one thing they were in accord, a feeling of pity for the Communards slaughtered after Paris fell to government troops in the May week of bloodshed. Madame Morisot, true to her type, was horrified by this humanitarianism and wrote from St Germain, where she had moved when the Commune was proclaimed, to Berthe, who by then was at Cherbourg: 'Tiburce [her son] met two Communards, MM. Manet and Degas, who are condemning the drastic measures being taken. I think that they're insane, don't you?'

Many of the people connected with the group were in fact hostile to the government and had made judicious disappearances: Tissot went to London; Duret embarked on a tour of the Far East and the USA, from which he was to bring back a cache of Oriental art; Zola, on the outbreak of war, had gone to Bordeaux as secretary to Glaize-Bizoin, a cabinet minister in Gambetta's government. Boudin and Diaz fled to Brussels, by now a favourite spot for French political refugees. Sisley, whose family was to be ruined by

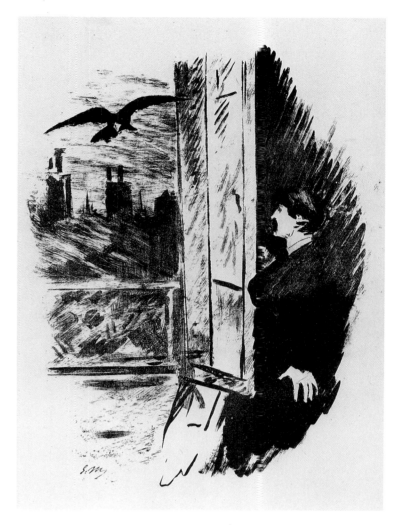

164 EDOUARD MANET *The raven at the window* 1875
Baudelaire had initiated the craze for the works of Edgar Allan Poe, and in 1875 the publisher Richard Lesclide produced, in an edition of 240 copies, Mallarmé's translation of *The raven* with lithographic illustrations by Manet.

the economic consequences of the war, and who was to spend the rest of his life dogged by poverty, stayed on at Louveciennes, despite his British nationality. Renoir had a comfortable enough time during the war and the Commune. On 19 July he had been called up into the Tenth Cavalry Regiment and posted to Libourne, near Bordeaux. There he developed a serious attack of dysentery and during his treatment and subsequent convalescence, as he later told Julie Manet, he 'stayed in a château where he was treated like a prince. He gave drawing lessons to a young girl and spent his days riding. They did not want to let him go in case he got killed.'

In fact, when he was recovered, he was posted to Vic-en-Bigorre, near Tarbes, and demobilized there on 10 March, his papers stating that 'he had conducted himself well for the duration of the war'. Returning to Paris he rented a room in the rue de Dragon on the left bank but was, unlike most Parisians, able to travel outside the city to sketch and to visit his parents at Louveciennes. This was due to a curious encounter, recorded many years later by the writer Paul Valéry. When he was working in the forest near Versailles in the 1860s, Renoir had come into contact with a man who was watching him paint, and then when he packed up started following him. On being questioned by the painter he confessed that he was a political journalist who was fleeing from the police after being sentenced to gaol for six months. Renoir's advice was, 'If I were you, I'd get hold of a box of paints, rent a room in Barbizon, and spend the days sitting in the forest, drawing and smoking cigarettes. Not a policeman in the world

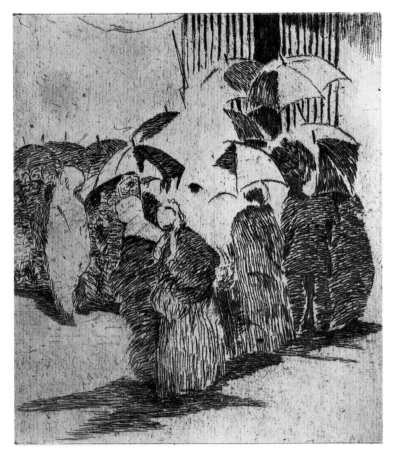

165 EDOUARD MANET *Queue in front of a butcher's shop* 1871
Manet was in Paris throughout the siege by the Prussians, when the food
situation was very serious. This, one of his most brilliant etchings, reveals,
especially in the patterns created by the umbrellas, the influence on his graphic
work of Japanese prints.

166 EDOUARD MANET *The barricade* 1871
Inviting comparison with Delacroix's *Liberty leading the people*, Manet's view of
an incident in the suppression of the Commune is more realistic, showing the
sense of confusion which actually prevails in such a context.

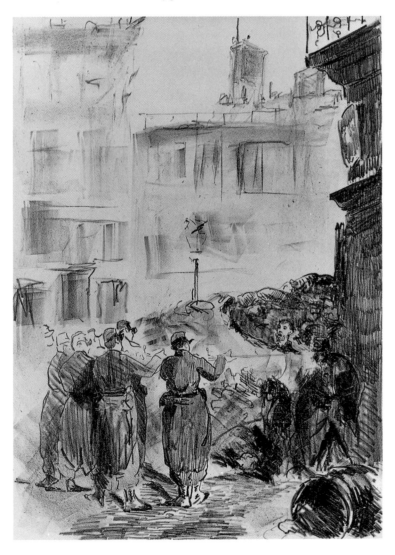

would dream of looking here for you.' The man thanked
him for the advice, gave him a card which read 'Raoul
Rigault, Correspondent of *La Marseillaise*' and disappeared.
Back in Paris in 1871, anxious to escape from the city to
paint in the surrounding countryside, he happened to pass
a photographer's which was showing portraits of leading
members of the Commune; amongst them he saw that of
his forest friend Rigault, who was now Prefect of Police,
and decided to pay him a visit. Rigault (who was later
executed) received him with open arms, toasted him in
champagne and gave him a pass which allowed him
complete freedom of movement both inside and outside
the fortifications.

Cézanne, when war broke out and he was not
immediately called up, went to the little village of
L'Estaque on the Mediterranean coast, some 30
kilometres from Aix. There he lived with Hortense and
painted, in an area to which he was to return time and time
again (see, for example, *View of L'Estaque and the Villa
d'If*, Plate 183). Zola described it in one of his novels:

When the sun falls perpendicularly to the horizon, the sea, almost
black, seems to sleep between the two promontories of the rocks, whose
whiteness is relieved by yellow and brown. The pines dot the red earth
with green. It is a vast panorama, a corner of the Orient rising up in the
blinding vibration of the day. But L'Estaque does not only offer an
outlet to the sea. The village, its back against the mountains, is traversed
by roads that disappear in the midst of a chaos of jagged rocks. Nothing
equals the wild majesty of these gorges hollowed out between the hills,
narrow paths twisting at the bottom of an abyss and slopes covered with
pines and walls the colour of rust and blood. Sometimes the defiles
widen, a meagre field of olive trees occupies the hollow of a valley, a
hidden house shows its painted façade with closed shutters. Then again,
paths full of brambles, impenetrable thickets, piles of stones and
dried-up streams, all the surprises of a walk in the desert. High above
the black border of the pines is placed the endless blue silk ribbon of the
sky. When this desiccated country gets wet it takes on colours of great
violence; the red earth bleeds, the pines have an emerald green hue, the
rocks have the whiteness of freshly washed laundry.

When the Imperial government fell, the Republic was
proclaimed in Aix on 4 September 1870. In the subsequent
elections Cézanne's 72-year-old father, who had virtually
retired from business, became a member of the finance
committee; he got Paul appointed a member of the
committee which looked after the museum and art school,
but he never attended meetings and so lost the opportunity
of filling the vacant post of curator, which was taken over
by the far more suitable Joseph Gilbert.

The experiences of Monet and Pissarro during the
troubles were very different from those of the other
members of the group, and were to have a more
important, if accidental, effect on its subsequent history. As
the Prussians advanced on Paris, Pissarro had to leave
Louveciennes, which was in their path, and took refuge
with his small family at the farm of Ludovic Piette at
Montfoucault in Brittany. (An ex-pupil of Couture and an
habitué of the Académie Suisse, Piette, whose paintings
were almost indistinguishable from those of Pissarro, was
to participate in the third and fourth Impressionist
exhibitions, but he died early in 1877.) After a couple of
months, however, Pissarro decided to go and stay with his
half-sister at 2 Chatham Terrace, Upper Norwood, one of
the prosperous suburbs which had grown up around the

Crystal Palace in south London. His mother accompanied him there. His arrival had been anticipated some three months before by that of Monet, who was living in Le Havre, virtually on the doorstep of England, and decided to go there in September 1870, leaving his wife and child behind. He rented a room at 1 Bath Place, Kensington, and soon found himself in financial difficulties.

The choice of London was, theoretically at least, a good one for them. Whistler, in this as in so many other matters, was an influential catalyst in the evolution of Impressionism, and was equally at home in London and in Paris. There was already a nucleus of French artists there: Tissot, who because of his political beliefs would have faced death or imprisonment had he returned to France; Alphonse Legros, who had been staying with Whistler's brother-in-law and patron Seymour Haden, dispenser of hospitality and patronage to French exiles, and who was teaching etching at the National Art Training Schools in South Kensington; Fantin-Latour, who had already started building up a small group of English patrons, as had François Bonvin. But most significantly for Monet, Daubigny, his hero and supporter, was also there.[4] He introduced him to Paul Durand-Ruel, who had left Paris and opened a gallery at 168 New Bond Street, and persuaded him to exhibit works by both Monet and Pissarro at an exhibition he mounted in the December of 1870. Durand-Ruel did not actually meet the latter until January of the following year, when he sent him the following note:

My dear Sir, you brought me a charming picture, and I regret not having been in the gallery to pay you my respects in person. Tell me please the price you want and be kind enough to send me others when you are able to. I must sell a lot of your work here. Your friend Monet asked me for your address. He did not know that you were in England.

Durand-Ruel had indeed been aware of the works of the Batignolles group for some time. In the magazine which he was then editing, the *Révue internationale de l'art et la curiosité*, he had commented favourably on the paintings of Manet, Degas and Pissarro when reviewing the 1870 Salon, and even had good words to say about Monet, although his works were not represented there. As a kind of front for presenting what works of art he had available for sale in England, he had founded a largely imaginary 'Society of French Artists', which included a Committee of Honour featuring some of the most famous artists of the day, and which gave its name to 11 exhibitions taking place in the Bond Street gallery between 1870 and 1875. These included a strange mélange of artists ranging from David Wilkie and Pauline Alma-Tadema to Delacroix and Ingres. But in them he also included works such as Fantin-Latour's *A studio in the Batignolles Quarter*, for which he, unsuccessfully, asked 500 guineas, Manet's *The fifer*, at 300 guineas, and Degas's *A false start at the races* (now at Yale University Art Gallery), at 100 guineas. In fact he showed works by the Impressionists at all these Society of French Artists exhibitions except the second one in the summer of 1871. Pissarro and Monet were often included, although the prices he asked for their works gave some hint as to his own estimation of their comparative value. In the 1872 exhibition Pissarro's (spelt Pizzarro in the catalogue) views of Norwood and Sydenham were priced at 25 guineas each and in the following year Monet's *Houses of Parliament* (Plate 167) at 30 guineas.

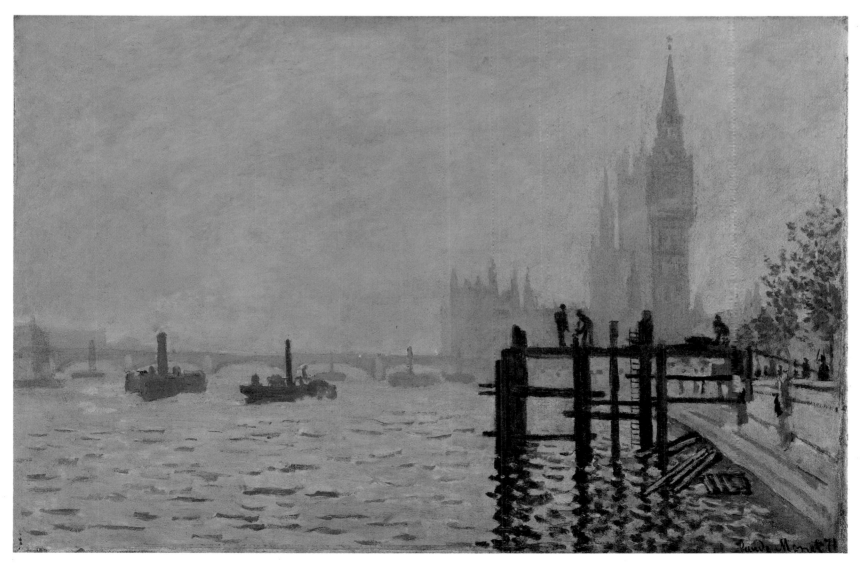

167 CLAUDE MONET *The Houses of Parliament* 1870/71

Both Monet and Pissarro were creatively active during their stay in London. Many years later, in 1906, Pissarro wrote to Wynford Dewhurst, the English critic, who was writing a book on Impressionism:

Monet and I were very enthusiastic about the London landscape. Monet worked in the parks, whilst I, living at Lower [sic] Norwood, at that time a charming suburb, studied the effects of fog, snow and spring [see *Dulwich College*, Plate 185]. We worked from nature. We also visited the museums. The watercolours and paintings of Turner and of Constable, the canvases of Old Crome have certainly had influence on us. We admired Gainsborough, Lawrence, Reynolds, etc but we were mainly struck by the landscape painters, who shared more in our aim with regard to *plein air*, light and fugitive effects. Watts, Rossetti strongly interested us among the modern men.

They could hardly have chosen a better time to study the effects of fog. The winter of 1870-71 was the worst of the century in London in this respect, and the presence of fog is very evident in Monet's view of the Houses of Parliament, which had been opened only the previous year, of Green Park and Hyde Park, and of the Pool of London. He himself, as he remarked to René Gimpel, liked the fog:

I like London much more than the English countryside. Yes, I adore London, it is like a mass, an ensemble, and it's so simple. What I like most in London is the fog. How could English painters of the nineteenth century have painted its houses brick by brick? These fellows painted bricks they couldn't see. I only like London in the winter.

168 CAMILLE PISSARRO *Penge station, Upper Norwood* 1871
In 1871 Pissarro and his family moved to London and settled in Upper Norwood. He painted several pictures here including this one, the precise location of which is the subject of some controversy. It is, however, almost certainly the station which later was known as Penge West.

In summer it's fine with its parks, but that's nothing beside the winter with its fogs, because without the fog, London wouldn't be a beautiful city. It's the fog which gives it its marvellous breadth. Its regular, massive blocks become grandiose in this mysterious cloak.

He was in fact to return to London on several occasions after his first visit, and to paint more pictures of it than any other non-British artist of repute has ever done.

Both Monet and Pissarro made unsuccessful submissions to the Royal Academy Summer Show but, as Pissarro ruefully noted, 'naturally we were rejected'. Thanks probably to Durand-Ruel's efforts they did have paintings on show in the French section of the International Exhibition at South Kensington in 1871, though they seem to have passed completely unnoticed, despite all the welter of comment in the English press on the exhibition as a whole. Durand-Ruel, who was living in a small house with a garden in Brompton Crescent, seems to have been extremely supportive, later writing in the brief autobiographical memoir printed in Lionello Venturi's *Archives de l'Impressionnisme* (2 vols., Paris 1939):

I was able to present a number of exhibitions which are still remembered by all men of good taste living in London, and which greatly helped to reveal to the English the talent of our fine artists. The money which I made from these enabled me to pay all my expenses, to support my family, as well as some painters who had taken refuge in London, and also to send some money to Millet at Cherbourg, J. Dupré who was at Cayeux, to Fromentin at La Rochelle and Diaz at Bonvin.

But the money he made must have been from the sale of works by older artists. There are doubts concerning the first Impressionist painting to have been bought by an English collector. Legros advised the businessman and

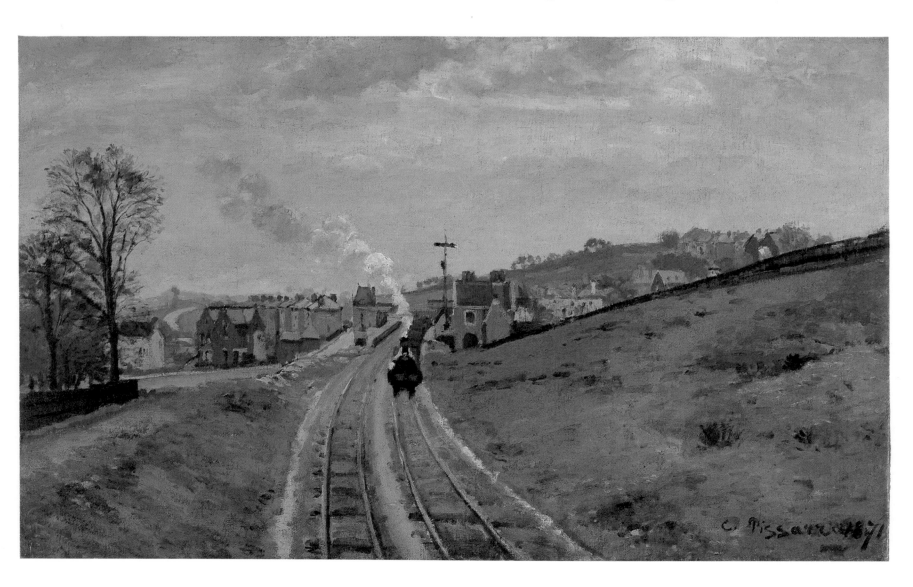

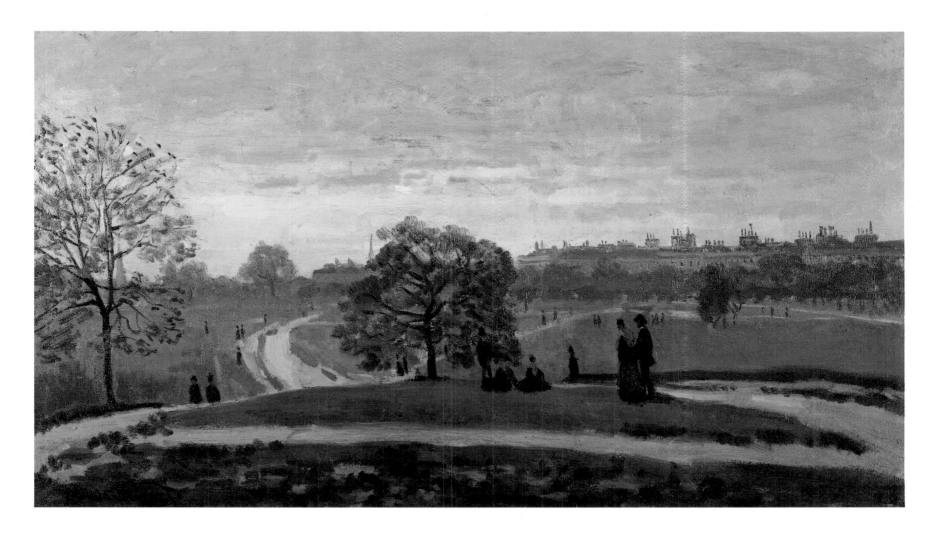

169 CLAUDE MONET *Hyde Park* 1871
During his visit to London, Monet painted two views of parks, two of the Pool of London, and one of the Thames near the Houses of Parliament. This view from the centre of Hyde Park is looking towards Lancaster Gate. He made considerable alterations to it later, adding the central tree, and partly obliterating two figures by a brush-stroke of lightly coloured paint.

connoisseur Constantine Alexander Ionides to buy Degas's *Ballet de Robert le Diable* at some date in the 1870s. The situation is complicated, however, by the fact that there are two versions, one of which was certainly bought by the American Henry Osborne Havemeyer at Durand-Ruel's 1872 exhibition, whereas the other, belonging to Ionides, was not painted until 1876. A competitor for the honour of being the first English collector of Impressionist paintings was a Brighton tailor, Henry Hill of Marine Parade, who owned no less than eight paintings by Degas, including *L'Absinthe*, which on his death was sold at Christie's in 1892 for the considerable sum of £180. Degas's near-academic and technically restrained style clearly appealed to the English in a way in which Monet and Pissarro's 'rougher' style did not, and they were not to be patronized in Britain to any extent until early the next century, long after they had been discovered by the Americans.

Pissarro, who had married Julie Vellay in Croydon, was a good deal less enthusiastic about England in general and London in particular than Monet had been, and when Duret suggested coming there had put him off in no uncertain terms, writing in June:

I'm only going to stay here for a short time, and count on returning to France as soon as possible. Yes, my dear Duret, I shan't stay here; it's only when one is abroad that one realizes how great, beautiful and hospitable France really is. It is very different here. One encounters only contempt, indifference and even hostility; amongst fellow painters there is the most selfish jealousy and resentment. Here there is no art; it's all a matter of money-making. As far as my private affairs are concerned, I've done nothing except with Durand-Ruel, who bought two small paintings from me. My work doesn't catch on at all here, not at all.

By July he was back in Louveciennes, to find most of the paintings he had left there gone. Monet too left England. not to return to his family but, probably on the advice of

Daubigny who had gone there earlier. to stay in Holland, where he remained until the beginning of 1872. There he painted a number of superficially picturesque views of windmills and Dutch towns, all of them in rather sombre, brownish colouring, but paying a great deal of attention to the varied and often complex sky effects to which the flat landscape gave special prominence, and emphasizing the subtle play of light on the waters of the canals.

By the end of the year the Batignolles group was back in residence, as it were, at the Café Guerbois. Monet and Boudin went to visit Courbet who, because of his health, had been transferred from prison to a nursing home, but the more radical members of the group, such as Manet, whose original political cynicism had been hardened by the suppression of the Commune into something more positive, took a dim view of Courbet's behaviour. 'His conduct before the War Council was that of a coward and he no longer deserves any attention,' he wrote to Degas. He himself, however, had every reason to feel elated. Durand-Ruel had become deeply interested in his work, and in January 1872 had paid a visit to his studio in the course of which he bought 23 paintings for the considerable sum of 35,000 francs. A few days later he came back and bought some more, including *Music in the Tuileries Gardens* (Plate 109). He was also buying or selling works by Sisley, Renoir (including the *Pont Neuf*, Plate 170, for which he paid 200 francs), Pissarro, Monet and Degas.

There was a change in the spirit of the times. The defeat

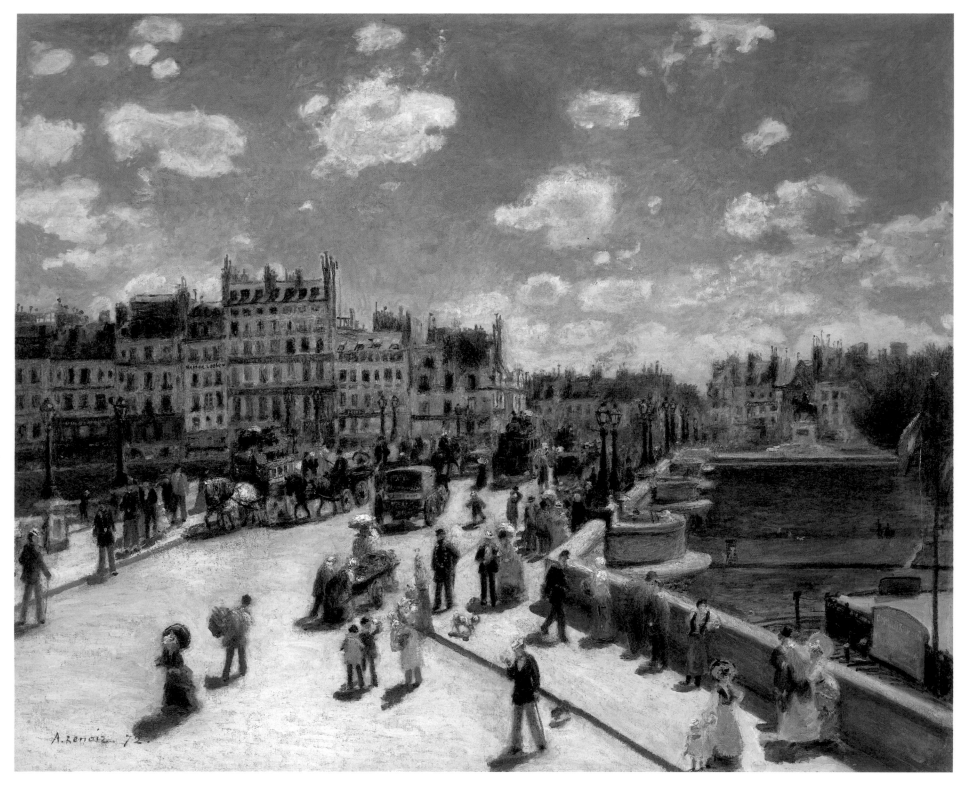

170 PIERRE-AUGUSTE RENOIR *The Pont Neuf* 1872

and humiliation of France led – as it would in the next century with Germany and Japan – to a positive sense of renewal and dedication. Within a remarkably short time France had paid off the indemnity to the Prussians, discovered new sources of mineral wealth, and established a cultural supremacy which was to last until the outbreak of the Second World War. The struggle to establish this moral victory was more explicitly realized than we are apt to think. The ghost of Colbert was clearly stalking the land, and it was hoped at first that the artistic grandeur presaged for the Third Republic would be achieved by the well-tried bureaucratic structures of the past. Charles Blanc, the founder of the Gazette des Beaux-Arts and an ardent republican, was made the first Minister of Fine Arts, a post he held for three years before becoming Professor of Aesthetic and Art History at the Collège de France. He started off by increasing the number of Prix de Rome scholarships and laying down that, as a condition of

their award, students should copy great works of art from galleries all over Europe, which would then be hung in a special museum to serve the same kind of purposes as the plaster reproductions of classical statues which proliferated in art schools. Nothing came of this, and in any case the growth of chromolithography and other graphic techniques for producing reproductions of great paintings made the scheme otiose.

Then Blanc turned his attention to the Salon. He abrogated the rule that those who had received *hors-concours* status (see p.81) should no longer be automatically admitted, and ruled that instead of all participating artists being able to elect the jury, they could only vote for a minority of members, all of whom had either to have won the Prix de Rome, or medals at previous Salons. The larger portion of the jury were members of the Institut. Inevitably, all this aroused great expectations for the first Salon of the new Republic, to be held in the spring

of 1872. In some ways they were fulfilled. There was a plethora of patriotic paintings depicting earlier wars which had been more successful in the outcome; the sculpture court was almost entirely populated with statues of Vercingetorix, Joan of Arc and other figures in French history more laudable than the deposed Emperor, now enjoying the questionable delights of Kentish suburbia. The band of the Paris garrison provided martial music to animate the breasts of visitors. But it had all been in vain. There was almost universal agreement that, as a vindication of a fresh spirit of creativity infusing French art with a new dynamism, it was a flop. 'Coming after the war and the terrible events of the past year the show should have had an exciting and novel make-up. Instead it is clearly entirely devoid of character. When you walk around the exhibition you can't tell what country you're in, or even what year it is,' commented Jules Castagnary, and other critics underlined the fact that there was nothing new or original, that French art had, in fact, run out of ideas, and that its quality was deteriorating. France was wanting, was needing, a new form of art.

This was a message which clearly offered some incentive to the members of the Batignolles group, only three of whom – Manet, Renoir and Berthe Morisot – submitted works, the others presumably being too occupied with the Durand-Ruel outlet to concern themselves with other points of sale. Renoir's submission, *Parisian women in Algerian dress* (National Museum of Western Art, Tokyo), was rejected, which was unexpected seeing that the artist had obviously painted it as a Salon-type picture, in effect a kind of paraphrase of Delacroix's celebrated *Women of Algiers* in the Louvre. It contains the last picture he was to paint of Lise Tréhot, the central figure in the work, who shortly afterwards married the architect Georges Brière de l'Isle. Manet's contribution was unusual, *The battle of the 'Kearsage' and the 'Alabama'* (Plate 171), which he had painted some eight years earlier. In view of the expectations which had been aroused by the Salon, it is interesting to find one critic, the dandified novelist Jules Barbey d'Aurévilly (1808-89), writing of it:

I have been affected in looking at this painting with a sensation which I didn't think Manet capable of giving me; a feeling of nature and landscape which is both simple and powerful. Here, in making this picture – a picture of war and aggression – he has conceived and executed it with the tension of a man who wants by any possible means to escape from the frightful conventionality in which we are all immersed. Whatever is most original, whatever has been in reach of every brush since the world began, has been expressed by Manet in his painting of the *Kearsage* and the *Alabama*.

It was natural that Manet, having spent some of his early life at sea, should have been interested in a naval action of this kind, though he did not see it himself, despite the fact that he was in Boulogne at the time; he apparently relied on newspaper reports, pictures and photographs. The affair had received a great deal of publicity, which probably explains why he decided to record it. The *Alabama* was a British-built ship, manned by a mainly British crew and provided with coal and other supplies from Britain, but captained by Raphael Seemes from Maryland on behalf of the Confederate government, with the mission of destroying as many Unionist ships as possible. She was extremely

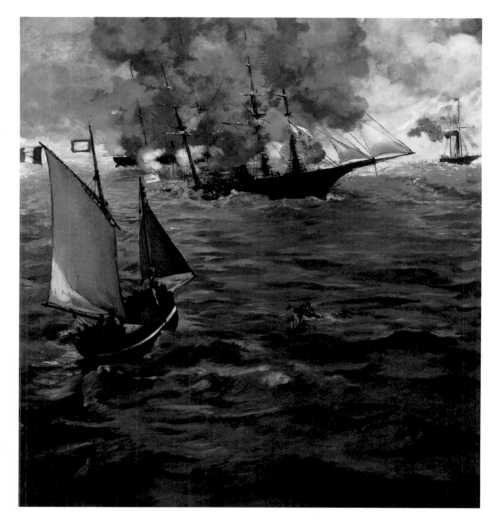

171 EDOUARD MANET *The battle of the 'Kearsage' and the 'Alabama'* 1864

successful, and sank, burned or captured 58. To cope with this menace, the Unionists dispatched the *Kearsage* under Captain John S. Winslow, which came up with the *Alabama* as she was coaling in Cherbourg harbour, but was not allowed entry. Seemes then sent word to the *Kearsage*, which was anchored outside territorial waters, that he would offer combat as soon as coaling was completed. Battle commenced at 10.57 on 11 June 1864. The *Alabama* was sunk, with nine of her men killed in action, ten drowned and 21 wounded, all in sight of a vast crowd assembled on the cliffs at Cherbourg. Perhaps the most remarkable thing about the painting is that it is entirely conceived within the limits of the sea, with no suggestion that the event might have been witnessed from land. It was one of the large batch of works which Durand-Ruel had purchased from Manet, and was lent to the Salon at the artist's request.

In the summer of 1872, after the Salon had closed, Manet paid one of his periodic visits to Holland, where he spent a good deal of time in Haarlem studying the work of Frans Hals. Largely ignored during the eighteenth century, Hals had been rediscovered in the 1850s as a master of 'realism'. His work achieved considerable popularity as the result of the publication by Wilhelm Bürger (alias Théophile Thoré) of a book in 1858 about the museums of Holland. A friend of Baudelaire, Courbet and Manet, who in 1864 gave him a still life, *Peony stems and pruning shears* (Musée d'Orsay), Bürger was especially struck by the freshness, spontaneity and realism of Hals's paintings, noting especially *The jolly toper* in the Rijksmuseum, Amsterdam. On his return from Holland, Manet decided to paint a modern version of this. *Le bon Bock* (Plate 172) was clearly designed to be a work of the sort which would attract the favourable attention

of the Salon jury, as indeed it did, and it was hung there the following spring. In some ways it was an easy work to do because, although it was a portrait, it was also a genre painting in the tradition of the Dutch school and had just enough contemporary relevance about it to attract the favourable attention of many differing shades of artistic opinion. At the time there was considerable controversy in France about the respective merits of beer (a 'bock' was a glass of beer, usually strong, measuring a quarter of a litre) and wine. The former had been growing in popularity for some time,[5] to the annoyance of the considerable wine lobby, which advocated the merits of their product as a patriotic and 'manly' drink. Emile Bellot, the subject of the picture, was clearly — as the girth of his stomach indicates — not only a devotee of beer, but a printer and engraver who published a weekly journal for the licensed trade, *Le bon Bock*, financed by the breweries; for this he engraved a version of Manet's picture on the mast-head. He was also an habitué of the Guerbois. Manet's most sanguine expectations must have been realized by the response of the critics. Paul Mantz wrote in *L'Artiste*:

Manet is an artist, and we are delighted to observe that the public has returned to more friendly feelings and has this year given him an unusual reception. With his resources unusually restricted, the painter has known how to obtain a sufficiently rich and complex harmony. What he has also discovered is a perfect revelatory pose which in itself expresses the whole personality of the sitter. He has caught a moment which encapsulates a whole lifetime.

Théodore de Banville invoked his old friend Baudelaire:

This painting is fine, sensitive and charming in colour. It is truth itself, apprehended so it would seem in a moment of luminous improvisation,

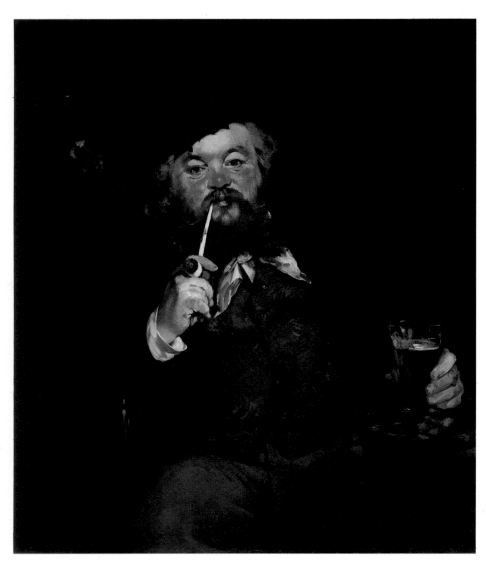

172 EDOUARD MANET *Le bon Bock* 1873

or so it would seem did one not know how much knowledge and study is needed to create works which blossom so spontaneously and effortlessly. Baudelaire was indeed right to have such a high opinion of Manet's painting, for this painstaking and sensitive artist is perhaps the only one in whose work one discovers that subtle feeling for modern life which underlay the exquisite originality of the *Fleurs du Mal*.

The painting was bought by the singer Jean-Baptiste Faure (1830-1914), a close friend of Durand-Ruel, mainly through the contact they had in London where he had a house, and who was to be one of the main patrons of the group during the next few decades.

Paul Mantz's reference to a restricted palette did not apply to all that Manet was doing at this time. There can be little doubt that his work was being influenced by that of Berthe Morisot and by his gradual conversion to *plein-air* painting. Typical of this new approach was *The railroad* (Plate 193), which he was painting in the autumn of 1872 when Philippe Burty, in an article about visits to artists' studios, wrote:

The swallows are gone. The artists return. Manet has in his studio a not quite finished picture, a double portrait he sketched outdoors in the sun. A young woman wearing the blue twill that has been so fashionable this year is the main figure. Motion, sun, clear air, reflections, all give the impression of nature, subtly grasped and finely rendered.

The woman was Victorine Meurent, the model for *Déjeuner sur l'herbe*, *Olympia* and many other pictures (see p.83); the child, whose back is to us, is the daughter of Alphonse Hirsch, in the garden of whose house overlooking the Gare St-Lazare the picture was painted. There could not be a more complete contrast with the sober solidity of *Le bon Bock*. The presence of the railway and the Gare St-Lazare, which was to play a significant role in the iconography of Impressionism, especially in the works of Monet, is indicated rather than described by the luminous effulgence of the great cloud of steam from a passing train and the implied sense of excitement emanating from the figure of the child as she watches it. The colours are brilliant, and the composition remarkable to a degree which must have seemed to contemporaries the merest eccentricity. The dominant iron railings insistently divide the picture into twelve sections, and this approach may have been influenced by Utamaro's woodcut of c.1795, *Young women at the inn*, which shows two girls in front of an equally emphatic articulated fence. More than any other of Manet's works it underlined his relationship to the Batignolles group, and the fact that it was accepted for the Salon of 1874, and on view there throughout the duration of the Impressionist exhibition in the rue des Capucines, emphasized his relationship to the works exhibited there. Jules Claretie, the art critic of *Le Temps*, made the point as clearly as anyone:

I really wonder whether M. Manet is out to win a wager when I see at the Salon a sketch such as the one he calls *The railroad*. M. Manet is one of those who believe that art can and should stop short with the *impression*. For that is the whole secret of the *impressionalistes* – they rest content with shorthand indications, dispensing with effort and style.[6]

The protests about the Salons of 1872 and 1873 had been so vigorous, and the desire to revivify French art so strong in official quarters, that it was decided in the latter year to

173 CLAUDE MONET *Camille (Woman in green)* 1866
Camille Doncieux, Monet's mistress and later his wife, gave birth to their first
child in 1867. When he painted this portrait of her he had just lost his allowance
from his aunt and was at the beginning of a very penurious period. Camille
seems to have been a rather mournful character, as this portrait implies.

resurrect Napoleon III's idea of having a Salon des Refusés.
This one opened on 15 May 1873 in a wooden barracks
behind the Palais de l'Industrie where the Salon was
showing. It was a great public success in terms of atten-
dances, but many of the originally rejected artists did not
participate. As far as the Batignolles group was concerned
the only significant work was Renoir's *A morning ride in
the Bois de Boulogne* (Plate 174), a large and impressive rather
than appealing work intended to catch the eye of those
socialites, whom Renoir was not slow to cultivate, who
wished their portraits painted. Renoir's really important
work was going on at Argenteuil, a small village 15
minutes' train ride from Paris. Originally dependent on
agriculture and the manufacture of plaster of Paris, it had
expanded to become both a suburban retreat and a
considerable industrial centre, given over to boat-building
and other commercial ventures. Its two sections were
united by a rail bridge and a road bridge spanning the
Seine, and it boasted a jetty at which coal barges were
loaded and unloaded. Its profile was pierced by several
factory chimneys, which the Impressionists were to depict
or omit entirely according to their varying compositional
whims in the numerous pictures they painted of the place.

Monet had rented a small house there at the water's edge
early in 1872, and started to give vent to a newly acquired

passion for gardening which was to stay with him for the
rest of his life. There he was frequently joined by Renoir, to
whom at this period he had become very close, and the
experiences they had painting together were influential in
the evolution of their individual styles and in the formation
of Impressionism itself. The summer of 1873 was a
particularly glorious one, and they frequently painted the
same scenes, expressed in tiny brush-strokes palpitating
with light and colour, which seemed to fall on the canvas
like a shower. At no other time in their respective careers
were their works so alike. In fact, in 1913 when two of their
paintings of the same subject – ducks swimming in a pond
– turned up at Durand-Ruel's, neither artist was able to
identify which was his. They both painted pictures of each
other painting in the garden of Monet's house at Argenteuil.
Renoir's (Plate 176) shows his friend against a clump of
multi-coloured dahlias, the bright shades of which are
enhanced by the yellow and grey colours of the houses in
the background, just as they set off the effulgence of the
light clouds, faintly tinged with the yellow of the late
afternoon sun. The preoccupation with light and sunshine
which exercised them both during what must have been
an idyllic period is conveyed by Monet with special brilliance
in the painting of the front of his house (Plate 175), with
Camille standing in the doorway and the diminutive figure
of a straw-hatted Jean holding his hoop in the carriageway.
The brush-strokes are as light and flickering as in the
Renoir picture, but there is a sharp distinction between the
detail of the foliage and the almost perfunctory handling
of other elements, such as the figure of Camille and the
blue flowerpots ranged along the front of the house. The
output of both artists during this summer at Argenteuil

174 PIERRE-AUGUSTE RENOIR *A morning ride in the Bois de Boulogne* 1873

179

175 CLAUDE MONET *The artist's house at Argenteuil* 1873

was prodigious, and in Monet's case continued to be so throughout the following winter. Never before apparent had there been so overwhelming an urge to express a visual experience in pictorial terms, translating the reality of this experience into intense, pure, prismatic colours, unadulterated by imaginary conceptual shadows.

During this period Renoir also worked closely with Sisley who, under the economic pressures brought about by the collapse of his father's business, was becoming at once more reclusive and more firmly dedicated to exploring the innovations which his friends were making. He was especially interested in the changes which the time of day and the seasons exerted on the same places (see Plate 186, *Snow at Louveciennes*). He too was a frequent visitor to Argenteuil, and Manet bought a painting he did of the bridge there (Plate 180).

Despite the fact that he was prominent in the Batignolles' gatherings at the Café Guerbois and was known there as

'the aesthetician' because of the complex clarity of the ideas which he enunciated, Degas did not share with Monet, Renoir, Pissarro and Sisley the passion for landscape which was driving them to the pragmatic exploration of new techniques. He was essentially an urban man, and the countryside usually came into his orbit only as the background to some human activity of a generally sophisticated kind. Typical of this is the *Carriage at the races* (Plate 179), which was bought by Durand-Ruel. It figured in the 1872 exhibition of the Society of French Artists in Bond Street, London, where it was highly praised in the pages of the *Pall Mall Gazette* by Sidney Colvin, Slade Professor of Fine Art at Cambridge and later the recipient of a knighthood as keeper of the department of prints and drawings at the British Museum. Small in scale, it was to be one of the artist's favourite works, and he showed it at the first Impressionist exhibition, borrowing it from Faure, who had bought it the previous year. The curious com-

position shows his friends the Valpinçons in their carriage against a wide Norman landscape near Exmes which, both in appearance and the way in which he has painted it, is reminiscent of the English landscape and of English landscape painters, the greenness being given an additional intensity by the velvety blackness of the carriage and the whiteness of Mme Valpinçon's dress and parasol.

He was, however, turning more avidly to themes which would largely obsess him for the rest of his life. Shortly before the outbreak of war he produced what even his usually critical father described to the originator of the work as 'a finished work, a real painting'. *The orchestra of the Opéra* (Plate 178) started off as a portrait of Désiré Dihau, chief bassoonist at the Opéra, whom Degas had known for some time and with whose family he was very friendly. Throughout his life he was a devotee of the opera and, of course, of the ballet, and in this richly complex painting he created not only a portrait of an individual player but a composite picture of the whole magic of a musical form. It is, in effect, not a picture of the actual orchestra. The figures surrounding Dihau are personalities from the music world of Paris, including the composer Emmanuel Chabrier, a friend of Manet, the Spanish singer Lorenzo Pagans, the cellist Louis-Marie Pilet, Louis Souquet, another composer, and Dr Pillot, a physician and amateur musician. Unlike other group portraits, however, Degas has here managed to present Dihau prominently, yet at the same time make convincing portraits of all the other participants, without imposing on them the constrained looks evident, for instance, in Bazille's portrait of his family on the terrace of his home.

Prominent in the painting and adding a counterpoint to the faces of the engrossed musicians in *The orchestra of the Opéra* is the brightly lit stage, with its group of ballet dancers. This was a theme to which Degas was being increasingly drawn. The ballet had played a significant role in French social history since at least the seventeenth century, and was considered musically an essential part of any opera. But for long one of its main functions had been as a source of sexual stimulation and supply for the wealthier classes. Nowhere else was there such an acceptable way of seeing young women, untrammelled by the inhibiting clothes of everyday life, performing gyrations which displayed their limbs and their agility to erotic advantage. When the Emperor attended the ballet, in addition to the public box he occupied, he had a more private one with peepholes giving directly onto the stage, and slots through which he could get an intimate view of the dancers in their more unguarded moments. To have a season ticket to the opera was considered essential to anyone who set himself up as a dandy or man about town. Since the time of Daumier, a stock image for cartoonists had been that of lechers of varying ages drooling over the *corps de ballet*. Subscribers to the principal *loges* had access to the corridors and dressing-rooms, and a popular work by Eugène Chapus, *Le sport à Paris*, first published in 1854, described the scene backstage:

Despite the measures which are being taken to thin out the crowds of visitors backstage at the Opéra, all that has really happened has been the elimination of a few journalists, librettists and composers. There is no room here for professional interests. But it is quite different if you

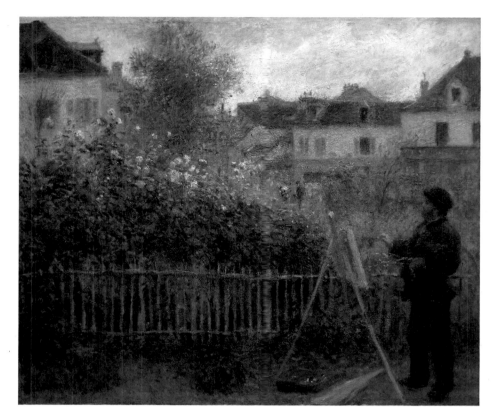

176 PIERRE-AUGUSTE RENOIR *Claude Monet painting at Argenteuil* 1873

happen to be a financier, an investor with chamois gloves, a stockbroker, a rich foreigner, a diplomat, an embassy attaché, a man of the world in high repute. Alternatively you have free access if you have influence in high places, or can manufacture for yourself a real or fictitious title, or if you are the uncle of a dancer or her protector, or keeper. Many respectable citizens whom one thinks of as being occupied all the time with weighty business, many financiers whom one thinks of as spending their time in their clubs smoking and playing whist, many diplomats whom one thinks of as circulating constantly in high society are there finding a pleasurable and out-of-this-world refuge behind the scenes at the Opéra.

Degas certainly had influence. His friendship with the Dihaus was only one avenue; another was through his close friend Ludovic Halévy, who wrote the libretto of Bizet's *Carmen* as well as several for Offenbach, and was a high-ranking civil servant who had much to do with the control of the Opéra – his uncle, the composer Fromental Halévy, had been leader of the chorus there. Degas himself had met Bizet when both were students in Rome, and he counted among his friends opera habitués such as the Vicomte Lepic, painter and engraver, who exhibited at the first and second Impressionist shows and of whom he painted a memorable portrait (since destroyed) walking in the Place de la Concorde with his two daughters. He also came to know several dance instructors such as François Mérante and Jules Perrot.

Degas's first important ballet picture, *The dancing class* (1871/2, Plate 177), was painted shortly after the publication of Halévy's *Madame Cardinal*, the first of a series of stories about two young dancers, Pauline and Virginie Cardinal, and their bourgeois family. When the stories were published in book form in 1877, Degas was to provide the illustrations. Painted in oil on wood, this small picture, which was to be included in the first Impressionist exhibition, shows a rather dingy room in the old Opéra in the rue Peletier, with a group of dancers practising individual steps. The central figure, with her back to the mirror, is Joséphine Gaujelin, who posed several times for Degas in

his studio. The dancing master, with his violin at the ready, holds a handkerchief which he will drop when he is ready for her to begin her exercise. Apart from the fact that his name was Gard and that he appears in *The orchestra of the Opéra*, nothing is known about him. The rather sombre light which illumines the room, the massing of the figures into the left of the picture to display a large area of floor, the intense patches of blackness comprising the piano and Gard's suit as well as the traditional watering-can, used to dampen the floor and so improve the dancers' grip, gives the work something of the intensity of a Flemish interior.

Shortly after painting *The dancing class*, Degas made a brief visit to London, staying at the Hotel Conte in Golden Square, visiting Tissot, Legros and Durand-Ruel. He apparently established some kind of contact with Agnew's, the Bond Street dealers, which he was to pursue intermittently for the next year or so, though eventually nothing came of it. In the autumn of 1872 he undertook a more enterprising excursion upon a visit from his brother René, who was established as a cotton broker in New Orleans, their mother's native city. The two of them travelled to Liverpool, where they embarked on the *Scotia*, arriving in New York 12 days later. 'Crossing on board an English boat is dull. It was even more uninteresting for me, who could not take advantage of the few acquaintances René made,' he wrote to his father. Despite seasickness, however, he made some lively sketches of his fellow-travellers. After a brief stay in New York, they took a train for New Orleans. Degas was flabbergasted by the sleeping-cars; he wrote to Dihau:

You must have heard of the Wagon-Lit, but you have never travelled in one, you have never slept in one, and so you cannot imagine what this marvellous invention is like. You lie down at night in a proper bed. The carriage, which is at least as long as two French ones, is transformed into a dormitory. You even put your shoes at the foot of the bed, and a kind negro polishes them whilst you sleep.

In another letter to Tissot — in which incidentally he expresses regret at not having met Millais: 'tell him of my appreciation for him' — he recounted the visual pleasures he found in New Orleans:

Villas with columns in different styles, painted white, in gardens of magnolia, orange trees, banana trees, negros in old clothes like the junk from *La belle Jardinière*, or from Marseilles, rosy white children in black arms, charabancs or omnibuses drawn by mules, the tall chimneys of the steamboats towering at the end of the main street, that is a bit of colour if you want some, with a brilliant light everywhere too which hurts my eyes. Everything is beautiful in this world of people. But one Paris laundry-girl with her bare arms would be worth it all for such a convinced Parisian as myself. The right way is to concentrate oneself, and one can only do this by seeing little. I am doing some family portraits, but the main thing will be after my return.

Few of the works he did there have survived — two portraits of his sister-in-law (in the National Gallery of Art, Washington, and in Copenhagen), and a picture of some of his nephews and nieces sitting on the steps of their house (Plate 181). The 'main thing', however, was achieved before he left New Orleans for Paris in March 1873, and he seems to have postponed his return just to finish it and another on the same subject, now lost or destroyed. One of the main incentives for painting *Portraits in an office*[7] (Plate 191) seems to have been to tempt Agnew's, which had started in Manchester, and at this time still maintained a branch there. Degas no doubt thought that a 'cotton' subject would attract a rich Lancashire magnate from that capital city of cotton. He unburdened himself to Tissot on 18 February 1873:

Having wasted a lot of time at home trying to paint portraits of the family in the worst possible conditions I have ever known or imagined, I have got myself harnessed to the task of painting a large picture, destined for Agnew, which he should be able to sell in Manchester, for if ever a cotton spinner has ever wanted to find an artist I must be the one. [It is called] *Interior of a cotton-buyer's office in New Orleans*. It shows some 15 people, most of whom are doing business around a table covered with the precious material; two men, one leaning over it, the other half-seated, the buyer and the broker, are discussing a sample.

After saying that he was painting another version, Degas went on:

If Agnew takes both off me, so much the better, but I do not want to leave here for Paris for another fortnight or so, which is the length of time it will take me to finish the picture. But it cannot travel with me. To shut up for 14 days or more a painting which is hardly dry would mean that the yellows would turn chrome. I cannot therefore bring it to London myself, or send it until at least April. Keep these gentlemen in good humour for me therefore until then. In Manchester there is a rich cotton-spinner named Cottrell, who has a considerable collection. He's just the kind of character who would suit me, and would suit Mr Agnew even better. But we mustn't count our chickens before they're hatched, and be discreet about the whole thing.

A group portrait, in the tradition of *The orchestra at the Opéra*, *Portraits in an office* is one of Degas's great masterpieces, arranging with consummate skill a large number of people without any apparent sense of contrivance. The figure in the left foreground is Michel Musson, the brother of Degas's mother and the owner of the establishment. Behind him is René Degas, reading the local newspaper, and beside him his brother-in-law William Bell; on the extreme left with his legs crossed, propped against a hatch, is Degas's other brother Achille. On the right-hand side of the painting, poring over a large ledger, is the cashier Jean Livaudais, and behind René Degas, in a beige jacket, is James Prestidge, Michel Musson's partner. An assortment of minor characters in the background

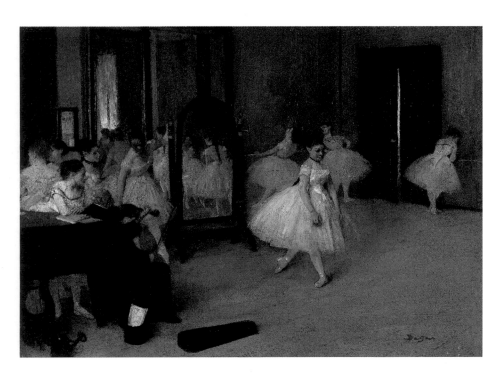

177 EDGAR DEGAS *The dancing class* 1871/2

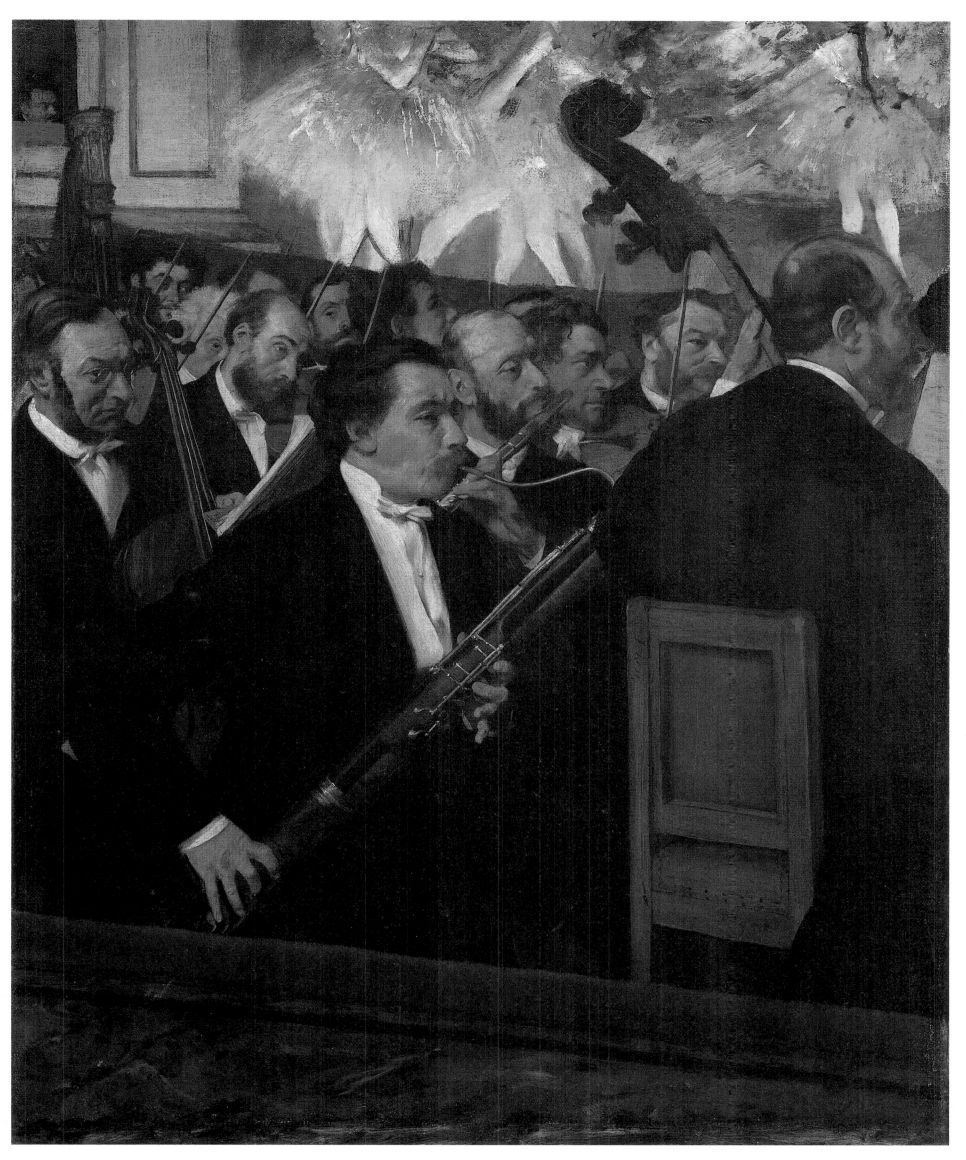

178 EDGAR DEGAS *The orchestra of the Opéra* 1868

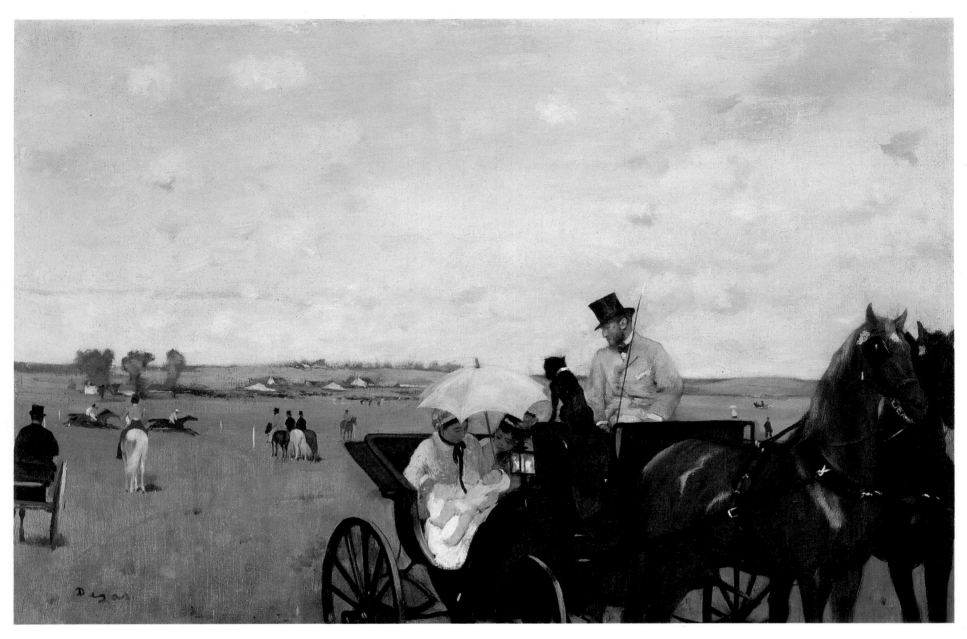

179 EDGAR DEGAS *Carriage at the races* 1872

brings the number of people in the picture up to the 15 mentioned to Tissot. When it was first exhibited at the second Impressionist exhibition in 1876, reactions were mixed. Armand Silvestre described it as 'a completely *spirituel* painting' (there is no English equivalent for the sense in which he is using this word, which implies wit, elegance, sprightliness and similar qualities). Many criticized it for its photographic qualities, its academic finish, or its dullness as a subject. This could have been expected of a critic such as Albert Wolff, already an enemy of the Batignolles group, as he was to continue to be when they became 'Impressionists', but Zola's reactions were unexpectedly hostile:

This painting is very much taken with the delights of modern life, of everyday life as it is lived behind closed doors. Boredom is what spoils all when it comes to putting the finishing touches on a work of art. Degas's best works are his sketches. When he comes to finishing anything in detail, his drawing becomes flabby and deplorable. He paints pictures such as his *Portraits in an office in New Orleans*, which are half-way between a marine painting and a coloured picture in a magazine. His artistic vision is admirable, but I fear that his brush will never become truly creative.

From the master of detailed literary realism this was a curious reaction. Perhaps what he was objecting to was the fine finish and lack of that 'roughness' which was beginning to mark the work of various other members of the group

such as Monet, Sisley, Renoir and above all Pissarro.

Whatever the opinions of Zola and other hostile critics, *Portraits in an office* had a fortunate future, becoming the first of Degas's works to enter a public collection. It was exhibited in 1878 by the Société des Amis des Arts de Pau, on the initiative of one of his friends, the collector Alphonse Cherfils, who had been born in that city, and whose son was later to dedicate a book of poems to the painter. Although he was paid the comparatively modest sum of 2,000 francs, Degas was delighted.

About a year after his return to Paris Degas was visited by a writer who more than any other could claim to have been the first exponent of literary realism, and was very like him in many ways. The 53-year-old Edmond de Goncourt recorded the event in his meticulous *Journal*:

Yesterday I spent the afternoon in the studio of a painter named Degas. After many experiments, many bearings taken in every direction, he has fallen in love with the modern, and for modern subjects he has decided to paint laundresses and dancers. I cannot find his choice bad, since I, in *Manette Salomon*,[8] have spoken about these two professions as being those that provide for a modern artist the most picturesque models of women in our time. Degas presents us with pictures of laundresses, whilst speaking their language and explaining to us the techniques of ironing, the straightforward down-pressing, the circular sweeps of the iron and the like. Next dancers file by. In the foyer of a dancing school, against the light from a window, fantastically silhouetted dancers' legs are descending a small staircase with the brilliant scarlet of a tartan in

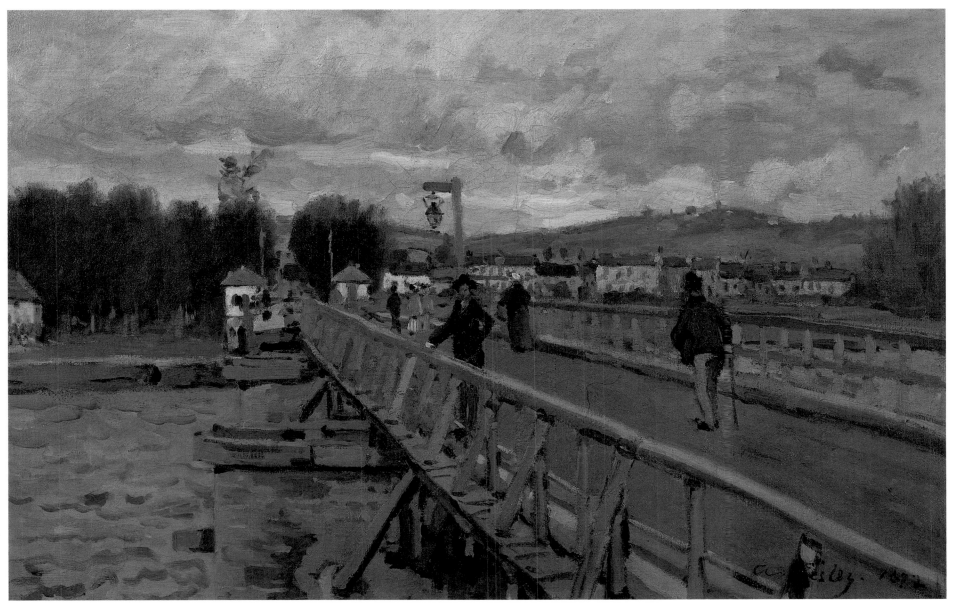

180 ALFRED SISLEY *The wooden bridge at Argenteuil* 1872

the midst of all this billowing cloud of tutus. [This is a description of *Foyer de danse*, Plate 260].

The artist shows you his pictures from time to time, adding to his explanation by mimicking choreographic progressions, or by imitating one of their arabesques in the style of the dancers. It really is very amusing to see him, his arms akimbo, imitating at the same time the attitudes of the dancers and the dancing masters. What an original fellow this Degas is, sickly, hypochondriacal, with such delicate eyes that he is always frightened of going blind, and just because of this sensitive to the other side of life. Nobody I have ever seen so far has been more successful in portraying modern life and its very soul.

181 EDGAR DEGAS *A courtyard in New Orleans* 1872

1 Edwin Edwards of Sunbury, a friend of Whistler and Fantin-Latour.

2 A pamphlet about Manet written by Zola.

3 Joseph Cuvelier, who had been killed at Malmaison, was a mediocre sculptor who specialized in horses, and who gave Degas a good deal of help in his first essays in this medium.

4 Daubigny had previously visited London in 1866, when he had sketched the Crystal Palace, and painted a small picture of the Embankment under construction and a view of paddle-steamers on the Thames.

5 Partly because the loss of Alsace-Lorraine had stimulated a drive for the products associated with that province, such as beer and choucroute.

6 It is an interesting comment on Manet's reaction to photography that he had a photograph taken of the painting which he then proceeded to colour in watercolour (Durand-Ruel Collection, Paris).

7 It is often known as *The Cotton Exchange in New Orleans*. Actually the place is the office of Michel Musson, at 63 Carondelet Street.

8 *Manette Salomon* was written in 1867, and was a novel about the life of artists. Its hero Coriolis painted modern subjects. However, it contained no references to dancers and only one to a laundress. There was a good deal of rivalry between Degas and the writer. The former once described his work as 'style Goncourt', and the latter, according to William Rothenstein, resented Degas's belief that writers drew inspiration from artists.

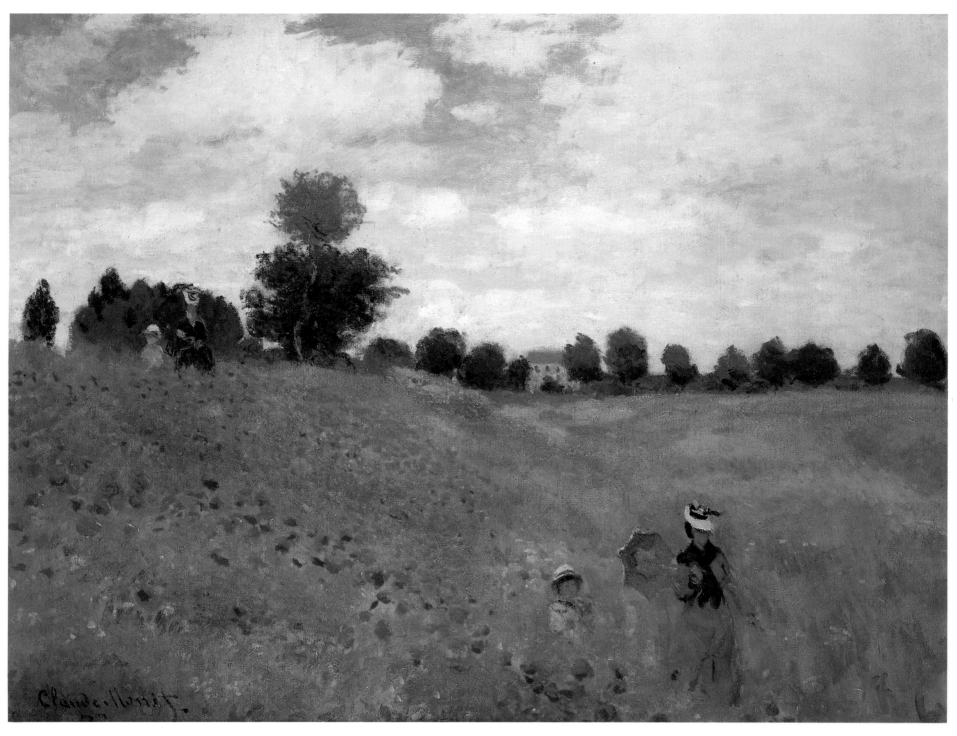

182 CLAUDE MONET *Wild poppies* 1873

Poppies were to play a very important role in Monet's iconography. Although this image of them was finished in time to feature in the first Impressionist exhibition, he reverted to the theme in the 1890s, painting a whole series of views of the poppies in the field around his house at Giverny. This early version of the theme does not differ greatly from the later ones except that the row of trees in the background gives the work a more dramatic effect. The figures in the foreground are in some ways a pictorial irrelevance: what gives the painting its real beauty is the skill with which he has realized the shimmering effulgent glow of the poppies, radiant in the grass.

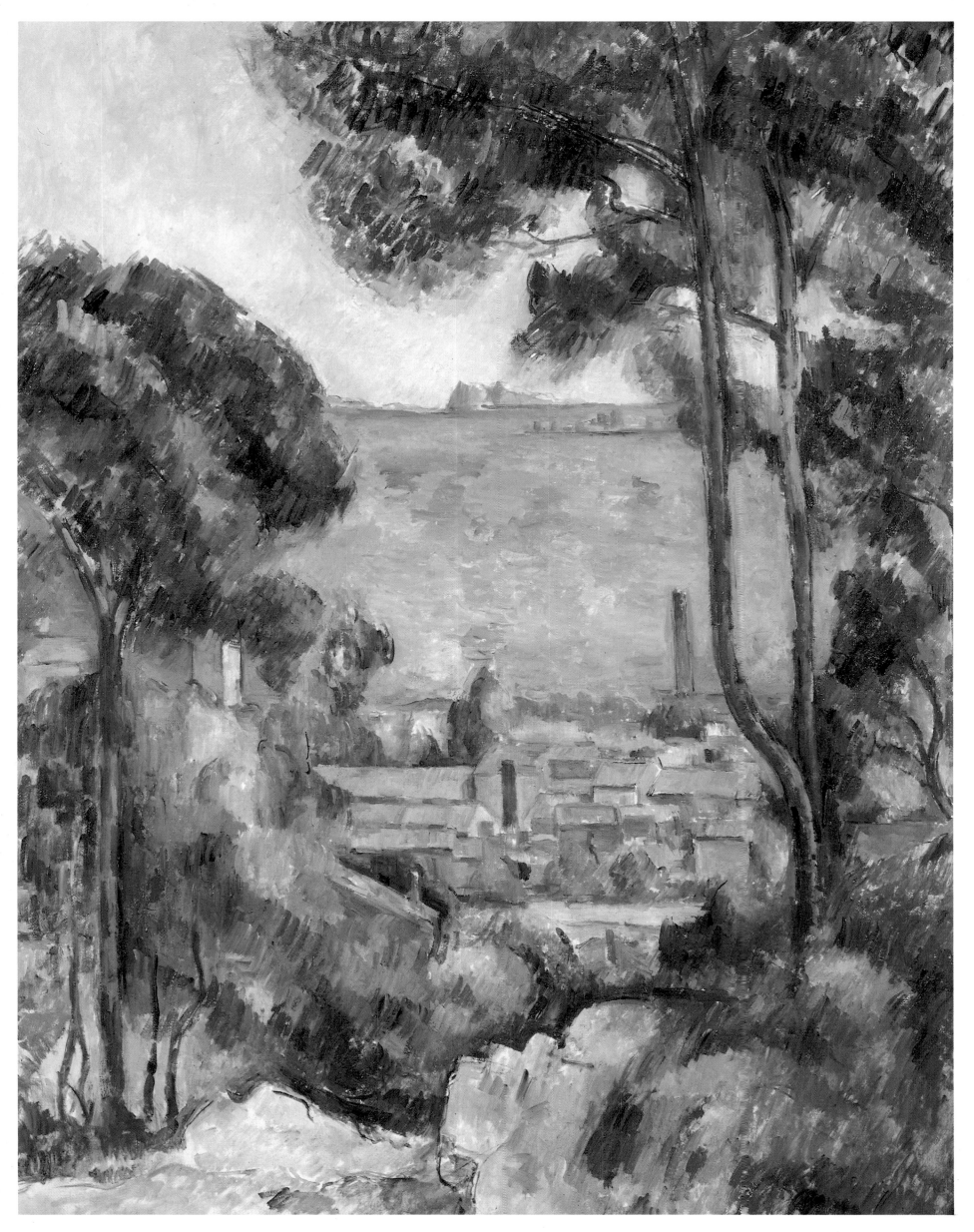

185 PAUL CEZANNE *View of L'Estaque and the Villa d'If* 1884

184 PAUL CEZANNE *Mont Sainte-Victoire from Bellevue* 1885
The viaduct provides a counterpoint to the twisting road which meanders
through the valley to the same disappearing point in the picture.

185 CAMILLE PISSARRO *Dulwich College* 1871

*In the summer of 1870 Pissarro, with Julie Vellay and their two
children, moved to London, where he had a half-sister, and took
up residence in a house in Upper Norwood. He painted several
pictures of the neighbourhood, including this view of the
recently built Dulwich College, one of the sights of the area,
described as 'the most florid Victorian school in London'.
Designed by the son of the architect of the Houses of Parliament,
it shared with Harrods, the department store, the dubious
distinction of pioneering the use of red encaustic tiles for building
purposes. The painting is one of the most emphatically
Impressionistic that Pissarro had so far produced, and the
influence of Monet is apparent, especially in the treatment of the
surface of the water.*

186 ALFRED SISLEY *Snow at Louveciennes* 1874

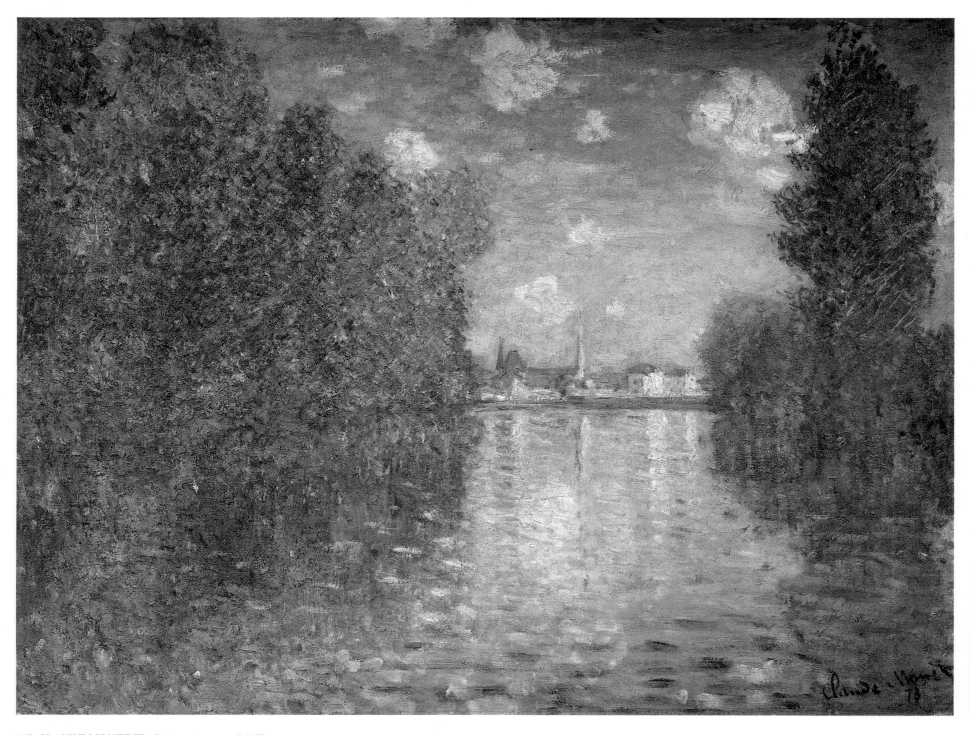

187 CLAUDE MONET *The Basin at Argenteuil* 1872
An example of Monet's skill at conveying differing impressions by tonal effect.
The deep greens of the trees and bushes are in striking contrast to the pellucid
light of the cloud-flecked sky.

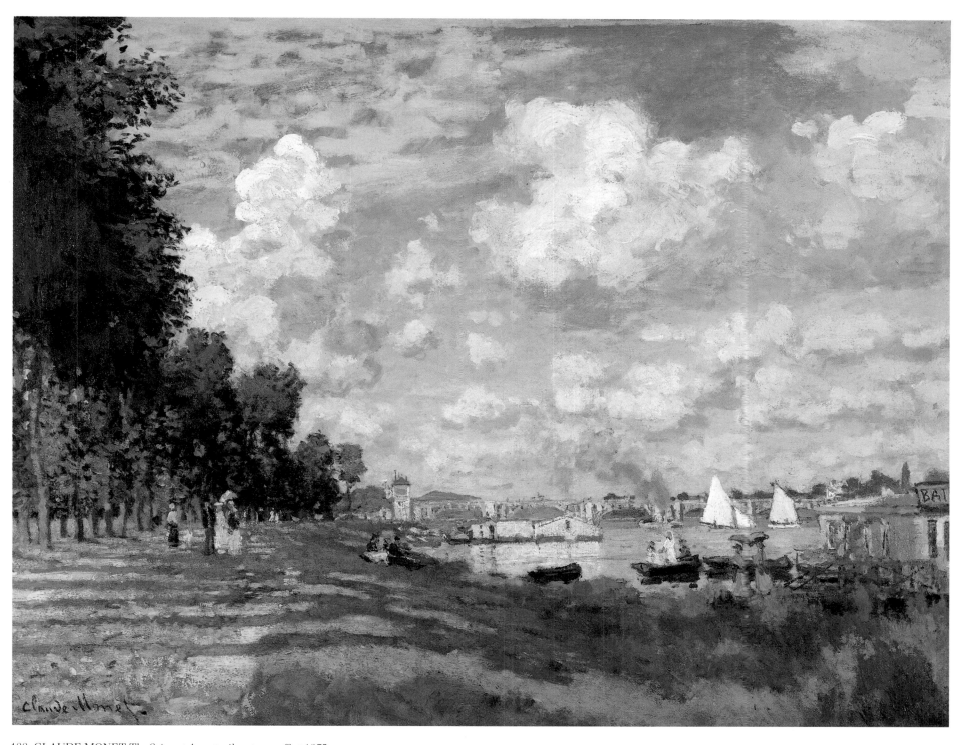

188 CLAUDE MONET *The Seine at Argenteuil, autumn effect* 1873
A preoccupation with the effect of time on landscape, which was to lead to the
great Series paintings at the end of the century, became manifest in Monet's
work at quite an early period. This is predominantly a view of the Seine; the
church of Argenteuil can be seen in the background.

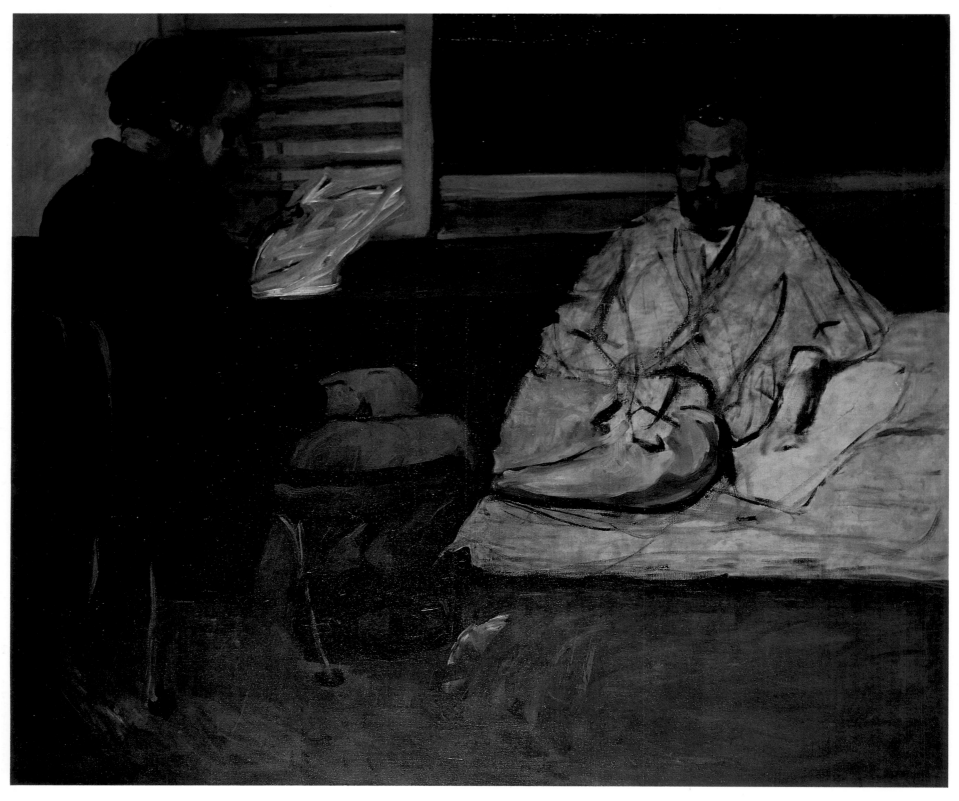

189 PAUL CEZANNE *Paul Alexis reading to Emile Zola* 1869

During this period Cézanne was very much involved in painting portraits of his circle. Here he chose two of his oldest friends. Paul Alexis, born in Aix-en-Provence in 1847, was a writer, playwright and critic, who had always been close to him since their schooldays, and was an impassioned defender of the Batignolles group and later the Impressionists. Zola's friendship with Cézanne had also been maintained since their early days in Aix. When Cézanne painted this portrait of him, he was already working in the Bibliothèque Nationale, amassing material for that projected series about life in contemporary France which was eventually to consist of the 20 novels about the fictitious Rougon-Macquart family. Cézanne's portrait makes an interesting contrast to that painted a year earlier by Manet (Plate 90).

Napoleon III's ill-fated attempt to make Maximilian, brother of the Austrian Emperor Franz-Josef, ruler of Mexico under French tutelage, came to a tragic end on 19 June 1867 when he was shot by the nationalist forces. France was deeply stirred by conflicting emotions of guilt, anger and humiliation. Manet, hostile to the Imperial government, more interested in the depiction of current happenings than any of his fellow Impressionists and anxious to make a name for himself as a chronicler of contemporary history, worked on the subject for more than a year, eventually producing four versions: besides this, one in the National Gallery, London, one in Copenhagen and one in Boston. He also did a lithograph which was suppressed by the censor, provoking an angry outcry in the press, led by Zola. Deeply influenced by Goya's The Third of May, which he had seen in the Prado, Manet, who always yearned for official recognition, saw this work as being in the great tradition of historical painting, a very un-Impressionist attitude.

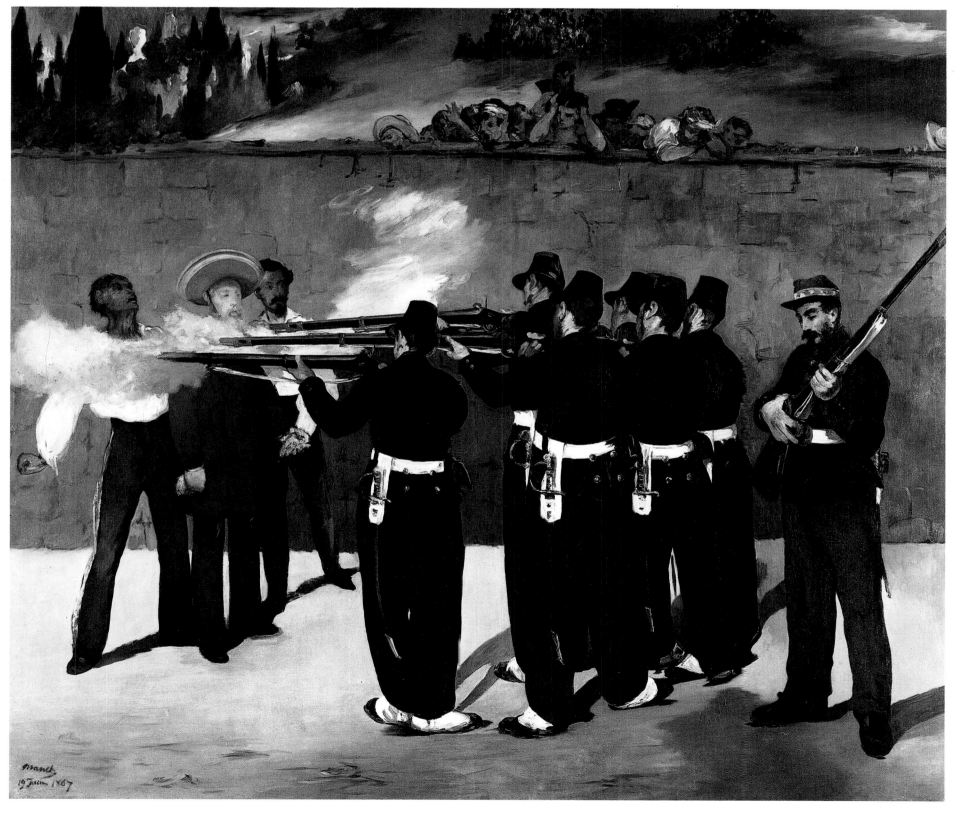

190 EDOUARD MANET *The execution of the Emperor Maximilian 1868*

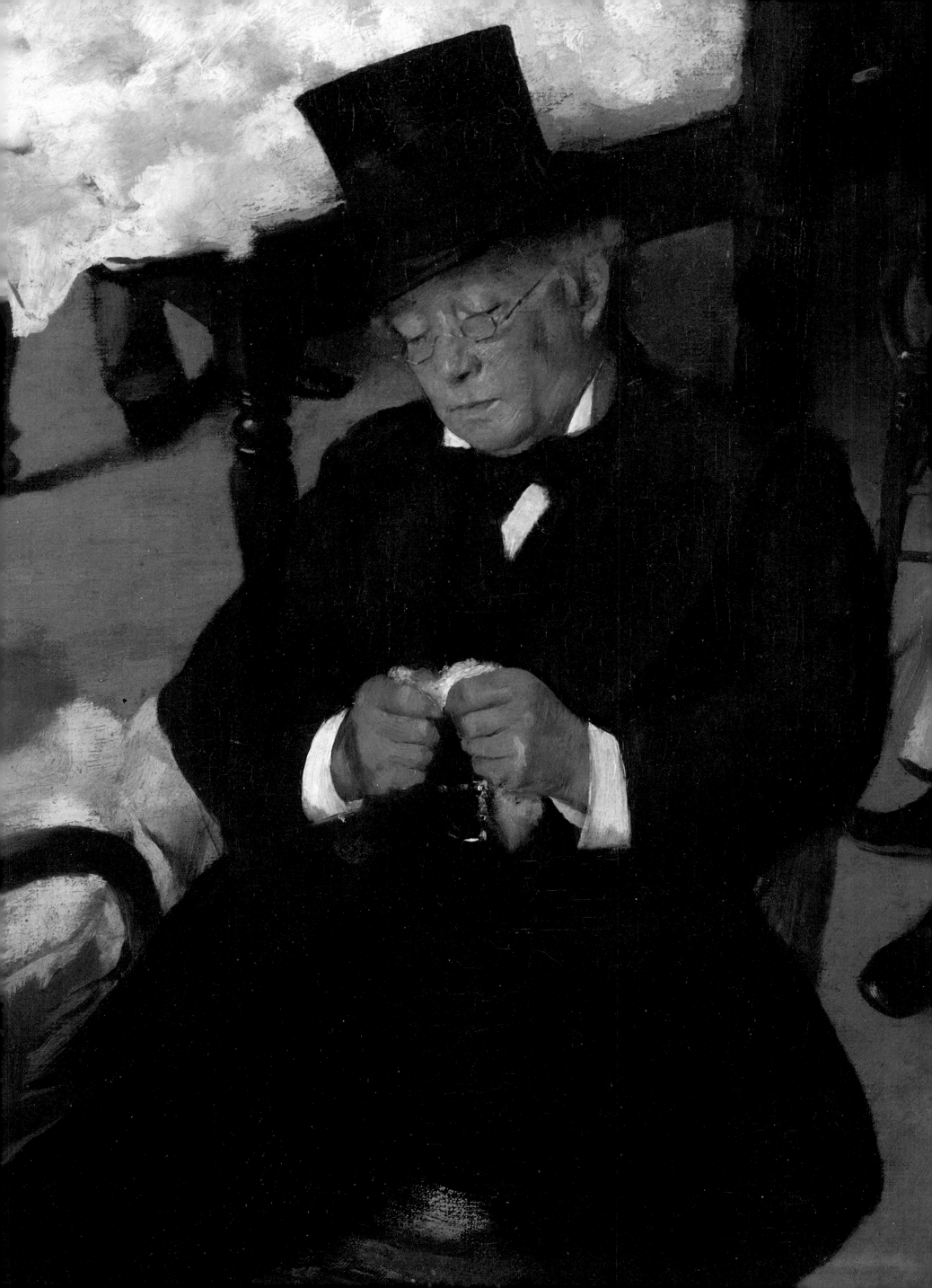

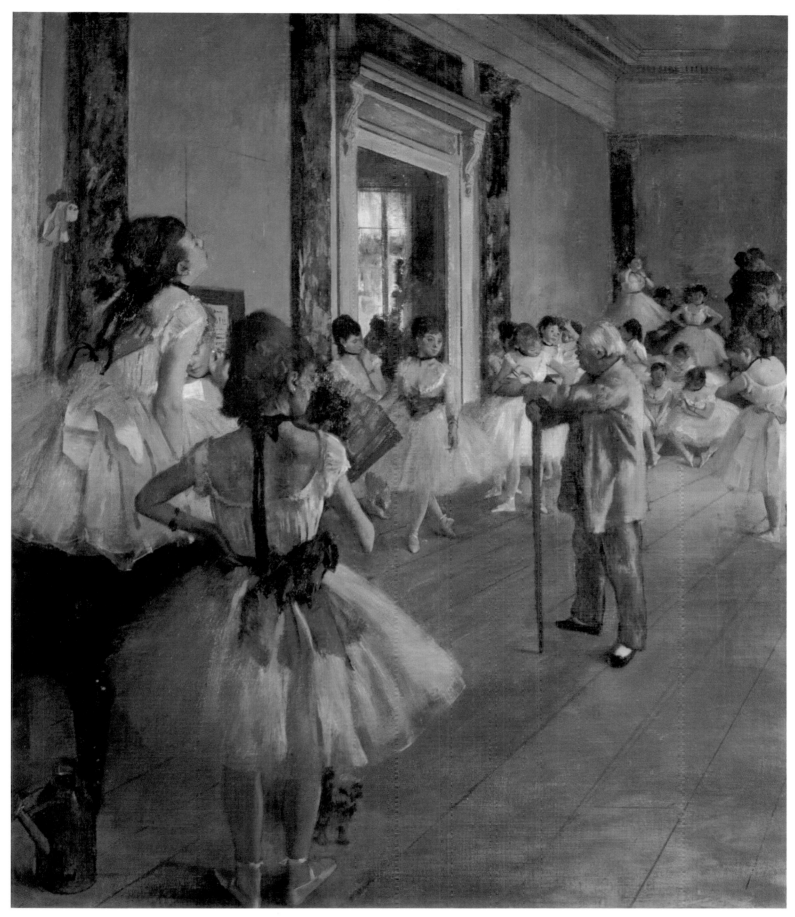

192 EDGAR DEGAS *The dance class 1873-5*

*This is the first large-scale ballet painting which Degas
undertook, and he seems to have had considerable difficulties
with its composition; X-ray pictures show extensive re-painting,
especially of Jules Perrot, the* maître de ballet. *The whole
picture is bathed in a pale light which accents the marble lintel
and door-frame. It has been noted that this must be the end of
the class, for hardly any of the dancers are looking at the
instructor, but are adopting various relaxed poses. This was one
of the series commissioned by the singer Jean-Baptiste Faure in
1873.*

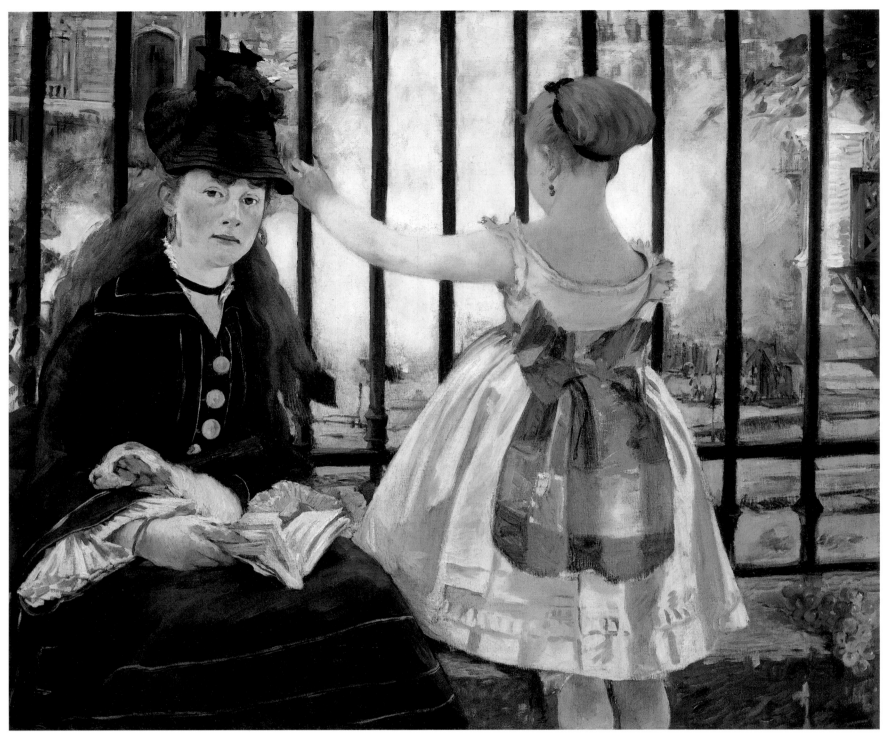

195 EDOUARD MANET *The railroad* 1872-3

The theme of a woman at her toilet, in one form or another, has been common in European art since the Renaissance, although it has sometimes been disguised by mythological trappings. To the nineteenth century, however, with its more widely diffused erotic interest, a woman's toilet proved an irresistible attraction, featuring in the paintings of both academic and progressive artists as well as in the novels of Gautier, Zola, the Goncourts, Flaubert and Maupassant. It had a special appeal to realists because it showed the intimate underpinning of the façade that women presented in public. Unlike the works of Degas, and later Toulouse-Lautrec, both of whom could be virtually sadistic in their approach to the theme, Morisot's exudes an air of gentle adolescent self-regard, closer perhaps to Proust than to Zola. Psyche was, after all, the personification of the human soul in the shape of a beautiful young girl; it was also the name given to the type of mirror seen in the picture. Quite apart from its subject-matter, the painting is a remarkably skilful exercise in depicting the effects of light, the texture of diaphanous materials and the quality of reflexions in a mirror.

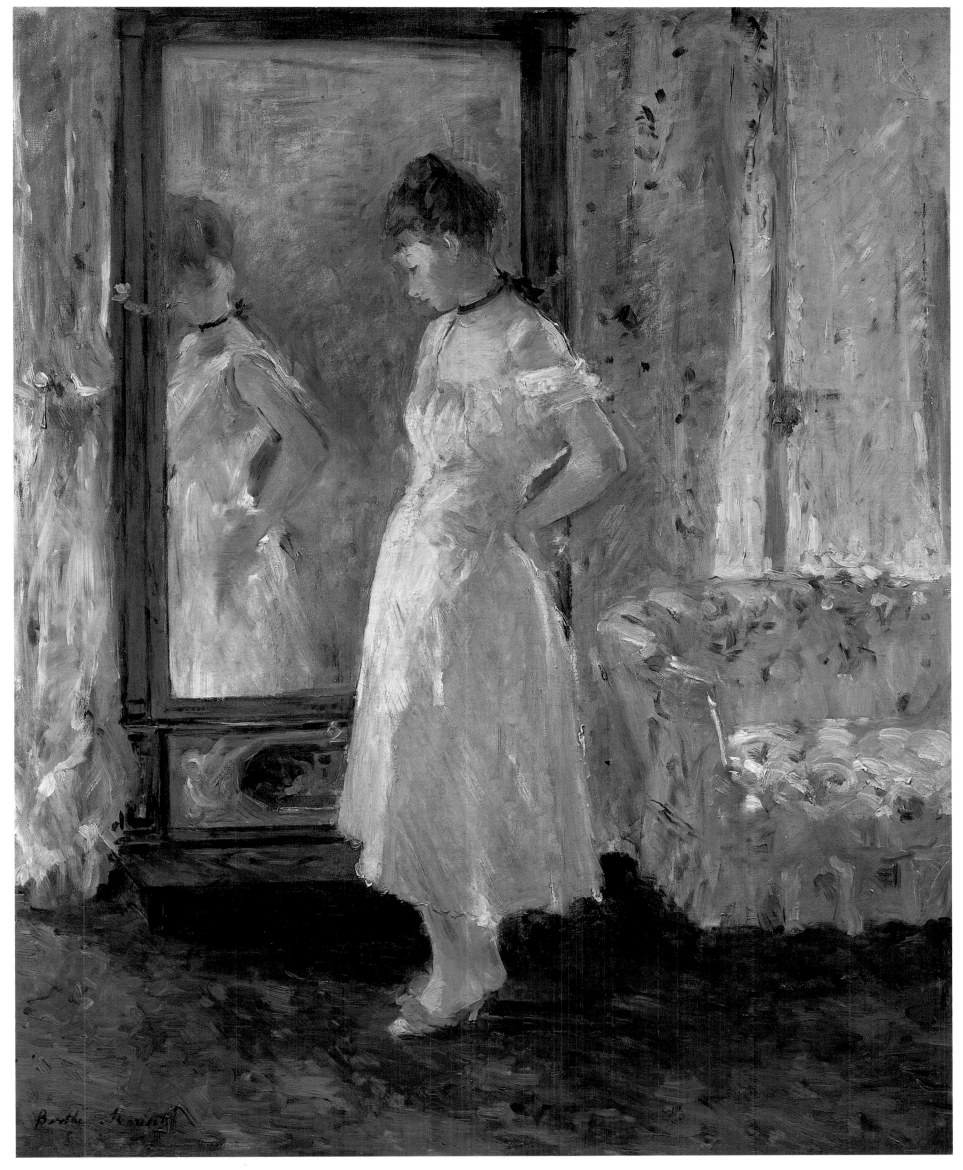

194 BERTHE MORISOT *Psyche* 1876

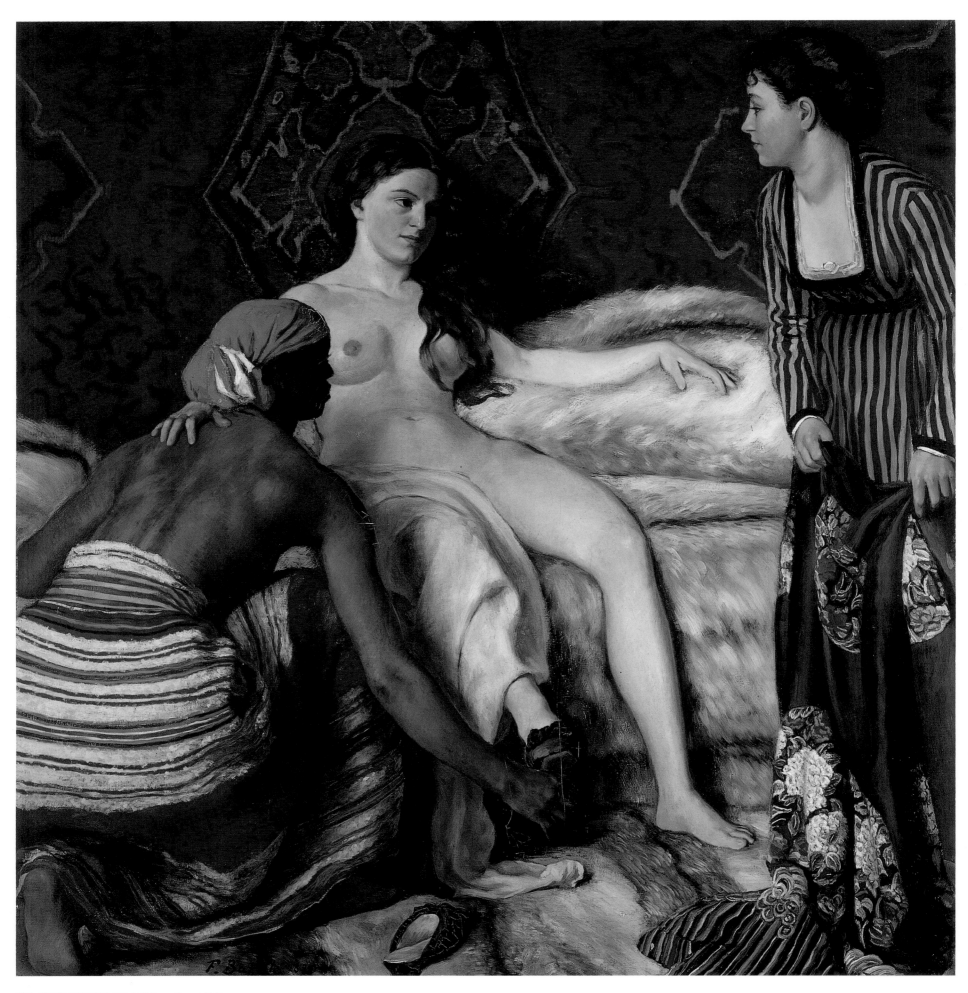

195 FREDERIC BAZILLE *La toilette* 1870
Strongly reminiscent of the style of Delacroix, this sumptuous painting was
rejected, strangely enough, by the Salon jury of 1870. It was probably painted at
Bazille's parents' home near Montpellier, and invites comparison with Renoir's
Bather of the same year.

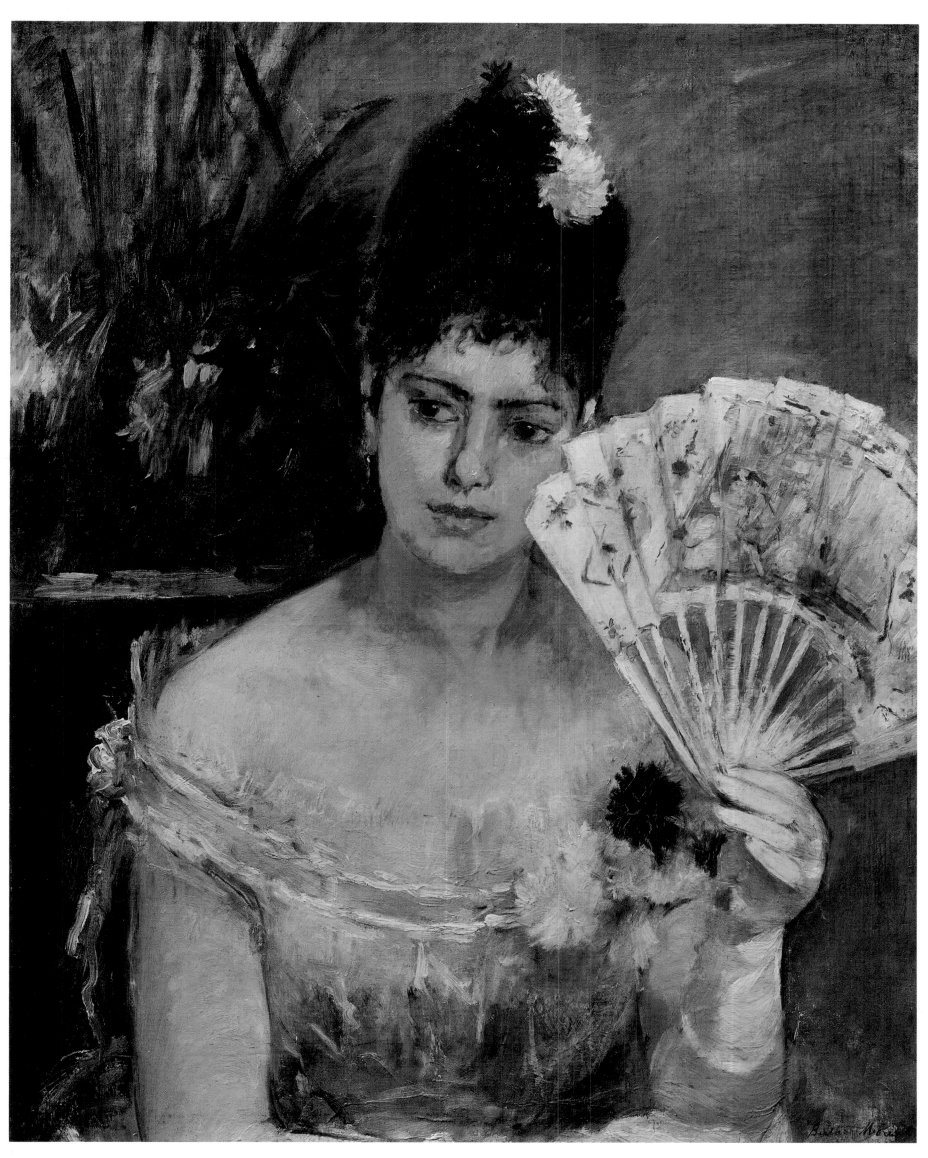

196 BERTHE MORISOT *Young girl at the ball* 1875
Of all the Impressionists none was more successful in catching the Proustian
atmosphere of feminine life than Berthe Morisot. Painted in the Morisot home
in the rue Franklin – the *jardinière* features in other paintings – its technical
virtuosity typifies the Impressionist revolution at its most sophisticated.

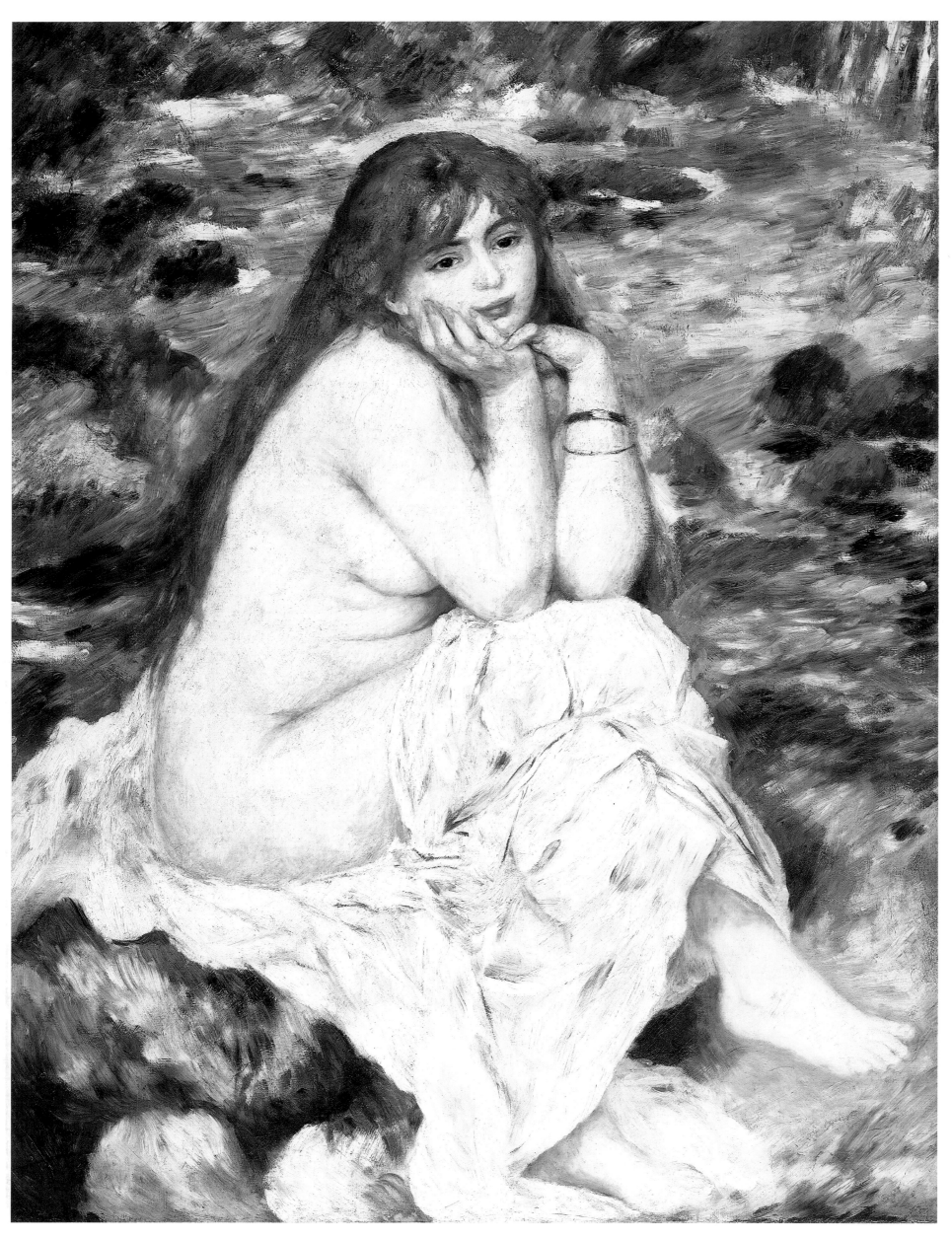

197 PIERRE-AUGUSTE RENOIR *Seated bather* 1883
Inspired by a visit to Guernsey, where Renoir was impressed by the freedom with which
young English girls undressed and bathed, this work was actually painted in Paris, although
the background was probably composed from sketches done out of doors, hence the lack of
relationship between the figure and the background.

Chapter 6

A United Front?

The appearance of Paul Durand-Ruel as a dealer, and indeed almost a manager, of the Batignolles group as a whole had enormously increased its coherence and its self-confidence. Although it did not have a unified body of artistic principles – the work of Monet, Renoir, Sisley and Pissarro had much in common, but not a great deal of resemblance to that of Manet, of Degas or of Cézanne – its members all shared an impatience, in varying degrees, with the fact that their main outlet for publicity and for sales was a Salon whose selection procedures they despised and rejected, especially when their own works were not shown. They were conscious too that their impatience was shared by others, and were aware of a general feeling that some alternative would have to be found. Charles Blanc, the Minister, after his unsuccessful attempts at reform, had wearily confessed that it would be better if the whole thing were run entirely by the artists themselves without any help or interference by the state. As we have seen (p.168), Bazille in 1867 had been writing to his parents about doing just such a thing, though by implication confining it to the Batignolles group and their supporters, and in this he was mainly abetted by Monet. When Paul Alexis printed an article in *L'Avenir National* on 12 May 1873 condemning the Salon and its jury and methods of selection, he went on to say that 'like any corporation, the artistic corporation has much to gain by organizing its own syndicate'. Monet immediately wrote a letter to the paper stating, with his not unusual reluctance to hide his light under a bushel, that 'A group of painters assembled in my house has read with pleasure the article which you have published in *L'Avenir National*. We are happy to see you defend ideas which are ours too, and we hope that *L'Avenir National* will, as you say, give us assistance when the society which we are about to form comes into existence.' To this letter, when it was published, Alexis added a note saying that several artists of great merit had joined Monet, including Pissarro, Jongkind, Sisley, Béliard, Armand Gautier and Guillaumin; he went on:

These painters, most of whom have already exhibited at the Salon and elsewhere, belong to that group of naturalists which has the correct ambition to paint nature and life in their entire reality. Their association however will not be just a small clique. They intend to represent interests not tendencies, and hope for the adherence of all serious artists.

It was becoming obvious that ideas about forming some kind of association were being powered by very complex concerns, some at least of which had economic and even political undertones. It was an age of trade unions, syndicates and professional organizations. As early as 1844 there had been established an Association des Artistes, Peintres d'histoire et de genre, Sculpteurs, Graveurs, Architectes et Dessinateurs ('Association of Artists, History and Genre Painters, Sculptors, Engravers, Architects and Sketchers'), to which Pissarro belonged, and which provided financial assistance and pensions to its members from the annual dues paid by each; literature had its Société des gens de lettres ('Literary Society'), and a whole host of splinter groups, medicine its Union Médicale. The sense of democratic optimism engendered by the birth of the Third Republic undoubtedly stimulated notions about organizing

198 EDOUARD MANET *Portrait of Claude Monet* Drawing, c. 1874

artists in defence of their own rights and, though nothing practical emerged, such ideas gave to the creation of artistic groups a kind of ideological pretext they had never possessed before.

It was this aspect which made Pissarro, with his socialist-syndicalist views, the natural protagonist in the creation of an organized association. In the increasingly more pragmatic discussions which were starting to take place, he designed a whole structure for such a group, based on the charter of a professional bankers' union in Pontoise where he was living. The opposition that such a scheme provoked was intense. Renoir, always coming down on the side of instinct, would have nothing to do with it. Pissarro's friend Piette (see p.172) expressed the scepticism of many in a letter written in the summer:

Of solidarity there is not a shred in France. You and some other artists, generous and sincere spirits, will have given a strong lead. But who will follow you? A gang of incompetent bunglers. And they, as they gain in strength, they will be the first to abandon you. I would have no quibble about an association restricted to people of talent, who work and are loyal, inspired by enlightened daring, people like yourself and those around you. I would expect much of an association of this kind and do believe that it would be both profitable and right to establish it, but I am distrustful of the mass of those idle and treacherous colleagues, who possess no moral or political convictions, and only want to use others as stepping stones.

Advice of a different kind came from Théodore Duret:

You now possess a group of admirers and collectors with whom you are established and by whom you are supported. Your name is known to

199 Photograph of Nadar in his balloon, taken by himself.

artists, critics and a specific public. But you must take one more step to be widely known. You won't get anywhere in exhibitions put on by special groups. The public doesn't go to such exhibitions. There will only be the same nucleus of artists and admirers you know already. I strongly urge you to exhibit this year at the Salon. Your name is now known, and they won't refuse you. Besides you can send in three pictures, and they are bound to accept one or two.

At the exhibition you will be seen – amongst the 40,000 or so visitors who go there – by at least 50 art lovers and critics who would never see your works anywhere else. If you achieve that it would be enough. But you'll achieve more, because you are now in the limelight among a group of artists which is talked about, and which, despite some reservations, is coming to be accepted...I urge you to exhibit; you must succeed in making a noise, in defying and attracting criticism, coming face to face with the public at large. You can begin to do all that only at the Salon.

The enthusiasms of Pissarro and others were, however, to be modified by considerations of a more practical nature. The heady economic optimism which had prevailed after the defeat of the Commune collapsed under the burden of inflation and over-optimistic speculation. A recession set in which was to last for several years; in the process of readjusting to it, Durand-Ruel had to draw in his horns and concentrate on his gilt-edged stock. He could no longer support the group as he had been doing. On the other hand, most of them felt that their works could command reasonable prices without the use of an intermediary. In 1873 Monet made about 20,000 francs, though this fell to 10,000 in the following year when Durand-Ruel had stopped buying, but even that was sufficient for a comfortable existence. Renoir was selling his works for between 500 and 800 francs, and even Pissarro was getting 500 francs for some of his. In 1873 Jean-Baptiste Faure commissioned a ballet painting from Degas (see p.222), who was already beginning to feel the beneficent effects of the American market. It seemed therefore to most of the Batignolles group that they had nothing to lose and much to gain from forming their own association and exhibiting and selling their own paintings.

Numerous meetings were held, many of them in Renoir's studio at 35 rue St-Georges; a plan was evolved to form a limited company, La Société Anonyme des Peintres, Sculpteurs et Graveurs, consisting of 30 members, which was formally registered on 27 December 1873. After a lot of bickering it was decided to invite outsiders to take part, mainly because this would reduce the amount each artist had to contribute to cover the expenses of the projected exhibition, and as a result all of them started cajoling their friends. Degas was especially active. To a reluctant Tissot he wrote:

Look here, my dear Tissot, there must be no hesitation, no attempt at escape. You positively must exhibit. It will do you good, for it is a means of showing yourself in Paris, from where people said you were running away, and also it will do us good. Manet is determined to keep aloof, but I am sure that he will regret it. Yesterday I saw the arrangement of the premises, the hanging and the effect in daylight. It is as good as anywhere. I am really getting worked up, and am running the thing with energy, and I think a certain success. The newspapers are beginning to allow more than just the bare advertisement and, though not yet daring to devote a whole column to it, seem anxious to be a bit more expansive.

The realist movement no longer needs to fight with the others – it already is; it exists, it must show itself as something distinct, there must

be a salon of realists. Manet does not understand that. I definitely think he is more vain than intelligent.

In actual fact Manet was reluctant to offend the adherents of the Salon, and thought that the correct policy was to continue hammering at its doors. To choose an alternative seemed to him cowardice. He was also reluctant to participate in an exhibition showing the works of Cézanne, who had been invited despite strenuous opposition, largely through the efforts of Pissarro and Monet. Eva Gonzalès agreed with Manet but Berthe Morisot, prompted by Degas, not only agreed to join but was quite active in making arrangements for the exhibition.

The greatest help of all came from Gaspard-Félix Tournachon, better known to his contemporaries and posterity as Nadar. One of the most remarkable figures in a Paris not devoid of them, he had commenced his career as an artist and a caricaturist, working for *Charivari* and founding in 1840, at the age of 20, his own satiric review, *Le Rire*. Very soon, however, he discovered the camera, and it was as a photographer that he made his mark on history, utilizing such new discoveries as aerial balloons and electric lighting to produce often startling images. His interest in art continued throughout his long life – he died in 1910. He was a collector, possessing an extensive selection of works by Constantin Guys and Daumier; he had been a friend of Delacroix and of Baudelaire, and he was an habitué of those cafés frequented by artists and writers. He became friendly with Manet in the late 1860s, taking several photographs of him, and became part of the Café Guerbois circle. There he learnt of their project to hold an

200 The cover of the fourth issue of *L'Impressionniste*, 1877

exhibition, and no doubt heard of the problems they were having in finding a suitable locale. He himself had just vacated his studio at 35 boulevard des Capucines, and had moved to 51 rue d'Anjou, letting the former to Gustave le Grey, another photographer. Le Grey had not yet taken up residence, so Nadar offered them the boulevard des Capucines premises, which were on the first floor of the building, with shops beneath. Access was by a broad staircase opening out on the street. The whole of the exterior was painted red and the rooms, which were spacious and well-lit, were hung with a reddish-brown cloth which was chosen to show off most of the paintings to their best advantage. Nadar made no charge for the rent.

Hanging obviously presented a problem. Pissarro, as was his wont, had organized this, with a hanging committee voting on the placing of each work. But, human nature being intractable to the best-laid plans, the whole thing was left to Renoir. His brother Edmond compiled the catalogue, which cost 50 centimes; admission was one franc. Each exhibitor paid 60 francs to show two pictures but, like the other rules, this was immediately broken and the sum covered as many paintings as each artist wanted to show.

The exhibition opened on 15 April 1874, two weeks before the Salon, so that it would not seem to be yet another Salon des Refusés. The opening times were unusual: from 10 am until 6 pm and then from 8 pm until 10 pm, presumably to allow those who worked during the daytime an opportunity to visit it.

It contained 165 works, including drawings, watercolours and pastels. Degas had the largest number, 11, and Monet showed five, including a view of the boulevard des Capucines (Plate 209), painted the previous year from the balcony of the exhibition site, showing some kind of street fair in progress; and of course *Impression, sunrise* (Plate 4). Renoir had eight paintings on show. These included *La Loge* ('The box', Plate 201), Renoir's first treatment of a subject to which he returned frequently in the course of his career. It attracted a lot of attention from the critics, mainly because of the 'modernity' of the subject. It was virtually the only work in the exhibition which did not draw hostile criticism of any kind, even though one commentator saw the girl as 'one of those women with pearly white cheeks, and the light of some banal passion in their eyes, attractive, worthless, delicious and stupid', whilst another saw her as 'a figure from the world of elegance'. Like another of his contributions, *The dancer*, it invites comparison with Degas. Berthe Morisot did well with nine works, including the delightful *The cradle* (Plate 202), about which Leroy wrote:

Now take Mlle Morisot! That young lady is not interested in reproducing trifling details. When she has a hand to paint, she makes exactly as many brush-strokes lengthwise as there are fingers, and the business is done. Stupid people who are finicky about the drawing of a hand don't understand a thing about impressionism, and the great Manet would chase them out of his republic.

Madame Morisot, always preoccupied with her daughter's career, felt a little unhappy about the exhibition and asked Berthe's old teacher Guichard to visit it and give his opinion. The reply was swift and alarming:

201 PIERRE-AUGUSTE RENOIR *La loge* 1874

I have seen the room at Nadar's and want to give you my spontaneous reactions. When I went in I was horrified to see your daughter's paintings in such vile surroundings. I said to myself, 'One doesn't live unscathed amongst madmen. Manet was quite right to have opposed her participation.' After a good deal of careful examination, you can find here and there in the exhibition some excellent bits of painting, but they all have more or less cross-eyed minds.

Presumably he was thinking especially of Cézanne's works. These included *A modern Olympia* and two landscapes, one of which was *The house of the hanged man* (Plate 203), a view of a house in Auvers-sur-Oise (where he had been staying) which foreshadowed much of his future development. Pissarro had five landscapes, mostly of views in and around Pontoise (for instance *The Hermitage at Pontoise*, Plate 135, and *The house of Pere Gallien, Pontoise*, Plate 133).

It is only with the hindsight of historical simplification that the first 'Impressionist' exhibition could be considered as Impressionist in the sense that later generations have come to understand the term. In the first place, amongst the 30 exhibitors there were several whose names mean little or nothing to any but the most highly specialized experts in the by-ways of French art history. Such, for instance, are Auguste de Molins, Louis Debras, Auguste-Louis-Marie and Léon-Auguste Ottin or Antoine-Ferdinand Attendu. Others, such as Boudin, Corot and the Italian de Nittis,

were already becoming conventional and were not at all motivated by the passion for experiment which characterized the main figures of the group, though de Nittis was to be a friend and patron of Monet and the rest. Then there were those who were in varying degrees Impressionists, but of what can only condescendingly be called a minor variety. The most prominent of these was Cézanne's friend Armand Guillaumin (see *The Seine at Paris*, Plate 9), who was to survive all the other exhibitors, dying in 1927 at the age of 86. Neither Monet nor Degas was greatly impressed by his work, which showed a passion for emotive colour hinting at the future developments of the Fauves and Expressionism[1] – at one point he had close connexions with Van Gogh. Then there was Edouard Béliard (1835-1902), an intimate of Pissarro and a frequenter of the Café Guerbois, who had worked on the inaugural committee and was a great help to Renoir in supervising the financial side of the exhibition. He was also on good terms with Zola, whom he frequently helped with matters of artistic technique in his novels. One of the most interesting of the lesser-known exhibitors was Stanislas-Henri Rouart (1833-1912). He had been at school with Degas, and their friendship deepened when they both served in the same artillery unit during the Franco-Prussian war. He was a prosperous industrialist who diversified the interests of his family firm, originally involved purely in armaments, into the manufacture of two of the latest discoveries, refrigerators and petrol engines. An enthusiastic collector who possessed works not only by the Impressionists but by El Greco, Poussin and Bruegel, he was an ardent amateur painter. He took part in most of the subsequent Impressionist exhibitions and at one point received painting lessons from Degas, who made several portraits of him and his family (such as *Henri Rouart in front of his factory*, Plate 206). Zacharie Astruc (see p.129), a close friend of Manet, although he exhibited paintings was better known as a sculptor, and a critic who was a defender of the Impressionists. Bracquemond was never really in sympathy with the painting ideals of the group and was in any case primarily an engraver; he gave Pissarro a great deal of help in that medium and later planned with him, Degas and Mary Cassatt a journal, *Jour et nuit* ('Day and night'), devoted to graphic art, which failed to materialize because of Degas's lack of co-operation.

Even among those who are now accepted as the main Impressionists there was a certain lack of cohesion. Manet, admitted by all as their 'leader', had not participated – and never would. Renoir, Sisley, Monet, Pissarro, Berthe Morisot and, to a lesser extent, Cézanne were all devoted to some degree of realism, opposed to academic and imaginative painting, enthusiastic about working in the open air and painting shadows not in grey or black but in colours complementary to that of the object. They sought to reproduce the seen image on the retina, to recreate in paint and canvas light, shadow and atmosphere. But there was a good deal of variation in the degree of rigour with which the members of the group followed these principles, a variation most apparent in the case of Degas. He was always apt to insist on the importance of subject-matter and clear definition of form, at heart preferring that the group should be thought of as naturalists or realists rather than 'Impressionists', and reacting against what he saw as

202 BERTHE MORISOT *The cradle* 1872

203 PAUL CEZANNE *The house of the hanged man* 1873

the formlessness of those who bent their technical skills towards the depiction of light, shade and atmosphere.[2] This dichotomy was to lie at the heart of Impressionism throughout its history, and would lead eventually to its being supplanted by Pointillism and the more formal explorations pursued by Cézanne. Degas was totally averse to the immediate, spontaneous approach on which the others were so insistent. The attention they devoted to light and atmosphere he devoted to the significance of closely observed objects. Round about this time he drew up a list in his notebook:

Draw all kinds of everyday objects placed and arranged in such a way that they have in them the life of the man or woman – corsets that have just been removed, for example, and which still retain the form of the body, etc. Series on instruments and players, their forms, the twisting of the hands and arms and neck of a violinist, or the puffing out and hollowing of the cheeks of the bassoonist, oboeist, etc.

Do a series of aquatints on mourning, different blacks – black veils of deep mourning floating on the face – black gloves, mourning carriages, undertakers' carriages, carriages like Venetian gondolas.

On smoke; smokers' smoke, pipes, cigarettes, cigars – smoke from locomotives, from tall factory chimneys, from steam boats, etc. Smoke compressed under bridges; steam.

On evening; infinite variety of subjects in cafés – different tones of the glass globes reflected in the mirrors.

On bakery. Bread – series on baker's boys, seen in the cellar itself or through the basement windows from the street – backs the colour of pink flour – beautiful kneaded dough – still lifes of different kinds of bread, large, oval, long, round, etc. Studies in colour of the yellows, greys, pinks, whites of bread. Perspectives of rows of bread, delightful arrangements of bakeries – cakes, the corn – the mills – the flour – the bags – the strong men of the market...

Neither monuments nor houses have ever been done from below, close up as they appear when you walk down the street.

Later he significantly noted, 'For a portrait, pose the model on the lowest floor level, and work above her to get used to retaining forms and expressions. *Never draw immediately and instinctively.*'

Despite the flexible opening hours, attendances were disappointing. On the first day there were 175 visitors, on the last 54, and the evening attendances averaged about 15. During the whole of the exhibition some 3,500 visitors came, not all of them, as Durand-Ruel noted, with the best intent:

The public flocked to the exhibition but with the fixed intention of seeing in these great artists only presumptuous ignoramuses, out to gain attention by their eccentricities.

Zola took up the same theme when he described the audience in *L'Oeuvre* (1886):

The laughter one heard was no longer smothered by the ladies' handkerchiefs, and the men's bellies distended as they gave vent to their mirth. It was the contagious mirth of a crowd which had come for entertainment, and was getting excited by degrees, exploding into laughter about nothing, stimulated to mirth as much by beautiful things as by execrable ones. They dug each other in the ribs, they doubled up. Every canvas attracted some kind of attention. People called each other over to point out some risible feature in a painting, witty remarks were being passed from mouth to mouth, expressing the sum total of asininity, of absurd comments, of bad and stupid ridicule that an original work can evoke from bourgeois imbecility.

204 ARMAND GUILLAUMIN *Bridge in the Mountains* 1870s

Time and time again hostile critics referred to the notion of incompetence, madness and a contempt for ordinary people. The pseudonymous F. O'Squarre commented, 'Public conscience was indignant. These works were terrible, dirty; the exhibition had no common sense.' Emile Cardon in *La Presse* wrote on 19 April, 'One asks oneself if there has not been a deliberate attempt to mystify the public, or it might be the effect of mental alienation, which one would certainly deplore. If the second supposition is correct, the exhibition calls for the opinion of Dr Blanche[5] and not a critic.' Marie-Amélie Chartroule, the critic of *L'Artiste* (who wrote under a male pseudonym) was even more explicit in reference to Cézanne's *A modern Olympia:*

M. Cézanne gives the impression of being a sort of madman who paints in a fit of *delirium tremens*. People have refused to see in this creation inspired by Baudelaire a dream, an impression brought about by oriental vapours and which had to be rendered by a bizarre sketch drawn from the imagination. Isn't the incoherence part of its very nature, the special quality of sleep? Why look for a dirty joke or scandalous theme in the *Olympia?* In reality it is only one of the strange dreams engendered by hashish, borrowed from a swarm of amusing fantasies that swarm around drug dens.

205 PAUL CEZANNE *Portrait of Armand Guillaumin* Etching, 1873

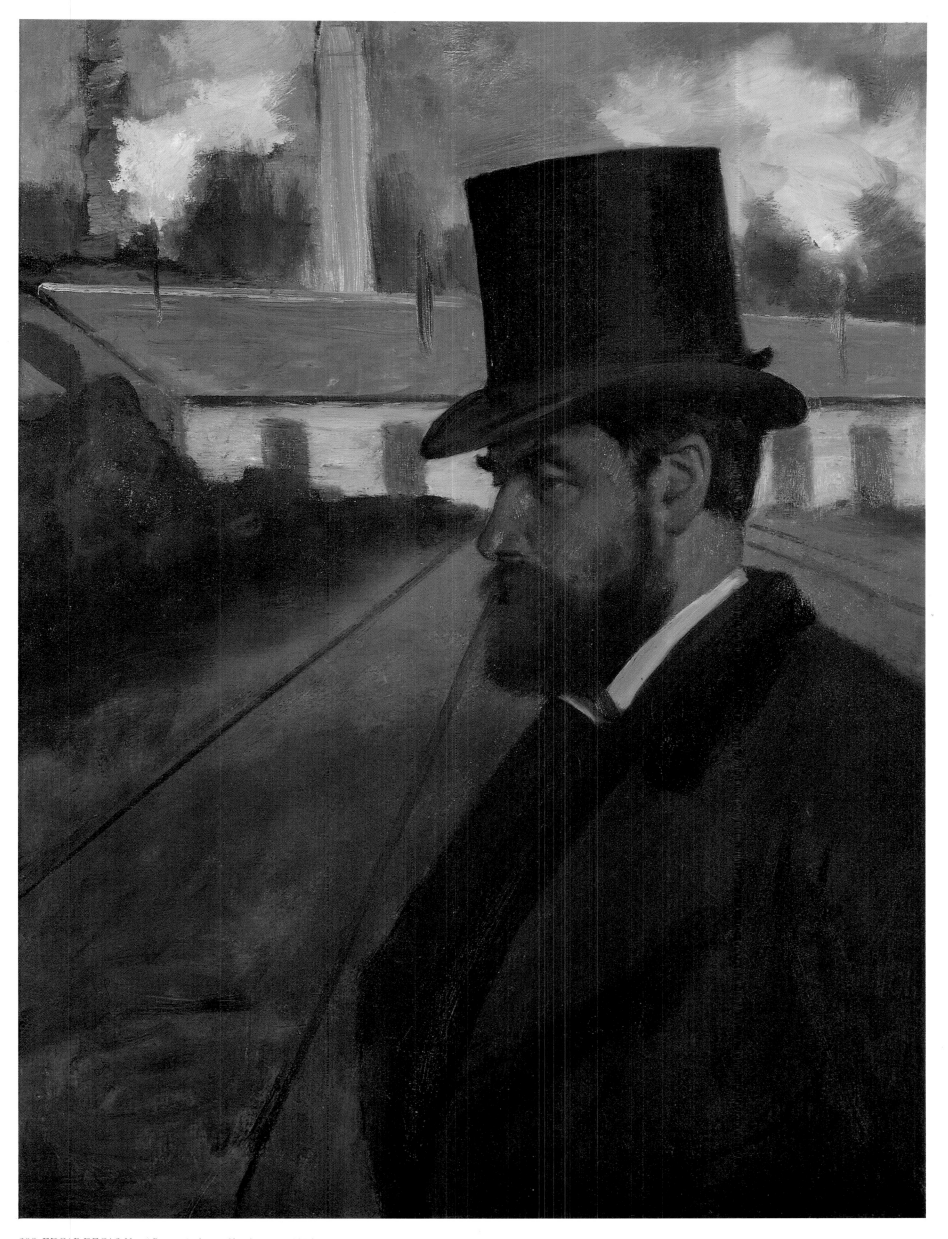

206 EDGAR DEGAS *Henri Rouart in front of his factory c. 1875*

A note of caution, however, must be sounded. Since 1874 there has been a tendency to exaggerate the animosity shown to the Impressionists by critics and the general public, in very much the same way that religions tend to exaggerate the sufferings of their martyrs and the villainy of their oppressors. Professor Paul Tucker, in a careful analysis of the reviews which appeared, has shown that of the 19 published, six were favourable, three were mixed but generally favourable, one was mixed but generally hostile, four were completely hostile and five were just notices or announcements (*Art History*, vol. 7, no. 4; December 1984). Even Leroy, whose bitter comments on Monet's *Impression* have already been quoted, liked his *Déjeuner*, and the *Boulevard des Capucines* was lauded by eight critics. Moreover, there were those who, while not entirely approving of the exhibition, thought that it represented a real challenge to the Salon and a blow against the insipidities of academic art. As one of them put it, 'It would be necessary to bless all the brutalities of the Impressionists if they delivered us from the facile perfection of Bouguereau.' Emile Cardon in *La Presse*, after saying that

'sketches of this new school are disgusting', went on to add that the exhibition 'represents not only an alternative to the Salon but a new road for those who think art, in order to develop, needs more freedom than that granted to it by the administration'.

Ernest Chesneau, who had already written favourably about Manet, was enthusiastic about Monet, praising especially the *Boulevard des Capucines*: 'Never has the prodigious animation of a public street, the movement of the leaves on the trees that line the boulevard, ever been understood and recorded with such prodigious fluency as in this extraordinary and wonderful sketch.' The use of the word 'sketch' was significant, for a constant theme in the criticism of friend and foe was the lack of 'finish' and the identification of the Impressionist style with those quick preliminary sketches which had long been an integral part of the academic process of creating a picture.

Perhaps the most percipient of all the reviews was that of Jules Castagnary, friend of Baudelaire and defender of Courbet, whose analysis of Impressionism and prophecies about its future are as valid today as they were more than a century ago.

The common view which unites this group and which makes them a collective force in the midst of our divided age is the deliberate intention of not looking for completion but stopping when a general view of the subject has been achieved. Once the impression has been captured and

207 CLAUDE MONET *The Pont de l'Europe* 1877
Spanning the railway line running out of the Gare St-Lazare, the bridge was considered one of the great engineering feats of its time. The centre-piece of the Quartier de l'Europe, it was also painted by Manet and Caillebotte.

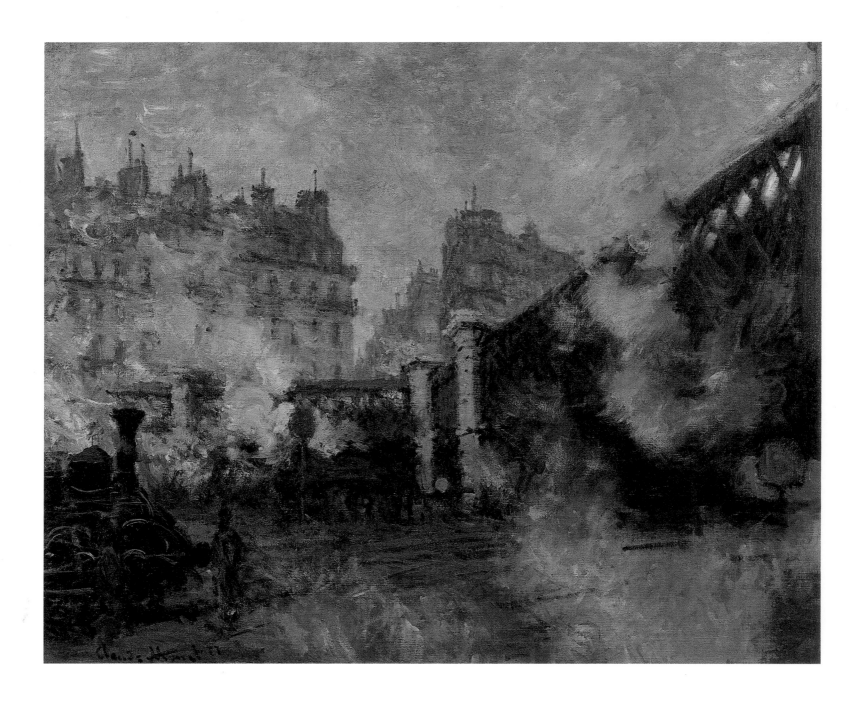

208 PAUL CEZANNE *A modern Olympia* 1872–3

fixed they have done their job. The label *Japanese* which was at first applied to them[1] is meaningless. If we must define them by a word which explains them, it is necessary to create a new name, *Impressionists*. They are Impressionists in that they render not landscape as such but the sensation produced by a landscape. The word has passed into their language. M. Monet's *Sunrise* is not labelled *landscape* in the catalogue, but *Impression*. In this way they leave reality behind them and enter the world of idealism.

In a few years' time the artists who have joined forces on the boulevard des Capucines will have split up. The strongest amongst them, those who are real professionals will have recognized that, while some subjects lend themselves to the Impressionist manner and are suitable for a sketched outline, others, and indeed the majority, demand clear expression and precise execution. They will see that the superiority of a painter consists precisely in treating each subject in the manner that is most suitable for it, not following a system, but boldly choosing the form that most fully embodies his concept of it. It is they, who in the course of their careers have succeeded in perfecting their drawing, who will leave Impressionism behind, as something that has become really too superficial for them.

Even the most enthusiastic supporter of the group, Armand Silvestre, who in the previous year had written for Durand-Ruel the introduction to a book of reproductions of works from his stock, including several by Manet, Monet, Pissarro,

Sisley and Degas, after praising the fact that 'everything in the exhibition is joyousness, clarity, vernal festivities, golden evenings, or blooming orchards', went on to make reservations about their lack of discrimination:

They do not select their sites with the discrimination of the more traditional style of landscape painter. Quite the contrary, and in this I find their affectation more than a little crass. If the reason for this is the philosophical notion that in nature everything is of equal beauty, this is wrong from the artistic point of view. Intended to demonstrate the wide range of their skills at interpretation, it actually emphasizes the merely manual aspect of their techniques, thus showing how little advanced their innovations are, and how it still needs a master capable of summarizing, formulating and giving it coherence.

It is difficult to discover how many works were sold at the exhibition. The Société exacted a commission of 10 per cent on sales, and in the accounts 360 francs were attributed to this source, which seems to suggest that 3,600 francs worth of paintings – approximately some 20 works – were sold. The largest commission – 100 francs – came from the sale of Sisley's works, 20 from Monet's, 18 from Renoir's and 13 from Pissarro's, with the balance being made up by a variety of other exhibitors. Boudin, Morisot and Degas sold nothing, though in the case of the

latter several works had been borrowed from their owners. Renoir was not able to sell *La Loge*, for which he was asking 500 francs, but being pressed for money disposed of it, after the exhibition was over, to Père Martin, a small-time dealer noted for his avarice, for 425 francs. The accounts for the exhibition, which were prepared by Renoir, Louis Latouche – a paint-dealer who sold works by the Impressionists – and Edouard Béliard, showed that the complete expenditure on the exhibition had been 9,272 francs and the receipts 10,221 francs, showing a profit of 949 francs, to be distributed amongst 30 people who had already contributed 1,800 francs in subscriptions. At the end of the year, on 10 December, Renoir called a meeting of the Société at his studio, and reported to the 13 members who turned up that, after paying all external debts, the liabilities of the association in terms of money advanced by members came to 3,713 francs, whereas only 277 francs remained in the till so that, to pay this internal debt in order to establish the operating fund, each of the now depleted membership would have to pay an additional 185 francs. It was therefore decided unanimously if reluctantly to liquidate the society as a legal entity.

Durand-Ruel analysed what he saw as the economic future of the group in a letter to Pissarro, whose situation was so dire that he had had to leave Pontoise and take refuge again in Piette's Norman farm:

You have succeeded, after quite a long time, in acquiring a public of select and discriminating art-lovers, but they are not the rich patrons who pay big prices. In this small world you will find buyers in the 300, 400 and 600 francs class, but I fear that before getting into the big money where you may get between 1,500 and 2,000 francs for a painting, you will have to wait several years. Corot had to wait till he was 75 before he got more than 1,000 francs for one of his works. The public neither likes nor understands good paintings. Artists such as Gérôme get gold medals, Corot nothing. People who know what it's all about and who defy ridicule and disdain are few, and very few of them are millionaires. But this doesn't mean that you should be discouraged. Everything can be achieved eventually – even fame and fortune, and while counting upon the judgement of connoisseurs and friends you compensate yourself for the neglect of the stupid.

209 CLAUDE MONET *The boulevard des Capucines* 1873

But who were these 'select and discriminating art-lovers' who were beginning to buy works by the Impressionists? One of the first to appear was an Italian, Count Armand Doria (1824-96), who, according to his friend Degas, had the features and manners of a Tintoretto. He bought Cézanne's *House of the hanged man* from the exhibition for 300 francs, and became a consistent patron of Renoir, ten of whose works were in his collection when it came up for sale after his death. Monet's *Impression: sunrise* was bought by Georges de Bellio, a homoeopathic doctor of Romanian origin, who was always being asked by Pissarro for advice on treating his children, and who rarely failed to buy a picture when an artist was in distress. He was continuously being assailed by Monet for help, as in the following letter.

I am as unhappy as possible; my belongings will be distrained at any minute now, just at the moment when I had hoped to straighten out my affairs. Once on the street and with nothing left, there will be only one course open to me, to take up employment, whatever it may be. That would be a terrible blow. I don't even want to think of it, and am making one last attempt. With 500 francs I can save the situation. I have 25 canvases left. I shall give them to you at that price. In taking them you would save them.

More poignantly when his wife died in 1879, he wrote:

My poor wife gave up the struggle this morning at half past ten, after the most ghastly suffering. I am in a state of great distress, finding myself alone with my poor children. I am writing to ask another favour of you; could you retrieve from the Mont de Pitié [the municipal pawnshop in Paris] the locket for which I am sending you the ticket. It is the only keepsake my wife has managed to hang on to, and I would like to be able to hang it round her neck before she goes.

De Bellio also bought eight Renoirs and works by Sisley, Morisot, Pissarro and Degas.

Monet's other great supporter was the Le Havre businessman and amateur painter Louis-Joachim Gaudibert (1812-78), who lived in a recently built château nearby at Montivilliers. In 1868 he acquired several of the artist's canvases when they were seized by creditors, and provided Monet with an allowance that year and the next. He also commissioned several portraits of his family from him. Another local magnate who later helped to support Monet by buying his paintings was the Swiss-born Oscar Schmitz, who had built up a large cotton business in Le Havre. The most significant patron during the first half of Monet's life, however, was Ernest Hoschedé (1838-90), with whom his personal life was to be very closely involved. The director of one of those large department stores which had arisen in Paris during the Second Empire, he lived in an impressive Renaissance-style house at Mogeron, near Paris; there he had a collection which included six works by Manet, 13 by Sisley, nine by Pissarro, six by Degas and no less than 16 by Monet, whom he commissioned in 1876 to paint a series of decorative panels for his house. In the following year, however, like some character from a novel by Zola, he was declared bankrupt and he, his wife and their six children went to live with the Monets, first at Vétheuil (see Plates 271 and 272), then at Poissy and finally at Giverny. Hoschedé spent most of his time in Paris during this period, in 1882 publishing a booklet about the Salon of that year with a cover illustration by Manet. Monet continued to live with Alice Hoschedé after the death of his wife Camille in 1879. On the death of her husband, Alice married Monet; her daughter Blanche later married Monet's son Jean and after his death in 1914 came back to Giverny to look after Claude.

Businessmen such as Hoschedé, Gaudibert and Rouart were typical of the *haute bourgeoisie*, whose life and backgrounds the Impressionists so often painted and who showed in their business life the same spirit of explorative innovation as the painters did in art. More impressive than any of these, however, was the publisher Georges Charpentier who, at the age of 25, had inherited a flourishing publishing house from his father Gervais, a patron of those Romantic painters considered advanced in the early part of the century. Georges quite quickly realized the way that literary tastes were developing and became the publisher of Alphonse Daudet, Flaubert, Zola, Maupassant and the Goncourt brothers. It was no doubt because the Impressionists were also, in their devotion to naturalism and realism, the pictorial equivalent of these writers that he first became interested in them. This interest was reinforced when in 1872 he married Marguerite Lemonnier (1848-1905), who combined pictorial sensibility with acumen and an ambition to run a salon. In this she was extremely successful, and their homes, first in the Place Saint-Germain-l'Auxerrois and later in the rue Grenelle, became the meeting places of writers and painters, where the Impressionists were able to discover and cultivate a wider range of patrons. Madame Charpentier was particularly drawn to Renoir, and in 1878 he painted a memorable portrait of her (Plate 227) which marked a turning point in his fortunes, leading to fame and security. It shows Marguerite Charpentier in her living-room, with her two children Georgette and Paul (often mistaken for a girl because of his long hair), whose godfather had been Zola. Proust described the painting at some length in *Le Temps retrouvé* ('Time Regained'),[5] comparing it with Titian at his best. Although unable to escape from innate snobbery – he described Madame Charpentier as 'ridiculously petite bourgeoise' – he pertinently acknowledged the role played by people such as the Charpentiers in discovering and supporting talent, and went on to say: 'Posterity will learn more about the poetry of an elegant home and the beautiful dresses of our day from Renoir's painting of the salon of the publisher Charpentier than from Cot's painting of the Princesse de Chagan or Chaplin's portrait of the Comtesse de la Rochefoucauld.' When it was exhibited at the Salon of 1878 praise was almost unanimous. Baignières in the *Gazette des Beaux-Arts* wrote, 'We must not pick quarrels with M. Renoir; he has returned to the bosom of the church, and we should bid him welcome. Let us forget about form and talk merely of his colouring.' There was indeed a general consensus that here was a work in the tradition of Rubens and Delacroix, marred only by weak draughtsmanship.

The Charpentiers were extraordinarily helpful to Renoir, making him a permanent part of their entourage, and starting a magazine, *La Vie moderne* to propagate the ideas of the Impressionists. This was eventually edited by Renoir's younger brother Edmond, who also looked after the exhibition space which they provided at the magazine's offices on the boulevard des Italiens. The series of exhibitions which took place there was very fruitful. The first,

devoted to the works of de Nittis, attracted 2,000 visitors a day and most of the exhibits were sold; the fifth was of pastels and drawings by Renoir, and others who exhibited included Manet, Sisley, Odilon Redon and Monet, who did not succeed in selling a single work, though as a kind of consolation prize Madame Charpentier bought one at a reduced price.

Typical of the kind of patron to be found at the Charpentier salon was the diplomat and banker Paul-Antoine Bérard (1833-1905), who played an important part in the life of Renoir. The painter was a frequent visitor to either Bérard's Paris house at 20 rue Pigalle or his Norman château at Wargemont, where he painted several pictures of the grounds and surrounding countryside, and also became very friendly with the chief servants, accompanying them on trips to the market at nearby Dieppe. Between 1879 and 1884 Renoir painted numerous portraits of the Bérard children, culminating in *The children's afternoon at Wargemont* (Plate 211). Unlike the small-scale intimacy of earlier portraits of the children this is a large-scale work, clearly inviting comparison with the portrait of Madame Charpentier. Painted in the corner of the salon at Wargemont, it shows Marthe, aged 14,

sewing; in front of her is four-year-old Lucie, and seated on the left reading a book, Marguerite, aged ten. The picture is dominated by an interplay of light and shadow, cold and warm hues, with the figures creating a dialogue of form, each surrounded by the aura of her own personality. It is in many ways a classical picture, the innovations of Impressionism digested into a form which has suggestions of a Renaissance painting about it.

In addition to the businessmen who supported the Impressionists in the early stages of their history, there was a group of professional people, of whom de Bellio has already been mentioned. A leading figure among these was another homoeopathic doctor, who was also a psychiatrist, a painter, an engraver, a Darwinian and a socialist; he built up one of the most remarkable collections of works by the Impressionists and their associates (subsequently given to the nation by his son), and is mainly known for the help he gave Van Gogh in the darkest days of his life. Paul Gachet (1828-1909) was born in the village of Ryssel near Lille, and throughout his life signed his works 'Paul van Ryssel'. During his student days in Paris he had been a frequenter of the Brasserie des Martyrs, and after concluding his medical studies at

210 PIERRE-AUGUSTE RENOIR *Children's afternoon at Wargemont* 1884

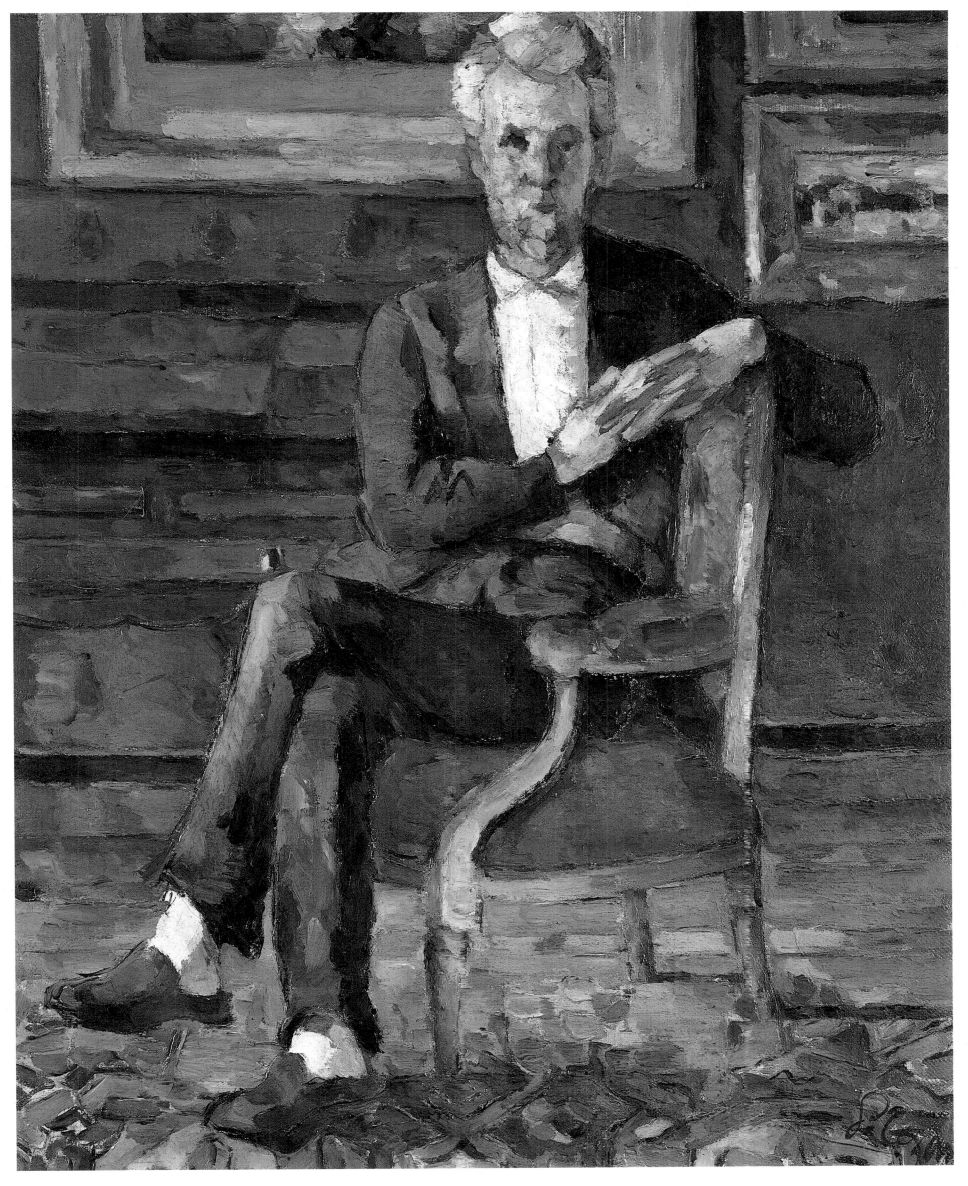

213 PAUL CEZANNE *Portrait of Victor Chocquet c. 1877*

to the Impressionists. In 1873 he bought an important group of four works by Manet, including *Le bon Bock* (Plate 172), for which he paid the very large sum of 8,500 francs. As he was earning in excess of 100,000 francs a year, he could afford an investment of this order; the word is deliberately chosen. More consciously perhaps than any other of the collectors so far mentioned, he was impelled very largely by considerations other than the aesthetic. The first was financial, the second publicity. To buy paintings of this kind at what then seemed inflated prices was good for his public image. It was this latter consideration which no doubt persuaded him in 1876 to commission Manet to paint his portrait, in the title-role of Ambroise Thomas's opera *Hamlet* (Plate 223). The hundredth performance of this work had been scheduled for the night of 28 October 1873, but the opera house, then in the rue Peletier, was burnt down. In 1875 the work was performed in the new opera house designed by Charles Garnier, and ran for 35 performances. In the following year Faure retired from the opera to concentrate on teaching and composing.[8] The portrait was obviously intended to mark the event, and possibly to adorn the museum which was to be one of the features of the new building. Manet found the greatest difficulty in completing the work – perhaps because he was moving into a more relaxed and sentient style of painting, but felt that a portrait of this kind showing the subject in sixteenth-century costume demanded that Spanish flavour of his earlier work, with its dependence on Velasquez. (Strangely enough, in the same year, Whistler was painting a portrait of Sir Henry Irving as Philip II in Tennyson's *Queen Mary*, which was very close in feeling and composition to Manet's work.) He needed some 38 sittings, and nine times cleared the canvas and started again from scratch. Originally he had intended showing the scene in which Hamlet confronts his father's ghost, but eventually decided to show Hamlet alone in the same scene, in the kind of composition he had used some 11 years earlier for his portrait of the actor-painter Philibert Rouvière playing the same role. Faure loathed the picture and refused to accept it. It was however shown at the Salon of 1877, where the critics condemned the pose as unconvincing, the eyes as too startling and the face as too wooden; 'a wooden head on which is stuck a false beard, with an open mouth shouting stupidly and eyes which look like two unlit gas lamps' was the verdict of Jules Comte in *L'Illustration*. This did not deter Faure from continuing to buy works by Manet, and eventually he amassed 68.

In the same year that Faure bought the group of works by Manet he also acquired Degas's *Horse-racing in Provence* for 1,300 francs and commissioned from him *The dancing examination* (Metropolitan Museum of Art, New York) for 5,000 francs, a work which Degas did not complete till 1874. In that year, however, complications arose. At Degas's request Faure bought back from Durand-Ruel for 8,000 francs six paintings which the dealer had acquired, with which Degas was not satisfied, and handed them over to the artist together with 1,500 francs, on condition that when they were finished he would receive four large paintings on which Degas was then working. Degas procrastinated endlessly in fulfilling his part of the bargain; months and years passed and Faure kept bombarding him with letters demanding the pictures, whilst Degas kept offering endless excuses. As late as 1887 he was writing to Faure:

It is becoming more and more painful to me to be in your debt. If I have not discharged it, it is because it is difficult for me to do so. This summer I again started work on your painting especially, and I had hoped to be able to finish it, but a certain Mr B. who had commissioned a painting and a drawing from me reneged on the deal. In the middle of the summer this sudden loss of 3,000 francs was a terrible blow for me. I had to leave all M. Faure's works to concentrate on some which would enable me to live. I can only work for you in my leisure time and that is rare. The hours of daylight are short, but they are getting longer, and I can get back to your works provided I can earn a little money. I could produce longer explanations. Those that I give you are the simplest and the most irrefutable. I ask you therefore to have patience, as I have, in the achievement of things which gratuitously eat up my time and which my own taste and my respect for my art preclude me from neglecting.

The letter hardly throws a favourable light on Degas. Having already received 9,500 francs from Faure some 14 years earlier, he was claiming that discharging his debt was an act of self-sacrifice on his part and at the same time was clearly cadging for more money. The affair was finally settled; three years later Faure sold all the works by Degas which he possessed – at a handsome profit – and never bought another.

[1] He was one of the few examples of an artist's having financial good fortune: after an early life of penury, he won a large prize in the Loterie Nationale of 1891.

[2] It was a reaction felt by most Italian artists and critics (see pp.53, 384-6), and could be seen as part of a larger contrast between the vision of the Mediterranean and Nordic peoples.

[3] A famous psychiatrist who revolutionized the treatment of the mentally disturbed and ran a hospital.

[4] See p.130.

[5] Part I, Chapter I.

[6] Murer's subsequent career is not without interest. In the late 1880s he bought an hotel at Rouen, where he frequently accommodated Pissarro and others, and was in close touch with Monet at nearby Giverny. He became a novelist and took up painting himself, holding exhibitions at the Théâtre de la Bodinière in 1895 and at Vollard's in 1898. He later retired to Auvers, near his friend Gachet, and on his tombstone in the local churchyard were inscribed the words 'Eugène Murer, Ouvrier, Littérateur, Peintre' (Workman, Writer, Painter).

[7] For a later view of L'Estaque by Cézanne see Plate 183.

[8] A song of his, *Les Rameaux*, can still be heard in the concert hall.

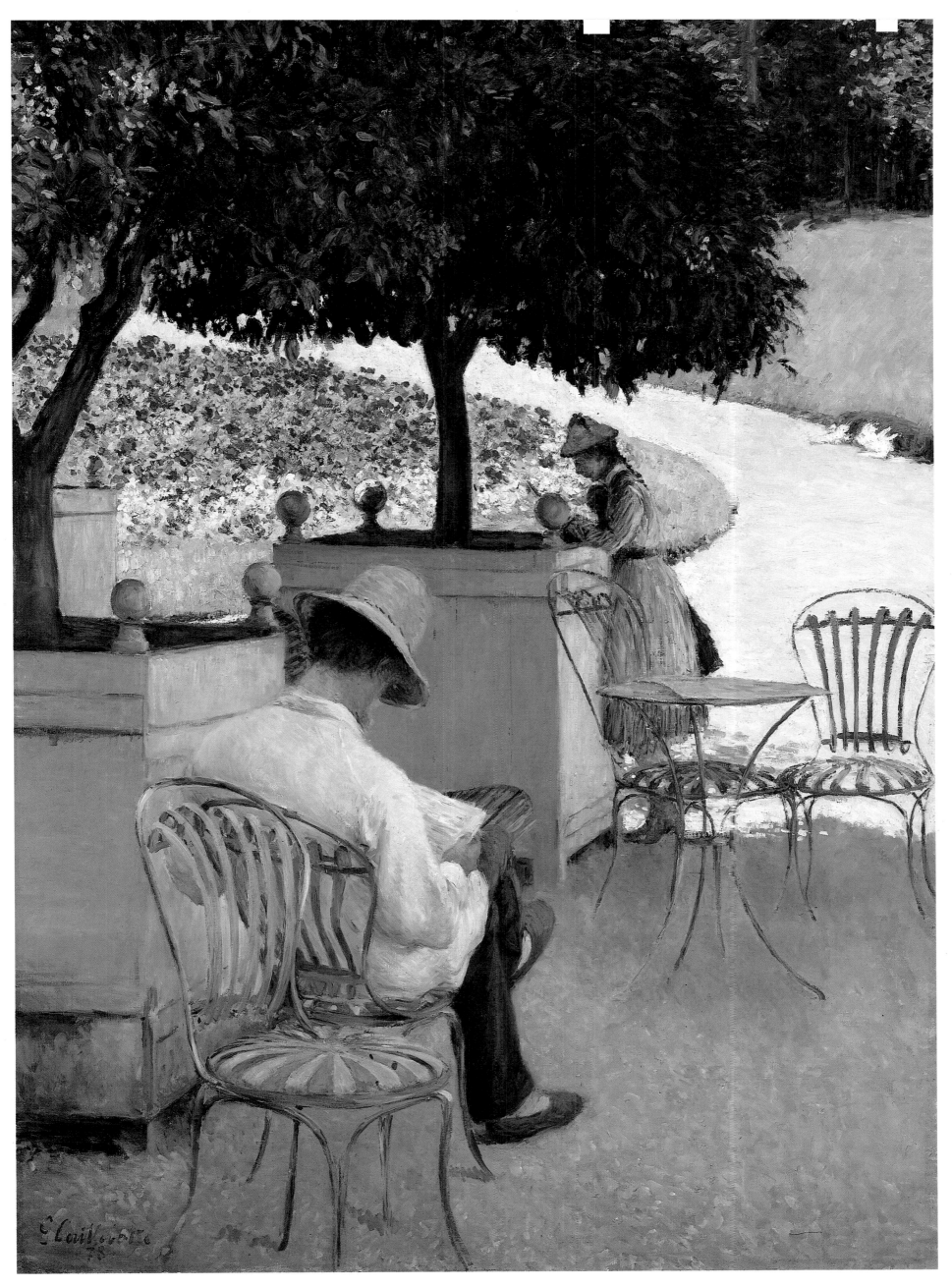

214 GUSTAVE CAILLEBOTTE *The orange-trees* 1878
This unusually large painting depicts Caillebotte's brother Martial and their cousin Zoë in
the garden of the family estate at Yerres. The whole scheme of the painting has a directness
and simplicity contrasting strongly with what we think of as a typical Impressionist work.

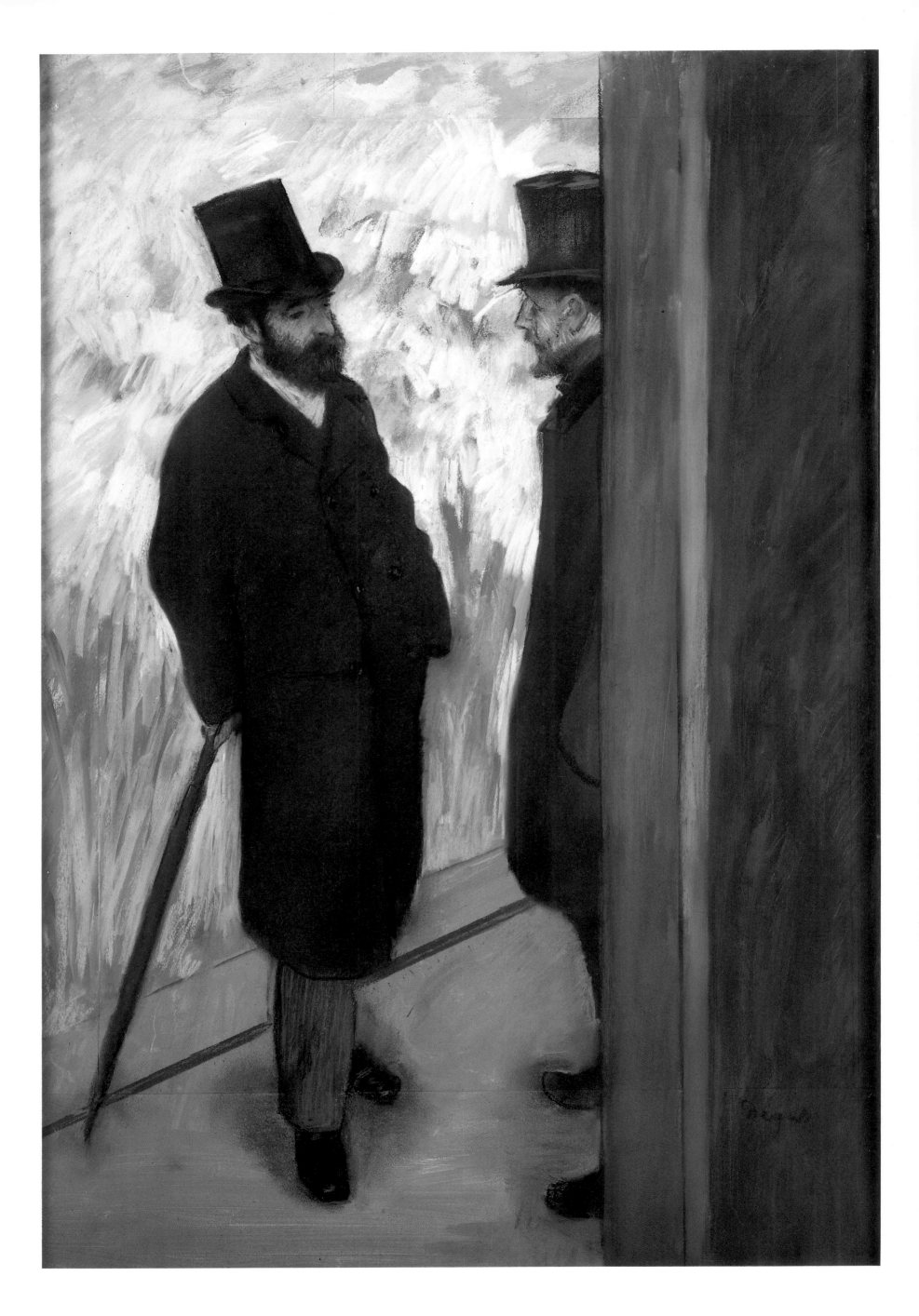

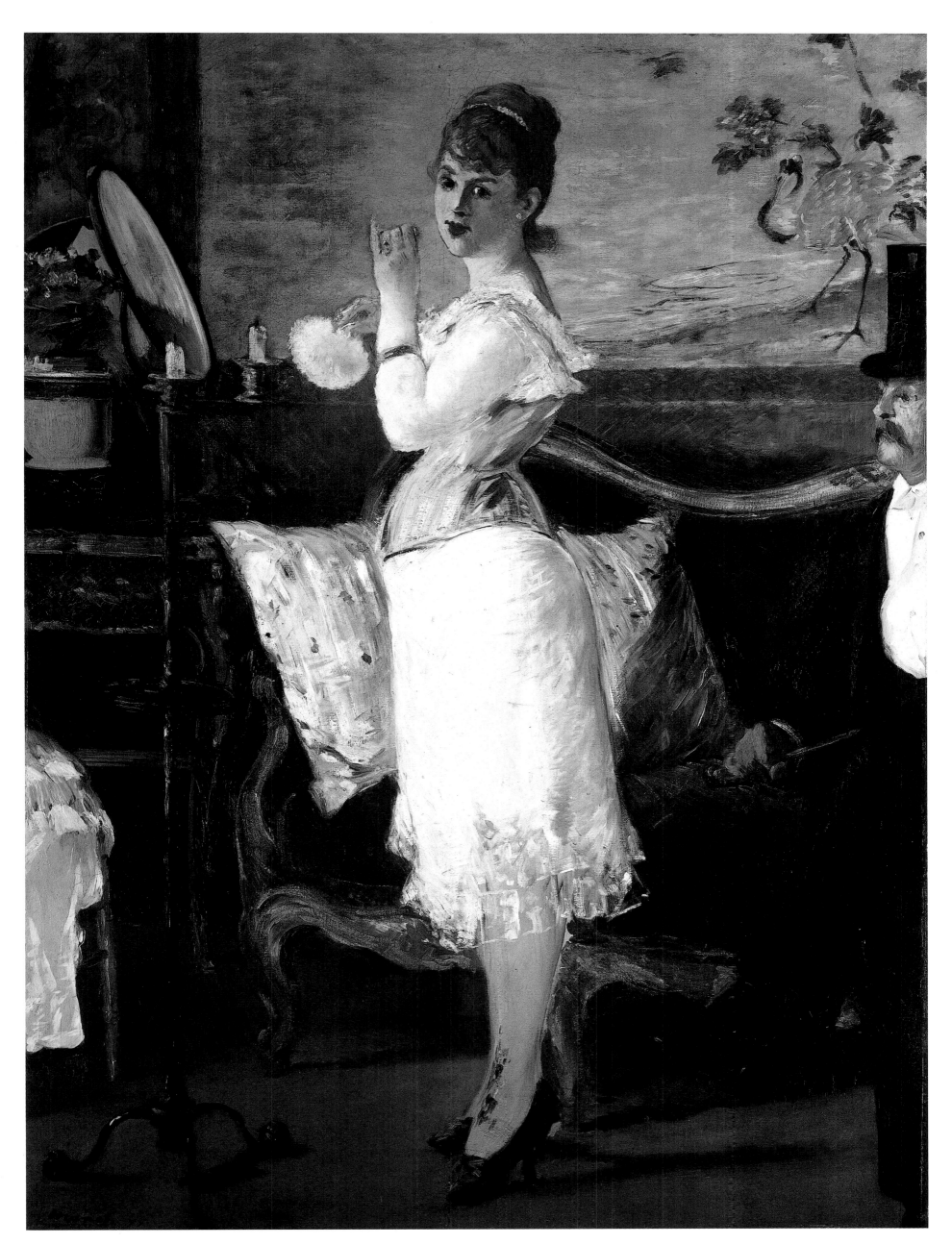

215 EDGAR DEGAS *Portrait of friends backstage* 1879
Two of Degas's most intimate friends, Ludovic Halévy and Albert Cavé, chat to each other in a remarkably spontaneous composition. Both men were great devotees of the theatre and opera. Halévy wrote many plays, the libretto of *Carmen* (Bizet was a cousin by marriage) and a highly successful novel. Cavé's mother was an artist who, on her husband's death, had married the director of the Beaux-Arts, Edmond Cavé. Albert was at the centre of artistic life.

216 EDOUARD MANET *Nana* 1877
This was actually painted before the appearance of Zola's novel, although it was obviously based on conversations Manet had with the author. Nana had in fact made a brief appearance in *L'Assommoir* in 1876: 'Since the morning she had spent hours in her chemise in front of the mirror. She had the fragrance of youth, the bare skin of a child and a woman.' Manet's image of the prostitute with a waiting client is purely realistic; it is devoid of the sententious undercurrents suggested by other artists.

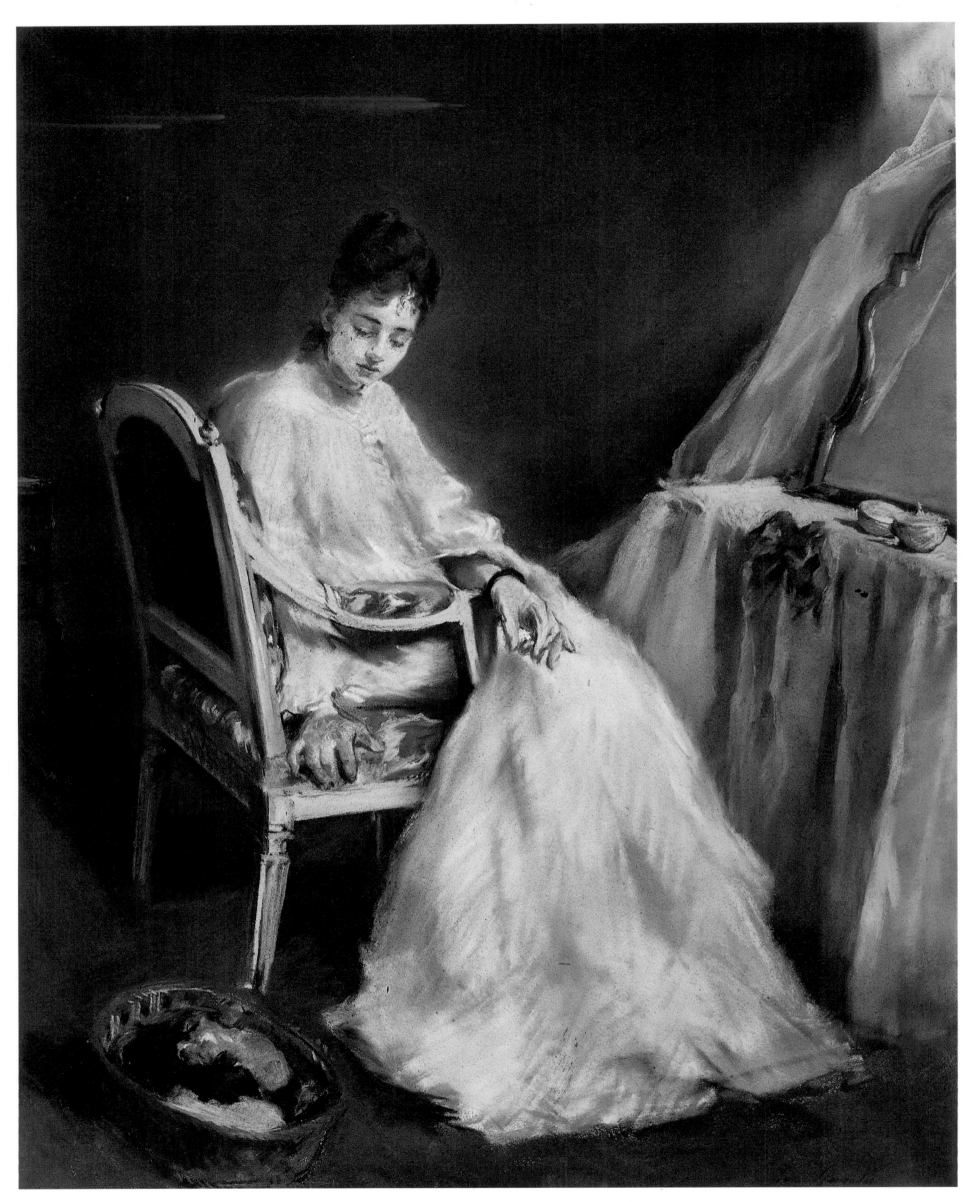

217 EVA GONZALES *Pink morning* 1874
It is impossible not to connect this pastel with the tradition of those eighteenth-century
artists, such as Nattier and Rosalba Carriera, who also dedicated themselves to the recording
of women and their lives. The sitter is probably Eva's sister Jeanne.

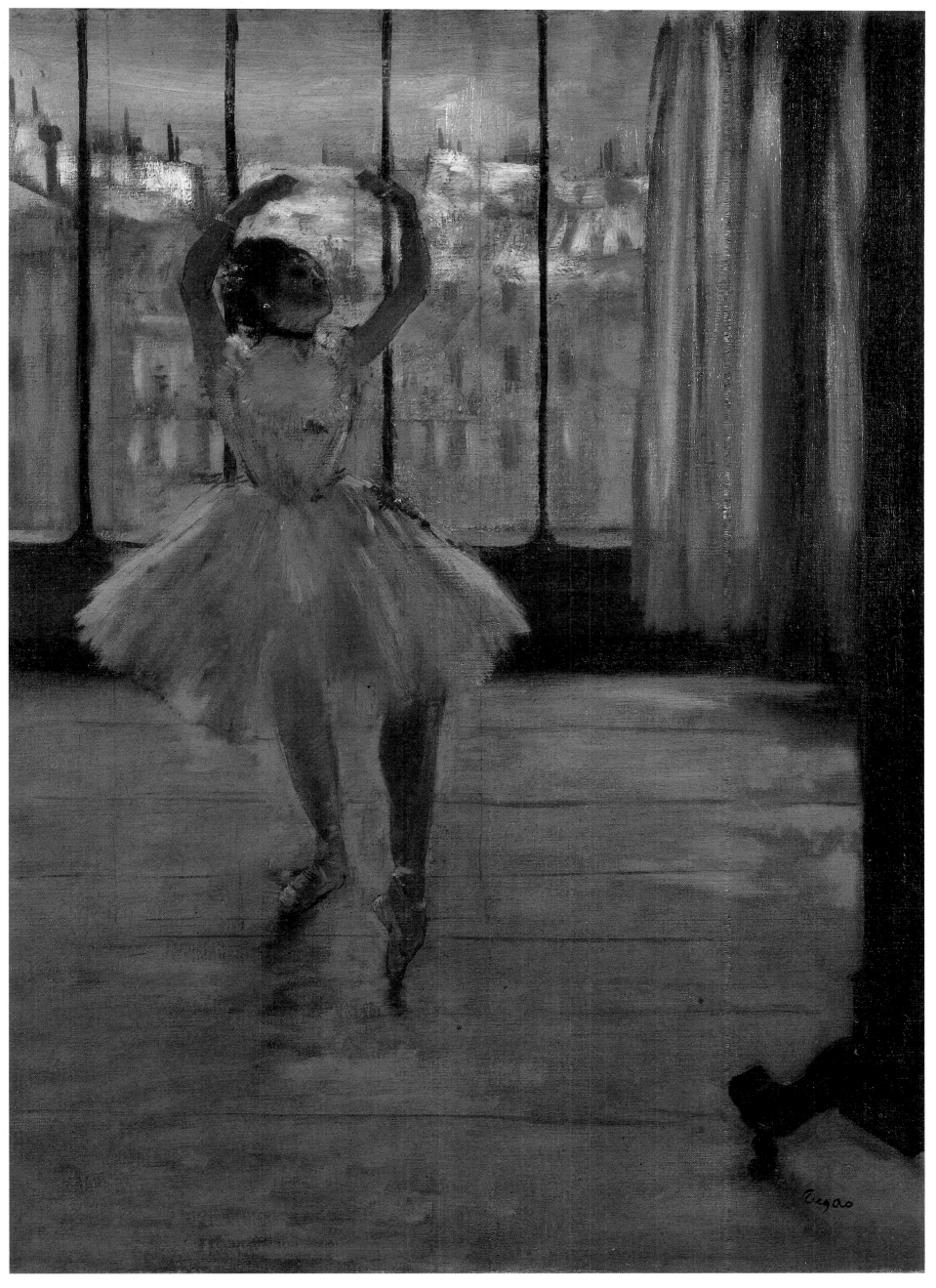

218 EDGAR DEGAS *Dancer before a window c. 1874*

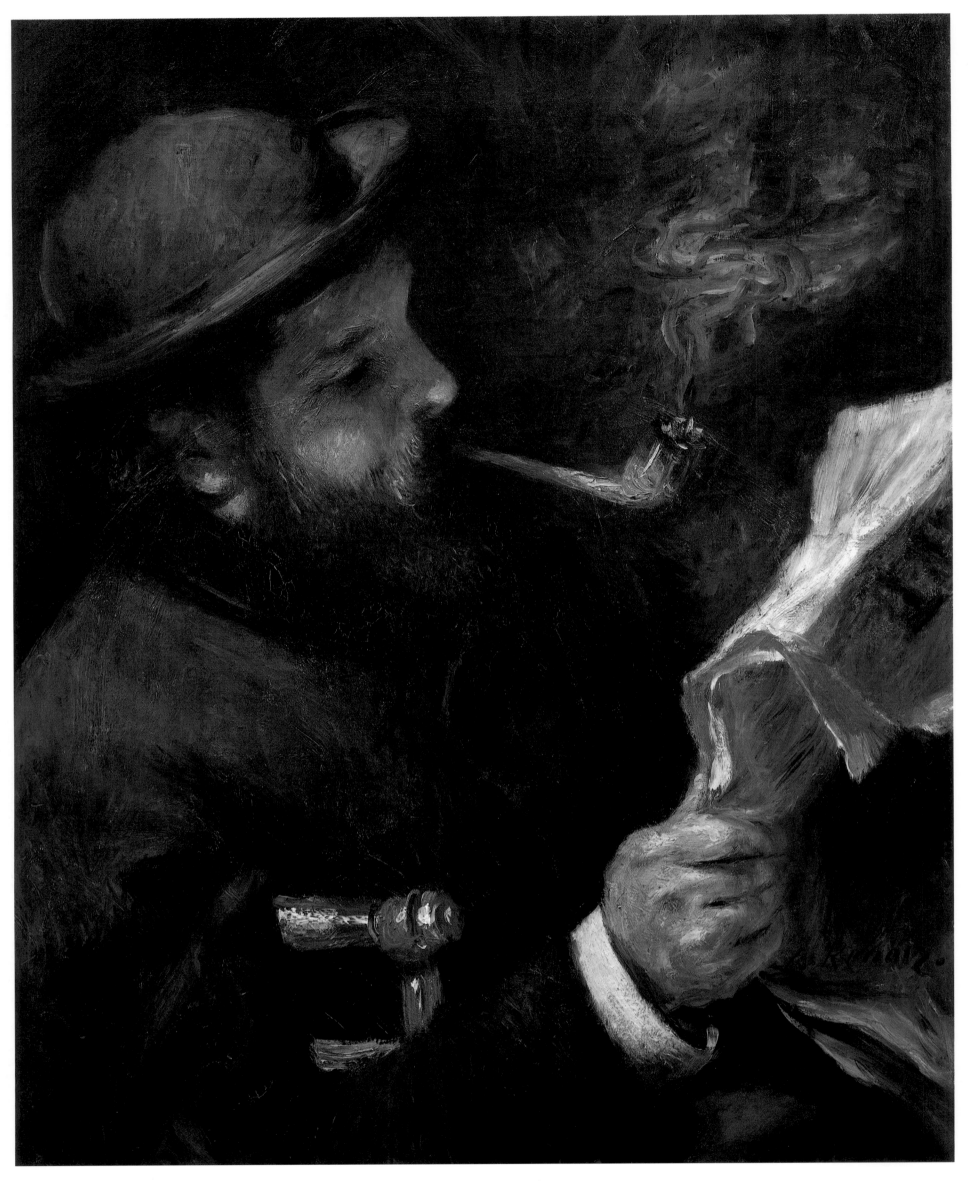

219 PIERRE-AUGUSTE RENOIR *Monet reading* 1872
Painted after Monet had moved to Argenteuil, it has a companion piece showing Camille also
reading. Renoir presented it to Monet, who kept it all his life. It was given to the Musée
Marmottan by Monet's son in 1966.

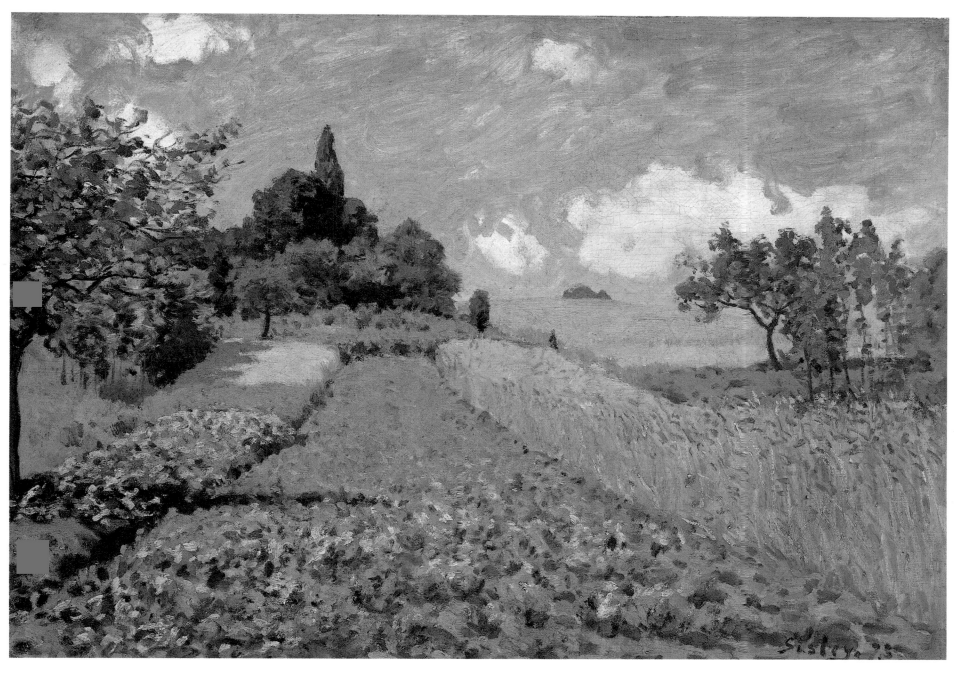

220 ALFRED SISLEY *Wheatfields at Argenteuil* 1873
Painted in the neighbourhood of Argenteuil, this was on view at the first
Impressionist exhibition and was bought by Durand-Ruel.

221 GUSTAVE CAILLEBOTTE *Monet resting* 1884
As the first enthusiasms of the Impressionists began to wane, and their cohesion
to disintegrate, Caillebotte began to pay more attention to gardening and
boating than to painting. But he was still in close contact with Monet and others.
This theme was a common one; Manet, Monet and Sargent all did similar
paintings of each other.

222 *Overleaf, left* EDOUARD MANET *The artist* 1875
Rejected by the Salon jury of 1876, *The artist* is a portrait of Marcellin Desboutin, painter,
engraver, playwright and professional Bohemian, who also featured in Degas's *The absinthe
drinker* (Plate 14).

223 EDOUARD MANET *Faure as Hamlet* 1877

224 PIERRE-AUGUSTE RENOIR *Piazza San Marco* 1881
In the autumn of 1881 Renoir visited Italy, stopping first at Venice; there he painted a number
of 'saleable' pictures of famous sites, which he exhibited at the 1882 group show. This view of
the Piazza, however, was left in its sketchlike state without any reworking in the studio.

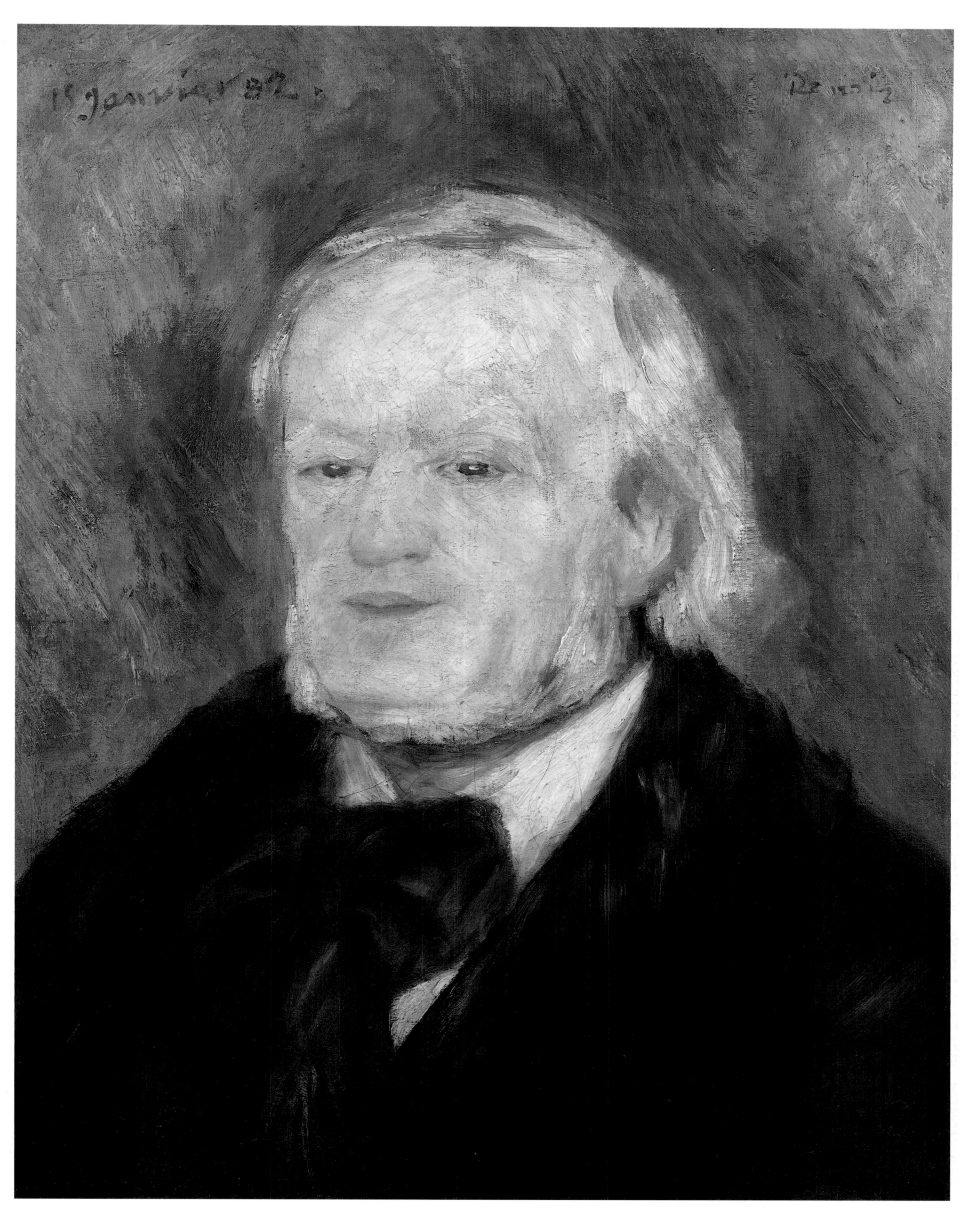

225 PIERRE-AUGUSTE RENOIR *Portrait of Wagner* 1882
The enthusiasm for Wagner which Bazille had instilled into Renoir led him to visit the
composer, who was then living in Italy, at the end of his Italian visit. The sitting lasted only a
short time, during which the two conversed mostly about the evils of the Jewish influence in
music. Wagner died in Venice in 1883.

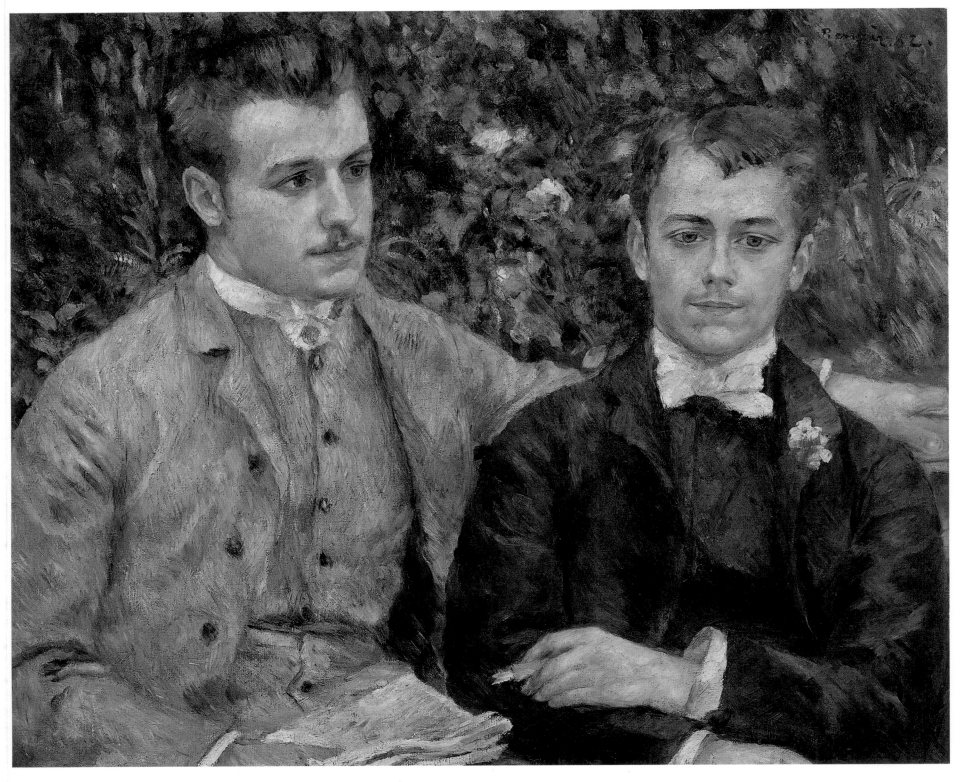

226 PIERRE-AUGUSTE RENOIR *Portrait of Charles and Georges Durand-Ruel* 1882
In 1882 Paul Durand-Ruel commissioned Renoir to paint portraits of his children. This one,
of the 17-year-old Charles and 16-year-old Georges, was painted in the garden of a house
which Durand-Ruel had rented in Dieppe. He was not very happy with the result, and
apparently had not expected the work to be painted out of doors.

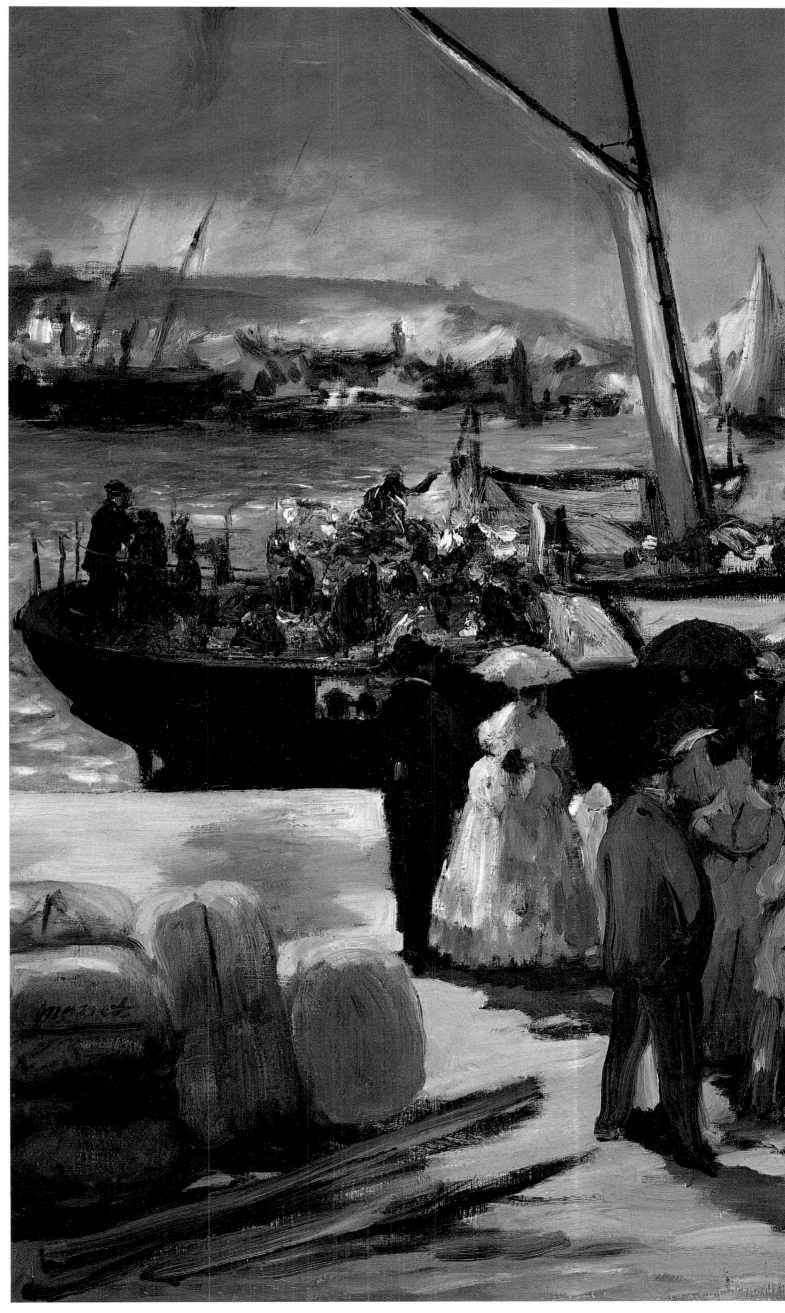

228 EDOUARD MANET *Departure of the Folkestone boat* 1869
One of a number of paintings of Boulogne-sur-Mer which Manet did during a family holiday in
1869. As a result of his early experiences on the sea in 1848, he was always fascinated by ships.

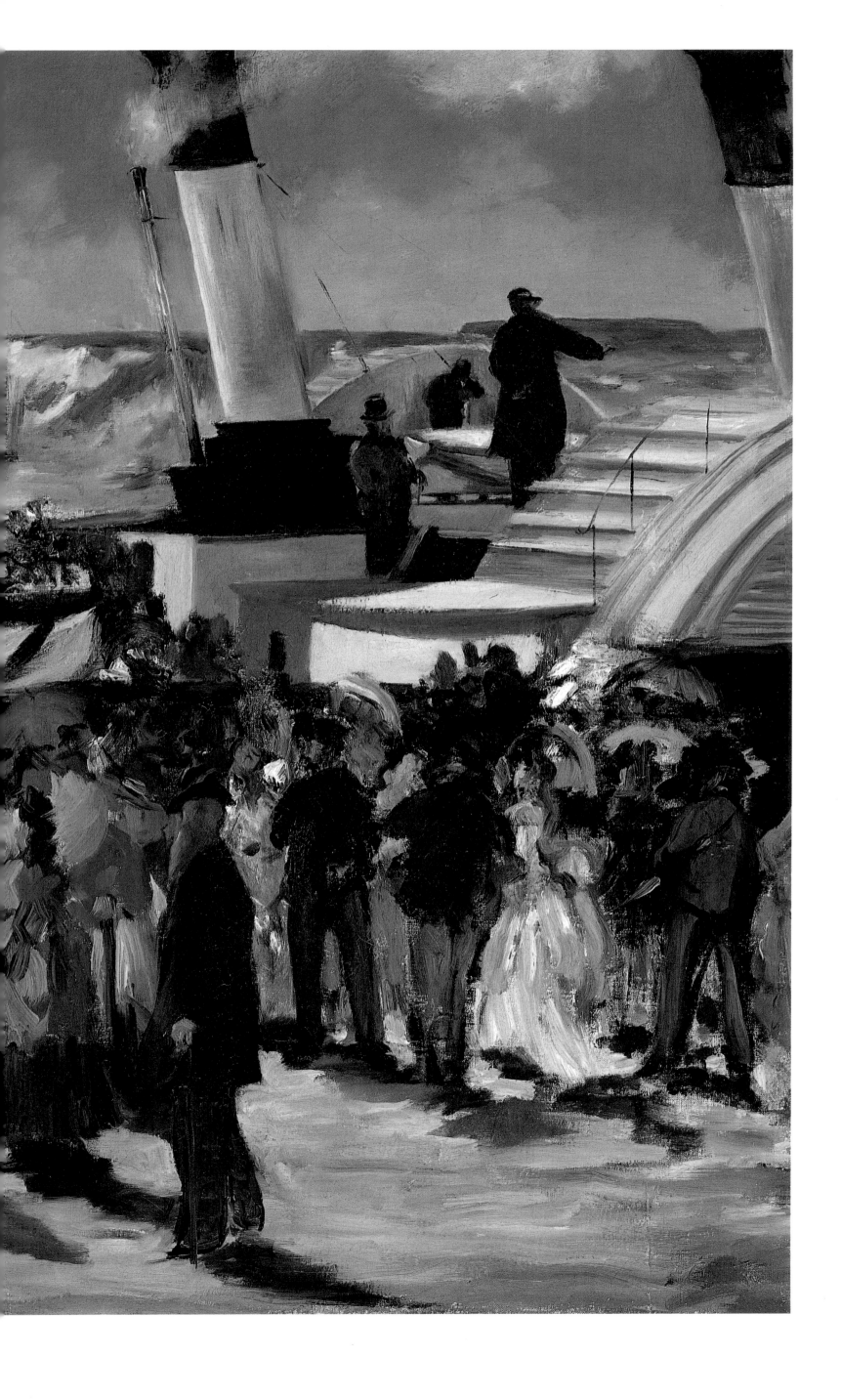

229 PAUL CÉZANNE *Winding road in Provence* 1868
From May until December 1868, having had his work rejected at the Salon, Cézanne
returned to Aix-en-Provence where he painted several landscapes in and around Saint-
Antonin at the foot of Mont Sainte-Victoire; this is a typical example.

230 EDOUARD MANET *Portrait of Mallarmé* 1876
Stéphane Mallarmé met Manet when he was in his early thirties, and on Manet's death
wrote, 'I saw my dear friend Manet every day for ten years, and I find his absence incredible.'
This portrait was painted in Manet's studio in the rue de St-Pétersbourg, shortly after the
poet had written two long laudatory articles about him.

231 EDGAR DEGAS *Diego Martelli* 1879
The spokesman and defender of the group of Italian artists known as the Macchiaioli. Diego
Martelli was a frequent visitor to Paris, and stayed there for some time as the correspondent
of a number of Italian papers in 1878-9, reporting the Universal Exhibition. He often went to
the Nouvelle-Athènes, and Degas painted two portraits of him, the other now being in the
Museo Nacional de Bellas Artes in Buenos Aires.

252 PIERRE-AUGUSTE RENOIR *Portrait of Jeanne Samary* 1877
Jeanne Samary was an actress at the Comédie Française whom Renoir met at
the home of his patron, the publisher Georges Charpentier, in 1876. The
painting was hung in the Salon of 1879 where it was accidentally varnished, an
error which was not rectified until the 1960s.

Chapter 7

The City Versus the Country

Now possessed of a corporate identity which was to persist, despite stresses of one kind or another, for some 12 years or more and was to find expression in seven joint exhibitions (the others being in 1876, 1877, 1879, 1880, 1881 and 1886), the Impressionists were becoming recognized as having a distinctive style and, to a certain degree, a common subject-matter. But this latter had two disparate categories: the extent to which they saw themselves as 'realists' or 'naturalists' governed the inclination in each interpretation for either the urban or the rural to predominate. Their newest adherent, Gustave Caillebotte, who became a member too late to exhibit in 1874, was firmly attached to the former category. Fourteen years younger than Degas, with whom he found most affinity, Caillebotte was the son of a successful Norman textile manufacturer who had moved to Paris and enhanced his fortune by real-estate deals of the kind which characterized the rebuilding of that city during the Second Empire. He built a luxurious house at the corner of the rue de Miromesnil and the rue de Lisbonne, in one of the upper-class residential areas which had been created by Baron Haussmann in his plan to departmentalize the new Paris according to the wealth and status of its citizens. After serving for nine months in the Garde Mobile of the Seine during the war, Gustave decided to abandon the law career which he had reluctantly undertaken at the behest of his parents and become a painter, studying in the atelier of the successful academician Léon Bonnat. There he picked up a remarkable technical virtuosity. His earliest portraits, landscapes and nudes from the years 1872-4, when he was in his 24th year, show skills of a remarkable order, combining the fluency of his teacher with a Corot-like tonality. By this time he was in contact with the habitués of the Café Guerbois and was becoming aware of the kind of practice and principles they were upholding.

In 1875 he painted a remarkable picture of three workmen planing the floor of a room. An exercise in almost painful realism, showing half-stripped human bodies bereft of the classic dignity of the academic nude, emphasizing the nature of arduous toil without dignifying it, the painting depicts a purely instantaneous slice of life, apparently uncomposed or artistically devised and with all the objectivity of a camera shot. Its rejection by the Salon of 1875 was probably responsible for Caillebotte's decision to participate in the 1876 Impressionist exhibition, in which he showed eight paintings. His interest in the group went beyond the limitations of aesthetic commitment, and he was to take over the role which Bazille had played as one of its chief supporters. At the unsuccessful auction of 1875 held by the Impressionists at the Hôtel Drouot he had bought Monet's *Déjeuner* (Plate 152), a work which had considerable affinities with the style he himself was evolving. He was to provide key support for the subsequent exhibitions and took great pains to reduce the tensions which kept appearing amongst the members of the group; the 1877 exhibition has been justifiably described as 'Caillebotte's exhibition'. He even rented at his own expense the premises at 6 rue Le Peletier where the exhibition was held, paid for the publicity and joined Renoir in hanging the show. Several works in the exhibition by Renoir, Pissarro, Degas and Monet were from the collection which Caillebotte had been accumulating, mainly as a means of supporting these artists, and at the exhibition he himself bought Renoir's *Bal au Moulin de la Galette* ('Dancing at the Moulin de la Galette'). His benevolence was endless. He frequently 'lent' Renoir and Monet sums of money (exempting them from repayment in his will); he hired the room in which Monet painted his pictures of the Gare Saint-Lazare, and when the group held another auction of their works in 1877, 'bought-in' his own paintings at inflated prices to increase the funds to be shared between all of them. By the time he died in 1894, his collection included seven works by Degas, two by Manet, five by Cézanne, 16 by Monet, seven by Renoir, nine by Sisley and no less than 18 by Pissarro.[1] A contemporary critic, Jules Montjoyeux, wrote an account of his role in *Le Gaulois* of 8 April 1879:

The Impressionists have welcomed him as a precious recruit. He has brought to them the credentials of unyielding youth. The kind of youth in mind and body that's headstrong to the point of error, rebellious against disappointments and victorious over the hard realities of life. He has entered the fray like a spoilt child. Assured against misery, strong with a double strength, he is well served by fortune. He has that other courage, one which is not all that common, which belongs to those from a hard-working wealthy background, and I know few of them like him who have forgotten that they do come from such a background, and think they also have their own way to make in the world.

His apartment on the boulevard Haussmann, which could be

luxurious, has only the simple comforts of a man of taste. He lives there with his brother, who is a musician. It is a curious relationship, each one pursuing his own path, neither knowing where the other is going; one of them painting, the other composing, without discussing their concerns with each other, without any conflict of feeling, talking about neither music nor painting with each other, and only rediscovering their consanguinity in the friendship they have for each other which endows their relationship with warmth and intimacy; two lives which are parallel but distinct.

Caillebotte's concern with and interest in the contemporary urban reality of Paris were displayed to startling effect in two of the works he exhibited in the 1877 exhibition. The *Pont de l'Europe* (Plate 234) chose a vista near his parents' home which typified the new Paris in the most startling way. The Quartier de l'Europe – so called because many of the streets in the neighbourhood were named after the capitals of Europe – had as its central point the Place of the same name, suspended over the railyards of the recently refurbished Gare Saint-Lazare, which serviced the lines to Dieppe and the Channel ports via a metal bridge – the whole construction a remarkable feat of engineering. Caillebotte's painting is dominated by this bridge, which he depicted with the ruthless fidelity other painters might have lavished on the dress of a society belle. Even in comparison with Monet's *Pont de l'Europe* of 1877 (Plate 207) and Manet's *Gare Saint-Lazare* of 1873 (Plate 193), both of which feature different aspects of it, Caillebotte's vision is startlingly realistic. This extends to other details, the

man's cravat, the shine on his hat, the movement of the dog, the reflective stare of the young train-spotter. Equally startling, as always with his works, is the complexity of the Mantegna-like perspective, for which he prepared numerous drawings. The focus of the picture is the head of the man – actually himself – which is the apex of a whole complex of converging lines, including the edge of the pavement, the line of the dog's back, of the handrail and of the inclination of the woman's figure. In contrast and cutting across these, however, is a variant line based on the inclination of the man's head towards the figure looking at the trains. The whole composition is fugue-like in its intricacy.

If Monet, Renoir, Pissarro, Morisot, Sisley and, to a lesser extent, Manet represent the mainstream of Impressionism in their concerns with light and atmosphere, with the juxtaposition of colours on the canvas to blend in the eye, in their belief in *plein air* painting, it is not all that easy to accommodate a painting such as Caillebotte's *Pont de l'Europe* within this orthodoxy. Technically it is more like the work of Fantin-Latour or even Tissot. In its depiction of urban life, another Impressionist aim, it is strikingly successful and its size meets the preoccupation then current amongst some of the group, such as Renoir in his *Moulin de la Galette* (see p.246), with painting large salon-scale pictures.

In Caillebotte's next important work, arguably one of the most arresting works in the whole Impressionist repertory, *Rue de Paris; wet weather* of 1877 (Plate 233), this divergence

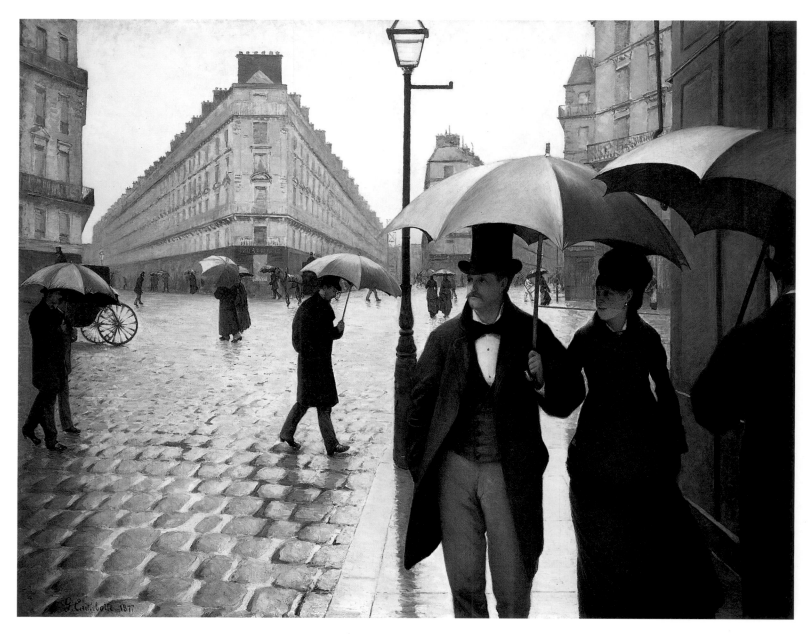

233 GUSTAVE CAILLEBOTTE *Rue de Paris, wet weather* 1877

from the core of Impressionist belief and practice is even more marked, a fact which can be vividly appreciated by comparing it with Monet's painting of the boulevard des Capucines (Plate 209), shown at the first Impressionist exhibition. On the other hand, it has considerable affinities with the work of such an 'unimpressionist' painter as de Nittis, in his view, for instance, of Trafalgar Square, now in the Petit Palais in Paris. Once again Caillebotte chose a typical section of the new Paris created by Haussmann, the intersection of what was then the rue St Pétersbourg (now Leningrad) between the Gare Saint-Lazare and the Place de Clichy. The site today is mellowed with age, presenting an image which we tend to think of as typically Parisian. But it was far from having that atmosphere at the time, and it must have looked to contemporary Parisians very much as the tower blocks which rose on the ruins of small streets and terraced houses seemed to the citizens of many European towns in the 1960s and 1970s. In Caillebotte's lifetime the area had been transformed from a maze of narrow, dirty streets into the gleaming, precisely planned, startling new vista of buildings which in the painting dominate the seemingly erratic pedestrians, so sparsely representing humanity against its threatening backdrop. No image so convincingly demonstrates the impact which the new great cities, spawned by industrialization, expansionist politics and ebullient capitalism, must have had on the men and women of the nineteenth century.

As a painting it is as complex and daring, and as 'photographic', as the *Pont de l'Europe* – the photographer Brassaï is reported to have said when first he saw a reproduction of it, 'Who took that?' – but it is strangely lyrical too, as Kirk Varnedoe, the author of the authoritative work on Caillebotte (Yale, 1987) explains:

Many of his other pictures are appealing and important, but none is so monumental (approximately seven by ten feet), so complex and so endlessly spellbinding as this intersection in the still, cool air of a rainy day. It is also one of the most lovely and subtle of his paintings. A pervasive grey-blue atmosphere cloaks the limestone buildings. The almost shadowless grey, reflected by the rain-washed surfaces, gives the picture a cool, pewter tonality accented by the slate and chestnut costumes of the strollers and offset by notes of earthier hue: the copper rust of the building fronts on the right, the deep green patina of the bronze lamp-post, and the lighter green accent of the umbrella handles.

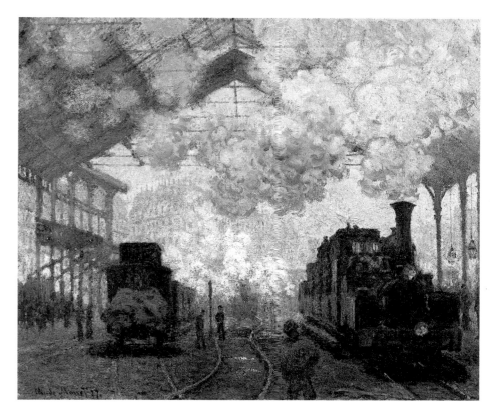

255 CLAUDE MONET *The Gare St-Lazare: arrival of a train* 1877
In the winter of 1876-7 Monet rented a studio on the rue d'Edimbourg and painted eight views of the Gare St-Lazare, which he showed at the Impressionist exhibition of 1877. Designed by an architectural genius, Eugène Flachat, the station became a symbol of the Impressionists' concern with the realities of contemporary life.

The elegance of the picture stems not only from the formal feel of the costumes and the overall understatement of the harmonies, but from the subtlest touches of gleam; in the gold of the PHARMACIE sign on the building at the left, and most especially in the pure magic of the one pearl (or diamond?) that shines from the ear of the delicately veiled lady on the right.

Very different from Caillebotte's smoothly elegant paintings of the area around the Gare Saint-Lazare are Monet's views of the station itself (Plates 7 and 235), with their densely encrusted surfaces, their bold, flamboyant brushwork, their almost sensuous delight in the steam-filled atmosphere, their evocation of the ambience of the station so vivid that one can almost smell it. These, virtually the last of Monet's Parisian paintings, views of that phenomenon which still exerts so potent a spell – steam locomotion – epitomized the very core of Impressionism. He succeeded perfectly in catching the sense of lightness with which, despite the basically ponderous quality of cast iron, Eugène Flachat (1802-73), the great railway architect, had endowed the station. To enhance this atmosphere Monet took some liberties with the actual building, painting the old, simple tie-rods under the skylights rather than the broader trusses which Flachat had installed some seven years earlier to enhance the sense of airiness.

Renoir at this time was showing that the Impressionist eye could view less weighty aspects of the Parisian scene, not all that far away from the Gare Saint-Lazare, and translate them into pictures which tallied with the professed aims and techniques of the majority of the group. The Moulin de la Galette (Plate 259), of which he painted two versions in 1876, was an old-fashioned dancing-place in the courtyard

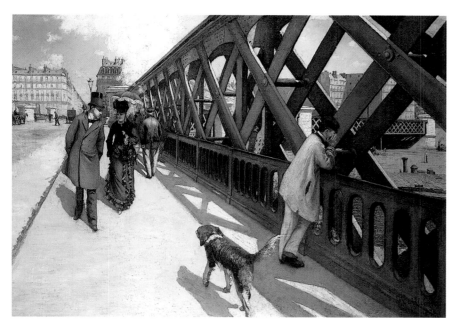

254 GUSTAVE CAILLEBOTTE *The Pont de l'Europe* 1876

of one of the mills dominating the heights of Montmartre, close to where the basilica of the Sacre-Coeur was then being built. Owned by the Debray family, the mill was still occasionally used for its original purpose of grinding orris-roots for Parisian perfume manufacturers. The dance hall itself was a bright green wooden hangar, and when the weather was suitable the dancers moved out into the courtyard, which had benches and tables around its periphery. The dances were held on Sundays between 3 pm and midnight, to the accompaniment of an orchestra of ten musicians who had an hour off for 'refreshments'. The clientèle was predominantly a respectable one, composed chiefly of the shop-girls, seamstresses, clerks, junior bureaucrats and other members of the bourgeoisie who lived in the quarter.

Georges Rivière, Renoir's friend and biographer, in *L'Artiste* of November 1877 stated that he completed the whole work on the spot. But this is unlikely and he probably relied on sketches made in this way. According to Vollard (*Renoir*, Paris 1920), Renoir told him, 'Franc-Lamy found under some stretchers in my studio a sketch of the Moulin de la Galette that I had done from memory. He told me all that I had to do was to make a painting of it.' Many of the figures in the work are identifiable. The couple dancing on the left are the Spanish painter Don Pedro Vidal de Solares y Cardenas, who actually came from Cuba, and Renoir's then favourite model Marguerite Legrand. Seated at a table are three close friends of the artist, Franc-Lamy (1855-1919), Norbert Goeneutte (1854-94), both painters, and Georges Rivière. The women in the foreground are Estelle, seated on the bench, and her sister Jeanne, another of Renoir's models. Jeanne featured in *The Swing*, a painting done in the overgrown garden of an old folly which Renoir had rented in the nearby rue Corot. Amongst those who posed for the dancers were Henri Gervex (1852-1929), later to win great fame as the painter of an operating scene in a hospital; Pierre-Eugène Lestringuez, a minor civil servant who was deeply interested in the occult and was a friend of the composer Chabrier; the

painter Frédéric Cordey (1854-1911) and a journalist named Paul Lhote. Just as it was not painted on the spot *en plein air*, neither was it in fact a picture of the young men and women of the artisan class who patronized the dances at the Moulin de la Galette. But, although it did not adhere to the strict realism of the Impressionist credo in technique and overall conception, it could not be faulted as a masterpiece of the movement. Renoir has succeeded in transferring to a large scale the techniques he had been developing in smaller works for some years. The unity of the extremely complex composition is achieved by the use of black and dark shades of blue, purple and violet which circumscribe areas of bright, dazzling colours. Light is scattered over the whole composition, in the circular patches of sunshine which irradiate the clothes of the participants, in the white gas globes, on the leaves of the surrounding foliage. Form and colour are inextricably interwoven with each other. It combines contrivance with versimilitude and absolute spontaneity. Essentially it succeeds in translating into the pictorial idiom of the nineteenth century the traditions of the *fête champêtre* of the eighteenth which had been so effectively resurrected by the Goncourts in their book on eighteenth-century French painting, first published some ten years earlier. Indeed, the general feeling of the art of that period was particularly attractive to Renoir, who seems in his depiction of the nude from this time onwards to have been indebted to Boucher.

In the Impressionist exhibition of 1877 the *Bal* was hung in the drawing-room in the centre of the suite of rooms, together with works by Cézanne, Berthe Morisot and Pissarro. There were some adverse criticisms; the writer in *Le Moniteur Universel*, for instance, though admiring the composition, found it absurd that the figures should be 'dancing on a surface which looks like the purplish clouds that darken the sky on a thundery day'. Rivière, naturally favourable, emphasized its realism, seeing it as 'a page of history, a rigorously accurate portrayal of a precious moment in Parisian life'; this we know it was not, at least in the sense that Rivière was implying. But the most enthusiastic eulogy came some years after, during the controversy about Caillebotte's collection entering the Luxembourg, when Gustave Geffroy (1855-1926), the most perceptive contemporary defender of Impressionism, wrote:

The *Bal au Moulin de la Galette* is one of the most successful products of direct observation and the use of light to create atmosphere; it expresses the intoxication of dancing, the noise, the sunshine and the dust of a dance in the open air, the excitement on the faces and the relaxed attitudes, the rhythmic swirl of the dresses, pink, light blue, dark blue and black – a burst of passion, a sudden sadness, a quick flare-up, pleasure and fatigue. These are the heroines of popular songs, with their delicate faces, their quick or tired gestures which express their hopes, their bursts of happiness, or their moments of sullen boredom.

Renoir continued for virtually the next decade to be interested in exploiting the theme of social observation with which he had been so successful in the *Bal*, and decided to look elsewhere for other suitable subjects. He had been spending a good deal of time at Chatou, three miles downstream from Argenteuil, where rowing rather than sailing was the main preoccupation of holidaying Parisians and where the main social centre was the restaurant La Fournaise. Chatou and its neighbourhood provided the background for nine of his figure paintings

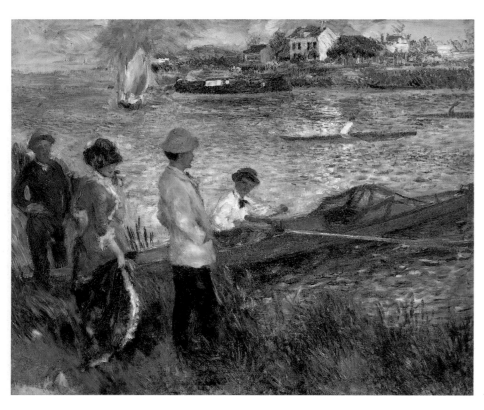

236 PIERRE-AUGUSTE RENOIR *Oarsmen at Chatou* 1879

257 GUSTAVE CAILLEBOTTE *The boating party* 1877

and seven of his riverscapes. The first important one of these was *Oarsmen at Chatou* (Plate 235), painted on the edge of the island of Chatou looking across to the inn of La Mère Lefranc on the opposite bank. Standing on the bank is Caillebotte, himself an ardent oarsman who painted some remarkable images of the sport (Plate 257), dressed in the appropriate clothes of a gentleman amateur; he is accompanied by Aline Charigot, a 20-year-old girl from Essoyes who, having recently moved to Montmartre with her mother, a dressmaker, had become Renoir's model and was eventually (in 1890), after the birth of their first son, to become his wife. There is another man who may be the painter himself. They are talking to an oarsman, as smartly dressed as Caillebotte, who is seated in a two-person gig of the type much used in the area, being at once easy to steer and capable of taking part in the races which formed part of the summer season there. The bright, sparkling colours, the interplay of light and shade on the ruffled waters of the Seine and the brisk vivacity of the brushwork make the painting a veritable epitome of the Impressionist technique at its most dazzling.

Although this work is concerned with people, they play a subordinate role to the wonderfully orchestrated landscape.

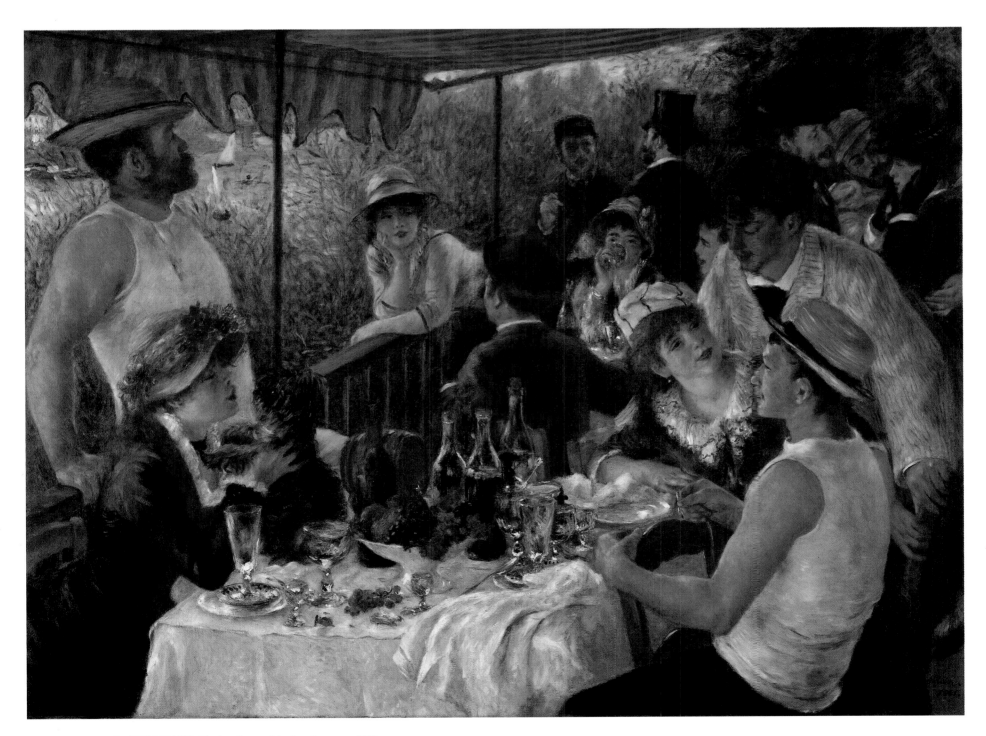

238 PIERRE-AUGUSTE RENOIR *The luncheon of the boating party* 1880

A year later, in 1880, Renoir started on a work which he rightly saw as a continuation of the successful formula of the *Bal*. In the late summer of that year he wrote to Paul Bérard at Wargemont:

I hope to see you in Paris on the first of October, for at present I am at Chatou. I couldn't resist sending all my more decorative jobs packing, and I'm doing a painting of oarsmen, which I've been itching to do for a long time. I'm not getting any younger, and I don't want to delay this little bit of self-indulgence, which later on I shan't be able to afford – it's difficult enough at the moment as it is. I don't know if I shall be able to finish it, but I've told Deudon[2] about my troubles, and he has given me his approval; even if the enormous expense I'm incurring prevents me from finishing my picture, it's still a step forward. One must from time to time attempt things that are beyond one's capacity.

He was therefore very aware that in painting *The luncheon of the boating party* (Plate 238) he was undertaking a work large not only in dimensions but in intention, and ambitious in concept. Perhaps he was influenced in part by the trenchant criticisms which Zola, previously so fervent a defender of the group, had levied at the fifth exhibition when it opened the previous April at 10 rue des Pyramides. After complaining that the Impressionists should direct their efforts to producing substantial and ambitious paintings of modern life, he went on to say:

The real misfortune of this group is that no artist has realized with force and definition the new formula, which is to be found fragmented through all the works they produce. The formula is there, but endlessly diffused, and nowhere in any one of their works is it to be found applied by a master. They are all forerunners. The man of genius has not yet appeared. We can see what they intend, and we can understand how right it is, but we seek in vain for the masterpiece which is to encapsulate and vindicate that formula. That is why the struggle of the Impressionists has not reached a goal. They never live up to what they promise; they stammer without being able to talk.

Whether or not Renoir was trying to produce this definitive work it is impossible to say. Its realism is apparent, the pleasures of the bourgeoisie up from Paris for the day enjoying themselves in a popular restaurant, described round about the same time by Guy de Maupassant as 'the restaurant Grillon' in *La femme du Paul*. It contains 14 figures, all of them clearly defined, finishing their lunch on the upstairs terrace of the restaurant La Fournaise. The standing male figure on the left, with the muscular arms of an oarsman and the obligatory straw hat of his kind, is Alphonse Fournaise. The girl holding the little dog is Aline Charigot. Leaning over the balustrade is the daughter of the house, Alphonsine Fournaise, talking to Baron Barbier, an ex-cavalry officer and friend of both Renoir and Maupassant. The figure with the top hat, looking sartorially out of place in this context, is Charles Ephrussi (1845-1905), editor of the *Gazette des Beaux-Arts*, friend of Deudon, expert on Japanese prints and collector of works by Monet, Pissarro, Sisley, Morisot and, of course, Renoir, to whom he frequently gave shrewd advice on the marketing of his works. The girl sitting in front of him is a model, Angèle, and on his left are Lestringuez and Lhote, both of whom appeared in the *Bal au Moulin de la Galette*. They are talking to a girl who is usually taken to be the actress Jeanne Samary, who moved a great deal in Impressionist circles. Leaning over the table on the right is the journalist Maggiolo talking to another girl, probably Ellen Andrée

who appears in Degas's *L'Absinthe* (Plate 14). Beneath him, wearing a straw hat and looking much younger than in other portraits about this time, is Caillebotte.

The painting fulfils Zola's prescriptions of encapsulating and vindicating the basic technical formulae of Impressionism. Hot and cool colours are juxtaposed; parts of the picture are thickly and heavily painted to catch the light and occasionally to disguise other colours painted underneath; other parts, especially in the background, are so thinly painted that the grey-primed canvas shows through. Dark and light tones are placed close to each other and, typically for an Impressionist painting, there is a high horizon line. On the other hand, and one must always remember that Renoir frequently had the ideals of the Salon on his mind, there are strong traditionalist elements. The composition forms a loose triangle, in the centre of which is the table, littered with the debris of a meal, having all the qualities of a still-life which would have found favour with any official jury.

As so frequently happens with Impressionist paintings, however, the degree of realism implicit in works such as these is problematic. Seen from one angle, *The luncheon of the boating party* is a convincing documentation of a social episode, of the type described by the journalist Gustave Goetschy in an article in *La Vie Moderne*, to which he occasionally contributed illustrations:

The meal is tumultuous, the glasses are filled and emptied with dazzling speed; the conversation becomes more and more animated, interrupted by the clatter of knives and forks performing a noisy fandango on the plates. Already a boisterous, rowdy conversation arises from the tables, filled with the debris of the meal, on which the bottles quiver and shake.[3]

259 PIERRE-AUGUSTE RENOIR *Edmond Renoir at Menton* 1883
An illustration for a story by Edmond in *La Vie Moderne*, 15 December 1883.

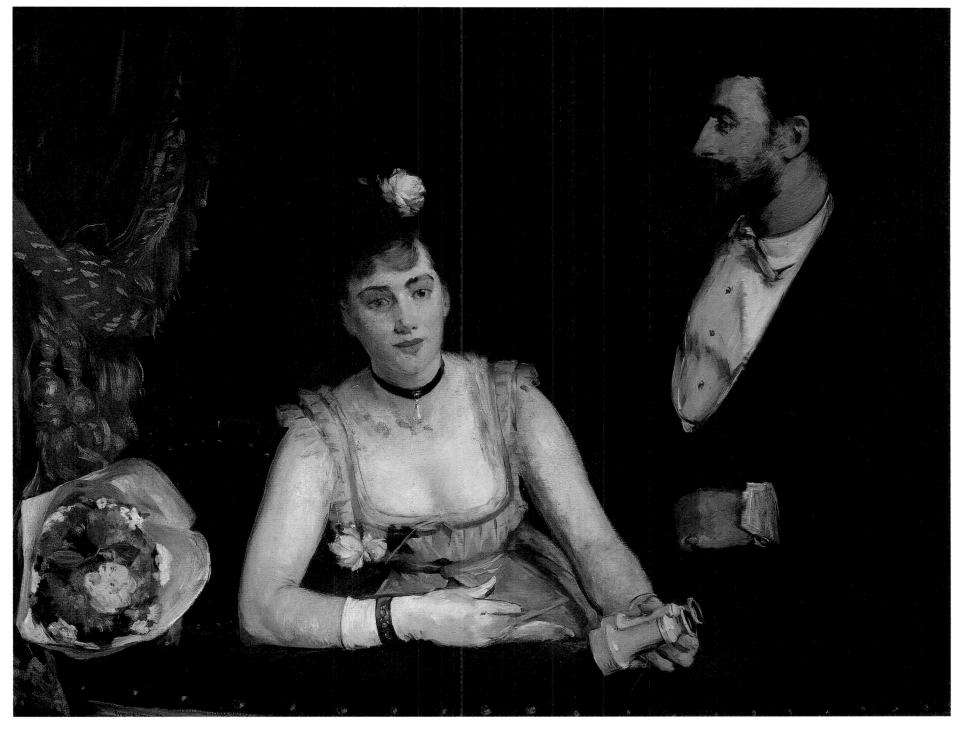

240 EVA GONZALES *A box at the Théâtre des Italiens* 1874

One of the problems about the concept of realism is that then, as indeed now, it tends, somewhat unjustifiably, to be identified with what the nineteenth century called the 'lower orders', a tendency which had been reinforced by the popularity of the sanitized peasants of Millet and the less than svelte Parisian maidens of Courbet. But this association was ill-founded, as Boudin pointed out in a letter to a friend at Le Havre on 3 September 1868:

Your letter arrived at the very moment when I was showing Ribot, Bureau and another person my little studies of fashionable seaside resorts. They congratulated me, especially on the fact that I had dared to put into paint the things and people of our own time, and for gaining acceptance of the gentleman in his overcoat and his wife in her raincoat – thanks to the sauce and the spice I season them with.

This is no new thing, however; the Italians and the Flemings simply painted the people of their own time, either in interiors or in large architectural settings. This approach is now making headway again, and a number of young painters, chief amongst whom I would put Monet, find that it is a subject which has hitherto been too much neglected. The peasants have had artists who have specialized in painting them,

men such as Millet, Jacque, Breton, and that is a good thing. These men produce good and serious work. They take part in the work of the Creator, and help Him to make Himself manifest in a way fruitful for men. That is good, but quite honestly, among themselves, don't these middle-class men and women walking along the pier towards the setting sun also have a right to be fixed on canvas, to be brought to light? Don't you agree that these people, getting away from the daily grind, are seeking relaxation after hard work? There may be some parasites amongst them, but there are others who really work hard. This is a serious argument, and I think that it is irrefutable.

Isn't it pitiable to see serious men like Isabey, Meissonier and so many others collecting carnival costumes and under the pretext of achieving a picturesque effect, dressing up models, who don't know what to do under their borrowed finery?...I should very much like to have one of these gentlemen explain to me what interest such subjects will have in the future, and whether the picturesque quality of these paintings will make any impression on our grandchildren.

The characters who throng *Dancing at the Moulin de la Galette* and the *Luncheon of the boating party* may not have been as resolutely proletarian as Renoir implied, but

journalists, painters, civil servants and art collectors have the right to claim a role in the iconography of realism just as much as anyone else.

No other group of artists had ever before documented with such minutely detailed exactitude and such obvious affection the life of a social group as the Impressionists did, drawing very largely for their inspiration on their own domestic circle and that of their friends. Renoir did not confine himself to group paintings of the kind just discussed. One of his contributions to the 1874 exhibition had been *La Loge* (Plate 201), which portrays a more intimate aspect of the enjoyments of the bourgeoisie, one which was exploited by Degas and had first found expression in the works of Daumier. The young man, who is so unchivalrously directing his attention to some more distant attraction than the pretty girl with him, is Edmond Renoir, his companion the model Nini, unflatteringly referred to by her colleagues as 'Gueule-de-raie' (Fish-face). Exhibited by Durand-Ruel in London in 1874-5, it passed through

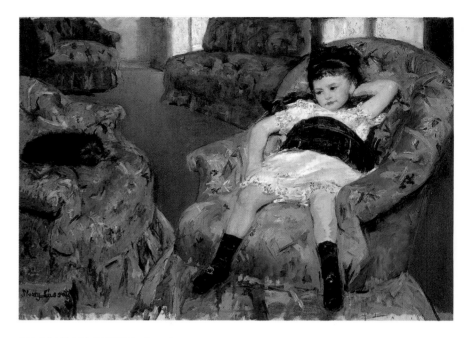

242 MARY CASSATT *Little girl in a blue armchair* 1878

several hands, until in 1899 he bought it back for 7,500 francs to retain in his own collection; there it remained until 1929 when it was bought by the English dealer Percy Moore Turner, who immediately sold it to Samuel Courtauld. Quite apart from the obvious appeal of the subject, the painting is remarkable in itself, the flesh tones perfect, the colours scintillating, the whole atmosphere of an outing to the magic world of the theatre caught perfectly.

The theatre and the opera as typical places of entertainment and pleasure for the bourgeoisie had great appeal to the Impressionists. Renoir reverted to the subject in his painting of a young girl on her first outing, and in 1874 Eva Gonzalès had submitted to the Salon her *A box at the theatre* (Plate 240), which was rejected then, although, significantly, accepted five years later. The couple are obviously respectable, despite the low-cut dress which the woman is wearing, and there is no hint of any tension or of any untoward relationship between the two. There is a strong Spanish feeling, derived no doubt from Gonzalès's close relationship with Manet, whose student she was described as being in the Salon catalogue. Some critics even maliciously suggested that the bouquet of flowers was the same one which Manet had used in *Olympia*. Others commented on the vigour of her brushwork, which they admiringly described as 'masculine'.

The most prolific explorer of the pictorial possibilities of the theatre box, however, was a newcomer to the group. Mary Cassatt had been born in Pittsburgh in 1844, the daughter of a successful entrepreneur with an interest in railways, whose French antecedents had endowed him with a passion for that country. Having initially studied painting at the Pennsylvania Academy of Fine Arts in Philadelphia she travelled extensively in Europe, and finally settled in Paris in the year of the first Impressionist exhibition, when she had a work accepted at the Salon. In 1877 a mutual friend brought Degas to her studio and they almost immediately struck up a relationship which was to be close and intimate – probably in all senses of the word – for many years. It was not as simple as that between master and pupil; Degas learned a lot from her, and she always retained her own crisp artistic personality and style, especially apparent in her later prints and pastels. Degas

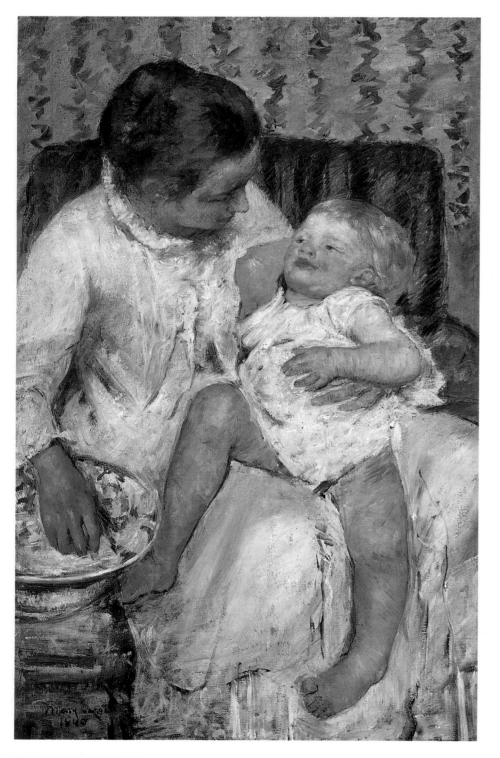

241 MARY CASSATT *Mother about to wash her sleepy child* 1880

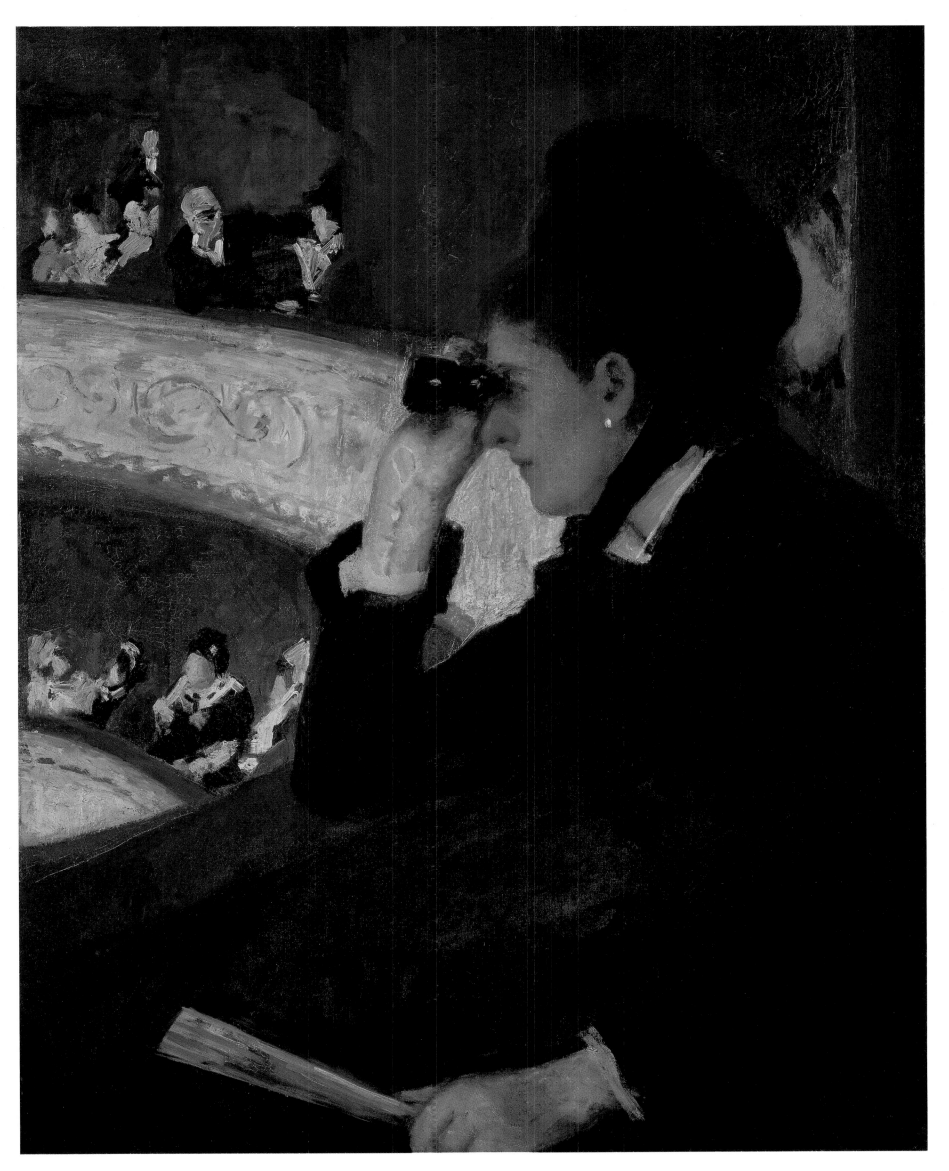

243 MARY CASSATT *A woman in black at the Opéra* 1880

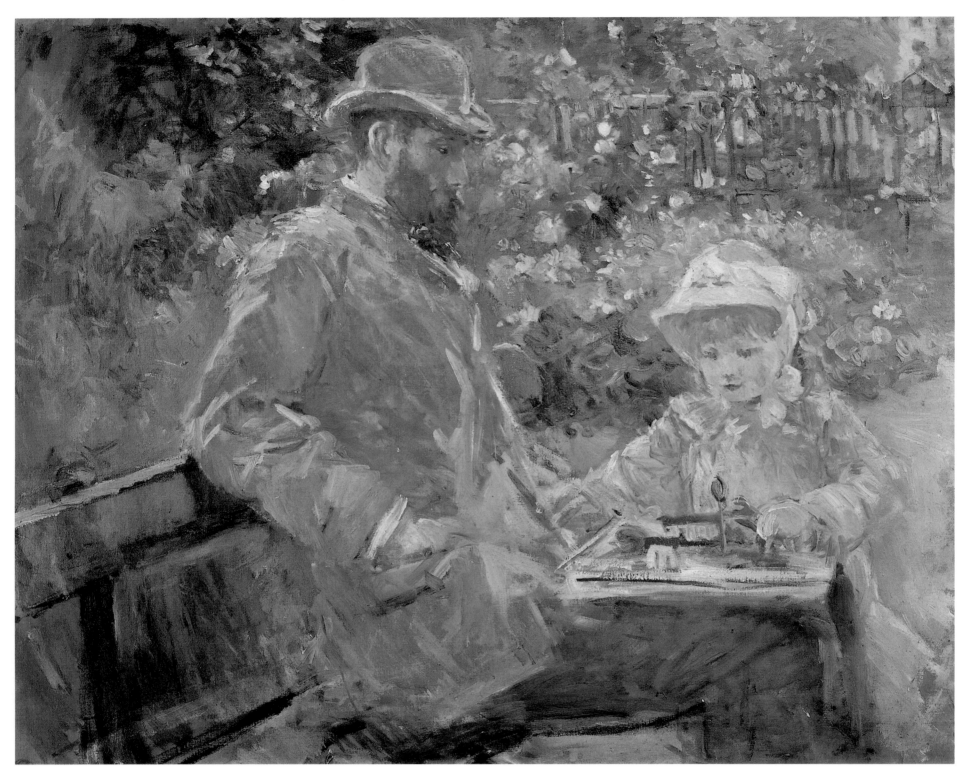

244 BERTHE MORISOT *Eugène Manet and his daughter at Bougival* 1881

persuaded her to join the Impressionists and, apart from anything else, she was to be a pillar of strength to the movement, giving financial support and through her extensive American contacts building up a sizeable group of patrons who were to be of inestimable help.

In her first appearance at the group exhibitions, in 1879, Cassatt showed amongst other works a painting of her sister Lydia in a box at the theatre, the first of a whole series dedicated to this theme. The masterpiece of the series is the *Woman in black at the Opéra* (Plate 243), which was painted in 1880. It is the only one in the genre which shows the woman actually using opera-glasses, and the impression of a woman of positive personality is emphasized by the vigour of the composition, with its Manet-like quality. The lines of the balcony are used to focus the viewer's attention on the emphatic triangular shape of the woman, whose self-containment is somehow accentuated by the frivolity of the gesture of the man on the other side of the theatre eyeing her through his opera-glasses. The

whole picture seems to sum up, however unintentionally, the confrontation of a Puritan American austerity with the frivolity of the Parisian scene.

Cassatt, however, like the other women members of the movement, had a natural penchant for the intimacies of domestic life. She portrayed these with instinctive affection, in a way which gives us quite a different picture of the real quality of family life in the nineteenth century from the sentimentalized Salon pictures of the time, which reduced its emotional realities to a kind of theatrical posturing. *Mother about to wash her sleepy child* (Plate 241), also painted in 1880, portrayed her sister-in-law – wife of her brother Alexander – who had spent a lengthy holiday in Paris that year, with her two-and-a-half-year-old child, whom Cassatt has painted in a convincingly Renoiresque style. The theme is real; the handling of the paint, especially in the dress, the bowl and the table on which it is placed, and the skin tones are emphatically Impressionistic. A similarly moving yet unsentimental portrayal of child-

hood, *Little girl in a blue armchair* (Plate 242), has an almost exaggerated casualness of pose – indicative incidentally of considerable painterly skills – and the use of colour in the encircling ring of blue-covered armchairs, the cool colours of the carpet, and the emphatic liveliness of the little girl's skin are especially impressive. Some years later Cassatt wrote about it to Ambroise Vollard:

I did it in '78 or '79 – it was a portrait of the child of friends of Degas. I had done it in a chair, and he highly approved of this, and gave me some excellent advice on the background, even working on it himself. I sent it to the American section of the great Exhibition, but it was refused. Since M. Degas had thought it good and because he had worked on it, I was furious; at that time it must have seemed very modern, and the jury consisted of three people, one of whom was a pharmacist.

Berthe Morisot, too, was an assiduous recorder of domesticity, but more often than not she preferred a garden environment. In the painting of her husband Eugène Manet and their daughter Julie, then aged three, in the garden of their house at Bougival (Plate 244), the effect of open-air painting makes its fullest impact. The sketch-like effect is heightened by the lightness of the paint around the outer edges of the picture and the rapid brushwork which describes the further reaches of the garden in the top right-hand corner. She became especially attracted to the Bois de Boulogne during those periods of the year when she lived in Paris at their house in the rue de Villejust nearby, and it provided the background to what is possibly her most completely Impressionist painting, *Summer's day*

(Plate 245), with its broad fluent brush-strokes, its capturing of the hot, hazy sunshine and the echoes of the riverside scenes of Renoir and Monet. Paul Valéry, one of her great admirers, explained her feelings for this essentially urban environment:

Living on the edge of the Bois, she found it gave her landscape enough; trees, the gleaming lake, and sometimes ice for skaters. She was sometimes teased by Mallarmé, who had a poetic enthusiasm for the remoter woods of Fontainebleau, on account of her liking for the scanty groves and mediocre glades which are all that is to be found between the Porte Dauphine and the Seine. For him the landscape of the Bois was a mediocre place, short on mystery, and devoid of stately groves. But Berthe was content with the parsimony Nature showed to Paris, taking from it all that it afforded, subjects for some exquisite paintings.

On the other hand, she did have a series of gardens on which she could rely. In addition to Bougival there was her sister Edma's house in Maurecourt, the setting for *Chasing butterflies* of 1879 (Plate 246): here the figures of Edma and the three children are framed in an arch of trees and foliage, the blossoms of which twinkle in the evanescent light. So fresh and spontaneous are her works that it is difficult to grasp that painting them was not the pure joy it seemed to be. Her letters are full of self-doubt and more basic irritations. In 1875, for instance, she wrote to Edma from Cowes, where they were staying in one of their frequent excursions to restore Eugène's fragile health:

I am horribly depressed tonight, tired and on edge, out of sorts, having

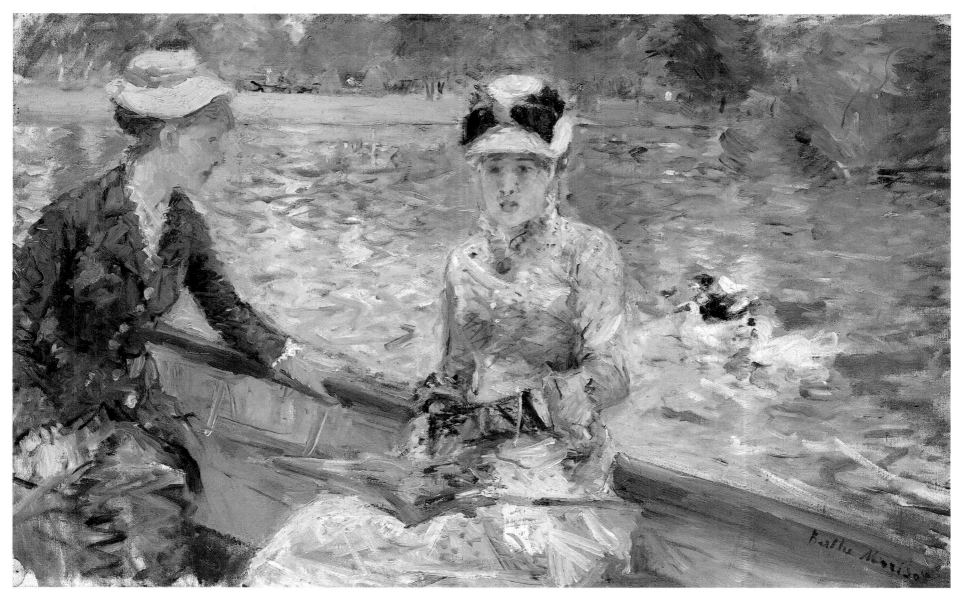

245 BERTHE MORISOT *Summer's day* 1879

once more had the proof that the joys of motherhood are not meant for me. That is a misfortune to which you would never resign yourself and, despite all my philosophy, there are days when I am inclined to complain bitterly about the injustice of fate.

My work is going badly, and this is no consolation. It is always the same story. I don't know where to start. I started to make an attempt in a field nearby, but as soon as I had set my easel up, more than 50 boys and girls were swarming about me, shouting and gesticulating. All this ended in a pitched battle, and the owner of the field came to tell me rudely that I should have asked for permission to work there, and that my presence attracted the village children, who did a great deal of damage.

On a boat one has another kind of difficulty. Everything sways, there is an infernal lapping of water; one has the sun and the wind to cope with, the boats change position every minute etc. The view from my window is pretty to look at, but not to paint. Views from above are almost always incomprehensible; as a result of all this I am not doing very much, and the little I am doing seems dreadful to me. I miss the babies as models, one could make lovely pictures of them on the balcony...I am sending you an article on Goodwood to give you an idea

of its splendours. I was enchanted by my day there, but it was rather costly – and horribly fatiguing. Never in my life have I seen anything as picturesque as those outdoor luncheons. Gustave Doré was there with a group of women of fashion. Why doesn't he know how to profit from all this?

Recurrent through Morisot's correspondence, cause enough, possibly, of her depression, is the realization that the Manet she would really like to have married was Edouard, not Eugène. The curious thing, though, is that she, along with Renoir and Monet, was responsible for converting Manet to real open-air painting and making him, as it were, a fully-fledged Impressionist. This became apparent in a whole series of 'garden pictures' which he painted between 1874 and 1880, in which the colours are bright and juxtaposed, the forms simplified, and the lighting more varied and diverse than in his earlier works. One of these was *The Monet family in the garden* (Plate 248). This was painted at Argenteuil, at a time when Manet had

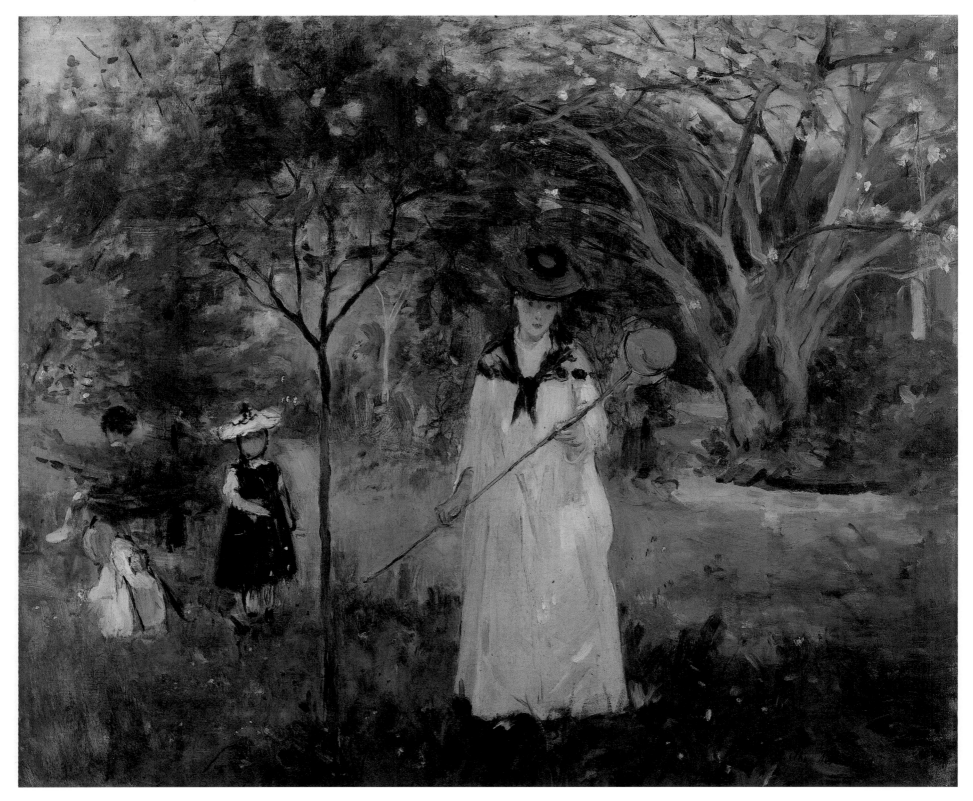

246 BERTHE MORISOT *Chasing butterflies* 1873

been helping Monet financially. While he was painting it Renoir also produced a version in exactly the same pose though from a slightly different angle (Plate 247). Many years later Monet recounted one aspect of the exercise:

This delicious painting of Renoir's, which I am happy to have today, is a portrait of my first wife. It was painted in the garden of our house at Argenteuil, one day when Manet, beguiled by the colour and the light, had begun a painting *en plein air* with the figures under the trees. During the session Renoir arrived. Captivated in his turn by the charm of the scene, he asked me for my palette, brushes and a canvas, and started to paint at Manet's side. Manet observed Renoir out of the corner of his eye, and from time to time would take a glimpse at the canvas. Then with a kind of grimace, he sidled up to me and whispered in my ear, indicating Renoir, 'That fellow has no talent at all. Please, you who are his friend, tell him to give up painting.'

Of the two versions, Renoir's is the more spontaneous, Manet's the more contrived in its composition – it includes a third figure, presumably Monet, characteristically at work on the flower-beds, and the width of the landscape background gives the whole work a sense of gravity, which is somehow balanced by the hens in the left foreground. At first sight it could well pass for a work by Morisot, were it not for the sobriety of the colour.

Manet turned again to the bourgeois delights of human beings in a garden with *In the conservatory* of 1879 (Plate 249). This was painted in the studio which he had rented from the Swedish neo-classicist painter Count Johann Georges Otto Rosen, and the figures are Jules Guillemet, who owned a luxury dress-shop in the rue Saint-Honoré, and

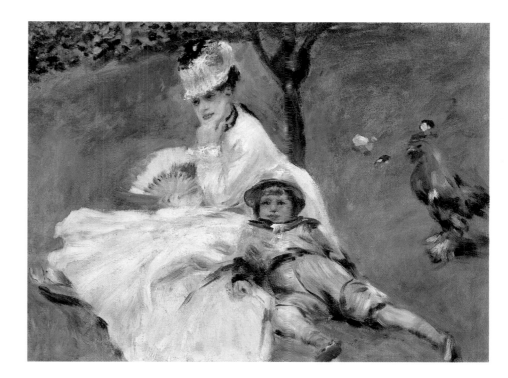

247 PIERRE-AUGUSTE RENOIR *Madame Monet in the garden* 1874

his American wife, celebrated for her beauty and elegance. The picture is bathed in an even, 'un-Impressionist' light, and the dominance of the two figures, with their heavily accented wedding rings, is partially counteracted by the care Manet has taken with the precisely observed plants which form the background to the work. Whilst he was painting the Guillemets, he also produced a less contrived portrait of his wife, who was a particularly close friend of

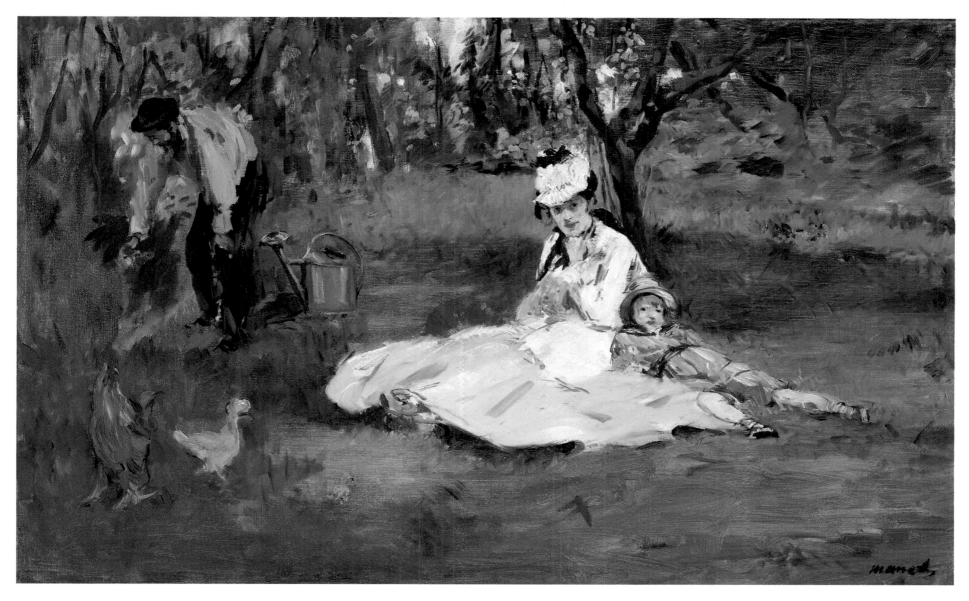

248 EDOUARD MANET *The Monet family in the garden* 1874

255

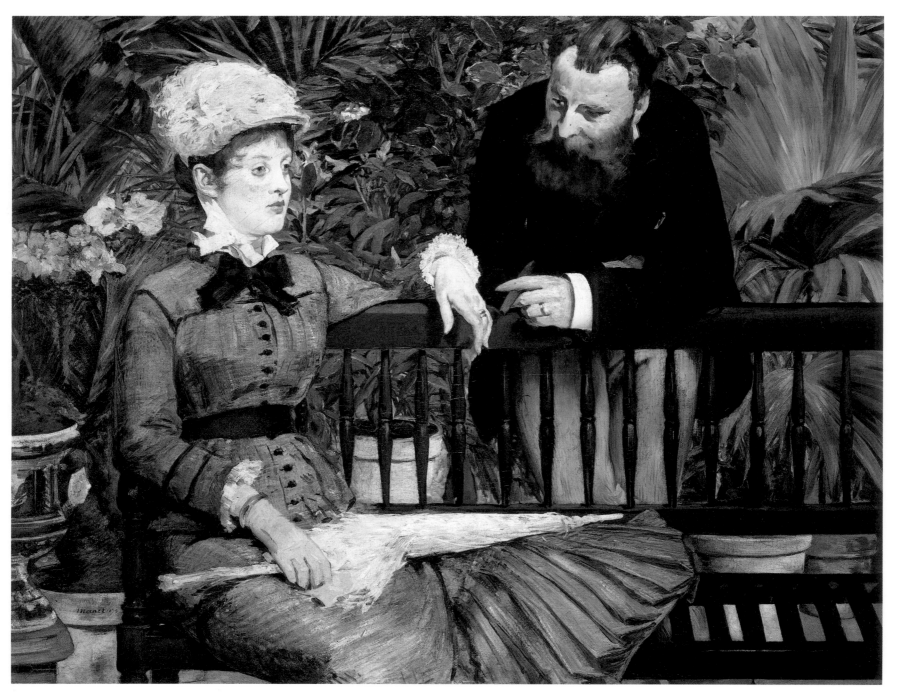

249 EDOUARD MANET *In the conservatory* 1879

theirs, seated on the same bench against the same background, but on this occasion focusing primarily on the hues and tones of the skin (Plate 251). This seems to be a totally convincing portrait of the amiable Dutchwoman that Suzanne Manet was. According to the painter Joseph de Nittis:

There was something very special about Madame Manet, the gift of kindness, simplicity, candour of spirit, an unruffled serenity. In her slightest words one could detect the deep love she had for her charming *enfant terrible* of a husband. One day he was following a pretty girl, slender and flirtatious. His wife suddenly came up to him, saying with a merry laugh, 'This time I caught you.' 'That's funny,' he replied, 'I was certain it was you.'

In the conservatory was accepted at the Salon of 1879, where it had a mixed reception. Great play was made with the location of the scene, as conservatories, ever since their introduction during the Second Empire, had acquired a reputation as ideal for seduction, a notion given publicity by Zola some years earlier when he had set in a conservatory the sexual escapades of the wife of the financier Saccard in *La curée*. One caricature of Manet's painting in *Le Journal Amusant* bore the caption 'An innocent young

250 Photograph of Suzanne Manet in about 1876.

woman caught in the fist of a seducer'. One favourable review came from a newcomer on the art scene, the Dutch-born Joris-Karl Huysmans (1848-1907), at this time a fervent protagonist of realism, who commented:

Thus posed in an interval of conversation, this figure is indeed beautiful: she flirts, she lives. The air moves, the figures are marvellously detached from the envelope of green surrounding them. Here is a modern work of great charm, a battle fought and won against the conventional rendering of sunlight, never observed from nature.

Manet himself, ever hopeful of official recognition, wrote on 6 June 1879 to the Under-Secretary of State for the Fine Arts suggesting that it might be considered for purchase by the state:

I had the honour of being received in audience by you about the middle of last May, and though you held out no great hopes concerning the purchase of one of my canvases exhibited at the Salon, you were kind enough to consider it and let me have your answer directly...I have the honour then to commend myself to your recollection, and trusting in your promise I remain...

Eventually, however, it was to become the first of Manet's paintings to enter a public gallery. Sold to Faure on the artist's death in 1883 for 4,000 francs, it was assigned to Durand-Ruel, who in 1896 sold it to the famous Berlin collector Eduard Arnhold. On the advice of Hugo von Tschudi (1851-1911), who had written a book about Manet and was then curator of the Prussian National Gallery in Berlin, it was donated to that institution, where it has remained ever since, apart from a short sojourn in a salt-mine during the last war.

Pissarro's life had been dominated since the 1870s by Pontoise, where he and his family lived in various rented houses. It was a little village mainly inhabited by small-holders — because of its geographical setting, surrounded as it was by small hills, it was incapable of sustaining any extensive field cultivation. The image of him which emerged from his identification with the place was Millet-like; one journalist wrote in 1886:

He lives deep in lower Normandy on a farm which he cultivates himself, and which feeds him from the very soil on which he works. When the harvest has been good and he is free from his labour in the fields,

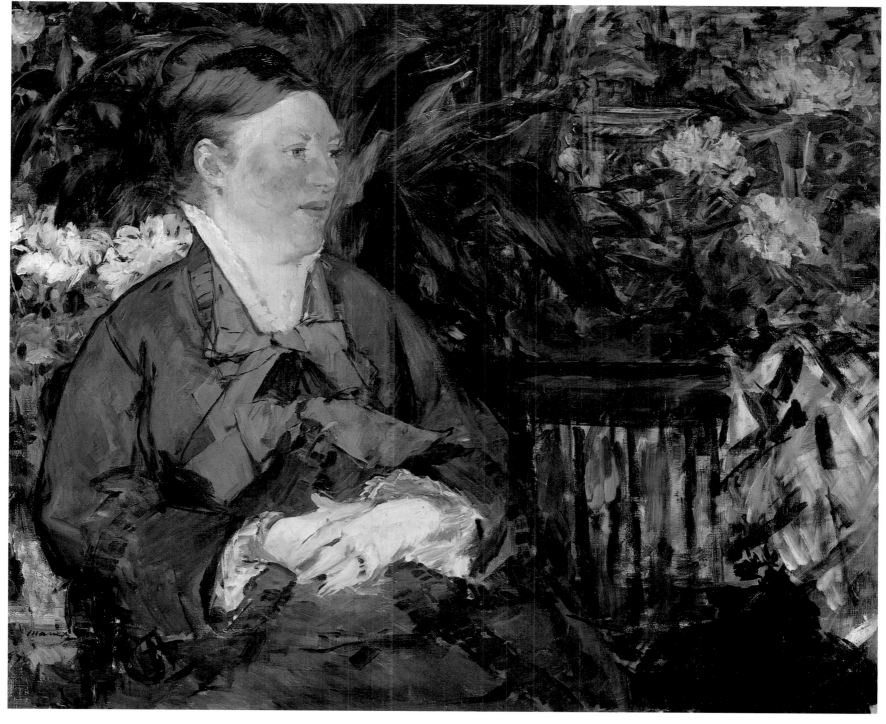

251 EDOUARD MANET *Madame Manet in the conservatory* 1879

Pissarro takes up his brushes and fixes on canvas the rough existence of the creatures and the country life that he leads himself.

Here then, it would seem, was the realism of the Impressionists stretching into that rural dimension which Millet and others had so successfully cultivated. Pissarro himself was very sensitive about this comparison. He admired Millet's drawings but found his paintings too sentimental, and compared them with those of Greuze, that purveyor of eighteenth-century kitsch. In any case, as he tartly pointed out, 'They throw Millet at me, but Millet was biblical. For a Jew that seems to me a bit much.' Moreover, his vision during most of his career up to this point had been predominantly one of landscape, views of the Seine, of country roads, of blossoming trees (Plates 252, 276). It was in this genre that he had worked out a formula and an approach which was recorded in the advice he gave to a young painter, Louis Le Bail, some years later (see p.338).

252 CAMILLE PISSARRO *Orchard in Pontoise, spring* 1877
This is identical in subject to a painting which Cézanne did at the same time (Collection of Mrs Alexander Albert, San Francisco), though in his case he chose a viewpoint from behind the tree in the foreground of Pissarro's painting.

However Pissarro's social and political preoccupations – which reached their most explicit form in the 1890s – were affecting his concern with realism in the 1870s, this was inhibited by his perfunctory approach to the depiction of human beings. The Hermitage at Pontoise, which he painted in 1874, was a section of the village which was mainly occupied with allotments; it also gave its name to a new road built through the village in the 1860s, which introduced into its rural tranquillity something of that suburban quality which was radiating out from as far away as Paris. The human figures which appear in it are not only subsidiary to the context but were sketchily painted, to the point of caricature. By the end of the decade he was becoming aware that this represented a weakness in himself, and the charming picture he painted in 1879 of his wife sewing (Plate 129) suggested a line of development he was going to take.

There were more pragmatic reasons for turning to a more aggressively rural iconography. The death of Millet in 1875 had promoted an increase in the value of his works; rustic scenes were becoming very popular with the Salon juries, and even within the confines of the Impressionist group

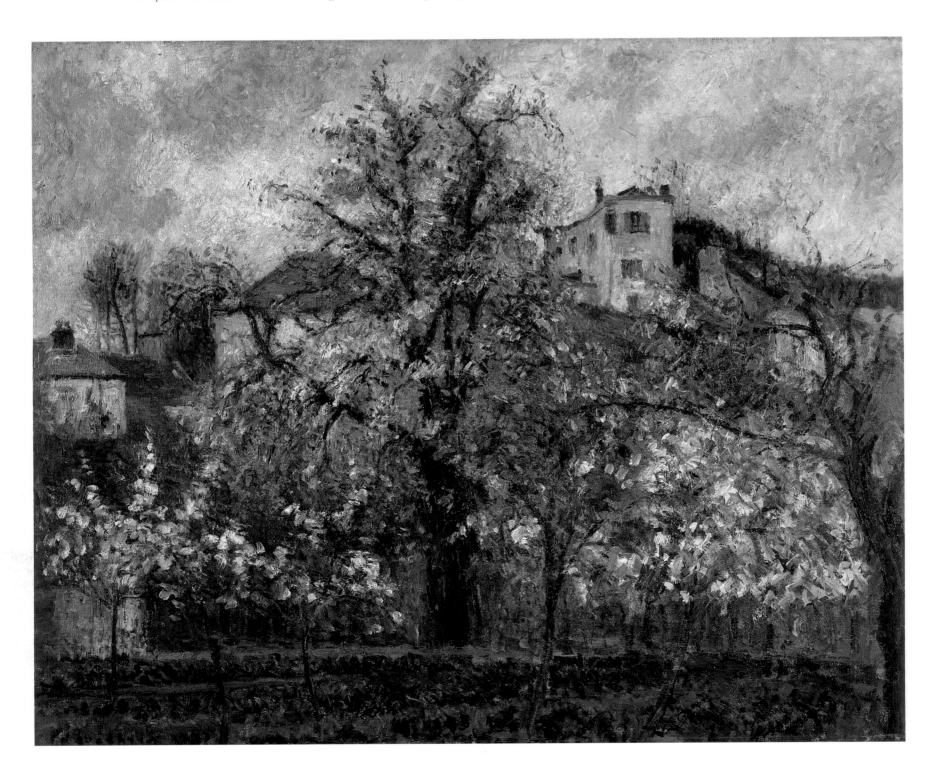

there lingered the old prejudice that landscape painting was a somehow inferior branch of the art. This attitude had been underlined by Huysmans when discussing the seventh Impressionist exhibition, which opened on 1 March 1882 at 251 rue Saint-Honoré. He had deplored the predominance of landscape and the internal bickering which went on: 'The circle of modernism has really been too much restricted, and one cannot but deplore this diminution which vile quarrels have brought about in this little group.' Pissarro, however, who had 25 oils and 11 gouaches in the exhibition, was delighted with it and wrote to de Bellio, who was in Romania, 'You would have been pleased with the overall aspect of our show, for this is the first time that we have had no blunders to deplore.' Among the works he exhibited were several of peasant girls, including one drinking coffee in a sunlit interior (Plate 254) which showed how far he had gone along the path of rural realism.

This was the year in which he moved to Eragny, a hamlet on the outskirts of the market town of Gisors. The area was also given over, as Pontoise was, to small farms usually run by a husband and wife, but it was very much in decline as a consequence of the cheapness of imported beef and lamb, the failure of its previously successful textile firms to keep up with the new processes of industrialization, and the increasing dominance of Paris. For the next few years Pissarro would continue to paint peasant girls, gleaners and harvesters in the fields, milking scenes and the like, in a style which often came close – despite his protestations – to the work of Millet and others of that more sentimental

253 Photograph of Pissarro (*right*) and Cézanne (*centre*) with an unknown man near Auvers, *c.* 1874.

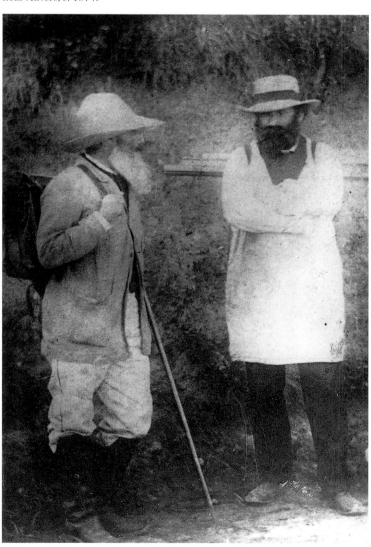

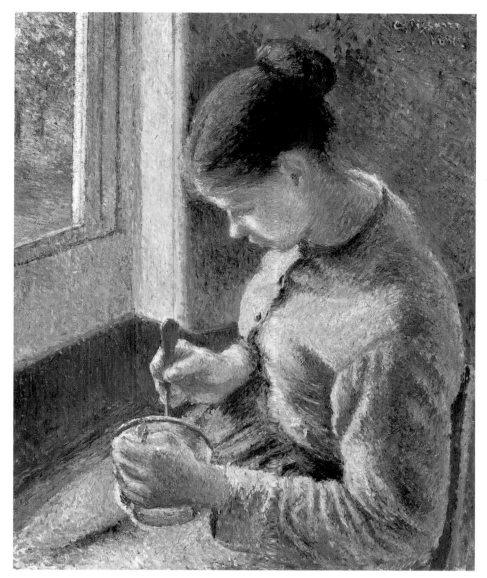

254 CAMILLE PISSARRO *Peasant girl drinking her coffee* 1881

school (*The gleaners*, Plate 289), as well as pictures of market life at Gisors (*The pork butcher*, Plate 291). At the same time, too, his use of other media was expanding. He continued his print-making activities, which had been stimulated by Dr Gachet, experimented with varying forms of gouache painted on ceramic tiles, and even made small models of cows for use in his paintings, hardly a vindication of his dedication to *plein air* painting.

In a letter to Huysmans about his review of the 1882 exhibition, Pissarro wrote:

Why is it that you did not say a word about Cézanne, whom all of us recognize as one of the most curious and astounding temperaments of our time, and who has had a very great influence on modern art?

Huysmans replied:

I find Cézanne's personality congenial, for I know through Zola of his efforts, his vexations, his defeats, when he tries to create a work! Yes, he has temperament, he is an artist, but in the long run, with the exception of some still lifes, the rest – to my mind – is not likely to survive. It is interesting, curious, suggestive in ideas, but certainly he is an 'eye case', which I gather he himself realizes. In my opinion Cézanne is typical of those other Impressionists who have not quite made the grade. You know that after so many years of struggle it is no longer a question of more or less manifest or visible intentions, but of works which are full of serious results, which are not monsters, odd cases for a Dupuytren museum of painting.[1]

He went on to point out that Cézanne had not exhibited in Paris since 1877 and that he could not therefore be reviewed. He had in fact shown works at two of the

Impressionist exhibitions, that of 1874, where he showed three, and that of 1877, when he was represented by 13 paintings and three watercolours.

Pissarro had always been one of Cézanne's most fervent supporters, and it had only been his persistent efforts, aided to a certain extent by Monet, which had secured his acceptance in the 1874 exhibition, despite some opposition from Degas. In 1872 Cézanne, together with his mistress Hortense Fiquet and their son, spent some time with the Pissarros at Pontoise and then went on to nearby Auvers, where he rented a house near that of Dr Gachet but still maintained close contact with the Pissarros. He was to return to Pontoise on several occasions, in 1877 for instance when he painted the *Orchard in Pontoise* (Private Collection, USA). The influence of the older artist was seminal, weaning him away from the dark colours which

had hitherto played such an important part in his art and persuading him to use long, narrow, flat and supple palette-knives. 'We are perhaps all derived from Pissarro,' Cézanne said later, though Pissarro himself acknowledged readily the influence Cézanne had on him. Cézanne was less interested even than Pissarro had been in any form of realism. The urban landscape had no appeal for him, and although from time to time he produced paintings such as *The large bathers* (Plate 326), these were idealistic ventures into the world of the old masters rather than records of contemporary life. In some ways this is curious, since he was still on terms of intimate friendship with that enthusiastic apostle of realism, Zola, and spent a great deal of time in the late 1870s and early '80s in the house which Zola had been able to acquire at Médan on the Seine about 20 miles from Paris. Here he was supremely happy, accepted as a painter, with his works hanging in the hall and the billiard room, and meeting people such as Paul Alexis, Huysmans and Duret.

Another close contact of Cézanne's, and one who was to contribute to the diverse mixture of influences which he was to meld into something so special to himself, was

255 PAUL CEZANNE *The Seine at Bercy* 1876
Cézanne and Guillaumin were very close to each other, especially between 1875 and 1876 when they both lived on the quai d'Anjou in Paris, near where this scene is set. Cézanne copied the painting from a virtually identical one which Guillaumin had painted in 1873, and was to continue this practice until 1879. It was no new thing for him: in 1872 he had copied a landscape by Pissarro, to familiarize himself with the work of the man he saw as his 'master'.

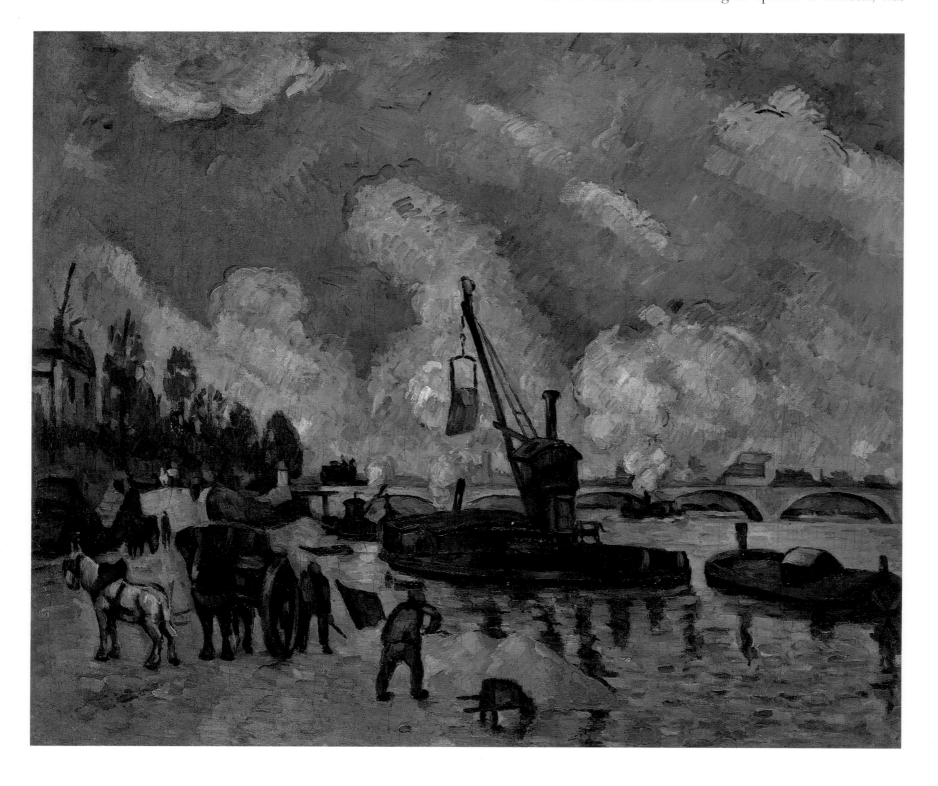

Armand Guillaumin, who had been his fellow-student at the Académie Suisse. It is a curious reflexion, not only on Cézanne's own creative personality but on the extent to which practices dating back to the Middle Ages still survived in nineteenth-century France, that Cézanne was quite happy not only to paint scenes from the same viewpoint and at the same time as his fellow-artist, but even borrow works to copy. This had happened in 1872, when he had begun to paint out of doors, and borrowed a view of Louveciennes by Pissarro, of which he made a reduced copy so as to understand the technique. Then in 1876 he copied literally *The Seine at Bercy*, one of a whole series which Guillaumin had been painting at the time (Plates 255, 256), using a canvas of the identical size. Cézanne's version repeats the composition exactly, but the technique is very different, looser and more dramatic, heavily emphasizing the clouds in the sky, and using brighter colours applied with regular square brush-strokes, especially apparent in the shadows on the water and the buildings on the left. At the same time too he used photographs which he often copied quite slavishly in several of his self-portraits as well as in landscape paintings such as a snow scene in Fontainebleau which he painted in 1879 and in which he uses the same brush-stroke technique apparent in the copy of the Guillaumin.

In the case of the landscapes of a scene near Issy painted around 1879, the identity between the two is more apparent than real, and possibly seems to have been occasioned by the fact that both artists set up their easels on the same hillside, probably side by side, with Guillaumin seated on Cézanne's left, as can be detected by using the small red-roofed houses as a point of topographical reference. There are other, less understandable differences too, which could possibly be explained on the different hypothesis that the two pictures were not painted at the same time but that Cézanne, looking at Guillaumin's painting, even perhaps borrowing it, set out to paint the same scene from approximately the same viewpoint. In Cézanne's version the two trees which frame the scene retain far fewer leaves and those in the valley have a more autumnal tint. Guillaumin's work represented a much closer conformity to main-line Impressionism. Indeed, unlike Cézanne, who in his search for a greater rigour of form was undermining the movement's central structure, and after 1877 never exhibited with the group, Guillaumin took part in the exhibitions of 1880, 1881, 1882 and 1885.

[1] For an account of the later history of this collection see p.347.

[2] Charles Deudon (1852-1914) was involved in the successful Parisian store Old England, and had for some time been a collector of paintings by the Impressionists; he had been patronizing Renoir since 1874. In 1880 he visited the painter at Chatou.

[3] The piece is entitled *Les canotiers; poème naturaliste traduit du javanais.*

[4] Guillaume Dupuytren (1777-1835) was a famous surgeon, who established an anatomical museum in the old convent of the Cordeliers in Paris, still in existence.

256 ARMAND GUILLAUMIN *The Seine at Charenton* 1878
Nothing is edited out of this view of the Seine, with its houseboats, its adjacent factory stacks belching out smoke, its pleasure-boats and small houses. It has the quality of a realistic Corot.

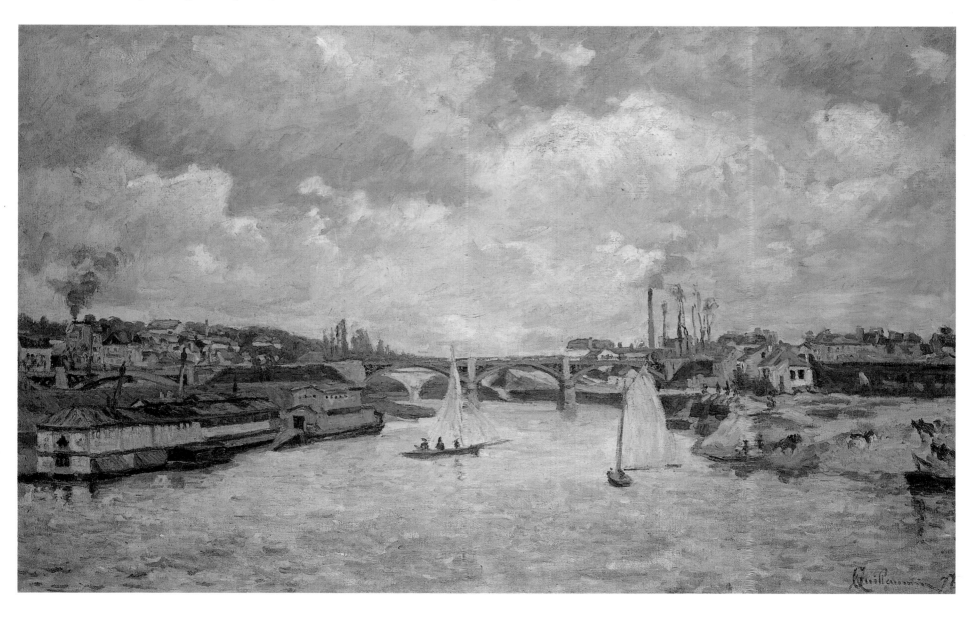

258 EDOUARD MANET *Boating* 1874
This is another painting showing Rodolph Leenhoff with an unknown woman.
It exemplifies very clearly the difference between Manet's technique and that of
his fellow painters at Argenteuil. This may be partly due to the fact that he had
intended to send it to the Salon, and so gave it a smoother finish than *Argenteuil*.

257 EDOUARD MANET *Argenteuil* 1874
When Renoir and Monet were painting at Argenteuil, Manet, who was spending
the summer nearby at Gennevilliers, often visited them. It was then that he was
fully converted to *plein-air* painting, and this is probably his first exercise in it.
The man is his brother-in-law Rodolph Leenhoff; the woman is unknown.

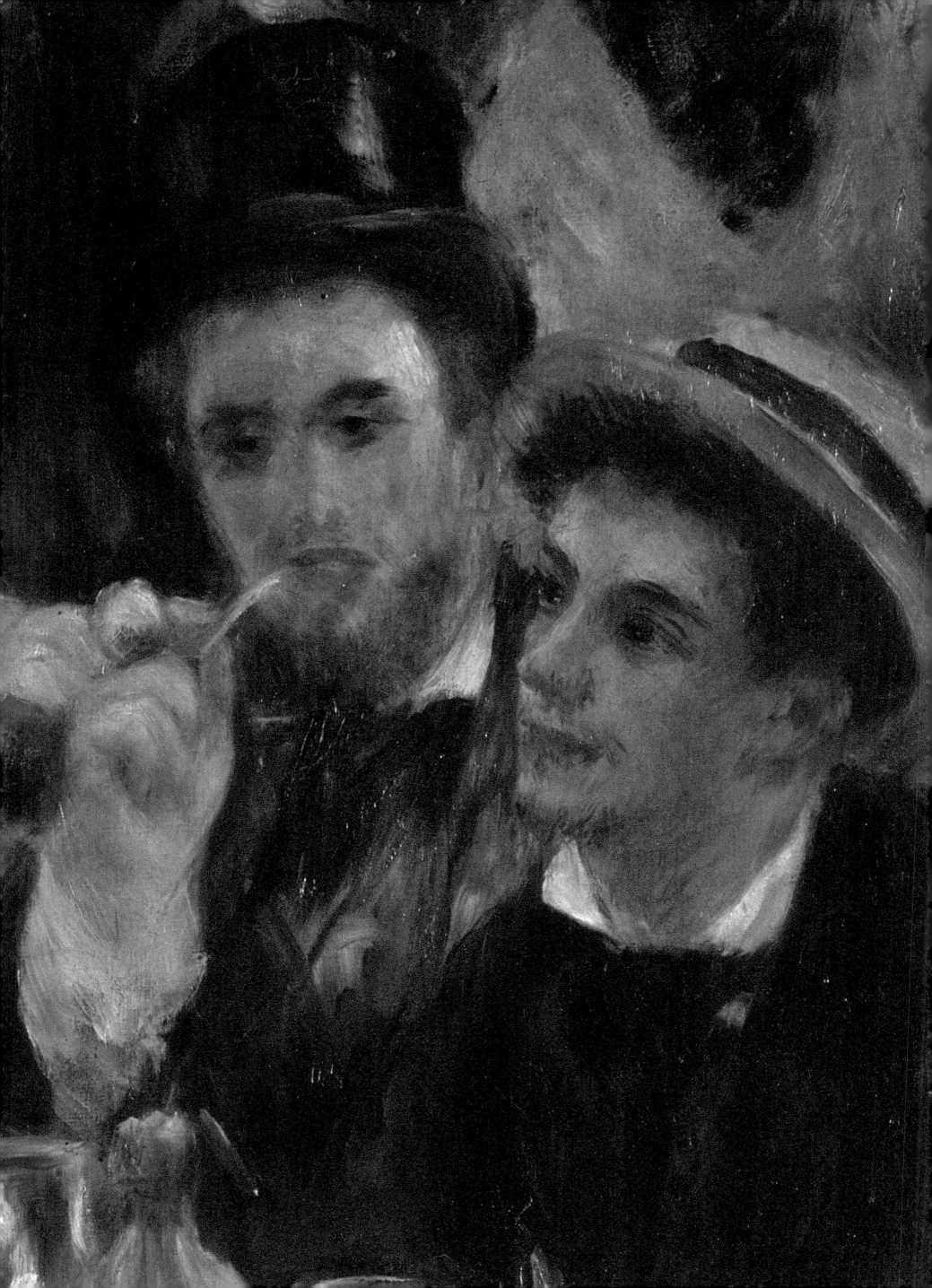

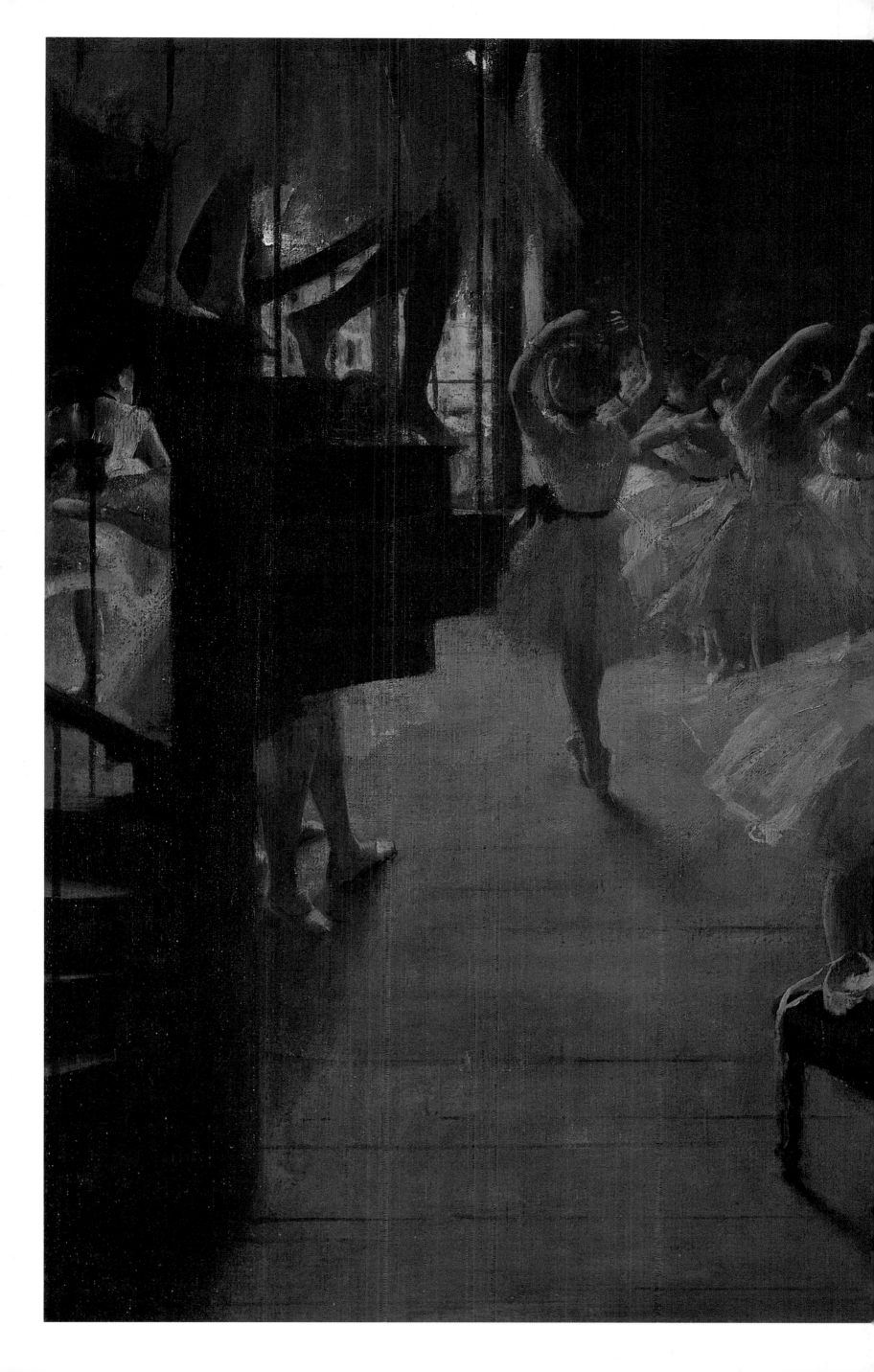

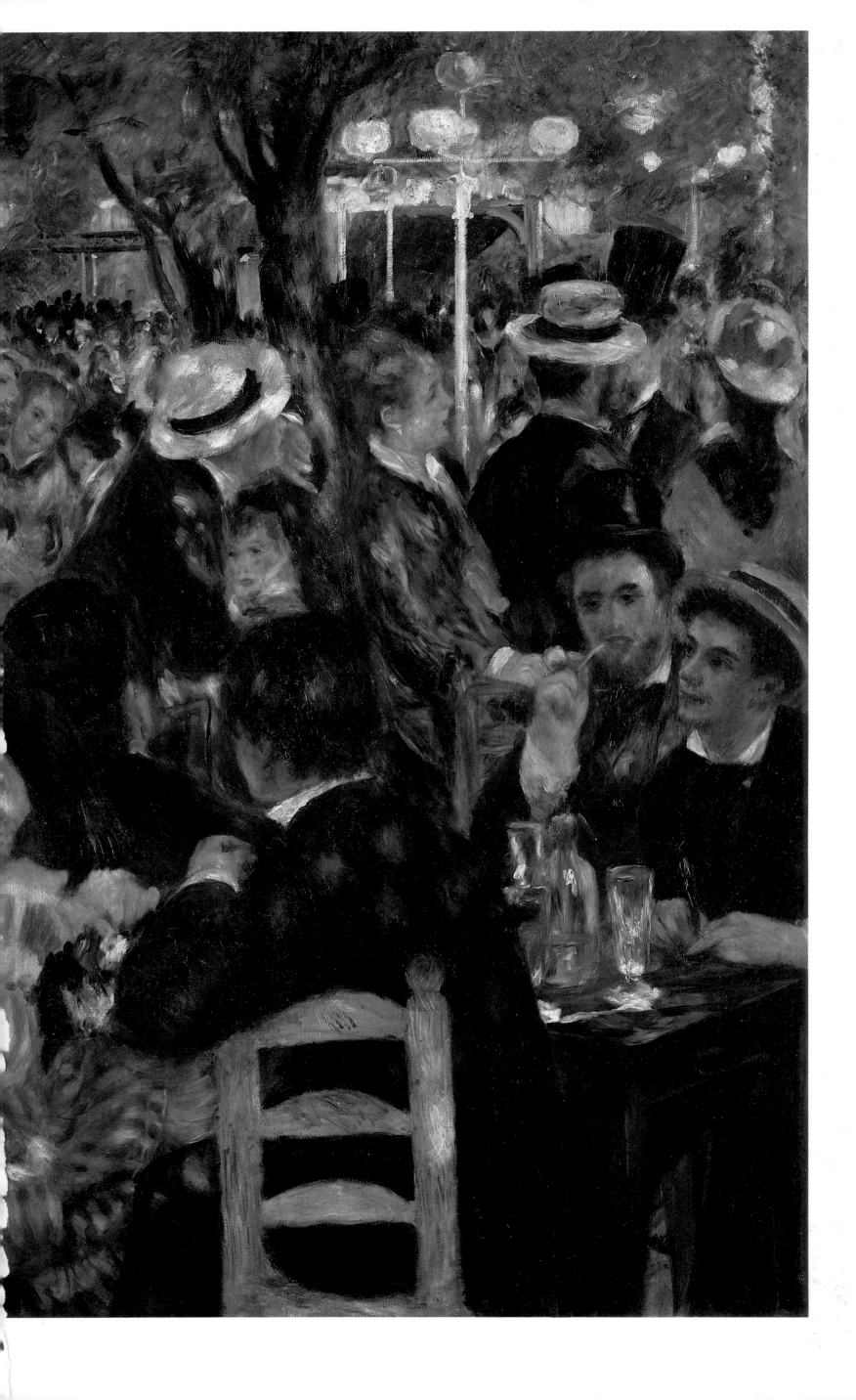

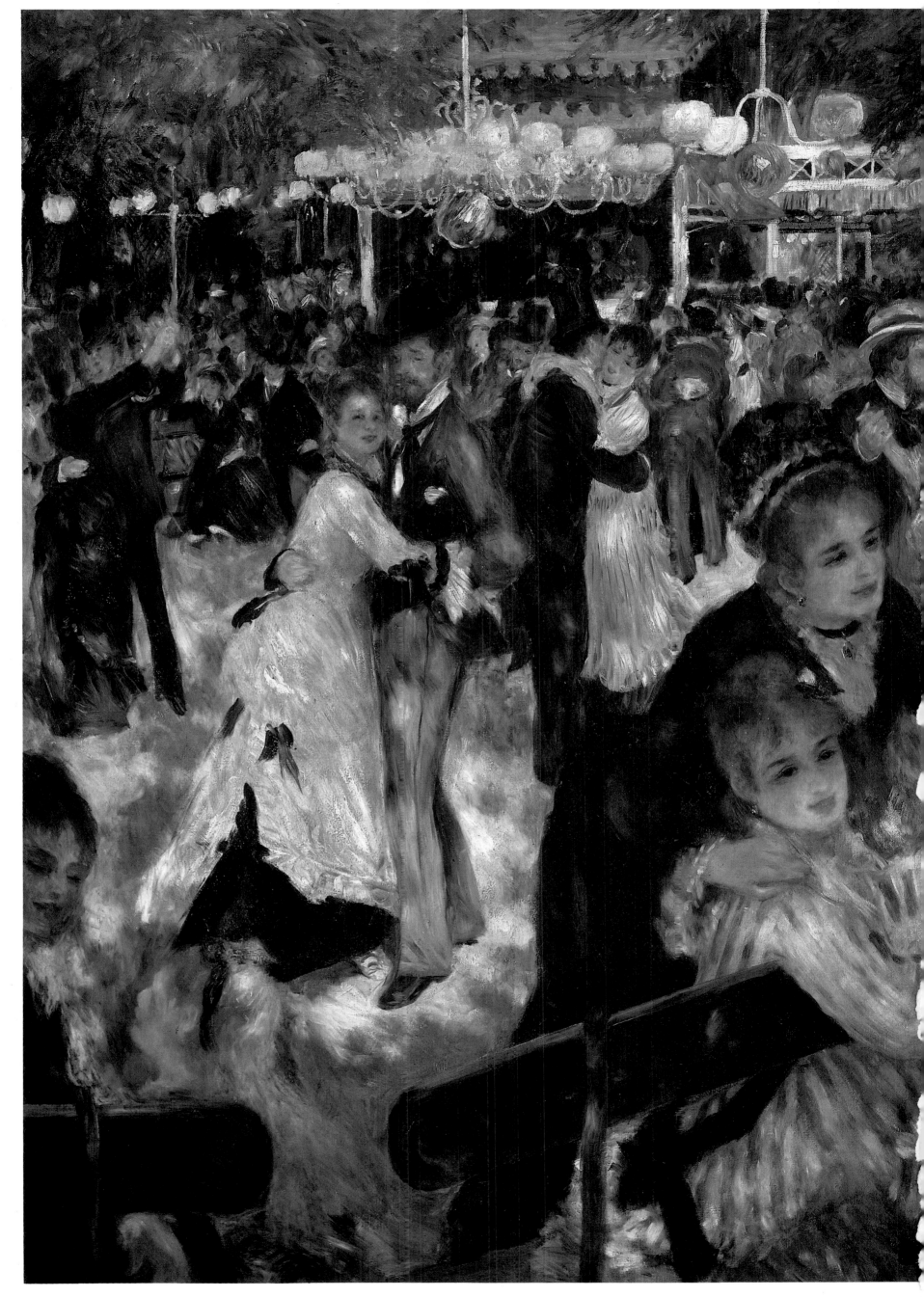

259 PIERRE-AUGUSTE RENOIR *Dancing at the Moulin de la Galette* 1876

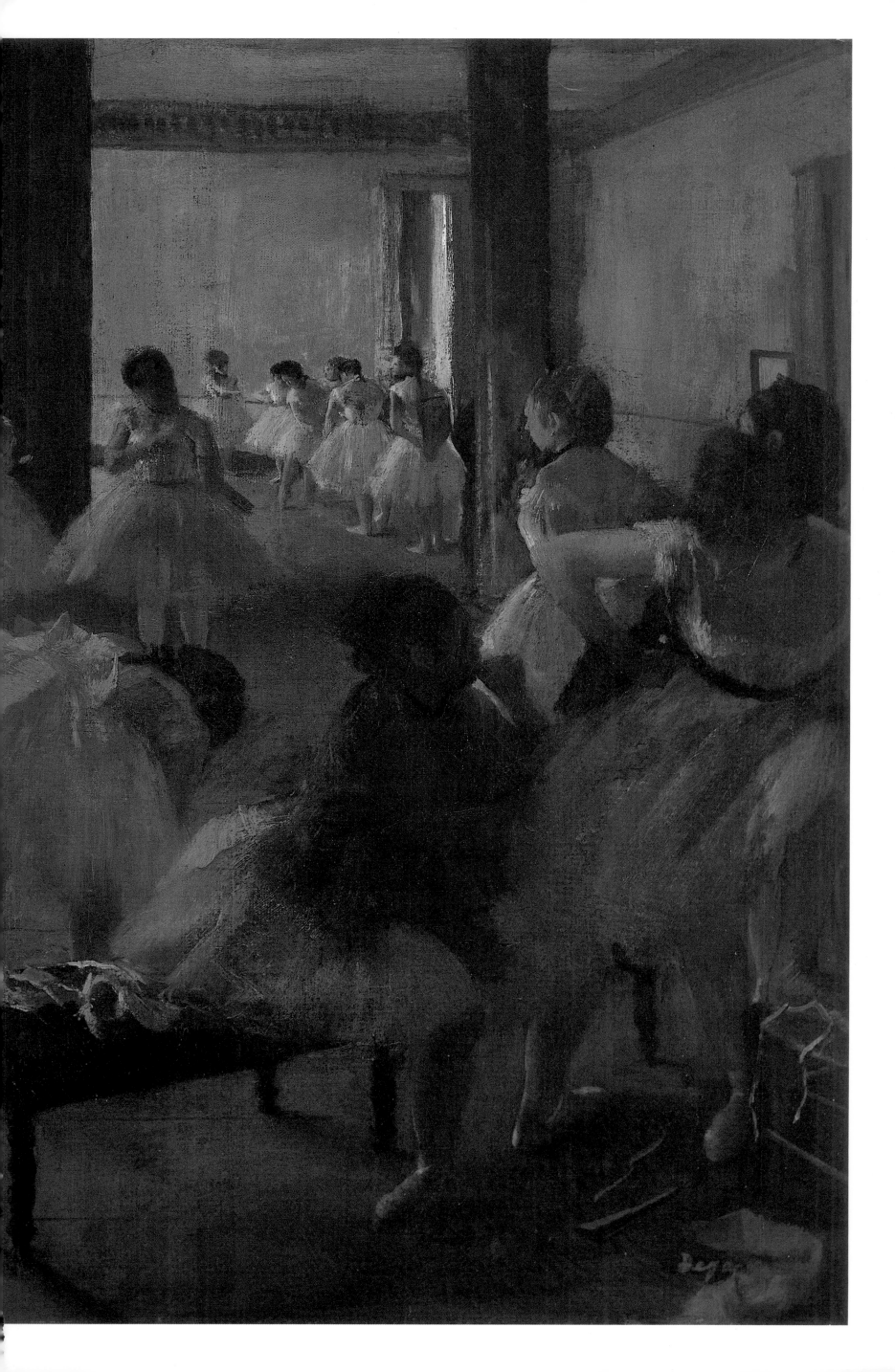

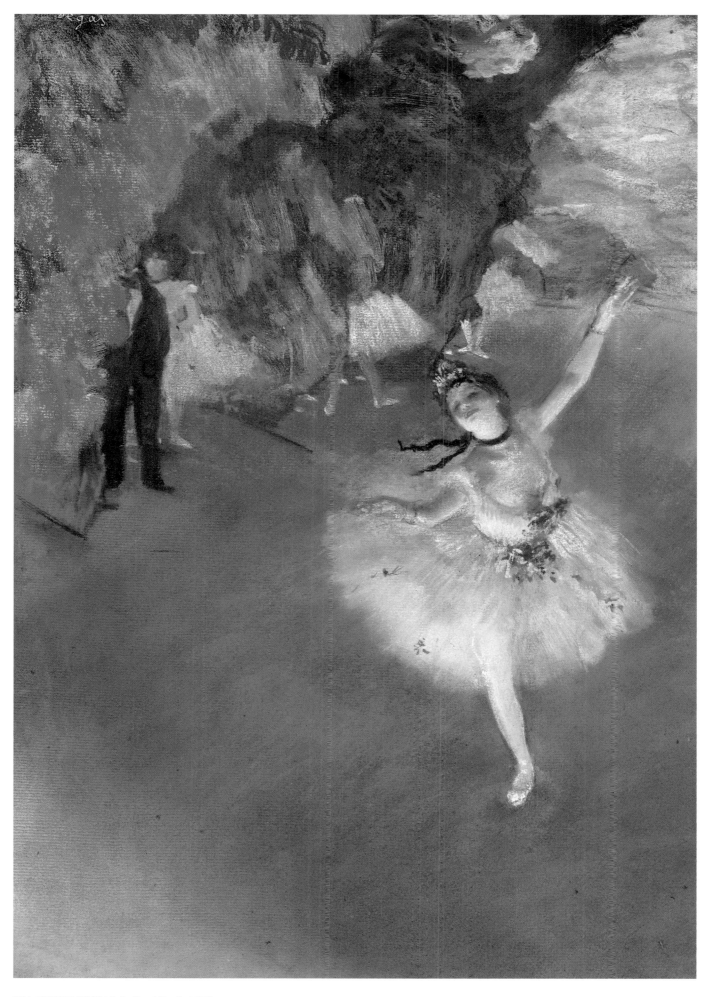

261 EDGAR DEGAS *Ballet: L'étoile* 1876
This, one of his most famous pastels, has achieved its celebrity in contradiction
to Degas's own opinions. He was irritated by so much attention being paid to
what he thought was one of his minor works. Exhibited at the Impressionist
exhibition of 1877, it was bought by Caillebotte. The pastel is superimposed
on a monotype.

260 EDGAR DEGAS *The foyer de danse* 1872
This is the very epitome of Degas's reputation as a painter of the ballet. He was
prompted to undertake it by the success of his *Dancing class* (Metropolitan
Museum) of the previous year. The scene is the foyer of the old Opéra in the rue
Peletier. The *maître de danse* is the famous Louis-Alexandre Mérante
(1828-87). The painting was highly praised by Sidney Colvin in *The Pall Mall
Gazette* when shown in London in 1872.

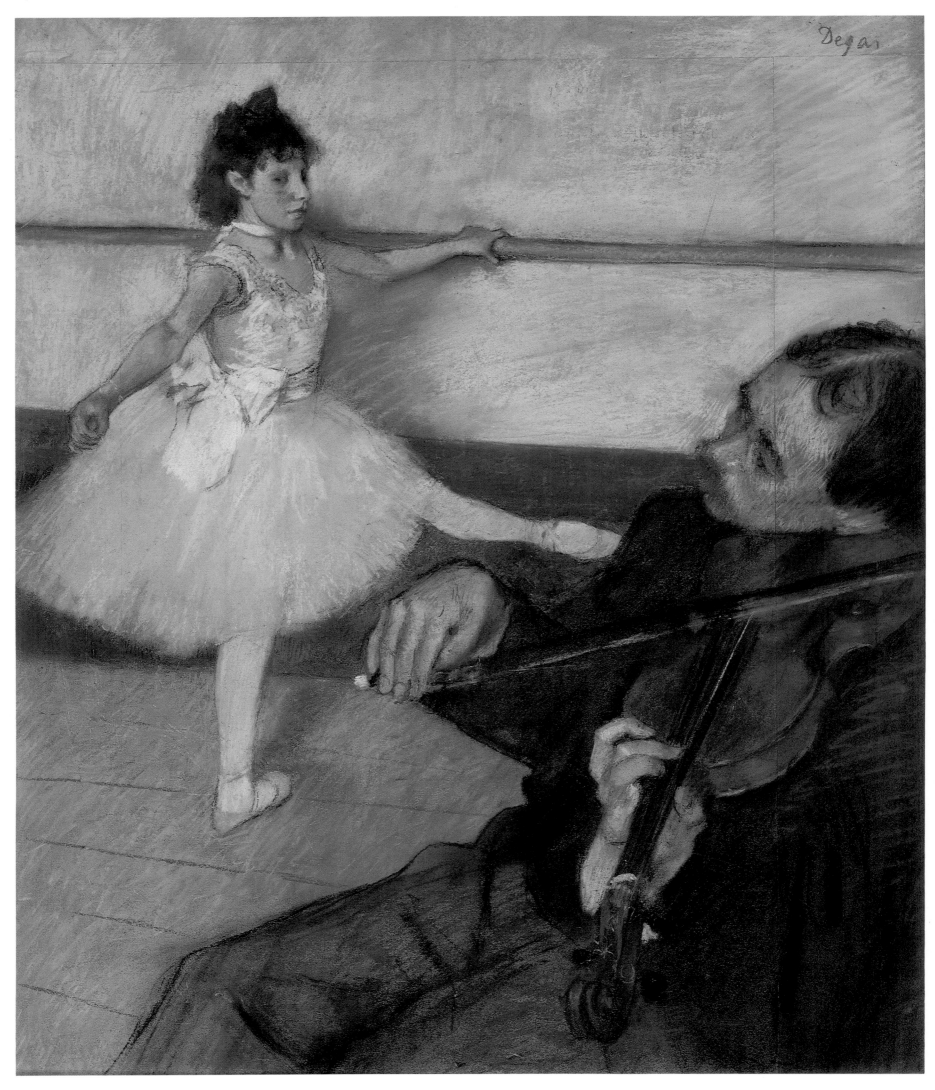

262 EDGAR DEGAS *The dance lesson c.* 1879
Although the violinist occupies a large part of this pastel, the work is dominated
by the young pupil, whose face is rendered with an accuracy unusual in Degas's
ballet pictures. It was bought by Caillebotte at the 1879 Impressionist exhibition.

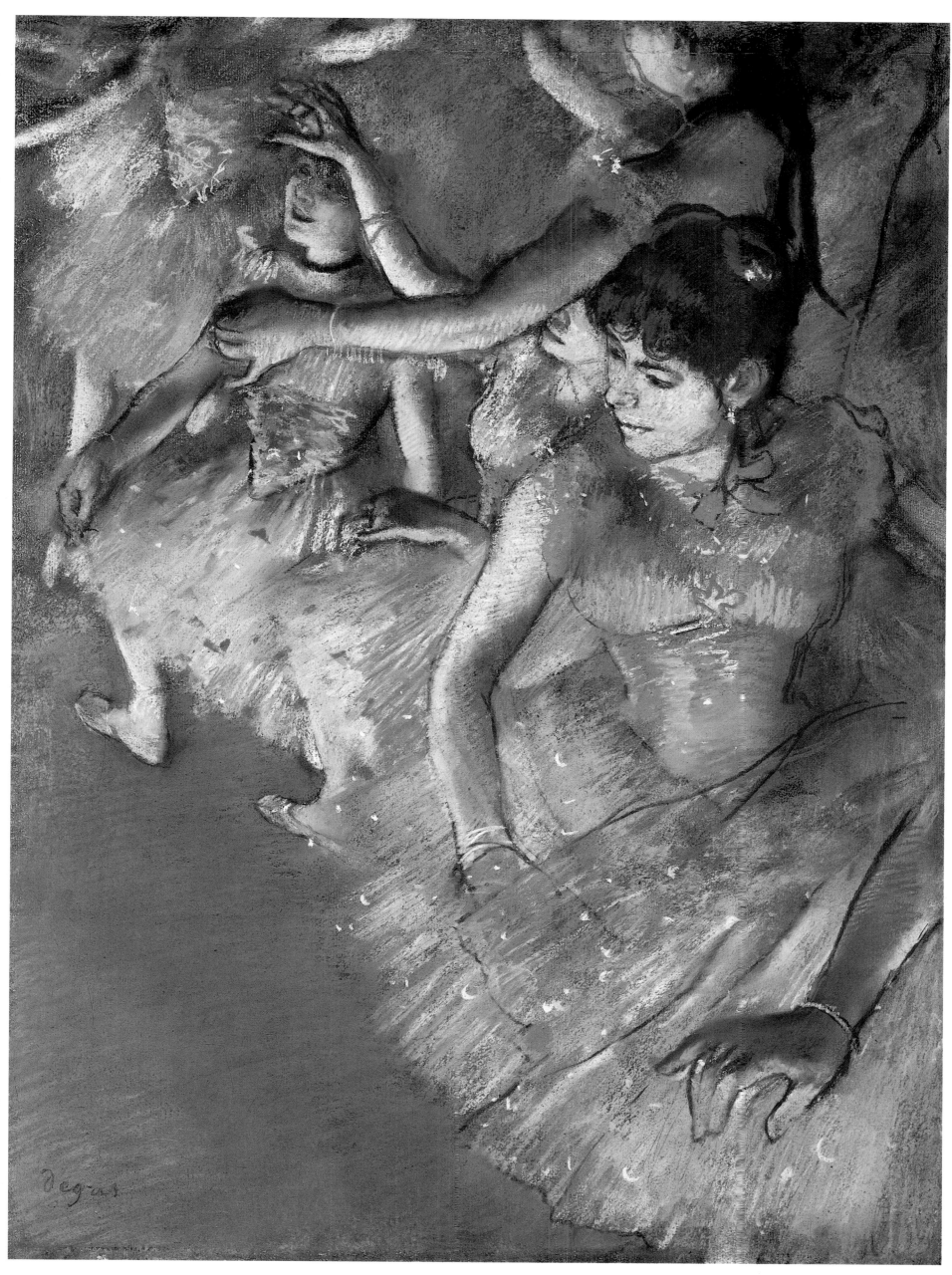

263 EDGAR DEGAS *Dancers* 1883
No other ballet picture by Degas presents such a variety of motions and poses as
this pastel, nor anywhere else has he used yellow tonalities with such single-
minded dexterity.

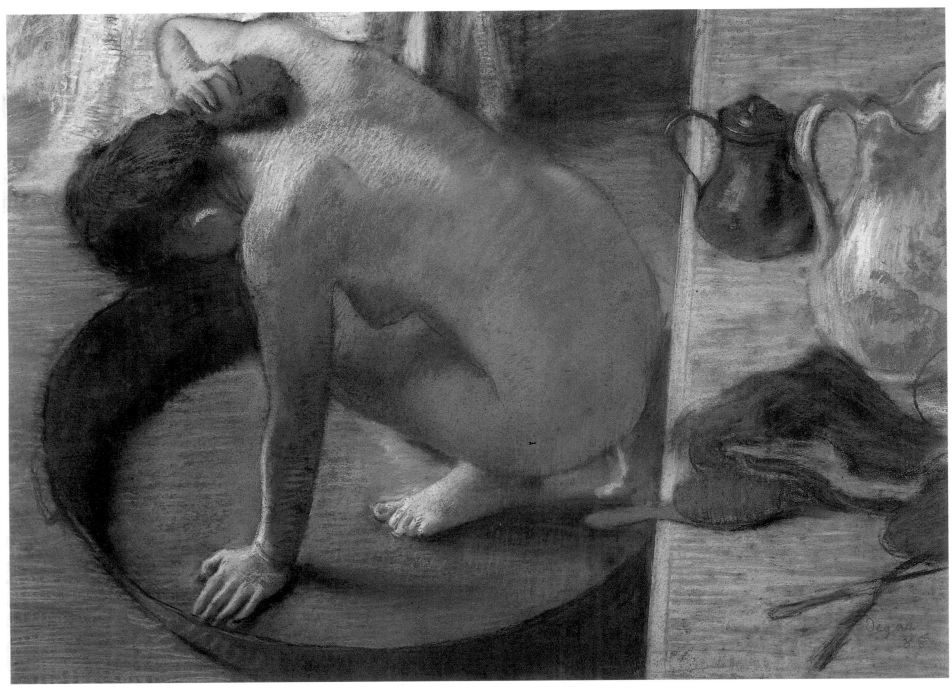

264 EDGAR DEGAS *The tub* 1886
This is one of many pastels that Degas produced in the middle 1880s on the
theme of the bath, all of them showing a woman in a crouching or bent position.
In some ways they may be thought of as his version of the series paintings of
Monet, and they doubtless owed something to Muybridge's sequential
photographs.

265 PIERRE-AUGUSTE RENOIR *Nude in sunlight* 1875
The model for this work was Alma Henriette Leboeuf, who died at the age of 23
despite the ministrations of Dr Gachet, whom Renoir implored to visit her.
When it was shown at the second Impressionist exhibition in 1876, one critic
described it as 'a mass of decomposing flesh with the green and purple patches
that indicate decomposition in a corpse'.

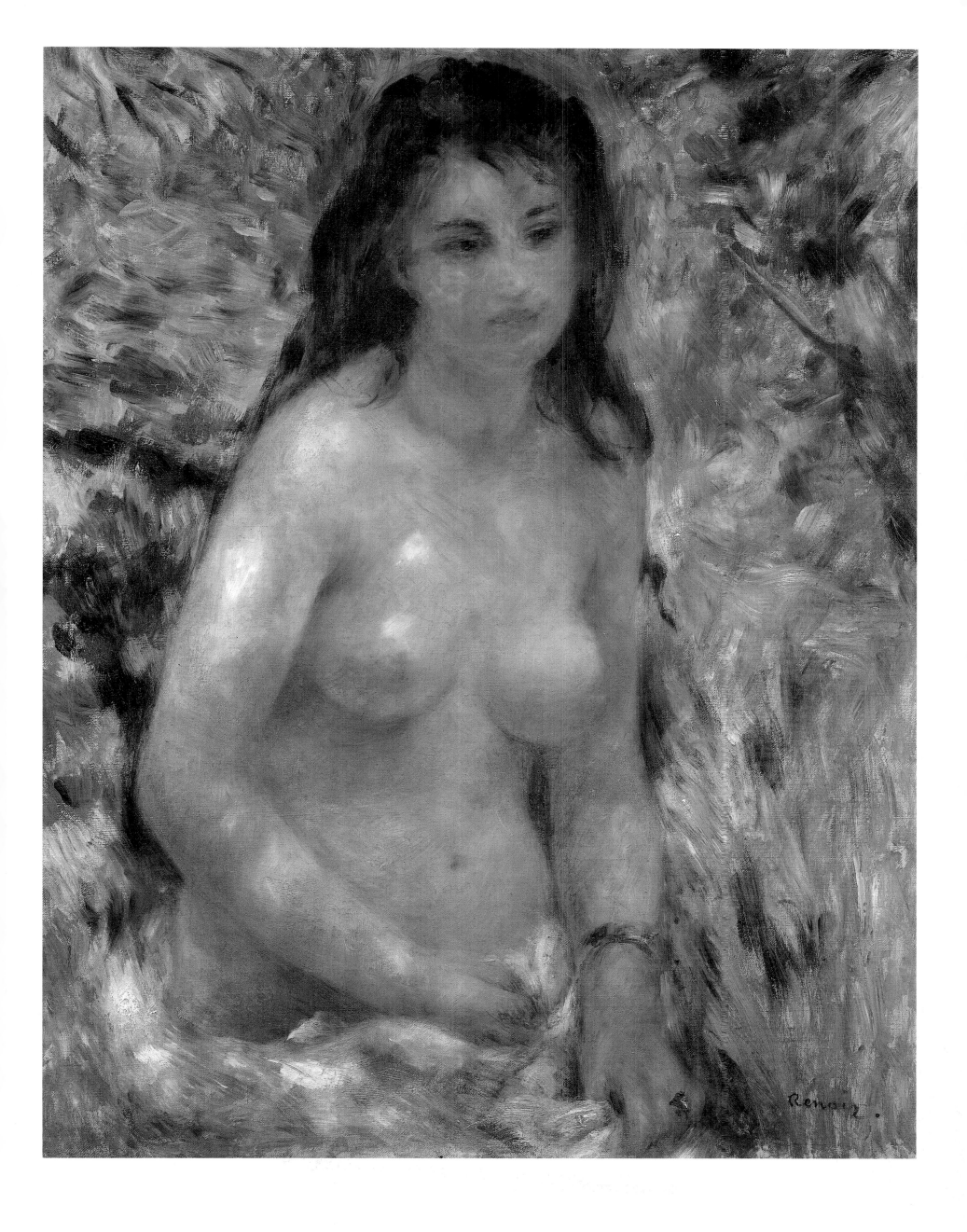

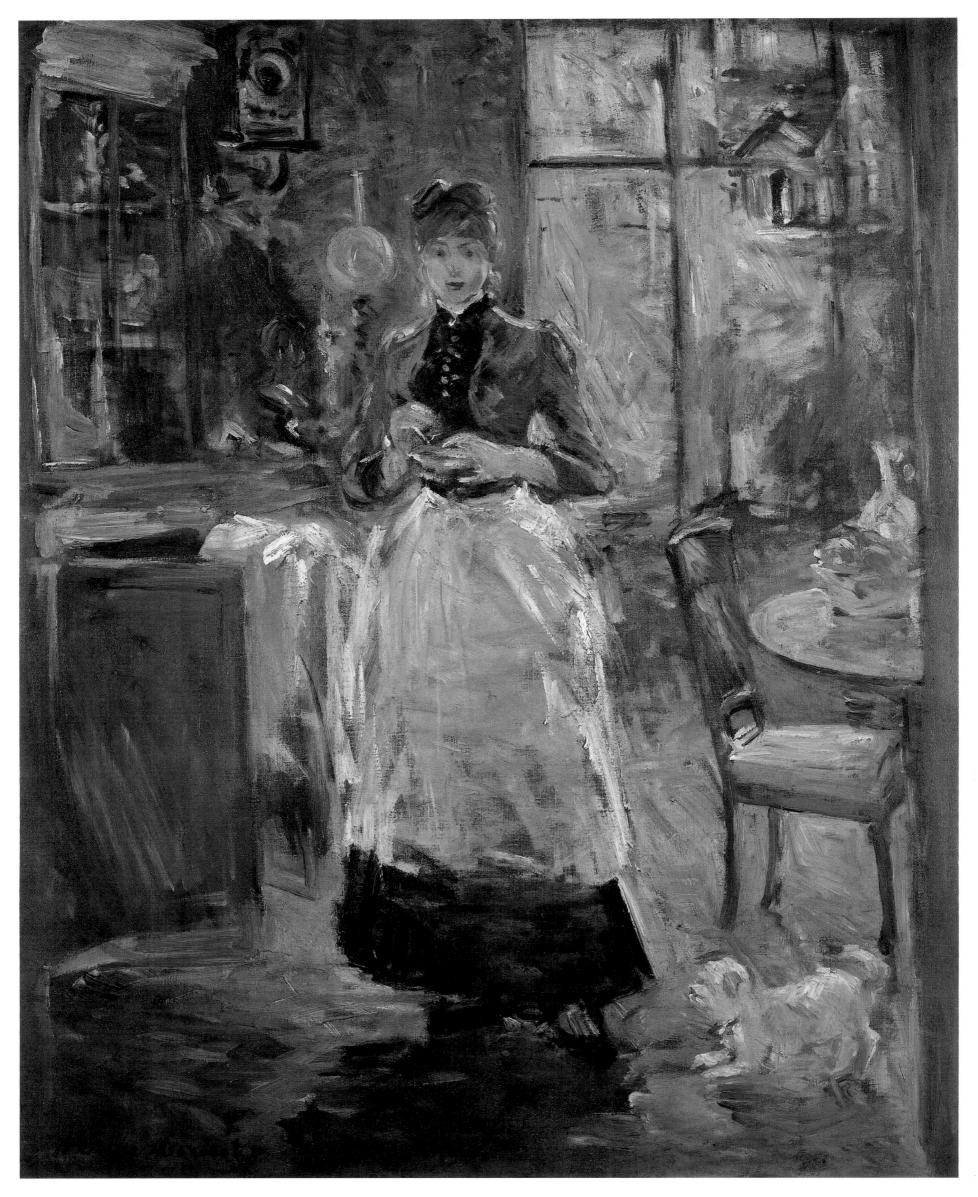

266 BERTHE MORISOT *In the dining-room* 1884
There is a Proustian delicacy and accuracy of observation in Berthe Morisot's
recordings of domestic life which gives justification to the title of the age as *la
belle époque*. This picture of a maid in the Manet/Morisot house in the rue de la
Villejuste is a remarkable exercise in the depiction of transfused light.

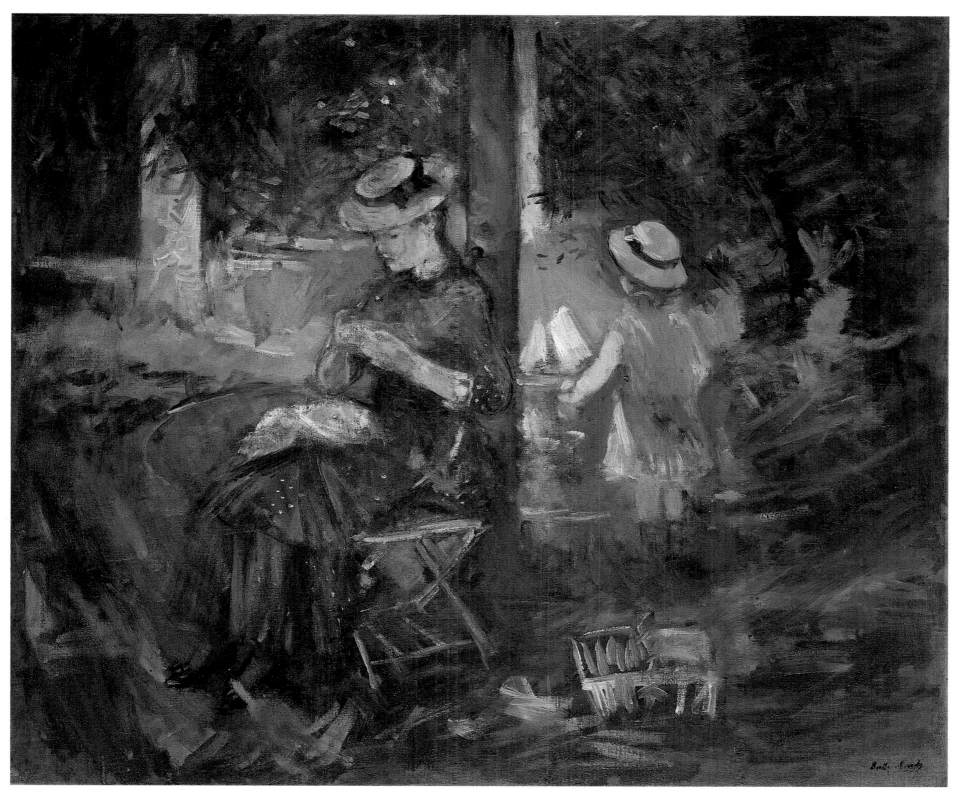

267 BERTHE MORISOT *Young woman sewing in a garden* 1884
Painted in the large garden of a house they rented at 4 rue de la Princesse at
Bougival, the favoured haunt of so many Impressionists; the spontaneous
plein-air feeling of the work is immediately apparent. The child is Julie, who was
to be one of her mother's favourite models, and was later to keep a diary
remarkable for its freshness and candour. The young woman is probably a nurse.

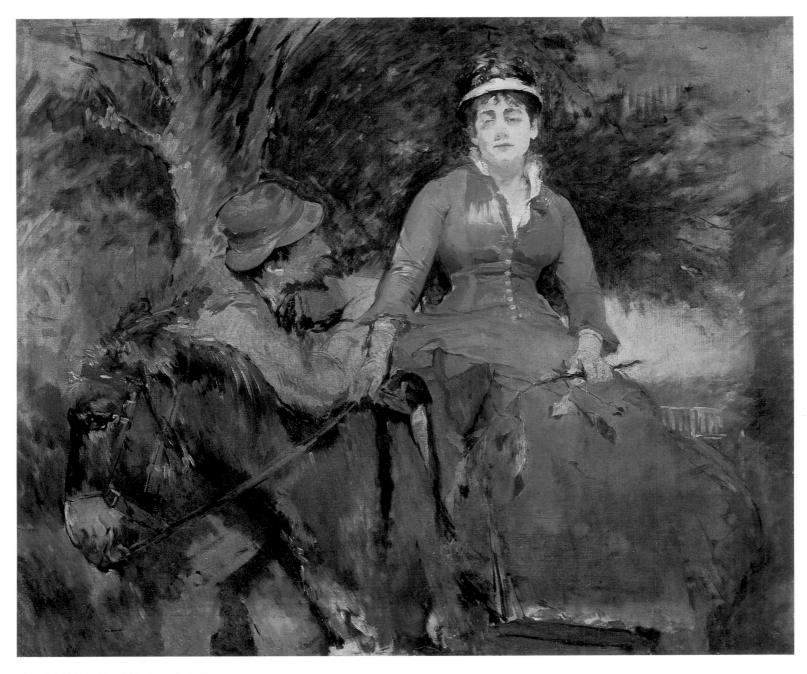

268 EVA GONZALES *Donkey ride* 1880
The influence of Manet on Gonzalès is at its most evident in this portrait of her
sister seated on a donkey, with her husband Henri Guérard looking at her.

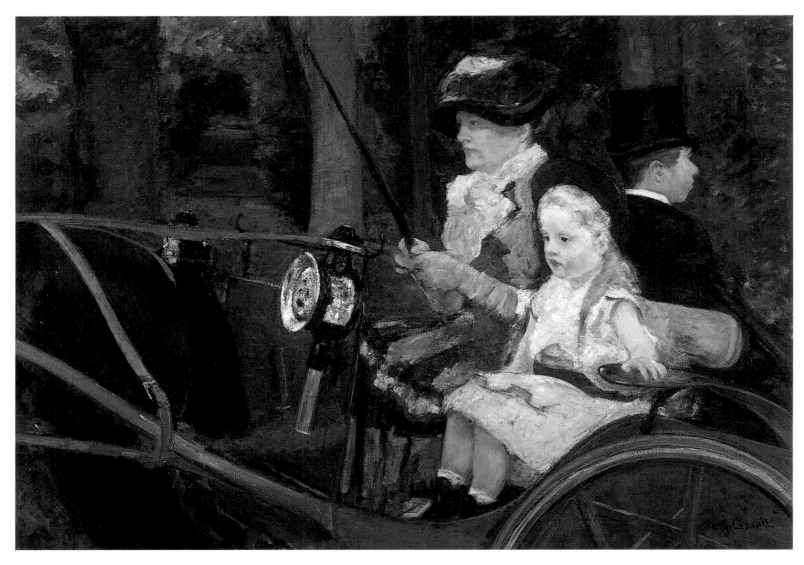

269 MARY CASSATT *Woman and child in a carriage c.* 1879
Driving a newly acquired carriage is Lydia, Mary Cassatt's sister, accompanied by
Adeline Fèvre, the daughter of Degas's sister Marguerite, who had married
Henri Fèvre, an architect. It was a period when Degas and Cassatt were on the
closest of terms, and when she had virtually become a member of his family.

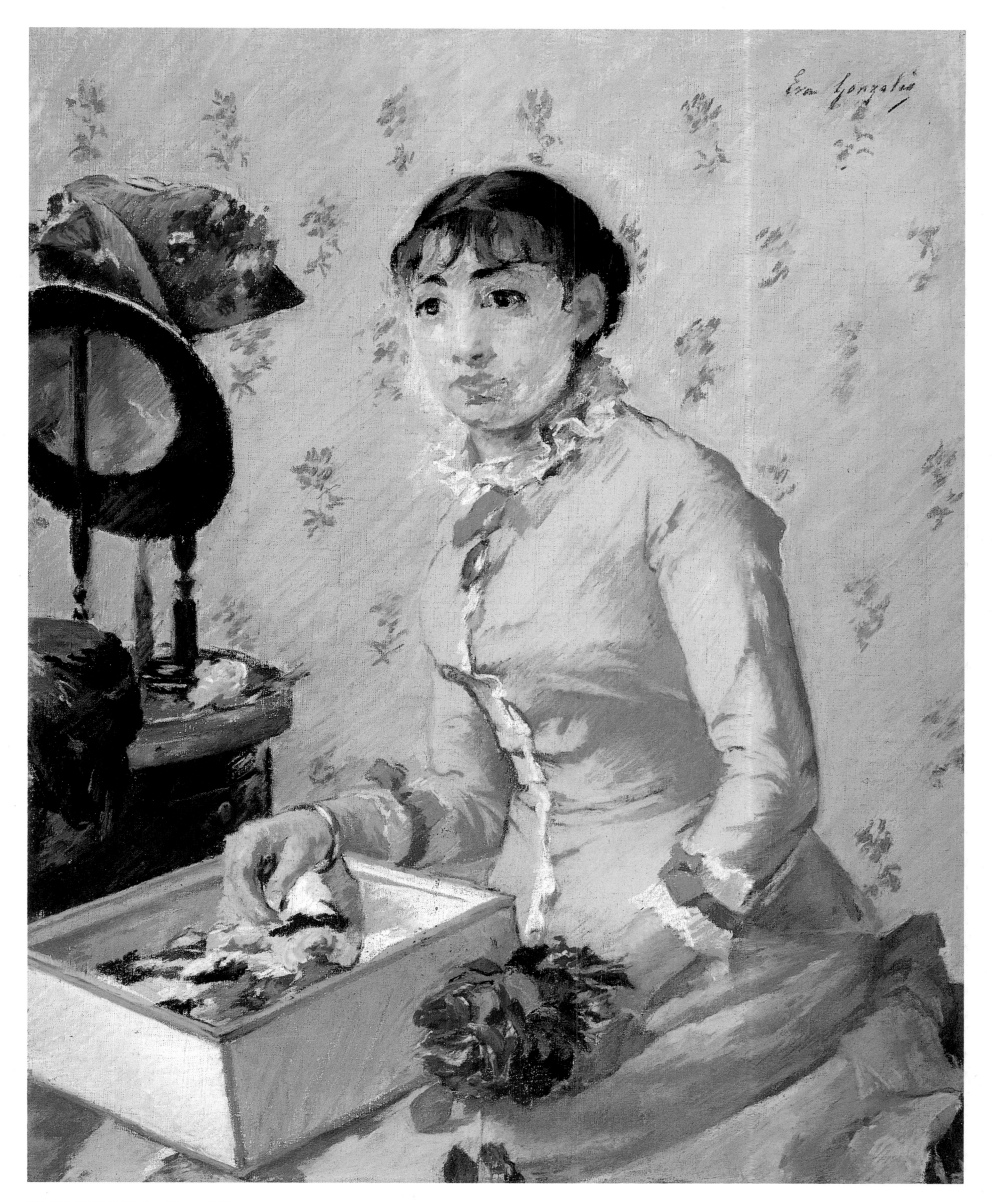

270 EVA GONZALES *The milliner c.* 1877
The milliner as a symbol of the 'realist' working-class girl had first been broached
by Degas at the second Impressionist exhibition in 1876, the year before
Gonzalès used her daily help as model for this charming pastel version of the
theme. It shows her following Manet in the adoption of lighter colours and more
fluent brushwork.

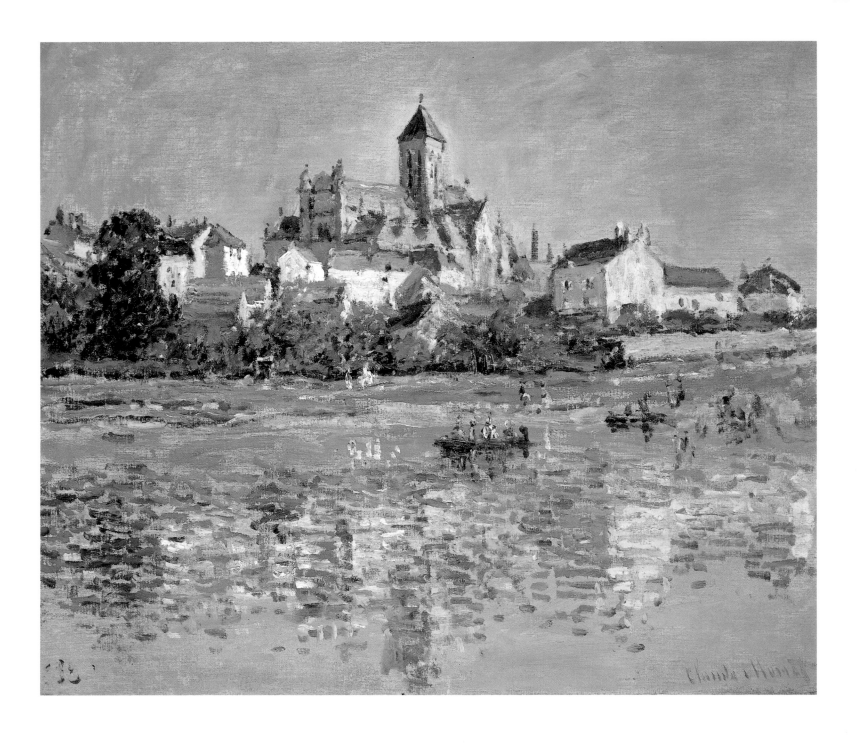

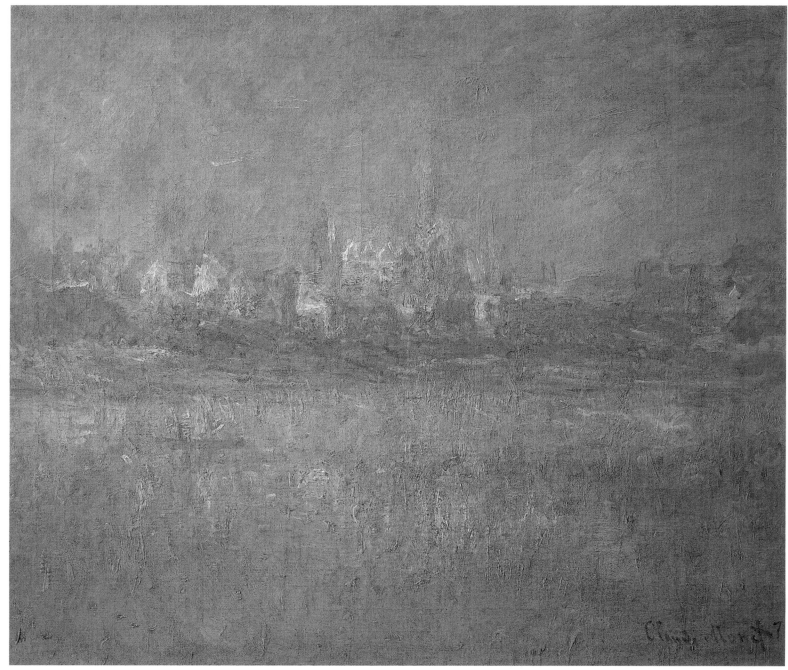

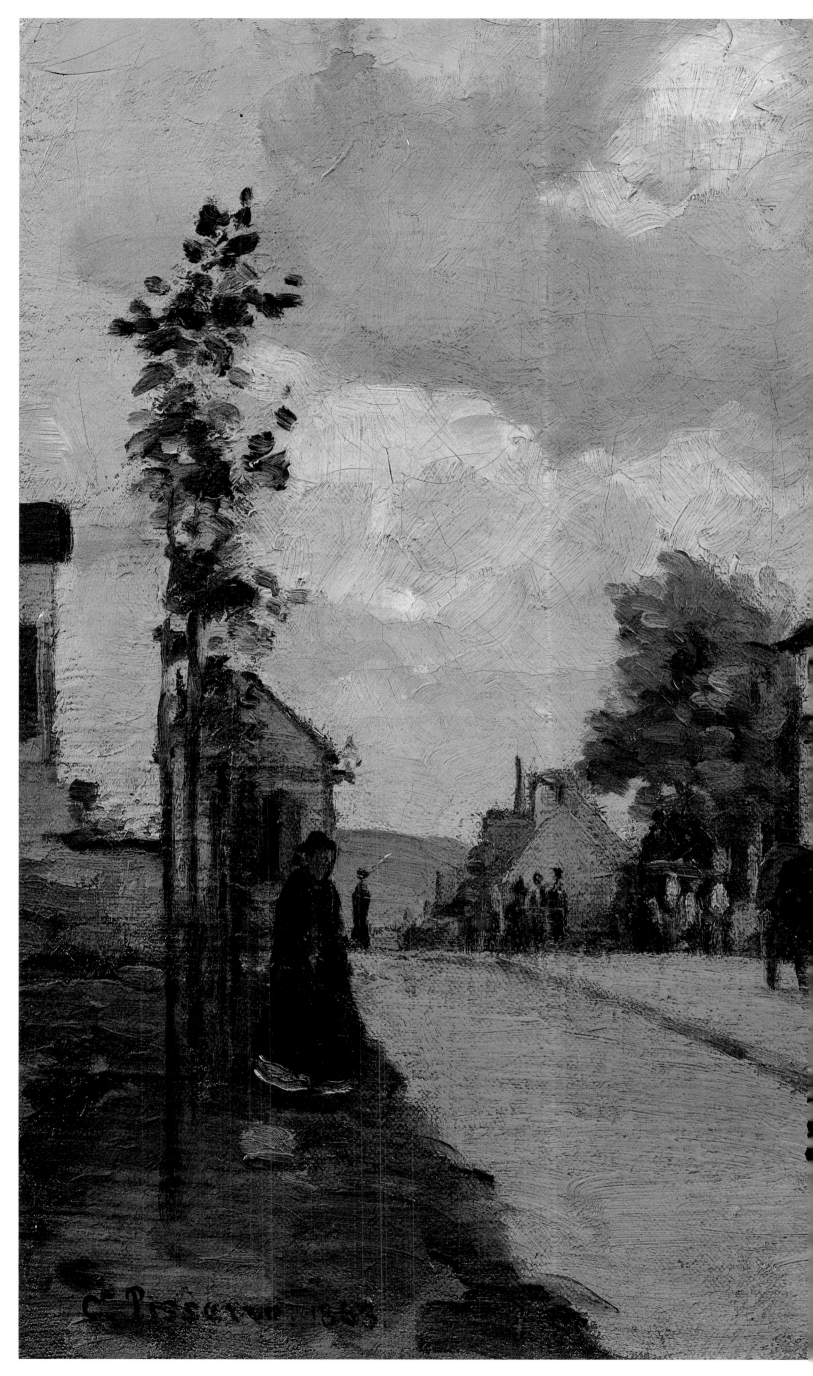

274 CAMILLE PISSARRO *The road to Gisors* 1863

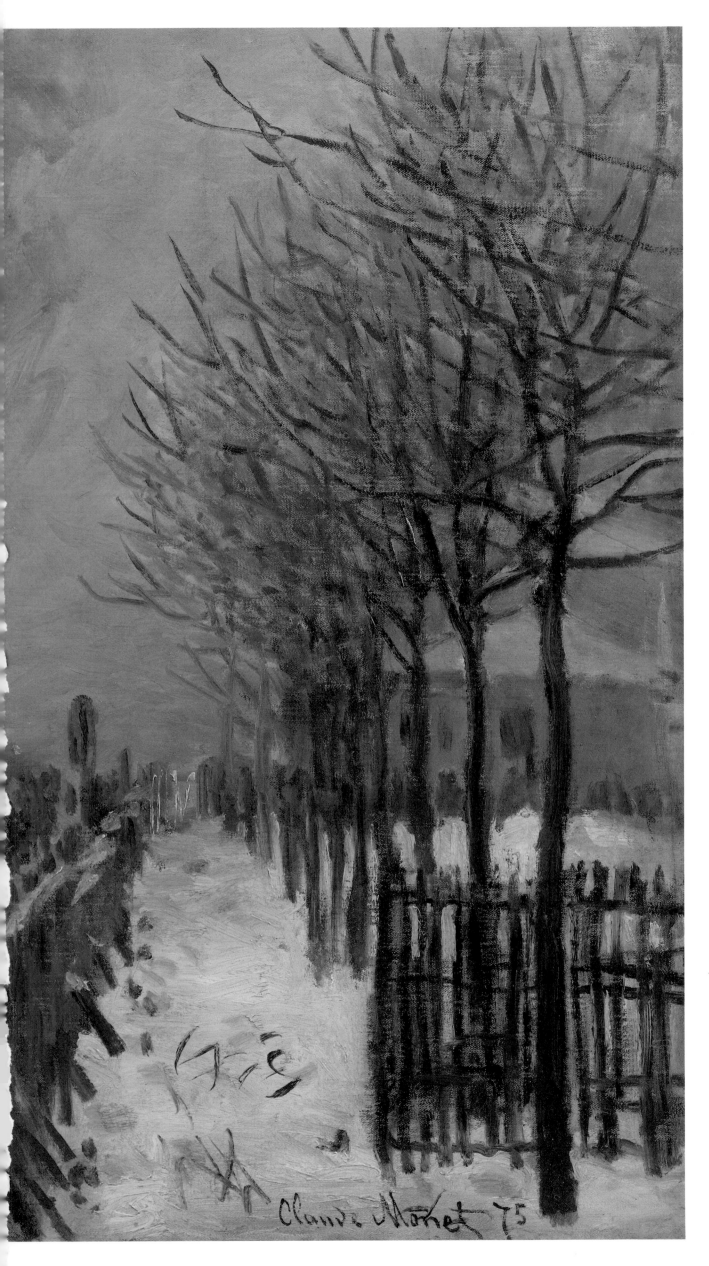

Claude Monet 75

(Opposite top)
271 CLAUDE MONET *The church at Vétheuil* 1878
Monet's interest in churches – he painted those at Vernon and Varengeville as well as Saint-Germain-l'Auxerrois – may have stemmed in part from the sense of religious revivalism prevalent at the time and which led eventually to the Rouen cathedral series. It was painting this picture, Monet later said, that led him to the Haystack series as well.

(Opposite below)
272 CLAUDE MONET *Vétheuil in the fog* 1879
When it was shown in 1887 Monet subtitled this 'Impression', and later said that 'it would inform people about his working methods and his ideals'.

273 CLAUDE MONET *Train in the snow* 1875
Monet's concern with trains was beginning to assume a kind of cyclic nature. In 1872 he had painted *Train in the countryside* (Plate 143), a distant view seen in a park-like neighbourhood, and now, three years later, his interest had become more concentrated.

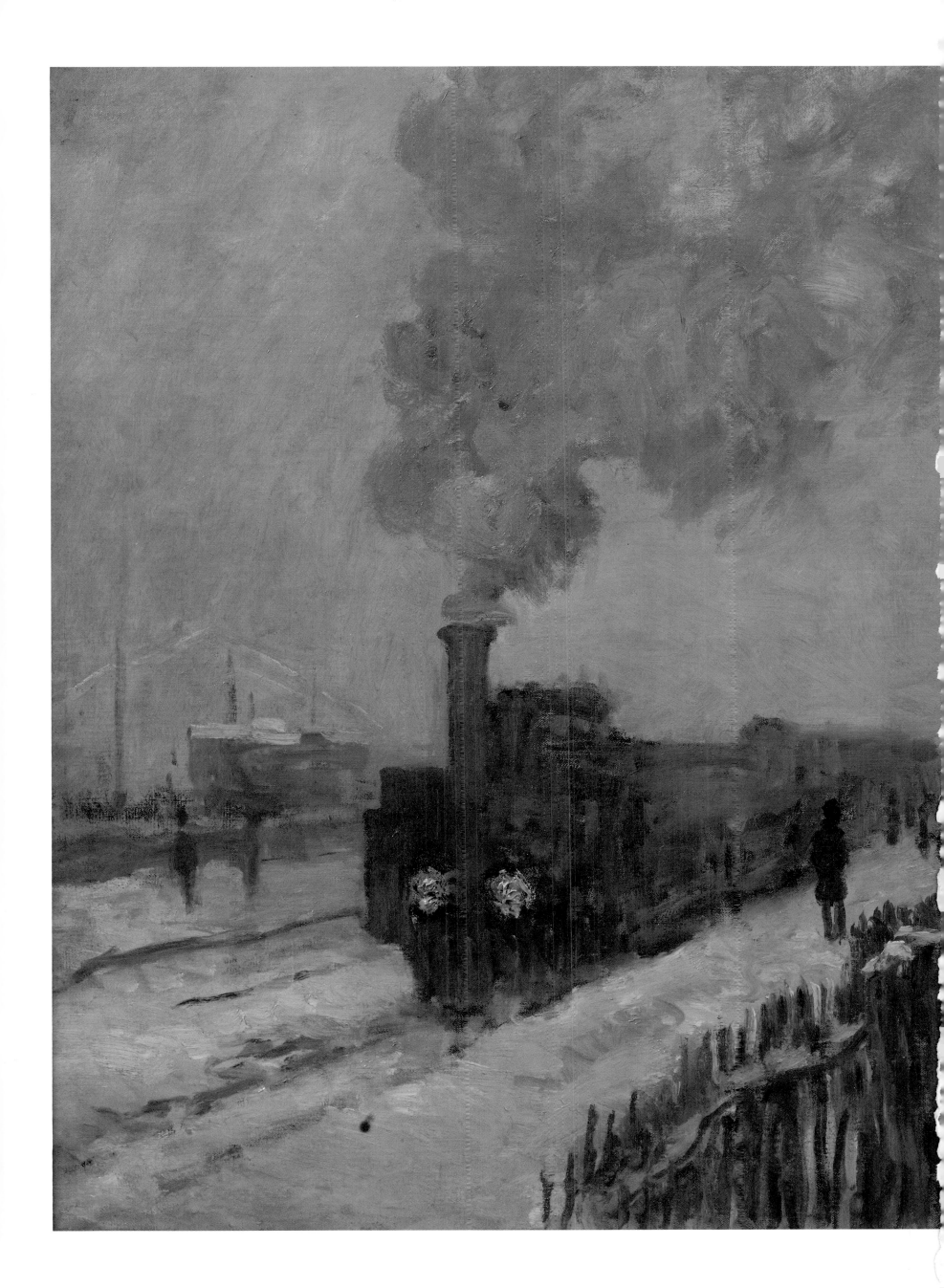

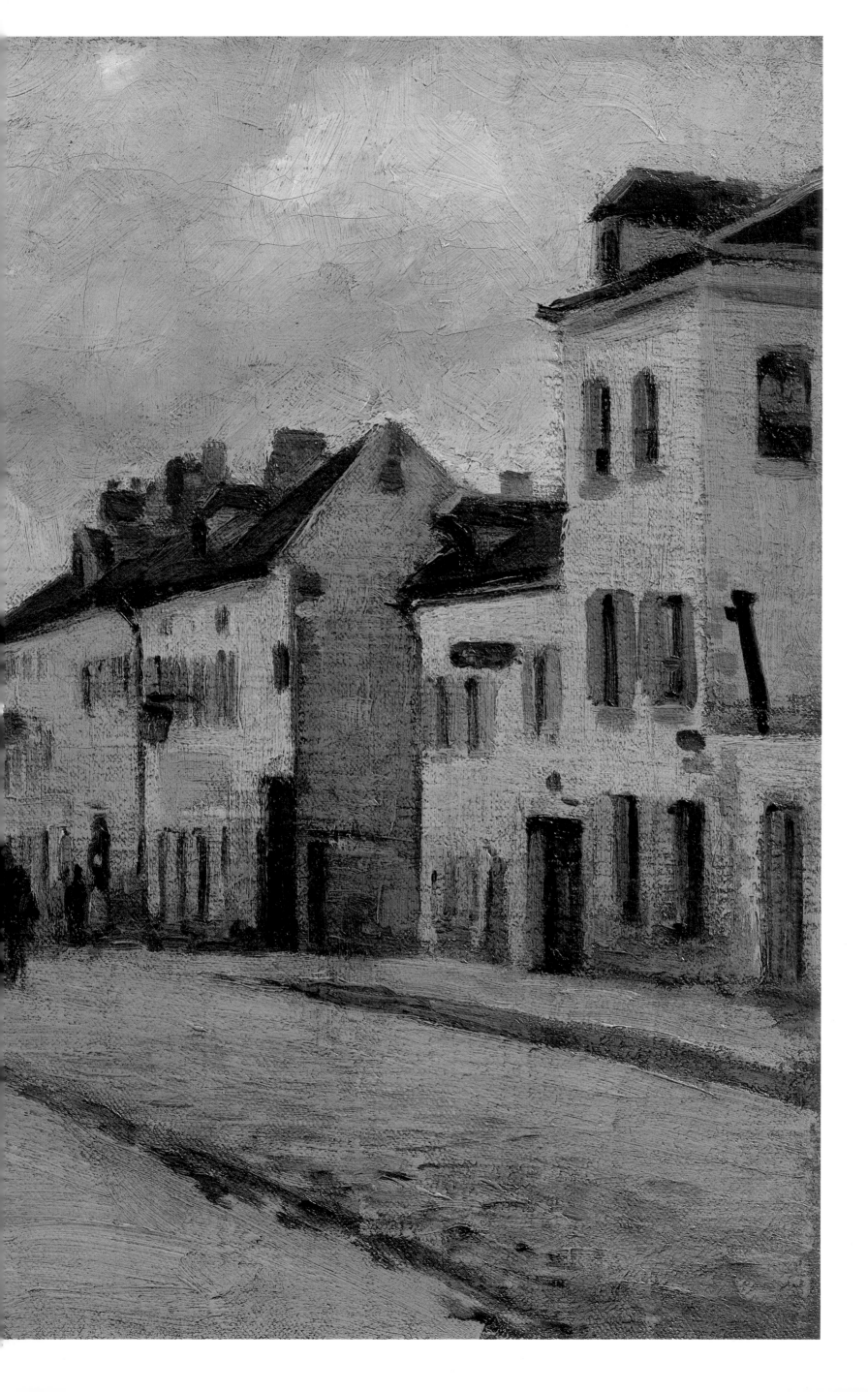

275 CAMILLE PISSARRO *The banks of the Marne in winter* 1870
The early influence of Corot may have been partly responsible for Pissarro's
interest in rivers, especially during the period between 1863, when he painted his
first view of the Marne, and 1870, the date of this one.

276 CAMILLE PISSARRO *The Seine at Port-Marly* 1872
Painted in the year he moved to Pontoise, this landscape shows the growing
influence of Monet on Pissarro's work.

277 PIERRE-AUGUSTE RENOIR *Path winding through tall grass* 1874
Painted in the neighbourhood of Argenteuil, where Renoir was working with
Monet, this shows the extent to which they had produced a fully-fledged
expression of the technique of open-air painting.

278 CAMILLE PISSARRO *Red roofs* 1877

*From 1866 until 1883 Pissarro lived mainly at Pontoise, a village
situated on the edge of a plateau overlooking the river Oise, and
commanding views over the plain of Montmorency as far as
Paris itself. Of great strategic importance, it was inhabited
largely by small peasant farmers, with whose lives Pissarro has
often, probably erroneously, been seen to have identified.
Whatever the truth of this, he found in it a constant source of
subject-matter for his paintings, and one which did not demand
the overt lyricism sought by other Impressionists such as Monet
and Renoir. This painting, for instance, has a solidity, a sense of
structure suggesting the qualities for which Cézanne was to
become famous. The technique is Impressionist, but the
conception is in a sense traditionalist. Like most of the paintings
he did of the village after his return from his temporary exile
occasioned by the Franco-Prussian war, this one is done from
the viewpoint of his own home.*

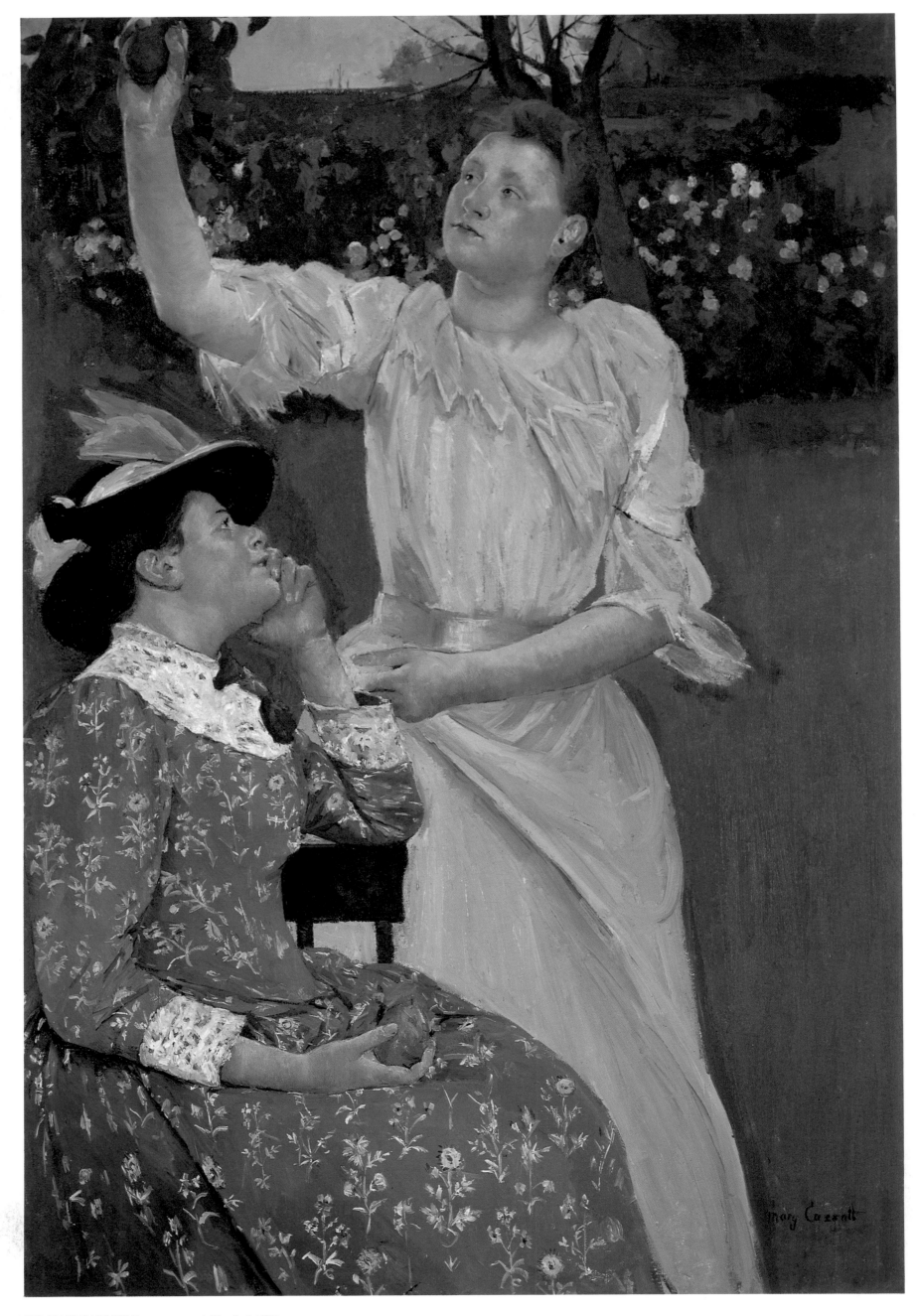

279 MARY CASSATT *Young women picking fruit* 1891
This is one of the first oil paintings Cassatt did after experiencing the impact of the great
exhibition of Japanese prints held at the Ecole des Beaux-Arts in 1890.

Chapter 8

The World of Pleasure

The realities which Degas saw in life around him were very different on the whole from those seen by Renoir, Pissarro or Monet. His landscapes were those of the stage or the boudoir, his favourite stamping ground Paris, not the villages of the Seine, the fields of Provence or the cliffs of the Channel coast. His eye was analytical rather than caressing. 'He's a curious observer', wrote Charles Bigot in a review of the Impressionist exhibition of 1877 in the *Revue politique et littéraire* on 27 April, 'who looks for himself, and sees things others have never seen.' Degas had acquired this acuity, not by some inspired gift, but by detailed scrutiny, expressed often in words, recorded and analysed in drawings and sketches in a variety of media. Here, for instance, is a Notebook entry recording his visit to the Opéra to see an examination of young hopefuls for admission to the dancing classes held there. He had obtained a permit through his friend Albert Hecht, to whom he confessed when doing so, 'I have done so many of these examinations without having seen them, that I am a little ashamed of it.'

We go on stage; he walks across, followed by his staff; he takes a place in the middle with the jury. The whole hall in darkness, large grey-green cloths covering the boxes. Six big gas lights on stands with large reflectors in the orchestra pit. It begins. The little boys in their black or blue jackets, short trousers, white socks, looking like street urchins. Fr. Mérante standing on the left playing the violin. First group of little girls. Madame Théodore on the right, playing a violin quite out of tune. Second group; I recognize Guerra with Madame Théodore. Third, Madame Théodore standing on the right. It is the time of life with children when dancing is pretty, naïve, primitive, self-confident. The jury claps frequently. Fourth group, in a *pas de trois*, a dancer falls and lies on the ground, she cries, people cluster round her, she is carried away by her arms and legs, sadness. Mérante, then Vaucorbeil, then Meyer, then others climb on the stage by a little staircase in a corner of the orchestra pit. It seems that it is just a strain. Mérante announces this. Everybody recovers. The exam has been very successful, people clap frequently. Curious silhouettes around me and in front of me. Fifth group. Madame Mérante on the left, behind her a violinist and a sitting viola player, music stand behind which, since the beginning, Pluque has been sheltering from view. A bow and it is all over. People come back on the stage, everyone, parents, teachers, jury, etc; excited dancers. The classes are set up. Thanks addressed to Vaucorbeil. We go home. Mérante on familiar terms.

All his paintings and most of his pastels and prints are supported by an infrastructure of preliminary and related studies. Even so comparatively simple a work as the pastel *The visit to the museum* of 1879 (Louvre) is the centrepiece of a whole range of related works: drawings of a seated woman reading a book, a pastel of the figure in the major work seen both from behind and from the front, in the latter pose holding a book and apparently looking up at a picture, another frieze in pastel of the same figure in three poses, one leaning on her umbrella, and a third with her holding a closed book in her hand. Then, presumably after the completion of the pastel, he produced a print on Japanese paper involving a number of techniques in which the viewpoint is different, with the seated person shown from the front, placed against an elaborately textured marble pillar in the same vertical plane as the figure looking at the picture.

The major work is in fact a portrait of Mary Cassatt, and it falls into a category of portrait about which Degas during this period was very enthusiastic, and which added a new element of realism to the genre. It consisted of what might be called 'psychological' portraits, in which the artist sets his sitters in a context relevant to their personality or occupation, and emphasizes this by contrasting them with somebody else; here for instance Cassatt, by reason of her artistic activities a frequent visitor to the Louvre, is absorbed in the paintings, whilst her companion, possibly her sister Lydia, has her nose buried in a book. It is the most Japanese of all Degas's works, and relates very closely to the *has-hir-a* prints which adorned the pillars of Japanese houses; it must be one of the very few works of art in existence that is dominated by the back of the central figure.

Among other examples of this type of portrait is that of Degas's two friends Ludovic Halévy and Albert Cavé (Louvre, Paris) talking to each other in the corridors of the Opéra, which they attended frequently; of Henri Rouart in front of his factory (Plate 206); and, most strikingly of all, the portrait of Diego Martelli (Plate 231, painted from an elevated position of the kind which he recommended (see p.211), surrounded by a confusion of papers and inkwells, revealing the paraphernalia of life to which he had also referred in the Notebook entry. A Florentine art critic and writer, Martelli was the spokesman of the Italian group of painters known as the Macchiaioli whose ideals and techniques came very close to those of the Impressionists

(see p.384), and he may first have met Degas during his visit to Florence in 1859. In 1878-9 Martelli was in Paris to report on the World Fair for the Italian press, and in December wrote to the wife of a friend in Italy, mentioning Degas 'with whom I am becoming linked by bonds of friendship. He is a man of wit and an artist of talent who is haunted by the fear of losing his sight, and who, according to circumstances, can be sad and despairing.'

However much Degas may have owed his dispassionate eye to his exhaustive preliminary work on a subject, more than any of the other Impressionists he used the camera as a tool, as a compositional inspiration, and as an art form in itself. According to Marcel Guérin some of his landscapes were based on his own photographs, and amongst the many found in his studio after his death were even some of women ironing. Many of his earliest portraits, including one of himself, were based on daguerreotypes, but in the mid-1880s he became increasingly interested in practising photography. This was probably due to an English photographer named Barnes, whom he met when spending the summer of 1885 at Dieppe, and who took a number of photographs for him, including one of his latest friend Sickert, as well as of the Halévys and his own mother. Barnes also took a photograph of the painter and some friends posing in a parody of Ingres's *Apotheosis of Homer*. Degas may have been influenced as well by the Norwegian landscape painter Frits Thaulow, an enthusiast for the use of the camera in art. Having secured an Eastman-Kodak he began to tyrannize his friends,

especially the Halévys, one of whom gave an awe-inspiring account of Degas the photographer at work:

As soon as he had got hold of his camera, the social joys of an evening with him were over. His voice got louder and more authoritarian, demanding that a light be brought into the anteroom and that anybody who was not prepared to pose should go there. A time of compulsion had arrived; everybody had to obey Degas's iron will, his artistic ferocity. At times like this all his friends spoke of him with fear. If you invited him round for the evening you had to be aware of what was in store for you, two hours of military obedience. Despite the order forbidding anybody who was not going to pose not to enter, I went into the room, and stood silent in a corner watching Degas. He had got Uncle Jules, Henriette and Mathilde sitting on a small sofa in front of the piano. He walked up and down in front of them from one corner of the room to the other with a look of ineffable bliss on his face. He moved the lamps about, altered the reflectors, tried to get more light on the legs by putting a lamp on the floor – especially those slender legs of Uncle Jules, the thinnest and most elegant in Paris, about which Degas always spoke with ecstasy.

'For goodness' sake get that leg in line with your right arm, move it up – further up. Now look with affection at the young lady beside you. You can smile quite nicely when you want to. And you, Mlle Henriette, incline your head towards him – more, still more. Lean on the shoulder of your neighbour.' Then, as she didn't quite do what he wanted, he pulled her into the right position, and then he did the same with Mathilde, and turned her face towards her uncle. Then he stepped back, and with a look of joy on his face exclaimed 'That's it!'

Then the group had to pose for two minutes. The photographs would be ready either that night or the following one. These were his real moments of happiness.

This passion for the camera and its achievements permeated much of Degas's work, giving it an air of spontaneity, of moments frozen in time, of that riveting arbitrariness which could also be seen in the works of Caillebotte and, in so far as it was part of the new visual experience of the nineteenth century, to a lesser degree in many other Impressionist paintings. But there were more specific lessons Degas learnt from the camera. In 1872, at the suggestion of the Californian racehorse owner Leland Stanford, the British photographer Eadweard Muybridge started on a series of photographic studies of the movements of horses by means of a number of cameras activated by trip wires. The sensational results of these experiments, which proved that the assumptions made by artists over the centuries about the actual movements of a horse trotting or galloping were quite inaccurate, were first published in France in the specialist journal *La Nature* in December 1878. A few weeks later a feature-length article about them appeared in the more popular *L'Illustration*, attracting all the more attention since a French physiologist, Etienne-Jules Marey, had also been working along the same lines in relation to the movements of human beings. In 1881 Muybridge gave a lecture on his discoveries at Meissonier's studio but, though it was attended by many artists, Degas does not seem to have been there. It was not until the publication of Muybridge's researches in book form in 1887 that he really used them in his own art, most startlingly in a series of sculptures of horses – made originally in yellow wax but later cast in bronze – which he created between 1888 and 1890. At the same time, however, he did not completely absorb Muybridge's discoveries into his painting; as late as 1896 in *Injured jockey* (Plate 361) he was still making use of the old convention of

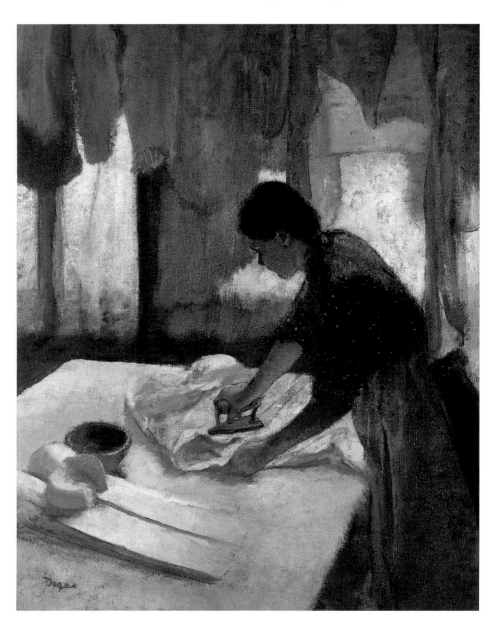

280 EDGAR DEGAS *Laundress* 1882

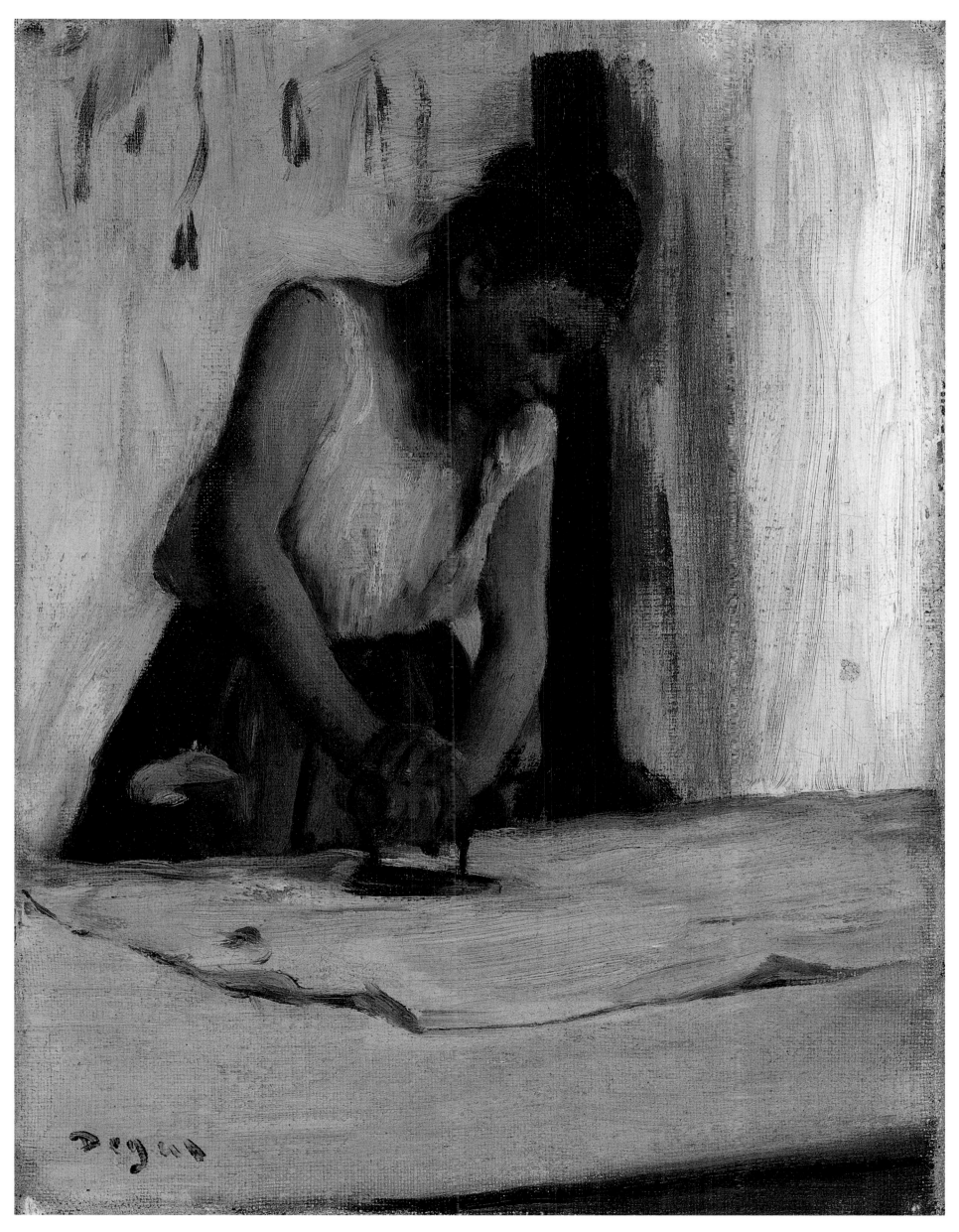

281 EDGAR DEGAS *Laundress* 1873

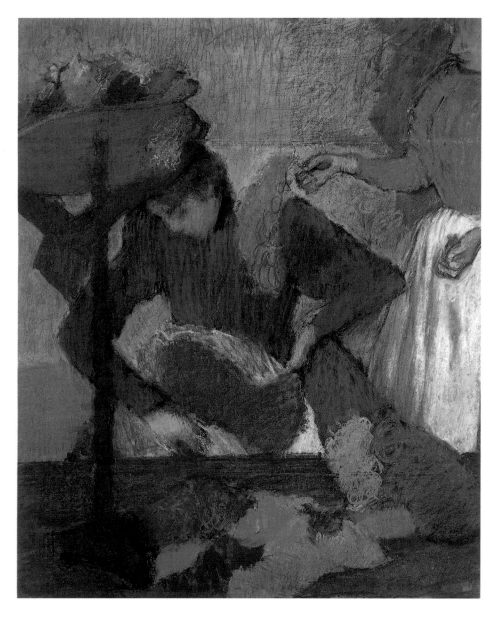

282 EDGAR DEGAS *At the milliner's* Pastel, 1885

representing a horse in motion with both its forelegs stretched out in front of it.

The camera seemed ideally suited to providing material for that recording of the life of Paris which so constantly preoccupied Degas. We know that he possessed photographs of laundresses, but it is doubtful if they had any direct influence on the series of paintings and pastels on this emphatically realist theme which he produced between 1876, when most of them were started, and 1885, when he felt that he had really finished them (Plates 280, 281). Apart from one version commissioned by Faure, which got involved in Degas's row with him (see p.222), most are based on the contrast between two laundresses, one indulging in a gigantic yawn which, as George Moore suggested, seems to convey the whole history of a life of toil; the other bent exhausted over an iron on which she leans with heavy determination. In complete contrast to the peasant-like ugliness of the laundresses, the shop girls who appear in the series connected with scenes in a hat-shop (Plate 282) have an elegance and felicitous absorption in their self-indulgent activity which satisfies Boudin's claim for the right of the bourgeoisie to have their own iconography.

Degas, however, was perhaps even more passionately interested in another aspect of existence, the minutiae of women's lives. The first and the most startling expression of this was in a series of monotypes showing brothel life, executed in 1866-7. The brothel has always played a role in French culture more important than that in any other

country, with the exception of Japan. By the 1880s there were some 34,000 registered prostitutes working in Paris, in addition to many amateurs such as laundresses and shop girls. There was a special directory, *Le Guide Rose*, listing their addresses and prices, and a whole range of brothels from squalid rooms in the Porte St Denis to palatial establishments catering for every possible taste off the Place de la Madeleine (appropriately enough). In the course of the century the prostitute had acquired in France a special kind of glamour. *Grandes horizontales* such as Cora Pearl or Cléo de Mérode were figures of national repute; prostitutes, whether golden-hearted or not, had become the heroines of literature, in the works for instance of Prosper Mérimée, the Goncourts, Zola and Pierre Louÿs, whose *Aphrodite* has been described as 'the breviary of prostitution'. Degas too may have had more specific reasons for his interest in them. Manet observed once that he tended to be shy and reticent with women. Apart from some kind of emotional involvement with Mary Cassatt, he does not seem to have had a mistress after 1870 and, though his conversation was often salacious, his behaviour to his models seems to have been exemplary. It may well have been that, like others, he found in prostitution the means of effecting some kind of sexual rapport which involved no emotional entanglement, no real intimacy.

Typical of the series is *Madame's birthday* (Plate 283), which exemplifies the kind of roguish humour, hovering on the verge of malevolence, common to all of them. It is virtually an apotheosis of a dressed Madame seated amongst a bevy of naked, plump, unlovely but vivacious prostitutes who are bringing her bouquets of flowers. Picasso, who was especially enamoured of this particular work and possessed ten others from the same series, produced in 1971 his own series of etchings on the same theme, in all of which he introduced the figure of Degas either as a spectator or in a picture on the wall.

For most of his life Degas seems to have yearned to participate in the intimacies of female existence, and no other artist has recorded these with such fervour; in all he produced some 280 images on the theme, mostly coloured drawings in a predominantly expressionist style which had little resemblance to the smooth-textured form and precise outlines of his oil paintings (Plates 264, 284). Gauguin commented, 'Drawing had been lost; it needed to be rediscovered; and when I look at these nudes, I am moved to shout. It has indeed been rediscovered.' Far removed from conventional notions of beauty, dealing for the most part with figures which bulge and are involved in intimate activities of a not particularly edifying kind, their realism is undeniable, and of an intensity which no other Impressionist had achieved. At the last group exhibition in 1886, Degas showed ten of these pastels, describing them as a 'sequence of female nudes bathing, washing, drying themselves, combing their hair and having it washed'. They particularly aroused the interest of the anarchist writer and critic Félix Fénéon, the evangelist of the new Pointilliste movement, then starting to undermine the position of the Impressionists, who wrote about them:

The skin acquires a strong, individual life of its own in M. Degas's works. His art is thoroughly realistic, and is not the outcome of simple observation; as soon as a living human being feels that it is being

observed, it loses its natural candour. And so Degas does not work from nature; he accumulates a multiplicity of sketches about the self-same object from which his work derives an unassailable veracity. No pictures have ever produced less of a painfully posed effect than his. His colour is masterly in a highly personal way; while previously the garishly coloured clothes of the jockeys, the ribbons of the ballerinas, provided the source of his colouring, his tonality derives muted, might one say latent, effects from the reddish sheen of a strand of hair, the bluish folds of damp linen, the pink of a wrap...Women are crouched like melons, swelling in the shells of their bath-tubs; one, chin against her breast, scrubs her neck, another's whole body is contorted, her arm clutches her back, and she rubs soap on its lower parts with a sponge. A bony spine is clearly articulated; upper arms shoot past juicy, pear-shaped breasts and shoot straight down between the legs to wet a face cloth in the tub of water in which the feet are immersed. Her hair has come falling down over her shoulders; her bosom comes down to her hips, her stomach to her thighs, and viewed from above as she stands on her bed with her hands pressed against her buttocks, the slut looks like a series of ungainly jointed cylinders.

Huysmans, on the other hand, ventured into a reasonably plausible account of their motivation:

M. Degas, who in the past, in his admirable paintings of dancers, conveyed quite remorselessly the decline of the salaried ballerina, coarsened by her mechanical skipping and monotonous jumping, furnishes us now in these nude studies with a lingering cruelty and a patient hatred. It seems as though he is tormented by the baseness of the society he keeps, and has determined to retaliate, to throw in the face of his century the worst insult he can devise, overturning that cherished idol woman, degrading her by showing her actually in the bath in degrading circumstances in the intimate posture of her intimate toilet.

Degas himself took a less intricate stance: 'These women of mine are decent, simple human beings who have no other concern than their physical condition. It is as though one were watching through a keyhole.' On the other hand, the nude studies and especially the brothel monotypes hint at a deep division in Degas's personality, reflected in his style. In the main his paintings and his drawings during the first period of his career are controlled, dominated by painterly disciplines inherited from Ingres and the masters of the Italian Renaissance. But with these other works there is a certain fierceness of form, a forcefulness of expression suggesting less controllable feelings simmering away beneath the detached elegance of his paintings and of his social persona. They look forward not only to the vehemence of some of Toulouse-Lautrec's imagery, but to the more savage visual brutalities of the Expressionists and artists such as George Grosz or Raoul Hausmann.

If art history were an ideally accurate discipline, Degas would never have been classified as an Impressionist in the way that Monet, Sisley or Renoir were. It was not merely a question of allegiances but of personalities, *quot homines, tot sententiae*, and this is most strikingly illustrated in the differences between Degas's nudes and those with which Renoir became increasingly preoccupied from the beginning of the 1880s onwards. Curiously, they had more in common with each other in their attitudes to women than might appear on the surface. On the one hand, although he once said, 'In literature as well as in painting, talent is

only shown by the treatment of the feminine figures', Renoir also claimed that he painted women 'as I would do carrots'. His view of women was patriarchal, but tinged with nervousness; he was always certain that in the long run women held the power, and seems almost to have been driven to paint them, especially in the nude, as a way of dominating them, laying great emphasis on reconstructing their 'touchability', the tangible quality of their bodies and their flesh. Jeanne Samary, the actress whom he painted in 1874, wrote, 'He marries all the women he paints with his brush, "It's with my brush that I make love," he used to say.' His treatment of the nude altered considerably. *Nude in the sunlight* (Plate 265), which was shown at the second Impressionist exhibition of 1876, was the very epitome of the Impressionist ideal, the bright, speckled sunshine enveloping the whole scene and competing on the girl's body with the pattern of shadows. The rich complexity of the colouring and the 'vagueness' of the outline are all a complete contrast to later works such as *Blonde bather II* (Private Collection), a duplicate with variations of an earlier version which he had painted in 1881 in Italy for the jeweller and collector Henri Vever, and which had been commissioned by Durand-Ruel. The model is Aline Charigot, later his wife, and the new crispness of style might have been influenced by his experiences of Italian paintings such as Raphael's *Triumph of Galatea*, which he had recently admired in the Villa Farnesina. The clarity of the outline and the comparative hardness of the lines are exaggerated by the sharp blue of the Mediterranean, itself accented by the distant line of white cliffs. The whole picture has a porcelain-like quality.

Renoir was to travel much further along this road, which technically was to bring him closer to the formal preoccupations of Degas, and reduce that element of 'formlessness' which many, including some of the Impressionists themselves, were beginning to see as the movement's great weakness. Preoccupied with figure painting, he felt that he

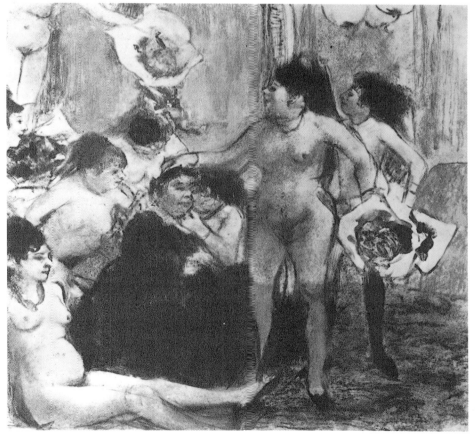

285 EDGAR DEGAS *Madame's birthday* 1878-9

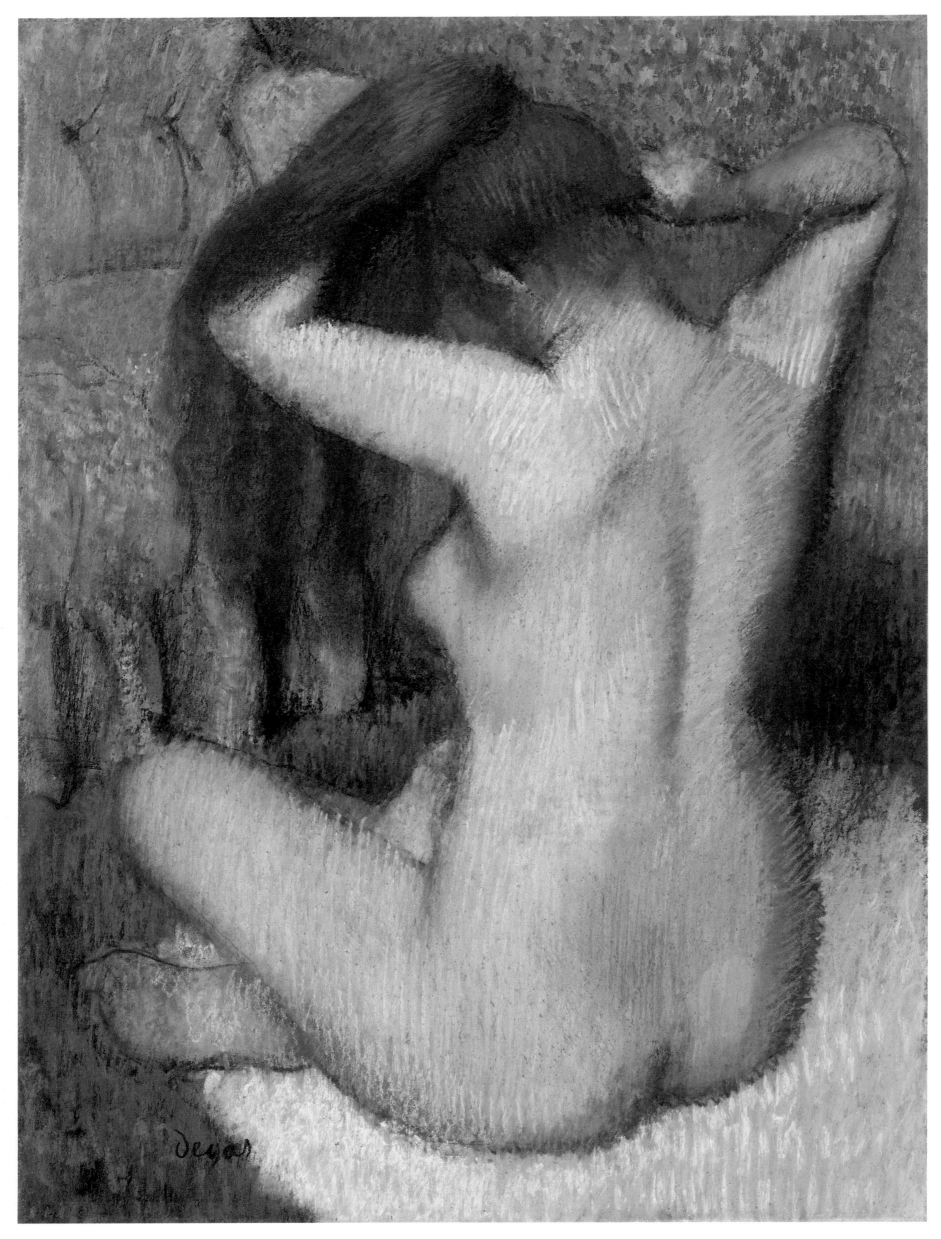

284 EDGAR DEGAS *Nude doing her hair* Pastel, 1888

had exhausted all that Impressionism had to offer; he became unsure of his technical skills and abilities, and proposed founding a new society, 'The Irregularists', for which he wrote a kind of manifesto (never published) with a good deal to say about the crafts as well as art and stating, amongst other things:

At a time when our French art which, till the beginning of the century, had been so replete with penetrating charm and imaginative fantasy, is about to perish through aridity, regularity and a misguided mania for a bogus perfection, stemming from the engineer's drawing-board, which has become the ideal, we think it necessary to react promptly against these deadly doctrines which threaten to destroy French art, and to unite people in this cause.

In the course of his Italian trip of 1881 he became deeply interested in the *Libro dell'Arte*, the manual on painting techniques written in the early fifteenth century by the Florentine artist Cennino Cennini, and wrote an introduction to a French translation of it. There can be little doubt that he was deeply impressed by the clarity of the fresco painting which he had discovered in Italy; he then set himself the task of producing a work which would be a restatement of the principles of the old masters translated into the idiom of the nineteenth century. The result was the so-called *Grandes baigneuses* ('Large bathers', Plate 325), a massive composition with four main figures on which he worked between 1884 and 1887 and which was first exhibited at George Petit's gallery in the latter year. It was the fruit of a long series of preparatory drawings to establish the composition, and watercolours to determine the eventual colour schemes. Thinly painted, it had little of the spontaneity of a truly Impressionist work, and it drew a lot of criticism from the more dedicated traditionalist supporters of the group. Both Astruc and Huysmans reacted unfavourably, and Pissarro wrote to his son Lucien, 'I do not understand what he is trying to do. It is quite right not to want to stand still, but he has chosen to concentrate on line. His figures are all separate entities, detached from one another without regard for colour.'

The general public, however, was enthusiastic. So, too, was a comparative newcomer to Impressionism, who was to remain under its influence for only a short time before exploring fields of sensibility and expression which he was to make peculiarly his own. The 33-year-old Vincent van Gogh had arrived in Paris in 1886 to live with his brother Theo, who was turning the art-dealing firm of Boussod-Valadon into a rival of Durand-Ruel, buying and selling works by the Impressionists with discrimination and enthusiasm. After five years of diligent struggle to fulfil his late-found ambition to become a painter in the art schools of Belgium and Holland, Vincent had begun to realize that his works were both provincial in feeling and dull in

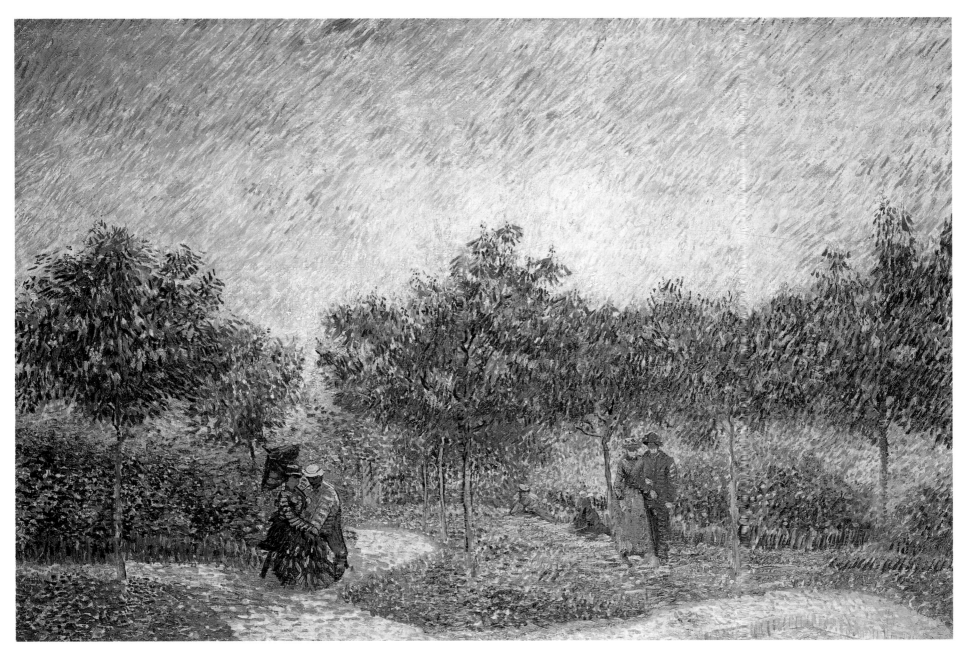

285 VINCENT VAN GOGH *Park in Asnières (the Voyer d'Argenson)* 1887

expression, and that it was only in Paris that he could remedy this. At first, however, he had been disappointed, and later wrote to his sister Wil, 'One has heard so much about the Impressionists, and when one sees them for the first time one is very much disappointed and thinks they are ugly, sloppily and badly painted, badly drawn, of poor colour, everything that's miserable. That was my first impression when I came to Paris.' It was not to last long; Pissarro, who later said that he felt that Van Gogh 'would either go mad or leave the Impressionists far behind', gave him a lot of advice, and he came into close and fruitful contact with Emile Bernard and Paul Signac, whose 'dot' technique (see p.298) he was sometimes to employ with more enthusiasm than understanding.

He became acquainted with the works of Cézanne through his visits to the shop of Père Tanguy, who combined the sale of artists' materials with that of avant-garde paintings. Typical of this combination of Impressionism with what has come to be called Neo-Impressionism are the *Voyer d'Argenson Park in Asnières* (Plate 285), a place to which he frequently went in the company of Bernard, and the *Interior of a restaurant* (Plate 286). Although he was clearly influenced by the Impressionists' palette, his style had something of the meticulous quality which so often characterized Pissarro's work; in the view of the park there is almost an over-emphasis on a highly complex arrangement, with the arabesque of the winding path and its adjacent flower-beds dominating the composition in a manner reminiscent of Seurat. The *Interior of a restaurant*, however, in which the dot technique predominates, seems to be a gesture towards the urban realism which was another facet of the Impressionist ethos. Not that it is in any way proletarian; neatly laid tables, the vases of flowers, the top hat hanging on the hook, the pictures on the wall, all suggest a 'family' restaurant of the type patronized by the bourgeoisie.

Since the death of Manet in 1883, the result of an amputation of the leg occasioned by a circulatory problem, the movement had lacked its titular head. Dissensions were rife. Some of these were stylistic, mainly centring around whether or not the common style which they aimed at lacked form, whether colour or line was to predominate; some were strategic: whether or not to exhibit at the Salon, whether or not to stick to Durand-Ruel or, like Monet, open up contact with other dealers. In this respect the position was complicated by the fact that Durand-Ruel was in a parlous financial position as a consequence of the short-lived financial slump of 1882.

He had opened a new gallery in the boulevard de la Madeleine, where in 1883 he started to show a series of one-man exhibitions, first of Boudin, then of Monet, Renoir, Pissarro and Sisley. This type of exhibition was an

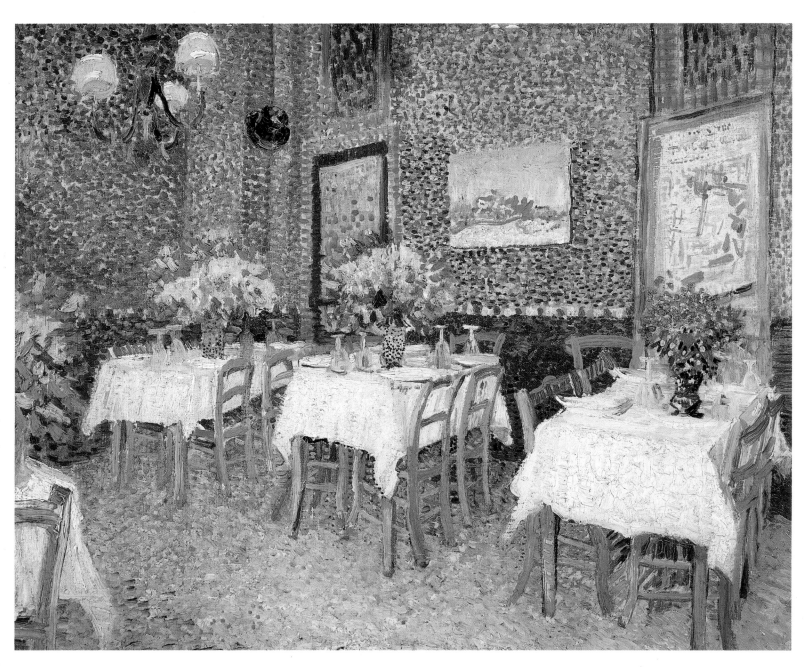

286 VINCENT VAN GOGH *Interior of a restaurant* 1887

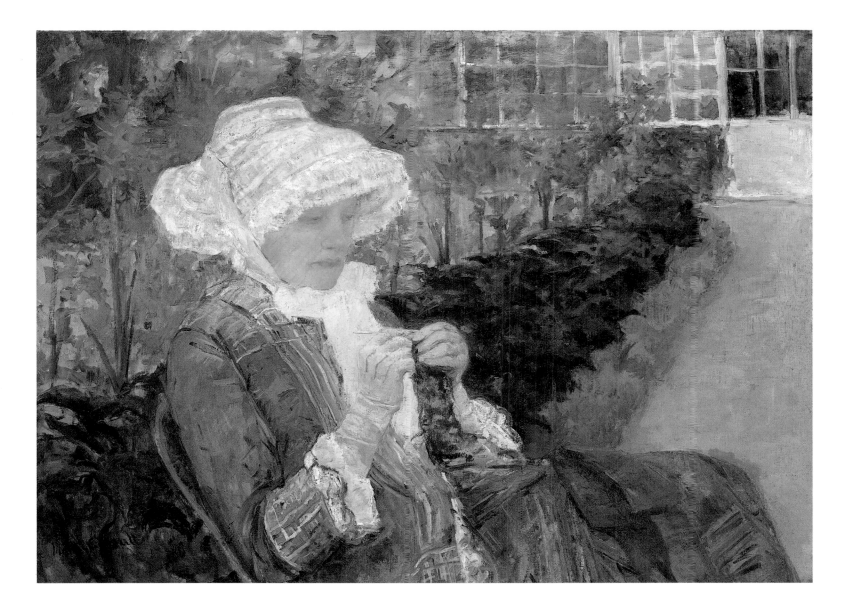

287 MARY CASSATT *Lydia crocheting in the garden at Marly* 1880
When the Cassatts returned from a visit to Marly-Le-Roi in the summer of
1880 Degas noted about Mary's work, 'What she did in the country looks very
well in the studio light. It is much stronger and nobler than what she did
last year.' This picture of her sister was done when Lydia was already suffering
from the disease which was to kill her two years later

innovation in the Paris art world, and had the indirect
result of hastening the gradual disintegration of the group's
coherence by accenting their personalities. At the same
time he also started looking for markets outside France. In
1882 he organized a small exhibition of works in a London
gallery he rented at 13 King Street, St James's, and then
from April until July 1883 a much larger one of 65 works at
Dowdeswell's Galleries, 113 New Bond Street. This included
seven works by Degas, two by Mary Cassatt, three by
Manet, seven by Monet, three by Berthe Morisot, nine by
Renoir and eight by Sisley. It was something of a *succès de
scandale*, an aspect stimulated by advertisements which
appeared in *The Times* in June, containing 13 quotations
from the most provocative reviews which had appeared. In
actual fact English critics did make a determined attempt
to understand this new art. There was inevitably a certain
amount of hostile comment about the brightness of the
colours, the lack of finish and the disregard of 'beauty'. On
24 April *The Times* nicely encapsulated the adverse reaction
when its critic wrote:

If anyone wishes to note to what lengths a reaction in art can go, he
should look at the Parisian Société des Impressionistes [sic], the chosen
representatives of the Extreme Left in painting...Their theory of a
picture is that it should seize 'l'aspect fugitif, la notation spéciale du
moment, l'impression, en un mot l'objet'; and to carry out the theory
they proceed to fly in the face of all tradition, in most cases, the tradition
that an artist should know what is beautiful, and should give as
complete a representation of it as he can.

The identification of Impressionism with the capitalized
'Extreme Left', no less than the romantic concept of

'beauty' implying some variation of the picturesque, are
typical of an artistic environment still dominated by the
ideas of Ruskin. But other journals were considerably
more understanding. *The Artist*, which could be considered
the trade-journal of the art world, understood the notion
of realism, 'That their art should concern itself most with
life around them is natural enough; the past is not
changeful', and was especially appreciative of Monet:

How remarkable in all his landscapes is the expression of nature! We
seem in one to feel the breeze which bends the long grass on the cliff
and ruffles the surface of the sea below; in another we almost perceive
the quiver of the leaves which cast a flickering shadow on the
sun-scorched ground, while in a third we fancy how great is the heat
which keeps the shimmering haze hanging over that sultry down. In
each is the same truth of relative tone, the same perfect accord of one
part of the picture with another.[2]

In other journals Pissarro was commended as 'being
worthy of attention, though unequal'; Renoir as 'a man of
talent, a man of acquirements, a serious artist', and *The
Standard* praised Monet for pictures which were 'full of
colour and glowing light'. Holman Hunt, however, com-
mented apocalyptically: 'The threat to modern art, meaning
nothing less than its extinction, is Impressionism.' In the
sense that he understood the phrase 'modern art', of

course, he was right. He was probably delighted that not a single work was sold, one contributory reason no doubt being that Durand-Ruel had set high prices for the pictures.

Two years later the dealer was approached by James F. Sutton, the co-founder, with the auctioneer Thomas I. Kirby, of the American Art Association, which was in effect a commercial undertaking masquerading under the façade of encouraging modern art and artists in America. Sutton suggested holding an exhibition of Durand-Ruel's gallery-painters in New York. Naturally he was enthusiastic, though some of his artists were less so. Monet did not want his most recent works sent to 'the damned land of the Yankees' on the familiar grounds that only in Paris was there 'good taste', and Renoir felt that some of his older, well-received pictures such as the *Luncheon of the boating party* and *La Loge* should go, but not his more recent works. From a more pragmatic point of view the idea appealed especially to Durand-Ruel because, as the Art Association was considered 'educational', it could import works into the United States without paying duty, that bugbear of the international art trade. On 23 March 1886 he imported into New York 43 cases containing some 300 paintings with a nominal declared value of $81,799. Most of them were by the Impressionists, including early works by Signac and Seurat, and about 50 by modernist Salon painters such as John Lewis Brown and Alfred Roll, as well as some by the now universally popular Corot.

The exhibition was opened at the premises of the Art Association on 10 April, with a catalogue which confused Manet with Monet, contained extracts from Théodore Duret's writings about Impressionism, and featured reviews of earlier exhibitions taken from French and English journals. A month later, because there was a restriction on the length of time exhibitions could run at the Association's gallery, it was moved to the National Academy, with an additional 21 pictures. Of these 13 had been lent by American collectors, most of whom had earlier been coaxed into buying them by Mary Cassatt, a stalwart support to Durand-Ruel in this as in so many other instances. Admission to the exhibition was 50 cents and one critic complained that it was 'the dearest 50 cents' worth I have ever had in the States', dismissing most of the works as 'French smears'. He was, however, on the whole exceptional. Critical reaction followed the British pattern pretty closely. The reviewer from *The New York Herald* suggested that, though many of the artists were technically inferior to their American contemporaries, the exhibition was most 'interesting' (10 April); the *Art Amateur* shrewdly noticed Monet's debt to Turner, saw in Seurat some of the qualities of the Italian frescoes, and commented on Manet's 'perverse, but powerful imagination' (14 April). *The Critic* was altogether adulatory. Degas was seen as 'abrupt, bizarre, fierce and almost terrifyingly fascinating', Monet as 'tender and subtle', whilst of Manet it said if he 'chose to ignore the elements of tone, he did so with perfect knowledge and intention' (17 April).

When Durand-Ruel left New York that summer, he had to pay duty on the pictures he had sold. This amounted to $5,500 and, since duties were levied at 30 per cent of the value of the goods, this meant that he had sold for $18,000 20 per cent of the pictures he had exhibited, a not inconsiderable sum in the circumstances. Amongst the buyers were Erwin Davis, who had been buying works by Manet and Degas some years earlier in Paris, Desmond Fitzgerald, who was to become an assiduous patron of the movement, Henry Osborne Havemeyer, head of the American Sugar-Refining Company, whose adored second wife Louisine (née Waldron-Elder) had been a friend of Mary Cassatt since childhood, and William H. Fuller, a dealer who became especially interested in Monet, writing an article about him in *The New York Evening Sun* (January 1891) and arranging a one-man exhibition of his works at the New York Union League Club later the same year.

The experiment was repeated in 1887 and although, because of complications with the import arrangements, it was not a financial success, it confirmed Durand-Ruel's belief that America was to be a source of prosperity, as indeed it did turn out to be – Monet complaining that he sent all his works there. Within a couple of years he had opened a gallery at 389 Fifth Avenue, and all his problems were behind him; so, indirectly, were those of most of the Impressionists.

It had been Pissarro who had insisted on the inclusion of works by Seurat and Signac, both of whom, through his support, had participated in the last group exhibition of 1886. The relationship between Pissarro and Seurat was to exemplify the problem which was exercising so many of the group, and which Renoir had solved by the adoption of his new 'hard line' approach. Immensely prolific, exploring a wide range of media, assiduous in pressing his work on dealers and potential patrons, ever generous with advice and help – 'he was so much a teacher, he could have taught stones to draw', Mary Cassatt once remarked – Pissarro was consistently striving to find an ideal way of painting. At the same time he was under constant financial pressure to support his growing family. To Lucien, the eldest of them, he wrote when the young man was beginning his career as an artist:

I have such a longing for you all to be great that I cannot hide my opinions from you. Accept only those that are in accord with your own sentiments and modes of understanding. Although we have substantially the same ideas, these are modified in you by youth and a milieu strange to me; and I am thankful for that; what I fear most is for you to resemble me too much.

In the early 1880s Pissarro was often getting only between 50 and 100 francs for his works. He was experiencing, too, great self-doubts. When, after the Durand-Ruel London exhibition of 1883, Lucien wrote to him suggesting that he should have an exhibition there, he replied:

You tell me that if I have a show in London I must send my best works. That sounds simple enough, but when I reflect and ask myself what are my best works, I am in all honesty greatly perplexed. Didn't I send to London my *Peasant girl drinking coffee* [Plate 254] and my *Peasant girl with a branch?* Alas, I shall never do more careful, more finished work, and yet these paintings were regarded as uncouth in London, so it is not an improper selection that explains why my work offends English taste. Remember that I have the temperament of a peasant, I am melancholy, harsh and savage in my works, it is only in the long run that I can expect to please, and then only those who have a grain of indulgence, but the eye of the passer-by is too hasty and sees only the surface. Whoever is in a hurry will not stop for me. As for the young misses, touched with the modern neuroticism, they are even worse; the romantics were much less

ferocious! If they looked into the past they would see to how slight a degree the old masters were – how shall I put it – precious, for they were indeed elegant in the artistic sense of the word.

I have just completed my series of paintings. I look at them constantly. I, who have made them, often find them horrible. I understand them only at rare moments, when I have forgotten all about them, on days when I feel kindly disposed and indulgent to their poor maker. Sometimes I am horribly afraid to turn round canvases which I have piled against the wall. I am constantly afraid of finding monsters, where I believed there were precious gems! Thus it does not astonish me that the critics in London relegate me to the lowest rank. Alas, I fear that they are only too justified. However, at times I come across works of mine which are soundly done, and are in my style, and in such moments I find great solace. But no more of that. Painting, art in general, delights me. It is my life. What else matters? When you put all your soul into a work, all that is noble in you, you cannot fail to find a kindred soul who understands you, and who does not need a host of such spirits. Is not that all an artist should wish for?

That he should think of his works as being 'melancholy, harsh and savage' seems ludicrous; to us today they have the light elegance and beauty of Schubert's music, made all the more lyrical by the occasional hint at some industrial element in the landscape, as in the *View of Saint-Ouen-l'Aumône* of 1876 (Plate 288). This was one of his rare excursions into panoramic views, taking in the gently undulating countryside, lightly marked by the industries which were growing up in the area of Pontoise, the steam from a train, the scattering of small houses, the factory chimneys and mills on the left, the strip cultivation, all seen against the wide sky flecked with blue, yellow and red, all painted in intricate dabs of brushwork to create an almost tapestry-like texture.

The 'kindred soul' about whom he wrote to Lucien was to appear from an unexpected direction and in profoundly changing, at least for a period, his technique, if not his vision, was to give him a framework within which to find security from the self-doubts assailing him. Georges Seurat (1859-91), a Parisian by birth, with a solid middle-class background, who later claimed that he had been working on a scheme for the rationalization of colours, pursued these researches during his student days at the Ecole des Beaux-Arts, where he devoured the works of Charles Blanc, Professor of Aesthetics and Art History at the Collège de France, as well as the colour studies of Eugène Chevreul. Obsessed with a Cartesian desire to combine art and science, he was influenced by Ingres and by the remarkable drawings of Millet and of Odilon Redon. His

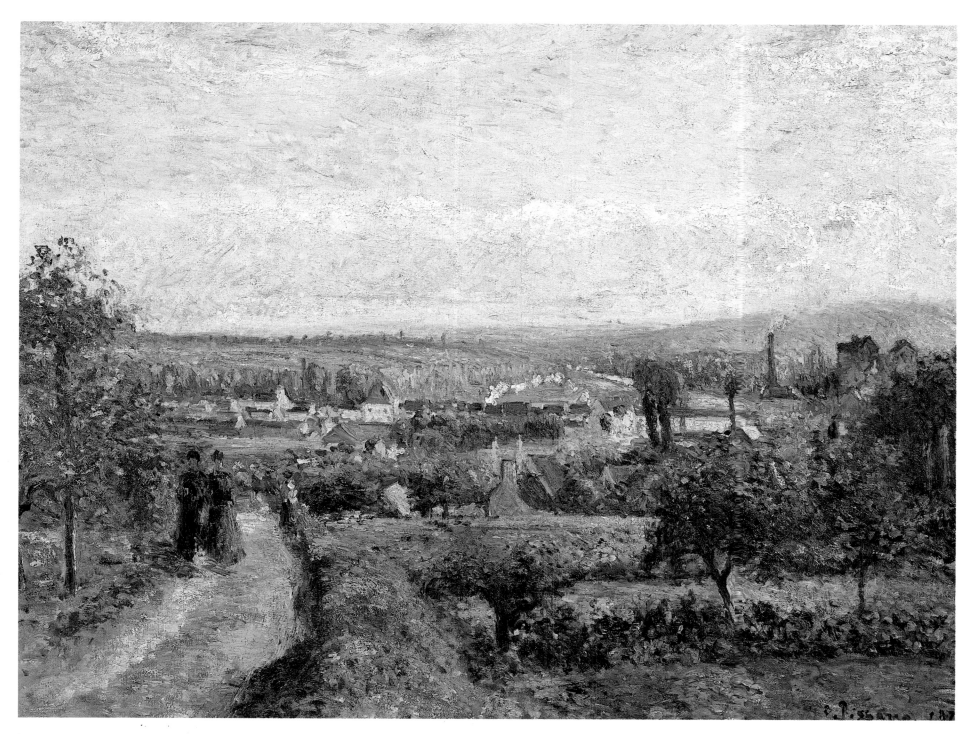

288 CAMILLE PISSARRO *View of St-Ouen l'Aumône c.1880*

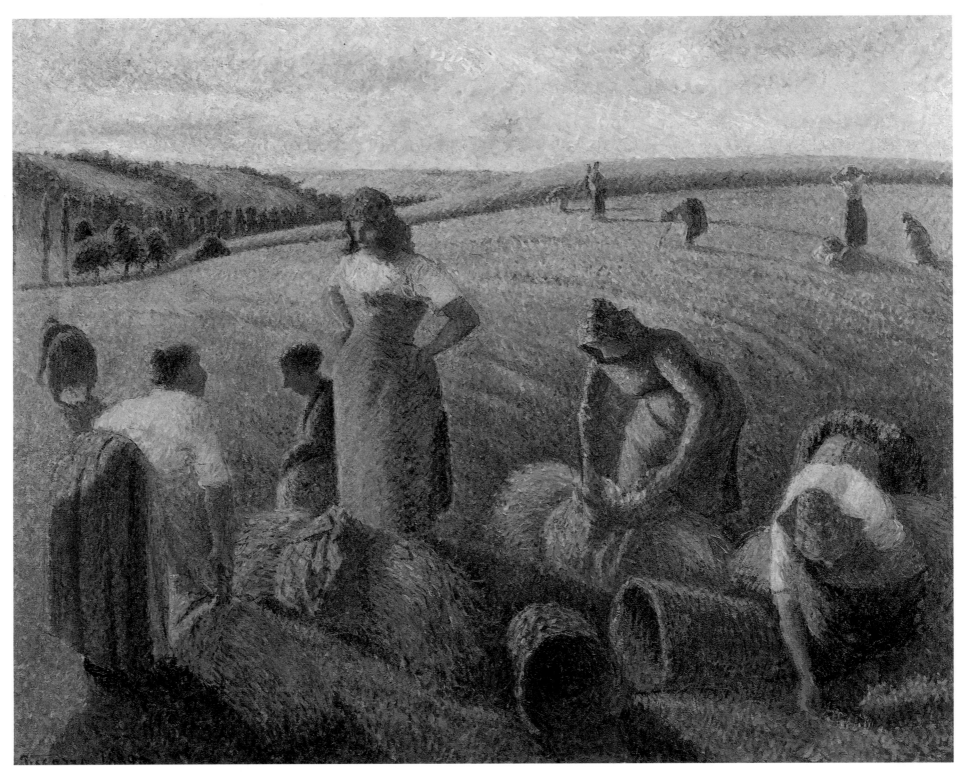

289 CAMILLE PISSARRO *The gleaners* 1889

early works, mostly painted in the forest of Fontainebleau, were basically Impressionist in style (Plate 383), but between 1882 and 1884 he produced his first truly personal work, *The bathers* (Art Institute of Chicago), a remarkable exercise in visual discipline, involving the most carefully studied composition, and a use of colour dominated by optical laws rather than by the desire to convey impressions of light and atmosphere. *The bathers* was seen by another young artist, Paul Signac (1863-1935), who had been evolving along similar lines, and the two became the nucleus of an alternative to Impressionism variously called Neo-Impressionism or Pointillism. This found its most remarkable expression in Seurat's *Sunday afternoon on the island of La grande Jatte* (1884-6), which created a sensation when, largely on the insistence of Pissarro, it was shown at the last Impressionist exhibition in 1886. Their main outlet was, however, the Société des Artistes Indépendants, an amorphous, ill-regulated group which was to have a more successful future than its beginnings

presaged, and which became the centre of what was later to be called Post-Impressionism, showing the works not only of Seurat and Signac but of Gauguin, Van Gogh (retrospectively), Guillaumin, Toulouse-Lautrec and others.

In the pictorial disciplines evolved by Seurat and Signac were to be found, as it seemed to some, an antidote to the looseness of mainstream Impressionism and a formula for creative inspiration which would substitute an elaborate but logical technique for the haphazard impulses of spontaneity. In essence the Pointillist style involved the application onto wood or canvas of tiny points of colour – not dissimilar to the half-tone technique for reproducing photographs on the printing press, which had just been invented – the colour, determined by using the optical researches of Chevreul, James Clerk Maxwell and O.N. Rood, placed in juxtaposition in such a way as to blend in the eye of the spectator, and so create an overall impression of solidity and 'poise'.

Pissarro, who had met Signac in Guillaumin's studio

and Seurat at Durand-Ruel's, saw in this new approach the answer to the problems which had been exercising him for some time and wrote to Lucien in 1886:

Seurat has something new to contribute which these gentlemen [his fellow exhibitors at the Impressionist exhibition], despite their talent, are not able to appreciate. I am totally convinced of the progressive nature of his art and certain that in time it will yield extraordinary results. I do not accept the snobbish judgement of 'romantic' impressionists in whose interests it is to fight against new tendencies. I accept the challenge. That's all.

For the next two years he continued to paint in a Pointillist style (Plate 329). His friends and Durand-Ruel were appalled, quite unjustifiably so. Despite his commitment to the doctrines of Seurat and Signac, his own specific vision emerged from even the most Pointillist of his paintings, and the whole experience had begun to work through his system by 1889 when he painted *The gleaners* (Plate 289), one of his most important works. Motivated on one plane by his commitment to socialist ideals and by his residual admiration for Millet, the painting owed its existence to his desire to produce what he described as 'a major canvas' marking not only his acquisition of a new style, but his absorption of it. He worked on the painting for the best part of a year, the general composition first finding expression on a fan (now lost) and the landscape being explored in a large number of sketches. Once again the view is panoramic, with the line of workers in the foreground duplicating the arc of the sloping field, and those in the background contrasting with it. The bent figures are very close indeed to those in Millet's *The gleaners* of 1857, and inevitably recall works on the same theme by Lhermitt and Breton, but, as Richard Thomson pointed out in the catalogue of the 1990 exhibition organized by the South Bank Centre, London, the theme was archaic by the late 1880s. Gleaning had been a form of rural charity whereby the poor had been allowed to pick up from harvested fields what corn remained, and was as old as agriculture itself. In the gleaning pictures of the 1850s this had usually been emphasized by placing in the background images of the hired hands who had collected the corn and were stacking it on carts. But in the country-side of the Eragny downs, where small farms predominated and where the scythe had replaced the sickle, harvesting was a good deal more efficient than it had been some 30 years before; all over France in general gleaning had become a thing of the past.

Pissarro's evocation of labouring women was in fact a sentimentalized one, influenced rather by the art of the past than the realities of the present. But, like many of his other works, it was an attempt to translate into a rustic context the sense of social realism which was such a basic element of the Impressionist ethos. The choice of subject, and even the diluted Pointillist style, with its claims to scientific accuracy, were part of Pissarro's deeply felt political convictions. Because he moved in socialist circles, by the early 1880s he had already gained a reputation as a potentially dangerous figure, in a France gripped by fear of anarchist plots and communist conspiracies. When in 1882 Durand-Ruel tried to persuade Renoir to exhibit with the group, he replied, 'To exhibit with Pissarro, Gauguin and Guillaumin would be like exhibiting with a

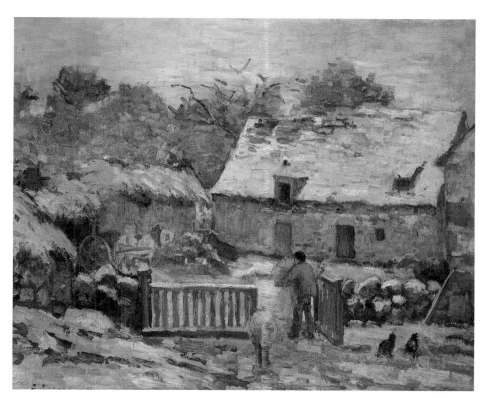

290 CAMILLE PISSARRO *Farm at Montfoucault; snow effect* 1874
Most of the Impressionists, especially Monet, Sisley and Pissarro, were preoccupied with the transformation of the landscape effected by snow, and the effects of light reflected on it. Pissarro painted a large number of snow-covered scenes, including three at the Hermitage in Pontoise, and this one at Montfoucault in Brittany where he was staying with his friend Ludovic Piette.

bunch of socialists. Soon Pissarro will be asking the Russian Lavrof[5] to join us. The public doesn't like anything that smacks of politics, and at my age I don't want to become a revolutionary.'

By one of those curious tangles of thought not uncommon amongst writers and artists – the relationship between the Surrealists and the Communist party is one outstanding example – the scientific study of nature, as putatively exemplified by the Pointillists, had become identified in certain circles with Socialism. Although Seurat himself seems to have been apolitical, Signac remained a member of the Communist party until his death in 1935; Maximilien Luce, another member of the group, Félix Fénéon, its greatest critical advocate, and Lucien Pissarro were all involved in the extreme left in the 1890s. How close was the connexion between art and politics is suggested by the fact that, just when Pissarro was beginning to realize that for him divisionism was too arid a discipline to be followed in all its demands, so he started to abandon the notion that any political party had any real value; he moved towards the idealistic anarchism of Prince Kropotkin, which looked forward to a Messianic age when law, the state, property, religion and nationalities would all be abandoned. At the same time, though, this utopian concept was underpinned by a belief that the anarchist dream could only be achieved by violence. This view was advocated by Jean Grave, especially in his *La société mourante et l'anarchie* ('A dying society and anarchy'), all copies of which were confiscated and destroyed, and its author sentenced to a term of imprisonment. Grave was a close friend of Pissarro, who contributed to his anarchist newspaper *La Révolte* not only drawings but actual financial help. He also compiled in 1889 a folio of 28 drawings accompanied by texts from *La Révolte*. Most of these are about fairly simplistic examples of social

oppression, though two of them bear disguised allusions to one or other of the family rows which were so integral a part of his life. When Grave was sent to prison for six months Pissarro wrote enthusiastically, 'The Republic of course defends its capitalists, that is understandable. It is easy to see that a real revolution is about to break out – it threatens on every side. Ideas don't stop.'

Pissarro's own ideas, as outlined in his letters to his beloved eldest son Lucien, were startling in their naïve idealism: they looked forward to a future world in which people will learn to love the country and will appreciate all art that brings out the beauty of nature, a task to which painters must dedicate themselves. Peasants too, because they are closest to nature and possess artistic gifts, will be able to see and interpret their surroundings in a straightforward way unclouded by religious or mystical connotations. At the same time too, the artist will have to provide cheap art for the people – hence Pissarro's own concern with prints and other reproductive works, as well as painted fans, though it is difficult to see the immediate attraction of these for the peasant women of Languedoc or the fish-gutters of Le Havre. This rusticated idealism was of course part of the spirit of the age, which spawned the medievalism of Morris and the bucolic fantasies of Chesterton, Knut Hamsun, Eric Gill and even the Nazis, as well as such recent manifestations as the Ruralists.

On the whole it could be said that, as he grew older and more concerned with marginal preoccupations, Pissarro's art showed a decline from its earlier standards. It is interesting that Sisley, on the other hand, who was little concerned with either artistic or political ideologies, main-

291 CAMILLE PISSARRO *The pork butcher* 1883
In the early 1880s Pissarro became more interested in figure subjects, and applied this to his socialist-orientated concern with peasant life. He painted, drew and printed numerous market scenes at Gisors, Pontoise and even Paris. *The pork butcher* is one of his most sophisticated compositions, drawing the spectator deep into the picture.

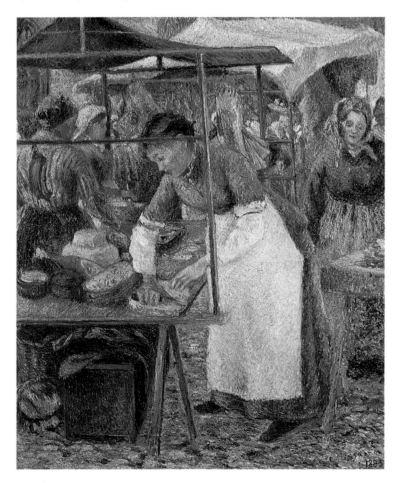

tained a stylistically homogenous output of paintings, nearly all of them landscapes, despite his penury, a lack of general recognition, and a deep-seated diffidence. By the middle and late 1870s works such as his views of the Seine at Marly were receiving recognition outside the group, and when in 1882 the Danish writer and critic Georg Brandes saw his first Impressionist paintings in Berlin he was especially struck:

Another painting, by Sisley, of a coastline with villas by the sea, is so delicately light and shimmering, so harmonious in composition, that one could find no fault with it. Here is no attempt to paint anything which could not at will be made out by the naked eye. The painting achieves its effect by means of its airy lightness and unique harmony.

Sisley was close in many ways to Monet, though not nearly so explorative, eschewing to some extent a concern with that 'envelope' of atmosphere which so greatly occupied Monet, though always using the light-coloured palette so brilliantly exploited by Renoir. Apart from occasional trips to England and the Isle of Wight, as well as an excursion to Wales, he spent most of his life at Moret, on the Seine, not far from Fontainebleau. He hardly maintained any contact with the Impressionists as a group, though he participated in the 1882 exhibition. According to the introduction to the catalogue of his studio contents, the sale of which took place after his death from cancer of the throat in 1899:

He was irritable, dissatisfied, agitated. With poignant and moving avidity he accepted any expression of consideration or interest from strangers, but almost immediately, full of suspicions, began to avoid these new friendships. He grew constantly more unhappy and made life unbearable for himself. Little by little all joy left his life, except that of painting, which persisted to the end.

In fact his latter years were in some ways more fortunate than his early life had been. In 1881 he had held a one-man show at the gallery of *La Vie Moderne*, his works were becoming popular in the United States, and in 1883 Jules Castagnary, then Minister of Fine Arts, bought one of his paintings for the state. The supreme irony, however, was that in the year after his death the affluent Count Isaac Camondo (1851-1911), a banker who left his collection to the Louvre, paid 43,000 francs for *Floods at Port Marly* (Plate 292), for which in 1876 Sisley had received 150 francs.

Sisley's consistency of style had withstood the pressure which Renoir, Pissarro and, to a lesser extent, Monet were feeling towards evolving a more disciplined, less spontaneous view of nature. For Cézanne, however, the problem was partly solved by circumstances: most of his later life was spent in Provence. He had never been comfortable in Paris and, though he had participated in the exhibitions of 1874 and 1877, he did not really belong to the group – his later references to them took on a historic, or sometimes a nostalgic, note. Speaking to Joachim Gasquet, the son of one of his childhood friends, some time in the 1890s, he gave a revelatory account of his connexion with the movement, adding a few acerbic comments on some of his erstwhile colleagues:

Take the Impressionists. Now they do their thing at the Salon, admittedly it's very shrewd of them to do so. I too, and I shan't attempt

to hide it, was an Impressionist. Pissarro had an enormous influence on me. But I wanted to make out of Impressionism something durable, something solid: like the art you find in museums. I have already said this to Maurice Denis.[1] Renoir is a clever man; Pissarro a peasant. Renoir was once a painter on porcelain, and there has always been something a little too glossy and pearly in his immense talent. What fine bits he has produced all the same! I don't very much like his landscapes. He makes everything seem so fluffy. Sisley? Yes of course. But Monet is an eye, the finest eye since painting started. I take my hat off to him. Courbet too always had an image ready-made in his eye. Monet spent a lot of time with him in his youth. But a green brush-stroke is enough to give us a whole landscape, just as a flesh tone can produce a whole face. What we are all doing we all got perhaps from Pissarro. He was moulded by the fact that he was brought up in the Antilles, where he learned to draw without a master. Already by 1865 he had eliminated black, bitumen, burnt sienna and ochre from his palette. This is a fact. Never paint except with the three primary colours and their immediate derivatives, he used to say to me. Yes, he was indeed the first Impressionist.

With Cézanne it was almost a matter of topography. France has to some extent always maintained its old division between the North and the South, the one tending towards the culture of the immigrants from the east and Scandinavia which had formed its early history, the other still dominated by the ideas and attitudes of the classical world. The Provençals lived in a land of clear light and sunshine, dominated by sharply defined hills and hard-edged rock formations. They still used their own language, the *langue d'oc*, which in Cézanne's time was undergoing a revival led by the poet Frédéric Mistral. They were a fiercely independent people, with very much the same kind of reputation in France that Northerners have in Britain. When the poet and writer Prosper Mérimée got off the boat at Avignon to visit the region for the first time, he felt that he was landing in a foreign country. And Cézanne's Aix was still, as it had been in the time of King René,[5] the capital of Provence, a city rich in historic remains, with a bustling and prosperous economic life. As well as a museum and art gallery of distinction, the Granet, with which the painter had been familiar since childhood, it boasted several commercial art galleries, an art school and an active artistic community centred in the Café Beaufort (originally the Café des Arts et Métiers), where Cézanne occasionally exhibited. Its Ecole de Dessin, nestling under the church of St Jean, today houses the museum, which had been founded in the eighteenth century. In choosing to spend most of his creative life in and around Aix, Cézanne found for himself a cultural and physical environment which was to provide him with just that degree of 'classicism' he needed, and for which other Impressionists were looking.

From the comparison of two forest scenes which he painted, *Rocks in the forest* and *Forest interior* (Plate 295), there is not only a clear topographical difference but evidence of an extraordinary evolution effected within the course of 30 years. Painted probably during the long country excursions he used to take with Zola to the forest of Fontainebleau in the late 1860s, the former, with its dramatic evocation of the joys of nature, the thick impasto

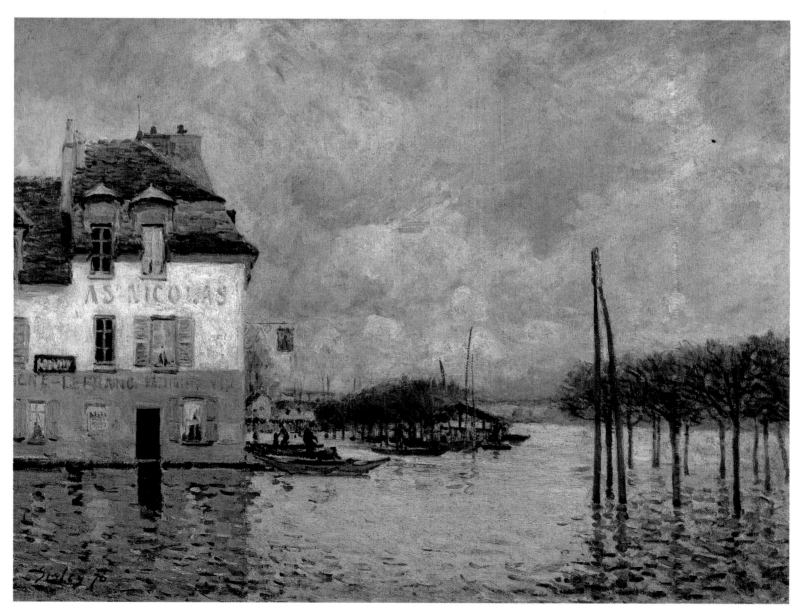

292 ALFRED SISLEY *Floods at Port Marly* 1876

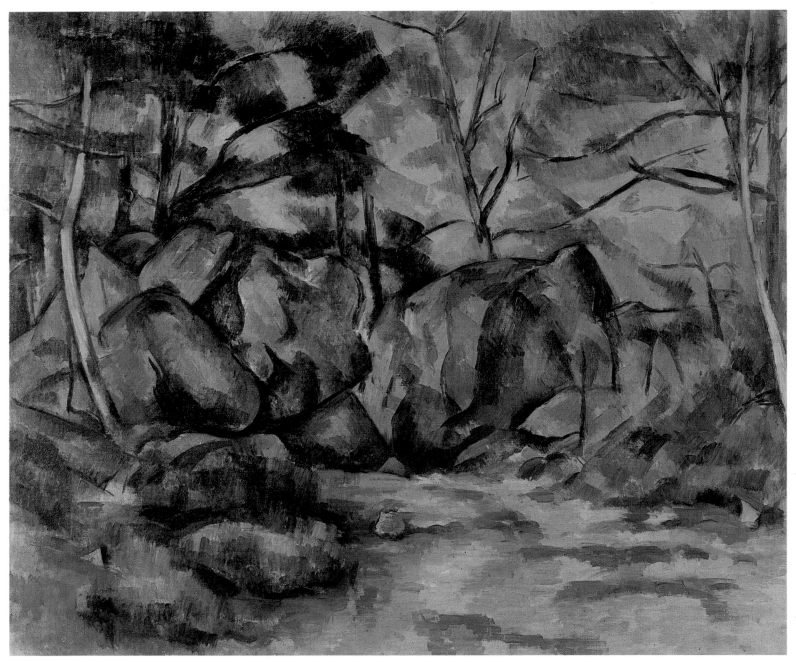

293 PAUL CEZANNE *Rocks in the woods* 1894/8

in the foreground, the careful observation of the surface of the rocks, the glimmering autumn leaves, its echoes of Courbet, is a pure exercise in ocular sensibility, in that romantic worship of nature as the source of all inspiration which characterizes those cultures stemming mainly from outside the Roman *imperium*.

By 1898, however, when he painted a whole series of works including *Forest interior* (Plate 295) and *Rocks in the woods* (Plate 293), his father had died, and the parental home from where he had painted some of his earlier Aixois landscapes (such as *Farmhouse; chestnut trees at the Jas de Bouffan*, Plate 294) had been sold to divide amongst the heirs. Living in the town of Aix, Cézanne trudged out daily to paint, usually in and around the Bibémus quarry, on a plateau then thickly covered with pine trees which were subsequently destroyed by fire. The quarry itself consists of a large number of excavations, often of intricate geometrical shapes which were determined by the quarrymen's skill at extracting units suitable for the demands of builders. The stone is ochre-coloured, and can be seen in many of the buildings in Aix itself. Cézanne rented a workman's cabin in the area, and applied to the visual exploration of the area that same obsessive fervour which had come to dominate his entire artistic activity. The difference between

Forest interior and the Fontainebleau picture could not be greater. Instead of sensibility there is rigorous analysis of form, instead of atmospheric suggestiveness there is emphasis on the plasticity of objects, the solidity of the rocks, the deployment of planes, enhanced by the distribution of the colours themselves, which are restrained and unified. Instead of the natural light which irradiates the earlier picture, the later one is suffused with what might be called a pictorial light engendered within the painting itself and expressed in terms of pure colour. Whereas the Impressionists were concerned with the fleeting world – indeed, catching it was their distinctive preoccupation – Cézanne was concerned with creating images which were permanent in themselves, statements of a new reality.

It was this quest for what a later generation of critics would describe as 'significant form' which made Cézanne so often concentrate on single themes. The most important of those, and the one with which he has become so closely identified, is Mont Sainte-Victoire, at the foot of which in 100 BC the Roman general Marius inflicted a crushing defeat on the Teutons and so saved the Provincia for the civilization of the Mediterranean rather than losing it to the culture of the north. Towering over the valley from which it rises abruptly with such jagged vehemence, it

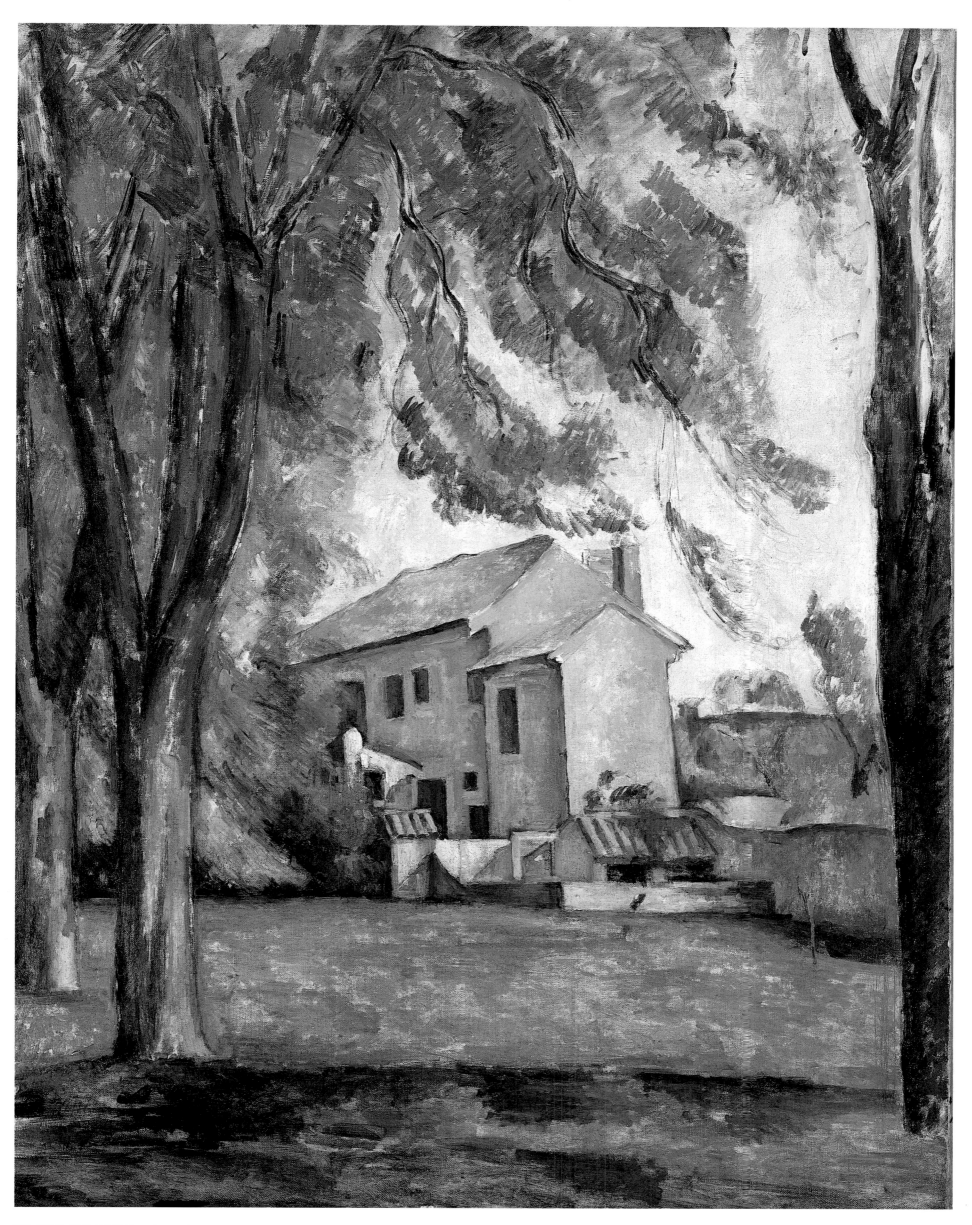

294 PAUL CEZANNE *Farmhouse, chestnut trees at the Jas de Bouffan* 1894

295 PAUL CEZANNE *Forest interior* 1898

dominates at least 12 of Cézanne's major paintings (Plates 184, 324), and was the subject of countless watercolours and drawings.

Despite his often quoted aphorism about reducing nature to geometrical forms, his reactions to it were far from clinical. Contact with nature was as essential to him as it was to his fellow Impressionists, and though he could concoct paintings from fashion periodicals, from photographs or from the works of others, he still painted out of doors as assiduously as Monet or Sisley. In an article written for the periodical *L'Occident* in 1904, Emile Bernard recorded some of Cézanne's maxims about art which reflect perfectly the principles underlying his work:

We must read nature, and express our sensations in a manner which is both individual and traditional at the same time. The strongest will be he who, having looked most deeply, expresses what he has seen most fully, like the great Venetians.

To paint after nature is not to copy what one sees, it is to express one's feelings.

In painting there are two things, the eye and the brain, both of which must work in unison. One must work to achieve their mutual growth: the eye by developing its vision of the natural world, the brain by developing the logic of organized sensations which provides the means of expression.

There is no such thing as line; no such thing as an object; there are merely contrasts. These contrasts are not between black and white, they are the apprehension of colour. From this apprehension the object being painted emerges. When they are harmoniously juxtaposed and they are all there, the painting models itself.

Shadow is a colour like light, but less brilliant. Light and shade are only the relationship between two tones.

Everything in nature is modelled according to the sphere, the cone and the cylinder. You must learn to paint according to these simple constructions, and then you will be able to do what you want.

Drawing and colour are not separate from each other. In so far as one paints, one draws at the same time. The more harmonious the colouring, the better the drawing. When colour is at its richest form is at its fullest. The secret of drawing and modelling is achieving the right tonal contrasts and relationships.

[1] 'The fugitive aspect, and the special recording of the moment, the impression, in a word the object'. This is a quotation from Théodore Duret's introduction to the Renoir exhibition, which opened at Durand-Ruel's in April; impressive proof that the *Times* critic had taken pains over his piece.

[2] From the May 1883 issue.

[3] Petr Lavrov, born in Melenkhovo in 1823 and dying in Paris in 1900, was a noted populist writer and theoretician, who had been a member of the Commune in 1871.

[4] Maurice Denis (1870-1943), painter and critic important in the context of the Nabis and the Symbolists. His most memorable statement is probably 'Remember that a picture, before being a warhorse or a nude woman or an anecdote, is essentially a flat surface covered with colours assembled in a certain order.' He quotes this remark by Cézanne in his *Théories*, 1912, p.170.

[5] René (1408-80), Duke of Anjou, Count of Provence, King of Sicily, was versed in Latin, Greek, Italian, Catalan and Hebrew. Musician, poet and painter, he studied mathematics, geology and law and imported the muscatel grape from Sicily into France. He spent the latter part of his life entirely in Aix and the surrounding countryside.

296 GUSTAVE CAILLEBOTTE *Self-portrait* 1892
Painted when he was 44 and had only two more years to live, this is one of the two
self-portraits Caillebotte executed (the other has been lost). It combines the realistic gravity of
a Renaissance portrait with the technical sophistication of Impressionism.

298 GUSTAVE CAILLEBOTTE *Sailing boat at Argenteuil* 1885-90
Done after Caillebotte had bought a property at Petite-Gennevilliers, near Argenteuil, this
was painted more than ten years after Monet and Renoir had immortalized the area. Running
across most of the picture is the road bridge which Monet painted.

297 PIERRE-AUGUSTE RENOIR *Dance at Bougival* 1883
In 1883 Renoir started a series of couples dancing (see also Plates 304 and 305). This one
and *Dance in the country* are very similar, and he himself did little to clarify the confusion:
Dance in the country was first entitled *Danseur (Bougival)*, while *Dance at Bougival* was
called *Danseurs à Bougival* at Dowdeswell's in London later the same year. But when Renoir
had originally handed over the paintings to Durand-Ruel, *Dance in the country* was called
Danse à Chatou while *Dance at Bougival* was described as *Danse à la campagne*. As in Plate
305 the model is Suzanne Valadon.

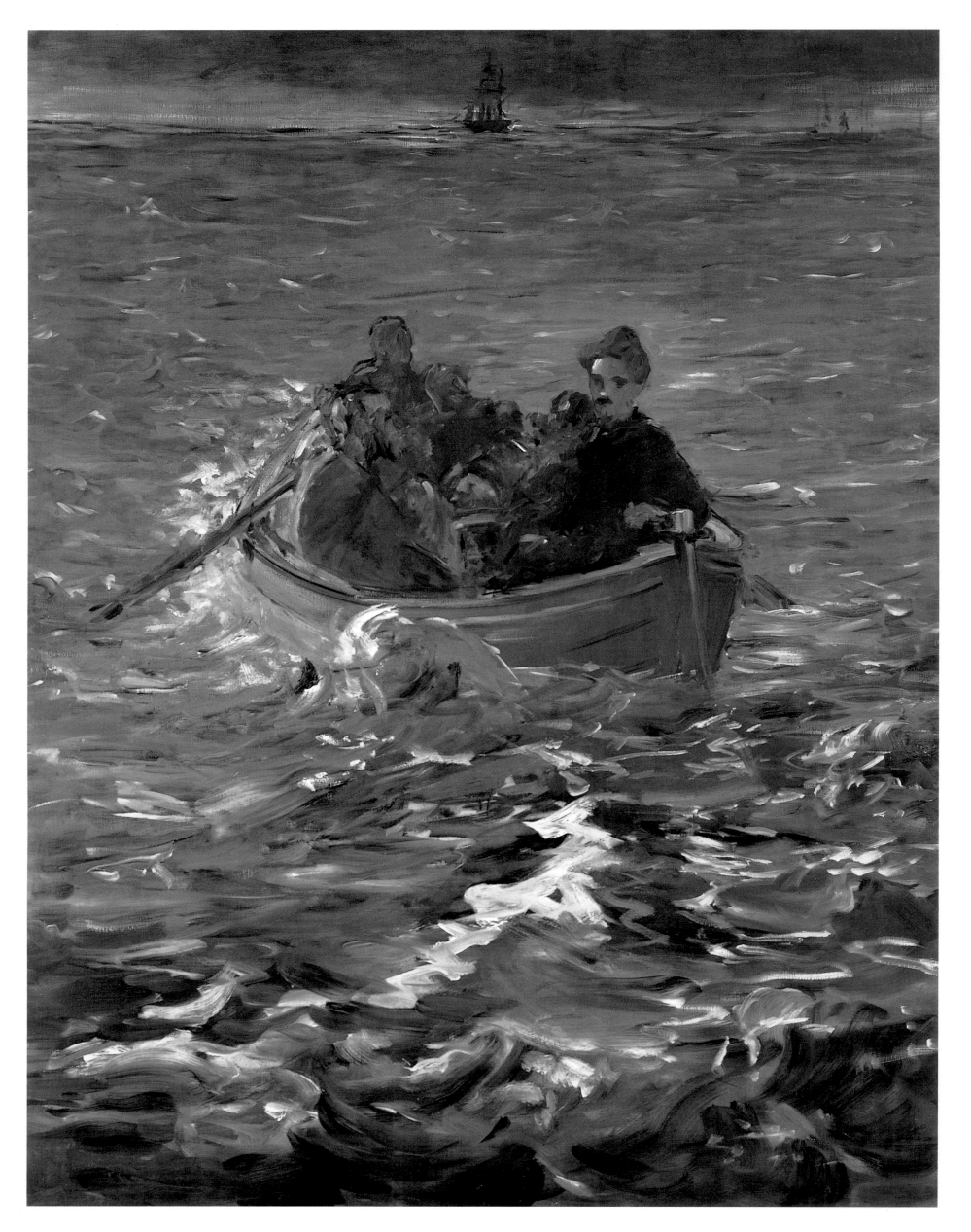

299 EDOUARD MANET *The escape of Rochefort* 1881
Manet was the only one of the Impressionists to paint subjects from contemporary history.
Henri Rochefort had been a firebrand and enthusiastic Communard. After the suppression
of the Commune he was sentenced to deportation to Nouméa in New Caledonia, but escaped
in a rowing-boat with some others. Picked up by an Australian coal-boat, he went first to the
United States, then to London and Geneva, where he published a radical paper. In 1880 all
the ex-Communards were amnestied, and Manet decided to paint the episode from accounts
by Rochefort. This sketch was part of his preparations.

300 CLAUDE MONET *The Manneporte at Etretat* 1883
Monet painted several pictures of this curious rock formation, in which he recorded with
dedicated attention the texture of the rock, the varying effects of sunshine and the play of
light on the choppy waters.

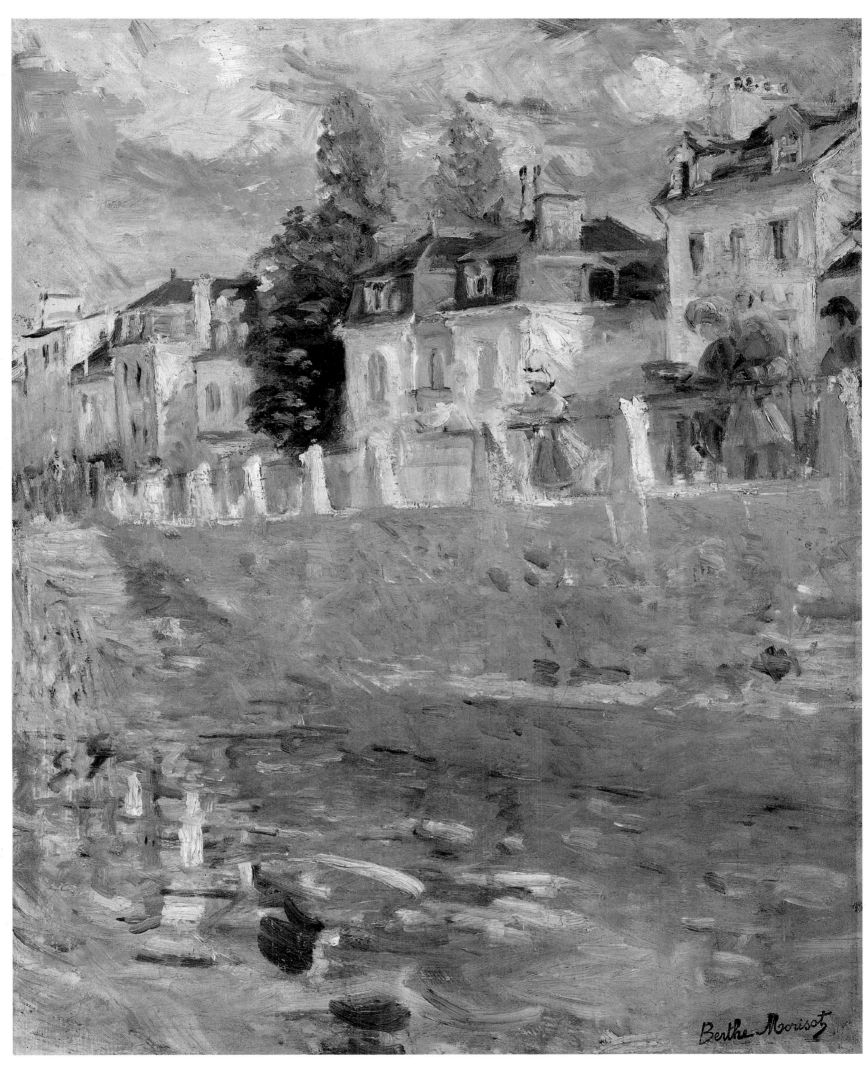

301 BERTHE MORISOT *The water's edge: the quay at Bougival* 1883
Between 1881 and 1884 Berthe Morisot and her family rented a house at Bougival, one of
the most popular resorts on the banks of the Seine, and a favourite haunt of Renoir, Manet,
Pissarro and Monet. Morisot did not frequently address herself to predominantly
architectural subjects, but this essay is a resounding success, especially in the treatment of the
stonework of the quay, the stucco of the houses and the play of light on the water.

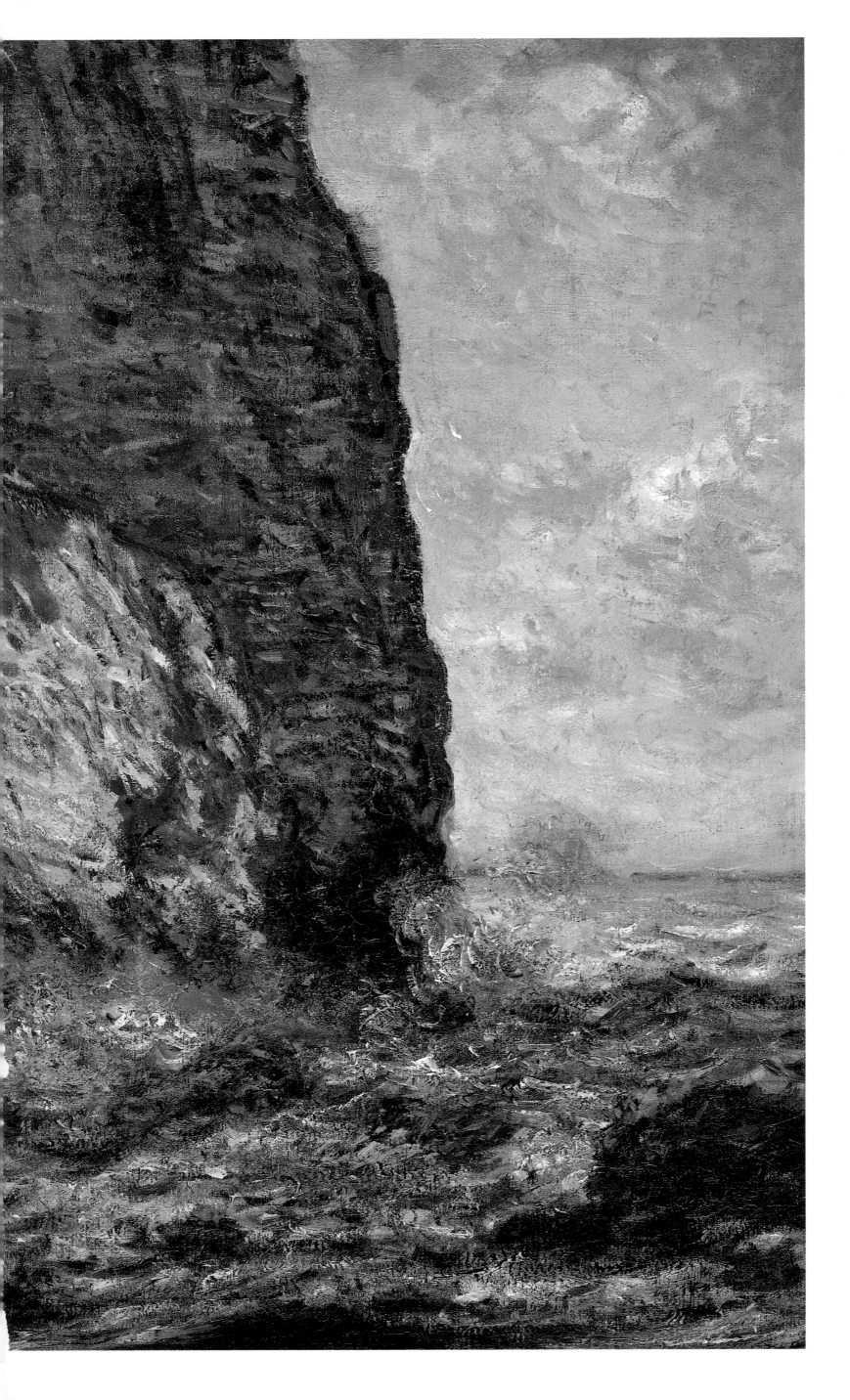

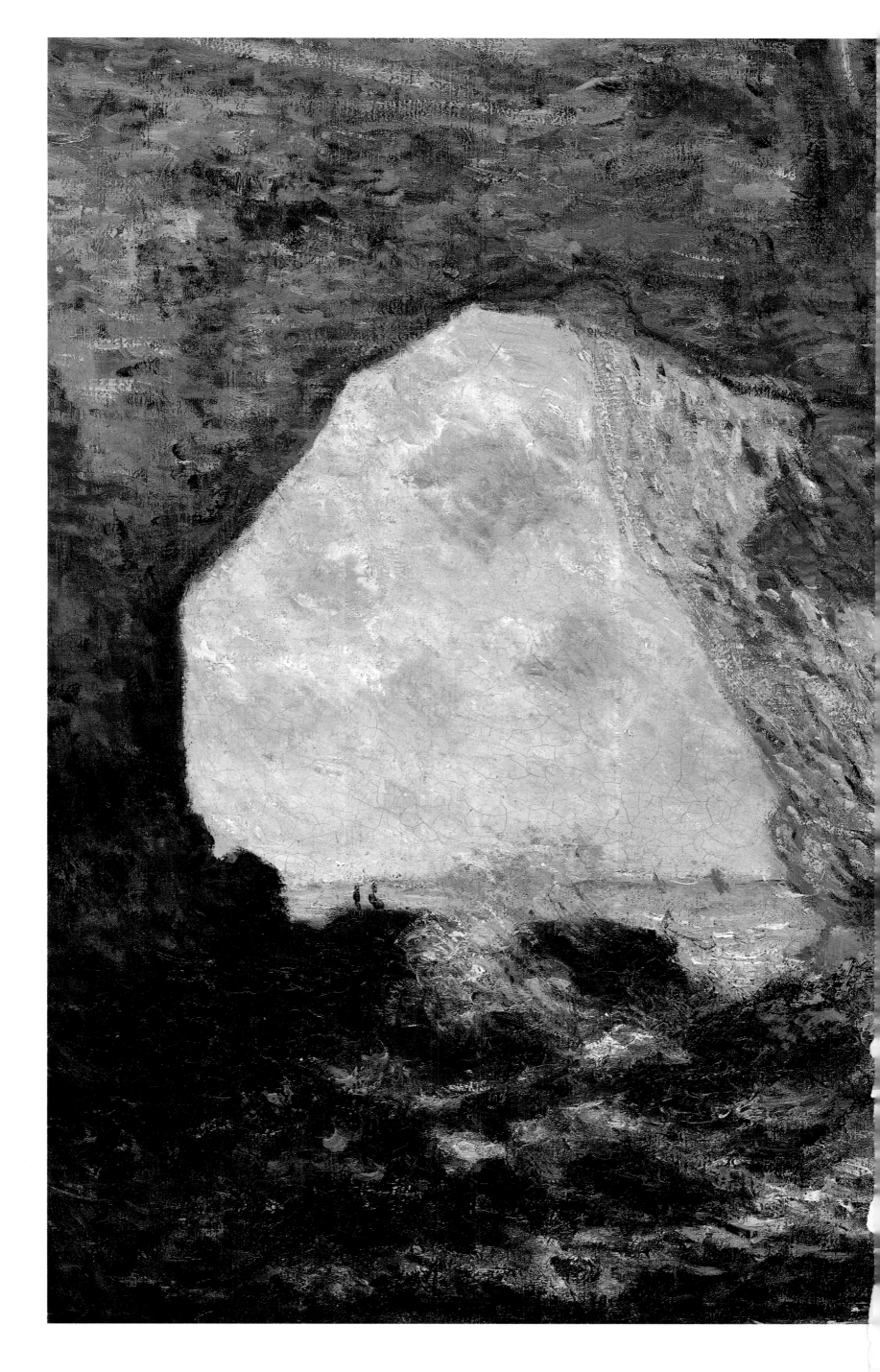

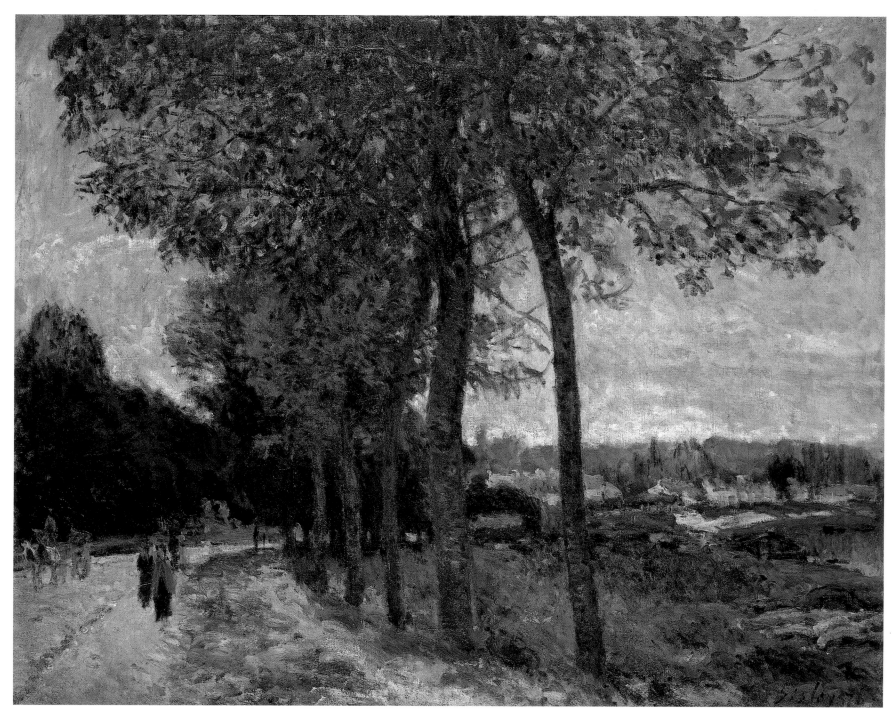

502 ALFRED SISLEY *The Seine at Marly* 1876

303 ALFRED SISLEY *View of the water's edge at St-Mammès* 1884
Sisley's consistent ability to catch the shimmering quality of water, the airy quality of light,
and blend them into a harmonious unity did not desert him, whatever the difficulties of his
life and however long it took him to achieve recognition.

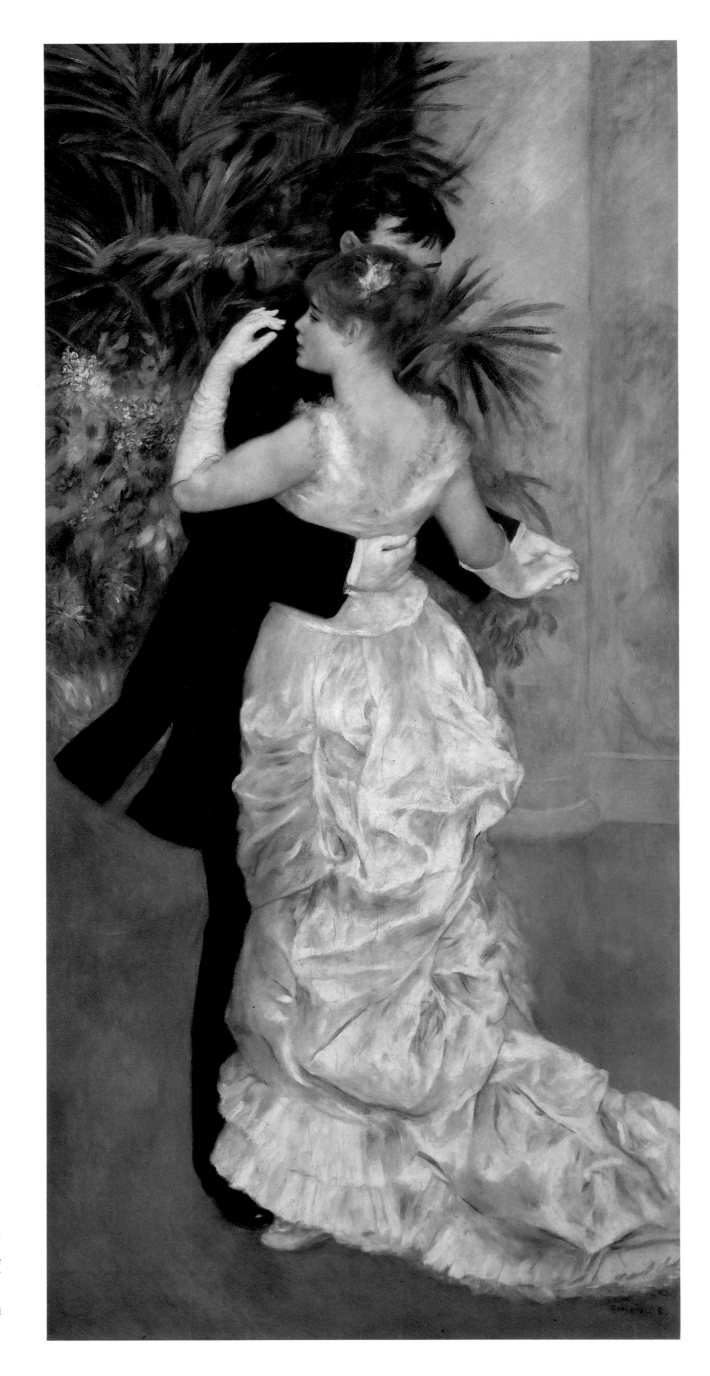

304 PIERRE-AUGUSTE RENOIR
Dance in the city 1883
Originally entitled *Danse (Paris)*, it is one
of a pair (see also Plates 305, 297). The
models for this sophisticated version were
the 17-year-old Marie-Clémentine (later
Suzanne) Valadon and Paul Lhote, who
appears in many of Renoir's paintings at
the time. The clarity of the figures against
the background suggests the lessons
Renoir had learnt from his Italian trip.

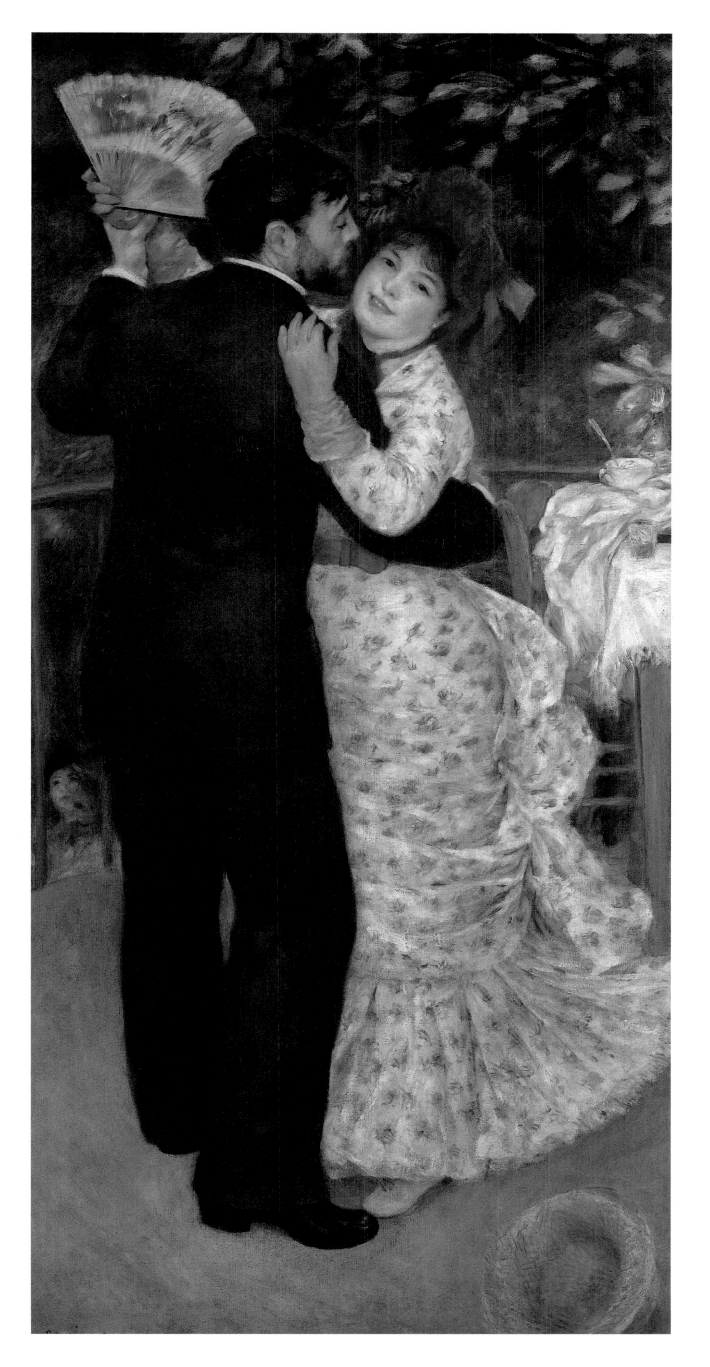

305 PIERRE-AUGUSTE RENOIR
Dance in the country 1883
Originally called *Dance at Chatou*, this
companion piece to *Dance in the city*
(Plate 304) seems intended to depict
simple, honest enjoyment in contrast to
the more formal delights of the city. The
happy, smiling face of Aline Charigot and
the attentive, admiring face of Paul Lhote
contrast strikingly with those of the city
couple. This is emphasized too by the
difference between the backgrounds:
potted plants in the one, the natural tree
in the other.

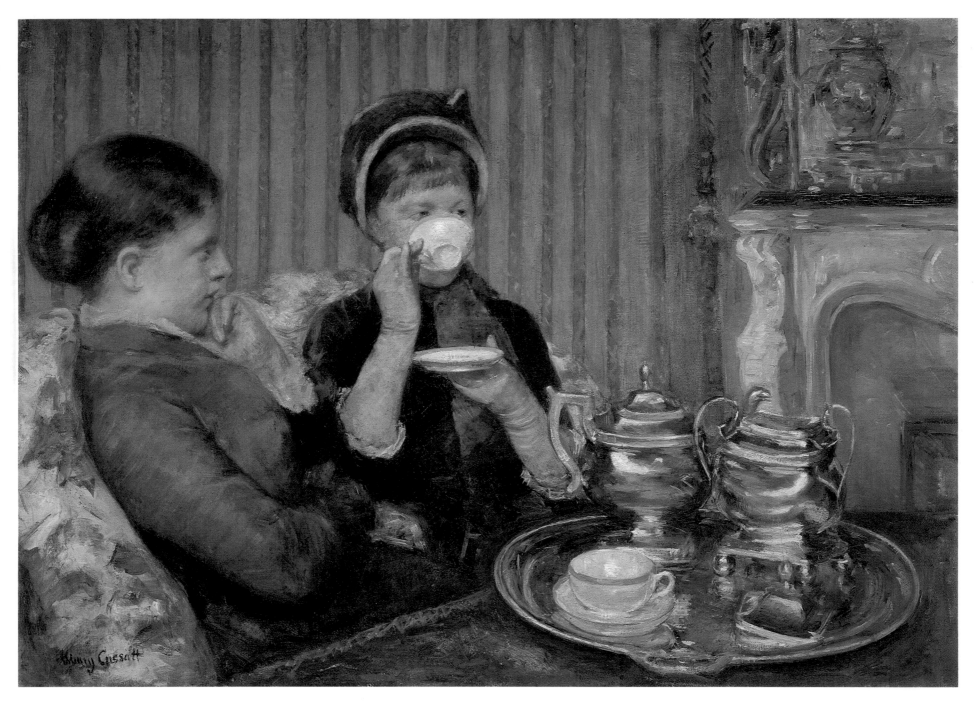

306 MARY CASSATT *Five o'clock tea* 1880
The figure in brown is Mary's sister, Lydia; the subject a ritual which had become a part of the Parisian social timetable, derived from the then fashionable English way of life. The influence of Degas is obvious, but so too is the meticulous observation of Cassatt, apparent in the finely rendered teapot and sugar-basin and the Japanese-looking vase in the painting over the fireplace.

307 MARIE BRACQUEMOND *Teatime* 1880
In many ways a more interesting painter than her husband Félix, who was primarily an engraver, Marie was deeply interested in open-air painting which, she once said, 'has produced not only a new, but a very useful way of looking at things'. Although her favourite artist was Monet, her own speciality was the domestic life of her own time and class.

308 (*Opposite*) MARIE BRACQUEMOND *Young woman in white* 1880
This carefully studied composition, for which there are a number of preliminary drawings, is a portrait of her sister Louise Quiveron, who was one of her favourite models.

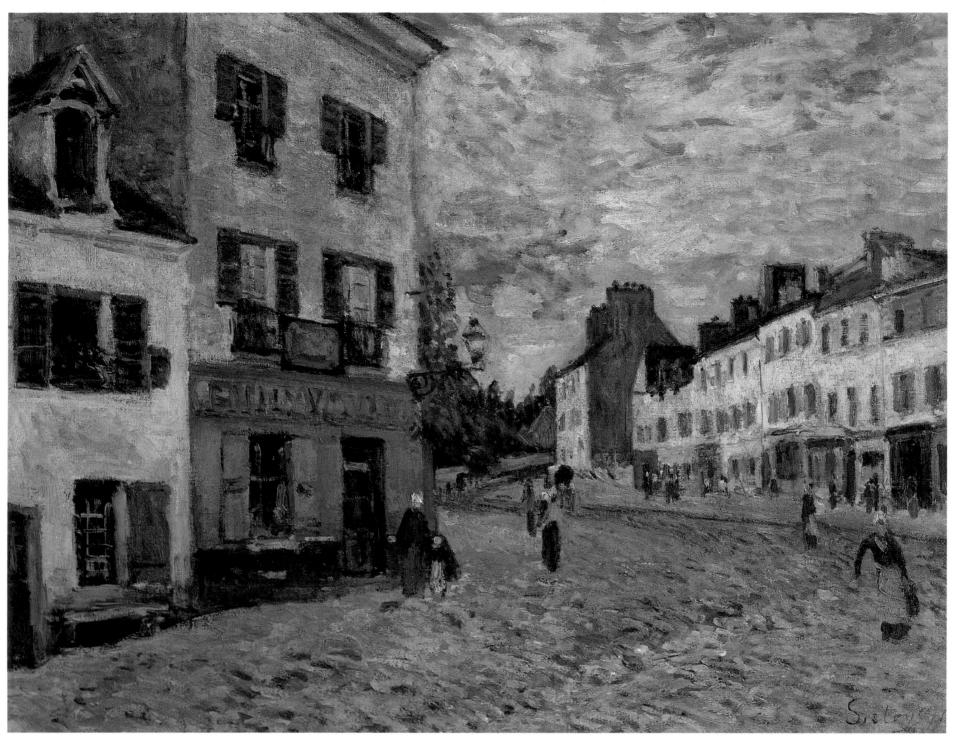

309 ALFRED SISLEY *Market-place* 1876

Starting off as a pupil of the highly successful society portrait-painter Charles Chaplin, Eva Gonzalès became an Impressionist very largely because of her devotion to Manet, a sentiment which made her automatically the rival of Berthe Morisot. Although in her more personal and intimate works she showed an almost complete adherence to Impressionist principles and technique, despite a tendency to a rather subdued palette, in paintings such as this there are clear signs of persistent influences from her early training. The trees in the background and the forest floor are painted in small mosaic-like brush-strokes, and the radiance of the sunlight filtering through the leaves is rendered with a fidelity which would have won the approval of Manet, indeed even of Monet; the figures of the two women could well have been painted by someone such as Tissot, were it not for the froth of lace which adorns the edge of each of their skirts. Nor are the figures completely absorbed into their background, the one on the left especially having something of the appearance of a cut-out. The composition is, in fact, over-studied – the presence of the dog to fill the space in the left-hand corner, and of the hat and glove on the right, smack of adherence to some academic ideal.

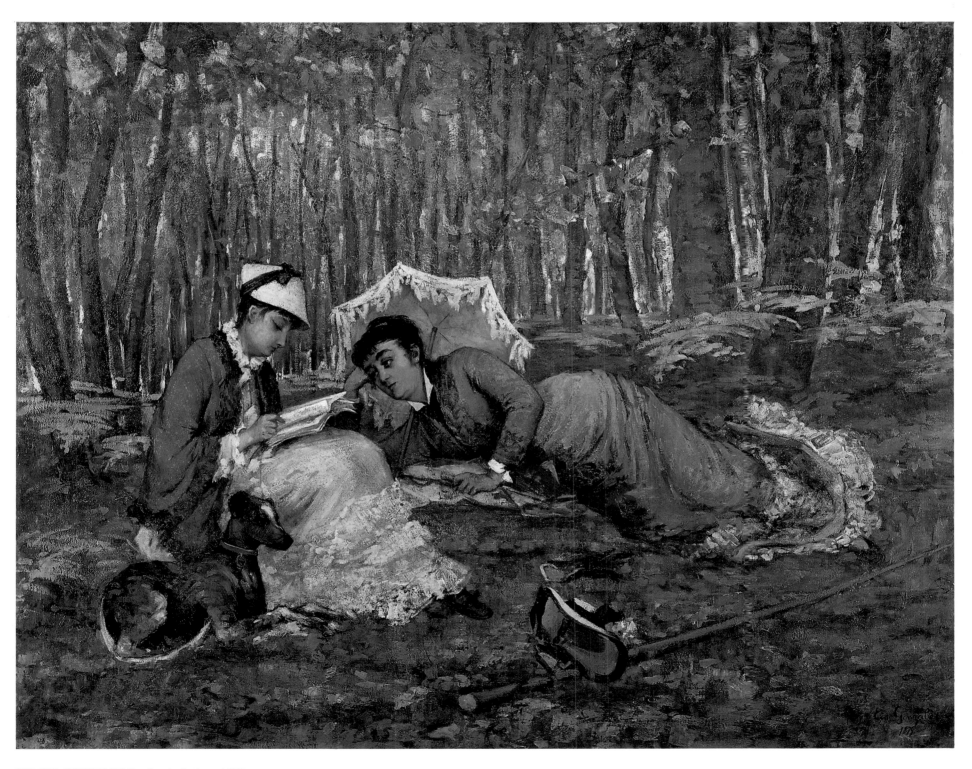

310 EVA GONZALES *Reading in the forest* 1879

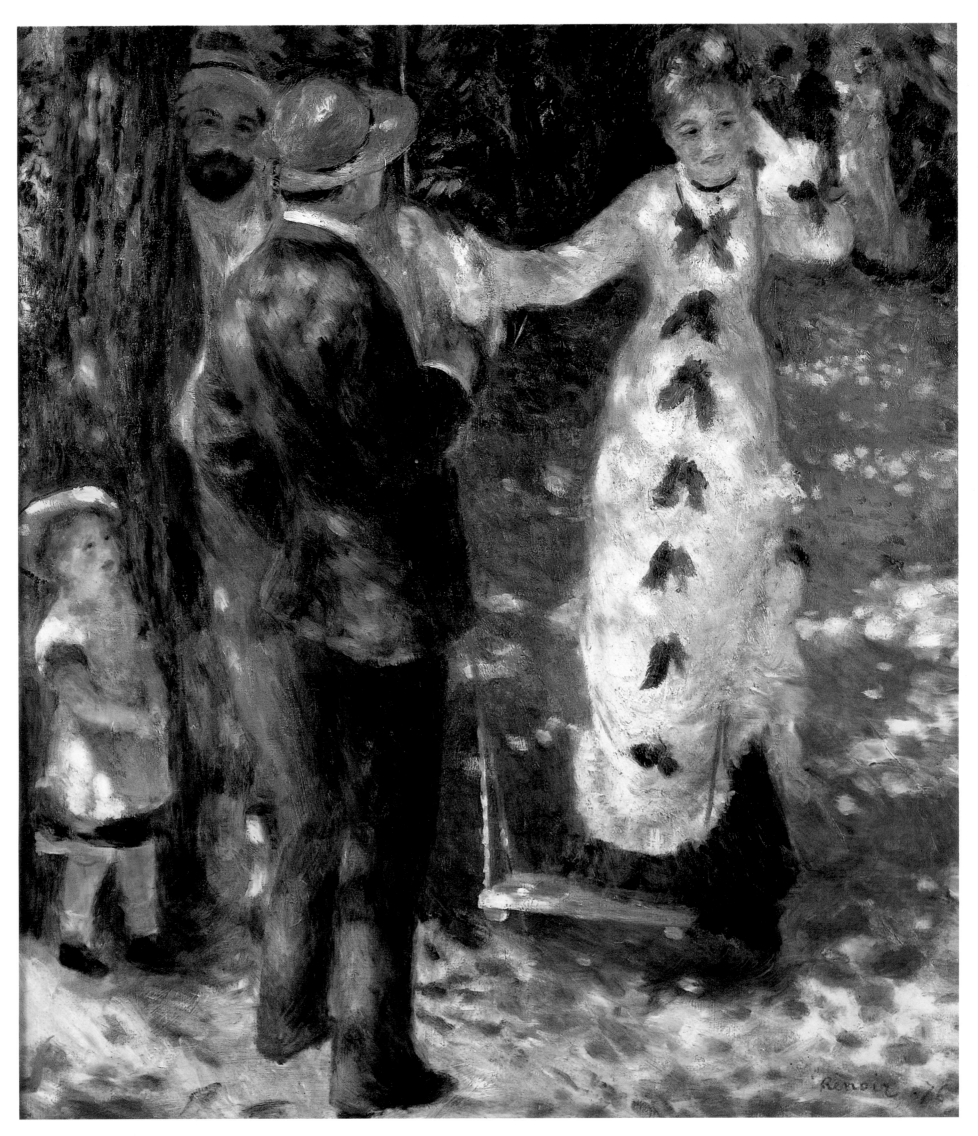

311 PIERRE-AUGUSTE RENOIR *The swing* 1876
The inspiration for this painting, with its elaborate depiction of the effects of sunshine and shadow, is a passage in Zola's *Une page d'amour* (1878), where he describes the heroine 'standing on the very edge of the swing, holding the ropes with her arms outstretched; she was wearing a grey dress adorned with mauve bows… a gentle rain of sunbeams fell between the leafless branches.'

312 EDOUARD MANET *Autumn* 1881-2
In 1881 Manet conceived the idea of representing the four seasons by portraits of women. He finished only two: *Spring*, showing Jeanne Demarsy, and *Autumn*, a portrait of the actress Méry Laurent, described by Mallarmé as 'one of the most beautiful women in Paris'. Dressed in expensive furs, she is placed against a background with Japanese decorations.

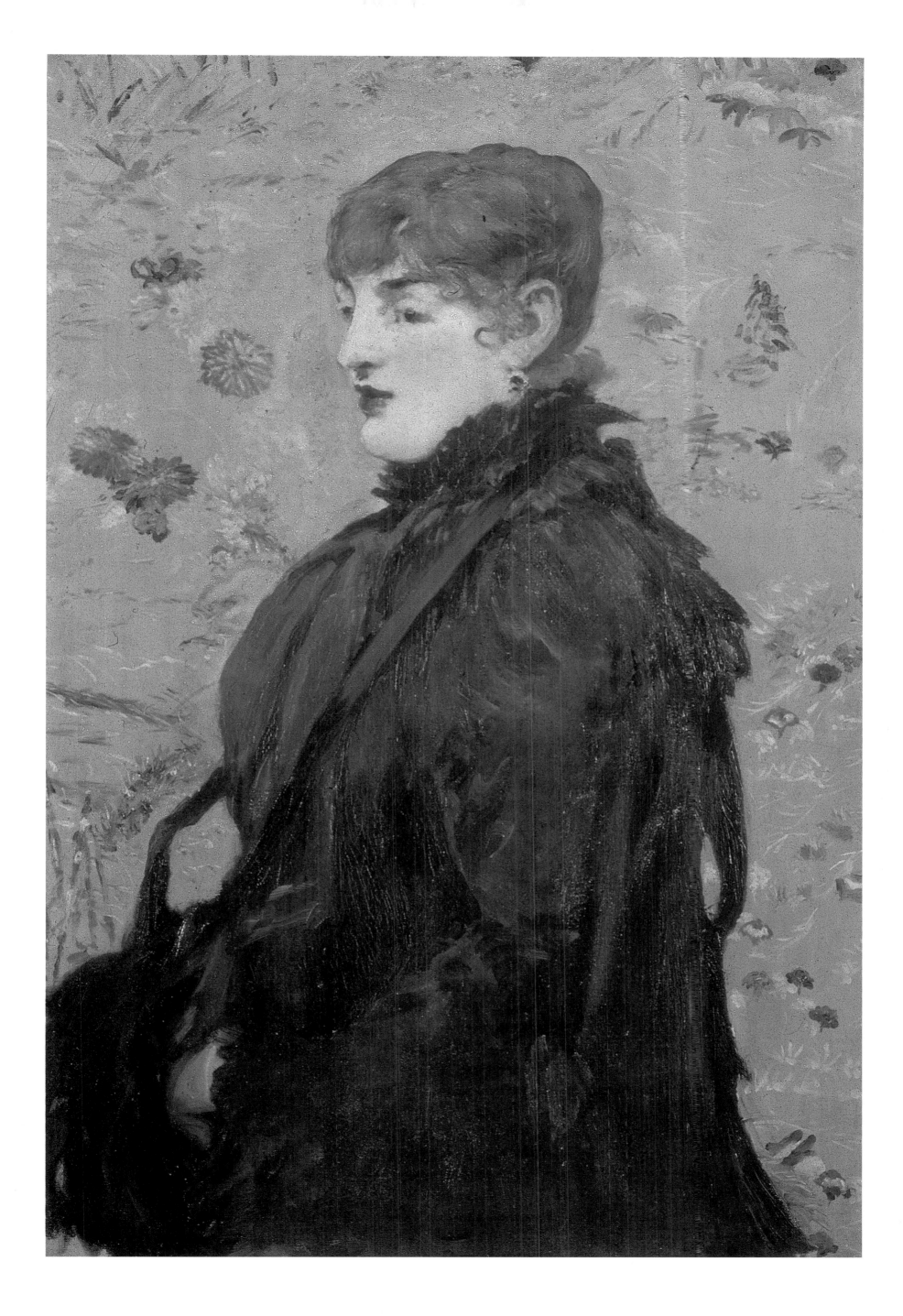

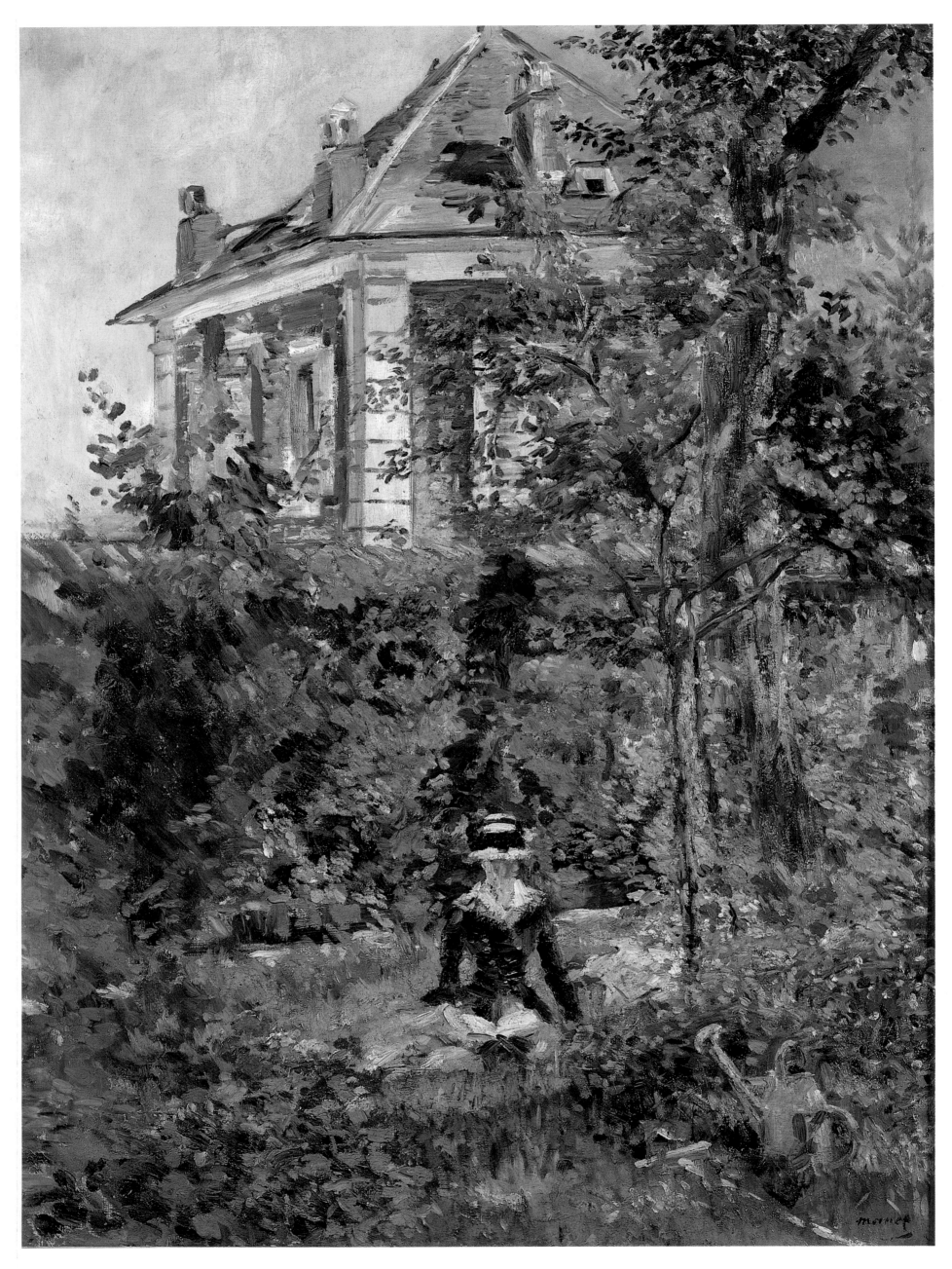

313 EDOUARD MANET *Young girl in the garden (A corner of the garden at Bellevue)* 1880
This painting, as so often with Manet's later works, has a lightness and spontaneity about it
which is generally associated with the works of Berthe Morisot.

314 CLAUDE MONET *Stone pine at Antibes* 1888
The minute brush-strokes coalesce to form a wide-sweeping landscape, with the pine placed
at precisely the position where it co-ordinates the whole of the composition with its
horizontal bands of sky, town, water and scrubland.

Claude Monet 86

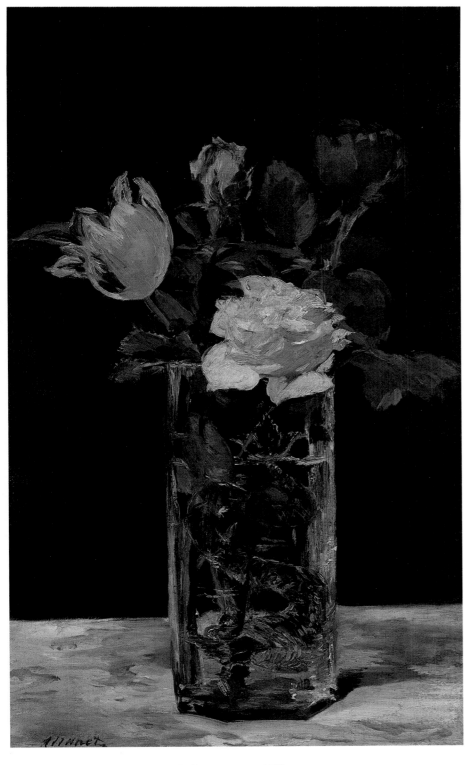

During the last months of his life Manet painted a large number of still-lifes, often of flowers brought to him in his illness by friends such as the actress Méry Laurent (Plate 312), who sent them round by her maid Elisa. This particular work is thought to have been one of his last. The vase with the dragon on it appears in two other similar paintings. The contrast with Cézanne's treatment of a similar theme painted some ten years later is emphatic and revealing. Manet's version glows with a softly diffused colour, the roses especially revealing an almost self-indulgent sensuality of form and handling. There is a strong interplay of rhythms between the shape of the flowers, their leaves and stems, and the writhing contortions of the dragon etched on the vase. The background is monochrome to heighten still further the sensuous splendour of the colours. Cézanne, on the other hand, has chosen a more diverse and dramatic background which looks like the sky, though this is visually impossible in the perspectival context. Looming in the top left-hand corner is a dark, threatening cloud-like shape which emphasizes the head of the tulip and its drooping petal, perched as they are on the top of a stem whose ungainly length dwarfs the height of the vase. Whereas the dominant elements of Manet's composition are rotund, those of Cézanne's are linear, but this overall surge upwards is balanced by the exquisitely sited apples and oranges on the table as well as by the beautifully painted glaze cascading over the earthenware vase.

316 EDOUARD MANET *Roses and tulips in a vase c. 1882*

317 PAUL CEZANNE *Tulips in a vase 1890*

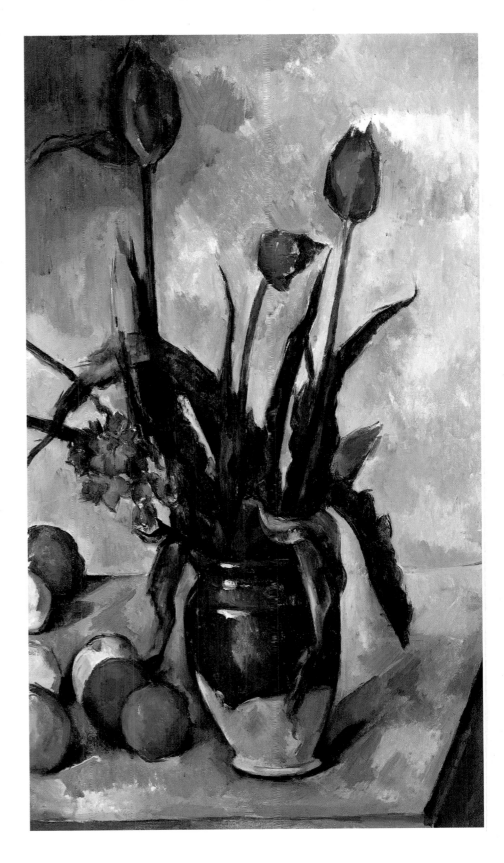

315 PAUL CEZANNE *Small bridge at Maincy 1879*

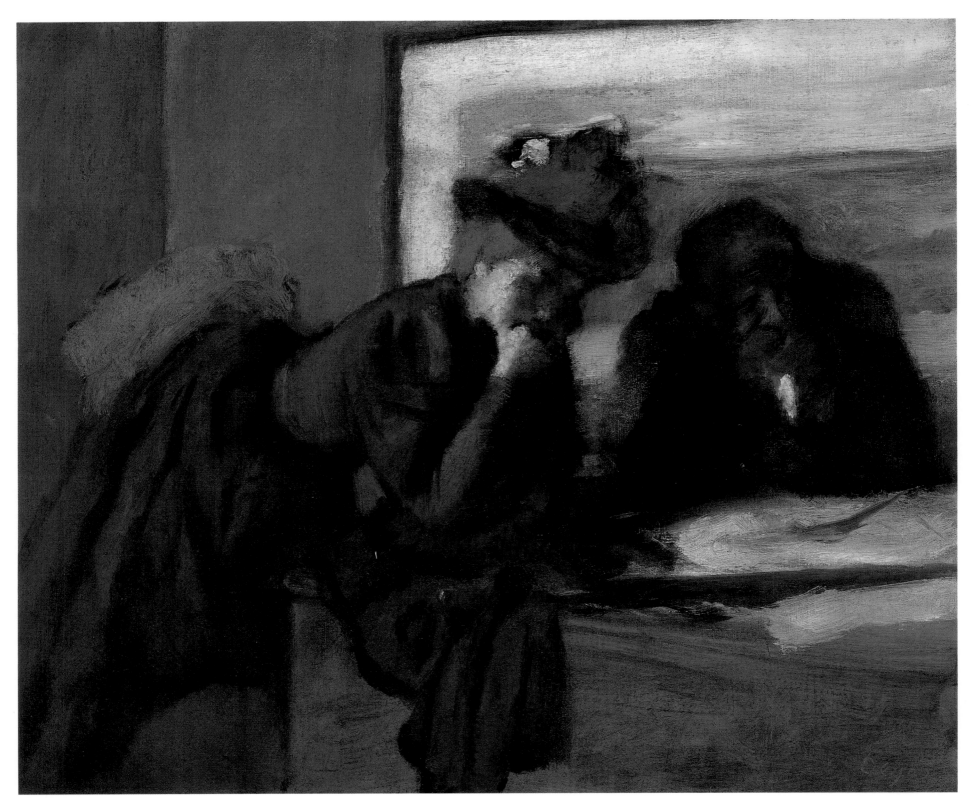

318 EDGAR DEGAS *The conversation c.* 1895
It would seem that Degas commenced this work in 1884, but did not finish it until 1895. The most likely identification of the figures is that they are Paul Albert Bartholomé, the painter and sculptor, who was a close friend of Degas and helped him in preparing his own exercises in that medium, and his wife Périe, who died in 1887. If such is the case it must have been meant as a consoling offering to Bartholomé. It is known that Degas did paint posthumous portraits of his father and the singer Pagans.

319 EDGAR DEGAS *Miss La La at the Cirque Fernando* 1879
Exhibited at the fourth Impressionist exhibition in 1879, this remarkable *tour de force* may have owed something to the assistance of one of those perspectival artists used mainly by architects, but who hired out their services to painters as well.

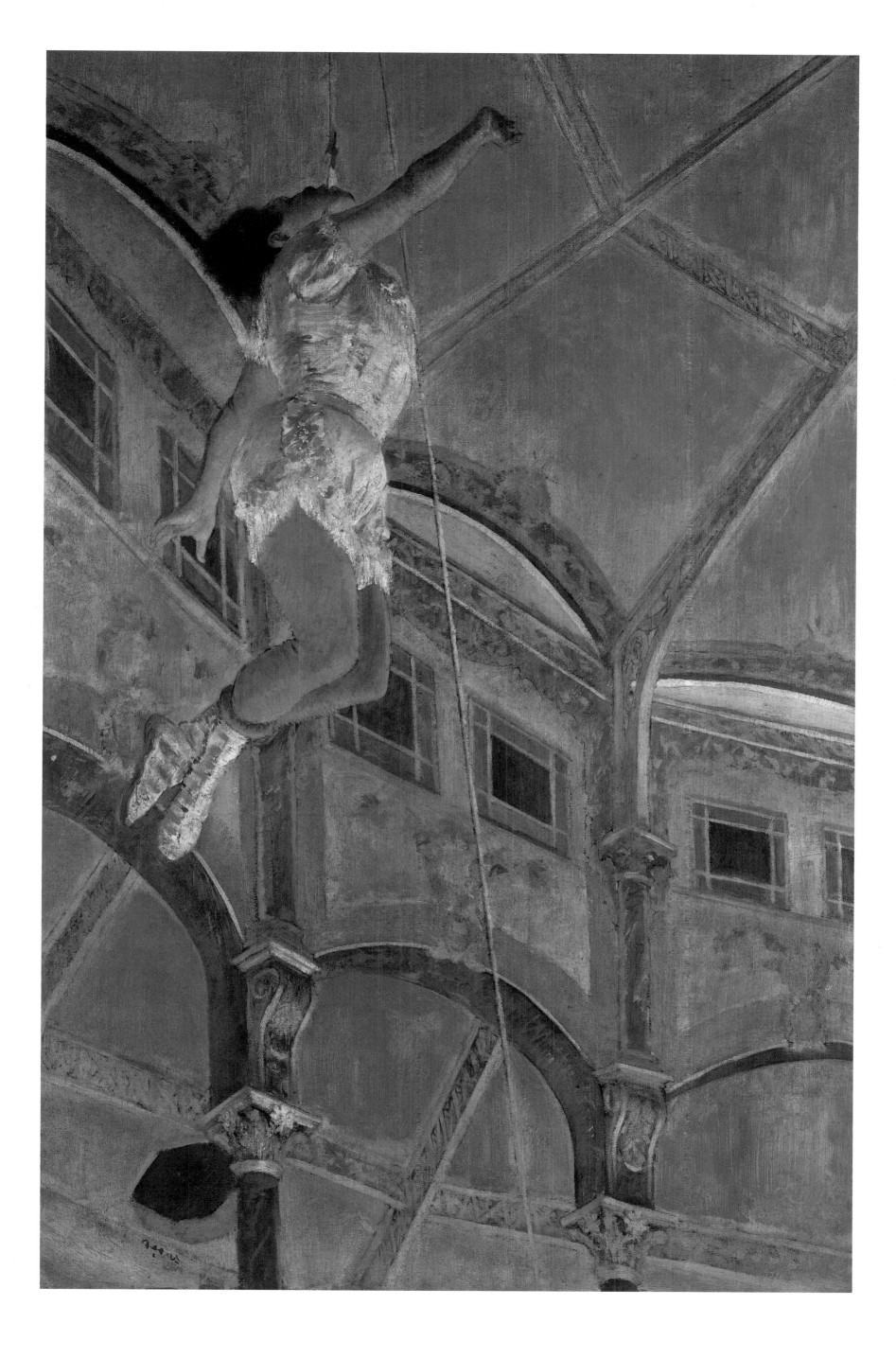

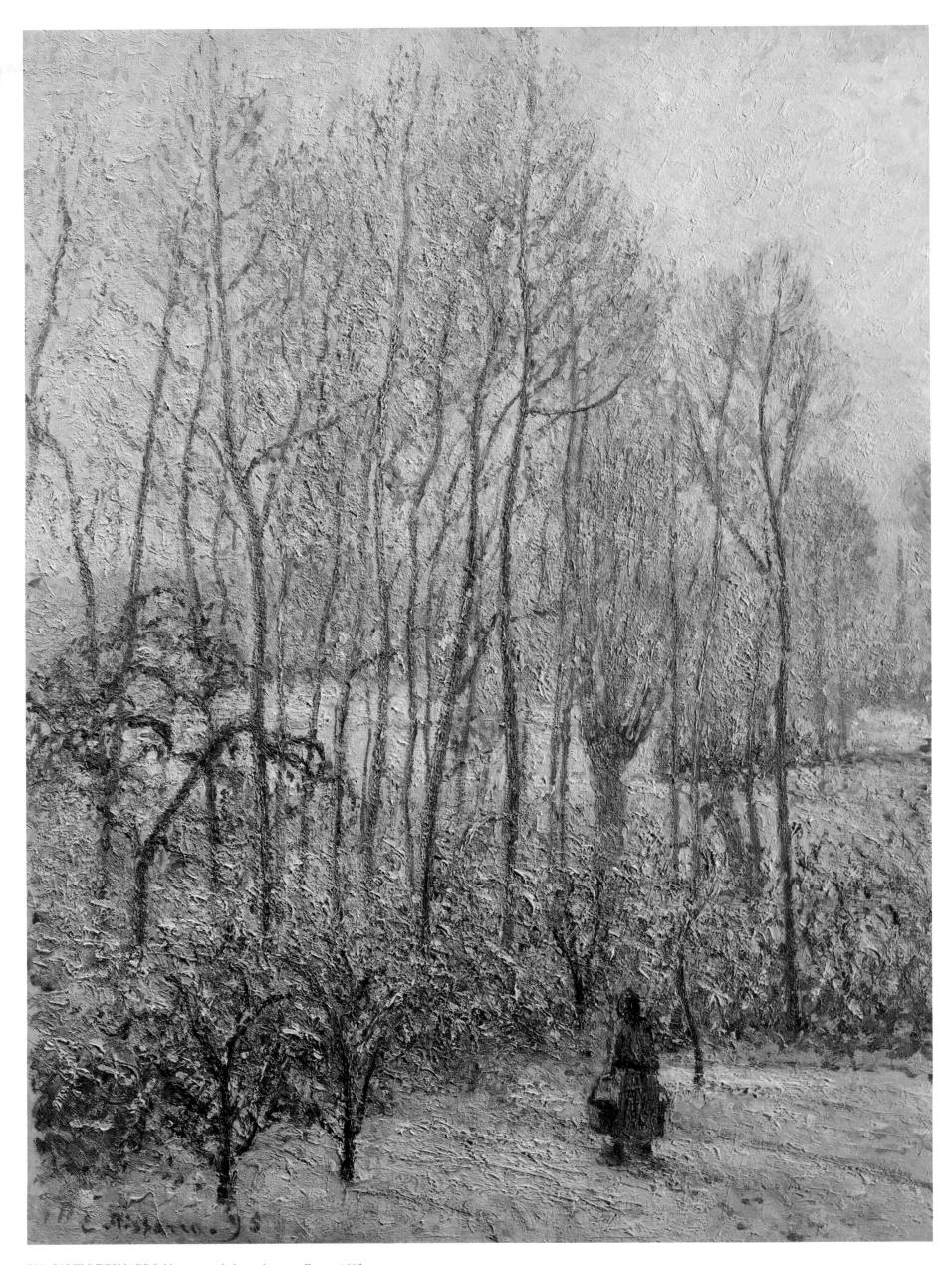

320 CAMILLE PISSARRO *Morning sunlight on the snow, Eragny* 1895
Although painted in a lightly Pointillist style, this emotive picture of winter, with
the rather clumsy figure of a peasant woman, is still redolent of main-line
Impressionism.

Chapter 9

Doubts and Dissensions

The eighth and last Impressionist exhibition, held in rooms over a well-known restaurant, the Maison Dorée, opened on 15 May 1886, 12 years after the first. It epitomized what many saw as the 'crisis' of the movement. Symbolically the place was lit by electric light, and the great stumbling blocks – or revelations, according to taste – were the Degas pastels of nudes (see p.290) catalogued as a series of nudes of women 'bathing, washing, drying themselves, combing their hair or having it washed', and a room devoted entirely to the works of Seurat and his followers, dominated by his *Sunday afternoon on the island of La grande Jatte*. There were also about 20 works each by Pissarro, Guillaumin and Gauguin as well as a dozen paintings and some drawings and watercolours by Berthe Morisot. There was nothing by Monet, Renoir or Sisley. The percipient Félix Fénéon produced a lengthy review, in the form of a pamphlet entitled *Les Impressionnistes en 1886*, which seemed almost like an obituary of the movement. Starting with a brief history he made the point that:

The general public always saw Manet as the leading figure in the movement, yet in reality the mutation which transformed the bituminous painter of *Le bon Bock* [Plate 172] into a painter of light was achieved under the influence of Camille Pissarro, of Degas, of Renoir and above all of Claude Monet; they were the leaders of the revolution of which he became the titular herald. Renoir and Monet were absent from the eighth exhibition, as are Raffaëlli, Cézanne, Sisley and Caillebotte. In spite of these gaps the new exhibition is quite explicit. Degas, who resists the title of 'Impressionist', is there with characteristic works. Morisot as well as Gauguin and Guillaumin represent Impressionism as it was shown in previous exhibitions; Pissarro, Seurat and Signac innovate.

To him Renoir, Sisley and Monet were the 'luminists', Seurat, Signac and to a lesser degree the newly-converted Pissarro were the 'Neo-Impressionists' who concentrated on structure and a syntax of form.

Directly contrary to them, however, and seeking something other than the concern with recording the sensations of light and atmosphere which had characterized the 'luminists' was the new arrival, Paul Gauguin, represented by 19 rural scenes from the Normandy countryside. In these the main accent was on feeling rather than on form, and on the emotive rather than the descriptive functions of colour, even though at this stage in his career he still worked within the general framework of the Impressionist

tradition. He had first come into contact with the movement through his guardian Gustave Arosa shortly after he started to paint in 1872; he initially fell under the spell of Pissarro, with whom he painted at Pontoise, then of Cézanne, whose pictures fascinated him, and finally of Degas, of whose works he became a fervent admirer. He amassed a collection of paintings by Jongkind, Manet, Renoir, Pissarro, Sisley and Guillaumin before the self-imposed vicissitudes of his life rendered such bourgeois self-indulgences impossible. Not that economic considerations were far from his mind, even after he had decided to become a full-time painter. Pissarro wrote disapprovingly to his son Lucien on 31 October 1883

Gauguin disturbs me very much. He is so deeply commercial, at least that is the impression he gives. I haven't the heart to point out to him how false and unpromising his action is, it's true his needs are great, his family being used to luxury; just the same this attitude can only hurt him.

Having just sold his Manet for 1,200 francs and, after a short spell in Rouen, joined his wife in Denmark, Gauguin felt that his work was losing its earlier dullness and starting to conform more closely with the ideals of Impressionism (Plates 381-2). Once again he confided to Pissarro:

I have worked a little in Denmark, however, recently the vegetation has started to reappear and I have become attached to working *en plein air*. Without making a conscious effort to paint lightly and luminously, I have arrived at a result quite different from what I achieved in Rouen. I believe that I can say there has been enormous progress. I can feel it; my work is more subtle, more luminous, although my method hasn't changed; I still use colours which are closely related and not very different from each other. In Rouen I did not catch the cold tones in the sky, in the greens, and in the soil. You may be assured Danish painting does not terrorize me when I see it against my own; on the contrary its lack of vigour has inspired me with such a disgust that more than ever I am convinced that there is no such thing as exaggerated art. I believe that salvation only lies in the extreme; any middle road leads to mediocrity.

In his own terms, Gauguin was constantly going to extremes. To him colour was starting to become something independent of a visual reference point. He was moving slowly towards this when first he went to Pont-Aven in the year of the last Impressionist exhibition. The pictures he painted there were still basically Impressionist, though

tinged with a certain vehemence. He was not really to free himself from his dependence on the movement until the arrival in his life of Emile Bernard, who was to convince him that individually observed objects could be related to memory, myth and dream in such a way as to liberate them from conventional notions of colour and even line. He was to become one of the first to avail himself of the full potential of the liberation offered by Impressionism.

It seemed therefore by the late 1880s that the vigour of the ideals motivating those who participated in the exhibition at Nadar's old studio had abated. They seemed involved in what a slightly disillusioned Van Gogh described as 'disastrous squabbles, each member getting at each other's throat with a passion worthier of a nobler and better aim'.

Personal animosities, often centred round or stimulated by Degas, were compounded by divergences of artistic intent, creating groups of the kind just described by Fénéon. Worse than this, however, was the increasingly frequent accusation levied against them that they had not really produced anything of outstanding and permanent value. Zola, their main defender, had been of all people the first to make this suggestion. Writing in what he had hoped was the decent obscurity of a Russian periodical about the fourth Impressionist exhibition in 1879, he commented:

All the Impressionists are poor technicians. In the arts as well as in literature form alone sustains new ideas and new methods. In order to assert himself as a man of genius, an artist must bring out what is inside himself, otherwise he is no more than a pioneer. The Impressionists, as I see it, are precisely pioneers. For a short time Manet inspired great hopes, but he appears to have exhausted himself by over-hasty production; he is satisfied with approximations; he doesn't study nature with the passion of a true creator. All of these Impressionist artists are too easily satisfied. They woefully neglect the solidity of works over which they have pondered for a long time. And for this reason it is to be feared that they are merely preparing the way for the great artist of the future, whom everybody is expecting.

Unfortunately, *Figaro* got hold of the piece and published a translation under the heading 'M. Zola has broken with Manet'. After profuse apologies from Zola to Manet, the affair was smoothed over, but worse was to follow.

After the publication of his immensely popular novel *Nana* in the same year that his criticism of the Impressionists appeared, Zola had become one of the most widely read authors in France. Working on his great chronicle of French life under the Second Empire, the Rougon-Macquart series, by the beginning of the 1880s he had started approaching a subject with which he was familiar, and which had always been popular, the art life of Paris. When in 1882 Paul Alexis wrote a book on Zola, based on his own notes and conversation, he outlined the writer's plans, referring especially to a book

for which the documentation will be less difficult; the novel he plans to write on art. Here he need only recall what he saw in our circle and experienced himself. His chief character is all ready; this painter, captivated by the modern ideal of beauty, who appears briefly in *Le ventre de Paris* (1873), is Claude Lantier. Zola's purpose is to describe in this novel his years in Provence. I know that in Claude Lantier he plans to study the dreadful psychology of artistic impotence. Around the central man of genius, the sublime dreamer whose production is paralysed by an infirmity, other artists will gravitate, painters, sculptors,

musicians, men of letters, a whole band of ambitious young men, who have also come to conquer Paris, some of them failures, others more or less successful; all of them cases of the sickness of art, varieties of the great contemporary neurosis. Of course Zola in this work will be obliged to use his friends, to assemble their most typical traits.

Alexis's prognostication was all too correct. The novel, *L'Oeuvre* ('The masterpiece'), published in 1886, revolves round a painter and a writer, both of whom fail to achieve the real artistic success which they desire and which is expected of them. In despair the painter Claude Lantier commits suicide. In depicting him Zola drew on two main sources: himself, preoccupied as he was with a sense of frustration at never being the writer he really wanted to be and tormented by occasional bouts of creative sterility; but, much more evidently, he based the character on his friend Cézanne. In fact, in his preliminary notes he frequently revealed the fact by calling his hero 'Paul' instead of 'Claude':

Not to forget Paul's despair; he always thought he was rediscovering painting. Complete discouragement; once ready to give up everything; then a masterpiece, nothing but a sketch rapidly done, which rescues him from complete discouragement. The question is to know what makes him powerless to satisfy himself; it is in fact he himself, primarily his physiognomy, his parentage, his eye trouble; but I would also like to attribute it partly to our modern art, or our feverish desire to want to do everything, our impatient overthrowing of traditions, in a word our lack of equilibrium. What satisfies G [Guillemet?] does not satisfy him; he goes further ahead and spoils everything. It is incomplete genius, without full realization. He lacks very little; he is a bit hit-and-miss due to his physical make-up, and I add that he had produced some marvellous things, a Manet, a dramatized Cézanne, nearer to Cézanne.

A little later he tried to disentangle the autobiographical elements:

In Claude Lantier I wish to paint the artist's struggle against nature, the creative effort in the work of art; an effort of blood and flesh to incarnate something, always wrestling with the truth and always beaten; the battle with the daemon. In short, I shall relate my intimate life as a creative artist, wrestling with the truth and always beaten, this perpetual and painful childbirth, but I shall enlarge the subject and dramatize it through Claude, who is never satisfied, who is tormented by his inability to give birth to his own genius, and who at the end kills himself before his unfulfilled work. He will not be an impotent artist, but a creator with too great an ambition who wants to put all nature on a single canvas, and who dies in the attempt.

But the general public was not aware of these creative niceties. They – and more of them were likely to read a novel than to peruse serious art criticism – saw in Claude Lantier a typical Impressionist painter, and concluded that the writer who had done so much to defend the movement had now turned against it. The Impressionists themselves and their supporters were dismayed. Monet, in a letter to Zola, was most explicit:

I have always had great pleasure in reading your books, and this one interests me doubly because it raises questions of art, for which we have been fighting for such a long time. I have read it, and I remain troubled, disturbed, I must admit. You have obviously intentionally taken pains that not one of your characters should resemble any of us, but in spite of that I am afraid that the press and the public, our enemies, may use the name of Manet, or at least of our friends, to prove us to be failures, something which is not in your mind – I refuse to believe it. Excuse me for telling you this. It is not a criticism; I have read *L'Oeuvre* with great pleasure, discovering old memories on every page. You know in any case

my fanatical admiration for your talent. It has nothing to do with that, but I have been struggling fairly long, and I am afraid that just at the moment I am starting to succeed, our enemies may make use of your book to deal us a knock-out blow.

Guillemet thought it a 'depressing book' and added, 'Let us hope, please God, that the little gang [the Impressionists] as Madame Zola calls it, do not try to recognize themselves in your uninteresting heroes, for they are evil into the bargain.'

Of course they did, but since in the novel Claude Lantier had been the leader of a group of revolutionary painters, most people thought for a long time that he had been based on Manet, and it was only gradually that his identification with Cézanne emerged. The painter himself wrote a brief letter to Zola on 4 April 1886 thanking him for a copy of the book, but making no comment on it. It was the last letter of a correspondence which had started 26 years earlier. Neither Monet, Renoir nor Pissarro were to have any real contact with Zola again.

Apart from the aesthetic judgement involved in Zola's view of Claude Lantier, it is difficult not to wonder how far his portrayal of the personality of what was meant to be a typical Impressionist artist was justified. There can be little doubt that their lives were far from being as radiantly happy as their paintings so frequently suggest. Degas, who for most of his life was convinced that he was going blind, was a constant prey to despair. When he had reached the age of 50 he looked upon himself as an old man. On 14 August 1884 he wrote to his friend Henry Lerolle, apologizing for not having thanked him for a box of sugared almonds, and went on to say:

If you were unmarried, 50 years of age, you would know similar moments when a door shuts inside one, and not only on one's friends. One suppresses everything around one, and once all alone, one finally kills oneself out of disgust. I have made too many plans. here I am blocked, impotent. And then I have lost the thread of things. I thought there would always be enough time. Whatever I was doing. whatever I was prevented from doing, in the midst of all my enemies, and in spite of my infirmity of sight, I never despaired of getting down to it some day.

I stored up all my plans in a cupboard, and always carried the key on me. I have lost that key. In a word, I am incapable of throwing off that state of coma into which I have fallen. I shall keep busy, as people say who do nothing, and that is all.

His latter years were especially miserable, his only pleasure wandering through the streets of Paris, and when Renoir heard of his death in September 1917 he commented, 'It is indeed the best for him. Every imaginable kind of death would be better than to live as he was living.'

Renoir himself did not find painting all that fulfilling or easy, despite appearances. In the summer of 1892, for instance, he wrote to Berthe Morisot from Brittany:

I have ended up at Pornic, where I'm teaching my boy to swim. All's well in that quarter, but I've got to get down to some landscapes. The country here is so pleasant, and that puts me in a great rage with myself. I find landscapes more and more of an ordeal, especially as I feel duty-bound to do them. It's the only way to keep one's hand in practice. But to take up my stand out there like a performing animal is something I can't stomach any more.

He was beginning to have physical problems too. In 1897, when learning to ride a bicycle, he fell off and broke his arm; a few years later he had the first attack of that

321 Degas photographed in the boulevard de Clichy.

rheumatoid arthritis which crippled his arms and legs and after 1911 confined him to a wheelchair, from which he could paint only with his brushes strapped to his hands.

Berthe Morisot's own letters to her family and friends are replete with complaints about the difficulties of painting, and alternate between bursts of praise for what she had done, and anxious dubieties about whether she should ever actually have become a painter. Despite his seeming self-confidence and his prolific output, Monet's canvases reveal, sometimes to the naked eye, sometimes through X-ray examination, the constant changes which he kept making to them, an obvious sign of dissatisfaction. In 1893 he wrote from Rouen to Geffroy, 'I tell myself that anyone who says he has finished a canvas is terribly arrogant. Finished means complete, perfect, and I toil away without making any progress, searching, fumbling around without achieving anything much.' His letters to his wife contain phrases such as 'I'm very unhappy, really miserable, and I haven't the heart to do anything; the painter in me is dead, a sick mind is all that remains of me' and, when he was doing the Rouen cathedral paintings (Plate 337):

I'm working away like a madman, but alas all your words are in vain, and I feel empty and good for nothing...What's the good of working when I don't get to the end of anything? This evening I wanted to compare what I'd done with the old paintings, which I don't like looking at too much in case I fall into the old errors. Well, the result of this was I was right to be unhappy last year; they're ghastly, and what I'm doing now is just as bad, but bad in a different way, that's all.

Pissarro did not suffer from quite such wracking doubts and uncertainties, though his letters to his son Lucien reveal day-to-day troubles of a more practical kind.

Ever since he had had corneal ulcers at the age of eight, Pissarro had been plagued with eye problems, and these became acute in the 1890s, making it impossible for him to paint out of doors. Although it may well be coincidence, it is worth recording that in the 1880s, as a result of starting to wear the appropriate glasses, Zola's eyesight — he was afflicted with myopia and astigmatism — improved dramatically, at the very moment when he started to become highly critical of Impressionism. Although the

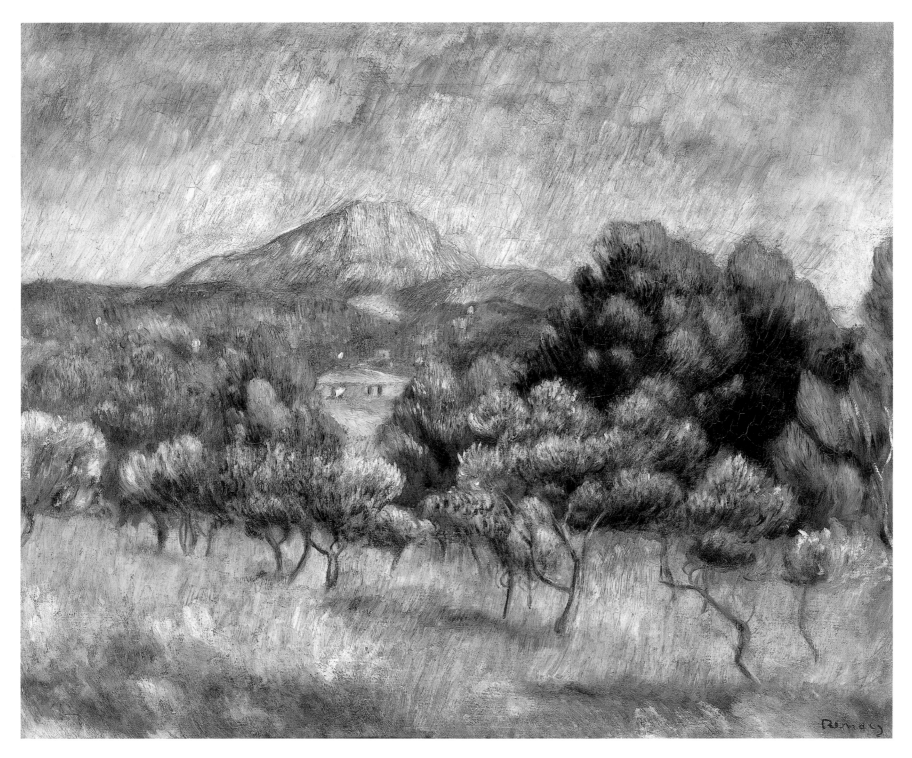

322 PIERRE-AUGUSTE RENOIR *Mont Sainte-Victoire* 1889

influence of physical defects on the work of creative artists is debatable it cannot be disregarded, and it is an undisputed fact that five of the Impressionists were myopic to varying degrees. Although he does not reveal the fact in his self-portraits, Degas, who was always frightened of going blind and was rejected from the army in 1870 because of poor sight, nearly always wore glasses, and in about 1893 was prescribed spectacles that entirely covered the right eye and left only a small slit on the left lens. This may well explain his use of photographs, which he could more easily bring within his limited focal range, and his interest in the tangible, as opposed to visual, qualities of sculpture (Rodin also was myopic). It may also have had something to do with his fondness for pastel, the manipulation of which allowed closer proximity to the working surface than oil painting did. With myopia objects beyond the limit of the natural focus of vision become 'peripheral' – i.e. similar to that which a normally-sighted person sees out of the corner of his eye, with a loss of detail except for basic outline and colour. This may well explain certain aspects of the paintings of Monet, whose myopia was related to the

323 Photograph of Renoir, his wife Aline and son Claude in 1912.

cataracts which he developed in his sixties. Cézanne, too, suffered from the same defect, aggravated by the retinal damage he must have suffered as a result of diabetes. He always refused to wear glasses.[1]

Renoir presents an even more interesting example of the influence of eyesight problems on artists. According to Vollard he used to step away from a picture to get it out of the range of his clear vision, and so simplify its contours. It is also obvious that, as he grew older, the amount of red and orange in his paintings noticeably increased. This had already been remarked in the work of several painters such as Turner, Mulready, and Antonio Verrio, whose later paintings at Hampton Court have been described by Edward Croft-Murray as possessing a surfeit of ill-assorted pink colours. Cataracts begin to form in the eye at varying rates with age. In addition to a general blurring of vision, they absorb mostly the shorter spectral wavelengths, starting with violet and blue, and may end in allowing only the red rays to reach the retina, thus creating what seems to be a rose-tinted world. This clearly happened to Renoir and also, to a lesser extent, to Monet, whose whites and greens became increasingly yellowish, and whose blues became more purple after about 1905. His cataracts led to temporary blindness, but when they were removed in 1923 the effect was such that he became preoccupied with touching up his most recent works to make them accord with his newly-restored colour sense.

Cézanne obviously was involved in a lifelong struggle with his attempts to achieve the kind of art he knew was right for him. When he left Paris after a short stay in 1895 he wrote to Monet about the portrait he was doing of Gustave Geffroy, 'I was forced to abandon for the time being the study I've been doing at Geffroy's, who generously made himself available to me, and I am somewhat distraught at the meagre results I obtained, especially after so many sittings and such alternating enthusiasms and disappointments.' These alternations were part of his life. His whole character, however, seems to have been complicated by his diabetes which he suffered for a considerable part of his life and which made him irascible and moody. Joachim Gasquet, the son of one of the painter's childhood friends, who published in 1921 a

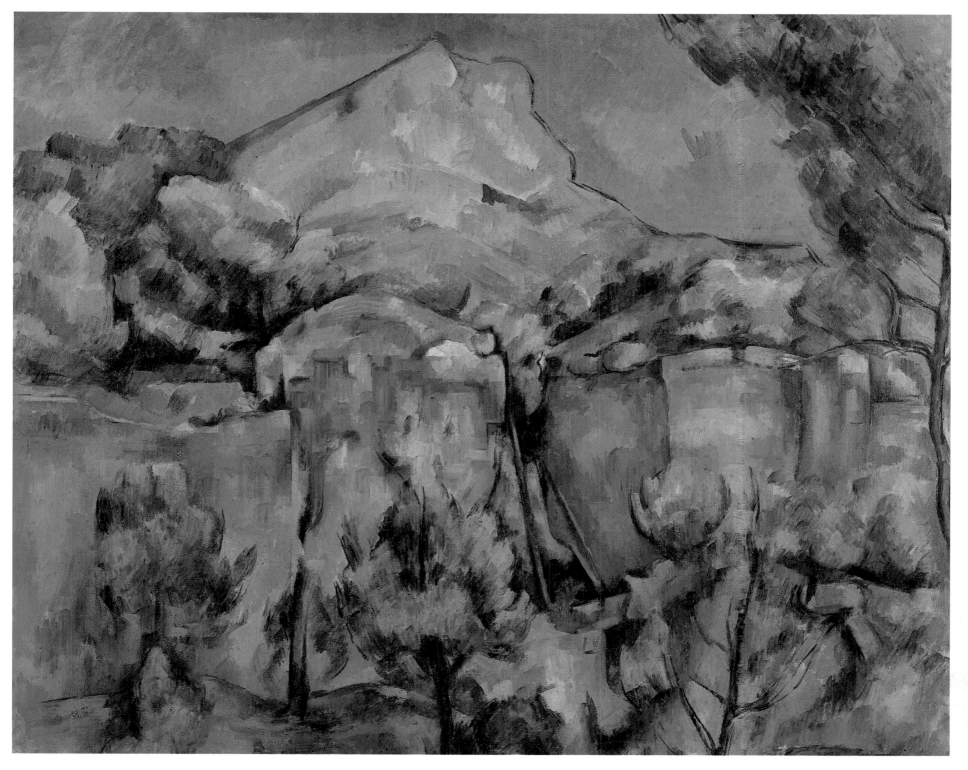

524 PAUL CEZANNE *Mont Sainte-Victoire seen from the Bibémus quarry c.* 1897

book of largely imaginary conversations with Cézanne, described people's reactions to him in the 1890s:

Those who saw him at that time described him to me as frightening, full of hallucinations, almost bestial in a kind of suffering divinity. He changed models each week. He was in despair because he could not satisfy himself. He suffered from those combinations of violence and timidity, of humility and pride, of doubts and dogmatic assertions which shook him all his life. He shut himself up for weeks, not wanting a living soul to enter his studio, shunning all his acquaintances.

According to a letter Pissarro wrote to his wife in 1895 he had been told by a mutual friend that Cézanne fell into fits of rage against his former friends, saying, 'Pissarro is an old animal, Monet a sly dog, they've not got one amongst them who can produce a real red'. Yet on other occasions he could be warmly enthusiastic about them, especially Pissarro, whom he always claimed as his master. The irony is that when Matisse went to see his widow she dealt his reputation the greatest blow of all, explaining to his young admirer, 'You know Cézanne didn't understand what he was doing. He didn't know how to finish his pictures. Renoir and Monet, they knew their craft as painters.'

It might have seemed so at the time. When one compares Renoir's *Mont Sainte-Victoire* of 1889 (Plate 322) with one of Cézanne's many views of the mountain painted in 1897 (Plate 324), however, it is easy to see what she meant, but impossible to comprehend why she said it. Renoir's painting has an air of delicious impermanence, it is a fugitive vision seen on a hot afternoon, shimmering in the heat, almost melting into the banks of white and pink clouds which echo its shape. The clumps of trees are so heavily marked by the rotund brushwork that one expects to find a bather

cavorting in the sunlit grass, which still exemplifies in its flickering light and colour the very essence of those impulses which Impressionism first embodied. Cézanne's mountain, however, is an object, independent of time, awesome in its implacable permanence, its solidity, emphasized by the interplay on planes and lines in the landscape which frames it. The same kind of contrast exists between the two great bathing scenes which both Renoir and Cézanne produced, the one (Plate 325), for all its comparative austerity of line in contrast to Renoir's earlier and later works, a rich indulgence in visual hedonism; the other (Plate 326) built rather than painted, like some cathedral. The human bodies are here stripped of personal identity to fulfil a function within a greater design, which he explained in general terms to Emile Bernard:

Put everything in proper perspective, so that each side of an object or a plane is directed to a central point. Lines parallel to the horizon give breadth – that is a section of nature. Lines perpendicular to this horizon give depth. But nature, for us men, is more depth than surface, hence the necessity of introducing in our vibrations of light, represented by reds and yellows, a sufficient quantity of blue to give the feeling of air.[2]

It is significant that he speaks of the 'feeling' of air; he was concerned not at all with that envelope of light and atmosphere which was the major preoccupation of Monet, Sisley and the other Impressionists. Already one is beginning to hear premonitions of both Expressionism and Cubism sounding in the late nineteenth century.

His attitudes to the human figure were not always so clinical, as works like *The card-players* (Plate 327) and other pictures of local workers painted in the 1890s so clearly show. In these paintings there is apparent the influence of

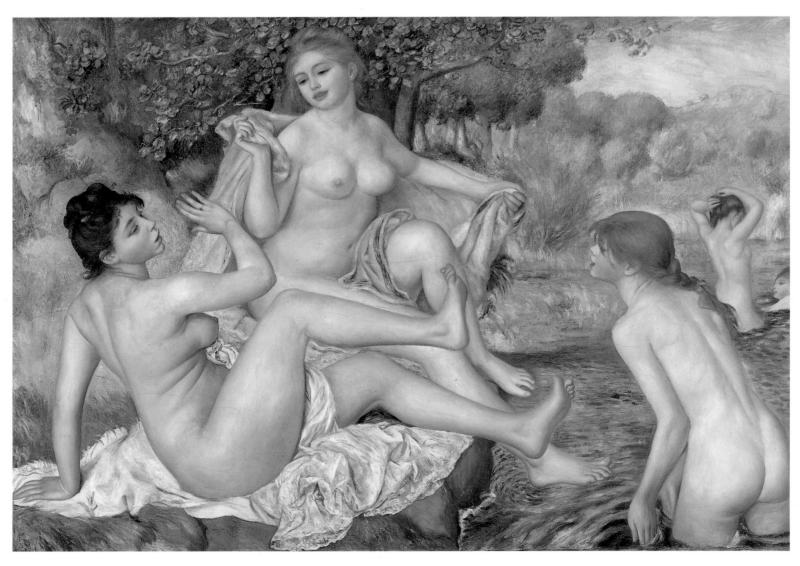

525 PIERRE-AUGUSTE RENOIR *Large bathers* 1887

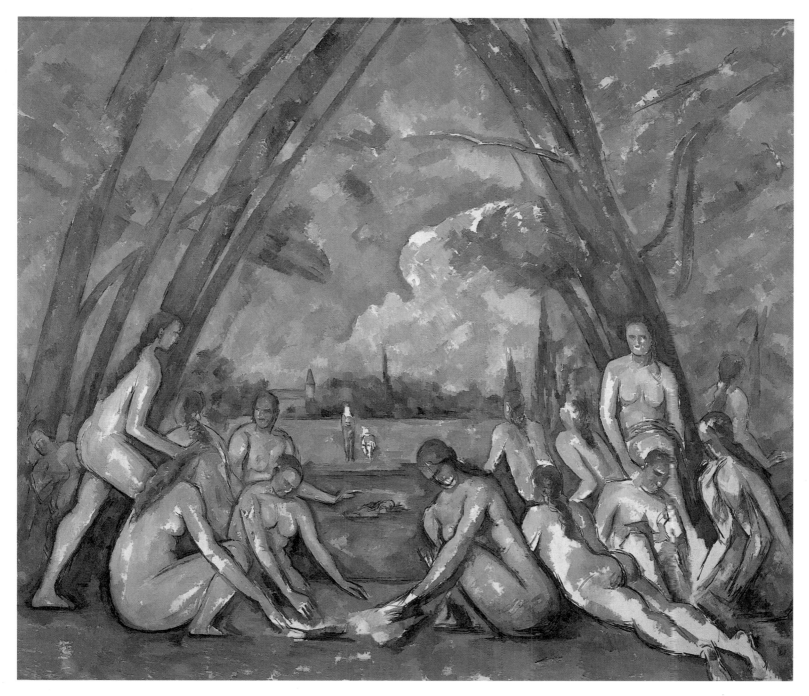

326 PAUL CÉZANNE *Large bathers* 1906

those recently rehabilitated early 'social realists', the seventeenth-century Le Nain brothers, whom he so much admired. It is difficult to decide what painters of the past really influenced him. He was apt to claim descent from many, including Poussin, Rubens, Chardin and Delacroix. In the latter's studio in the rue Fürstemberg he wanted to paint an 'Apotheosis' in which the Master would appear surrounded by Pissarro, Monet, Chocquet and, of course, Cézanne himself. His contact with a consistent reality was always at best precarious.

The connexion with Chardin is, of course, undeniable. Cézanne rehabilitated still life, which in the past two centuries had tended, apart from the works of Chardin himself, to get side-tracked into trivial decoration. To Cézanne it was a major art-form. It is significant that it was to retain this position for at least another half-century, dominating, for instance, the output of the Cubists, who were, in any case, his most devoted disciples. He seemed to transform the trivia of domestic life, onions, a bottle, a dish-cloth arranged on the altar of the kitchen table (Plate 328) into the cult objects of some arcane rite, heavy with significance. One day a friend described him composing the material for a still life, consisting of a napkin, a glass containing a little red wine and some peaches:

The cloth was very lightly draped upon the table with innate taste. Then Cézanne arranged the fruits, contrasting the tones one against the other, making the complementaries vibrate, the greens against the reds, the yellows against the blues, tipping, turning the fruits as he wanted them to be, using small coins for the purpose. He brought to this task the greatest care and many precautions; one could guess that it was a real feast of the eye for him. When he had finished he remarked, 'The main thing is the modelling; in fact one shouldn't say modelling but modulating.'

It is, of course, difficult always to be clear about what motives impelled him. When in 1904 Emile Bernard went to visit him he found on his easel one of his large bathing scenes:

The drawing seemed to me to be quite deformed. I asked Cézanne why he did not use models for his nudes. He replied that at his age he did not have the right to ask a woman to undress herself so that he could paint her and that, though it would be all right were she 50 or so, it would be impossible to find such a person in Aix. He pointed to some sheets of life drawings which he had pinned up on the wall, which he had done at the Atelier Suisse when he was a student. 'I have always used these drawings,' he said. 'They aren't really good enough but they're all right for somebody of my age.' I realized that he had become the slave of extreme conventionalism, and that this slavery had two reasons: the one that he was diffident in his approach to women; the other that he was the prey to religious scruples, and had a real feeling

that these things just weren't done, especially in a provincial town, without giving cause for scandal. On his studio wall I saw in addition to landscapes and pictures of apples on white plates (what young student today hasn't painted imitations of them?) a photograph of Thomas Couture's *A Roman orgy* and of works by Delacroix, Daumier and Forain. We spoke of Couture[5] and I was surprised to find that he was a great admirer of this painter. He was quite right, of course, I subsequently realized, for Couture was a great master.

Despite a certain amount of soul-searching when he assumed a Pointillist style, Pissarro had no deep anxieties about the nature of his art, which he approached with dogged pertinacity, certain of having found a language of expression which he was always trying to perfect within its own ordered confines. To Louis Le Bail, the young artist who had watched Cézanne 'modulating' his still life, he delivered his opinions in 1896. His words express perfectly

the formula through which the creative impulses of Impressionism had become codified into a syntax of painting capable of being absorbed by anyone:

Look for the kind of nature that suits your temperament. The motif should be observed more for shape and colour than for drawing. There is no need to tighten the form, which can be achieved without that. Precise drawing is dry and hampers the impression of the whole, it destroys all sensations. Do not define too closely the outline of things. It is the brush-stroke of the right value and colour which should produce the drawing. In a mass the greatest difficulty is not to give the contour in detail, but at the same time to paint what is inside it. Paint the essential character of things, try to convey it by any means whatsoever, without bothering about technique. When painting make a choice of subject, see what is lying at the right and the left, then work on everything simultaneously. Don't work bit by bit, but paint everything at once by placing tones everywhere, with brush-strokes of the right colour and value, whilst noticing what is alongside. Use small brush-strokes, and try to put down your perceptions immediately. The eye should not be fixed on one point, but should take in everything, while observing the

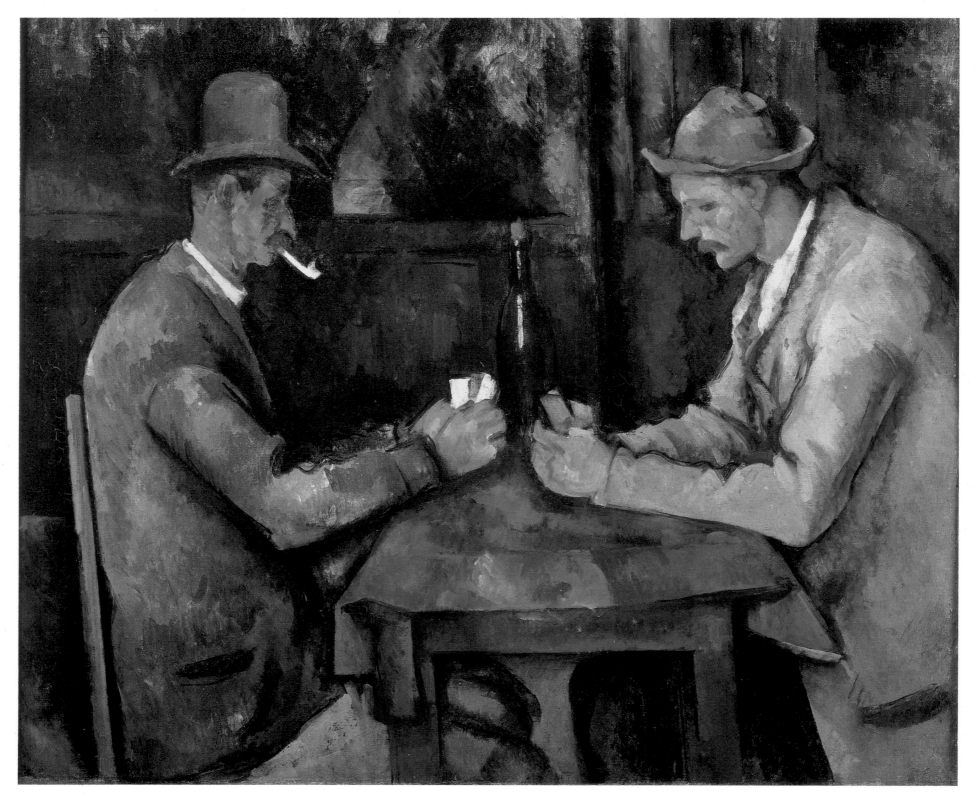

327 PAUL CEZANNE *Card-players* 1898

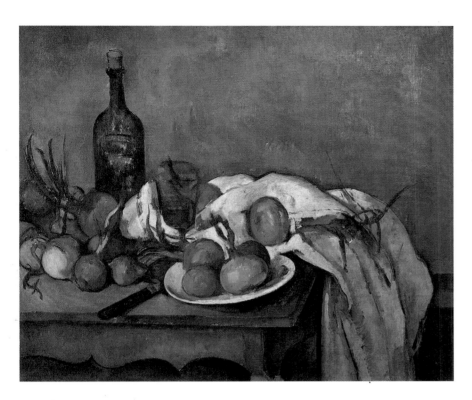

328 PAUL CEZANNE *Still life with onions* 1896

reflections which the colours produce on their surroundings. Work at the same time upon sky, water, branches, ground, keeping everything going on an equal basis, and unceasingly rework until you have got it. Cover the canvas at the first go, then work at it till you can see nothing more to add. Observe the aerial perspective well, from the foreground to the horizon, the reflections of sky, of foliage. Don't be afraid of putting on colour, refine the work little by little. Don't proceed according to rules and principles, but paint what you observe and feel. Paint generously and unhesitatingly, for it is best not to lose the first impression. Don't be timid in front of nature; one must be bold in front of nature at the risk of making mistakes.

Pissarro's flirtation with Pointillism ended with the beginnings of the 1890s and his purchase of his house at Eragny with money lent to him by Monet. At the same time his work became a good deal looser. This is especially apparent in two views of Rouen which he painted in 1896 and 1898 (Plates 330 and 333). It was a city which had pre-occupied him for some 15 years, and came to play in his artistic life the same role which Le Havre had played in that of Monet; indeed *Sunset; port of Rouen* has many resemblances to Monet's seminal painting, whilst the painting of Boieldieu bridge in damp weather, with its lively interpretation of bustle and movement and its evocation of the dampness in the air, harkens back to the earlier paintings of the Parisian boulevards. On the other hand he was never really happy with the human figure, understandably enough since in 1894 he counselled his son Georges, 'You must do the nude like you do the chickens, ducks or geese.' His *Bather in the woods* (Plate 332) has the uneasy feeling of a kind of compromise between Millet's *Goose girl* (Baltimore) and something from the Salon. He was, however, at last achieving recognition and economic security. From 1892 onwards he had regular one-man exhibitions at the galleries of Durand-Ruel, who in December 1893 bought paintings to the value of 23,600 francs from him, and at the Universal Exhibition in Paris in 1900 he had eight works hung in the room devoted to the Impressionists. He was to repay Monet in 1892 and in the following year had the barn at Eragny converted into a studio. His engravings too were now bringing in a considerable income,

and in 1894 two of his etchings were bought by the state.

Le Bail, who clearly spent a good deal of his time as a young man seeking advice from the leading lights of Impressionism, received from Monet precepts less cautious than those proffered by Pissarro: 'One ought to be daring in the face of nature, and never be afraid of painting badly, nor of redoing work with which one is not satisfied, even if it means ruining it. If you don't dare when you are young, what are you going to do later?' Monet himself had no problems about answering that particular question. Not for him the anxious questionings about structure and form which nearly demented Cézanne. He had devised for himself a programme opposed to that of recording the immutable. His was to capture time, to record that dimension which ever since the sixteenth century had fascinated the imagination of Western man, and in the nineteenth century had come to dominate it. He was, at last, in a position to do what he wanted to, without preoccupying himself with producing works which would sell. Ever since his one-man exhibition at Georges Petit's in 1880 his circle of patrons had enlarged. In 1881 his income from Durand-Ruel was 20,000 francs, in addition to the sales he made privately and through other dealers. In 1889 a further increase in his status came when he held an exhibition at Georges Petit's with Rodin, which received wide acclamation. Americans now entered upon the scene in a big way, as a result of Durand-Ruel's New York exhibition in 1886 (see p.296), with beneficent results. In 1887 his total income had reached 44,000 but in 1891 he earned around 100,000 francs from Durand-Ruel and Boussod & Valadon alone. Between 1898 and 1912 it fluctuated around 200,000.

The security for which he had so desperately yearned in his earlier days was at last his and he took every advantage of it, creating for himself an impregnable economic and emotional citadel. It had physical dimensions too. Monet has become more closely associated with a place than perhaps any other painter in history. For 43 years, from 1883, when he originally rented the property from a Norman landowner who had gone to live in the local

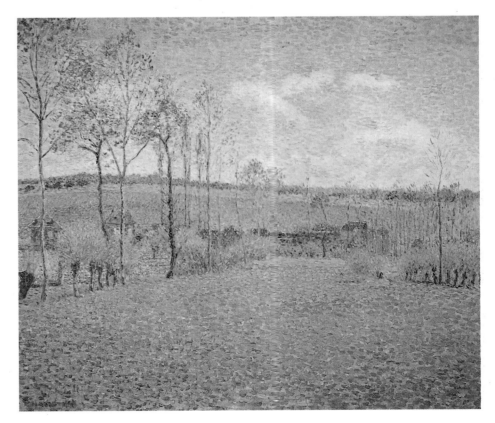

329 CAMILLE PISSARRO *Springtime in Eragny* 1886

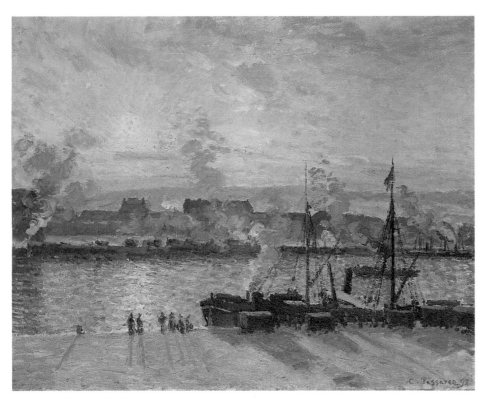

330 CAMILLE PISSARRO *Sunset, port of Rouen* 1898

Van Gogh, Seurat and Gauguin; also those of Vuillard and
Bonnard, both of whom visited him at Giverny. He read
widely, being especially devoted to Michelet's great *Histoire
de France*, which he had known since adolescence and
which fed a strong sense of patriotism underlying much of
his work.[4] At the same time, however, he was an assiduous
reader of contemporary writers such as Flaubert, Ibsen,
the Goncourts, Mallarmé, Tolstoy and Ruskin. He had an
important collection of books on gardening, including the
French translation of George Nicholson's authoritative
Illustrated history of gardening, and the 23 volumes of the
rare and expensive *Flore des serres et des jardins de l'Europe*
illustrated with a wealth of lithographic plates.

He took special pains over his actual surroundings, con-
verting the rather ramshackle Norman house into an ideal
background for his life. Julie Manet, the daughter of
Berthe Morisot and Eugène Manet, who visited it in 1893
shortly after Monet had been making some alterations,
recorded in her charming diary:

The house has changed since last we went to Giverny. M. Monet has
made himself a bedroom above the studio, with big windows, doors and
a floor in pitchpine, decorated in white. In this room lots of paintings
are hung, among them Isabelle combing her hair, Gabrielle at the
basin, Cocotte with a hat on, a pastel of Maman's, a pastel by Uncle
Edouard, a very attractive nude by M. Renoir, some Pissarros, etc.

Madame Monet's bedroom has blue panelling, those of Mlles
Blanche and Germaine are mauve. We didn't see Mlle Marthe's
bedroom. Mlle Blanche showed us some of her own paintings, which
are of a lovely colour, two of them are of trees reflected in the Epte and
are very like M. Monet's. The drawing-room is panelled in violet – lots
of Japanese prints are hung there, as well as in the dining-room, which
is yellow.

village of Vernon, until his death in 1926, he lived at
Giverny, where his house and garden assumed the signifi-
cance for the art world, both then and now, that Assisi
holds for admirers of St Francis. Surrounded by an
adoring gaggle of stepchildren and a loving but cantank-
erous wife, Monet maintained contact with a whole gamut
of friends: from a near neighbour, the redoubtable
Clemenceau who was to be a useful contact with the
establishment, through a whole range of artists, not only
his old colleagues but other more unexpected figures such
as Félicien Rops, Carolus-Duran and Jules Chéret, to
writers such as Guy de Maupassant, Léon Daudet,
Mallarmé and Huysmans. He was a dedicated gourmet,
whose salads were especially popular. He became the
owner of two cars in which he and his family would make
frequent excursions, sometimes with a gastronomic goal –
to buy oysters at Isigny, or consume the famous *tartes* of
the Hôtel Tatin at Lamotte-Beuvron; sometimes to watch
wrestling matches, to which Alice Monet was passionately
addicted; or to show off their best car – a Panhard-
Levassor, with headlamps the size of searchlights – at the
speed trials at Gaillon. On one occasion, seized with a
desire to see the works of Velasquez in the Prado, he
ordered their chauffeur to drive them to Madrid, where
they stayed for three weeks.

He was indeed the most assiduous traveller of all the
Impressionists. Apart from Norway, where his stepson
Jacques lived (see p.382), he made excursions to Venice,
Antibes, Holland, Switzerland and on several occasions to
London. In France he visited Petites-Dalles on the Norman
coast where his brother had a house, Belle-Isle, Noirmou-
tiers, the valley of the Creuse in the Massif Central, and
Rouen where he stayed for several days. From all these
localities he brought back batches of paintings to be
finished off at Giverny. Paris was near enough to allow of
fairly frequent visits to the theatre or the Opéra, where he
saw and enjoyed *Boris Godunov* and later Diaghilev's
Ballets Russes, of which he highly approved. He kept a
keen eye on current exhibitions, noting especially those of

331 Photograph of Clemenceau and Monet at Giverny in about 1912.

These striking colours, with their vague suggestion of a Whistlerian or *art nouveau* influence, were an interesting comment on Monet's taste, and were especially noted by visitors, one of whom observed a carefully arranged bowl of lemons on the window-sill.

The garden at Giverny, however, was even more remarkable, and must in itself be considered not only as an expression of Monet's personality but as an actual artefact. For most of his life he had lived in houses with gardens, especially at Argenteuil and Vétheuil, and he had always produced paintings of them (Plate 175). Moreover, he had been greatly stimulated by Caillebotte, who had a remarkable garden at Petit-Gennevilliers and who corresponded with him frequently about horticultural matters. The times were propitious for gardeners. New plants were constantly being imported into Europe from the Americas and the Far East, and in the 1880s there had been a boom in mail-order seedsmen, opening up an entirely new range of products for those who did not have easy access to nurseries. Monet collected seed catalogues avidly and right from the beginning 'composed' his gardens as he would have done a painting. His notebooks at Argenteuil, for instance, list the colour sequence for seven rows of hollyhocks: purple, white, red, violet, yellow, cream and pink.

When first he arrived at Giverny there was a kind of kitchen garden of the type which most French farmhouses

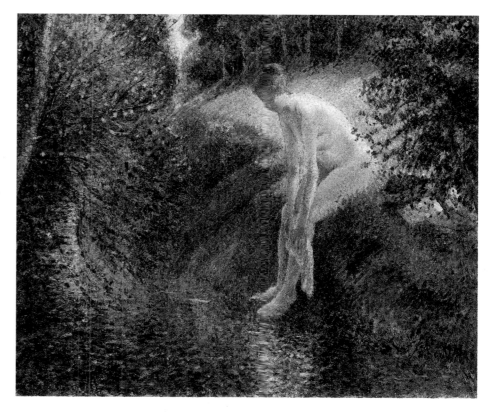

532 CAMILLE PISSARRO *Bather in the woods* 1895

533 CAMILLE PISSARRO *Rouen, Pont Boieldieu; damp weather* 1896
Eugène Murer, the enthusiastic patron of the Impressionists, had opened an hotel in Rouen and both Gauguin and Pissarro visited it. The latter became very interested in the place, and produced a large number of paintings and lithographs of the city.

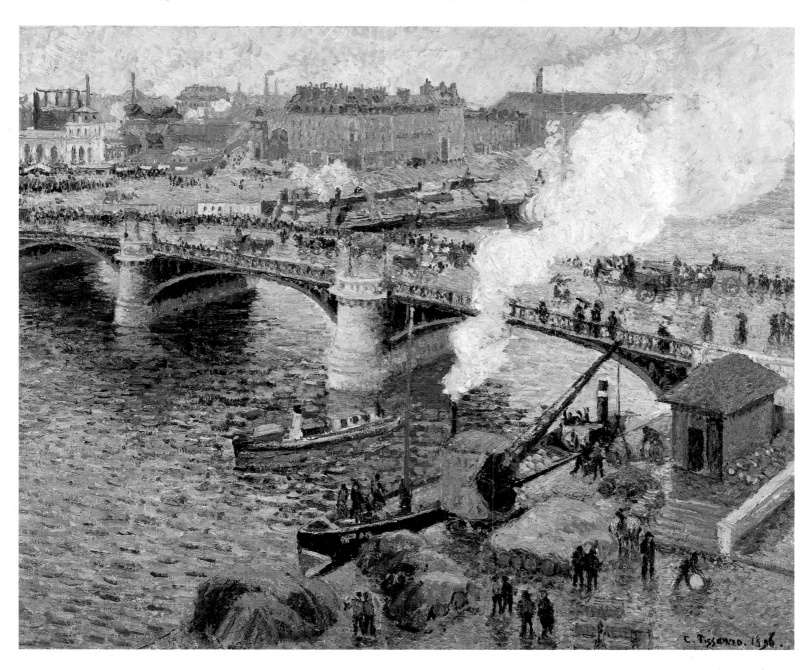

have. He set about transforming it immediately, first of all adopting a predominantly geometric pattern and using 'cottage garden' flowers, hollyhocks, dahlias, roses, nasturtiums and gladioli, arranging them to grow in sequence so that there would be some kind of floral display for most of the year. The whole garden, part of it on the other side of the road, covered some two acres. Nearby was a small pond, which with its adjoining land he purchased in 1893; he obtained the reluctant permission of the local authorities to convert it into a water garden by diverting into it through a series of sluices water from the nearby river Epte. He built a pond surrounded by a variety of flowers and bushes, some native, such as raspberry bushes, peonies, holly trees and poplars; some exotic, such as Japanese cherry, and pink and white anemones. There was an obvious intention to contrast the two gardens. That around the house still retained the traditional French formal pattern, with creeper-covered walkways, paths at rigid angles to each other, and flights of steps leading from one element of the garden to another. That on the other side of the road, however, which centred around the pond and its feeder stream, was deliberately exotic and romantic at the same time. In its arrangement he had the advice of a Japanese gardener who came and stayed at Giverny for some time, and scattered amongst the more homely vegetation were ginkgo trees, Japanese fruit trees, bamboos and a Japanese bridge, which seemed to leap straight out of a print by Hokusai. Water-lilies floated on the water, and the paths through the garden twisted and turned with sinuous complexity.

'My most beautiful work of art is my garden,' Monet was reported as saying, and his contemporaries agreed with him. Proust had a clear image of it:

A garden less of the old florist garden, than a colourist garden, if I may use that word, of flowers arranged as a unity which is not one created by nature, since they have been planted in such a way that only flowers with matching shades will bloom together, harmoniously in an infinite expanse of blue or pink.

Curiously enough, although he had told the Clermont-Tonnerres, with whom he had been staying on a visit to Normandy in 1907, that he was going there, it is doubtful whether Proust actually ever did. Octave Mirbeau, however, a writer and critic never economical with his epithets, gave the place his full treatment:

In spring against a background of flowering orchards, the irises raise their strange curling petals, frilled with white, mauve, lilac, yellow and blue, streaked with brown stripes and crimson purple markings. In summer on either side of the sandy path nasturtiums of every colour and saffron-coloured Californian poppies collapse into dazzling heaps. The surprising fairy-tale magic of the poppies rises on the wide flower-beds, covering the withered irises. It is a remarkable combination of colours, a riot of pale tints, a resplendent symphony of white, pink, yellow and mauve, set off against a drum-roll of light flesh tints, against which shades of orange explode, fanfares of blazing copper break out, reds bleed and flare, violets disport themselves, blacks and purples are licked with flame.

Monet claimed that he spent most of his income on his garden, and the statement was only a modest exaggeration. He employed a gardener and five assistants and was

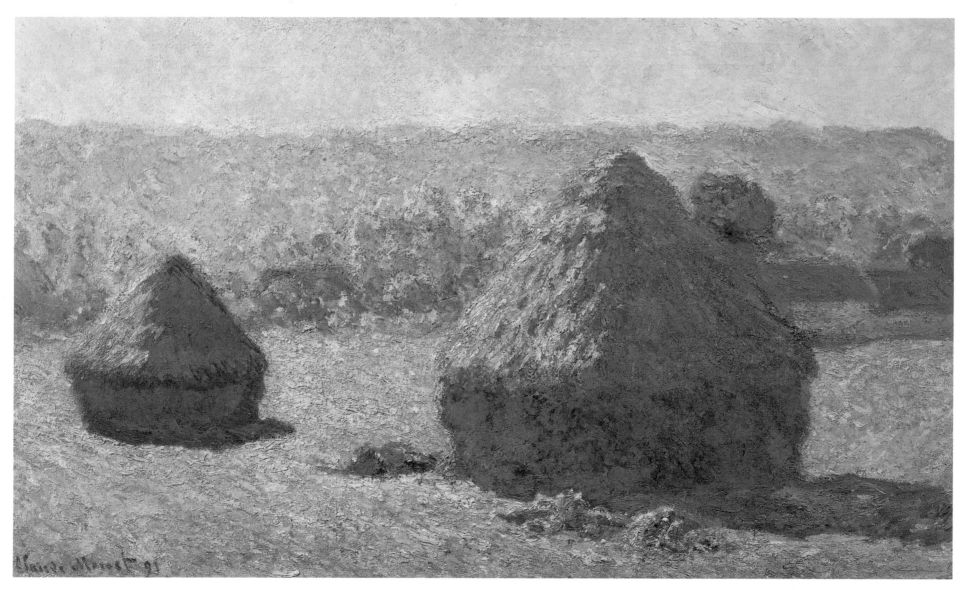

334 CLAUDE MONET *Haystacks: end of summer* 1890/1

342

constantly carrying out improvements and extensions. He gave a lot of thought to the very minutiae too. On the eve of a visit to London in 1900 he left the following instructions for the staff:

Sowing: around 300 pots of poppies – 60 sweet peas, around 60 pots white Agrimony – 30 yellow Agrimony – Blue Sage, Blue Waterlilies in beds (in the greenhouse) – dahlias, iris Kaempferi. From the 15th to the 25th lay the dahlias down to root. Plant out those with shoots before I get back. Don't forget the lily bulbs – Should the Japanese peonies arrive, plant them immediately if weather permits, taking care initially to protect the buds from the cold as well as from the heat of the sun. Get down to pruning; rose trees not too long except for the thorny varieties. In March sow the grass seeds, plant out the small nasturtiums, keep a close eye on the gloxinias, orchids, etc. in the greenhouse, as well as in the frames.

When applying for permission to the local Préfet to make the alterations involved in creating the pond, Monet had said that they were necessary 'for the pleasure of the eye, and for motifs to paint'. In fact Giverny and its gardens not only provided him with motifs to paint; they gave him a kind of base from which to carry out a project which was to be the greatest undertaking of his life, and which would culminate in this garden.

Ever since the Renaissance the Western world had been becoming preoccupied with time. In medieval man's perspective of eternity there was little concept of the passage of time: Julius Caesar, for instance, was seen as dressed in the same clothes and speaking the same language as himself. The day was measured by the liturgical hours; clocks were rare; even by the fourteenth century there were fewer than ten public clocks in the whole of Britain. But the very machinery of timepieces, as it was perfected by Swiss and German craftsmen, came to create mechanization. When the power of the steam engine was harnessed to machines, the inexorable demands of industrialization imposed on people the necessity of conforming to a timetable. By the 1820s public clocks had started to proliferate and had become the central features of most towns and cities. Personal watches became commonplace, and proverbs such as 'time is money' or 'a stitch in time saves nine' part of vernacular wisdom. Time had become a dimension of life, and that study of life in its context which is known as history was transformed from an inaccurate collection of ramshackle anecdotes into something halfway between an art and a science. Producing memorable figures such as Macaulay, Froude, Michelet, Ranke, Mommsen and others, it powered the writings of romantic novelists such as Dumas, Scott and Hugo. It fuelled as well the two most influential thought structures of the time, Darwinism and Marxism, both of which based their conclusions about the nature of man and of his behaviour on observation of the patterns of the past.

This awareness of time led to a concern amongst artists as well as scientists to record the passage of time and freeze the transitory into static and comprehensible imagery. Early in the century Constable had been recording the changing movements and configurations of clouds in carefully documented sketches, and Turner had similar concerns with the effects of time. In 1809, for instance, he exhibited at the Royal Academy two views of Tabley House

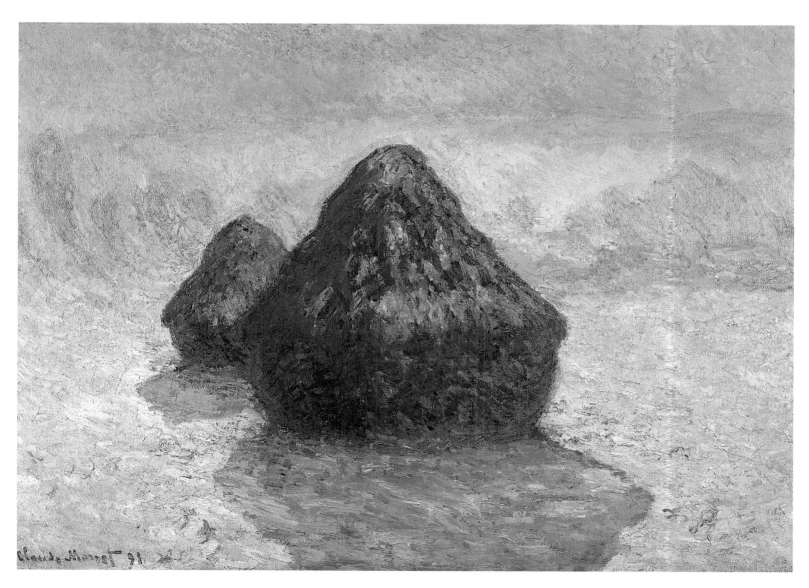

335 CLAUDE MONET *Haystacks: snow effect* 1891

at different hours of the day. Théodore Rousseau emphasized to the critic Philippe Burty the extent to which 'the varying light of day changes the physiognomy of a landscape', and painted several identical views of the forest of Fontainebleau at differing times of the day. In the meantime, however, the camera had arrived, with its peculiarly objective ability to perpetuate a moment in time, a discovery which had a great influence on many painters, including the Impressionists. This was to lead to further developments, all intended to reactivate that static image, first of all by a repetition of hand-drawn images – the *bande dessinée*, the ancestor of the strip cartoon, first made its appearance in France in 1860 – and then, by way of Muybridge's researches (see p.288), which so influenced Degas, to the cinema which seemed the final solution to halting the passage of time, and storing the past for the delectation of the future.

In the quest to endow Impressionism with a function deeper than the mere observation of nature, Cézanne was seeking to give objects and places a kind of monumentality which enhanced their reality, and brought them close to what he called 'the art of museums'. Monet, impelled by the same general ambitions, now that he had won freedom from the necessity of producing paintings primarily to sell,

embarked on an ambitious programme to place objects and places in their temporal perspective. In 1890, the year in which he was able to buy the house at Giverny, he started off on the realization of this idea, which had been latent in his earlier work. Already there had been the influence of Courbet, whose one-man exhibition in 1867 contained 13 pictures of roughly the same expanse of the Normandy coast, and of Jongkind, who often painted versions of the same subject (such as Notre-Dame) seen in different lights. Then there was the example of Japanese artists such as Hokusai, many of whose differing views of Mount Fuji were in Manet's own collection, as well as a pair of prints by Hiroshige of *The Isle of Tsukuda* in which the same block was used to produce a daytime and a night-time view of the same place by altering the inking.

Monet had always been obsessed by finding suitable sites to paint. In 1884, for instance, when he was in Bordighera, he wrote:

I climb up, go down again, and then climb up once more; between all my studies as a relaxation I explore every footpath, always curious to find something new... The motifs are very hard to get hold of, to place on the canvas; it's all so thickly wooded. One can walk indefinitely beneath the palms, the orange and the lemon trees, and the admirable olive trees, but it is very difficult when one is looking for motifs. I would

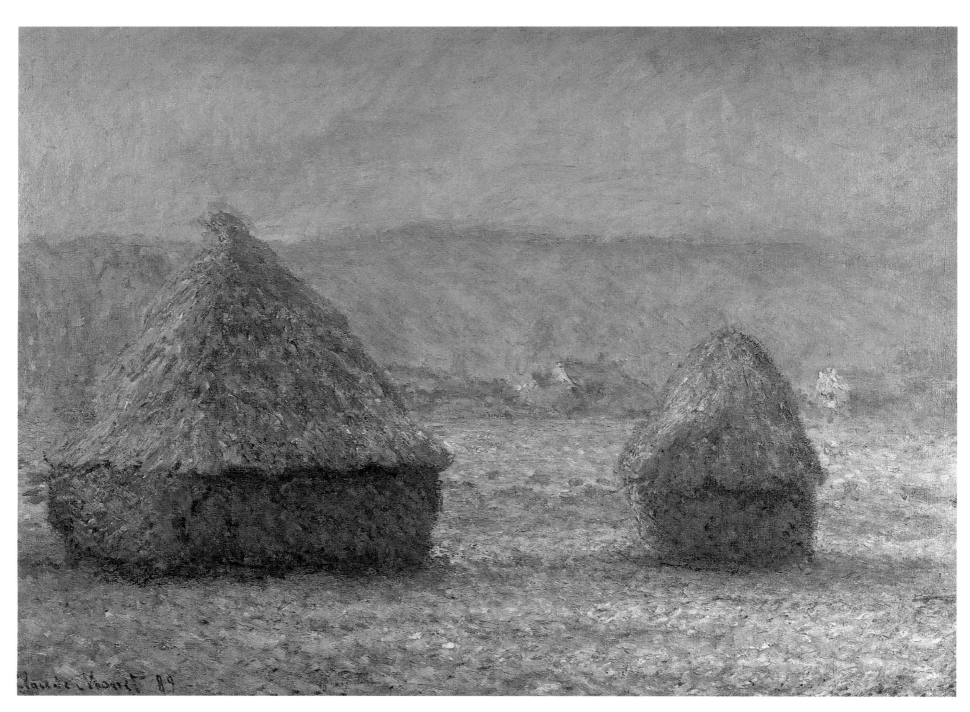

336 CLAUDE MONET *Haystacks: hoar frost* 1889

love to do orange and lemon trees silhouetted against the blue sea, but I cannot find them the way I want them.

He even seems to have consulted a guidebook written by Charles Garnier, the architect of the Paris Opéra, entitled *Les motifs artistiques de Bordighera*. The inevitable result was that right from the start, when he had found a suitable subject, he exploited it to the full. This was true of the harbour at Le Havre back in the early 1870s; the fact that he had done so many views of it was what prompted him to call one of them *Impression* (see p.11). It was true of Vétheuil, of Argenteuil, where he concentrated especially on the railway bridge, of the cliffs at Etretat, and of the Gare Saint-Lazare.

It was therefore almost inevitable that he should progress to recording the effects that the differing times of day had on any favourite site, and this became increasingly attractive to him once he had at Giverny a settled viewpoint from which he could pick an endless supply of 'motifs'. It is significant that this became a deliberate policy in 1890, the year in which he bought the freehold of the place. His first essay was a series of views of his poppy field, which Clemenceau described him painting 'at four different easels, on which in turn he gave a vigorous stroke of the brush as the light changed'. This led to the first group of his 'Series' paintings, which were to dominate the rest of his life and maintain the continuation of the original Impressionist impulse into the next century. On 7 October 1890 he wrote to Geffroy:

I'm hard at it working away stubbornly on a series of different effects, but at this time of the year the sun sets so suddenly that it's impossible to keep up with it. I'm getting so slow in my work that it makes me despair, but the further I get, the more I see that a lot of work has to be done in order to produce what I'm looking for, 'instantaneity', the 'envelope' above all, the same light diffused over everything, and more than ever I'm disgusted by easy things that come easily at the first attempt. Anyway I'm increasingly obsessed by the need to express what I experience, and I'm praying that I'll have a few more good years left to me, because I think that I can make some progress in that direction.

The subject of these 'different effects' was a number of haystacks situated in a field just west of the house at Giverny, as seen from a spot near the wall of his own garden. There are various, sometimes contradictory, accounts of how he became so interested in producing a linked series of views of them in different lights and at different times of the day. According to one account, 'Monet felt that his cycle of Hay Stacks was due to a chance circumstance. He tells how one day, attracted by the opulence of a beautiful stack in the plain of Giverny, he had come with the stepdaughter to make a study of it, and at the time had no intention of multiplying his observations of the theme', and was then beguiled into painting the changes in its appearance effected by the passage of time. Another version dates Monet's decision to an earlier experience when he was painting the church at nearby Vernon, in the sun and early morning mist, 'I felt that it would not be trivial to study a single subject at different hours of the day, and to note the effects of light which, from one hour to the next, modified so noticeably the appearance and colouring of the building. For the time being I did not put the resolution into effect, but it germinated in my mind gradually.' The interesting point

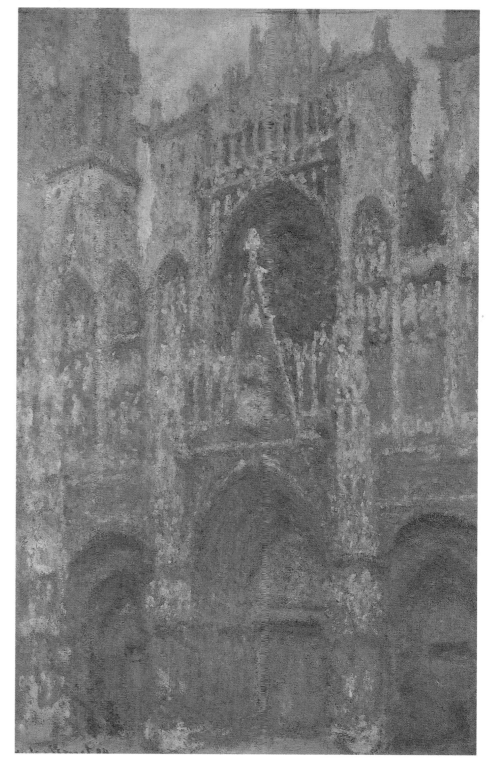

337 CLAUDE MONET *Rouen cathedral* 1892/3

about this particular version is that it gains some credence from the fact that two years later he did precisely this with Rouen cathedral, producing more than 30 paintings of it in a wide variety of differing lights and atmospheres (Plate 337). Whatever the truth of the matter it would seem that although the haystacks impelled him to a more consistent exploration of the relationship between time and appearance, the idea had been nagging away at him for more than a decade.

He went on painting the haystacks, monuments of a rural France, standing some 20 feet high, wrapped in a kind of mysterious solemnity with almost symbolic undertones, until the spring of the following year, eventually producing 30 versions. Their impact, aided by his own astute sense of publicity, was enormous. He sold two to Boussod & Valadon in February and in May Durand-Ruel mounted an exhibition of 15 of them, all of which were sold out at prices between 3,000 and 4,000 francs within three days of the opening. Pissarro lamented:

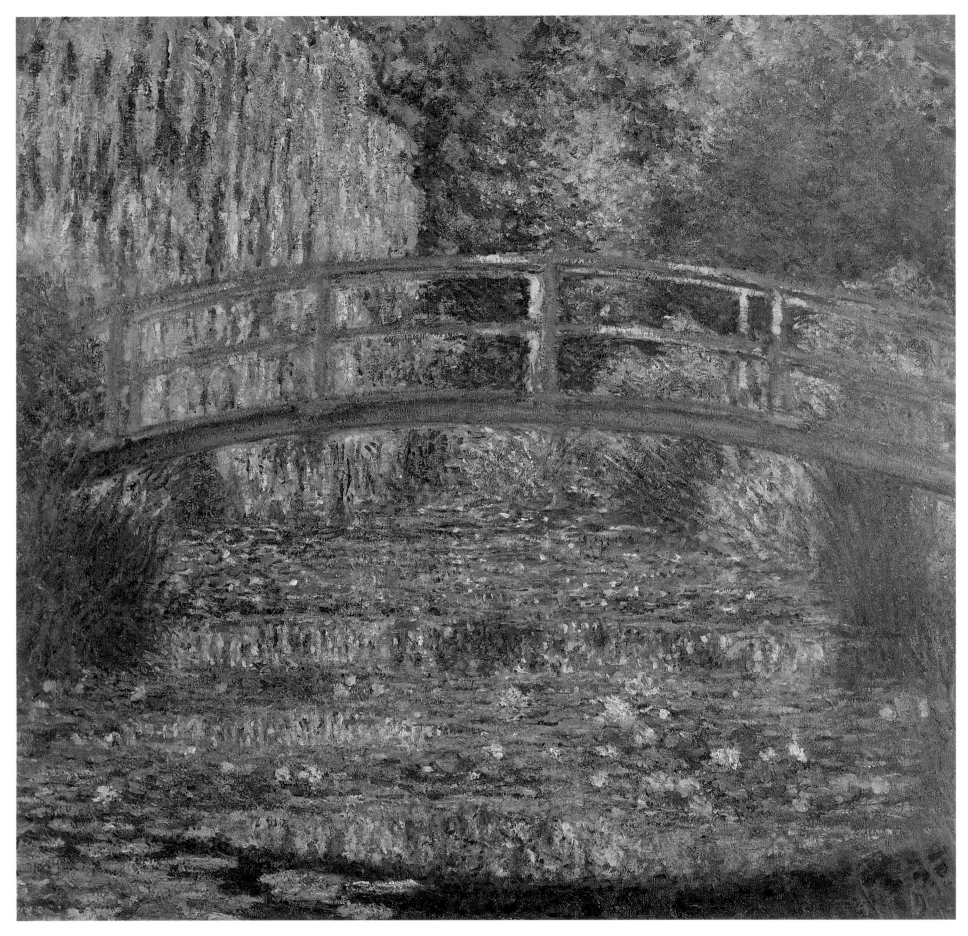

338 CLAUDE MONET *Water-lily pond* 1899

'This is a bad moment for me. Durand doesn't want my paintings. Worst of all, they all want *Haystacks in the setting sun.* Always the same story, whatever he does goes to America at prices of four, five, six thousand francs. Life is hard.' Amongst those who purchased pictures from the exhibition was the American dealer James Sutton (see p.371), who in the previous year had bought Millet's *Angelus* for a record sum of 600,000 francs, and sold it back at a healthy profit to the owners of the Magasins du Louvre for 800,000. The critics were almost uniformly ecstatic. Roger Marx praised Monet's 'acuity of vision,

absolute sincerity and compositional powers', and Gustave Geffroy waxed quite lyrical:

They are transitory objects on which are reflected, as in a mirror, the influences of the environment, atmospheric conditions, random breezes, sudden bursts of light. They are a fulcrum for light and shadow, sun and shade circle about them at a measured pace; they reflect the final warmth of the last rays; they become enveloped in mist, sprinkled in rain, frozen in snow; they are in harmony with the distance, the earth and the sky.

When Octave Mirbeau wrote a special article about them,

the paper in which it appeared sold 20,000 copies and had to be reprinted.

But there was a greater significance to their success. They represented the triumphant acceptance of Impressionism, all the more so in that Monet had maintained the original principles of the movement, and instead of changing his style as Pissarro had done, extended the vocabulary of the movement to embrace new concepts. The sluggish bureaucracy of culture began to react. The city of Pau had acquired a Degas in 1878. In 1889-90 Monet, with enormous energy and application, ably seconded by Sargent, organized a subscription to buy Manet's *Olympia* (Plate 98) for the nation, and exercised great skill in having its acceptance so worded that it would be kept in Paris – first at the Luxembourg and then, when the requisite number of years had elapsed after the artist's death, at the Louvre. It would not, therefore, like so many paintings by artists of whom the establishment disapproved, be relegated to the provinces. Two years later the state bought Renoir's *Young girls at the piano*. Then on 11 March 1894 Renoir himself wrote to Henry Roujon, Directeur des Beaux-Arts, informing him that Gustave Caillebotte, who had recently died, had bequeathed his collection of 76 paintings by Manet, Monet, Renoir, Degas, Sisley and Cézanne to the nation 'on condition that they should go neither to an attic, nor to some provincial museum, but first to the Luxembourg and then to the Louvre' because of their quality. Having initially accepted the bequest, the authorities haggled about fulfilling their undertaking, and after two years eventually agreed to accept 40 of the original 65: eight by Monet, seven each by Degas and Pissarro, six each by Renoir and Sisley, two each by Manet and Cézanne, as well as two by Millet; they were hung in the Luxembourg in 1896. In 1907, when Clemenceau became Prime Minister, Manet's *Olympia* was transferred to the Louvre, and the state bought one of a new series of views of Rouen cathedral which Monet had painted between 1892 and 1894 (Plate 337).

Clemenceau himself had lauded this series when 20 of the 30 views were exhibited in May 1895, writing a front-page article in his newspaper, *La Justice*, in which he called upon the President, Félix Faure, to buy the whole group for the nation:

You are President of the Republic, and the French Republic at that. Why has it not occurred to you to go and look at the work of one of your countrymen on whose account France will be celebrated throughout the world, long after your own name has fallen into oblivion? Remembering that you represent France, perhaps you might consider endowing her with these 20 paintings that together represent a moment for art, a moment for mankind, a revolution without a gun being fired.

This was the supreme irony. Twenty-one years after the exhibition in Nadar's studio had introduced a group of artists whose work was often reviled for its revolutionary nature, for its 'Communism' and its scorn for the great cultural traditions of France, the painter whose work had given the movement its name was being hailed as one of the glories of France. Indeed, in choosing Rouen cathedral as the subject of a series, Monet had shown some degree of acumen in picking a subject with especial appeal to the feeling of defensive patriotism which was very much in the

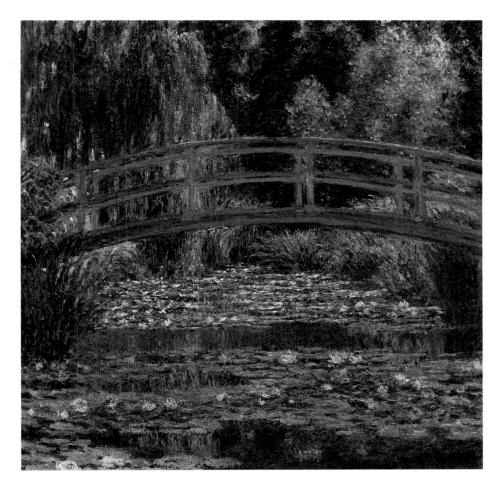

339 CLAUDE MONET *Japanese bridge and water-lily pond* 1899

air at the time. Fanned by the xenophobia and high passions stirred by the Dreyfus case and the posturings of a belligerent Kaiser, this widely felt sentiment had become closely allied to an aggressive revival of Catholicism which had found expression in that newly-opened religious equivalent of the Eiffel Tower, the basilica of the Sacre-Coeur on Montmartre. No more evocative symbol of this alliance could have been conceived than Rouen cathedral which, though not architecturally in the same class as, say, Chartres or Amiens, was deeply embedded in the history of France. The Dukes of Normandy had been crowned there; it was in the square outside that Joan of Arc had been burnt at the stake; William the Conqueror had lain in state there after his death in 1087, and it had been occupied by the Germans in the war of 1870-1. Moreover, during the latter part of the century the city had experienced a great commercial revival and had become a popular tourist resort. Flaubert was a local author and Proust, who praised Monet's view of the cathedral in his translation of Ruskin's *Bible of Amiens*, had planned (although he never wrote) a book on Rouen, to be entitled *Domrémy*. One indication of the kind of emotional status of the Rouen series is that even before they were finished François Depeaux, a Rouen businessman, ordered two, one for himself, one for the city's museum. When Durand-Ruel staged a large exhibition devoted to the work of the major Impressionists, in which Monet had a whole gallery devoted to his works, the critic Raymond Bouyer stated explicitly:

Monet's work above all expresses France, at once subtle and ungainly, refined and coarse, subtle and ostentatious. He is our greatest national painter, he knows the nuances of our countryside, whether they are harmonious or contradictory; the red pine trees against the blue sea, clear and warm; the contours of the cliff, modulated by the mist, the water running beneath the green foliage, the haystacks erected on the naked plains; he has expressed all that creates the soul of our race.

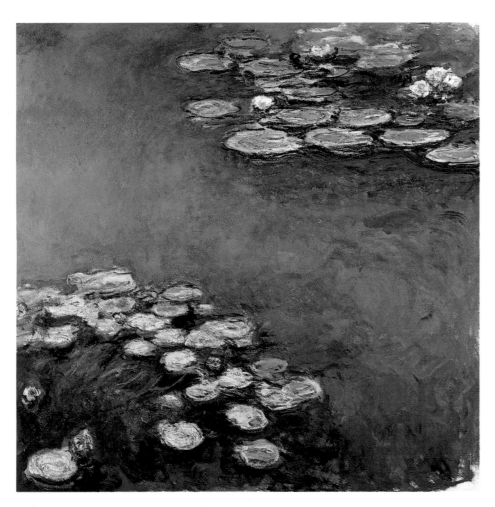

340 CLAUDE MONET *Water-lilies* 1914-17

He was not, however, to progress along these patriotic lines as far as series paintings were concerned. From 1908 onwards he concentrated almost entirely on depicting his garden, usually emphasizing its most un-French and Japanese characteristics. He started with a series centring on the bridge, of which he produced some 18 versions, all in a square format. Then he went on to concentrate on the water-lilies in the pond, recording their appearance at differing times of the day and year. This gigantic undertaking led eventually to an apotheosis which brought the whole history of Impressionism full circle, so that what had started off with a maligned painting of a Norman port ended up with an internationally acclaimed *tour de force* in a specially constructed pavilion in the Orangerie, an extension to the Louvre. The idea first took shape – in a patriotic context – in late 1918 when he wrote to Clemenceau:

I am on the verge of finishing two decorative panels which I want to sign on Victory day, and am writing to ask you if they could be offered to the state with you acting as intermediary. It's little enough, but it's the only way I have of taking part in the victory. I'd like the panels to be placed in the Musée des Arts Décoratifs, and would be delighted if you were to accept them.

From this there emerged the commissioning by the state of a whole series of paintings of water-lilies, the panels forming a circle some 80 yards in circumference and hung according to his own directions. No other artist in French history had been so honoured. Jacques Lassaigne (in *L'Impressionnisme*, Lausanne, 1966) analysed brilliantly the effect of this extraordinary composition:

Repeating an experiment which he had first carried out about 1910, Monet shortens the visual fields of his subjects, observing them from a closer viewpoint, and thus enlarging the field of perspective. By this

means he turns the whole world upside down, and puts the lightest tones at the feet of the spectator who would normally expect to find them above his head. Thus it is difficult for the spectator to locate himself. The substance of what he is looking at is dissolved in light and its reflexions. Vertical and horizontal, the opaque and the transparent, are no longer opposed to each other in the mind of the spectator, who finds himself in a world where the specific qualities of things, their weight, location and plasticity are all melded together. Finally, the circular arrangement of the works, on which Monet insisted and which is scrupulously observed in their present display, increases even more this effect of a strange new world. As the Baroque architects discovered, a circular space does not easily allow a spectator to realize his position, and he tends to get disorientated. This sense of confusion is accentuated; the eye, not finding a suitable place on which to focus, glides over the border and perceives a kind of passing of time. Instead of the usual contemplation from immediately in front of the painting, it seems to be immersed in what it is seeing, taking in an immense conspectus, which has no beginning and no end. The height of the work also upsets one's viewpoint. Between luminous worlds, skilfully modulated transitions avoid too abrupt a sense of transition. Everything is linked – dawn, noon and twilight – to form a continuous whole. Thus the spectator, with his basic perceptions confused, his normal landmarks gone and his conception of the fragmentation of time lost, feels himself transported into a world where categories and the ordering of experience have become confused and finally vanish. The world becomes dematerialized and is transformed before our eyes. It becomes a fluid liberation of sheer energy. Only light subsists in a world stripped of the usual restraints of human experience. In an instant man becomes identified with the elements.

By the time that Monet had this final triumph all the others except Mary Cassatt had died, all of them acknowledged in one way or another by the world of officialdom and public opinion. A year after his death a painting by Sisley, *Floods at Port Marly* (Plate 292), for which he had received 120 francs, was sold for 43,000 francs. Renoir was awarded the Legion of Honour in 1900, the year in which a special section of the Fine Arts division of the Universal Exhibition in Paris was devoted to the Impressionists.

By this point Impressionism had ceased for some time to exist as an organized movement. It had been torn apart not only by the varying beliefs of its practitioners, and by their occasional personal hostilities – Manet and Caillebotte had both hated Degas, and Degas at one time or another hated nearly everybody, describing Manet as an eternal student, Monet as a mere decorator and Pissarro as 'that Israelite'. But as a group they were destroyed by their very success. There is the basic fact that, right from the start, being like all artists supreme egoists, they resented belonging to a group which hid their individual identities and diminished their own sense of personal achievement. Shortly after the success of his *Haystacks* had become apparent, Monet wrote to Durand-Ruel:

I personally am dead set against doing anything to re-establish the shows of the old group. You have enough paintings by all of us to constitute a kind of permanent exhibition already. It would be much more interesting to do small exhibitions from time to time of select recent work by each of us individually. To restart our old exhibitions, it seems to me, would be unproductive and maybe harmful.

Yet, for all its incoherences and all its drawbacks, the notion of a group, of a movement of common aims and a shared technique, had provided a number of brilliant painters with a carapace under which they were able to protect themselves from the hostility of the establishment

and to offer the critics and the public a recognizable alternative art. They created a sect which became an orthodoxy, a protest which became a creed. Succeeding generations would reject it, but in doing so would pay tribute to its potency, which had made possible their own achievements.

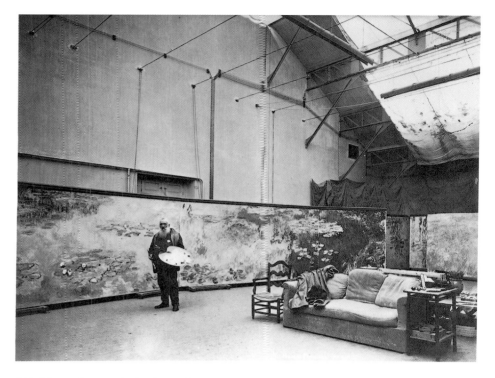

341 Monet photographed in his studio at Giverny working on the *Water-lilies* series for the Orangerie.

[1] This information is largely derived from P. Trevor-Roper's illuminating *The World through Blunted Sight*, London 1970, in which he also notes that in a survey of 128 teachers and students at the Ecole des Beaux-Arts in Paris 48 per cent were myopic, three times as many as in the general population. For Zola's sight see J. Adhémar in *Aesculape*, vol. 33, November 1952.

[2] Cézanne's palette consisted of four shades of yellow, seven of red, three of green, three of blue and black.

[3] Thomas Couture (1815-79), a Salon painter whose fame was founded on this work. An inspired teacher (see p. 50), he encouraged spontaneity.

[4] This notion of Monet being partly motivated in his work by a desire to emphasize the 'glory' of France, especially after her humiliation in 1870, has been extensively developed by Professor Paul Hayes Tucker, especially in an article in *Art History*, Vol. 7, no. 4, December 1984, pp. 465-476, and in his introduction to the catalogue of the exhibition *Monet in the '90s*, Royal Academy of Arts, London 1990.

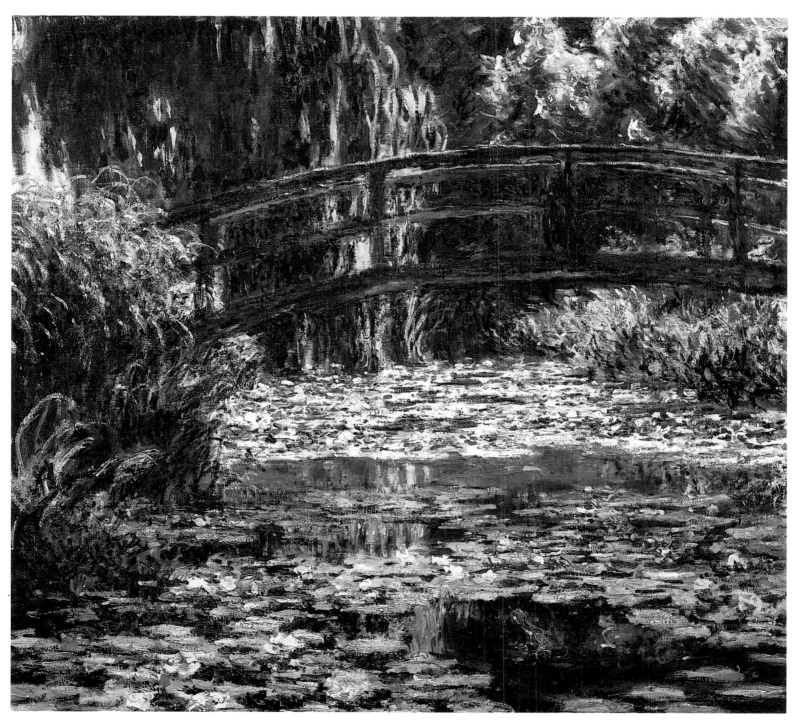

342 CLAUDE MONET *Japanese bridge at Giverny* 1900

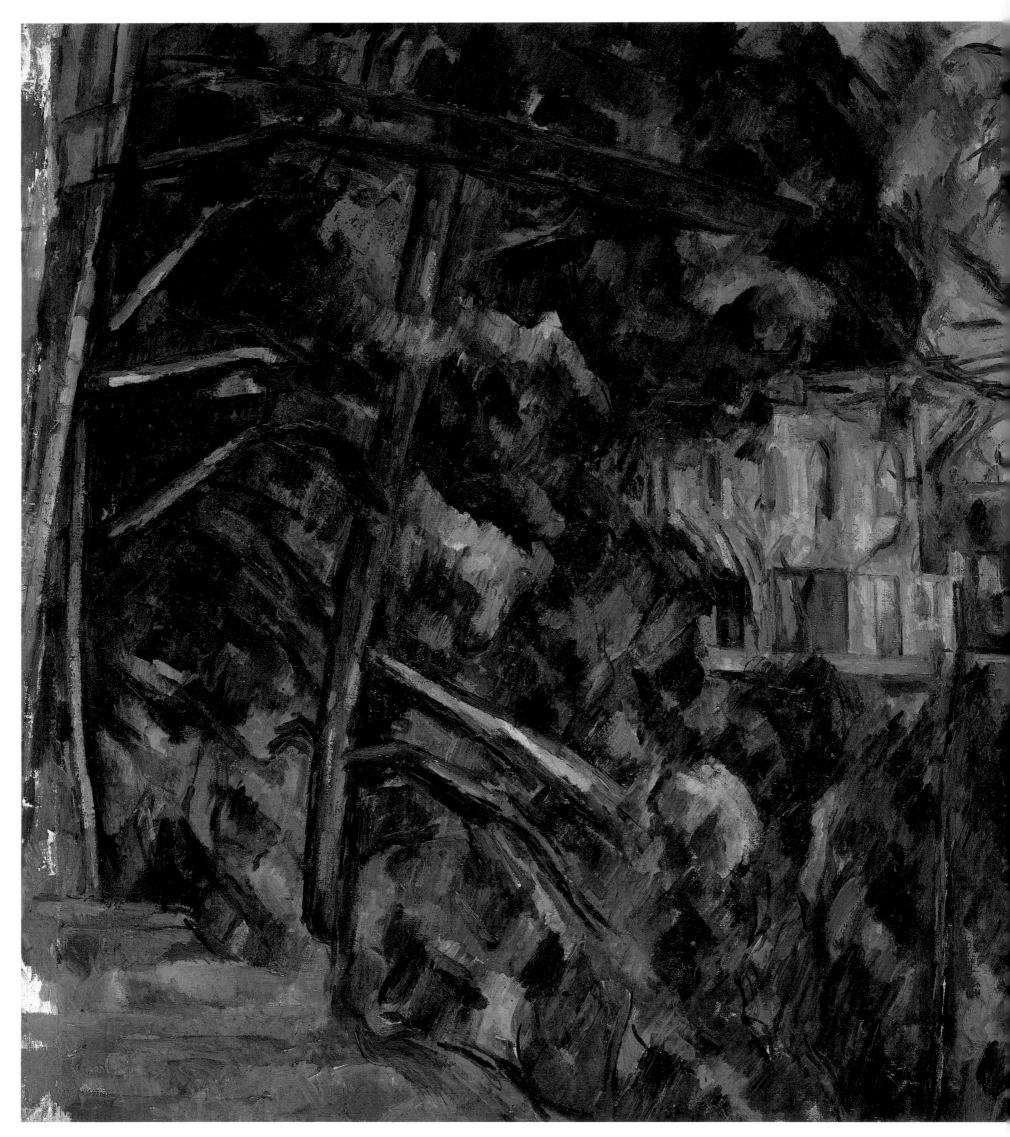

343 PAUL CEZANNE *The Château Noir* 1900–4
Cézanne returned to the subject of the Château Noir time and time again. This view is
painted from a sloping pathway leading down to the strange house, built in a vaguely
neo-Gothic style in two distinct units joined by a series of pillars which was planned to be
converted into an orangery.

344 PAUL CÉZANNE *Millstone in the park of the Château Noir* 1898–1900
Cézanne was fascinated by the Château Noir near Aix (so called because it had been built by
a coal merchant – actually it is golden yellow) and its grounds, which he once tried to buy.
The millstone was left over from an abandoned attempt to build an oil mill.

345 MARY CASSATT *Girl arranging her hair* 1886
The story behind this painting is that Cassatt produced it to prove to Degas that a woman was
capable of painting a work which would conform to his own artistic ideals. The resulting
picture obviously did, and he acquired it in exchange for one of his own pastels.

346 PIERRE-AUGUSTE RENOIR *Nude on cushions* 1907

Between 1903 and 1907 Renoir painted a series of three reclining nudes of which this is the last. All of them show a looseness of handling, a spontaneity and apparent ease of composition which differentiate them from the more rigidly controlled nudes of the 1880s, though there are marked resemblances to The Spring *of 1895, allowing for the fact that the model is lying in the reverse direction. The shape of the canvas would seem to suggest that the work had some decorative purpose, for Paul Gallimard, the publisher who had recently become his patron, was very keen on paintings such as this, on vaguely classical themes, being used to adorn the salons of the affluent. There is a marked tendency too in these recumbent nudes to revert to a more traditional style than before. Whereas in the 1880s he seemed to have been looking towards the linear, volumetric traditions of Florence, in this and its two companion pieces it is the radiant sensuality of the Venetian masters which seems to predominate. There is an immense awareness here of the presence of a woman's body, the haunches, too heavy perhaps for what seems to be a young girl, whose almost perfectly rounded breasts belie the creases of fat around her stomach. The thighs are almost unnaturally long, the knees and legs painted with affection; the face is reflective rather than pert or provocative. The quite elaborate treatment of the background, and the care taken over the painting of the folds of the sheet and the creases in the cushions, are both intended to emphasize the rhythmic pattern of the whole painting.*

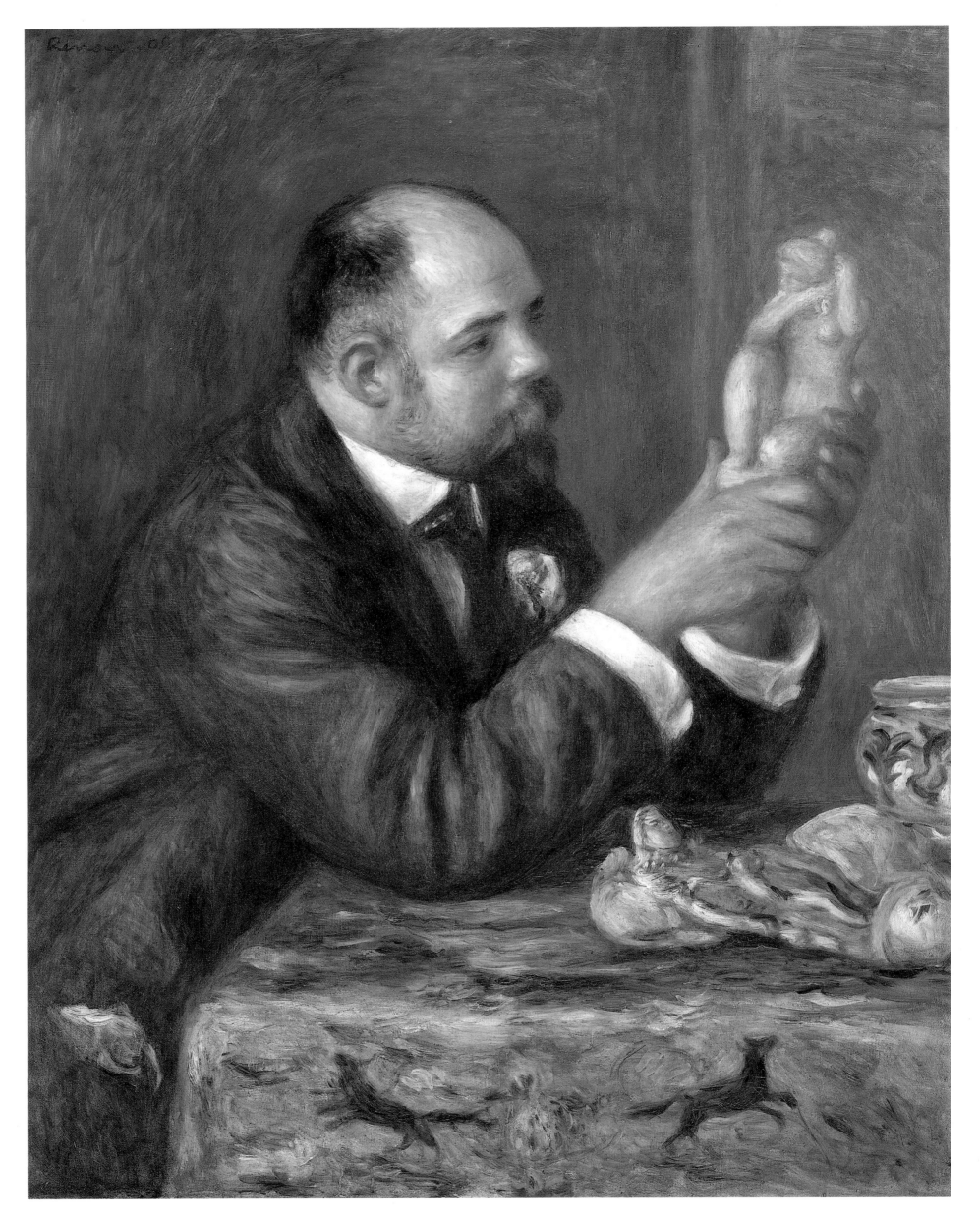

347 PIERRE-AUGUSTE RENOIR *Portrait of Vollard* 1908
Painted when Vollard was 40, this shows the dealer examining a statuette by Maillol. On the table, which is covered with a curiously patterned cloth, are a vase and other bric-à-brac. In 1927 Vollard sold the painting to Samuel Courtauld.

348 PIERRE-AUGUSTE RENOIR *The clown* 1909
This is a portrait of his son Claude, who later remembered: 'The costume was completed with white stockings, but I refused to put them on because they tickled me. Then my mother brought in some silk stockings, but they tickled too. Negotiations then started. I was promised a spanking, an electric train set, being sent to boarding school, and a box of paints. Finally I agreed to put on the cotton stockings. The railway and the box of paints rewarded my sacrifice.' Claude was eight at the time.

349 MARIE BRACQUEMOND *On the terrace at Sèvres* 1880
In 1871 Félix Bracquemond had been appointed art director of the porcelain factory at
Sèvres, and the family acquired a house there; Marie made designs for its products. This work
was shown at the 1880 Impressionist exhibition. There is some confusion about the identity
of the sitters.

350 MARIE BRACQUEMOND *Interior of a salon c.* 1890
Bracquemond was in constant conflict with her husband, her own sense of domestic
responsibility and her desire to be an artist. It was a situation encapsulated in this
watercolour, showing the domestic delights of her home, dominated by her own magnificent
portrait of her sister Louise Quiveron, a strong-willed woman impatient with Marie's lack of
intellectual courage.

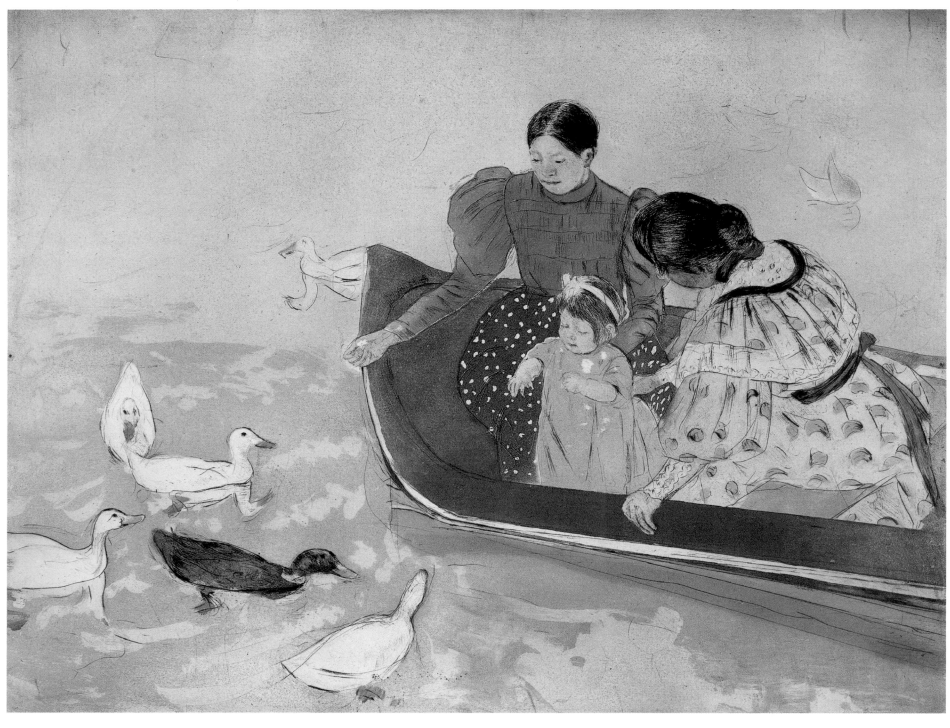

351 MARY CASSATT *Ducks* 1895
Cassatt had been taught the technique of etching by Degas and Bracquemond. In 1890 she set up her own printing press and hired a professional printer at the Château Bachivillers on the Oise: there she produced works such as this coloured etching, which in subject-matter and style reflects the deep influence of Japanese prints.

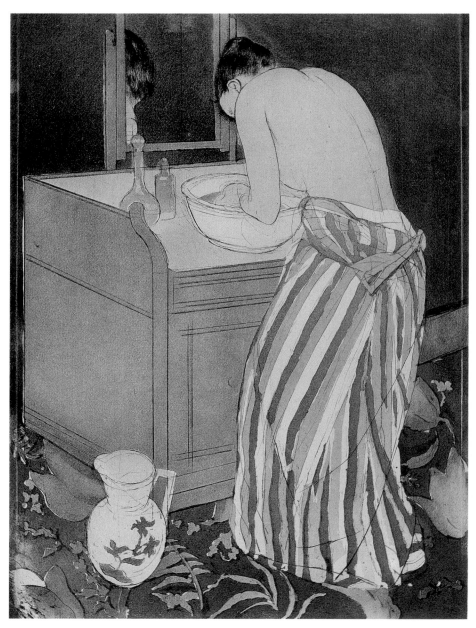

352 MARY CASSATT *The toilette* 1891
Cassatt achieved considerable prowess as a print-maker in various media. This aquatint, on a theme which often occurs in her oeuvre, shows the difference between her own work and that of her idol Degas, whose approach was much more acerbic.

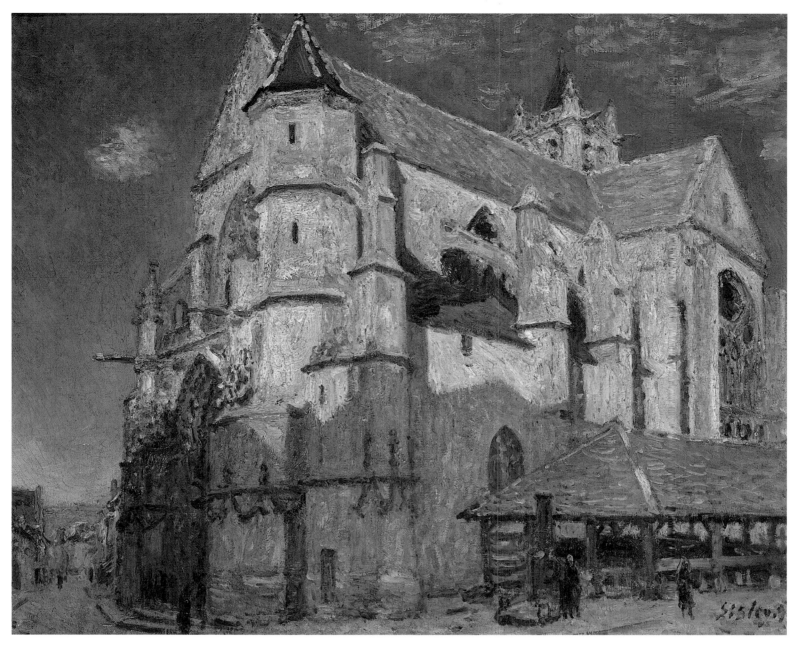

353 ALFRED SISLEY *The church at Moret* 1893
Sisley spent the latter half of his life in almost complete obscurity at Moret, near Sens, his
style showing little variation from its original form.

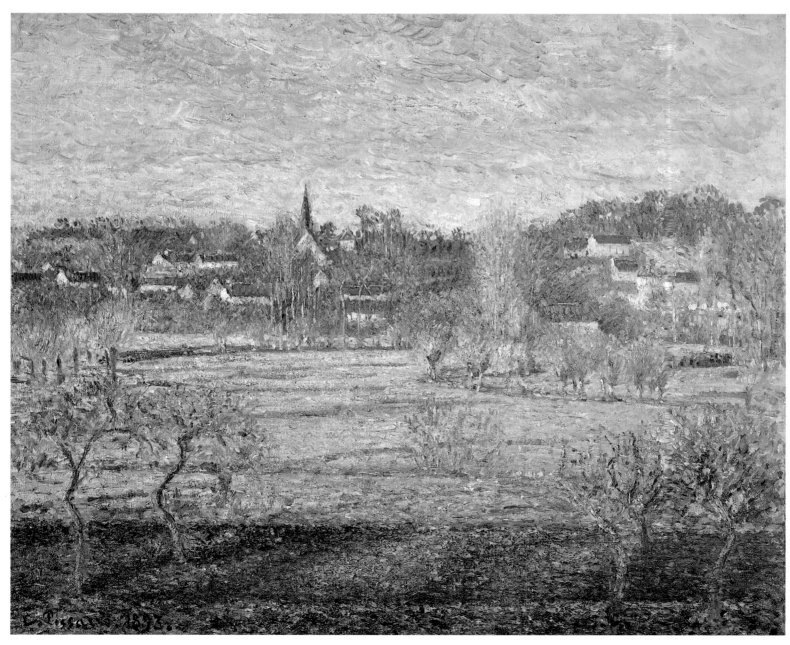

354 CAMILLE PISSARRO *February sunshine* 1893

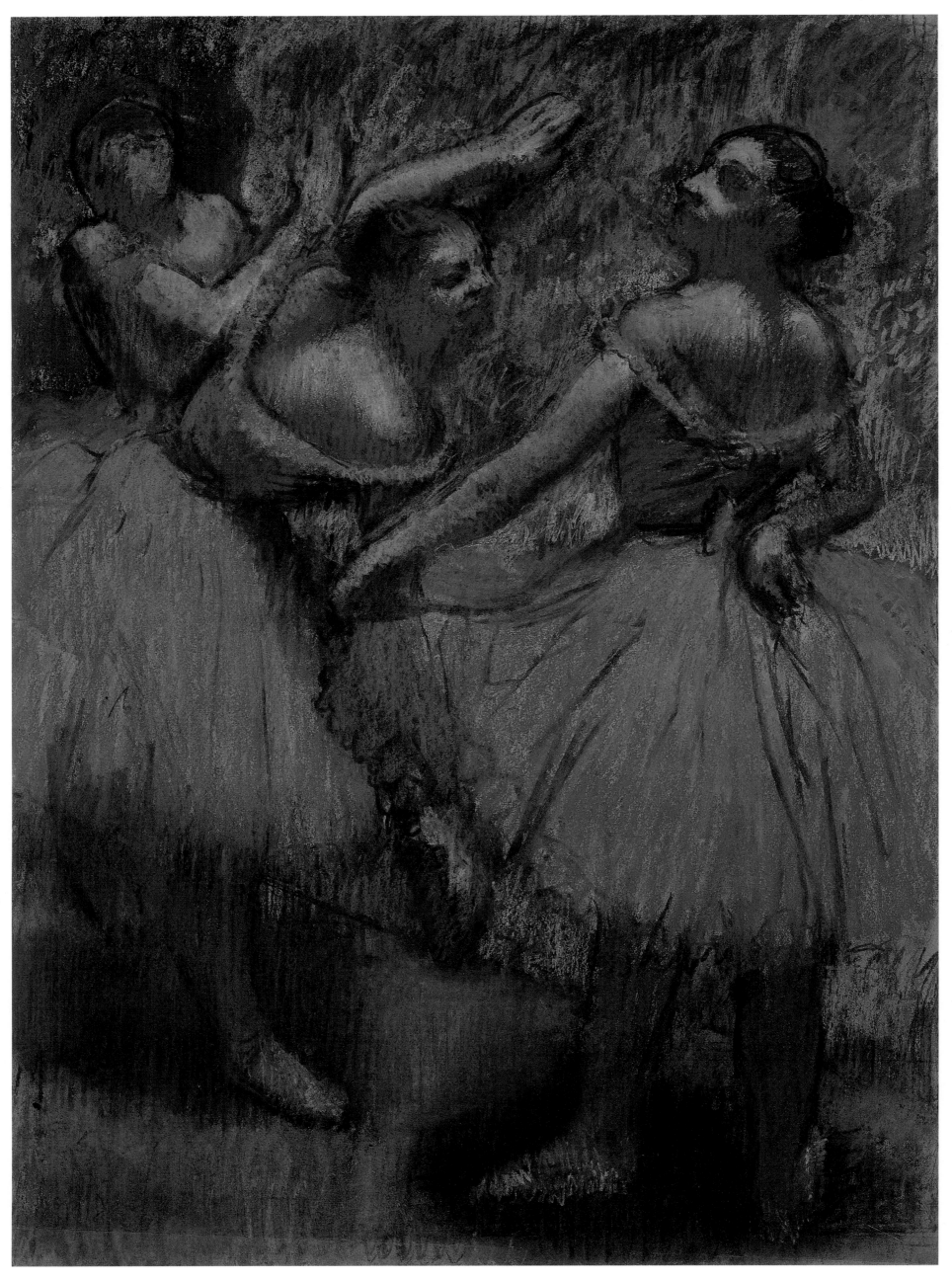

355 EDGAR DEGAS *Red skirts c. 1900*
In the last years of the century Degas produced a number of pastels of dancers in groups of
two or three in which he made much use of arm motions to create patterns with the line of
their skirts. Several of these were in a dominant colour accent: green, blue or, as here, red.

356 EDGAR DEGAS *The coiffure 1892–5*
The audacious flame-coloured tonality may be due in part to eyesight problems.

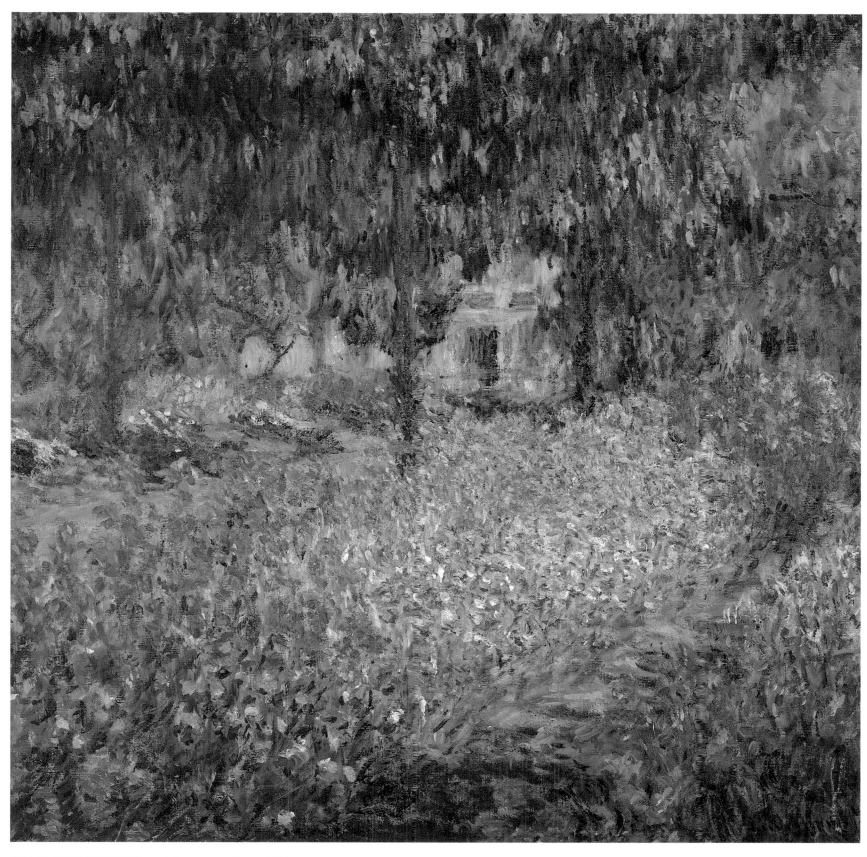

357 CLAUDE MONET *The artist's garden at Giverny* 1900

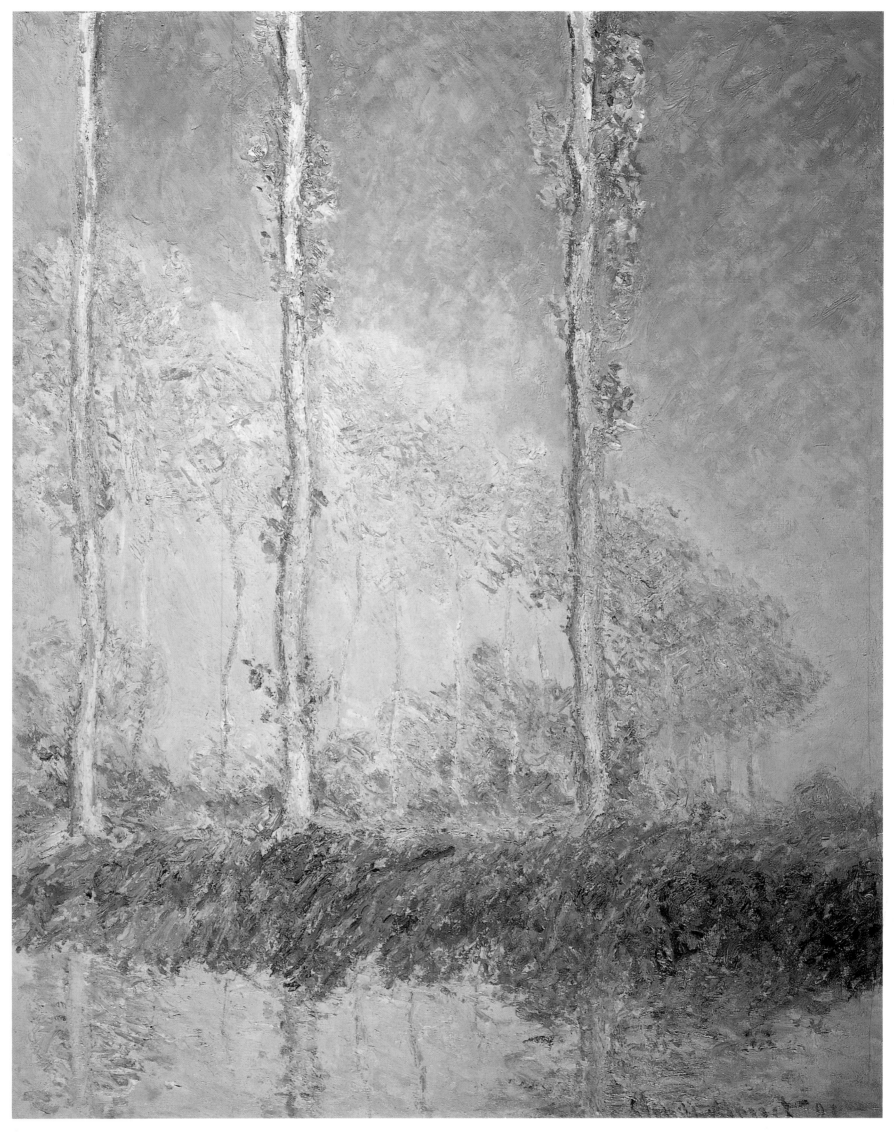

358 CLAUDE MONET *Poplars* 1891

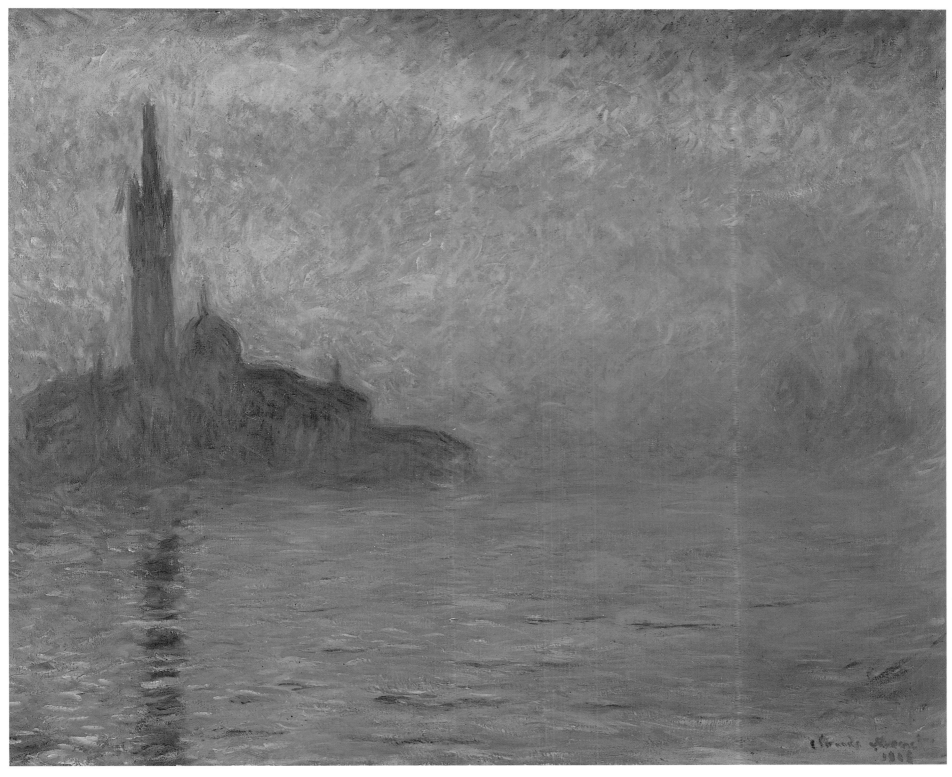

359 CLAUDE MONET *Twilight, Venice* 1908
On 25 October Monet wrote to Gaston Bernheim-Jeune from the Grand Hotel Britannia in
Venice, 'I'm excited by Venice, and have a few paintings of it under way. I'm very much afraid
that I shan't be able to bring back anything but a few beginnings which will serve purely as a
record.' In the event he did bring back a number of views under different atmospheric
conditions and times of day, which he finished at Giverny.

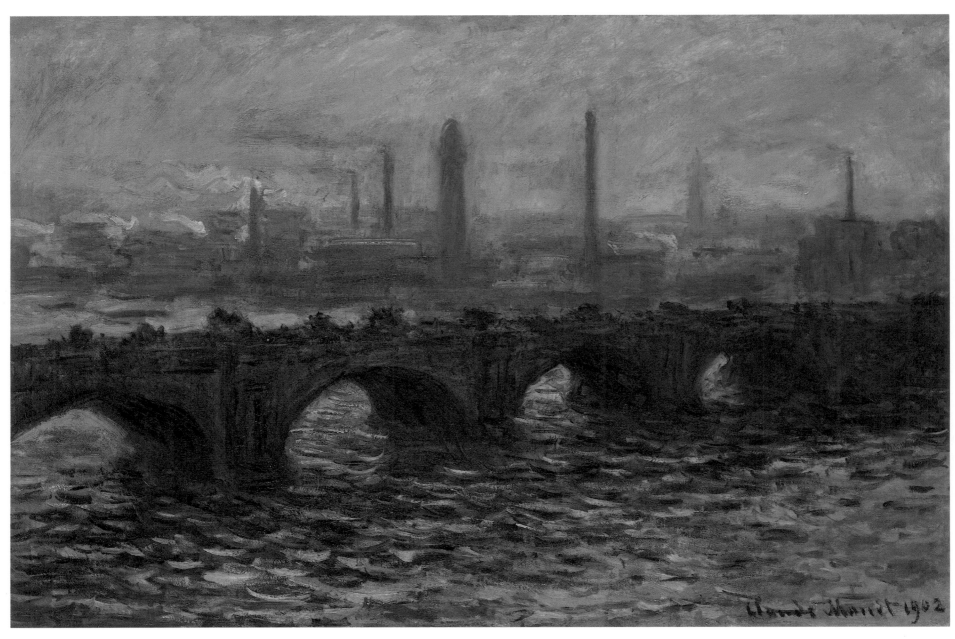

360 CLAUDE MONET *Waterloo Bridge* 1902
When Monet was staying in London at the Savoy Hotel he painted from his window a
number of series paintings including this one, subtitled 'cloudy weather'.

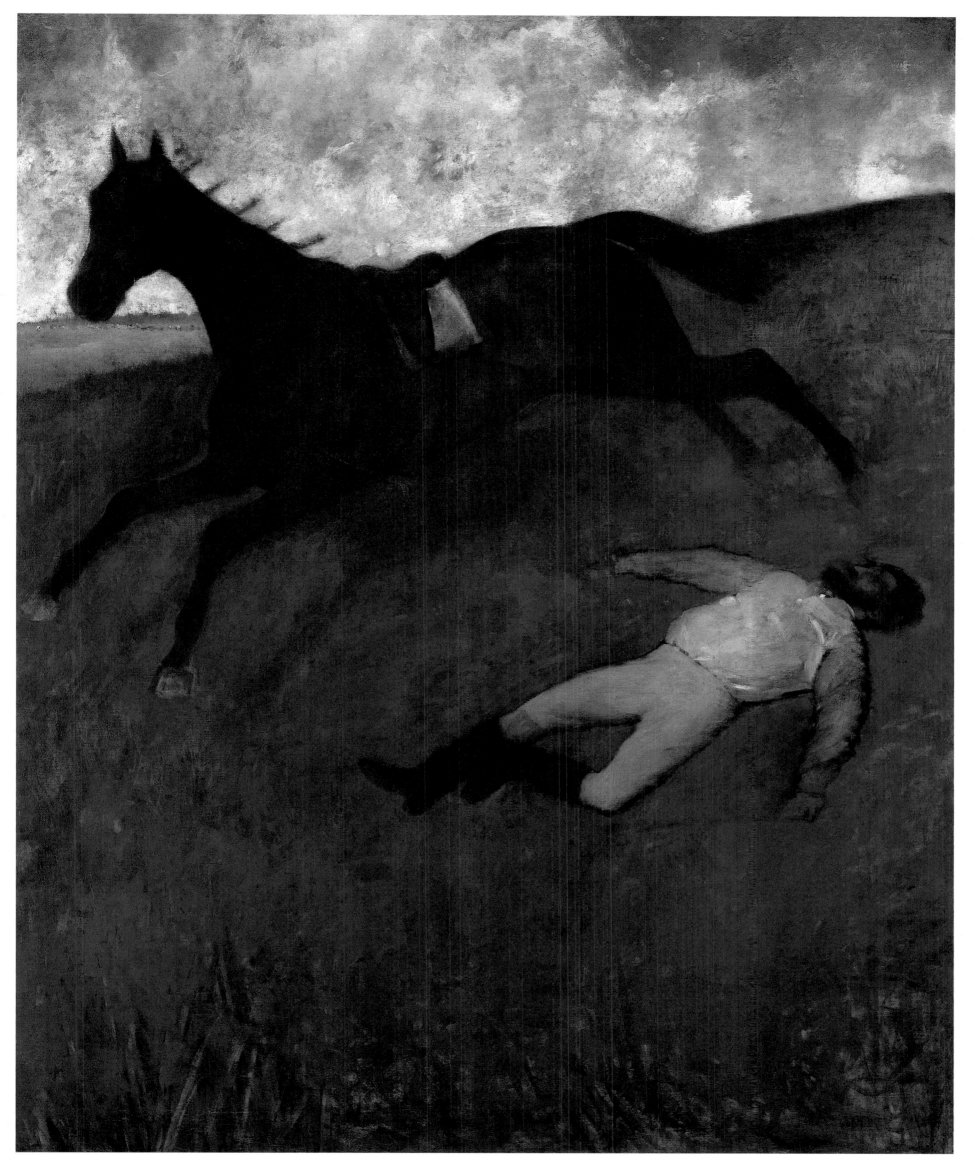

361 EDGAR DEGAS *Injured jockey* 1896/8
In the 1890s Degas repainted or completed a number of racing scenes which he had
originally painted in the 1860s (compare Plate 87). This strangely ominous work with its
lowering sky, its heavy colours and the minatory shape of the horse seems to reflect the
darker side of Degas's personality.

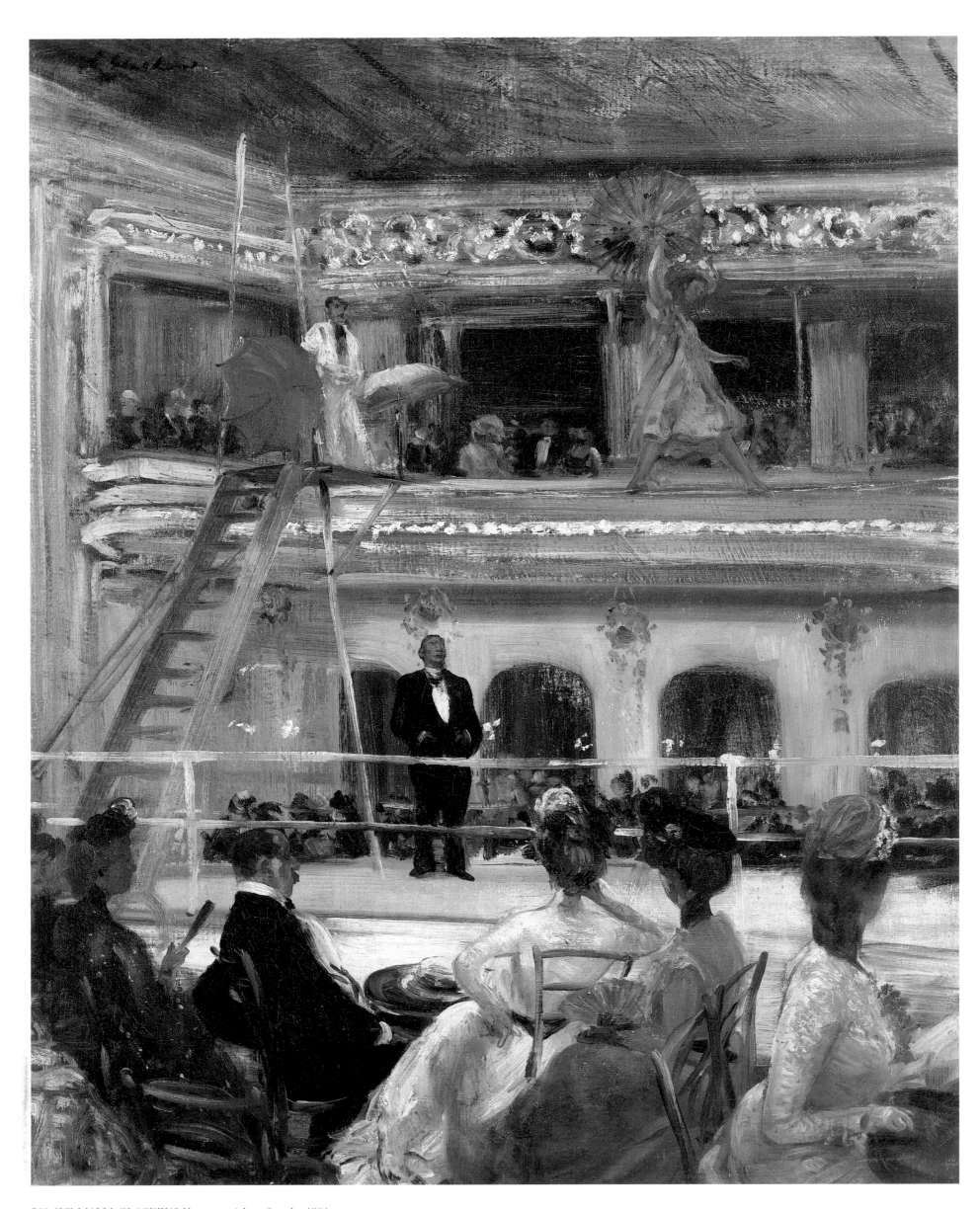

362 WILLIAM J. GLACKENS *Hammerstein's roof garden* 1901
Inheriting from Degas, Toulouse-Lautrec and others an interest in the music-hall. Glackens
painted many views of New York life such as this. He had commenced his career as an
illustrator in Philadelphia, but then travelled extensively and spent a year in Paris in the
mid-1890s, where he became a devotee of Impressionism.

Chapter 10

The End of an Epoch

In 1884, exactly ten years after the first Impressionist exhibition, the well-known American painter George Inness (1824-94) wrote an angry letter to the editor of a magazine which had described him as an Impressionist:

I am sorry that either of my works should have been so lacking in the necessary detail that from a legitimate landscape painter, I have come to be classed as a member of the new fad 'Impressionism'... We are all the subjects of impressions, and some of us seek to convey the impressions to others. In the art of communicating impressions lies the power of generalizing without losing that logical connection of parts to the whole which satisfies the mind... And Impressionists, from a desire to give a little objective interest to their pancake of color, seek aid from the weakness of Preraphaelitism as with Monet. Monet was made through another kind of humbug. For when people tell me that people see nature in the way that the Impressionists paint it, I say 'Humbug' – from the lie of intent to the lie of ignorance.

The interesting thing is that Inness should have been sufficiently aware of Impressionism in general, and of Monet in particular, to have been driven to this near-incoherent outburst of indignation. Impressionism was seen and acknowledged, at first with caution, but quite soon with enthusiasm, in the United States sooner than in any other European country, and Monet especially was to establish himself there as the most popular figure of the movement, with Degas a close second.

It is a seductive hypothesis that this was due to the intellectual vigour of a 'new' people and of an application to aesthetics of the rugged frontier spirit which was enlarging the nation throughout the century. There were, however, other more prosaically comprehensible reasons. By the 1860s the development of railways and of steam-powered Atlantic liners had opened up to the increasing number of the well-to-do in the United States the riches and cultural attractions of the continent from which virtually all their ancestors had come. To visit, and preferably to study in, Rome, Paris, Munich or Oxford had become both an educational necessity and a social obligation. This was particularly so as far as art was concerned. The Parisian studios of teaching academicians such as Carolus-Duran, Bonnat and Bouguereau were packed with those who would become famous names in American art during the latter part of the century, and what was happening in the French art world was probably better known in Boston than in Birmingham or Barcelona.

Two major figures connected with Impressionism, James McNeill Whistler and John Singer Sargent, though basically expatriates, were Americans, and considered as such. Sargent did a great deal to serve the cause of the Impressionists, and in 1889 he was largely responsible for the sale of the whole of Monet's *La Creuse* series to an American collector. The most influential of all those Americans who went to work and often live more or less permanently in Paris was Mary Cassatt, who was not only a great help to Durand-Ruel in his transatlantic undertakings but cajoled and bullied her affluent friends and relations in the States into buying works by the Impressionists, especially of course by Degas. Equally valuable in this context was Louisine Havemeyer who, first through her husband and then on her own initiative after his death, built up the great collection of paintings which is now one of the glories of the Metropolitan Museum in New York. Cassatt's own paintings, too, frequently appeared in American exhibitions[1] and a number of her prints were

363 GEORGE INNESS *Grey day, Goochland* 1884
The light-saturated landscapes of Inness (1825-94) are indicative of an innate American feeling for depicting nature, which was powerfully reinforced by the example of the Impressionists.

acquired by the Metropolitan Museum in about 1903.

By the late 1880s there were several American artists whose style of painting was influenced, at least superficially, by the Impressionists. One of these, despite his protestations to the contrary, was George Inness himself (Plate 363). Another was the eclectic W.M. Chase, who was attracted by what was going on in Paris; when under his aegis the National Academy of Design staged an exhibition to help raise funds for the cost of the Statue of Liberty several Impressionist paintings were included, with Manet being given a position of special prominence. There were other artists of a later generation who were more directly involved with the Impressionists, and in the 1890s large numbers of American art students used to visit Giverny to sit, if only momentarily, at the feet of Monet, whom they saw as their master. More dedicated than most of them in his enthusiasm and more single-minded in his dependence on Monet was the New Yorker Theodore Robinson (1852-96), who first visited Giverny in 1888 and spent some time there, sometimes painting the same subjects alongside the master and keeping an invaluable diary recording his experiences (now in the Frick Art Reference Library). In the Detroit Institute of Arts there is a painting by him of a haystack (Plate 364) which can be compared with a similar one, from a slightly different angle, painted in the previous year by Monet. It would seem, too, that he reciprocated this influence by arousing in Monet a greater interest in the use of photography, which he himself employed extensively.

The reactions of the art-conscious public and of collectors were more positive and unprejudiced in America than in almost any other country. When the first painting by an Impressionist, Manet's *The execution of the Emperor Maximilian* (Plate 190), was brought to America in 1879 by his friend the soprano Emilie Ambre, to mark her appearance as Carmen in New York and Boston, it was advertised in those two cities by a poster which read 'Come in! come in! to see the famous painting of the famous painter Ed. Manet'. A hundred and twenty people were asked to the opening reception at the Clarendon Hotel on the corner of Eighth Street and Broadway, but only about 50 guests turned up to enjoy the buffet. Reactions, however, seem to have been favourable on the whole. *The New York Tribune* wrote on 29 November 1879:

Manet is the apostle of French naturalism in painting as Zola is in literature. None of his work, as far as we know, has ever been exhibited in this country. *The execution of the Emperor Maximilian* has many faults as a work of art, and is woefully inaccurate, but it has many qualities of excellence which will appeal more to the artist and the amateur than to the general public, as the work of an original and unconventional man. As coarse as a piece of theatrical scenery, its extreme naturalism is artistically excellent. Its confused splashes of paint, looking at first sight like frozen beef, at a distance assume the form and action of clasped hands. The faithfulness of figures and impression of action is almost photographic. One is, in countless instances, reminded of Goya.

The Boston papers were less enthusiastic when it was shown there, but one long-term result may have been that four years later Mrs T.A. Scott of Philadelphia bought the

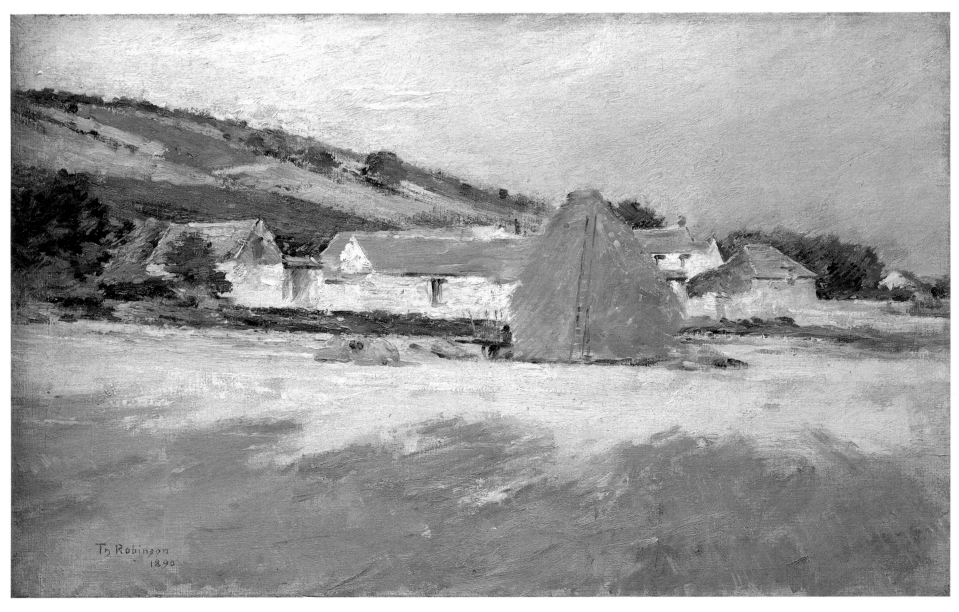

364 THEODORE ROBINSON *Scene at Giverny* 1890

portrait of Emilie Ambre in the role of Carmen which Manet had painted in 1880. Round about this time, too, Erwin Davis, a New York collector who had already been buying works by Corot and the Barbizon painters, acquired Manet's *Boy with a sword* for 10,000 francs and *Lady with the parrot*, as well as Degas's *Little ballet girls in pink*, for an undisclosed sum through his agent J. Alden Weir, who was then in Paris.

Before Durand-Ruel's initial appearance in the USA at the exhibition at the National Academy of Design in 1886 (see p.296), he had sent Impressionist works to the International Exhibition for Art and Industry, held at the Mechanics' Hall in Boston in the autumn of 1883 under the auspices of various foreign governments. Durand-Ruel was among a number of participating Parisian dealers, and he showed two works by Manet, six by Pissarro, three by Renoir, including *The luncheon of the boating party* (Plate 238), and three by Sisley. Manet's *Entombment of Christ* (Plate 67) was the frontispiece of the catalogue, and thus became the first painting by an Impressionist to be reproduced in America. So comparatively popular, however, had the Impressionists become after Durand-Ruel's efforts that by 1889 an article in *The Collector* was warning, in its first issue (which appeared that year), of the dangers of imitation (not fake) Impressionist works. In the same year the Metropolitan Museum accepted for its collection the two Manets bought by Erwin Davis (mentioned above), and these were followed by the acquisition in 1907 of Renoir's *Madame Charpentier and her children* (Plate 227) for $14,000 (then £3,500) and in 1913 of Cézanne's *La Colline des pauvres*.

Another boost was given to the status of the Impressionists in America by one of those formidable matrons who dominated the patronage scene there for almost a century. In the Columbian Exposition of 1893 held in Chicago, the French artistic representation, organized by the Ministry of Fine Arts in Paris, consisted exclusively of academic painters such as Bouguereau. This did not suit Mrs Potter Palmer, a perspicacious and enthusiastic collector of works by the Impressionists, who organized a Loan Exhibition of works owned by American collectors – it included paintings by Manet, Degas, Monet, Pissarro, Renoir and Sisley, some of them owned by A.J. Cassatt (Mary's brother) and others of course by herself. It was extremely successful. The short-lived magazine *Modern Art*, edited by John Moore Bowles, referred to it as 'the most remarkable collection of modern art ever to have been seen in America. It is said that Frenchmen groan when they see how much of the best work of their greatest men has been allowed to come to this country.' Other collectors included Albert Spencer, who in 1888 sold his collection of older paintings to concentrate on the Impressionists; James S. Inglis, a partner in the New York art firm of Cottier and Company, who lent works to the Loan Exhibition and owned Manet's *Bullfight* and *The dead toreador*; and James F. Sutton, the President of the American Art Association and also a dealer, who had been responsible for arranging the Durand-Ruel exhibitions, but who also bought and kept a large number of Impressionist paintings for his own collection (sold very profitably in 1927 after his death). By the turn of the century it had become apparent not only that Impressionism had made a greater impact on American

365 Poster for the exhibition of Manet's *Execution of the Emperor Maximilian* (Plate 190) in New York, 1879.

taste than in any other country outside France except Germany, but that the USA had become one of the Impressionists' most profitable outlets, helping them incidentally to raise their prices on the home market.

Despite its geographical proximity to France, England reacted far more sluggishly to the movement. Durand-Ruel's explorations of the London market in the 1870s had not been especially successful, though one of the earliest collectors, Henry Hill of Brighton, set the pattern by collecting some seven works by Degas, an artist who, because of his meticulous draughtsmanship and smooth finish, always appealed to the somewhat inhibited taste of the English more than did Monet, with his spontaneous approach.[2] Another early collector was Samuel Barlow, a botanist and owner of a bleach factory in Lancaster, who in the early 1880s bought four paintings by Pissarro. The first major Impressionist work to be sold in England had been the second version of Degas's *Ballet of Robert le Diable*, painted for Faure in 1876. The Greek financier Constantine Alexander Ionides (1833-1900), who had lived in London for most of his life and was deeply involved in the cultural life of the city, bought it from Durand-Ruel for the quite considerable price of 200 guineas (in about 1880 Durand-Ruel had paid Degas 3,000 francs, about £135, for it, so his profit was not excessive). Sickert's purchase from the Hill sale in 1889 of *Ballet rehearsal on stage*, now in the Metropolitan Museum, New York, was one of several purchases he made of works by Degas round about this

366 MAX BEERBOHM *The New English Art Club in 1907*
Sickert, Conder, John, Orpen, Tonks, MacColl, Steer, William Rothenstein on table, his brother Albert beneath, Roger Fry, L.A. Harrison and W. Russell.

time, largely as a consequence of his having married into money; but on his divorce the pictures went to his ex-wife. It is obvious that Degas's popularity amongst English collectors was outstanding. It was enhanced by his connexions with Legros, Fantin-Latour and Tissot, as well as with Carlo Pellegrini, a Neapolitan by birth, who had settled in England in 1864 and who, through his cartoons in *Vanity Fair*, earned from Max Beerbohm the accolade of being 'by far the best caricaturist who has lived within our time'. On his occasional visits to London Degas saw a lot of Pellegrini, who was a member of the Arts Club, also frequented by Whistler, Tissot and Fantin-Latour. It was

367 JOHN SINGER SARGENT *Monet painting at the edge of a wood* 1888
Sargent and Monet had been in close contact since they met at the second Impressionist exhibition in 1876. The American visited Giverny on several occasions, and virtually acted as Monet's agent during his London excursions. He bought four of Monet's paintings between 1887 and 1891, and wrote about one of them to Monet, 'It is only with great difficulty that I can tear myself away from your delightful painting. . . I have remained in front of it for whole hours at a time in a state of voluptuous stupefaction.'

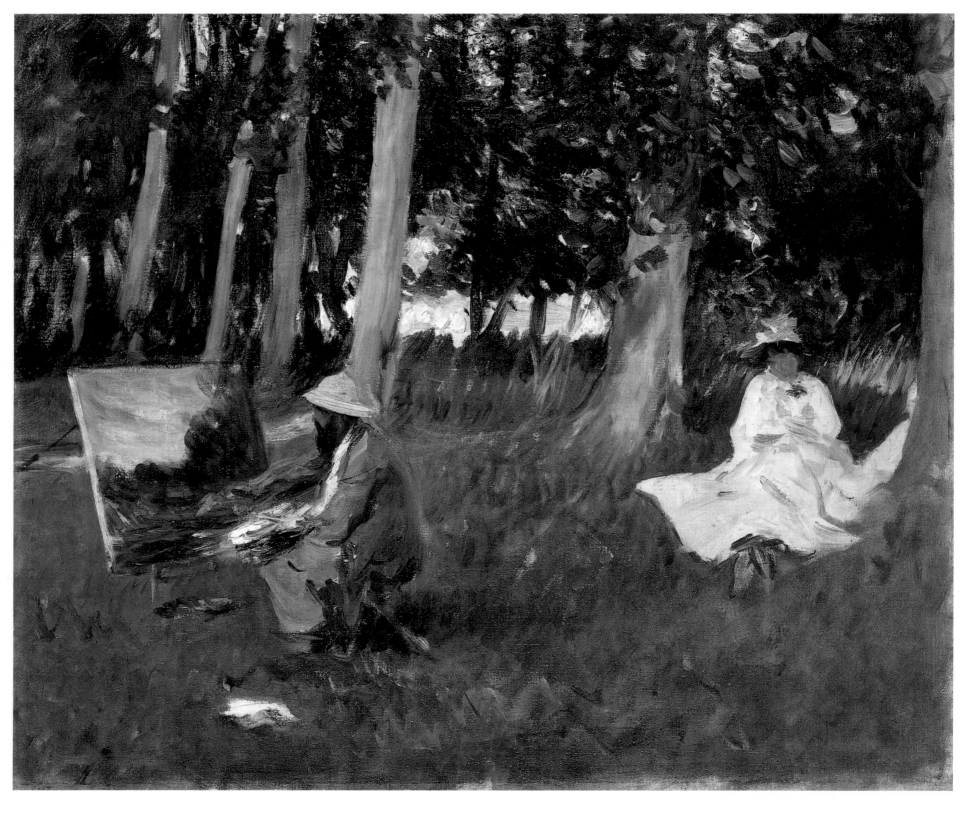

368 The Durand-Ruel exhibition at the Grafton Galleries, London, 1905: the photograph shows 7 Monets and 3 Renoirs.

probably on one of these occasions that he painted the caricature-portrait of Pellegrini, subsequently purchased in 1916 by Lord Duveen for £350 and in due course given to the Tate Gallery through the National Art Collections Fund.

One of Degas's few visits to London was to attend the first night of the English translation of a play, *La Cigale*, by his friend Ludovic Halévy, about the art life of contemporary Paris, for which he had sketched the décor for a scene in a studio. In the play there are several references to the Impressionists, and it is a significant comment on English unawareness of the movement that the word was translated as 'followers of Whistler'. Whistler himself, of course, was a dedicated supporter of the group in England. When he founded the International Society of Sculptors, Painters and Engravers to further his ambition of becoming the head of a world-wide organization of artists, he encouraged the Impressionists, including Renoir, Pissarro and Cézanne, to participate in its exhibitions, held from 1898 (they continued after Whistler's death, until 1908). Sargent was also active in promoting Impressionism in England, especially the works of Monet. One of these, a *Haystack*, was bought in 1892 for £200 by Arthur Studd, a fellow student of William Rothenstein at Julian's in Paris. Studd had earlier acquired Degas's *Absinthe* from the enterprising Glasgow dealer Alexander Reid, whose portrait was later painted by Van Gogh.

All these purchases, however, were trifling compared with what was happening in America or in Germany. Up until 1905, when Durand-Ruel held an important London exhibition at which he sold ten works, English collectors had acquired 25 works by Degas, six by Manet, four by Monet and about 20 divided between Renoir, Pissarro and Sisley. Amongst the buyers, in addition to those mentioned, were George Moore, who bought works by Manet, Monet and Berthe Morisot; Sir William Eden, Whistler's patron and enemy; and the formidable Baron Grimthorpe, lawyer, mechanician and theological contro-versialist who, amongst other achievements, designed Big

Ben and the clocks on St Paul's cathedral. At the 1905 exhibition, however, there appeared the first really significant British collector of Impressionist pictures, the Irish-born Hugh Percy Lane, who bought there Manet's *Music in the Tuileries Gardens* and the portrait of Eva Gonzalès, Monet's *Vétheuil*, Renoir's *Umbrellas* and Pissarro's *Spring in Louveciennes*. He later increased his collection to 59 paintings of the finest quality, the first of its kind to exist in the British Isles.

The subsequent history of the collection is a remarkable comment on the attitude of British cultural bureaucracy, faced with the most outstanding art movement since the Renaissance. In 1900 the Victoria and Albert Museum had unconditionally accepted Ionides's bequest of his *Ballet of Robert le Diable*, but when in 1905 the enlightened art critic Frank Rutter started to get up a subscription to buy an Impressionist painting for the National Gallery he was told that the gallery would not accept a work by a living artist. He pointed out that Manet, Sisley and Pissarro were all safely dead.

'It will be difficult', the Director and Keeper said. 'We shall make enquiries.' They did so, but Manet, Sisley and Pissarro were considered too 'advanced' for the Trustees of the National Gallery. 'We must do something', I protested. 'Well, there's Boudin,' said MacColl soothingly.

369 WILLIAM ORPEN *Homage to Manet* 1909
This brilliantly characterized conversation piece, based on similar paintings by Fantin-Latour and Maurice Denis, reveals more reverence for Manet than observation of his style. Beneath the portrait of Eva Gonzalès are Moore, Steer, MacColl, Sickert, Tonks and Hugh Lane.

370 RODERIC O'CONOR *Field of corn* 1892
O'Conor (1860-1940) was the only Irishman of his generation who became an artist on the international scene. After studying in Dublin and Antwerp he joined Carolus-Duran's studio in Paris, and was then influenced by the Impressionists, especially Sisley. He became intimate with Gauguin, who borrowed his studio in Paris and based one of his paintings on a drawing by him. He was associated with the Pont-Aven school, and several of his works show the influence of Monet. He was a prolific print-maker.

'I have ascertained that the Trustees will go as far as Boudin, and you know there's nothing by him in the National Gallery yet.' So it was settled.

The National Gallery bought *The harbour at Trouville*. MacColl, in fact, who had been an art student at the Slade School, where Legros taught, had defended Impressionism in the columns of *The Spectator* and *The Saturday Review*, as well as in his book *Nineteenth-Century Art* (1902) but, even when he became director of the Tate Gallery shortly after its foundation, he did nothing to acquire any work by an Impressionist. It was he, however, who encouraged Lane to offer his collection on loan to the National Gallery. At first the Trustees accepted; then they had second thoughts and decided to take only a selection, excluding Renoir's *Umbrellas* and Monet's *Vétheuil*, and only on condition that Lane bequeathed them to the nation. This he refused to do. The collection languished in the basements of Trafalgar Square until his death on the *Lusitania* in 1915, after which, because of the confused wording of his will, a dispute about their ownership broke out between the National Galleries of London and Dublin, dragging on for the next 30 years, the paintings being shared between the two galleries. Official recognition of the Impressionists in England came only after the National Gallery itself bought its first Impressionist paintings in 1918, when the director, Sir Charles Holmes, attended the posthumous sales of Degas's studio contents in Paris and bought works by Degas, Manet, Gauguin and Forain, which were absorbed into the gallery's collections.

Despite the hostility of artists such as Holman Hunt and Rossetti, there was a certain amount of early contact between English artists and the Impressionists. Certain figures straddled the Channel. Whistler and Sargent were very close to most of the members of the movement, and Fantin-Latour had become almost a naturalized Englishman. When Sir Edward Poynter was appointed head of the newly established Slade School of Art in 1871, he introduced there French methods and attitudes to teaching of the kind which the Impressionists had experienced. Poynter insisted on the appointment as his successor of Alphonse Legros, who had been a marginal figure during the emergence of the movement in Paris and who, during his tenure of office between 1876 and 1892, was to train a generation of painters, instilling in them an awareness at least of some of the achievements in Paris since the 1860s. Then there was Sickert, who had met Degas in 1883; he had been living in Dieppe, where the two were in close contact between 1900 and 1905. Highly articulate, he was largely a stylistic maverick who picked up from the Impressionists their concern with contemporary urban reality and with moments of surprised intimacy, as well as their sense of pictorial structure. But he was very much his own man and his version of Impressionism, if indeed it can be called that, was closer to that of German and Scandinavian practitioners of the same approach than to the Impressionists themselves.

Sickert was a powerful personality, and he became a nucleus around which the more Francophile of the younger generation of English artists tended to coalesce. In 1886 15 of them, all of whom had studied in France, met together to form what they originally contemplated calling 'The Society of Anglo-French Painters', but eventually decided to name 'The New English Art Club'. This has subsequently come to be regarded as the centre of 'English Impressionism'. As a writer in the *Pall Mall Gazette* explained on 13 April of that year:

The desire of the new school is to vindicate the engrafting of English feeling and sentiment upon what is known as French technique – French only because no adequate attention is paid to the teaching of technique out of France. The three score works in its first exhibition reveal a quite unexpected variety of subject and treatment, and undoubtedly a very much higher level of excellence than is to be found in the average Academy or Grosvenor Gallery exhibition.

He was certainly right about the variety. Many of the members, such as Henry Tuke with his nude boys (which so alarmed the dealer Colnaghi that he withdrew his promise to support the Club), Benjamin Kennington with his heartrending images of distressed widows, and George Clausen with his sentimentalized Millet-like pictures, had nothing to do with Impressionism. There was a group of others, however, including William Rothenstein, Philip Wilson Steer (Plate 372), William Stott of Oldham and Augustus John, whose works revealed that they had absorbed something of its significance. Associated with them for a short time were the 'Glasgow Boys', whose work had a fresh spontaneity about it close to much Impressionist painting, though they tended to have a preference for anti-naturalistic colours and superficially decorative effects (see Plate 384). Sickert did his utmost to

promote an awareness of what had happened in France during the last quarter of a century. In 1889 he arranged for lithographs by Degas and photographs of paintings by Manet to be shown, and pictures by Degas and Monet were hung at the Club's annual exhibitions in 1891, 1892 and 1893. In the long run a kind of diluted and attenuated Impressionism came to be accepted in England for the next half-century as a new kind of official art and the New English Art Club came to dominate that Royal Academy which it had originally intended to supplant.

German interest in French art had been stimulated by the international exhibitions which took place in Paris, and also as an indirect consequence of the war. At the International Art Exhibition held in Munich in 1869 the

371 BERNHARD SICKERT *The Old Curiosity Shop, Dieppe* 1886
The younger brother of Richard, Bernhard (1862-1932) described himself in catalogue entries as an 'English Impressionist' and was active in the affairs of the New English Art Club. Like his more famous brother he spent much time in Dieppe and painted a whole series of shop fronts.

works of Courbet had made a considerable impact, and started to influence a group of artists there who shared many of the initial impulses of Impressionism. These revolved around Wilhelm Leibl (1844-1900), who had lived and worked in Paris shortly before the outbreak of war and had won a gold medal at the Salon of 1869. Concentrating on 'realistic' subjects painted with great technical virtuosity, he often experimented with interesting manipulations of light and shade which he used to structure his compositions. The group around him included Carl Schuch (1846-1903) and Johann Sperl (1840-1914), all of whom tried to advance from the point reached by Courbet; in their case, however, this led them only marginally closer to Impressionism.

But it was in the new and more cosmopolitan capital, Berlin, that developments of greater interest took place. Here the most important figure was Max Liebermann (1847-1935), who had originally studied in Munich and then, like Manet, had fallen under the influence of Dutch artists such as Frans Hals and developed a taste for palette-knife painting. His deeper commitment to Impressionism came in the 1880s, when colour became

more of an optical experience in his works; partly from his appreciation of Degas, he also began to absorb the influence of Japanese prints. He was almost certainly affected by two exhibitions held in Berlin in 1882 and 1883. The first was devoted to a collection of ten Impressionist paintings owned by an anonymous 'Russian gentleman', who may have been Carl Bernstein, a cousin of Renoir's patron Charles Ephrussi (see p.248); the second was a selection of works shown by Durand-Ruel at the Gurlitt Galleries. The young Danish literary critic and historian Georg Brandes (1842-1927), whose brother was married to Gauguin's sister-in-law, wrote:

The first reaction among German painters was one of astonishment, almost consternation on the part of the youngest and most impressionable artists. Some did not know whether to take this seriously; one naively asked the owner whether he had actually paid for this mess of paint. However, even those who at the beginning had been the most amazed and dismayed came back after several days and asked to see the pictures once more. The impression had not left them a moment's peace, and they will, I think, in the end, include some of the new ideas in their work.

Liebermann certainly did, and a painting such as the *Terrace of the restaurant Jacob* (Plate 373) shows the extent

to which he manipulated light, shadow and form, dissolving them as it were in the colours he used. He, Lovis Corinth (1858-1925) and Max Slevogt (1868-1932) were known as the 'Triumvirate of German Impressionism'. This phrase is only meaningful if it indicates that for them Impressionism had made possible a liberation of light, colour and atmosphere which was to bring German painting into contact with the mainstream of European painting, and which was to lead in a decade or so to Expressionism, an art form more compatible than Impressionism with the romantic sensibilities of the country's cultural traditions. This was true of Corinth, who came from eastern Germany, and who had a tendency to paint pictures with titles such as *The childhood of Zeus* or *The judgement of Paris*. Slevogt on the other hand was especially admired for his sketches; these came closer to Impressionism than his more studied works, which mainly reflect the influence of Manet with an added element of theatricality.

Underpinning this interest in Impressionism on the part of German painters was a substructure of museum curators, critics and patrons who showed an early and informed interest in Impressionism and its significance. In the 1890s a number of German collectors in Berlin, Hamburg and Lübeck had started collecting Renoirs, influenced no doubt by the laudatory piece about him written in 1883 by Julius Meier-Graefe, who in 1902 published a book, *Manet und sein Kreis* ('Manet and his circle'), containing sections on Monet, Pissarro, Cézanne and Renoir. This

372 PHILIP WILSON STEER *Boulogne sands* 1888-91
Steer (1860-1942) studied at the Académie Julian, and was influenced by Whistler. Between 1887 and 1894 he emerged as England's most successful Impressionist painter, and later reverted to more traditional styles of painting.

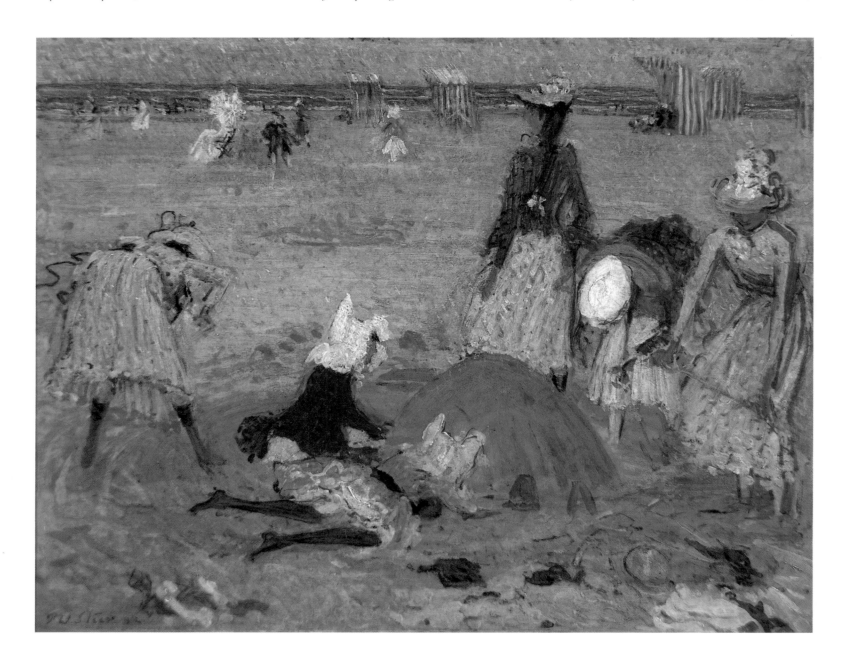

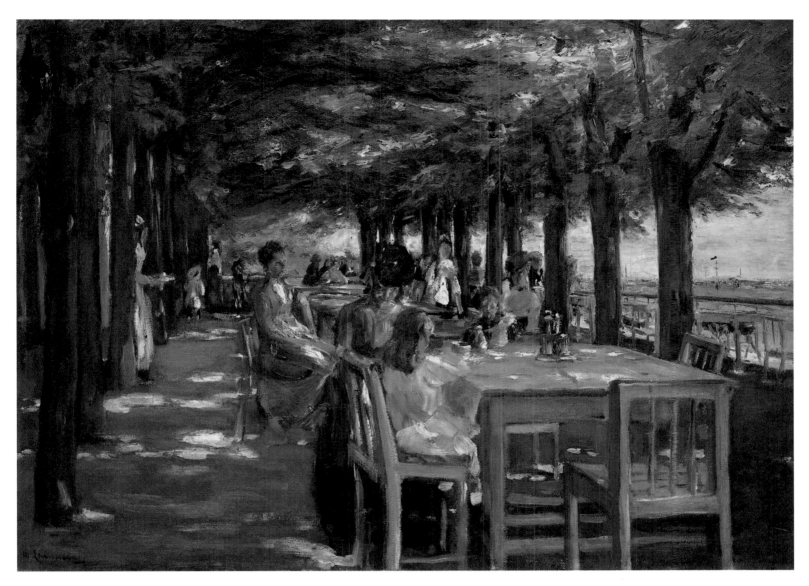

373 MAX LIEBERMANN *The terrace of the restaurant Jacob* 1902

was followed two years later by his *Der moderne Impressionismus*, largely devoted to Toulouse-Lautrec and Gauguin. But his most important contribution to establishing the status of the Impressionists was the amount of space he gave them in his masterly history of modern art, published in two volumes in 1908. An even earlier book on the same pattern had been written in 1893 by Richard Muther, Professor of Art History at Breslau University, which had been notably sympathetic to the Impressionists. Another outstanding patron of Renoir at this time was the Munich industrialist Franz Thurneyssen, who invited the painter to stay with him at Wessling; there Renoir painted the portrait of the family now in the Albright Art Gallery, Buffalo. Other collectors of this period included Graf Harry Kessler and Paul von Mendelssohn-Bartholdy.

At the heart of this Impressionist cult was the Berlin publisher, critic and dealer Paul Cassirer, who acted as Durand-Ruel's agent in Germany and was involved in the avant-garde magazine *Pan*. Another important figure was the writer Jules Lafargue, who had been Ephrussi's assistant at the *Gazette des Beaux-Arts*; he became a familiar figure in Berlin cultural circles and an habitué of the famous Bernstein salon.

What really established Impressionism as an acceptable and even popular art form, however, was the support given to it by Hugo von Tschudi, who in 1896 was appointed director of the National Gallery in Berlin. He was himself a rich man and a collector; his tastes had been deeply influenced by Max Liebermann, and he had acquired for himself a considerable collection of Impressionist paintings, many of which he hung in the gallery. His first purchase on taking office was Manet's *In the conservatory*, followed by works by Pissarro and Monet. In 1909, however, he ran foul of the quirky aesthetic sensibilities of the Kaiser and was obliged to resign his post, but was immediately offered the directorship of the Neue Staatsgalerie in Munich, where he continued his adventurous buying policy. Though von Tschudi's curatorial purchases were on a munificent scale, other German public art galleries were equally adventurous. The Städel Institute in Frankfurt bought a Sisley in 1899, a Van Gogh in 1908, a Renoir in 1910 and a Degas and a Manet in 1912. Bremen bought a Degas in 1903, a Monet in 1906, a Manet in 1908, a Pissarro in 1909 and a Van Gogh in 1911. The Wallraf-Richartz Museum in Cologne bought Gauguins in 1909 and 1913, Van Goghs in 1910 and 1911, a Renoir in 1912 (and a Picasso in 1914!). No other country, France included, had at this time a comparable record in public purchases of works by the Impressionists.

To many Russians, and that did not only include political refugees, France was a second homeland, and it was visited by Russian artists in increasing numbers. One of the most celebrated Russian painters of the nineteenth century, Ilya Repin (1844-1930), for instance, born the son of a

common soldier in the tiny provincial town of Chuguyev, who had achieved fame and distinction by his paintings of biblical scenes and the life of workers, arrived in Paris in 1873 and stayed there for some two years. Although deeply impressed by the old masters in the Louvre, he was fascinated by the work of the Impressionists, sometimes admiring them greatly, sometimes accusing them of shallowness and frivolity. But the paintings which he did there, especially of café life and landscapes painted *en plein air* on the Normandy coast, were clearly Impressionistic in style and approach, showing most strongly the influence of Manet. This experience was profoundly to modify his subsequent work, though often the nature of the Russian themes with which he dealt allowed it no greater effect than a brighter palette, a more vigorous brush-stroke and a greater concern with light and atmosphere.

By the late 1870s *pleinairisme* had become an accepted part of the more advanced Russian landscape tradition, as exemplified in the works of Alexei Savrasov (1830-97) and Ivan Shishkin (1932-98); but the dominant influence was a native one derived initially from French painters such as Corot, several of whose works were in the Kusheliev Gallery in St Petersburg. The 1890s saw the emergence of a number of painters whose work was close to mainstream Impressionism. Chief of these was the short-lived Isaac Levitan (1860-1900), one of whose works, *Twilight; haystacks* in the Tretyakov Gallery in Moscow, inevitably invites comparison with Monet's monumental series on the same theme (see pp.345-6). It is doubtful how much Levitan actually knew about the Impressionists themselves, but enough young artists were aware of them to create in Moscow a Union of Russian Artists, which played very much the same role of a nucleus of Impressionism as the New English Art Club did in England. It was in opposition to rival groups such as The World of Art Group, which supported the doctrines of *art nouveau*, and The Blue Rose which, as its name suggests, was a hotbed of Symbolism, both of them centred in St Petersburg. It was within the ambience of the Union of Russian Artists that both Wassily Kandinsky (1866-1944) and Kasimir Malevich (1878-1935) started their artistic careers; the latter was painting fully-fledged Impressionist paintings between 1905 and 1910.

The critical groundwork for the reception of Impressionism in Russia had been laid as far back as 1874, when Turgenev secured for Zola a job as Paris correspondent of the St Petersburg *Messager de l'Europe*, one of the main links between Russia and western Europe. Zola saw in the job an outlet for his views on the current French art scene less circumscribed by discretion than any hitherto available to him in Paris. Castigating vigorously the works of successful Salon painters, the prices their work fetched and their popularity amongst English and American collectors, he claimed that a new art was in the process of being born, headed by Manet, and outlined the general principles of Impressionism, whose works he lauded, quoting at length Théodore Duret's *Les Peintres impressionnistes*, an admirable and admiring account of the movement published in 1878.[5] Other Russian periodicals such as *Zoltoye Runo* ('The Golden Fleece') and *Apollon* published extensive comments on the Impressionists and their immediate successors, and scholars and critics of the calibre of Yakov Tugendhold and Sergei Makovsky established the credentials of the movement as an integral part of the development of Western art.

An even greater contribution to the status of Impressionism was provided by Russian collectors. Prominent amongst these was Sergei Shchukin (1851-1936) and his four brothers, who belonged to a family of rich Moscow textile manufacturers. He started collecting French paintings in 1890 on the death of his father, and then bought a massive house in Grizevets Street, where he built an art gallery. His early acquisitions had been works by Puvis de Chavannes and artists who painted French rural life, such as Lucien Simon and the ever-popular Charles Cottet. In 1897, however, he was introduced to the work of Monet by Fiodor Botkin, one of his mother's relations, who had lived for many years in Paris and who took him to Durand-Ruel's gallery. His first purchase was one of Monet's early works, *Lilac in the sun*, and over the years he increased his holdings of this artist's works. Eventually, with some 30 paintings in all, his became (until the opening of the Musée Marmottan) the most important collection of Monets in the world; it included several from the various series of haystacks, Rouen cathedral and the water-lilies at Giverny (see pp.345-8). A whole room in the gallery was devoted to 26 Renoirs, some of which had been originally bought by Sergei's brother Piotr, and there were important works by Pissarro, Sisley, Degas, Guillaumin and Cézanne. On Sundays Shchukin opened his gallery to the general public and mixed with the visitors, explaining the pictures and expatiating on their merits, thus making available to the Russian public an experience unobtainable even in France.

The other great Russian collectors, the Morozovs, were also brothers, whose father owned a textile mill in Tver. Mikhail (1870-1903), the eldest, who was also a literary critic, used to organize meetings of painters and writers at his house in Glazovsky Lane, and started buying works by the Impressionists including Manet, Renoir and Monet. His younger brother Ivan (1871-1921) had first come into contact with Impressionism when he was a student at the Ecole Polytechnique Supérieur in Paris. From 1903, when he bought Sisley's *Frosty morning in Louveciennes*, he continued for some time to spend between 200,000 and 300,000 francs annually on similar paintings. Ivan was influenced in his tastes by the Union of Russian Artists and was more rational in his collecting than Shchukin, who was more instinctive. He built a gallery in Prechistenka Street to accommodate the works he had acquired by Sisley, Renoir, Monet, Pissarro and Cézanne, but it was open to invited visitors only. After the Revolution of 1917 these collections were nationalized and are now divided between the Pushkin Museum in Moscow and the Hermitage Museum in Leningrad.

There had always been close links between Belgium, since its creation in 1830, and France, which shared with much of the country a common language and a common religion. These links were further strengthened since Brussels provided an easy place of refuge for French political dissidents of all shades of opinion, from

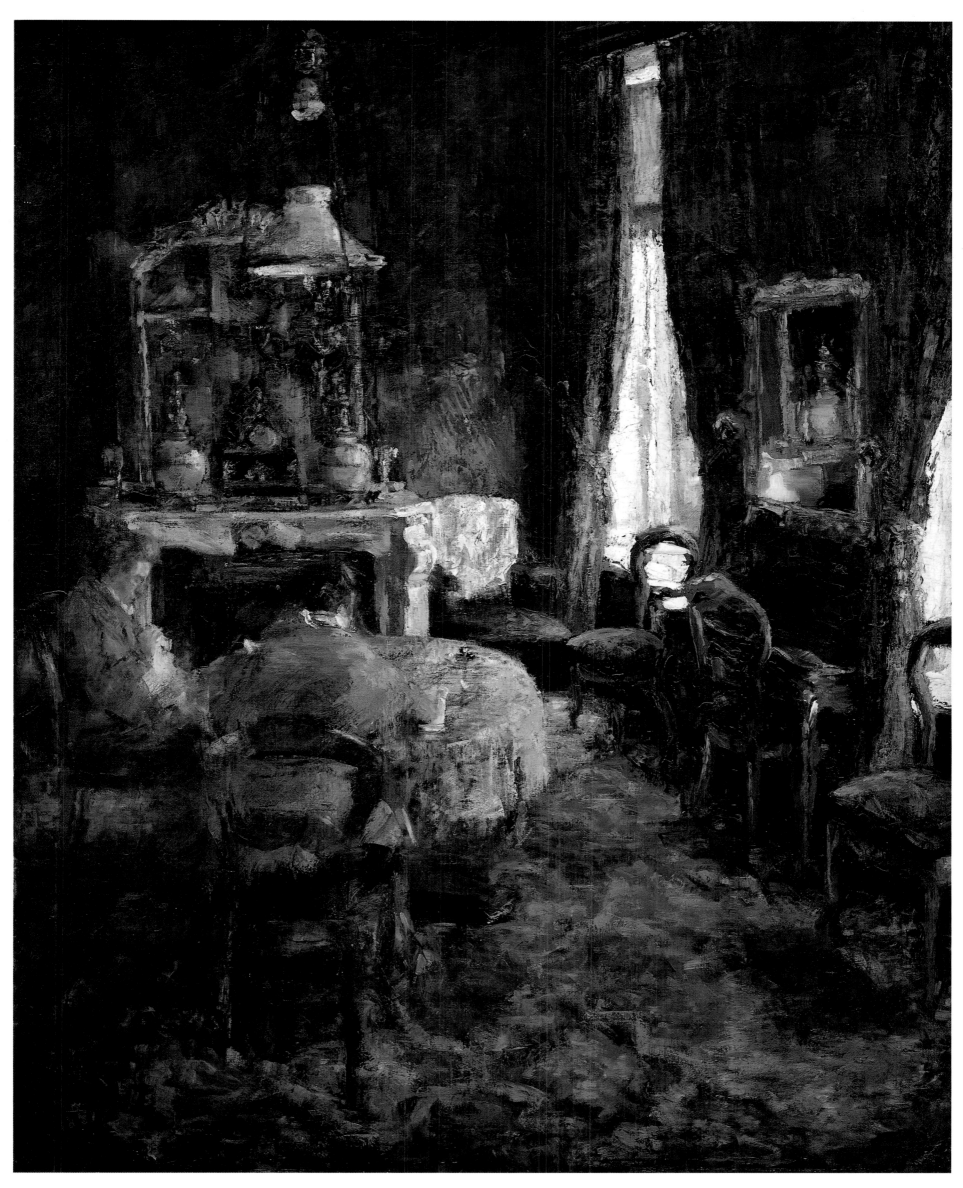

374 JAMES ENSOR *The bourgeois drawing-room* 1881
One of the founder members of the Brussels group Les Vingt, Ensor's early style gave place
in the 1880s to a more Impressionistic palette, and he was for long preoccupied with
depicting the effects of light, especially on domestic interiors, which later brought him close
to Bonnard and the Nabis.

Baudelaire to the right-wing General Boulanger. During the Franco-Prussian war more French artists went to Brussels than to London; they included Boudin and Diaz, who attracted a sizeable body of patrons there. Durand-Ruel opened a gallery in 1871 in premises on the Place des Martyrs which he had rented from a famous photographer, Ghemaand. It attracted an impressive list of clients, including the Prime Minister, Van Praet, and Pierre Allard, the director of the Mint. At first the taste was for the painters of Barbizon and for Courbet, who had always been favoured especially in Antwerp – his works attracted several collectors there. His kind of realism became the style of a group of painters which centred around the Société Libre des Beaux-Arts. Alfred Stevens (1823-1906), who built up a successful career as a portrait painter in Paris and was part of what might be called Impressionist society, being especially close to Manet and Fantin-Latour, was a member of this group. Closer to Impressionism at this time was the gifted Hippolyte Boulenger (1837-74), who was preoccupied with conveying the effects of light and atmosphere, and was especially attracted by extreme weather conditions and overtly

375 JAN TOOROP *Annie Hall at Lissadell* 1885
A barometer of the various stylistic influences at work in Holland during the late nineteenth century, Toorop (1858-1928) went through a marked Impressionist phase before going on to Pointillism and a kind of religious Symbolism.

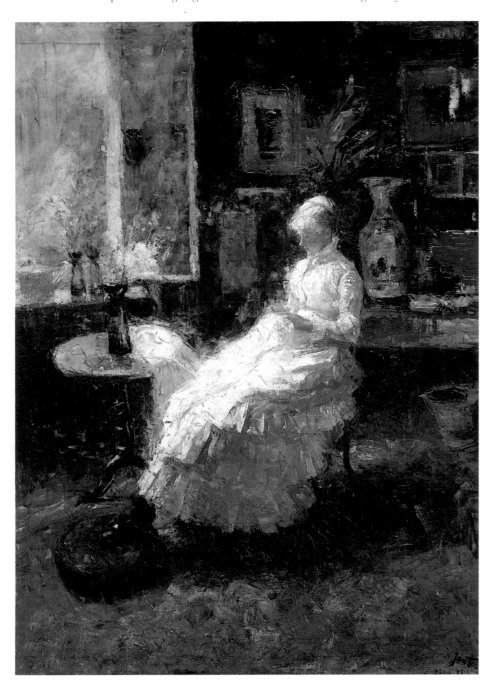

evocative landscapes. He established a group of artists with feelings similar to his own which he called the School of Tervueren, a village near Brussels where he lived. Prominent members were Alphonse Asselbergs (1839-1916) and Theodore Baron (1840-99) but, charming though their works often are, they had learnt to copy only the most superficial aspects of Impressionism.

In the 1880s, however, a new vitality began to appear in Belgian art, thanks very largely to the energy and imagination of a remarkable man, Octave Maus (1856-1919). Lawyer, musicologist, journalist, art critic, he founded a magazine, *L'Art Moderne*, which propagated the ideas first of Impressionism and then of its successors. In 1883 he became secretary of a group of artists which he had been mainly instrumental in founding, Les Vingt or, as they were usually referred to in print, Les XX, the name deriving from the fact that there were 20 founding members. They included painters whose names were to be synonymous with twentieth-century art in Belgium, and who, in the years preceding the Great War, practised in varying degrees an Impressionist style of painting: James Ensor (1860-1949), Henry van de Velde (1863-1957), Jan Toorop (1858-1928) and Theo van Rysselberghe (1862-1926). Of especial importance were the exhibitions which the group held every year, and which did a great deal not only to internationalize Belgian taste but to spread the fame and enhance the status of the participants. In 1886 Renoir sent eight works including *Madame Charpentier and her children* (Plate 227) and Monet exhibited ten; in subsequent years Pissarro and Bracquemond also featured. Cézanne, on being invited to participate in 1889, replied to Maus:

Having read your flattering letter, allow me first to thank you and I shall, with pleasure, accept your kind invitation.

However, will you allow me to refute the accusation of contempt you have made against me because of my refusal to participate in such exhibitions.

In this connexion I would say that, since the numerous efforts I have undertaken have yielded only negative results, fearing some all-too-justified criticism, I had made up my mind to work in silence until the time I could provide theoretical justification for the fruits of my efforts.

Faced with the pleasures of finding myself in such good company, I do not hesitate to alter my resolve, and I would ask you, Sir, to accept my thanks and my confraternal greetings.

In the event he sent several works including *The house of the hanged man* (Plate 203), borrowed from Chocquet.

The only Impressionist not to exhibit was Degas, although he was twice invited to do so. He had in fact visited Brussels in 1869, and his younger brother Achille wrote to their uncle Michel Musson in New Orleans:

Edgar has come with me to Brussels. He met M. Van Praet, a cabinet minister, who had bought one of his paintings which now features in one of the most important collections in Europe. This has given him great pleasure, as you can imagine, and has done something to re-establish his confidence in himself and his very real talent. He has sold two more works since he has been in Brussels and a very well-known picture dealer, Stevens, has offered him a contract at 12,000 francs a year.[4]

The initial contact between Holland and the Impressionists had occurred when Manet met the young Dutch girl, Suzanne Leenhoff, who later became his wife. He made

several visits there, and was almost as much influenced by Dutch art as by Spanish. His *Le bon Bock* (Plate 172) is indebted to Frans Hals, his portraits of Suzanne at the piano to Metsu's *Woman playing the clavichord*, and *The surprised bather* of 1860 to Rembrandt's *Bathsheba* in the Louvre.

Monet first visited Holland in 1871 at the instigation of Daubigny, who had spent some time there and had been deeply influenced by Dutch seventeenth-century landscape painters. Monet painted several views of Holland, marked by a certain sombre quality and heaviness of texture. He made subsequent visits in the 1880s, on one occasion to paint the tulip fields at the invitation of Baron d'Estournelles de Constant, secretary in the French Embassy at The Hague. His original interest in Holland must have been kindled by a close friend who had a great influence on his early work. Johann Barthold Jongkind (1819-91) had been born at Latrop near Rotterdam and, after studying art at The Hague, came to Paris, settling there in 1861. His sense of colour and concern with light and atmosphere, as well as the spontaneity of his brushwork, transmitted to the Impressionists something of the quality of a specifically Dutch tradition.

The flowering of this tradition in the late nineteenth century was reflected in nearly all the works of the so-called Hague School, consisting of painters such as J.H. Weissenbruch (1824-1903) and Jacob Maris (1837-99), all of whom were oriented towards selective aspects of Impressionism – the urban scenes of G.H. Breittner (1857-1923) are remarkably similar in their photographic perspectives and their sense of immediacy to some of Caillebotte's works. On the whole, however, the Dutch were more concerned with the expression of feeling than with that pragmatic exploration of form and colour which exercised the Impressionists.

The Scandinavian countries had always been inclined towards a form of landscape painting with strong romantic undertones. By the 1870s its exponents were being

576 NILS KREUGER *Old country house* 1887
Kreuger (1858-1930) was the leading figure in the rejuvenation of Norwegian landscape painting in the nineteenth century, as a result of his stay in Grez-sur-Loing just south of Barbizon, where he was initially influenced by Bastien-Lepage and then by the Impressionists.

overtaken by changing modes of expression, of which the Impressionists were the most coherent and innovative advocates. These changes were largely initiated by artists such as the Swedes Karl Frederick Hill (1849-1911) and Nils Kreuger (1858-1930), who had studied in Paris and picked up a style reflecting that of the Barbizon painters and Bastien-Lepage. This kind of work was disseminated largely by the various artistic colonies – the Swedes and Finns at Lemland, the largest of the Aland Islands, and the Norwegians on the farm of Erik Werenskiold (1855-1938), who spent a good deal of time in Paris and there picked up a knowledge of Impressionist techniques. He and many other Scandinavian painters of the latter part of the nineteenth century were especially attracted to the notion of realism which had informed so much French painting after Courbet, especially as many of them were beguiled by both bucolic idealism and social preoccupations of one kind or another. This was especially true of the popular Carl Larsson (1853-1919), who came from a Swedish working-class background and first became famous as an illustrator. In 1882 he went to stay and work at Grez in the forest of Fontainebleau. This experience converted him into

a kind of crypto-Impressionist, exemplified in works such as *Old man and new planting* of 1883 (Plate 377), with its limpid light, its Corot-like tonality and delicate brushwork.

Grez was to become the centre of a whole colony of Scandinavian artists for some 20 years, its activities reported avidly in the Swedish press, not least by one of its members, August Strindberg. An active painter, though much more famous as a writer, Strindberg was always to practise a Post-Impressionist style which came closer to Expressionism than anything else. Grez, where 20 or more Swedish artists found an idyllic retreat from the more puritanical rigours of their homeland, was to be a consistent channel for the introduction into the whole of Scandinavia of French ideas about painting. The effectiveness of this contact can be gauged from the knowledge that the museum of Helsinki acquired a Van Gogh in 1903 and a Cézanne in 1916.

A key figure in the dissemination of paintings by Impressionists and those connected with them was Prince Eugen (1865-1947), a son of King Oscar II of Sweden and Norway, whose own paintings infused elements of Impressionism into symbolic landscapes suggestive of the influence of Odilon Redon. He bought works by the Impressionists for his own private collection, and for the national museums. In 1913, for instance, Mary Cassatt told Durand-Ruel that he had paid 25,000 francs for a Degas. Eugen's niece Margaret, daughter of the Duke and Duchess of Connaught and a granddaughter of Queen Victoria, arrived in Sweden in 1905 to marry the future King Gustav VI Adolf. She had previously spent some time in Paris and Giverny studying painting with Monet, whose work had a crucial influence on her own paintings. Some of these were on view at the significant Baltic exhibition at Malmö in 1914, organized by her friend the architect Ferdinand Boberg, which was a catalyst for future artistic developments in the Scandinavian countries.

Monet's influence in Norway was enhanced by his personal knowledge of the country, acquired during the 1880s and in 1895 when he visited his stepson Jacques, who had settled there. Despite his initial dislike of Christiania (now Oslo), he came to appreciate the more remote town of Sandviken, dominated by Mount Kolsaas, which enraptured him and of which he did several paintings. He wrote to his stepdaughter Blanche Hoschedé on 31 March 1895:

The fjord and its surroundings were marvellous and have given me an enormous pleasure. I have a delicious motif there of little islets, almost level with the water, and a mountain in the background. One would say it was Japan, which is a common experience in this country. I am at work on a view of Sandviken, which looks like a Japanese village, and I am also doing a mountain which one can see from anywhere here and which makes me think of Fuji-Yama.

During this visit a fellow-guest was the young Norwegian poet Henri Bang, who wrote a lengthy interview with him; published in the *Bergens Tiede* on 6 April, it is a totally convincing exposition of his personality:

One evening when he came back after ten hours of work in the bitterly cold Norwegian air, watching the sun and the colours of the landscape, this 60-year-old said:

'No, it was no real hardship, and anyway what else could I have expected? I am chasing a dream, I want the unobtainable. Other artists

377 CARL LARSSON *Old man and new planting* 1883

378 JEAN-FRANÇOIS RAFFAELLI *Guests waiting for the wedding* 1881
Although he participated in the Impressionist exhibitions of 1880 and 1881,
mainly on the insistence of Degas, Raffaëlli was never really an Impressionist,
painting in a style which a later generation would have called 'magic realism'.
Painter, sculptor, lithographer and writer, he was a master of urban genre scenes
such as this.

paint a bridge, a boat, and that's the end. They're finished.

'I want to paint the air which surrounds the bridge, the house, the
boat, the beauty of the air in which these objects are located, and that is
nothing short of impossible. If only I could satisfy myself with what is
possible.'

At the heart of the relationship between the Impressionists
and Italy was Degas, whose family came originally from
Naples, although the political vicissitudes of that kingdom
under the Bourbon kings had forced most of them
elsewhere. His cousin Gustavo Morbilli had been shot in
the rising of 1849; his father's sister had married Gennaro
Bellelli (see p.95), and they lived in exile in Florence with
their two children. Strong though his family loyalty was,
other considerations drew Degas to Italy. He was deeply
attracted to the Italian art of the Renaissance, which had a
marked influence on his own style (see p.92), and between

the ages of 22 and 25 he spent most of his time there,
working in Rome, Naples and Florence as well as visiting
Siena, Pisa and Venice. He did everything he could to help
Italian artists in Paris, insisting, despite a lot of opposition,
on the inclusion of de Nittis, Zandomeneghi and Raffaëlli
in the seventh Impressionist exhibition. He also maintained
close contacts with Diego Martelli (see p.384), Carlo
Pellegrini and other Italian artists and writers.

Manet's first visit to Italy had been in 1853 in the
company of his brother Eugène, when he visited Venice,
Florence – where he copied paintings by Ghirlandaio and
Filippo Lippi – and Rome. He returned four years later in
the company of the sculptor Eugène-Cyrille Brunet, when
he apparently copied Andrea del Sarto's frescoes in the
cloisters of the Annunziata in Florence. In the summer of
1875 he went for a few months to Venice, staying at the
Palazzo Barbaro, which had been rented by the American
Curtis family (who later bought it). His reactions to Italian
art in general and Venetian art in particular were not
friendly. The painter Charles Troché met him one evening
in a little restaurant opposite the Giudecca, and afterwards
explored the city with him, recording his comments:

One morning I was looking with him at *The Glory of Venice* [Veronese?]
in the Ducal Palace. 'There's something about it that leaves one cold,'

he said. 'So much useless effort, so much wasted space in it. Not a shadow of an emotion. I like the Carpaccios, they have the naïve grace of illuminations in a missal. And I rank highest of all the Titians and Tintorettos of the Scuola di San Rocco. But I always come back, you know, to Velasquez and Goya.'

Tiepolo irritated him. 'These Italians get boring after a time with their allegories and their *Gerusalemme Liberata* and their *Orlando Furioso*, and all that noisy rubbish. A painter can say all he wants to with fruits, or flowers, or even clouds...'

In October 1881 Renoir set out on a two-month visit to Italy, painting energetically wherever he went, from views of Venice in the north to a portrait of Wagner, which he sketched out in the Villa Gangi in Palermo on 14 January 1882. In Rome he was deeply impressed by the Raphael frescoes in the Villa Farnesina, and even more so by the Greco-Roman paintings at Pompeii. They gave him an understanding of what he described as 'the grandeur and simplicity of the ancient painters', and this led to a profound change in his style (see p.293), combining a clarity of outline in the dominant figures with unalloyed Impressionist settings.

Monet was ravished by his visit to Venice in 1908, writing to Geffroy:

Absorbed as I am in my work, I left my wife the task of writing to you and giving you the news. She no doubt told you of my enthusiasm for Venice. Well, it increases day by day, and I'm very sad that I shall soon have to leave this unique light. It's so very beautiful but we must resign ourselves to the inevitable, we have many pressing obligations at home. I comfort myself with the thought that I'll come back next year, since I've made some studies, some beginnings. But what a shame I didn't come here as a younger man, when I was full of daring! Still, I've spent some delightful hours here, almost forgetting that I'm now an old man.

He did not, in fact, return but made the sketches and studies into full-scale paintings at Giverny.

The reactions of Italian artists to Impressionism were complicated by the fact that painting there had, for some time, been developing along rather similar lines. Romanticism as a style had started to lose its impact in Italy in the 1850s, and in 1855 there emerged a group of artists centred on the Caffé Michelangioli in Florence, who came to be called the Macchiaioli (the word means blots or stains and is not far removed in implication from the French word 'taches'). Their initial impulse had come from one of their number, the flamboyant Neapolitan Domenico Morelli (1823-1901), who had been very impressed during a visit to the Paris Exposition of 1855 by the works of the Barbizon School, as well as by those of such comparatively academic painters as Rosa Bonheur. He influenced a number of his contemporaries to paint in a style which involved vigorous brushwork, strong *chiaroscuro* and brilliant colouring. Fired by the political passions of the Risorgimento, which set a premium on innovation and on opposition to official attitudes in any sphere of life, his followers proceeded further along the paths which the Impressionists were taking in Paris. They took up *plein-air* painting with fervour; they began to experience the impact of photography through the camerawork of such firms as Alinari of Florence; and their political convictions predisposed them to deal with realistic themes.

An increasing number of Italian artists began to visit Paris. One or two stayed there, chief amongst whom was Federico Zandomeneghi (1841-1917). He arrived in 1874 and became acquainted with Renoir, Pissarro and Degas, who took him under his wing and ensured that he participated in four of the Impressionist exhibitions. Durand-Ruel also took him up, and he had considerable success, especially with his pastels. Whatever his merits as an artist, however, Zandomeneghi's major contribution to the establishment of links between Italy and Impressionism was through his friendship with Diego Martelli (1836-96). A man of some wealth who had an estate at Castiglioncello, a coastal resort near Florence, Martelli was both a painter and an art critic. He was a most consistent and enthusiastic supporter of the Macchiaioli, affording them publicity in the magazines to which he contributed, and giving them more tangible types of support. Although he was a frequent visitor to Paris, his outlook for some considerable time was dominated by the concept of realism, and his enthusiasms were limited to the works of Courbet, Millet and Corot. After 1874, however, the frequent letters which Zandomeneghi sent him from Paris stimulated his interest in the Impressionists and their potential links with the Macchiaioli. He became especially close to Pissarro, who explained with his usual clarity and sense of conviction the principles of the group.

In September of 1878 Martelli persuaded Pissarro and Degas to send two works each to the annual *Promotrice* exhibition in Florence, the showcase of the Macchiaioli. They were not well received. One of the Macchiaioli, Francesco Gioli, wrote to Martelli:

When I tell you that I do not like Pissarro at all you are not pleased and it seems to you a position I have taken to go along with the majority. Nothing could be further from the truth. I went on my own to see Pissarro's pictures, without prejudice and with my eyes wide open, and I was not impressed with the painting...The cabbage, which you say is the more beautiful of the two, strikes me as being worthy of an untalented boy...I went back to see them again; I had been told that what was necessary to assess the artist was the whole, the total impression, the feeling of the subject, in short the characteristics of the totality of the colour, the tonal values and the ambience. With much effort I succeeded in finding one small good passage of painting next to another, but then immense gaps where I could find nothing but emptiness. This is my opinion, and perhaps it is not the best, but it is shared by others.

In the event Martelli bought the paintings himself. On the whole, Italians tended to find the Impressionists 'formless', but Martelli saw in the movement the kind of doctrines which would give the Macchiaioli the artistic coherence they needed. His efforts were indefatigable. Nobody was better qualified than he. He had a reputation as a critic which had spread far beyond Italy, and an understanding of the nature of Impressionism unrivalled even by his French contemporaries. In 1877 he gave a lecture to the Circolo filologico of Livorno – one of those cultural clubs so popular in Italy at the time, which were important agencies in effecting political and philosophical changes – in the course of which he gave an analysis of the movement which could hardly be bettered:

Impressionism is not only a revolution in the field of thought, it is also a revolution in the physiological understanding of the human eye. It is a new theory which depends upon a different mode of perceiving the sensation of light and of expressing impressions. The Impressionists did

379 EDVARD MUNCH *The rue Lafayette* 1891
Living in Paris in the late 1880s, Munch was in close contact with Impressionist
circles and was considerably influenced by Pissarro and Monet, whose styles are
reflected in this street scene.

not construct their theories first and then adapt their paintings to them after the fact but, on the contrary, as is usual with all great discoveries, the paintings were born out of the unconscious processes of the artist's eye, which, when considered later on, gave rise to the reasoning of the philosophers.

Until now, drawing has generally been believed to be the firmest, most certain and positive part of art. To colour was conceded the unpredictable magic of the realm of the imagination. Today we can no longer reason in this manner, for analysis has shown us that the real impression made on the eye by objects is an impression of colour, and that we do not see the contours of forms but only the colours of these forms.

By the end of the century Impressionism was established as the 'style' used by what had now become accepted as an essential part of the art world, the progressive avant-garde. In Barcelona, for instance, the 19-year-old Pablo Ruiz Picasso was painting pictures which showed strong Impressionist influences. A year or so later he would fall under the influence of Toulouse-Lautrec, who considered himself the follower of an unappreciative Degas. There were indeed hardly any of the artists who were to dominate European painting in the first half of the twentieth century who did not start their careers under the umbrella of Impressionism. Edvard Munch, who was to be one of the founding fathers of Expressionism, had been galvanized by the work of Caillebotte and was hailed at the time as 'Norway's first and only Impressionist'. For five years Malevich painted Impressionist works, and in 1895 the young Kandinsky saw one of Monet's *Haystacks* in the Shchukin collection in Moscow, later writing:

Previously I only knew realistic art. Suddenly for the first time I saw a 'picture'. The catalogue informed me that it was a haystack, but I could not make it out. This inability to recognize it upset me; I also felt that the painter had no right to paint so indistinctly. I had a muffled sense that the object was missing in this picture, and was overcome with astonishment and perplexity that it not only engraved itself indelibly on my memory but unexpectedly, again and again, hovered before my eyes down to the smallest detail. All this was unclear to me, and I could not draw the simple consequences from this experience. But what was absolutely clear to me was the unsuspected power previously hidden from me of the palette, which surpassed all my dreams. Painting took on a fabulous strength and splendour and unconsciously the object was discredited as an essential element of the picture.

There could be no more cogent description of the parentage of even the most absolute forms of abstraction, as indeed of most subsequent movements in European art, with the exception of Surrealism.

This needs constant emphasis, if only because the word Impressionist has involuntarily assumed a whole range of meanings which have little to do with its real significance. It is still used to denote anything which the viewer finds difficult, and is applied to sculpture, music and even literature as being vaguely synonymous with modern. It is used to describe any style of art which does not possess clearly defined and articulated outlines. It is applied to a style of painting which until the 1920s was considered 'advanced' and then became the accepted visual idiom of academicians and a large proportion of amateur painters. But it was much more than that. As Kandinsky suggests, it freed painting from dependence on the object as its *raison d'être*. It abrogated almost completely those categories of subject-matter, religious, historical and narrative, on which the relative importance of works of art had previously depended. It set art firmly within the context of its own time, dealing with contemporary life and with those classes of society which dominated the modern world. In their approach to matters of technique, the Impressionists relied heavily on science, the dominant discipline of their age. In their rejection of preconceived notions, not only of what an artist should paint but of what he should actually *see*, they rejected the concept of the outline as the determinant of form, and put into practice what Bishop Berkeley had first noted in 1707:

All that is properly perceived by the visive faculty amounts to no more than colours, with their variations and different proportions of light and shade. What we strictly see are not solids, nor yet planes variously coloured; they are only diversity of colours and some of these suggest to the mind solids, and others plane figures, just as they have been experienced to be connected with one or the other.

The Impressionists in their varying ways — and their great diversity must be recognized — were a group of painters who vindicated, probably for the first time in history, the notion that a painting is, as Maurice Denis expressed it (see p.304), 'essentially a flat surface covered with colours arranged in a certain pattern'. They introduced into art, too, a preoccupation with recording time, with catching the instant before it is gone, the light before it changes, the gesture before it becomes a stance. They used the great discovery of their fifteenth-century predecessors, perspective, not as a rule but as a tool, in their exploration of experience. They discovered that colours were not merely what the labels on a lead tube said they were. Words are only rough guides to the complexity of reality. What we call the Renaissance is a notion only a century and a half old; Ruskin used it first in English in 1851 and in France Michelet adopted it three years later; but as a concept more varied in its manifestations, more disparate in its motivations than any one word can encompass, it is one of the realities of history. The same can be said about Impressionism: if it had not existed, to paraphrase Voltaire, we would have had to invent it.

[1] In 1879 the Society of American Artists invited her to participate in their second exhibition.

[2] After his death Hill's collection was sold at Christie's on 25 May 1889 and included the following: *Pas de deux*, 41 guineas; *Maître de ballet*, 54 guineas; *A rehearsal*, 60 guineas. Sickert paid 66 guineas for another version of the same work, and the art dealer Goupil, active in this area, paid 61 guineas for *Ballet girls*; prices which, though not high, were at the time reasonable.

[3] Zola's St Petersburg articles are to be found in E. Zola, *Salons*, Geneva-Paris, 1959, passim.

[4] Arthur Stevens, himself a painter as well as a dealer, was the brother of Alfred. Nothing seems to have come of this contract. It is perhaps worth noting in this context that the only painting to be sold by Van Gogh in his lifetime was bought by a Belgian collector, Anna Boch, for 400 francs.

580 HENRI DE TOULOUSE-LAUTREC *Rice-powder* 1888
For most of his short career Toulouse-Lautrec's oil paintings showed his dependence
on Impressionist techniques and subject-matter. This picture of a putative prostitute, sitting
with her jar of cosmetic rice-powder in front of her, recreates an image made familiar by
Manet, Van Gogh and especially Degas, Lautrec's idol.

381 PAUL GAUGUIN *Garden in the snow* 1883
Painted in the year in which he finally gave up his banking job, this landscape reveals how
completely Gauguin had absorbed the techniques of the Impressionists – especially that of
Pissarro.

382 PAUL GAUGUIN *On the beach at Dieppe* 1885
In the summer of 1885 Gauguin visited Dieppe and, although he complained of a lack of
suitable sites, painted this view of the beach, which clearly owes a good deal to Monet's
paintings of the same area.

383 GEORGES SEURAT *Sunset* 1881
Seurat was 21 when he painted this picture and had only just returned from doing his year
of military service at Brest, where he filled his notebooks with impromptu sketches. His
painting was still very much under the influence of both Delacroix and the Impressionists,
except that, as this work shows, he laid more emphasis on broad tonal areas.

384 GEORGE HENRY *Autumn*
Henry (1859-1943) was one of the group of 'Glasgow Boys' who, together with Charles Rennie Mackintosh, gave their city international cultural renown at the end of the century. In close contact with France, they were mainly influenced by Bastien-Lepage, and then by the Impressionists. Henry's later work suggests the impact of Gauguin.

385 MAXIMILIEN LUCE *View of Montmartre* 1887

Painted in the year after the last Impressionist exhibition, Luce's view of the seedier, more industrialized aspects of Montmartre reflects to a certain extent his own political convictions and his belief that art should concern itself with the lives and background of the working classes rather than of the bourgeoisie – on his death in 1941 he was still a member of the Communist party. At the same time, however, it is a striking example of how far the example of the new Pointillist ideas had influenced artists who would otherwise have continued painting in the style of the Impressionists. Indeed, even one of their own number, Pissarro, the first owner of this work, was seduced into this new way of painting. It had all the attractions of a new orthodoxy, as Signac, another convert, wrote: 'Our formula is certain, demonstrable, our paintings are logical, and no longer done haphazardly, right or wrong, like those of earlier times'. Pointillism was a method of painting using tiny juxtaposed dots of colour which mix in the eye of the spectator, and it was therefore a development of practices initiated by the Impressionists, who had not attempted to create a stylistic syntax out of it. There were few Pointillists, however, who achieved the purity of execution attained by Seurat and his most devoted follower, Signac. Although in this painting Luce employs the small dots and the colour technique of Seurat, he does so in a very unmathematical and 'painterly' way. The sort of Pointillism which he exemplifies is very similar to that practised by artists such as Pissarro, Gauguin and Van Gogh, in whose artistic careers Pointillism formed a comparatively brief episode, though he himself never moved into any other style.

386 HENRI MATISSE *The courtyard of the mill at Ajaccio* 1898
When Matisse painted this picture he was just 19 and had been overwhelmed by the
Caillebotte Collection (see p.347) which had recently been hung in the Luxembourg. He
had also received a good deal of friendly advice from Pissarro, who suggested that he go to
London and look at the Turners. This Matisse did, and then went on honeymoon to Corsica.
The combination of the two experiences brought a new chromatic vigour into his work.

387 KER-XAVIER ROUSSEL *Haystacks at the seashore* 1894
The appearance in Maurice Denis's *Homage to Cézanne* (1901) of Roussel indicates his
artistic lineage. Although he was a member of the Nabi group, the lightness of his palette and
the clear influence of Monet on his work suggest the debt he owed to the Impressionists.

589 GIOVANNI FATTORI *Lancer by the sea c.* 1895
Born in 1825, Giovanni Fattori was one of the older generation of Italian painters who, as this
work shows, had absorbed the influence of both Courbet and the Impressionists. Fattori was
in very close contact with Degas during the latter's stay in Florence, and there are clear signs
of interdependence in their works.

388 LUCIEN PISSARRO *Blossom, sun and mist* 1914
The eldest son of Camille, who nurtured his artistic growth, Lucien (1865-1944) settled in
England in 1890, and having abandoned his earlier flirtations with Pointillism became an
active member of groups such as the New English Art Club, the Camden Town Group and
the Fitzroy Street Group.

390 VICTOR PASMORE *Green landscape with a gate* 1941
The persisting influence of Impressionism is manifest in many places at different times. In the late 1930s Britain saw the emergence of the Euston Road School which, revolting against the formalism of the School of Paris, went back to Impressionist beginnings to create an art comprehensible to ordinary people. Pasmore, the most brilliant painter of the group, later became an abstractionist.

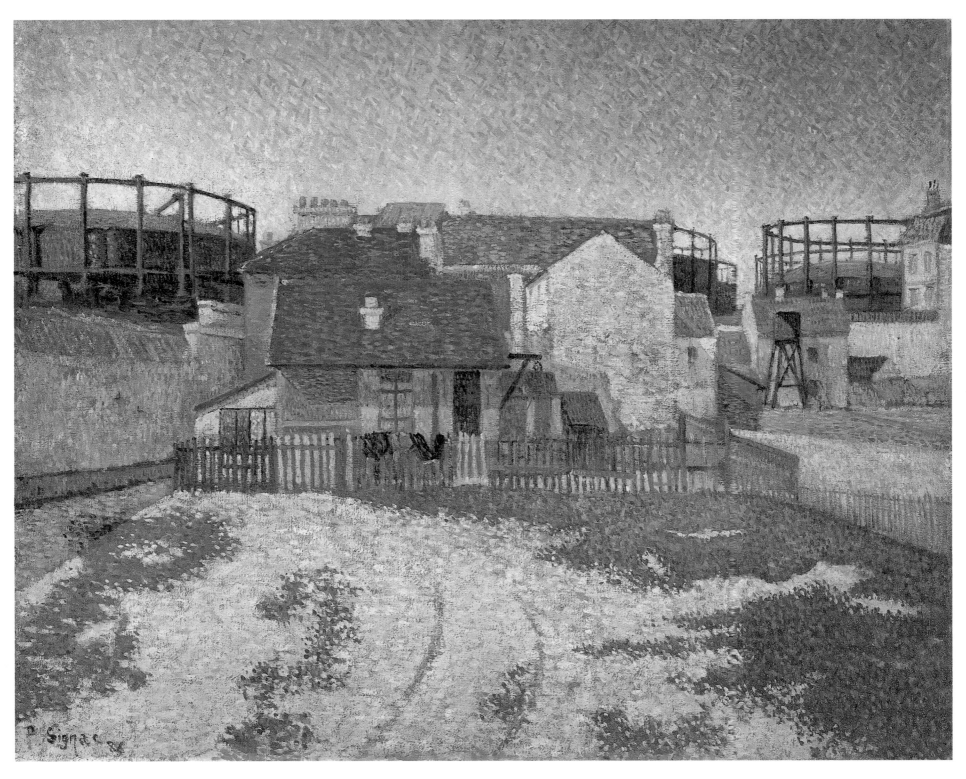

391 PAUL SIGNAC *Gas tanks at Clichy* 1886
Shown at the eighth Impressionist exhibition, this painting, with its embryonic Pointillism,
underlines the schisms which were taking place amongst the group.

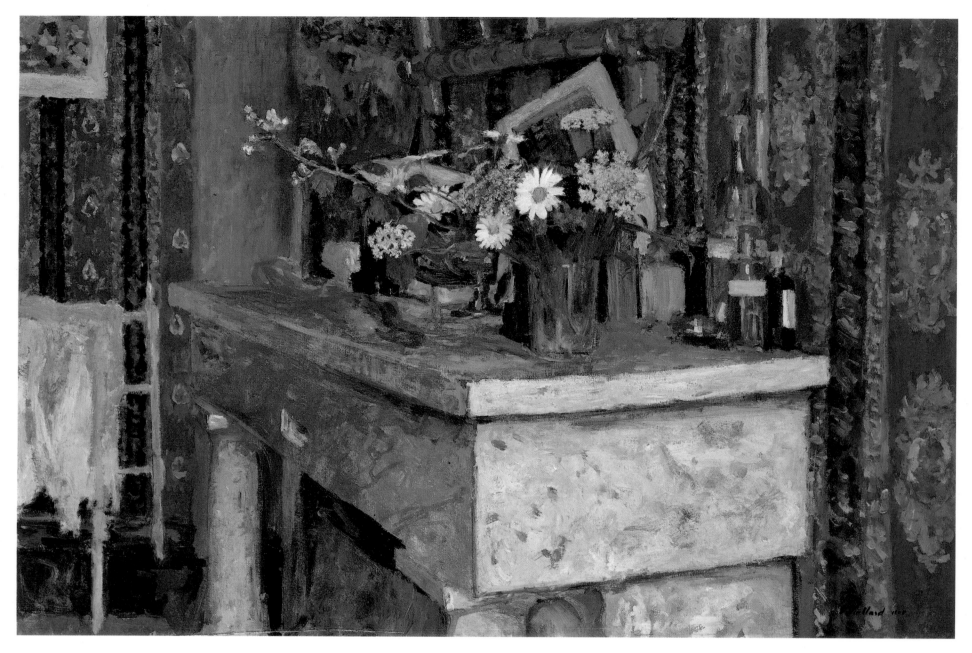

392 EDOUARD VUILLARD *The mantelpiece* 1905
One of the main legacies of Impressionism to its immediate heirs, the Nabis, was a passion for
the cosy intimacies of the bourgeois domestic scene. Both Vuillard and Bonnard mined this
rewarding seam, sometimes, as here, in a style which showed the influence of their
predecessors.

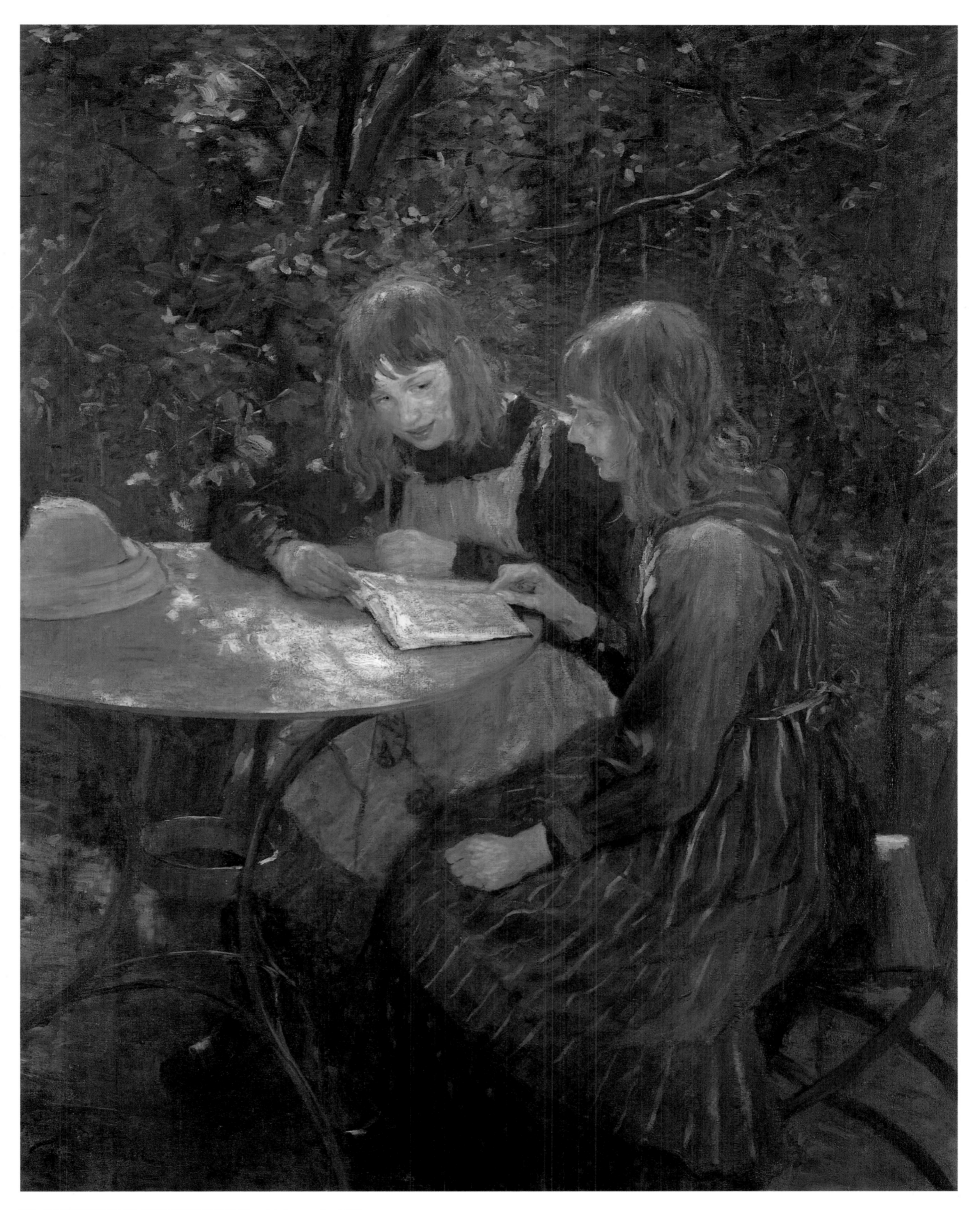

393 FRIEDRICH KARL HERMANN UHDE *Two girls in a garden* 1892
Beginning his career as an army officer, Uhde (1848-1911) turned to painting and became
leader of the Munich Secession, which was the centre of Impressionist influences in
Germany. Too often, however, his paintings have a spiritual or symbolic significance.

CHRONOLOGY

THE ARTISTS	DATES	BORN
PISSARRO, Camille	1830-1903	St Thomas, Virgin Islands
MANET, Edouard	1832-1883	Paris
DEGAS, Hilaire-Edgar	1834-1917	Paris
SISLEY, Alfred	1839-1899	Paris
CEZANNE, Paul	1839-1906	Aix
MONET, Claude	1840-1926	Paris
BAZILLE, Frédéric	1841-1870	Montpellier
MORISOT, Berthe	1841-1895	Bourges
RENOIR, Pierre-Auguste	1841-1919	Limoges
GUILLAUMIN, Armand	1841-1927	Paris
CASSATT, Mary	1845-1926	Pittsburgh
CAILLEBOTTE, Gustave	1848-1894	Paris

Impressionists and their Associates

1855

The World's Fair is held in Paris. The art section is devoted to Ingres. Delacroix and Rousseau. Courbet sets up his own Pavillon du Réalisme. Baudelaire writes a panegyric of Delacroix.

MANET	is at the Ecole des Beaux-Arts under the tutelage of Couture.
DEGAS	abandons his law studies and commences work at the Ecole des Beaux-Arts under Lamothe; makes summer trip to S. France and Italy.
PISSARRO	arrives in Paris from the Virgin Islands; visits Corot; enters the Ecole des Beaux-Arts then changes soon after to l'Académie Suisse.
CEZANNE	is at college at Aix; MONET living with his parents at Le Havre; RENOIR and SISLEY with theirs in Paris, BAZILLE at Montpellier and MORISOT at Bourges.

1856 and 1857

Delacroix is elected to the Institut de France.
Bracquemond discovers Japanese prints e.g. Hokusai's *Mangira*.
Duranty publishes the art periodical *Le Réalisme*. Millet exhibits *The gleaners*.

DEGAS	after returning to Paris January to April travels to Italy again, visiting Florence, Rome and Naples.
MANET	leaves Couture's studio; travels in Holland, Germany and Italy. Copies at the Louvre.
PISSARRO	paints in the countryside round Paris.
MONET	tries his hand at caricature in Le Havre.
RENOIR	is apprenticed to a porcelain painter; takes evening classes in drawing.
SISLEY	is sent to England to study commerce.
MORISOT	studies painting with Chocarne, then Guichard, a pupil of Ingres and Delacroix.

Other Events

1855

Crimean War: Fall of Sebastopo
Whitman publishes *Leaves of Grass*. Kierkegaard dies.

1856 and 1857

Anglo-Persian War; End of Crimean War. Peace Congress in Paris. Birth of G. B. Shaw. Deaths of Heine, Schumann. Victor Hugo publishes *Les Contemplations*. Liszt *Preludes*. Birth of Oscar Wilde, George Moore. Deaths of Alfred de Musset and Glinka. Baudelaire publishes *Les Fleurs du mal*, Flaubert *Madame Bovary*: both prosecuted for offending public morality. Introduction of the cage crinoline in women's fashions. Spectrum analysis of light by Kirchhoff and Bunsen.

1858 and 1859

Baudelaire writes a Salon review. Birth of Seurat.

DEGAS	paints the *Portrait of the Bellelli Family* in Florence; copies and studies Italian painting in Pisa, Rome, Siena; returns to Paris and his own studio in rue Madame.
MANET	submits work which is rejected at the Salon despite Delacroix's backing.
PISSARRO	has a landscape accepted at the Salon; works at La Roche-Guyon and Montmorency; meets Monet at L'Académie Suisse.
MONET	meets Boudin; goes to Paris (1859) with introductions from Boudin to Troyon and Manginot; is advised by Troyon to study with Couture; frequents Brasserie des Martyrs.
CEZANNE	studies law at Aix but wants to become a painter; his father acquires Jas de Bouffan (1859).
RENOIR	abandons porcelain painting for other money-making activities, such as fan painting, to pay for his tuition fees in drawing.
SISLEY	continues his business studies in London whilst visiting museums and art galleries and getting to know the works of Turner and Constable.
MORISOT	copies old masters in the Louvre with her sister Edma; they meet Fantin and Bracquemond.

1860

Large exhibition of paintings by Delacroix, Millet and others of that generation. Birth of Sickert.

DEGAS	paints *Young Spartan girls provoking the boys*. Spends April in Florence.
MANET	rents studio in the Batignolles quarter.
PISSARRO	continues working in the countryside around Paris; commences liaison with his mother's maid, Julie Vellay.
MONET	works at Académie Suisse. Paints at Champigny-sur-Marne.
RENOIR	applies for permit to copy in the Louvre.
MORISOT	becomes interested in *plein-air* painting against advice of Guichard.

1861

Delacroix finishes the frescoes at St Sulpice. Corot works in Fontainebleau. Births of Maillol, Félix Fénéon.

DEGAS	paints *Semiramis founding a town*. Becomes interested in horses and racing subjects.
MANET	is successful at the Salon and gets an honourable mention; meets Duranty, Baudelaire.
PISSARRO	rejected at Salon; meets Cézanne and Guillaumin at Académie Suisse. Paints in Montmartre; applies for permit to copy at the Louvre.
CEZANNE	leaves Aix and law studies and goes to Paris; studies briefly at Académie Suisse; meets Pissarro; returns discouraged to Aix to work in father's bank.
MONET	does military service in Algiers.
MORISOT	is introduced to Corot, becomes his pupil, and establishes familial social relations with him.
CASSATT	begins studying at Pennsylvania Academy of Fine Art.

1862

Courbet opens a studio January to April.

DEGAS	paints at the races at Longchamp; establishes friendship with Manet and Duranty.
MANET	paints *La musique aux Tuileries*; inherits a substantial patrimony on the death of his father; becomes friends with Degas.
CEZANNE	has another attempt at studying painting in Paris but fails the entrance exams for the Ecole des Beaux-Arts.
MONET	completes military service. Lives and works in and around Le Havre with Jongkind, Boudin. Returns to Paris later and enters Gleyre's studio.

1858 and 1859

Slavery abolished in Russia. French acquire Indo-China. The Suez Canal is started. The first oil well drilled in Texas. Cathode rays discovered by Pückler.
Darwin publishes *The Origin of Species*.
Births of Leoncavallo, Puccini.
Deaths of de Quincey, Macaulay, Wilhelm Grimm.
Tennyson publishes *Idylls of the King*.
Wagner starts to compose *Tristan and Isolde*.

1860

The kingdom of Italy is formed. France acquires Nice and Savoy. Free Trade Treaty between France and England. Abraham Lincoln becomes President of the USA.
Births of Chekhov, Mahler, J.M. Barrie, Ensor.
Death of Schopenhauer.
In England Lister introduces surgical antisepsis and Bullock the rotary press.

1861

Civil War breaks out in USA. French expedition to Mexico.
Births of Maillol, Félix Fénéon.
Deaths of Prince Albert, Cavour, Elizabeth Browning.
Dostoyevsky publishes *House of the Dead*, George Eliot *Silas Marner*. Siemens invents the electric furnace in Germany.

1862

Bismark becomes Prime Minister of Prussia. Garibaldi defeated at Rome.
Foundation stone of the Paris Opéra by Garnier laid.
Births of Debussy, Maeterlinck, Briand.
Flaubert publishes *Salammbô*; Hugo *Les Miserables*, Turgenev *Fathers and Sons*, Spencer *Principles of Psychology*. Nobel uses nitroglycerin as explosive.

RENOIR joins Gleyre's studio.

SISLEY gives up commercial studies in England to paint at the Ecole des Beaux-Arts and in Gleyre's studio.

BAZILLE who had been studying medicine in Montpellier, arrives in Paris to continue this but also joins Gleyre's studio to paint.

1863

Ecole des Beaux Arts reorganized. Salon des Refusés is established and shows works by Manet, Pissarro, Jongkind, Guillaumin, Whistler, Fantin and Cézanne. Birth of Signac. Death of Delacroix.

MANET marries musician, Suzanne Leenhoff; has an exhibition at Martinet's which the public finds risible; exhibits *Le Déjeuner sur l'herbe* at the Salon des Refusés.

PISSARRO has a son, Lucien, by Julie Vellay.

CEZANNE works at the Académie Suisse; applies for permit to copy at the Louvre.

MONET paints in Fontainebleau forest; watches Delacroix at work in his studio.

RENOIR visits and copies at the Louvre.

SISLEY protests at changes in the rules of the Ecole des Beaux-Arts.

MORISOT works at Pontoise; meets Daubigny, Daumier, Guillemet; paints under guidance of Corot's pupil Oudinot; copies works by Corot; studies sculpture with Aimé Millet.

1864

Gleyre's studio is closed. Birth of Toulouse-Lautrec.

DEGAS paints several portraits of Manet.

MANET is unsuccessful at the Salon. Rents apartment on the boulevard Batignolles.

PISSARRO has two landscapes accepted at the Salon; continues working on country subjects at Montfoucault and La Varenne St Hilaire, being advised by Corot.

MONET works in Honfleur with Bazille, Boudin, Jongkind.

RENOIR works at Fontainebleau forest where he meets Diaz.

BAZILLE fails medical examinations and abandons the subject in order to paint full-time; works with Monet at Honfleur.

MORISOT exhibits two paintings in the Salon.

1865

Birth of Ambroise Vollard.

DEGAS exhibits medieval war scene at the Salon; continues copying in the Louvre.

MANET exhibits *Olympia* at the salon which is greeted with howls of angry protest, but 9 works at Martinet's are favourably received. He spends two weeks in Spain in August.

PISSARRO shows at Salon as 'pupil of Corot'; daughter Jeanne is born at La Varenne St Hilaire.

CEZANNE works in Paris all year at Académie Suisse; returns to Aix in the autumn.

MONET shares studio with Bazille in Paris; shows two pictures at the Salon; paints *Déjeuner sur l'herbe* in Fontainebleau; is subsequently at Trouville, where he works with Courbet.

RENOIR exhibits two paintings at the Salon; works with Sisley at Fontainebleau then goes on a boat trip to Rouen; meets Courbet.

MORISOT exhibits at the Salon; copies Rubens at the Louvre; holidays in Normandy.

BAZILLE poses for Monet's *Déjeuner sur l'herbe* whilst they share a studio and entertain Pissarro, Cézanne, Courbet.

1863

Poland revolts against Russia.

Haussmann commences rebuilding of Paris. Nadar starts making balloon ascents.

Births of Munch, d'Annunzio, Santayana.

Deaths of Horace Vernet, Alfred de Vigny, Thackeray.

Renan publishes *History of the Origins of Christianity*.

In France Beau de Rochas invents the four-stroke combustion engine, and Tellier the refrigerator.

1864

The Geneva Convention lays down guidelines for the conducting of wars, resulting in the birth of the Red Cross organization. The Workers' Association is founded in London. The right to strike becomes legalized in France. Maximilian is proclaimed Emperor in Mexico.

Birth of Richard Strauss.

Maxwell in England produces the theory of electro-magnetism.

The first petrol-driven car appears on the roads of France, the work of Delamare and Deboutteville.

The brothers Goncourt publish their realist novel *Germinie Lacerteux*, Chevreul his *Notes on colours*, Tolstoy *War and Peace*, Michelet *Bible of Humanity*.

1865

Abraham Lincoln is assassinated; Palmerston dies; Rockefeller opens his first petrol refinery in Ohio.

Births of Sibelius, Yeats.

Death of Proudhon.

Lewis Carroll publishes *Alice in Wonderland*, Baudelaire *Grotesque and Serious Stories*.

Richard Wagner completes *Tristan and Isolde*.

Mendel produces his Law of Heredity.

1866

Corot and Daubigny become members of the Salon jury. Zola dedicates *Mon Salon* to Cézanne.

DEGAS	exhibits a horse-racing subject at the Salon.
MANET	is rejected at the Salon but encouraged by Zola, Cézanne and Monet who are new friends; paints *The fifer*.
PISSARRO	falls out with Corot; exhibits at the Salon; establishes himself and family at Pontoise.
CEZANNE	returns to Paris from Aix in the Spring; is rejected at the Salon about which he protests to the Director of Fine Art.
MONET	exhibits at the Salon where his *Camille in a green dress* is acclaimed; also paints his *Women in a garden*; is introduced to Manet; works at Sainte-Adresse and Le Havre.
RENOIR	is rejected at the Salon despite support of jurors, Corot and Daubigny. Continues to work at Fontainebleau and Paris where he shares Bazille's studio, and in August is fellow guest with Sisley of the Le Coeur family at Berck on the Channel coast.
SISLEY	has one painting in the Salon; works with Renoir at Fontainebleau and accompanies him to Berck with the Le Coeur family. Marries Marie Lescouezec.
BAZILLE	has one painting accepted, one rejected at the Salon. Paints *The artist's family*; shares studio with Renoir.
MORISOT	exhibits two paintings in the Salon. Works in Pont Aven, Brittany.
CASSATT	arrives in Paris.

1867

At the Paris World's Fair Courbet and Manet organize special pavilions and exhibitions for themselves.

Deaths of Ingres, Théodore Rousseau, Baudelaire.

DEGAS	has two pictures in the Salon. Becomes interested in music and opera subjects.
MANET	enters nothing in the Salon, and has little success at the World's Fair where his painting *Execution of the Emperor Maximilian* is debarred. Zola publishes articles about him and considers him as illustrator for his *Contes à Ninon*.
PISSARRO	rejected at Salon. Signs petition for Salon des Refusés.
CEZANNE	rejected at Salon; a painting exhibited at Marseilles causes violent protest. Spends summer in Aix. Back to Paris in the autumn; begins to frequent the Café Guerbois, artists' meeting-place.
MONET	continues to paint in Paris, sharing Bazille's studio, and in Honfleur with Sisley; has a temporary loss of sight.
RENOIR	rejected at Salon along with Pissarro, Sisley, Bazille, with whom he signs a petition for a Salon des Refusés. Works at Chantilly and Fontainebleau, where he produces his first large painting *Lise* out of doors. In the autumn he is in Paris sharing Bazille's studio with Monet.
SISLEY	signs petition for another Salon des Refusés with fellow rejectees from the Salon – Renoir, Bazille, Pissarro. Works at Honfleur, sees Monet.
BAZILLE	*The artist's family* rejected at the Salon. Signs petition for Salon des Refusés with fellow sufferers Renoir, Sisley, Pissarro. Discusses plans for an exhibition of work by all this group. Buys Monet's *Women in a garden*.
MORISOT	continues to work and exhibit.

1868

Reviews appear appraising members of the group. Redon writes favourably of Pissarro along with Courbet and Daubigny when reviewing the Salon. Zola likewise, but adds Manet to the constellation.

DEGAS	exhibits *Mlle Fiocre: La Source* at the Salon. Copies in the Louvre.

1866

The Prussians defeat the Austrians at Sadowa. The French abandon Mexico.

Nobel invents dynamite; Scholes and Soule the typewriter in the USA.

Births of Kandinsky, Eric Satie, Romain Rolland.

Dostoyevsky publishes *Crime and Punishment*, Alphonse Daudet his *Lettres de Mon Moulin*.

Johann Strauss composes *The Blue Danube waltz*, Smetana *The bartered bride*, Offenbach *La Vie parisienne*.

In the world of women's fashion, the full-skirted cage crinoline begins to fall out of favour.

1867

There are constitutional reforms in Hungary, Austria, Northern Germany. Trouble in Ireland. The execution of the Emperor Maximilian in Mexico.

Reinforced concrete is invented in France by Monier.

Births of Bonnard, Nolde, Granados, Toscanini, Pirandello.

Death of Faraday.

Karl Marx publishes *Das Kapital*, Ibsen *Peer Gynt*. Gounod's *Romeo and Juliet* has its first performance at the Paris Opéra.

1868

Gladstone is Prime Minister in England. The dynamo is invented by Gramme in Belgium.

Births of Gorki, Claudel, Vuillard.

Death of Rossini.

MANET	exhibits *Portrait of Zola* at the Salon. Works at Boulogne, takes a trip to England.
PISSARRO	has two pictures in the Salon, and is noticed by Redon and Zola.
MONET	has one painting rejected, one accepted by the Salon, like Pissarro with the help of Daubigny. Spends some time with Renoir and Bazille. Works at Etretat, Bennecourt. Exhibits at Le Havre where he finds a patron in Gaudibert but is nevertheless depressed enough to make an attempt at suicide.
RENOIR	paints portraits of Bazille, Sisley and Lise, his mistress, the latter accepted by the Salon and critically acclaimed.
SISLEY	moves to the same house as Bazille, 9l rue de la Paix. Is painted with his wife by Renoir and has a work accepted by the Salon.
BAZILLE	shares his studio with Monet and Renoir. Becomes a friend of Manet.
MORISOT	has one painting accepted by the Salon. Is introduced to Manet by Fantin while she is copying Rubens in the Louvre, and later poses for his work *The balcony*. She also meets Puvis de Chavannes and Degas at this time. with whom she establishes friendships, whilst that with Oudinot wanes.

1869

The Café Guerbois in the Batignolles quarter becomes a meeting-place for Manet and his friends.

DEGAS	has his *Portrait of Mme G.* accepted at the Salon. Visits Brussels and makes a financial contract with a Belgian dealer; travels in Italy; paints a portrait of Berthe Morisot's sister Yves; works in Etretat on pastel drawings of the coast.
MANET	exhibits *The balcony* at the Salon; visits Boulogne and England. Eva Gonzalès becomes a pupil and the subject for a portrait.
PISSARRO	shows one painting at the Salon; settles at Louveciennes with his family.
CEZANNE	returns to Paris from Aix and is rejected by the Salon; he meets Hortense Fiquet.
MONET	rejected at the Salon. Continues to work at Bougival with Renoir, at Etretat and Le Havre; is in difficult financial circumstances; creditors seize his works and he cannot afford paints. Manet and his friends offer staunch and cheering support at the Café Guerbois.
RENOIR	has a painting accepted at the Salon; lives with his parents in straitened circumstances but is supportive of Monet; they work together at Bougival.
SISLEY	is unsuccessful at the Salon; paints still lifes.
MORISOT	sends nothing to the Salon. Her sister Edma, also a painter, abandons her career for marriage.

1870

Courbet and Daumier refuse the Legion of Honour. Manet, Millet, Courbet, Daumier are not accepted as candidates for the Salon jury and Daubigny and Corot resign as jurors. All the group are affected by the outbreak of the Franco-Prussian war.

DEGAS	exhibits portrait of Mme Camus at the Salon; continues his works on the coast. Enlists in the infantry where he is discovered to be almost totally blind in his right eye.
MANET	joins the National Guard and serves under Meissonier. Two paintings are accepted at the Salon, but his candidature to serve on the jury is turned down. A group portrait by Fantin, *Studio in the Batignolles Quarter*, features him at its centre.
PISSARRO	avoids the war by fleeing from Louveciennes to England with his family – the two children and their mother Julie Vellay, whom he marries.
MONET	his financial affairs are ameliorated by marriage to Camille Doncieux, who has received a dowry. After working through the summer in Trouville and Le Havre, he, like Pissarro, takes refuge in England when the war breaks out in September.

Dostoyevsky publishes *The Idiot*.
Wagner produces *The Mastersingers of Nuremberg*. Grieg composes his piano concerto.
The first cycling race at St-Cloud takes place.
Synthetic perfumes are invented.

1869

The Vatican Council declares the infallibility of the Pope. The Suez Canal is opened. Hydro-electric power used for the first time.
Colour photography invented by Charles Cros.
Births of Matisse, Frank Lloyd Wright, André Gide.
Deaths of Lamartine, Berlioz, Sainte-Beuve.
Flaubert publishes *A Sentimental Education*, Verlaine *Les Fêtes galantes*.
Tchaikovsky composes his *Romeo and Juliet* overture.

1870

Outbreak of Franco-Prussian War, 18 July. King of Prussia becomes Emperor of Germany. Proclamation of the Third Republic, 4 September. Siege of Paris. Rome becomes the capital of Italy. Hyatt in America invents celluloid, the first synthetic plastic.
Birth of Lenin.
Deaths of Dickens, Alexandre Dumas.
Most popular paintings at the Royal Academy in London are Millais's *Boyhood of Walter Raleigh* and Frith's *The First Cigarette*.

CEZANNE	manages to avoid conscription and lives and works in Aix.
RENOIR	exhibits two paintings at the Salon then joins a regiment of cuirassiers posted to Bordeaux and then to Tarbes in the Pyrenees.
BAZILLE	killed in action on 28 November at Beaune-la-Rolande, having joined a Zouave regiment at the outbreak of hostilities.
MORISOT	has two works accepted by the Salon. She remains in Paris during the siege.

1871

Courbet becomes president of the Art Commission of the Commune and is involved with the destruction of the Napoleonic column in the Place Vendôme, resulting in his imprisonment. James McNeill Whistler paints *A portrait of the artist's mother*.

DEGAS	stays in Normandy during the Commune with the Valpinçons and makes a brief visit to London; embarks on his paintings of dancers.
MANET	spends time with his family near Bordeaux.
PISSARRO	makes an unsuccessful attempt to show at the Royal Academy in England but sells a couple of works to Durand-Ruel; meets Monet. Returns to France in June.
CEZANNE	returns to Paris after the Commune is over.
MONET	in England tries, without success, to show works at the Royal Academy; but Daubigny introduces him to Durand-Ruel who exhibits his paintings. He returns to France at the end of the year via Holland where he stops briefly; rents a house at Argenteuil on the Seine at the end of the year.
RENOIR	spends the period of the Commune in Paris, later works in Louveciennes, in Brittany and Bougival with Sisley; moves into a studio in rue Notre Dame des Champs in Paris.
SISLEY	works with Renoir at Louveciennes and Bougival; is taken up by Durand-Ruel, who exhibits one of his works in London.
MORISOT	abandons Paris for St-Germain for the duration of the Commune on the advice of Puvis de Chavannes, an admirer. Later, after a sojourn in Cherbourg with her sister, she returns to Paris.

1872

There are public protests by artists against the nomination of Salon jurors by the new Fine Arts Administration. Courbet is released from prison. Durand-Ruel exhibits works by the group in London.

DEGAS	is introduced to Durand-Ruel; continues to work at scenes of ballet classes and orchestral subjects at the Paris Opéra. In the autumn he goes with his brother to New Orleans, America.
MANET	sells 29 paintings to Durand-Ruel for 51,000 francs and shows two works at the Salon; travels in Holland; signs request for a new Salon des Refusés with other members of the group.
PISSARRO	continues working in Pontoise, sometimes joined by Cézanne and other painting friends who append signatures to a request for a new Salon des Refusés.
MONET	with Boudin visits Courbet in prison, soon to be released. Continues to work in Le Havre, Rouen; visits Holland again in the summer and sells a Dutch landscape to Daubigny. Later at Argenteuil he and Renoir work together. Paints *Impression: sunrise*.
CEZANNE	works with Pissarro at Pontoise.
RENOIR	lives and works in Paris with frequent visits to Monet at Argenteuil. Signs the petition for a new Salon des Refusés.
SISLEY	profits from his introduction to Durand-Ruel who takes four works to show in London. Continues painting in Brittany and on the Seine at Argenteuil.
MORISOT	makes a visit to Spain and is enthralled by Goya and Velasquez.
CASSATT	exhibits for the first time at the Salon; travels extensively in Italy, Spain, Belgium and Holland.

1871

Franco-Prussian War: armistice 28 January. France surrenders. The Paris Commune is established then viciously suppressed by Thiers, head of the Executive, who is elected President of the Third Republic.

Births of Feininger, Rouault, Marcel Proust and Valéry.

Verdi's *Aida* given its first performance at the Opera House in Cairo. Brahms composes *Song of Destiny*.

Zola publishes the first in his series of novels *Les Rougon-Macquart*, Nietzsche his first book, *The Birth of Tragedy*.

In England Ruskin becomes the first Slade Professor at Oxford, and Darwin publishes *Descent of Man*.

1872

France is in the throes of a commercial and business boom, despite large post-war reparations to the Germans and heavy taxes.

An International Congress is held at The Hague to seek universal peace.

Grant is re-elected President of the USA, and Brayton invents the two-stroke motor.

Birth of Mondrian.

Death of Théophile Gautier.

Daudet publishes *Tartarin de Tarascon*, Samuel Butler *Erewhon*. Mallarmé becomes a professor at the Paris Lycée. César Franck becomes professor at the Conservatoire.

1873

A new Salon des Refusés is established. Durand-Ruel exhibits in London works by the group soon to become known as Impressionists. Courbet, released from prison, decides to take refuge in Switzerland. Foundation of the Co-Operative Company of Artists, Painters, Sculptors, Engravers, etc.

DEGAS	still in New Orleans, paints his uncle's cotton exchange office there; returns to France in the spring and continues with his ballet and stage studies, now in temporary quarters as the opera house was destroyed by a fire.
MANET	has great success at the Salon with *Le bon Bock*, which, with four other paintings, he sells to Faure at prices from 2,500 to 6,000 francs. Establishes a long-lasting friendship with Mallarmé.
PISSARRO	continues working around Pontoise. His paintings begin to be noticed by connoisseurs and critics like Théodore Duret, and to sell for fairly good prices – at the Hoschedé auction for instance.
CEZANNE	moves to Auvers-sur-Oise near Pontoise where he works from Dr Gachet's house. Paints *Modern Olympia* and landscapes; meets Père Tanguy.
MONET	painting at Argenteuil, constructs his boat-studio and takes action on his late friend Bazille's idea of a group show. He meets Caillebotte.
RENOIR	achieves financial stability by an introduction to Durand-Ruel, who includes him in his stable of artists. He takes a large studio, 35 rue St Georges in Paris. Though rejected by the Salon, he has two paintings in the new Salon des Refusés. Through Guillaumin he meets another helpful contact, Eugène Murer, restaurateur and collector.
SISLEY	still working doggedly in the Pontoise area, also meets Murer.
MORISOT	continues to paint; shows a pastel at the Salon.

1874

First exhibition of the group of painters subsequently known as the Impressionists is held at 35 boulevard des Capucines, 15 April to 15 May. The group are called 'Impressionists' by Louis Leroy in an article published in *Charivari* on 25 April. Durand-Ruel shows Impressionists in London. Death of Gleyre.

DEGAS	exhibits 10 works in group show. Sells *Dancing examination* to Faure for 5,000 francs.
MANET	refuses to participate in group show; one oil, one watercolour in the Salon. Mallarmé protests at two rejections; paints with Monet at Argenteuil; illustrates Mallarmé's translation of Poe's *The Raven*.
PISSARRO	exhibits five works in group show; paints in Brittany in the winter.
CEZANNE	is admitted to group show at the insistence of Pissarro; sells one landscape. *Modern Olympia* is unmercifully ridiculed. Models for his portrait by Pissarro. Divides his time between Aix, Paris, Auvers, painting with undeterred confidence.
RENOIR	takes an active part in group show; exhibits 7 works. Paints with Monet at Argenteuil; establishes friendship with Caillebotte. Paints *La Loge*.
MONET	exhibits 12 works in the group show; his painting *Impression: sunrise* is used by journalist Leroy to entitle the whole movement.
SISLEY	exhibits 5 landscapes in the group show; visits England with Faure, works in and around Hampton Court.
MORISOT	exhibits 9 works in the show; spends the summer with the Manet family at Fécamp. In December marries Manet's brother Eugène.
CASSATT	exhibits works at the Salon which are noticed by Degas.

1875

Works by the Impressionists are put up for auction at the Hôtel Drouot on 24 March, the average price 144 francs. Durand-Ruel exhibits their work in London, and closes his gallery there. Deaths of Corot, Millet and Carpeaux.
Vincent van Gogh is employed in an art gallery in Paris.

DEGAS	continues to work from 77 rue Blanche, Montmartre. Visits Florence.

1873

German occupation of France terminates.
Marshal Mac-Mahon is President of the French Republic.
Economic recession hits picture sales amongst other things.
Napoleon III dies in England.
Births of Caruso and Chaliapin.
Zola publishes *Thérèse Raquin*, Tolstoy *Anna Karenina*, Hans Christian Andersen his *Fairy Tales*, H. Spencer *The Study of Sociology*.

1874

In England Disraeli replaces Gladstone as Prime Minister.
Alfonso XII becomes King of Spain.
In Paris the foundation stone of the Sacre-Coeur is laid.
Stanley commences his major African explorations.
Births of Marconi, Schoenberg, Gertrude Stein.
Death of Michelet.
Flaubert publishes *The Temptation of St Anthony*, Gautier *History of Romanticism*.
Verdi conducts the first performance of his *Requiem*; Mussorgsky composes *Pictures at an Exhibition*.
Lady Butler paints *The Roll Call*.

1875

The Third Republic of France is formally constituted by a series of laws. Pierre Savorgnan de Brazza explores the area north of the Congo, extending the limit of the French empire in Africa. Chromosomes are discovered in Germany (Strassburger) and Great Britain (Fleming).

MANET	painting of the Seine, *Argenteuil*, is accepted by the Salon but bitterly criticized.
PISSARRO	continues work in Pontoise; is involved with new artists' association, *L'Union* – joined by Cézanne and Guillaumin.
CEZANNE	sells a work to Chocquet and is introduced to him by Renoir; paints his portrait; works in Paris, quai d'Anjou, sometimes with his neighbour and friend Guillaumin; joins Pissarro's association, *L'Union*.
RENOIR	sells 10 works for less than 100 francs each; rejected at Salon; commissioned by Chocquet to paint portrait of Mme Chocquet. Sells painting to Rouart from Salon des Refusés 1873 show. Is helped by Caillebotte.
MONET	in great financial difficulties; auction prices of canvases 165-325 francs; appeals to Manet for help; colour merchant refuses credit; his wife Camille is ill.
SISLEY	prices of canvases at auction vary between 50 and 300 francs. Continues work at Marly-le-Roi where he settles, and at Bougival, St-Germain, Louveciennes, Versailles.
MORISOT	Auction prices are better than Monet, Renoir or Sisley. Visits and works in England on the Isle of Wight.

Births of Marquet, Ravel.
Deaths of Bizet, Hans Christian Andersen.
Edvard Grieg produces *Peer Gynt*.

1876

The second group exhibition is held in April at 11 rue le Peletier, with 19 participants. Gustave Caillebotte is a new young recruit and exhibits *Raboteurs de Parquet*, a sensational work, at this show. The exhibition gets comments from Henry James and Rivière, and the critic Louis-Edmond Duranty writes about the Impressionist painters in his *La nouvelle Peinture*. Strindberg, visiting Paris, shows interest in their work.

DEGAS	exhibits 24 works; his financial independence undermined by having to rescue his brother's family business affairs, he is now obliged to sell some canvases. Paints *The absinthe drinker*, amongst other works.
MANET	does not show with the group; invites people to see the 2 works rejected by the Salon, in his studio. Paints portraits of Carolus-Duran and Mallarmé; the latter subsequently writes a flattering article about him, and publishes *L'Après-midi d'un faune*, illustrated by Manet. Suffers from depression.
PISSARRO	shows 12 paintings; continues working in and around Pontoise.
MONET	exhibits 18 paintings in group show; financial difficulties continue; is helped by Gustave Caillebotte who rents for him the studio from which he begins the *Gare St Lazare* series; visits the collector and potential client of future significance to himself, Ernest Hoschedé, for the first time.
RENOIR	exhibits 15 works in the show and is busy in his studio, 12 rue Cortot, Montmartre, painting masterpieces such as *Dancing at the Moulin de la Galette* and *The Swing* and establishing useful contacts: Charpentier, Zola's publisher, Daudet and Caillebotte, whom he had invited to show with the group back in February.
SISLEY	exhibits 8 paintings; continues working in Louveciennes.
MORISOT	exhibits in the group show and continues working near Paris.

1876

First Socialist International is dissolved.
The telephone is invented in America by Alexander Graham Bell.
Births of Brancusi, Falla.
Deaths of George Sand, Bakunin.
Turgenev publishes *Virgin Soil*; Mark Twain *Adventures of Tom Sawyer*.
Wagner produces *The Ring*, Brahms composes his first symphony.

1877

The third group exhibition at 6 rue le Peletier in April, with 18 participants; Renoir persuades Georges Rivière to start a weekly journal, *L'Impressionniste: journal d'art*, devoted to the group, as publicity for them. It runs for four weekly issues. In May another auction sale is held at which the average price is 169 francs; the new meeting-place for socializing is now the Nouvelle-Athènes. Durand-Ruel is in financial difficulties. Death of Courbet.

DEGAS	exhibits 27 works in the group show and is active in its preparation; he is working now largely in pastels; Ludovic Halévy becomes a friend.
MANET	declines as ever to show with the group. Has a painting accepted at the Salon. Begins but does not finish a portrait of the critic of *Figaro*, Albert Wolff, who detests the Impressionists' works.
PISSARRO	exhibits 22 landscapes; his prices at the auction sale are between 50 and 260 francs; he resigns from *L'Union*. Murer, the restaurateur and collector, friend of Guillaumin, organizes a lottery in aid of Pissarro, Sisley and others in need.

1877

War breaks out between Russia and Turkey.
Queen Victoria becomes Empress of India.
Edison invents the phonograph in the USA and Thomson invents electric welding; industrialization of the four-stroke motor takes place in Germany.
Death of Thiers, 1st President of the Third Republic.
The Grosvenor Gallery opens in London.
Walter Pater publishes *The Renaissance*, which puts the *Mona Lisa* on the cultural map.
Saint-Saëns produces *Samson and Delilah*.

CEZANNE	shows 16 works; is rejected at the Salon. Resigns from *L'Union*. Works with Pissarro in Pontoise and other places around Paris.
MONET	exhibits 30 paintings; continues with *Gare St Lazare* series; makes second visit to Hoschedé; is still in dire financial straits.
RENOIR	is very active in preparing the group show which is done mostly from his studio, with much assistance of every sort from Gustave Caillebotte. He exhibits 22 works, *Dancing at the Moulin de la Galette* amongst them, which is bought by Caillebotte. Works at the auction fetch between 47 and 285 francs.
SISLEY	exhibits 17 landscapes; auction prices 105-165 francs; is dropped from Durand-Ruel's stable; is introduced to Charpentier and Murer.
MORISOT	exhibits 19 works in the show.
CASSATT	is invited by Degas to exhibit with the group; she stops exhibiting at the Salon.

1878

Paris World's Fair: Durand-Ruel shows 300 Barbizon paintings: Zola writes about the art section for a Russian periodical. Théodore Duret publishes *Les Impressionnistes*. Two important picture sales, those of Jean-Baptiste Faure and Ernest Hoschedé, fetch disappointingly low prices. Death of Daubigny.

DEGAS	works on circus subjects; Pau museum acquires his painting of *Portraits in an office*; paints portrait of his friend Diego Martelli.
MANET	sends nothing to the Salon; low prices at the Faure and Hoschedé sales; has health problems; moves to 77 rue d'Amsterdam.
PISSARRO	continues working in some dejection at Pontoise; paints portrait of Murger; rents a room in Montmartre to show his works; has another son; sends 2 paintings to Florence at instigation of Degas's friend Martelli.
CEZANNE	no work in the Salon; soldiers on at Aix despite paternal hostility; Zola is supportive.
MONET	settles in Vétheuil, still in straitened circumstances with a second son and his wife Camille ill. Manet as ever is helpful. The Hoschedé sale prices average 184 francs. The Hoschedé family liaison starts in the summer when Alice Hoschedé and her children join the Monets at Vétheuil.
RENOIR	exhibits again at the Salon; paints portraits of Mme Charpentier and of Murer and his son and daughter.
SISLEY	sells several pictures through Duret; decides to try the Salon again.

1879

Fourth group show, 10 April to 11 May, 28 Avenue de l'Opéra. 15 participants, each of whom receives 439 francs benefits. Zola writes a critical review, 'Insufficient Technique', for the Russian periodical. Charpentier founds the magazine *La Vie Moderne* together with an art gallery on its premises. Huysmans writes a highly critical review of the Salon. Deaths of Daumier and Couture.

DEGAS	exhibits less than a dozen works in the show; plans publication of print portfolios to be called *Le Jour et le Nuit* in collaboration with Pissarro, Cassatt, Bracquemond.
MANET	does not show with the group; two paintings in the Salon; paints portrait of George Moore and begins one of Clemenceau. Takes the water cures at Bellevue. The singer Emilie Ambre shows his *Execution of the Emperor Maximilian* in New York, which attracts little interest.
PISSARRO	shows 38 works in the show, in which he invites Gauguin to participate.
CEZANNE	tries the Salon again unsuccessfully; continues working on the coast and in Paris.
MONET	exhibits 29 works in the show; de Bellio buys *Gare St Lazare*; continues painting on the Seine and at Vétheuil, still dogged by poverty. His wife Camille dies in September.
RENOIR	has a good year. His portrait of *Mme Charpentier and her children* is well received at the Salon and in June Charpentier gives him a

1878

Romania becomes an independent kingdom.
The Congress of Berlin attempts to settle the affairs of Eastern Europe, i.e. Russia and Turkey, one result of which is the acquisition of Cyprus by the British.
Sédillot works on microbes in France; the telephone system is installed in Paris.
Births of Picabia and Malevich.
In London *And When Did You Last See Your Father* by W.F. Yeames is the crowd-pulling picture of the year at the Royal Academy, and the Whistler v. Ruskin libel case is in full swing.

1879

Organized rebellion against British rule starts in Ireland.
The French socialist party is formed.
Reforms in the French educational system are inaugurated.
Siemens introduces the first electric locomotive in Germany. Edison produces the electric light bulb in the USA, and Hughes the microphone.
Strindberg publishes *The Red Chamber*, George Meredith *The Egoist*.
Births of Paul Klee, Respighi.

one-man show at the gallery in his publishing establishment. His brother Edmond publishes an important article on him in *La Vie Moderne*. On a visit to the Bérard family in Wargemont he meets his future wife Aline Charigot, which perhaps consoles him for the death of his favourite model Margot.

SISLEY rejected by the Salon. Ejected from his house in Sèvres. Dejected but dogged, he paints on with help from Charpentier.

MORISOT is pregnant and temporarily *hors de combat*.

1880

Fifth group show, 10 rue des Pyramides, 1 to 30 April. 18 participants. The critic and writer Joris-Karl Huysmans publishes an attack on the Impressionists. Durand-Ruel recovers from his financial crisis. Louis-Edmond Duranty, art critic, author of *La Nouvelle Peinture* and champion of the Impressionists, dies in April during the course of the show.

DEGAS exhibits 8 paintings, including a portrait of Duranty, several drawings, etchings, pastels. Travels in Spain.

MANET does not participate in the group show but has a portrait of Antonin Proust, who is to become Minister of Fine Arts in 1881, accepted at the Salon; a one-man show at Charpentier's gallery at *La Vie Moderne* follows. Health deteriorates.

PISSARRO exhibits 11 paintings in the show and a series of etchings done for Degas's publication.

CEZANNE does not seem to have submitted works to the fifth show.

MONET does not participate in the fifth show and acrimoniously berates the organizers for 'opening doors to first-time daubers'. He has a one-man show at *La Vie Moderne*, and a painting accepted but apparently not well hung at the Salon.

RENOIR like Monet and Cézanne, he drops out of the group show but has 2 paintings in the Salon about the hanging of which, with Monet, he complains.

SISLEY continues working in the Louveciennes area; Durand-Ruel's improved financial circumstances enable him to buy Sisley's works.

MORISOT is working again and sends 15 paintings and some watercolours to the show.

1881

Sixth group show at 35 boulevard des Capucines, 2 April to 1 May. 13 participants. Control of the Salon ceases to be in the hands of the state; *Société des Artistes Français* is created. Durand-Ruel is back in business again and buying Impressionist works. Antonin Proust becomes Minister of Fine Arts. A new young critic, Félix Fénéon (b.1861), arrives in Paris, who will champion the next generation of 'modern' artists.

DEGAS exhibits wax statuette of a dancer in a *tutu* and other works in pastel at the group show.

MANET has two paintings in the Salon and receives the Legion of Honour, for which he has been nominated by Antonin Proust. Is seriously ill, but works on *Bar at the Folies-Bergère*.

PISSARRO shows 11 landscapes at the exhibition; continues working around Pontoise, sometimes with Cézanne and Gauguin.

MONET does not exhibit with the group and abandons the Salon entirely. Continues working in the country north-west of Paris, and in December moves to Poissy with Mme Hoschedé and children.

CEZANNE no record of exhibits but continues to work with Pissarro at Pontoise; visits Zola at Médan; returns to Aix at the end of the year.

RENOIR does not show with the group; exhibits 2 portraits in the Salon; works at the Bérards'; makes a short and fruitful trip to Algiers and a more extended one to Italy, visiting Venice, Rome, Naples, Florence, Calabria and Pompeii.

SISLEY spends some time on the Isle of Wight; frustrated by non-arrival of canvas to paint on. Has a one-man show at *La Vie Moderne* gallery, financed by the Charpentiers and run by Edmond Renoir.

MORISOT exhibits 7 works in the group show. Paints at Bougival in summer, Nice in winter.

1880

The Panama Canal Company is founded. Gladstone introduces Home Rule Bill for Ireland.
Lawson and Starley invent the modern bicycle.
Births of Derain, Kirchner, Epstein.
Deaths of Flaubert, George Eliot, Offenbach.
Dostoyevsky publishes *The Brothers Karamazov*, Maupassant *Boule de Suif*.
Ibsen's *The Doll's House* given its first performance.

1881

The Boer War starts.
Tsar Alexander II is assassinated.
The French occupy Tunisia.
The first electric tramway is inaugurated in Berlin; Meisenbach invents the technique of process-engraving.
Births of Picasso, Léger, Weber, Bartók.
Deaths of Dostoyevsky, Carlyle, Mussorgsky, Disraeli.
Two posthumous first productions are Flaubert's *Bouvard and Pécuchet* and Offenbach's *Tales of Hoffmann*.
Odilon Redon holds his first one-man show at La Vie Moderne.

1882

The seventh group show is organized by Durand-Ruel at 251 rue St Honoré. There are 8 participants. His financial affairs are once again plunged into chaos by the collapse of the Union Internationale bank, his backers. Georges Petit, another dealer specializing in 'modern' movements in painting, inaugurates the first of a series of annual Expositions Internationales de Peinture at which eventually Monet, Renoir and others will exhibit. There is a large Courbet retrospective at the Ecole des Beaux-Arts.

DEGAS	does not participate in the group show; he visits at various times Geneva and Spain.
MANET	increasingly ill, exhibits *Bar at the Folies-Bergère* at the Salon.
PISSARRO	exhibits as usual at the group show, 36 paintings and gouaches; continues working at Pontoise.
CEZANNE	has one work accepted at the Salon as 'pupil of Guillemet'; appears as a figure of ridicule in Duranty's posthumously published novel. Works at L'Estaque where he nurses Renoir through an attack of pneumonia. Moves to Jas de Bouffan from Paris in September.
MONET	shows 35 paintings in the show; continues working in and around Poissy.
RENOIR	sketches a portrait of Wagner in Palermo in January before returning to France; is stricken with pneumonia at L'Estaque, looked after by Cézanne; takes a trip to Algiers to convalesce.
SISLEY	exhibits 27 landscapes at the show.
MORISOT	exhibits 9 paintings and pastels at the show.

1883

Durand-Ruel opens a new gallery at 9 boulevard de la Madeleine, where he organizes a series of one-man shows, and exhibits his stable of Impressionists in London, Berlin, Rotterdam, Boston and New York. Georges Petit has a show of Japanese prints. Caillebotte draws up a will leaving his considerable collection of Impressionist works to the State, with the proviso that they should eventually hang in the Louvre. A new young artist, Georges Seurat (b.1859), shows his first work at the Salon, a large portrait drawing of Edmond Aman-Jean, and begins work on his first large composition, *Bathing at Asnières*. Whistler exhibits *Portrait of the artist's mother* at the Salon. Huysmans publishes *L'Art Moderne*. Death of Manet.

DEGAS	turns down Durand-Ruel's invitation for a solo show at his new gallery. Exhibits in London and New York.
MANET	dies on 30 April.
PISSARRO	has a one-man show at Durand-Ruel's gallery in May. Works with Gauguin and sometimes Monet on the Channel coast and around Rouen.
CEZANNE	continues working around Aix, where he is visited later by Monet and Renoir.
RENOIR	has a one-man show at Durand-Ruel's in April, and shows a portrait at the Salon. Visits the Channel Islands and later, with Monet, the Riviera.
MONET	his turn for a one-man show at Durand-Ruel's occurs in March. In May he settles in Giverny with Mme Hoschedé and works in that area of Normandy, going south in December to join Renoir in a trip to Genoa and then the Côte d'Azur, visiting Cézanne on the way back.
SISLEY	originally opposes Durand-Ruel's project of one-man shows, but nevertheless shows there in June with little success. He works continuously and peripatetically throughout the year.
MORISOT	is kept busy moving house and arranging with her husband Eugène Manet a retrospective of Edouard's works and the sale of his estate.

1884

The Société des Vingt is founded in Brussels and holds its first exhibition. In Paris the Groupe des Artistes Indépendants, backed by the younger generation of painters, Seurat, Signac and Redon, proposes the idea of 'free' exhibitions, i.e. without a jury or awards, and holds its first Salon. Durand-Ruel's affairs are again in a depression. Félix Fénéon becomes editor of *Revue Indépendante*. Seurat starts work on *La Grande Jatte*. A memorial exhibition of Manet's works is held at the Ecole des Beaux-Arts, the catalogue introduction by Zola. In

1882

A Triple Alliance is formed between Germany, Austria and Italy.
There are major financial upheavals in France, banks collapse, bankruptcies and losses result.
The folding camera is invented in the USA.
Births of Boccioni, Braque, James Joyce, F. D. Roosevelt, Stravinsky.
Deaths of Dante Gabriel Rossetti, Darwin, Emerson, Longfellow, Garibaldi.
Wagner finishes *Parsifal*; Oscar Wilde publishes his *Poems*; Gaudí begins the cathedral of La Sagrada Familia in Barcelona.

1883

There is improvement in France's financial position and stability is restored.
Brazzaville, capital of the French Congo, is inaugurated.
The Marxist party is founded in Russia.
The first petrol-driven car is seen on the roads of France.
The Maxim machine gun is produced in the USA.
Births of Van Doesburg, Utrillo, Severini, Mussolini, Kafka, Gropius.
Deaths of Karl Marx, Wagner, Turgenev, Gustave Doré.
Ibsen produces *An Enemy of the People* and *Ghosts*. Robert Louis Stevenson publishes *Treasure Island*, Maupassant *A Life*.
Pasteur vaccinates against anthrax.

1884

Germany occupies the Cameroons.
Trades unions are legalized in France.
The fountain pen is invented in the USA by Waterman; the electric transformer by Gaulard and Charles Algernon; Parsons perfects the steam turbine; Chardonnet invents artificial silk.
Births of Modigliani, Dunoyer de Segonzac, Beckmann.

February the sale of the contents of his studio at the Hôtel Drouot – 93 paintings, 30 pastels, 14 watercolours, 23 drawings – fetches a total of 115,000 francs. Renoir laments the fact that he cannot 'afford to buy a souvenir of our late friend'.

DEGAS	works on a bust of Hortense Valpinçon whilst staying with the family at Gace (Orne).
PISSARRO	now lives and works around Eragny, near Gisors.
CEZANNE	with no apparent success at the Salon, works mostly around Aix. Père Tanguy sells one of his landscapes to Signac on the recommendation of Pissarro.
MONET	has no more financial problems. He travels and works and shows at Georges Petit's 3rd Exposition Internationale. Suggests to Renoir and others the institution of monthly dinners for meetings of the Impressionist group.
RENOIR	is dissatisfied with Impressionism and his current style, and plans a new painters' association: the 'Société des irregularistes'. He spends the summer with the Bérards where he paints *Children's afternoon at Wargemont*, and then visits La Rochelle: 'the last painting I saw by Corot made me want desperately to see this port'.
SISLEY	continues to work on his favourite themes, the Canal du Loing and the Seine.
MORISOT	spends her time between Bougival and Paris, where she works in the Bois de Boulogne.

1885

Delacroix retrospective at the Ecole des Beaux-Arts. Durand-Ruel mounts an exhibition in Brussels which greatly impresses the avant-garde there. Van Gogh paints *The potato eaters* and Seurat's *Grande Jatte* is nearing completion. The 19-year-old Munch visits Paris for three weeks. Rouault is apprenticed to a stained-glass maker.

DEGAS	makes trips to Le Havre, Mont St-Michel and Dieppe, where he meets Walter Sickert and Gauguin: he quarrels with the latter.
PISSARRO	meets Theo van Gogh. Later Guillaumin introduces him to Signac and Seurat, whose theories he is greatly interested in and influenced by.
CEZANNE	works in L'Estaque and Aix; spends the summer with his wife and son at La Roche-Guyon, near Giverny, with the Renoirs and later with Zola at Médan.
MONET	is comfortably established at Giverny and exhibits at Georges Petit's 4th Exposition Internationale; decorates Durand-Ruel's Paris apartment with murals. At the end of the year he stays at the home of the singer Faure at Etretat.
RENOIR	is in the midst of forming a new, more structured style; Aline Charigot produces their first son in March and he moves from his rue St Georges studio to 37 rue Laval. After a summer at La Roche-Guyon with the Cézannes he visits Aline's home in Essoyes for the first time. The pattern is set also for two regular social meetings, monthly dinners at the Café Riche with Impressionist painters, and Berthe Morisot's informal gatherings.
SISLEY	continues painting around the countryside and is still in financially straitened circumstances; Theo van Gogh of the Boussod & Valadon gallery takes one landscape; seeks help from Durand-Ruel.
MORISOT	works in Bougival and later in Holland. She begins to hold regular social Salons for her artist friends, Renoir, Monet, Degas, Mallarmé.

1886

The eighth and last group show is held at 1 rue Lafitte, 15 May to 15 June, with 17 participants. Vincent van Gogh arrives in Paris and is influenced by Seurat. Durand-Ruel has his first successful show in America; Georges Petit holds his 5th Exposition Internationale in Paris and in the winter puts on a Whistler retrospective. Félix Fénéon publishes *Les Impressionnistes en 1886* and becomes correspondent for *L'Art Moderne*, published by the Brussels Les Vingt group. The Douanier Rousseau shows at the 2nd Salon des Indépendants. In England the New English Art Club is inaugurated.

DEGAS	shows 5 works with the group and a series of 10 pastels of nudes; is included in Durand-Ruel's American exhibition.

Death of Smetana.
Debussy wins the Prix de Rome. Bruckner's 7th Symphony is given its first performance, as is Massenet's *Manon*.
Huysmans publishes *A Rebours*.
Burne-Jones exhibits *King Cophetua and the Beggar Maid*. Ibsen's *The Wild Duck* is performed for the first time.

1885

The Belgian Congo is founded.
Pasteur invents a vaccine against rabies.
Births of Delaunay, Alban Berg, Ezra Pound, D.H. Lawrence.
Death of Victor Hugo.
Nietzsche's *Thus Spake Zarathustra*, Zola's *Germinal*, Karl Marx's *Das Kapital Volume III* are published.
In London, Whistler gives his 'Ten O'Clock' Lecture; Millais is made a baronet.

1886

The Statue of Liberty is unveiled in New York.
Births of Diego de Rivera, Kokoschka, Pevsner, Mies van der Rohe.
Deaths of Liszt, Monticelli.
Zola publishes *L'Oeuvre*, Henry James *The Bostonians*; Moréas publishes the Symbolist Manifesto.

PISSARRO	exhibits his first canvas showing Seurat's influence at Clauzet's; submits 20 paintings to the group's exhibition and insists that Seurat and Signac should be included. Meets Vincent through Theo van Gogh. Is shown by Durand-Ruel in New York, but they fall out.
MONET	is irate at the inclusion of Seurat and Signac in the group show and does not participate. Attends the recently instituted Impressionist dinners at the Café Riche. Shows at Georges Petit's 5th Exposition Internationale, with Les Vingt in Brussels, and Durand-Ruel in the USA.
CEZANNE	marries Hortense Fiquet; breaks with Zola over his depiction in the latter's novel *L'Oeuvre*. Inherits a fortune on the death of his father.
RENOIR	refuses to participate with the group. Shows at Georges Petit's, at Brussels and with Durand-Ruel in New York.
SISLEY	does not exhibit with the group, but Durand-Ruel includes him in American show. Remains hard-working but impecunious.
MORISOT	exhibits in Jersey and with Durand-Ruel in America.

1887

Puvis de Chavannes exhibits at Durand-Ruel and is commissioned to paint murals at the Sorbonne. A large Millet exhibition is held in Paris. Eadweard Muybridge publishes his series of photographs, *Animal Locomotion*. Seurat exhibits in Brussels with Les Vingt. Gauguin leaves France for Martinique. Dealers begin to find it easier to sell Impressionist work. Durand-Ruel holds second Impressionist show in New York.

DEGAS	buys a copy of Eadweard Muybridge's portfolio of photographs *Animal Locomotion* and begins to apply these discoveries to his own depiction of horses in movement.
PISSARRO	continues to work in his newly adopted Pointillist mode influenced by Seurat, and shows work in this style at Brussels with Les Vingt.
MONET	shows works in London at the Royal Society of British Artists, and also in a mixed show at Petit's Exposition Internationale in Paris; disapproves of Durand-Ruel's American venture; paints at Belle-Isle-en-Mer in Brittany; meets Gustave Geffroy, art critic of *Le Justice*, Clemenceau's journal, which leads to re-establishment of friendship with the latter.
RENOIR	exhibits *The large bathers* at Petit's Exposition Internationale, a major work in his new style which is liked by Van Gogh but not by Huysmans or Astruc. Paints a portrait of Berthe Morisot's daughter Julie Manet.
CEZANNE	works on assiduously in Aix with no apparent success at the Salon.
MORISOT	exhibits with Monet, Renoir, Pissarro and Sisley at Georges Petit's Exposition Internationale.
SISLEY	shows at Georges Petit's Exposition.

1888

Durand-Ruel opens a gallery on Fifth Avenue, New York, and gives Whistler a one-man show in Paris. Mallarmé translates the latter's 'Ten O'Clock' Lecture. Gauguin and Bernard at Pont Aven hammer out the principles of Synthetism. James Ensor in Belgium paints *Christ's entry into Brussels*.

DEGAS	excited by the photographic studies of Muybridge, works passionately on sculptures of horses; also writes 8 sonnets on the themes of his paintings, horses, dancers, singers (published 1946). Exhibits some works at Boussod & Valadon. Sees and admires Gauguin's works.
PISSARRO	exhibits at Durand-Ruel.
MONET	falls out with Durand-Ruel; disapproves of his paintings leaving France for America permanently. Durand-Ruel objects to Monet's dealings with Petit. He (Monet) signs a contract with Theo van Gogh at Boussod & Valadon. He paints in Antibes.
RENOIR	shows in a mixed exhibition at Durand-Ruel in rue Le Peletier; stays with Cézanne at Jas de Bouffan, later with Caillebotte near Argenteuil, visits his sick mother at Louveciennes and spends the autumn in Essoyes, his wife's village, in order to paint *Washerwomen on the riverbanks*. His new style still meets criticism, he tells Pissarro. In December a chill leads to facial paralysis.

1887

France signs a Treaty with China. French President J. Grévy resigns over Wilson scandal.

The foundations of the Eiffel Tower are laid.

Lanston invents the monotype printing process; Hertz discovers the nature of electro-magnetic waves.

Births of Juan Gris, Chagall, Le Corbusier, Marcel Duchamp, Macke, Archipenko, Arp.

Deaths of Borodin, Laforgue and A. Krupp, German industrialist.

Verdi's *Otello* and Fauré's *Requiem* are given their first performances, as are Richard Strauss's *Aus Italien* and *Macbeth*; Wagner's *Lohengrin* is heard and seen in Paris for the first time.

In London, Albert Gilbert's statue of Eros is unveiled.

Strindberg produces *Father* and Chekhov *Ivanov*.

1888

Wilhelm II becomes Kaiser of Germany.

The nationalist Boulangist movement is at its height in France, and the Société des Droits de l'Homme is founded.

Photographic film and the bellows camera are invented by Eastman.

Hormones are isolated. The Institut Pasteur is founded in Paris.

Ruskin publishes *Praeterita*, George Moore *Confessions of a Young Man*, containing recollections of his meetings with the early Impressionist painters.

Rimsky-Korsakov's *Schéhérazade*, Richard Strauss's *Don Juan* and César Franck's Symphony in C Minor enter the musical repertoire.

T.S. Eliot and de Chirico are born.

CEZANNE	is host to Renoir at Aix in the early part of the year; later is in Paris. Works in Chantilly and the outskirts, based in his studio, 15 Quai d'Anjou, next to Guillaumin. Huysmans publishes a short article on him, his name begins to appear in Symbolist periodicals, and he is mentioned occasionally by the critics Aurier and Fénéon.
MORISOT	works near Nice.
SISLEY	at Les Sablons.

1889

The group of painters known as the Nabis is formed. The Symbolist magazine *La Revue blanche* is published. Huysmans publishes *Certains* lauding Puvis de Chavannes, Moreau, Degas, Cézanne, amongst others. Durand-Ruel organizes an exhibition of painters and engravers, including Impressionists. Two paintings by Manet are bequeathed to the Metropolitan Museum, New York.

DEGAS	refuses a special display of his work at the World's Fair; visits Spain with Boldini, and Morocco briefly, returning to Paris via Cadiz and Granada.
PISSARRO	begins to suffer from chronic eye infection; builds studio at Eragny; Durand-Ruel buys an important group of work.
MONET	shares a successful exhibition with Rodin at Georges Petit's, also shows at Goupil's in London. Breaks his contract made the preceding year with Boussod & Valadon. Organizes a private subscription to buy Manet's *Olympia* for the Louvre to prevent its sale to an American collector.
RENOIR	his health is improving. Refuses to participate in retrospective exhibition of nineteenth-century French art planned for Exposition Universale owing to his own current low opinion of his work. Spends summer painting in Aix. Is financially unable to subscribe to Monet's fund for *Olympia* at this time but later (January 1890) sends 50 francs.
CEZANNE	in Paris manages to get a painting, *House of the hanged man*, shown at the World's Fair with the help of Chocquet and Roger Marx. Huysmans in *Certains* considers him a leader of Impressionism more important than Manet, despite his 'sick retina' and 'exasperated vision'. Visits Chocquet in Normandy. Works in Aix, where Renoir visits. Declines, then accepts, participation in Les Vingt show in Brussels.

1890

Exhibition of Japanese Art at the Ecole des Beaux-Arts. A more liberal salon, Société Nationale des Beaux-Arts, is founded by Puvis de Chavannes, Meissonier and Rodin. Cauchard buys Millet's *Angélus* from an American dealer for 750,000 francs. Durand-Ruel publishes *L'Art dans les Deux Mondes*. Vincent van Gogh dies in July, his brother Theo six months later.

DEGAS	visits the Japanese exhibition; acquires Van Gogh's *Deux Tournesols* from Durand-Ruel in exchange for 2 of his dancer sketches; contributes 100 francs to Monet's *Olympia* fund; sells a number of works to Durand-Ruel and Theo van Gogh for Boussod & Valadon.
PISSARRO	abandons Divisionism, exhibits with Les Vingt in Brussels and with Theo van Gogh at Boussod & Valadon. His son Lucien settles in London, studies typography and woodcuts and corresponds regularly with his father.
MONET	buys the house at Giverny which he has been renting since 1883; starts cultivating his garden. Continues work on the *Haystack* series; makes peace with Durand-Ruel. Is financially secure.
RENOIR	is persuaded to overcome his reluctance to show with Les Vingt in Brussels. Marries Aline Charigot. Refuses an official decoration. Exhibits at the Salon for the last time. Visits La Rochelle and the Manets, Eugène and Berthe (Morisot).
CEZANNE	shows 3 canvases with Les Vingt in Brussels and is mentioned in the review of the exhibition by Signac. Spends 5 months with his wife and son in Switzerland. Works at Aix during autumn, possibly on the *Card player* series. Begins to suffer from diabetes. Bernard publishes a pamphlet on him in *Les Hommes d'aujourd'hui*.
MORISOT	spends summer painting at Mézy, frequently visited by Renoir.

1889

Paris World's Fair. The Eiffel Tower is completed. Workers' Congress in Paris declares 1st May Workers' Holiday. Le Moulin Rouge is opened in Montmartre.

Haematology is discovered. The chemist Chevreul, whose discoveries and theories on colour influenced the Impressionists, dies at the age of 103; deaths of Villiers de l'Isle Adam and Robert Browning.

Births of Milhaud, Poulenc, Cocteau, Adolf Hitler and Paul Nash.

1890

Kaiser Wilhelm II dismisses Bismarck.

Valette founds *Mercure de France*; Dunlop invents the pneumatic tyre.

Deaths of César Franck, Cardinal Newman.

First performance of Ibsen's *Hedda Gabler*.

SELECT BIBLIOGRAPHY

Adhémar, Jean and Cachin, Françoise: *Degas: The Complete Etchings, Lithographs and Monotypes*. Trans. Brenton, Jane. London & New York 1974 [1973].

Arts Council of Great Britain: *The Impressionists in London*. Catalogue, London 1973.

Bailly-Herzberg, Janine (ed.): *Correspondence de Camille Pissarro*, 5 vols. Paris 1980-88.

Bataille, Marie-Louise and Wildenstein, Georges: *Berthe Morisot, catalogue des peintures, pastels et aquarelles*. Paris 1961.

Baudelaire, Charles: *The Painter of Modern Life and Other Essays*. Trans. and ed. Mayne, Jonathan. London 1964.

Berhaut, Marie: *Gustave Caillebotte: sa vie et son oeuvre*. Paris 1978.

Blunden, Maria and Godfrey: *Impressionists and Impressionism*. Geneva and London 1981.

Braudel, Fernand and La Brousse, Ernest: *Histoire économique et sociale de la France. III: L'Avènement de l'ère industrielle (1789 - années 1880)*. 2 vols. Paris 1977.

Breeskin, Adelyn D.: *Mary Cassatt: a Catalogue Raisonné*. Washington 1970.

Cailler, Pierre (ed.): *Manet raconté par lui-même et par ses amis*. Geneva 1945.

Champa, Kermit S.: *Studies in Early Impressionism*. New Haven and London 1973.

Chevalier, Louis: *La Formation de la population parisienne du XIXe siècle*. Paris 1950.

Clark, Timothy J.: *The Painting of Modern Life, Paris in the Art of Manet and his Followers*. New York 1958.

Cooper, D.: *The Courtauld Collection*. London 1954.

Corbin, Alain: *Les Filles de noces; misère sexuelle et prostitution: 19e et 20e siècles*. Paris 1978.

Courtine, Robert: *La Vie parisienne, cafés et restaurants des boulevards, 1814-1914*. Paris 1984.

Crespelle, Jean-Paul: *La Vie quotidienne des impressionnistes*. Paris 1981.

Daule, François: *Alfred Sisley: Catalogue raisonné*. Lausanne 1959.

Dauzet, Pierre: *Le Siècle des chemins de fer en France*. Paris 1948.

Denvir, Bernard: *The Impressionists at first hand*. London 1987.

——*An Encyclopaedia of Impressionism*. London 1990.

Elwitt, Sanford J.: *The Making of the Third Republic, Class and Politics in France, 1868-1884*. Baton Rouge 1975.

Evitt, Eliza: *The Critical Reception of Japanese Art in Europe in the late nineteenth century*. Ann Arbor 1982.

Flint, K.: *Impressionists in England. The Critical Reception*. London 1984.

Gordon, Robert and Forge, Andrew: *Monet*. New York 1983.

Grand Palais, Paris: *Hommage à Claude Monet*. Catalogue, Paris 1980.

Grand Palais, Paris: *Degas*. Catalogue, Paris 1988.

Guest, Ivor: *The Ballet of the Second Empire, 1858-1870*. London 1974 [1953, 1955].

Hamilton, George H.: *Manet and his Critics*. New Haven 1954.

Hanson, Anne Coffin: *Manet and the Modern Tradition*. New Haven and London 1977.

Hayward Gallery, London: *Pissarro 1830-1903*. Catalogue, London 1981.

Hayward Gallery, London: *Renoir*. Catalogue, London 1985.

Herbert, R.L.: *Impressionism: Art, Leisure and Parisian Society*. London 1988.

House, John: *Monet: Nature into Art*. New Haven and London 1986.

Jean-Aubry, G.: *Eugène Boudin d'après des documents inédits*. Lausanne and Paris 1968 [1952].

Lemoisne, Paul-André: *Degas et son oeuvre*. 4 vols. 1946-49. Supplement accompanying reprint by Philippe Brame and Theodore Reff. New York 1984.

Levine, Steven: *Monet and his critics*. New York 1976.

McMullen, Roy: *Degas: His Life, Times and Work*. Boston 1984.

Journal of Social History. Marrus, Michae: 'Social Drinking in the Belle Epoque'. Vol. 7, Winter 1974.

Nochlin, Linda: *Realism*. London 1971.

Philadelphia Museum of Art; Detroit Institute of Arts; Grand Palais, Paris: *The Second Empire, 1852-1870. Art in France under Napoleon III*. 1978-79.

Pollock, Griselda: *Mary Cassatt*. New York 1980.

Rearick, Charles: *Pleasures of the Belle Epoque*. New Haven and London 1985.

Reff, Theodore: *Degas: The Artist's Mind*. New York 1976.

——*Manet and Modern Paris*. Washington 1982.

Renoir, Jean: *Renoir, My Father*. Boston 1962.

Rewald, John: *The History of Impressionism*. New York and London 1973 [1946].

Rivière, Georges: *Renoir et ses amis*. Paris 1921.

Sandblad, Nils G.: *Manet: Three Studies in Artistic Conception*. Lund 1954.

Seigel, Jerrold: *Bohemian Paris, Culture, Politics and the Boundaries of Bourgeois Life, 1830-1930*. New York 1986.

Tabarant, Adolphe: *Manet: Histoire catalographique*. 1931.

——*Manet et ses oeuvres*. 1947.

Tucker, Paul Hayes: *Monet at Argenteuil*. New Haven and London 1982.

——*Monet in the '90s*. Royal Academy, London. Catalogue, 1990.

Varndoe, Kirk: *Gustave Caillebotte*. New Haven and London 1987.

Venturi, Lionello: *Les Archives de l'Impressionnisme*. 2 vols. Paris and New York 1939.

White, Barbara Ehrlich (ed.): *Impressionism in Perspective*. Englewood Cliffs, New Jersey 1978.

——*Renoir: His Life, Art and Letters*. New York 1984.

Wildenstein, Daniel: *Claude Monet, biographie et catalogue raisonné*. 4 vols. Lausanne and Paris 1974-85.

Zeldin, Theodore: *France 1848-1945*. 2 vols. Oxford 1973 and 1977.

Zola, Emile: *Thérèse Raquin* (1867); *La Curée* (1872); *Le Ventre de Paris* (1873); *Son Excellence, Eugène Rougon* (1876); *L'Assommoir* (1877); *Nana* (1880); *Au Bonheur des dames* (1883); *Germinal* (1885); *L'Oeuvre* (1886); *L'Argent* (1891).

LIST OF ILLUSTRATIONS

416

PHOTOGRAPHIC ACKNOWLEDGEMENTS

ARTOTHEK: 24, 29, 32, 152, 393
BOARD OF TRUSTEES OF THE MUSEUMS AND GALLERIES ON MERSEYSIDE: 159
BRIDGEMAN ART LIBRARY: 4, 8, 19, 44, 50, 54, 72, 76, 152, 154, 185, 190, 208, 209, 216, 218, 223, 257, 264, 268, 282, 292, 305, 512, 359, 381, 382, 385, 589
AGENCE BULLOZ: 85, 211
Photo: RAY DELVERT: 160
ARCHIVES DURAND-RUEL: 323, 341, 368
COLLECTION DURAND-RUEL (Photos J-M ROUTHIER): 20, 226
EDIMEDIA: 2
AGENCE GIRAUDON (Photos LAUROS-GIRAUDON): 5, 6, 17, 41, 51, 79, 80, 93, 257, 508, 357, 353
COLORFOTO HANS HINZ: 289, 361
Photo: LUIS HOSSAKA: 39, 58, 189, 222
MANSELL COLLECTION: 11, 98, 199
MARY EVANS PICTURE LIBRARY: 21
REUNION DES MUSEES NATIONAUX, FRANCE: PHOTOTEQUE: 1, 14, 55, 56, 66, 75, 84, 87, 88, 90, 92, 94, 96, 98, 100, 110, 114, 115, 116, 128, 136, 143, 147, 151, 156, 178, 180, 182, 187, 192, 202, 215, 217, 225, 230, 240, 246, 252, 256, 259, 261, 264, 265, 277, 278, 296, 297, 298, 311, 315, 327, 328, 334, 338, 346, 348, 350, 378
AGENCE ROGER-VIOLLET: 253, 331
SCALA FOTOGRAFICA: 3, 10, 28, 99, 104, 134, 150, 205, 389
STUDIO BASSET: 65, 302
STUDIO LOURMEL (Photos: J-M ROUTHIER): 25, 196, 198, 207, 219, 271, 273, 340
SYGMA: 124
Other photographs have been kindly supplied by the museums, galleries and collections cited in the List of Illustrations.

INDEX